Past for the

Contents

OBJECTS OF MEMORY: MUSEUMS, MONUMENTS, MEMORIALS

Introduction

The Futures of the Past

PÉTER APOR AND OKSANA SARKISOVA

Since the late 1980s, when the changes in Eastern and Central Europe seemed overwhelming and access to previously restricted information grew exponentially, this region could safely claim an unpredictable past. Today, almost two decades after the fall of communist regimes, scholars working on the recent past are paradoxically challenged by the abundance of memory and the variety of witnesses' accounts, which confront the professional historical narrative with the simple claim "I was there and it was completely different." Walking down the street, having a family dinner, or flipping through postcards and photo albums, we all make daily inroads into history. What happens to the sites of memory which remain fiercely contested in the present? What role can historians play in the "foreign country" of the past—that of natives, tourguides, or a select priestly caste? What new meanings are inscribed on the images retrieved from the past?

The individual contributions in this volume share a common methodological concern: how can visual material participate in the (re)constructions of the past? The invention of photography, the subsequent spread of documentary filming and the relatively recent boom of a global television culture do not merely provide the historian with an abundance of new visual sources, but also inspire the scholar to develop innovative research tools to cope with this challenging historical material. Whereas visual material has been long used for historical reconstruction, its relationship to written sources was always controversial. During the institutionalization of the profession in the nineteenth century, information obtained from different kind of sources were ordered hierarchically. In the heyday of historicism, the conclusive information for the historian generally meant various forms of written text. While visual sources were also studied extensively, this task was usually delegated to "auxiliary sciences" like archeology, numismatics or heraldry or confined to the independent discipline of art history. Due to the relative paucity of written documents in these periods,

mostly students of ancient or medieval history achieved considerable expertise in working with visual material.[1] Historians of more recent periods learned to value the increase in the amount of written sources and focused their investigations on well-documented aspects of diplomacy, high politics and military operations. With the appearance of modern social and cultural history and the growing amount of visual documentary, increasingly from the mid-twentieth century, this hierarchy of sources started to be questioned and challenged and more sophisticated methodologies of simultaneous utilization of visual and written material have been elaborated. Continuing this tradition, questions about the relationship of written archival documents and other types of evidence—photographs and artifacts, sculptures and monuments, documentary and fiction films—will be raised throughout this volume.

Historiography, the history of historical knowledge, generally means almost exclusively the study of the changes and modifications in the modes and genres of historical writing; the historicity of visual perception and its contribution to the shaping of modern historical comprehension have only recently come to the attention of scholars.[2] The essays in this volume analyze the way visual practices produce historical representations. In the cinema, historical narratives can be created both with and without involving professional historians, while the impact of the work only indirectly depends on the quality of professional expertise. Nonetheless, directors of both documentary and feature films evoking the past rely on historical methods of inquiry, collecting (visual) traces, and creatively (re)imagining past occurrences, as Natalie Zemon Davis has shown in her analysis of historical re-constructions of slavery through motion picture.[3] The volume, therefore, cannot avoid addressing the controversial relationship of the historian and the artist. In films evoking different historical contexts, the double role of the artist and the historian is fairly obvious. This is true, however, also of museums, where a historical exhibition,

[1] Jacques Le Goff, *History and Memory* (New York: Columbia University Press, 1992; Jan Assmann, *Das kulturelle Gedächtnis: Schrift, Erinnerung und politische Identität in frühen Hochkulturen* (Munich: C. H. Beck, 1992).

[2] Reinhart Koselleck, "Modernity and the Planes of Historicity" in *Futures Past: On the Semantics of Historical Time* (Cambridge MA–London: MIT Press, 1985), 3–20; Carlo Ginzburg, "Distance and Perspective: Two Metaphors" in his *Wooden Eyes: Nine Reflections on Distance* (New York: Columbia University Press, 2001), 139–56; Chris Jenks (ed.), *Visual culture* (London: Routledge, 1995).

[3] Natalie Zemon Davis, *Slaves on Screen: Film and Historical Vision* (Cambridge, MA: Harvard University Press, 2000).

albeit acknowledged as a professional scholarly activity parallel to the formation of historical research, is usually the result of the collaboration of the expert in historical matters and the creative artist designer. To what extent can the activities of the artist and the historian reinforce, contradict, or remain in dialogue with each other? What are the similarities and the dissimilarities between the artist using historical allegories and analogies to produce general moral claims and the historian explaining particular situations? Where are the limits of moral judgments by artists and historians? Is there an inherent responsibility of historical interpretation embedded in the tradition of visual representation?

Cinema and museums are fruitful grounds for exploring these questions. Using the mimetic "authenticity effect," the moving images construct the stories which work towards gradually reshaping the image(s) of the past. A comparison of the national case studies of cinematic output in Eastern and Central Europe demonstrates the transformations experienced by the cinema as an institution and provides additional insights into the cultural context of the present. The possibility of bringing together historical transformations and visual material facilitates the use of the latter in teaching while calling for the development of analytical tools following the further erosion of academic boundaries after the "visual turn."[4] The mechanisms—from narrative devices to experiments with montage—used for creating coherent images about the past, can work towards demonizing some historical periods or coloring others with a shade of nostalgia. The mechanisms of meaning attribution are explored in numerous examples; the fusion of "authentic" footage and "invented" fiction creates opportunities for legitimizing the most contradictory statements. Despite an imposed geographical classifier, the Eastern European cinematographies of the past decades demonstrated very diverse developments, bearing witness to a plurality in representing the past, the strength of national traditions, and a variety of artistic responses to the political, economic, and cultural changes. Along with the narrative structures, the objects of the past are able to generate immediate recognition and emotional resonance. In this context, films act as "virtual museums," putting on displays and contextualizing the artefacts in a manner similar to museum exhibitions. Bringing together the cinema and museums makes it possible to design landscapes of individual memories via a collective enterprise.

If one recollects the strange but characteristic obsession with obscure relics of the recent past, such as communist medals or images of the "great

[4] Nicholas Mirzoeff (ed.), *The Visual Culture Reader* (London: Routledge, 1998).

leaders,"[5] as well as the frenzy of demolishing old statues and erecting new monuments or the mushrooming of peculiar museums dedicated to the terror of a dictatorship,[6] the conclusion that physical objects play a significant role in the relationship of the present to the recent past becomes obvious. The museums of classical historicism—where the value of the exhibited objects derived from the fact that they were able to authentically represent and preserve the meaning of the past—tangibly demonstrated the origins of nations in the past and their unbroken historical continuity since.[7] It is precisely this "touch of the real" that makes historical exhibitions so attractive for many variants of the politics of history and memory. The relationship of the present to its recent past—or pasts—is generated through a peculiar practical activity concerned with the construction and destruction of things. Many of the museums representing Communism are either the actual result of, or closely connected to, resolutely articulated politics of commemoration. Museums, which are able to re-present the past, that is to say to make the past once again present, are perfect devices to fulfill the function of commemorations, to serve as "connective structures" towards history.[8]

<div align="center">***</div>

The research presented in this volume draws on and continues the work already started in different fields and academic cultures by a large number of scholars. The role of memory in connection with public memorialization and changing institutional norms of history production were thematized, among others, in the works of David Lowenthal, Pierre Nora, Jacques Le Goff, Dominick LaCapra, and Patrick H. Hutton.[9] Within a

[5] An eloquent example is in Svetlana Boym, *Common Places: Mythologies of Everyday Life in Russia* (Cambridge—London: Harvard University Press, 1994), 225–38.

[6] Volkhard Knigge, Ulrich Mählert (eds.), *Der Kommunismus im Museum: Formen der Auseinandersetzung in Deutschland und Ostmitteleuropa* (Cologne: Böhlau, 2005).

[7] Gottfried Korff, Martin Roth (eds.), *Das historische Museum: Labor, Schaubühne, Identitätsfabrik* (Frankfurt am Main: Campus, 1990).

[8] The goal of commemorative ceremonies is to make the past present and to eliminate the distance in time in order to create a consciousness of continuity. Paul Connerton, *How Societies Remember* (Cambridge: Cambridge University Press, 1989), 41–71. Assmann, *Das kulturelle Gedächtnis*.

[9] David Lowenthal, *The Past is a Foreign Country* (Cambridge: Cambridge University Press, 1985); Pierre Nora (ed.), *Les Lieux de mémoire*, vol. 1–3 (Paris: Gallimard, 1984–1992); LeGoff, *History and Memory*; Dominick LaCapra, *History and Memory after*

decade after the regime change in the region, first conclusions were drawn, concentrating mainly on the political and economic transformations.[10] In the last decade the teleological "transition" was replaced by a less linear "transformation" and the research expanded from political and social history to cultural dimensions of the changes.[11]

The considerable corpus of earlier scholarship related to East-Central Europe usually registered the disorder that characterized the evocations of the recent past and tried to explain this fact by arguing that historical interpretations in this region are politically driven and usually supported and maintained by various political groups.[12] History, thus, has become

Auschwitz (Ithaca: Cornell University Press, 1998); Patrick H. Hutton, *History as an Art of Memory* (Hanover—London: University Press of New England, 1993).

[10] See, for example, the special issue of *Slavic Review* 58 (Winter 1999) edited by Philip G. Roeder and titled "Ten Years after 1989: What Have We Learned?" Daphne Berdahl, Matti Bunzl, and Martha Lampland (eds.), *Altering States: Ethnographies of Transition in Eastern Europe and the Former Soviet Union* (Ann Arbor: University of Michigan Press, 2000); Sorin Antohi and Vladimir Tismaneanu (eds.), *Between Past and Future: the Revolutions of 1989 and their Aftermath* (Budapest: CEU Press, 2000); Hall Gardner, Elinore Schaffer, Oleg Kobtzeff (eds.), *Central and Southeastern Europe in Transition: Perspectives on Success and Failure since 1989* (Westport, CT: Praeger, 2000); Peter J. Anderson, Georg Wiessala, Christopher Williams (eds.), *New Europe in Transition* (London: Continuum, 2000).

[11] Sibelan Forrester, Magdalena J. Zaborowska, Elena Gapova (eds.), *Over the Wall/After the Fall: Postcommunist Cultures through an East-West Gaze* (Bloomington: Indiana University Press, 2004); Knigge, Mählert (eds.), *Der Kommunismus im Museum*, Dina Iordanova, *Cinema of the Other Europe: the Industry and Artistry of East Central European Film* (London: Wallflower, 2003); István Rév, *Retroactive Justice: Prehistory of Post-Communism* (Stanford University Press, 2005); Anikó Imre (ed.), *Eastern European Cinema*. See also *Kinokultura* e-journal, and especially the special issues devoted to Czech and Polish Cinema. Available at www.kinokultura.com/specials/4/czech.shtml and www.kinokultura.com/specials/2/polish.shtml (accessed 30 March, 2007).

[12] Maria Bucur, Nancy M. Wingfield (eds.), *Staging the Past: the Politics of Commemoration in Habsburg Central Europe, 1848 to the Present* (West Lafayette, IN: Purdue University Press, 2001); Stefan Troebst, *Postkommunistische Erinnerungskulturen im östlichen Europa: Bestandsaufnahme, Kategorisierung, Periodisierung* (Wroclaw: Wydawnictwo Uniwersytetu Wroclawskiego, 2005); Arnold Bartetzky, Marina Dmitrieva, Stefan Troebst (eds.), *Neue Staaten—neue Bilder? Visuelle Kultur im Dienst staatlicher Selbstdarstellung in Zentral- und Osteuropa seit 1918* (Cologne: Böhlau, 2005); Gabriela Kiliánová, "Lieux de mémoire and Collective Identities in Central Europe (The Case of Devín/Theben/Dévény Castle)," *Human Affairs. A Postdisciplinary Journal for Humanities & Social Sciences* 12 (2002): 153–65; Ulf Brunnbauer, Robert Pichler, "Mountains as 'Lieux de mémoire': Highland Values and Nation Building in the Balkans," *Balkanologie* 6 (December 2002): 77–100; Maria Todorova, "The Mausoleum

suspicious, and analysts of the East-Central European version of *Ver-gangenheitsbewältigung* tend to look for more authentic and allegedly undistorted methods. Historians, as well as other students of contemporary East-Central European public re-collections, try to understand the subject of their investigations as the result of collective mental practices and processes. This is usually described as collective memory, social memory or historical consciousness and believed to be possessed and dominated by the state or civil society; attempts to define it draw on insights from psychology, sociology or anthropology.[13] A number of works have introduced the issues of subjectivity and alternative memories which escaped both the totalitarian paradigms and a revisionism extolling grass-root resistance.[14]

The concept of collective memory as an appropriate way of studying public forms of evoking the past was derived from the Western European experience of coming to terms with Nazism and World War II.[15] The German and Western European process of critically rethinking the traumatic past has been catalyzed by considerable social pressure on the part of various collectivities that managed to open up channels for public communication and gain political support. Holocaust survivors, local communities, victims of rape, and ex-servicemen all claimed a voice for themselves in the on-going debate on the historical representation of the past. This current culminated in the most recent wave of resurrected inter-

of Georgi Dimitrov as lieu de mémoire," *The Journal of Modern History* 78 (2006): 377–411.

[13] Rubie S. Watson (ed.), *Memory, History, and Opposition Under State Socialism* (Santa Fe: University of Washington Press, 1994); Vieda Skultans, *The Testimony of Lives: Narrative and Memory in Post-Soviet Latvia* (London: Routledge, 1998); Jacob J. Climo, Maria G. Cattell (eds.), *Social Memory and History: Anthropological Perspectives* (Walnut Creek, CA: AltaMira Press, 2002); David Middleton, Derek Edwards (eds.), *Collective Remembering* (London: Sage Publications, 1990).

[14] Katherine Verdery, *What Was Socialism, and What Comes Next?* (Princeton, NJ: Princeton University Press, 1996); Alexei Yurchak, *Everything Was Forever, Until It Was No More: The Last Soviet Generation* (Princeton, NJ: Princeton University Press, 2005).

[15] Alf Lüdtke, "Coming to Terms with the Past: Illusions of Remembering, Ways of Forgetting Nazism in West Germany," *Journal of Modern History* 65 (Summer 1993): 542–72; Bernhard Giesen, "National Identity as Trauma: The German Case" in Bo Strath (ed.), *Myth and Memory in the Construction of Community* (Brussels: Peter Lang, 2000), 240–7; Tony Judt, "The Past is Another Country: Myth and Memory in Postwar Europe," *Daedalus* (Autumn 1992): 83–118; Charles S. Maier, *The Unmasterable Past: History, Holocaust and German National Identity* (Cambridge, MA: Harvard University Press, 1988).

est in re-thinking the memory of the European wars and the Shoah, and the attempt to capture and record their fading remembrance before the generation of witnesses finally died out.[16] One of the major transformations that occurred in the public assessment of the past in the Western hemisphere is the departure of professional history from its previous role of providing confirmation for the imagined glories of collective national histories. Instead of establishing and marking items worth remembering, it has begun to warn political communities not to forget and to remind them of those frequently uncomfortable memories they would like to cover up.[17] Simultaneously, a shared consciousness of Europeannes has begun to be based upon the re-assessment of the legacy of the continent's war-torn past in the twentieth century. British, French, German, Italian, and Spanish scholars have made tremendous efforts to re-allocate the memory of the two World Wars, the genocide and mass death, as well as public mourning, grief, and celebrations of heroes and victory as the common experience of Europeans.[18]

Our volume presents selected chapters on visual studies and museum studies as contributions to the debate which is slowly emerging mainly, but not exclusively in the former communist part of the world, concerning critical, and in most cases tragic, issues of recent history.[19] The contributions are based on research by young scholars from the region, many of whom studied at the Central European University (Budapest) and are

[16] Geoffrey H. Hartman, *The Longest Shadow: In the Aftermath of the Holocaust* (Bloomington: Indiana University Press, 1996); Lawrence L. Langer, *Holocaust Testimonies: The Ruins of Memory* (New Haven: Yale University Press, 1991); Harald Welzer, *Grandpa Wasn't a Nazi: Nazism and the Holocaust in German Family Remembrance* (Berlin: AJC, 2005).

[17] A theoretical reflection on this process is offered by Peter Burke, "History as Social Memory" in *Varieties of Cultural History* (Cambridge: Polity, 1997), 43–59.

[18] Jay Winter, Emmanuel Sivan (eds.), *War and Remembrance in the Twentieth Century* (Cambridge—New York: Cambridge University Press, 2000); T. G. Ashplant, Graham Dawson, Michael Roper (eds.), *The Politics of War Memory and Commemoration* (London: Routledge, 2000); Martin Evans, Ken Lunn (eds.), *War and Memory in the Twentieth Century* (Oxford: Berg, 1997); Helmut Peitsch, Charles Burdett, Claire Gorrara (eds.), *European Memories of the Second World War* (New York: Berghahn Books, 1999); Luisa Passerini (ed.), *Memory and Totalitarianism* (New Brunswick: Transaction Publishers, 2005).

[19] A separate volume with contributions on historical revisionism is published within the framework of the project. See Michal Kopeček (ed), *Past in the Making. Recent History Revisions and Historical Revisionism in Central Europe after 1989* (Budapest: CEU Press, 2007).

working on projects on recent history in an interdisciplinary perspective. As the largest international higher education institution in the region, and an example of the transformations in the region *par excellence,* the CEU has become the meeting point of different academic cultures, stimulating diverse generations of scholars to contribute to the on-going debate on regional transformations.

The OSA Archivum at CEU, whose mission is to obtain, preserve and make available research resources for the study of Communism and the Cold War particularly in Central and Eastern Europe, has been involved in exploring the issues of the historical memory of Communism since it was established in 1995. In 2004, it received support from the European Union Culture 2000 program for a three year cooperation project, entitled "History After the Fall—The Interdeterminacy of the Short Twentieth Century." It cooperated with five historical research institutions on this project: the Romanian Institute for Recent History (Bucharest), the KARTA Center (Warsaw), the Institute for Contemporary History (Prague), the Hannah Arendt Institut für Totalitarismusforschung (Dresden), and the Civic Academy Foundation (Bucharest).[20] The complex project was envisioned and completed under the guidance of István Rév (OSA Archivum) and included a series of seminars, workshops and exhibitions which concentrated on the intricate issues of historical revisionism. Among them was a workshop held at OSA Archivum in June 2006 and entitled "Visions after the Fall: Museums, Archives and Cinema in Reshaping Popular Perceptions of the Socialist Past,"[21] from which a number of the articles in the present volume were developed. The participants explored the way different themes and aspects of the history of the twentieth century came to be rewritten, reinterpreted and re-presented in a variety of media.

The authors, many of whom are at the beginning of their academic careers, experimented with inter-disciplinary approaches, interpreting visual material that brings together economic anthropology, legal studies, phenomenological close reading and a longitudinal study of visual material.

The volume concentrates on the historical problems of Eastern and Central Europe. However, the geographical delimitation does not seek to reify the region or to detach it from the debates on memorialization and *Vergangenheitsbewältigung* in other parts of the world. Taking up the

[20] For more information on the activities of the project, see www.osa.ceu.hu/2004/projects/culture2000/g.html (accessed 10 February, 2007).

[21] For a full program and presentation abstracts, see www.osa.ceu.hu/2006/2006-06-08.shtml (accessed 10 February, 2007).

concepts traditionally used in area studies and shaped either within the ideological framework of the Cold War (Eastern Europe) or (re)discovered as an alternative to it (Central Europe),[22] the contributions point to the divergence of both historical and contemporary experiences, placing writing about the recent past in the region in a comparative perspective.

Prior to introducing the structure of the volume and the individual articles, a note on terminology is needed. There remains a plurality of the terms in use in the region—"Communism," "Socialism," "State Socialism," and "really existing Socialism" among others—which have provoked both reflection and criticism.[23] However, the proposed solutions, such as, for example, Andrew Roberts's suggestion to apply universally the term "communism" to all the societies of Eastern Europe, since "[i]t is hard to take the democratic left seriously when it is put in the same camp as the former dictators of eastern Europe," has strong drawbacks.[24] While a refusal to accept the divergent regimes' self-definitions and the application of a uniform notion in their place would put a seeming end to the terminological confusion, our decision was to preserve the diversity of terminology used by the authors and the subjects of their analysis. This decision was rooted in the intention to further exemplify the heterogeneity of the region, which is all too often viewed with (post-)Cold War logic as a homogeneous set.

The role of visual representations of history in re-shaping the social imagery of the socialist past is examined from three angles in this volume. The contributions were selected so as to reflect upon the concepts of "document," "nostalgia," and "objects," which are crucial, but underexplored aspects of the complicated relationships between professional historical work and other social practices of evoking the past. The volume aspires to a geographical balance and refers to experiences in various countries and societies in East-Central Europe from the Baltics and Russia

[22] Peter J. Katzenstein (ed.), *Mitteleuropa: between Europe and Germany* (Providence, RI: Berghahn Books, 1997); Peter Stirk (ed.), *Mitteleuropa: History and Prospects* (Edinburgh: Edinburgh University Press, 1994).

[23] Andrew Roberts, "The State of Socialism: A Note on Terminology," *Slavic Review* 63 (2004): 349–66; Jan Kubik, *The Power of Symbols against the Symbols of Power: the Rise of Solidarity and the Fall of State Socialism in Poland* (University Park, PA.: Pennsylvania State University Press, 1994).

[24] Roberts, "The State of Socialism," 362.

through Poland, the Czech Republic, and Hungary to ex-Yugoslavia, Bulgaria, and Romania.

The articles in the volume are presented in three sections. The first section revisits the concept of a "document" by analyzing material and visual traces of the past, from secret police reports to film and television recordings, and disentangling the notions of "authenticity" and "fakery." The authors do not merely "discover" previously concealed or unaddressed sources, but raise complex questions as to the extent to which the material traces of the past can serve as "documents," and what happens in the process of their on-going reediting and reframing. Both István Rév and Renáta Uitz start by addressing the issues related to one of the most contentious legacies of the communist past, namely the workings of the secret police. Both concentrate on the powerful visual images which captured the public imagination and provoked extended debates. While Rév's story of a mysterious "man in the white raincoat" leads the reader from the story of filmmaker István Szabó towards the German cultural context and ends by raising questions of historical methodology as well as the historian's personal involvement and responsibility in passing a moral judgment, Uitz inserts visual material within a legal context of discussions on lustration and proper access to the preserved files of the secret police. She portrays the long afterlife of a "Duna-gate" scandal in Hungary and at the same time demonstrates the role of the media in reframing the visual material.

A different type of material traces is presented by Balázs Varga in his analysis of the montage film *Kádár's Kiss* by Péter Forgács, whose use of home footage in combination with "official" newsreels creates a contrapuntal structure, emphasizing the intertwining of the public and the private and pointing to the multi-layered and contradictory nature of memories. Forgács's methods of working with home cinema broaden the traditional ways of using visual material. The first section concludes with a short essay by a practicing documentary filmmaker and director of photography, Alexandru Solomon. His very personal account of his struggle to uncover one of the secrets of the communist past in Romania—the bank robbery that was turned into a show-trial of prominent Communists of Jewish descent in the 1950s—vividly demonstrates the misleading nature of visual traces as well as the fragility of personal memories. The ultimate impossibility of putting together a linear story prompts the filmmaker and the audience to look for more complex ways of coming to terms with the ever-evasive past.

The second section of the volume analyzes the context and visual formulas of the widespread nostalgia for socialism and/or its marked absence

and considers the dynamics of the change in different national contexts in Central and Eastern Europe. While nostalgia is far from being an exclusively regional phenomenon, its application to the socialist past has received insufficient attention.[25] The workings of nostalgia, taken here not as an individual longing but as a media-generated construct functioning as "memory with the pain removed,"[26] not only shed light on the mechanisms of ascribing new meaning to the visual material, but give great insights into the political and economic developments of the day. In an overview of how the past is (re)constructed on the screens in Poland, the Czech Republic, Serbia, and Russia, the authors address the on-going commercialization of the past in the cinema as an industry. At the same time, these articles emphasize the existing thematic and stylistic continuities, which challenge the originally welcomed radical break with the past. With a closer look at the thematic motifs and visual components of the film fabric, the past appears to be less of a "foreign country" to the audiences. Nevena Daković's case studies not only demonstrate how the dissolution of Yugoslavia is reflected in a variety of films and many different ways—from evoking deeply private memories to constructing meta-historical discourses—but they provide theoretical foundations for the concept of nostalgia in cinema, pointing out that its "constitutive elements" were already experimented with in the 1970–80s in Yugoslavia. Another strong continuity, this time with the tradition of the Czech New Wave, is introduced by Petra Dominková. Analyzing the films that portray the communist past and attitudes towards it in contemporary Czech cinema, she discovers the domination of light genres, where the past is reconstructed as farce rather than tragedy. Kacper Pobłocki and Oksana Sarkisova focus on the dynamics of the emerging nostalgia in a Polish and a Russian context respectively. They stress the importance of analyzing the late-socialist works for an understanding of the dynamics of change as well as the visual motifs and challenges faced by contemporary directors. The growing salience of "everyday Socialism" as opposed to the political crime stories, which are characteristic of the first years after the change of

[25] Among important exceptions see Svetlana Boym, *The Future of Nostalgia* (New York: Basic Books, 2001); Maya Nadkarni, Olga Shevchenko, "The Politics of Nostalgia: A Case for Comparative Analysis of Post-socialist Practices," *Ab Imperio* 2 (2004): 487–519; Zala Volčič, "Yugo-Nostalgia: Cultural Memory and Media in the Former Yugoslavia," *Critical Studies in Media Communication* 24/1 (2007): 21–38; Nicole Lindstrom, "Yugonostalgia: Restorative and Reflective Nostalgia in Former Yugoslavia," *East Central Europe* 32/1–2 (2005): 227–38.

[26] Lowenthal, *The Past is a Foreign Country*, 8.

regimes, exemplify a sensitive reaction on the part of the film industry to the changing tastes of the audience.

The third section takes the "objects of memory" as its subject. The contributions to this last sub-theme investigate the various practices of collecting, interpreting and exhibiting the physical remnants of the socialist past, that is, the various attempts at establishing museums of Communism. The section concentrates on these museums as actual exercises in displaying history, as they approach their subjects as an empirical and not simply a theoretical issue, thus providing close readings from inside the walls. Nonetheless, the authors, who are independent researchers, offer critical analysis from a proper distance.[27] Zsolt K. Horváth examines the emergence of four different post-socialist attitudes towards the socialist past in relation to four actual sites of memory. Drawing on Pierre Nora's observation on the role of social recollections in shaping the image of the past in modern Europe, his chapter points at the extraordinarily intricate relationship between the professional interpretation of recent history and the various social and political initiatives for commemoration. Horváth analyzes the role of Kádár's grave, the monumentalization of 1956 in Budapest, the Statue Park with its communist memorial statues, and the House of Terror museum in contemporary Hungarian historical culture. Gabriela Cristea and Simina Radu-Bucurenci reflect in their joint article upon current Romanian trends of exhibiting the communist past. Their contribution registers the recent momentum of an anti-communist imagery in Romania which connects the President's official politics of history with similar earlier attempts of the Orthodox Church and civil organizations. The authors argue—using the Museum of the Romanian Peasant in Bucharest and the Memorial and Museum of the Victims of Communism in Sighet as examples—that this anti-communist representation extensively builds on Christian symbols and articulates a quasi-religious interpretation of the martyrdom of the nation.

In contrast to these spectacular attempts to visualize Communism, Nikolai Vukov interprets the lack of similar initiatives in Bulgaria. Analyzing the sole attempt at "exhibiting Communism" in Pravets, in the museum of Todor Zhivkov, Vukov introduces a third way of evoking the past apart from remembering and forgetting. He claims that in contemporary Bulgaria the socialist period remains "unmemorable" and "unforgettable" at the same time. James Mark's article on the museums in the Baltic coun-

[27] Knigge, Mählert (eds.), *Der Kommunismus im Museum*, in contrast, provides either general theoretical contributions or descriptions by the actual museum staff.

tries points out the connection inherent in the representation of Communism and Fascism. However, as Mark argues, this relationship is very problematic in the region. The exhibition of Fascism seems to provide the means to highlight the crimes of Communism, whereas the way Communism is displayed tends to render the horrors of Fascism less relevant. Izabella Main surveys the various—actual and virtual, realized and planned—museums of Communism in Poland. Her contribution argues for the diversity of recollections and interpretations, while differentiating between two main tendencies, one of which evokes Communism in order to forget, whereas the other calls for more remembrance.

Contemporary Central and Eastern Europe arguably provides an eloquent example of the relevance of public representations of the recent past. The articles in this volume offer a selective mapping of cultural landscapes in Eastern and Central Europe and seek to encourage further investigation into the ever-changing pasts of the region. Despite the concrete geographical focus, the general theoretical implications go beyond the Central and Eastern European debates about the representations of contemporary history. The particular East European experiences of Fascism and Communism, and especially the peculiar ways of conceiving them, have entered the sphere of public discourse in Europe. The essays in this volume, while eschewing clear disciplinary boundaries, address this general European problem and contribute simultaneously to the areas of recent history, visual studies, film studies, museum studies, and nationalism studies.

Documents of Communism:
Lost and Found

The Man in the White Raincoat

ISTVÁN RÉV

In the late morning of 30 October 1956, revolutionaries attacked the head-quarters of the Budapest Party committee, next to the City Opera in the eighth district of the city. Most probably, it was not a well-planned, pre-meditated siege; the attack was triggered by unsubstantiated and never confirmed beliefs about the existence in the cellars of underground prisons and torture chambers with hundreds of prisoners, women and children among them. The Ministry of Defense sent six tanks to assist the commu-nist defenders, but the head of the unit and the driver of the leading tank were both unfamiliar with that part of the city. The tanks, which had come to Budapest from a location sixty kilometers away, mistakenly started shelling the party headquarters, from whose windows the defenders were shooting at the attacking crowd. In the process they completely ruined the City Opera, while the insurgents in their turn stormed and occupied the party headquarters, brutally killing the parliamentarians who had been sent out under a white flag to negotiate a ceasefire. "We fucked up," said Major Gallo, the head of the unit, summarizing the results of the unlucky expedition at his post-revolutionary trial in 1957.[1] Altogether twenty-six Communists were killed in what turned out to be the bloodiest anti-Communist atrocity during the thirteen days of the 1956 revolution. There is speculation, even today, that the Soviets eventually decided to come back to defeat the revolution by military might as a consequence of the bloodbath on October 30. Several Western photographers and photojour-nalists were on the square at the time of the siege. George Sadovy sent a photo report to *Life*, which was reproduced all over the world. Jean-Pierre Pedrazzini, the twenty-seven-year-old *Paris Match* photographer, was killed while covering the events in front of the party headquarters. A fair

[1] László Eörsi, *Köztársaság tér 1956* [Republic Square 1956] (Budapest: 1956 Institute, 2006), 80.

number of film crews documented the events, and after the defeat of the revolution, the photographs and the footage of the fighting were used by the communist courts that tried the so-called "counter-revolutionaries" involved in the storming of the building.

Some of the footage shows a man in a white raincoat in front of the fallen building after the fighting, carrying a machine gun on his shoulder. He is hard to identify, as his features are barely visible, and in a curious way, men in photographs from 1950s Hungary look surprisingly similar, even when taken from relatively close up. Communism was a society of visible uniformity: there was only a very limited choice of clothing, the state-owned hairdressing salons offered the same haircut, and it would have been dangerous in any case to try to be markedly different from the majority. Nevertheless, there is only one person wearing a white raincoat among the armed revolutionaries in the photographs.

<p style="text-align:center">***</p>

On 27 January, 2006 *Élet és Irodalom* [Life and Literature], one of the most influential Hungarian cultural weeklies, published a long article under the title "The identification of an informer."[2] It was a few days before the opening of the annual Hungarian Film Festival with István Szabó's new film, *Relatives* (*Rokonok*, 2006). "The identification of an informer" is a piece of accidental investigative journalism. The author, a film critic, while working on a monograph on the history of Hungarian film in the past decades, in the course of his research, stumbled upon a file in the Historical Archives of the State Security, which contains the forty-eight reports written between 1957 and 1963 by an informer under the pseudonym "Endre Kékesi." The author of the article keeps up the suspense for a long time, but before the end of his lengthy investigative report he reveals that the person under the alias was a member of the famous class of 1956 at the Budapest Film Academy, and none other than the only Hungarian film director to receive the Academy Award for the best foreign language film, *Mephisto*, in 1982: István Szabó, who also received the award for best screenplay at the 1981 Cannes Film Festival.

The reports of the informer are in general quite uninteresting; there is no downright damaging information about any of the seventy-two people about whom Szabó reported during his six years as an informer. However,

[2] András Gervai, "Egy ügynök azonosítása" [The identification of an informer], *Élet és Irodalom* 50 (27 January 2006).

we can never be sure about the consequences of seemingly innocent sentences sent to the secret police, who arranged and rearranged information received from different sources and used it in ways that would have been unimaginable to the naïve informer, who tried not to harm those whom he betrayed. Péter Esterházy, the Hungarian novelist, provides a telling anecdote about his father, Count Esterházy, who was also arrested and recruited as an informer after 1956. In one of his reports, reproduced in Esterházy's second novel about his father, *Corrected Edition*, Count Esterházy, who worked as an underpaid, half-unemployed, freelance translator, describes a visit to his former family estate, where his former servants and maids welcome him in the local pub, hoping that within the walls their gestures of nostalgia and gratitude would remain hidden from the eyes of the authorities, who eventually learn about their sympathy towards the former landlord from the report written by the object of the sympathy himself. Despite the matter-of-factness and neutral tone of his description, retribution follows, and the former servants either lose their jobs or suffer other kinds of punishment as a result of the report of the contrite informer, who certainly never meant to punish his faithful former servants.

Next day István Szabó gave an interview to the Hungarian daily with the largest circulation, the former official newspaper of the Communist Party:

> I am grateful to fate, and in retrospect, I can be very proud of what happened. My work for the state security was the bravest and most daring act of my whole life. With the help of my work for the security services, we managed to prevent one of our classmates being caught after the 1956 revolution and saved him from the gallows. (...) We succeeded, and he became a world famous film director. (...) I made a life-long commitment to my friends not to talk about this affair. But fifty years have passed since then, the regime has changed, and something for which one would have been hanged has turned into a glorious heroic act. (...) I am talking about Pál Gábor, [director of *Vera Angi*, 1979, a deservedly famous film about the Stalinist period in Hungary] who was my classmate in 1956. On the day of the siege of the party headquarters, I visited another classmate of ours. Then, unannounced, Pál Gábor arrived with a gun on his shoulder and said that he had come from Köztársaság square, where they had stormed and occupied the building. (...) Then the Soviets came in, and by that time Pali was very frightened. We promised each other that we would never talk about his participation in the storming of the building, and we would save him in every conceivable way. (...) I was arrested with two of my classmates in February 1957. The reason is unknown to me to this day. We were held at the police station for three days, and we had to tell them everything about our classmates and also about ourselves. One of the two is still alive, and I do not have the right to reveal his name. The other

was Ferenc Kardos [another film director], who is no longer alive. On the third day they forced me to sign a paper to the effect that I would report about life at the Film Academy. (...) When I came out I went to Gyöngyössy [another classmate, who would also become a film director] and told him everything. He was much older than most of us, very experienced, having already spent three years in prison in the early 1950s, and he persuaded me to accept that role, which would enable us to misinform the authorities and save our friend from the square. (...) This did not seem to be a too great a sacrifice for a friend. I really wanted to protect my classmates. This was my only ambition. I do not know how it was possible that although he was visible in that newsreel among the gunmen in front of the party headquarters, he was not recognized and arrested. (...) In 1958, while working as an assistant at the documentary film studio, I chanced to open the door of an editing room, and to my horror I glanced at footages from a documentary made on the square. I immediately recognized Pál Gábor in a white raincoat with a gun in his hand. It was a horrible moment. In the evening, I ran up to Gyöngyössy, and told him what I had seen. He asked me who else had seen the footage. I answered that there were only two people in the editing room, and nobody else had seen the pictures. It was he who told Pali what I had seen.[3]

From Szabó's words, it is fair to assume that what he felt in the face of the revelation was most probably shame; that is why it was so important for him to present his deed as a heroic act. The deeply buried secret had suddenly surfaced. Having been exposed, he felt it necessary to emphasize that he was proud of his act, which he did not consider as surrender, but rather as a sacrifice laid under mortally dangerous conditions on the altar of friendship. Pride is the opposite of shame, if shame is defined as "being seen, inappropriately, by the wrong people, in the wrong condition," as Bernard Williams, the moral philosopher, formulated its primary meaning.[4] Szabó insisted that his was an act of bravery, which is furthest from what one can be ashamed of, for "shame is the emotion of self-protection," as Gabrielle Taylor remarked.[5] He obviously did not feel any guilt. "The root of shame lies in exposure (...) in being at a disadvantage (...) a loss of power."[6] Szabó repeated several times in the interview that his enemies wanted to destroy him, that the news of the revelation was sent to the international media in order to undermine his position as an internationally acclaimed artist, that the

[3] István Szabó, "Szembesítés" [Taking sides], Népszabadság (27 January 2006), available at www.nol.hu/cikk/392171/ (accessed 28 March, 2007).

[4] Bernard Williams, Shame and Necessity (Berkeley: University of California Press, 1993), 78.

[5] Gabrielle Taylor, Pride, Shame and Guilt (Oxford: Oxford University Press, 1985), 81.

[6] Williams, Shame and Necessity, 220.

aim was to break his artistic career. He was afraid of the loss of his standing in the eyes of others. Shame is "the fear at anger, rather than fear of anger (...); [shame is] in its very nature a more narcissistic emotion than guilt."[7] Whereas shame can be considered as more self-centered, self-directed, guilt is directed to the other, the victim of the shameful act; guilt is closely connected to the acceptance of responsibility. Guilt and responsibility for one's despicable actions are related to the idea of reparation, compensation, healing. All such notions and emotions were apparently absent in Szabó's reaction.

Two days later the best-informed historian of the 1956 armed struggle contradicted Szabó's claims. The historian stated with real confidence that the man in the white raincoat was not Pál Gábor but László Marsányi, a twenty-one-year-old artisan, the head of a small insurgent group, who lived in the eighth district of Budapest and emigrated to the West after the revolution, at which point he disappeared from the sight of the authorities, the police, and scholars. Eight members of his group were identified, arrested and tried, and seven of them were sentenced to death and executed. The historian did not want to make Szabó's life even more difficult, but he felt it important to note that all those who had been so visible in the pictures taken at the site of the siege of the building—and had not emigrated in the meantime—were arrested and tried, and in most cases sentenced to death. The authorities did not let anybody escape who could be identified in the photographs.[8]

The next day the media found László Marsányi in Australia; he had not visited Hungary since he left at the end of 1956. He confirmed that he had been among the fighters on the square but the quality of the photograph he received made it impossible for him to state with confidence that he recognized himself.

The surviving members of the 1956 Film Academy class called an international press conference in defense of their friend István Szabó. All five filmmakers whom Szabó had reported on, claimed that they recognized beyond doubt their former classmate, Pál Gábor, in the pictures. They are outstanding, although somewhat elderly visual artists with—one would think—above average visual skills and excellent eyes, which should enable them to identify images. A few days later, one of them published an essay, in the same journal that had revealed Szabó's past, in

[7] Ibid., 221–2.
[8] "Ki a ballonkabátos férfi?" [Who is the man in raincoat?]. *Népszabadság* (30 January 2006), available at www.nol.hu/cikk/392467/ (accessed 28 March, 2007).

which he confessed that he had been one of the two men, arrested together with Szabó, and also recruited by the secret police as an informer.[9]

August 2006 saw the publication of an interview with György Hoffmann, a former photojournalist of MTI, the Hungarian National News Agency. Hoffmann had taken pictures in the square and sold them to well-known western photographers, who could pay him more than he would have received, had he sold them under his own name. "Laci Marsányi was my classmate at school, we sat together on the same bench for three years, and I am sure that it is not him in the photograph. I met Marsányi several times during the revolution, and he did not wear such a long coat; he wore a rather short coat instead. I remember this very well, there are things that remain inscribed in one's memory forever."[10]

In the meantime 117 public figures, including well-known artists, filmmakers, Szabó's former classmates, and politicians, signed a petition on Szabó's behalf, reminding the public that he had been making exceptional and important films, dealing with crucial and timely historical and ethical issues, for forty-five years; he had brought fame to Hungary, making Hungarian culture known all over the world. "We love him, we honor him, and we praise him," wrote the illustrious group, which included even the first post-communist president of the country, who had been sentenced to life imprisonment after 1956; his signing of the petition did not remain unnoticed.

A copy of the documentary on the siege of the party headquarters with the man in the white raincoat is in the collection of the OSA Archivum, where I work. I know the film, in which the man in front of the besieged building appears for less than two seconds. When Szabó accidentally caught a glimpse of the footage through the open door of the editing room, it would have been impossible for him to recognize his classmate. Even when the film is slowed down or stopped and the frame is enlarged (none of which was possible for Szabó at that moment back in 1958), it is still impossible to identify the figure with any certainty. It is therefore highly unlikely that Szabó was able to recognize Pál Gábor in the footage. Gábor's widow has declined to tell in public what she knows.

The original report about Szabó's past was published only a few days before the opening of the annual film festival, and numerous voices in the media interpreted the timing as evidence of a premeditated smear cam-

[9] Zsolt Kézdi-Kovács, "Jelentek" [I report], *Élet és Irodalom* 50 (3 February 2006).
[10] "Interview with György Hoffmann, photographer on 21 August 2006," http://1956. mti.hu/ Pages/Hoffmann.aspx (accessed 27 March, 2007).

paign at the time of the release of the director's long-awaited new movie. The opening night at the largest cinema in Budapest turned into a public demonstration, with the socialist Prime Minister (a member of the successor party to the pre-1989 Communists) affectionately congratulating the director in front of the cameras, hugging him and calling him "a national treasure." The head of the right-wing opposition did not want to be left out, and he, too, expressed his support for the embattled artist in the presence of a cheering crowd, while a few others, in a demonstrative way, left the theater without waiting for the applause. The next day two hundred intellectuals signed a mock-petition with the clear intention of distancing themselves from those who had demonstrated in support of Szabó. A long and heated media battle started, centering on the case of the famous film director, but with more far-reaching moral implications in a country where after more than one and a half decades there is still no proper legal method of dealing with former informers and with the documents of the former secret services in general. Those historians who work on morally loaded events of the recent past, in particular on issues related to the life and work of former informers, have often been publicly accused of inappropriate treatment of contentious and sensitive events.

<p style="text-align:center">***</p>

In Hungary, unlike Germany, there was no Gauck Commission, no general vetting of former Stasi agents; in contrast to Czechoslovakia, no lustration; as opposed to Poland no systematic (although always unsuccessful and invidious) attempts to identify the informers of the past regime. As an almost natural consequence of the peaceful, negotiated nature of the political transition of 1989, based on mutual self-restraint and compromise, not only could the members of the former *nomenklatura* retain their positions in public life, but—except for a small and well-defined group of elected officials (members of Parliament and the government, editors-in-chief of the public media)—nobody was required to undergo an examination of his or her former connections with one particular branch of the secret service, the branch responsible for fighting the so called "internal enemy." This restraint meant that former members of the intelligence and counter-intelligence agencies, even if elected to high public office, were not obliged to reveal their past. (In 2002, immediately after the general election, an opposition newspaper revealed that the newly elected Prime Minister—a former Deputy Prime Minister of the pre-1989 regime—had been a top-secret counter-

intelligence officer from the late 1970s. The Prime Minister claimed that he had accepted the job in order to help Hungary's entry into the IMF, against the maneuvering of the Soviets, since as a counter-intelligence officer he was in a better position to neutralize their subversive activities. He made this claim in spite of the fact that until 1989 there were high-ranking Soviet officials, so-called advisors, in the Ministry of the Interior, and no serious personal appointment could be made to the secret services without the prior consent of the representatives of the Soviet secret services. He remained in office, and after the revelation, his popularity reached an all-time high.)

Until recently, files on former informers were available only to well-defined groups of individuals: people who had been informed on, or researchers who had received permission from the special archival commission set up by the government. In the past few years, files of other branches of the former secret services, including selected, pre-1989 documents from the archives of the intelligence and counter-intelligence services, have become available to researchers with permission from the same archival commission. Nevertheless, even today the successor services have far-reaching discretionary rights in deciding which documents to transfer to the Historical Archives of the State Security, and in the absence of proper inventories, indexes and catalogues, the researcher is completely dependent on the intentions and the good or bad will of the institutions and the archivist. Nobody has an overview of the extent or the exact nature of the files. Researchers are working in the dark, and the availability of documents is a matter of sheer luck and the helpfulness of civil servants, who do not know whom they are supposed to be helping: the institutions, the victims, the researchers, the public, or the data protection Ombudsman, whose overriding priority is to protect the privacy and informational self-determination of those individuals about whom information is available in the depths of the archive. According to the law, information concerning public figures should become public, but the status of public figure is dependent on the consent of the individual; if the famous film director, who later on became the powerful and highly influential head of a state-owned film studio under Communism, does not consider himself a public figure, information about his former secret life is not public information. The consequence of this situation is that politically sensitive information about selected individuals is leaked in the service of the ever-changing political needs of the day. (My agent only served the public good, while your agent was a morally corrupt traitor.)

In the past one-and-a-half decades the revelations have customarily been followed by expressions of sympathy and solidarity, as if the identification of important, publicly known figures as former informers could mitigate the collaborationist past of the wider public. In this situation the historian has a distinctive role and a special responsibility. It cannot be denied that the informer is the collaborator of the historian. The informer's reports are invaluable sources for the historian, who would not be able to understand the crucial issues of the buried and forgotten past without the rediscovered secret reports of this dubious character. The secret police archives are goldmines for the historian, who, nevertheless, cannot be unambiguously grateful for the help provided by the informer.

Szabó, in the interviews he gave after the revelation, repeatedly claimed that although he had remained silent about his past for sixteen years, even after the collapse of Communism, he was under oath (allegedly to his friends) not to speak, and that in any case he had treated the problem of his past in his own films. As he claimed, his film *Confidence* (*Bizalom*, 1979), nominated for an Oscar, could already serve as a key to his thinking about the central moral issues that confront the individual under dictatorship. "In *Confidence*"—as Szabó confided in the pages of *Film Quarterly*—"the Gestapo of suspicion and distrust" haunts the protagonists.[11] *Confidence* is a peculiar love story created under the spell of Ingmar Bergman's 1968 *Shame,* which takes place in wartime. It is set during the short-lived but tragic rule of the fascist Arrow Cross at the end of World War II in Hungary. The protagonist, an underground resistance fighter, falls in love with the wife of another partisan. The man is unable to have any real confidence in the woman, who loves him and whom he should trust, not only as a lover but also as a co-conspirator. He is unable to trust her because he cannot forget that it was his previous lover, in Germany in 1933, who had given him up to the Nazis. The film depicts a perverted world, where nobody can be trusted, where anybody might be reported on, betrayed, let down, and disappear without a trace.

[11] "Mephisto: István Szabó and the 'Gestapo of Suspicion,'" John W. Hughes' interview with István Szabó. *Film Quarterly* 35 (Summer 1982): 13.

Szabó's next film *Mephisto* was based on Klaus Mann's novel of the same title.[12] The protagonist of the novel is Hendrik Höfgen, whose real life model was Gustaf Gründgens, the famous German actor and stage director. Gustaf (later Gustav) Gründgens had appeared in Klaus Mann's first play, *Anja und Esther*, together with Klaus Mann's sister, Erika Mann, and Pamela Wedekind, the eldest daughter of the dramatist Frank Wedekind. The play, which portrayed a lesbian relationship, was staged at the Hamburger Kammerspiele, where Gründgens played more than seventy roles between 1923 and 1928. There are reasons to suppose that Klaus Mann became intimately attracted to Gründgens, who in 1926 married Erika Mann, although she was in love with Pamela Wedekind. Erika Mann and Gründgens divorced in 1929. During the time of the Weimar republic Gründgens, Bertolt Brecht's favorite actor, flirted with the Communists and he even planned—as Szabó showed in his *Mephisto*—to direct some sketches under the title "Revolutionary Theater." Max Reinhardt, one of the founders of modern theater, invited him to Berlin, and in the 1932–33 season Gründgens played Mephisto in Goethe's *Faust* for the first time under Reinhardt's direction. In 1931, Gründgens played the role of Schraenker, the crime boss, in Fritz Lang's first talking movie, *M.—Eine Stadt sucht einen Mörder*, which was seen by some, including Siegfried Kracauer and Klaus Mann, as a premonition of the Nazis' rise to power.[13] Although the film was banned by the Nazis, the speech made

[12] Klaus Mann wrote the book in exile in Amsterdam and it was originally published in 1936 in the Netherlands. The first German edition was published in 1956 by the East German Aufbau Verlag. In 1964 a West German publishing house in Munich announced plans to publish the book in the Federal Republic, but at that point Peter Gorski, Gründgens's companion and adopted son, the director of the film version of *Mephisto*, decided to sue the publishing house in order to prevent the publication, which—in his view—would violate the honor, the reputation and the memory of his father. Although the court first rejected the claim, the appeal court accepted Gorski's case, on the curious ground that "The public is not interested in receiving a false picture of the theatre after 1933 from the standpoint of an emigrant." The German Federal Supreme Court upheld the ruling, and at this point, the publisher went to the German Constitutional Court arguing that the ruling was an infringement of his constitutional rights. The Constitutional Court, in its famous "Mephisto Decision," insisted that an individual's death does not put an end to the obligation of a country to protect that individual against the violation of his or her human dignity. Thus, the protection of Gründgens's honor had priority over the freedom of (artistic) expression. See Götz Böttner, "Protection of Honour of Deceased Persons: A Comparison between the German and Australian Legal Situation," *Bond Law Review* 13 (1 June 2001): 109–35. Klaus Mann's *Mephisto* was finally published in West Germany as late as 1980.

[13] Klaus Mann, "What's Wrong with anti-Nazi films?" *Decision* (August 1941): 27–35.

before the court by the serial killer Hans Becker, played by the Hungarian-born Jewish actor Peter Lorre, was later taken out of context by Goebbels and inserted into the most famous Nazi anti-Semitic propaganda film, *The Eternal Jew* (*Der ewige Jude*, 1940), as an ersatz confession of Jewish guilt.[14]

After Hitler came to power, Gründgens found a patron in Herman Goering, who was married to an actress. Goebbels, the Nazi propaganda minister, himself a failed novelist, intensely disliked the homosexual Gründgens, but in 1934 he appointed him director of the Prussian Staatstheater in Berlin. Like Wilhelm Furtwängler, Gründgens was also appointed a member of the Prussian State Council. He became one of the most recognizable faces of Nazi cultural policy and propaganda, acting and directing both on stage and on the screen. Influenced by the Nazi "total war" efforts, he volunteered for the front in 1943. He was stationed at an airbase near Amsterdam, then recalled to continue his politically engaged "*kultur* efforts" at the Staatstheater. After the war, he was incarcerated in a Soviet prisoner of war camp, but following his anti-Nazi investigation trial, he was rehabilitated, and continued his theatrical career, first in East, later in West Berlin, Düsseldorf, and Hamburg. In 1954 the Federal Republic decorated him with the German Service Cross, the highest civilian award, for his services to post-war German culture. In 1957 Gründgens directed Goethe's *Faust* in the Deutsches Schauspielhaus in Hamburg. He played Mephistopheles once more, and the performance was turned into a film, directed by Peter Gorski, Gründgens's post-war companion and adopted son.[15] He died of an overdose of sleeping pills in Manila, where he stopped on his round-the-world travels after retiring from the stage in Hamburg. He left a short note behind, asking not to be woken, as he wanted to have a long sleep.

On 22 December, 1999 on the hundredth anniversary of Gründgens' birth, an exhibition opened in the Berlin Staatsbibliothek, "Gustav

[14] According to the 1961 edition of the *Merriam-Webster Third New International Dictionary*, the term "serial murderer" was first used by Kracauer, when discussing the character played by Peter Lorre in Fritz Lang's *M*.

[15] Wolf Lepenies attributes the fact that while "in 1949, the majority of Germans considered Faust the most important character in Goethe's drama, ... fifty years later Mephistopheles had sneaked into first place—if only in the West[ern part of Germany]," to the fact that Gründgens's Mephistopheles both on stage and on screen was superior to the performance of Will Quadflieg, who played Faust in the Hamburg performance and in the film. The film was a huge success in West Germany at the time. *The Seduction of Culture in German History* (Princeton: Princeton University Press, 2006), 155.

Gründgens—A German Career." His life was turned into a television documentary, his films were shown in German cinemas. At the entrance to the exhibition hung a poster with a quotation from Gründgens, from the time following the war: "I want to be regarded as someone who preserved and nourished the flame in a dark period and someone who can relate how it was, how it is now, and how one can possibly rebuild."[16] At the time of the centenary, the *Frankfurter Allgemeine Zeitung* wrote that Gründgens was "a participant who did not collaborate."

Szabó's *Mephisto*—in George Steiner's words—presented the unholy fusion between *Kultur* and barbarism.[17] However, Klaus Maria Brandauer, the Austrian actor who played Hendrik Höfgen (Gründgens' personification) in *Mephisto*, told the film critic of *The New York Times*: "I saw him only in his films, but I read his books. For me, he was the most important figure of the German language theater in the whole century. He was not only an actor but a director and the president of a big theater. His life was theater. Only theater. The stage was for him the world in which he was able to live. (…) He saved Polish people, Jewish people from his theater during the war, and after the war the communist actor Ernst Busch from East Berlin said to the military government: Mr. Gründgens was a very honorable man during the war. And for that reason Gründgens became free."[18] (As the title of his review testified, the film critic Lawrence Van Gelder, did not quite share Brandauer's characterization.)

Brandauer gave a stunning performance in *Mephisto*. Klaus Mann portrayed the Gründgens of the novel as follows:

> Hendrik Höfgen—typecast as an elegant blackguard, murderer in evening dress, scheming courtier—see nothing, hear nothing. He has nothing to do with the city of Berlin. Nothing but stages, film studio, dressing rooms, a few night-clubs, a few fashionable drawing rooms are real to him. Does he not feel the change in the seasons? (…) The actor Höfgen lives from one first night to the next, from one film to another, his calendar composed of performance days and rehearsal days. He scarcely notices that the snow melts, that the trees and bushes are in bud or in full leaf, that there are flowers and earth and streams. Encapsulated by his ambition as in a prison cell, insatiable and tireless, always in a state of extreme hysterical tension, Hendrik embraces a destiny that seems to him exceptional but is in fact nothing but a vulgar arabesque at the edge of an enterprise doomed to collapse.

[16] Stefan Steinberg, "Die Rehabilitierung von Gustaf Gründgens," available at http://wsws.org/de/ 2000/jan2000/ (accessed 27 January, 2007).

[17] Quoted by John W. Hughes, "Mephisto," 14.

[18] Lawrence Van Gelder, " 'Mephisto.' Tracks the Dark Ascent of a Nazi Collaborator," *The New York Times* (March 21, 1982).

The audience of the film, however, sees not only an uncontrollably vain character, but also a great actor. Brandauer knows, exactly as Gründgens did, that Mephisto is his real chance of fame. "For an actor, the principal role in *Mephisto* is a dream—the portrait of an artist in moral decay, the opportunity to sweep through a panorama of roles, to sing, to dance, to rage, to rut, to swagger before underlings and cower in the presence of over-whelming power, to depict public confidence and private agony."[19] Brandauer takes to it like a fish to water; this is his supreme moment, the height of his artistic career. And he does not only excel in portraying a character who deems no price too high to pay for success, who is willing to serve the darkest powers for a chance to act out his exhibitionism, but he also succeeds in persuading the audience of the film that he is playing a great actor. "To act the part of Höfgen was like therapy for me, because Mr. Höfgen is an actor and I am, too; so he is a brother to me. We all have vani-ties. We want to have the love of the audience. We want to have success, and sometimes we make great compromises with the public to win suc-cess."[20] There is something chilly, and deeply unnerving in this fine per-formance: Brandauer manages to substantiate Gründgens's claim to have been the man "who preserved and nourished the flame in a dark period."

After the revelation that he had been an informer, Szabó insisted that although he had remained silent about the details of his career, in his films he had returned time and time again to this most personal issue of his life and had courageously faced the moral lessons of his secret: "We want to do nothing more than tell the story of what has happened to us," as he stated in an interview he gave in 1982, after the American opening of *Mephisto*. However, in the same interview he claimed that "we are often unable to carry out the more difficult tasks set for us by history. But it's not always people who are to blame for that. The human tasks set by his-tory in this century may be unique in their difficulty. As has also been stated, history is a kind of director deciding the roles we play in our indi-vidual lives (…) the dice are thrown by history."[21]

We should remember that Szabó finished working on *Mephisto* in 1981. In 1975, Leni Riefenstahl was the guest of honor at the Colorado film

[19] Ibid., 1.
[20] Ibid., 4.
[21] John W. Hughes, "Mephisto," 18 and 14, respectively.

festival. Next year Riefenstahl's spectacular and disquieting photo album on the males of a Sudanese tribe, *The Last of the Nuba*, was published. Susan Sontag's famous and scandalous review, "Fascinating Fascism," triggered by the publication of Riefenstahl's book, appeared in the *New York Review of Books* in the same year. (It was republished in her celebrated book of essays, *Under the Sign of Saturn*, in 1980.) The cover of the *Last of the Nuba* asserted that Riefenstahl sprang to international fame "during Germany's *blighted and momentous 1930s*." Many Nazi works of art were exhibited in public for the time after World War II at the 1974 Frankfurt am Main exhibition, "Art in the Third Reich." In 1977, the Haus der Kunst in Munich organized "Die Dreissiger Jahre: Schauplatz Deutschland" exhibition that traveled to Essen and then to Zurich. Ursus Books published a massive catalogue of the works on show. The "Utopia and Apocalypse: A View of Art in Germany 1910–1939" exhibition opened in London in 1978. In 1981, the "Realism" exhibition was organized in Paris. "The Thirties: Art and Culture in Italy" show opened in Milan in 1982. When Szabó turned to the art and culture of the Third Reich, he was not a solitary artist, working in a cultural vacuum, who had suddenly discovered the sunken world of the 1930s and 1940s. Susan Sontag remarked that it was not that Riefenstahl's Nazi past has suddenly become acceptable. Simply, with the turn of the cultural wheel it no longer matters in the way it did before.

In several interviews he gave after the collapse of Communism, Szabó reiterated that that he had turned to Nazi Germany as the setting of some of his films, because it would have been politically impossible to portray another totalitarian regime, that is Hungary or the Soviet Union. The Third Reich, according to him, served as a laboratory to test general moral problems, a substitute for Communism, as he knew it from personal experience. Szabó himself appears for a brief moment in *Mephisto*, standing on a grand glittering staircase in the middle of a spectacular Nazi party, surrounded by a forest of black flags with enormous red swastikas, and whispering to his neighbor: "and we are even supposed to applaud this…" But he turned to Germany even after the fall of the communist regime, when he was no longer forced to replace his personal experiences with stories set in pre- or post-war Germany. In 2001 he finished *Taking Sides* (*Szembesítés*), a film whose protagonist was Wilhelm Furtwängler, another emblematic figure of German culture. It seems that apart from the alleged historical analogies, there was something else that pulled Szabó towards Germany. As the unsettling case of the *Mephisto* film has already indicated, the deeper reasons may be found somewhere else.

Three years after his son published *Mephisto*, and eight years before he would finish *Doktor Faustus*, Thomas Mann wrote a strange piece on Hitler for *Esquire* magazine, in which he claimed that "the moral sphere (...) is really not altogether the artist's concern."[22] In his Tanner Lecture delivered at Harvard, Wolf Lepenies, the cultural sociologist and German public intellectual, argues that in Germany, from as early as the nineteenth century, but especially after the devastating defeat in World War I, culture became accepted as a compensation for politics, and when this happened, the absence of morality in the public sphere was also accepted.[23] Lepenies claims that "[t]he aesthetic appeal first of fascism and later of National Socialism was not a superficial phenomenon. It must be one of the core elements in any attempt to explain the attractiveness of Nazi ideology for a large segment of the German bourgeoisie and many German artists and intellectuals."[24] Lepenies here follows Fritz Stern, one of the leading historians of modern German ideology, who wrote that German public life could be understood by reference to the preeminence of culture that prevailed in Germany from the beginning of the nineteenth century.[25] According to Lepenies, "1933 was not a break, it was the fulfillment of German history. As Gottfried Benn [the German writer, who was blacklisted after the war] put it, the new state had to be commended not least because it promised to give culture its due: the separation between politics and culture was about the end. In the state of the Nazis, the cultural nation would be reborn."[26]

There was something unsettling in German culture that Walter Benjamin called the aestheticization of politics, the perverted "aesthetic appeal first of fascism and later of National Socialism [that] was not a superficial phenomenon,"[27] and which was an inherent part of Nazi self-identity. One

[22] Thomas Mann, "This Man is my Brother," *Esquire* 11 (1939). Quoted by Wolf Lepenies in *The Seduction of Culture In German History*, 46.

[23] Wolf Lepenies, "The End of 'German Culture,'" The Tanner Lectures on Human Values, delivered at Harvard University, November 3–5, 1999 available at www.tannerlectures.utah.edu/lectures/lepenies_01.pdf (accessed 27 January, 2007).

[24] Ibid., 174–5.

[25] Fritz Stern, *The Politics of Cultural Despair: A Study in the Rise of the German Ideology* (Berkeley: University of California Press, 1974). Stern remarks in a long footnote: "During both world wars, German intellectuals pictured the Allied Powers as the protagonists of civilization and as the enemies of culture, represented chiefly by Germany. The most regrettable example of the specious antithesis appeared in Thomas Mann's *Betrachtungen eines Unpolitischen* [originally published in 1918]." Ibid., 196.

[26] Lepenies, "The End of 'German Culture,'" 177.

[27] Lepenies, *The Seduction of Culture in German History*, 47. Lepenies's culturalist approach to recent German history is itself, probably, symptomatic of the times. As

should look beyond Szabó's words, when he claims that he escaped (in his films) from the communist censors to the stage set of the Third Reich. The Germany Szabó discovered for his moralizing films was fascinated by her own culture, the special standing and treatment of the artist, who decided to stay at home, serve his country, keep culture alive, even in the darkest of all times. The productive artist, according to this deep-rooted conviction of Germany in Szabó's films, has a responsibility; his acts cannot be judged on the basis of simple political or moral standards. His case is

George Mosse, the best-known historian of fascist culture and aesthetics argued: "Fascist scholarship has become increasingly aware of the role which aesthetics played in the movement's appeal; and that exploring the link between aesthetics, politics and society could open up new dimensions in our understanding of fascism...The study of fascism is slowly emerging from the period when this movement was almost solely discussed from the point of view of socialist theory, anti-fascism, or parliamentary government—measured by the standard of other ideologies—to a time when we can take the measure of fascism on its own terms, investigating its self-representation, and attempt to grasp it from the inside out." "Fascist Aesthetics and Society: Some Considerations," *Journal of Contemporary History* 31 (1996): 245.

As Paul Betts put it: "One of the most curious things about contemporary academic culture is the amount of recent attention devoted to what is now known as 'fascist modernism.' These days there seems to be no end to the intense international preoccupation with a subject that only a generation ago was routinely regarded as reckless and even repugnant, more recycled Third Internationalism than legitimate scholarship. This was especially true during much of the Cold War in Western Europe and the USA (...) What has emerged quite clearly since the events of 1989, however, is the extent to which these perceptions were products of the Cold War. Nowhere was this more apparent than in West Germany, where cultural imperatives often went hand in hand with political ones (...) Often this meant recasting fascist culture as a 'regressive interlude' in an otherwise redemptive tale of modernism triumphant (...) While dissenting voices challenging the supposedly elective affinity of liberalism, progress and modernism could be heard with increasing intensity from the 1960s on, it is really the end of the Cold War that spurred new curiosity toward the shadowlands of modernism (...) Regardless of its scholarly values, this new literature certainly marks a sea change in historiographical attitude and approach. Where the Cold War scholarship on fascist culture by and large concentrated upon its diverse causes, the new trend inclines towards investigating its multiple effects (...) Of growing concern instead to many cultural historians these days is the extent to which fascist modernism—including its narrative forms, visual codes and/or political mythologies—continued to influence the reorganization of postwar life and culture (...) The dismantling of the Berlin Wall converted the Cold War into instant history (...) But it is not as if the 'rush to German unity' rendered only the Cold War as the past: the same went for fascism and the second world war, whose legacies shaped the political and moral lives of the German republics." Paul Betts, "The New Fascination with Fascism: The Case of Nazi Modernism," *Journal of Contemporary History* 37 (2002): 541–3.

complex, and this should be taken into account when portraying and judging his life and achievements.

Taking Sides, based on the South-African Ronald Harwood's play (he too came from the world of a repressive regime) of the same title, presents Dr. Wilhelm Furtwängler's so-called de-Nazification investigation in a ruined Berlin, after the fall of the Nazi regime. It was once remarked that "conductors in our time fall readily into two categories: Wilhelm Furt-wängler and all the others. Among those who recognized this truth early on was Adolf Hitler, possessor of perhaps the best musical ear of any twentieth century statesman—except for Ignaz Paderewski [the famed concert pianist, composer and Prime Minister of Poland in 1919]. Despite many importunities and provocations in later years, Hitler never wavered in this judgment. A photograph of the Führer reaching upward to the podium to shake the conductor's hand after a 1935 concert of the Berlin Philharmonic is remarkable testimony—such expressions of respect by Hitler were rare."[28] Furtwängler (1886–1954), one of the most acclaimed conductors in the history of western classical music, Arturo Toscanini's great rival, was head of the Berlin Philharmonic Orchestra. He came from a very prominent, strict, serious, German upper middle class family. His father, Adolf Furtwängler, a classical archeologist, was one of the founders of Greek studies in Germany, director of the Museum of Antiquities in Berlin. Wilhelm Furtwängler's private tutors included the famous archeologist Ludwig Curtius, whom the Nazis forced into exile, and the Beethoven expert Walter Riezler. Wilhelm Furtwängler succeeded Arthur Nikisch as the conductor of the Leipzig Gewandhaus Orchestra and the Berlin Philharmonic; he was the musical director of the Vienna Philharmonic, and the head of the Bayreuth Festival. At the end of 1933, Goebbels set up the *Reichsmusikkammer*, the National Chamber of Music, headed by Richard Strauss, and Furtwängler was installed as its vice-president, while Goering appointed him to the Prussian State Council. Although he resigned from both bodies as a consequence of his disagreement about the interpretation Paul Hindemith's opera *Mathis der Maler*, he remained in Germany as one of the most important cultural figures who did not choose or were not forced to emigrate. Having been cleared by the civilian authorities in his de-Nazification trial, he returned to the Berlin

[28] Andrew Grey's review of Sam H. Shirakawa's *The Devil's Music Master: The Controversial Life and Career of Wilhelm Furtwängler*. "Life of a Much-Maligned Conductor Examined in New Biography," *Journal of Historical Review* 14 (January–February 1994): 1.

Philharmonic to conduct his first post-war concert in May 1947. At end of
the concert, the ovation lasted an hour and fifteen minutes, and there were
forty-seven curtain calls.

Classical music occupied a special position in Germany, particularly
under totalitarian and autocratic regimes. "Artistic bolshevism was car-
ried to extremes. Against all this there was but one remedy: a return to
the pure sources. What art was purer than that born of the deep religios-
ity of Bach, Beethoven and Bruckner! Especially Bruckner's God-
consecrated art... [Besonders Bruckners gottgeweihte Kunst]"—stated
the official Bruckner biography, published in 1936, two years before the
Anschluss.[29] "Kurt Masur, like Furtwängler, had been principal conduc-
tor of the Gewandhaus Orchestra in Leipzig, but unlike Furtwängler,
who had been invited but eventually rejected because of his standing
under the Nazi regime, actually became the celebrated musical director
of the New York Philharmonic after the fall of the Berlin Wall." His
"pivotal role in the mass demonstrations in Leipzig that helped to bring
down the DDR was itself an indication of the social significance, inde-
pendence, and prestige of musical culture and traditions he represented,
despite the state's official embrace and its concomitant censorship of
rival musical aesthetics" as was asserted by Leon Botstein, himself a
conductor and the musical director of the American Symphony Orches-
tra.[30] Botstein reminds us that "like the communists, the National Social-
ists were all-too-eager patrons of so-called classical music. (...) One
marvels at how the music of Bach, Mozart, Beethoven, and Bruckner
has emerged unscathed from the singular effort on the part of the Nazis
to appropriate it into National Socialist ideology."[31] But we should be
careful when evaluating the role classical music played in bad times,
despite the fact that at the end of the 1930s in official German cultural
pronouncements, Germany was identified as "*das Volk Bachs, Bee-
thovens und Bruckners.*"

The persistence of the "classical" tradition of musical culture in repressive so-
cieties does not itself render that tradition complicit in the success of political

[29] Max Auer, *Anton Bruckner: Ein Lebens-und Schaffensbild* (Regensburg: Bosse, 1936).
 61–2. Quoted by Benjamin Marcus Korstvedt, "Anton Bruckner in the Third Reich and
 after: An Essay on Ideology and Bruckner Reception," *The Musical Quarterly* 80
 (Spring 1996): 136.
[30] Leon Botstein, "The Future of a Tradition," *The Musical Quarterly* 77 (Summer 1993):
 155.
[31] Ibid., 156.

repression. The failure of music alone, in the sense of the instruments in Mozart's *Die Zauberflöte* or Joshua's trumpet in the Old Testament, to immediately either diffuse violence or make physical reality crumble does not constitute a valid argument against the culture of classical music. As observers from Eastern Europe will testify, the actual response of listeners was more often than not in direct conflict with the overt objectives of state patronage. Exposure to music in the concert hall strengthened the spirit of resistance, not the spirit of compliance, which is why the ongoing performances of music by the Gewandhaus orchestra may have been so crucial during the pivotal days of the demonstrations in Leipzig before the fall of the Berlin wall.[32]

In *Taking Sides* a major in the U.S. army—played by Harvey Keitel—an insurance assessor in civilian life, is instructed to investigate the links between Furtwängler and the Nazis. The major is shown documentary films of the horrors of the Bergen-Belsen concentration camp, and he is told to do whatever it takes to get proof of Furtwängler's collaboration with the Nazis. The American officer interviews members of Furtwängler's orchestra, but they point out that the conductor refused to shake hands with Hitler, which was why he carried his baton in his right hand, and that he helped Jewish musicians to escape from Germany. However, the American insurance broker reminds himself that Furtwängler conducted even on the eve of the Nazi Rally and Hitler's birthday; and that it was his performance of Bruckner's Seventh Symphony that was broadcast over the radio when Hitler committed suicide. There is a Soviet colonel in the film, a curator from the Leningrad Museum of Art, an expert on German art and culture, who tries to persuade the American to drop the investigation, because he had been instructed to take Furtwängler with him to occupy a position in the Soviet Union.[33] The Soviet colonel confides to his American colleague that unless he manages to take Furtwängler to the Soviet Union, as a war trophy, his life is in mortal danger.

In the course of the interrogation, the major repeatedly humiliates Furtwängler, whom he describes as Hitler's bandleader. The insurance

[32] Ibid., 156–7.

[33] This episode, most probably, comes from Gustav Gründgens's biography. In the course of his de-Nazification interrogation after the war in Chemnitz, one of the members of the commission, "a Soviet theatre officer, Arsenii Gulyga, argued powerfully in his favour. A condition for Gründgens's liberation was that he used his talents to promote the theatre in the Soviet-occupied eastern sector of Berlin." Gründgens was cleared, but soon he left East Berlin and moved to the West. In 1960, at the time of his retirement, however, he paid back his debt to the Soviet officer, by touring in Moscow and Leningrad, and appearing on the Soviet stage. See Stefan Steinberg, *Die Rehabilitierung*.

broker turned investigator discovers that a second violinist in the Berlin Philharmonic had been a member of the Nazi party and an informer for the Nazis. The violinist, personified by Ulrich Tukur, who played with great empathy a cynical high-ranking Stasi officer in the Oscar winning 2006 German film, *The Lives of Others* (*Das Leben der Anderen*) explains that he had been a member of the Austrian Communist Party, and when the Nazis found this out, he had no choice but to agree to become an informer; that is how he could become a second violinist in the orchestra, which had been purged of Jewish musicians. The American threatens the former informer and offers him a way out, if he tells everything damaging he knows about the conductor. The frightened musician first calls Furtwängler "a man of genius" but later confides that the conductor had not only arranged to send an art critic he disapproved of to the Russian front, but had also sent Hitler a telegram wishing him a happy birthday.

Furtwängler tries to explain to the determined and uncultured American that it was important for him to stay in Germany because music has the ability to promote liberty, humanity and justice, and he had no idea of what was happing in Germany. He asserts that he did not leave Germany "because I am not Jewish, and because I tried to help from the inside." The American remains unconvinced and confronts Furtwängler with anti-Semitic statements he made during the Nazi rule. The major recounts that when Hitler shot himself the radio played one of Furtwängler's recordings. "When the devil died they wanted his bandleader to conduct the funeral march." In the end Furtwängler is charged with serving the Nazi regime and uttering anti-Semitic statements. Eventually he is acquitted of all the charges. The film ends with footage of the Berlin Philharmonic Orchestra performing for top Nazi party officials and Furtwängler shaking the hand of the Führer. As he takes a bow, he rubs his hand on a handkerchief in an apparent attempt to rub away all contact with Hitler.

The apparently nonrepresentational, and thus polysemous facade of music makes the musician a perfect example for István Szabó. ("Music is music," as Edward Said recalled his childhood discovery in his memoirs.) As a result of the perceived surface neutrality of music, it seems as if the isolated composer or conductor had been engaged only in the pursuit of

his artistic vocation, independent of the political, social, ideological and cultural environment of his existence.[34]

Taking Sides, produced before the revelation of his past, as Szabó has put it in an interview, " 'was prompted by the need to rebuff numerous attempts in post-Communist Eastern and Central Europe to bring to book famous artists and intellectuals who worked during Communism. In order to invite people not to judge the situation in black and white terms and to understand better the complexity of art and politics in a totalitarian regime.' That is why he introduced two fictional, but very important secondary characters: Major Arnold's English speaking secretary Emmi (…) daughter of a German officer, executed for the failed attempt on Hitler's life, and his assistant, the German–Jewish-born, American-raised Lt. David Wills. (…) The growing affection between Emmi and David counterbalances emotionally Arnold's arrogance and opens up the horizon of

[34] As opposed to the generally perceived apparently nonrepresentational surface of music, Bruckner—of whom Furtwängler was one of the greatest interpreters—figured prominently in the Nazi cultural pantheon. Mathias Hansen, "Die faschistische Bruckner-Rezepcion und ihre Quellen," *Beiträge zur Musikwissenschaft* 28 (1986): 53–61. "Both the image of Bruckner and his music were imagined to exemplify the essence of Aryan art and were thus enlisted in the campaign to legitimate Nazism. (…) Bruckner's music was featured at overtly political events; each of Hitler's speeches at the Nuremberg rallies, for example was preceded by the performance of a movement from a Bruckner symphony. Radio broadcasts were announced with the trumpet theme that opens Bruckner's Third Symphony (…) Hitler even hoped to hold an annual Bruckner festival in St. Florian [where Bruckner lived] that would rival the prestigious Bayreuth Festival (…) the Nazi appropriation of Bruckner was extreme even by the standards of its time and place." Korstvedt, "Anton Bruckner," 132. In 1937, Bruckner ('s bust) was enshrined, personally by Hitler in the Walhalla, the German Pantheon. The Austrian Bruckner was used to promote and symbolize the unity and common destiny of Austria and Germany. "After listening to a recording of the Seventh Symphony given to him by Goebbels, Hitler is reported to have said: 'How can anyone say that Austria is not German! Is there anything more German than old and pure Austrianness?!'" Quoted by Korstvedt, "Anton Bruckner," 137.

The dubious philological and musicological ideas and ambitions that underlined the allegedly authentic complete Bruckner edition, *Anton Bruckner, Sämtliche Werke: Kritische Gesamtausgabe* edited by Robert Haas between 1930 and 1944, contributed to the Nazi appropriation of the composer. As Leon Botstein remarked: "(…) the somber, dour, and frightening dimension that emerges from the 'classic' Bruckner readings of Furtwängler, Karajan, and Wand" should be understood in the apparent extra-musical meaning of Bruckner's music, that the complete edition of the 1930s and 1940s tried to promote by the suggested authentic and authoritative reconstruction of scores. Leon Botstein, "Music and Ideology: Thoughts on Bruckner," *The Musical Quarterly* 80 (Spring 1996): 1–11.

the film's philosophical and ethical arguments towards young audiences; moreover, their generous appreciation of a great artist ensures the continuity of Furtwängler's legacy."[35]

According to musicologists and cultural historians the real strength of musical life in Weimar Germany was not in composition, but in performance or, more precisely, in performers. "The strength of German music in the 1920s lay in conductors. To mention only the most famous names— Furtwängler, Karl Muck, Bruno Walter, Fritz Busch, Erich Kleiber, Otto Klemperer and [Hungarian-born] George Szell [besides] Kanppertsbusch, Fritz Zweig, Hans Rosbaud, Artur Rother..."[36] After Hitler came to power the Jewish musicians, including Klemperer, Walter, and Szell, left together with the non-Jewish Kleiber and Busch. Wilhelm Furtwängler, Szabó's protagonist, however, decided to stay.

As the centenary of Furtwängler's birth was approaching, his widow Elisabeth Furtwängler invited the music historian Fred Prieberg to write a book about him. *Kraftprobe* was published in 1986, triggering a renewed debate about the life and character of the conductor. Prieberg argued that "only as an accomplice of Hitler's barbarism was [he] able to save Jews (...) he lived for years in a complex world that placed almost unbearable strain on his nerves. (...) He was a double agent, living every moment under threat of discovery."[37] As Chris Walton remarked in 2004 "Prieberg had the strong view that Furtwängler's critics in the anti-fascist camp were led by their blind hatred, their criticism being a result of their having been themselves ideologically infected by the Nazis."[38]

At the end of his book, *The Devil's Music Master*, Sam Shirakawa provides a long list of names of the Jews Furtwängler saved or tried to save during the Nazi regime. However, a closer look at Furtwängler's writings and statements makes Prieberg's claim—even from the perspective of the revisionist literature of the past two decades and despite the Furtwängler renaissance—quite problematic. Furtwängler, who dreaded atonality, was a staunch supporter of "organic" music, so dear to Nazi ideologues and music theoreticians because of the close association of the organic with the notions of social Darwinism. In an undated memoran-

[35] Quoted by Christina Stojanova, "Taking Sides: The Case of István Szabó," *Kinema* (Fall 2003): 4.

[36] Samuel Lippman, "Furtwängler and the Nazis," *Commentary* (March 1993): 45.

[37] Fred Prieberg, *The Trial of Strength* (London: Quartet Books, 1991), 101.

[38] Chris Walton, "Furtwängler the Apolitical?" *Musical Times* 145 (Winter 2004): 9.

dum, Furtwängler says: "The cultural policy of the National Socialists consists primarily in the battle to defeat the demoralizing influence of Jews and others in cultural life. This struggle makes it necessary that public cultural institutions and institutions for artists themselves be reorganized by the party according to political criteria. (…) The task was in essence not so difficult, since futurism and Bolshevism in our cultural life had already been more or less defeated before the National Socialists took power and had been dismissed by all seriously-minded Germans; there remained only to make the Jews and the main exponents of futurism and Bolshevism disappear."[39]

Albert Speer, in his memoirs *Inside the Third Reich,* tells a story about the final concert he organized for the Berlin Philharmonic during the last days of the war. Speer, according to his recollections, had promised Furtwängler that he would warn him when the end was near, by ordering Bruckner's Romantic Symphony to be performed as a signal that he should pack and go into hiding. The concert was held on 12 April 1945 (Furtwängler was already in Switzerland by that time) at the Bluthner Hall, near Potsdamer Platz in Berlin. The destitute audience "was treated to Beethoven's violin concerto, the finale from Wagner's *Götterdämmerung*, and finally to the Bruckner. According to Annemarie Kempf, Speer's secretary, the evening concluded with uniformed Hitler Youths offering the departing spectators baskets laden with cyanide capsules."[40]

In his own defence Szabó claimed that in his works he had confronted those moral issues hidden in his past that had tormented him. He had done what an artist could do: he had transformed specific issues into products of high aesthetic quality, and thereby formulated the particular in a general way with a universal moral message for the well-being and enlightenment of the wider public. By fictionalizing his personal concerns, his own biography, he had turned necessity into artistic virtue.

As opposed to the options available to the artist, the work of the historian contains an element of hopeless, although, not necessarily naïve, specificity. In a particular and limited sense, there is not much difference between the natural sciences and the historical profession: both require experiments that can be repeated and then checked, verified, confirmed, or falsified using the same data.

[39] Quoted by Chris Walton. "Furtwängler the Apolitical?" 13.
[40] Paul Foss. *Facing War: The Good, the Bad, and the Nazi.* From the *Great Conductors of the Third Reich: Art in the Service of Evil.* DVD, 2005 Bel Canto society (BSC-D0052).

The facts the historian uncovers in support of his or her claims should be accessible from different angles, and they should be independent from the observer and the theorizing mind.[41] The facts the historian marshals in support of his or her arguments should naturally be audience-neutral.[42] For a historian, one of the most important data is the set of proper names, names of individuals connected to certain events, since "[s]entences containing proper names can be used to make identity statements which convey factual and not merely linguistic information."[43] Historians go back to the archives, sources, and documents to find, to check, to verify the names in order to ascertain the assertions of fellow historians, and to analyze the names in a new or different context. "The thread of Ariadne that leads the researcher through the archival labyrinth is the same thread that distinguishes one individual from another in all societies known to us: the name."[44] As Hegel stated in his *Phenomenology of Spirit*: "For it is in the name alone that the difference of the individual from everybody else is not presumed, but it is made actual by all. In the name, the individual counts as a pure individual, no longer in his consciousness, but in the consciousness of everyone."[45]

The Greeks already knew that things that had happened to a person left their mark, indelibly, on the individual, on his future life, and his actions, whether taken voluntarily, accidentally or under pressure of force. "The whole of *Oedipus Tyrannus*, that dreadful machine, moves towards the discovery of just one thing, that *he did it*. Do we understand the terror of that discovery only because we residually share magical beliefs in blood-guilt, or archaic notions of responsibility? Certainly not: we understand it

[41] See Robert Nozick's rather technical treatment of the characteristic features of objective fact in his *Invariances: The Structure of the Objective World* (Cambridge, MA: The Belknapp Press, 2001). Especially chapter 2, "Invariance and Objectivity," 75–119. Nozick argues that a fourth and most fundamental characteristic of objective truth, namely the fact that it is invariant under various transformations, is what explains the three additional features of objective truth (accessibility from different angles, intersubjectivity, and independence), not only in science but also in other areas.

[42] Bernard Williams, "What Was Wrong with Minos? Thucydides and Historical Time," *Representations* 74 (Spring 2001): 1–18.

[43] John R. Searle, *Speech Acts: An Essay in the Philosophy of Language* (London: Cambridge University Press, 1969), 165.

[44] Carlo Ginzburg, Carlo Poni, "The Name and the Game: Unequal Exchange and the Historiographic Marketplace" in Edward Muir, Guido Ruggiero (eds.), *Microhistory and the Lost Peoples of Europe* (Baltimore: Johns Hopkins University Press, 1991), 5.

[45] Georg Wilhelm Friedrich Hegel, *Phenomenology of Spirit* (Oxford: Oxford University Press, 1977), 309.

because we know that in the story of one's life there is an authority exercised by what one has done..."[46] The historian cannot subsume the documents related to István Szabó's actions in the figure, the life, and the actions of Wilhelm Furtwängler, by overlooking the specificities of the character and the context. Although a work of history can serve as an allegory, it can have that function only if—as Marc Bloch defined history—it is about man in time; identifiable men in well-defined times.

The historians who uncovered documents about one-time informers of the communist regime, have often been accused of illegitimate moralizing. According to their critics, they are not entitled to moral judgment, to a "moral zoology," as employed by Taine when he examined the protagonists of the French Revolution, with the attitude of a "supreme and imperturbable judge."[47] This criticism, in fact contains two assertions: 1. The historian does not, cannot, know all the relevant facts, and 2. the historian has no right to moralize, to judge. The two assumptions are naturally connected: the historian is not entitled to moral judgment since he is not in possession of *all* the relevant facts; some things always remain hidden from sight. Accurate philosophers would tend to define this stand as epistemological particularism. These are both reasonable postulates. The historian never knows all the relevant facts: important details cannot ever be recovered, some were never recorded in the first place, some are utterly misrepresented in the surviving documents, etc. All these factors make historical reconstruction extremely risky and difficult, but not, perhaps hopeless or impossible.

There is an implicit and specific moral particularism at work here. The basic assumption is that in general the historian is never in a position to discover all the important and relevant facts, and this is particularly so when he is working with the utterly unreliable documents of the former secret police. A fact that can make a (moral) difference in one case, can make a completely different difference in another case. Facts—pertaining to possible moral outcomes—can have variable relevance (and the historian does not even know whether a particular fact, or the lack of it, is relevant or not). The same fact, depending on the complexities of the particular situation, can count either in favor of or against the behavior of the historical actor. In order to arrive at any moral conclusion it would be essential to comprehend all the relevant non-moral features of the historical event under scrutiny. The historian cannot say that what mattered in a

[46] Williams, *Shame and Necessity*, 69.
[47] Carlo Ginzburg, *The Judge and the Historian* (London: Verso, 1999), 14.

particular case should also matter in another case. This emphasis on the specificities of particular—and never fully knowable—historical facts serves as a general blank acquittal from possible historical responsibility: the (unknown, undisclosed, unattainable, perished, destroyed) particular facts would shed a different light on the historical act, the (moral) consequences of which would be essentially different if all the facts could have properly been taken into consideration.

Although we usually do not know *all* the relevant facts—even in our ordinary everyday life—we are still able to form reasonable, usable opinions about incidents in the lives of others; despite the fact that those others are different from us, have a different gender, a different past, come with a different tradition, were raised in a different environment, have different reflexes, react in a different way. Historians, in each epoch, in a slightly or grossly different way, are trained to reconstruct incidents of the past on the basis of critical interpretation of only partially available sources and their connections. That is what historians are trained and employed, paid and read for. It is not only by aiming at absolute knowledge, based on *all* the facts, that the historian can achieve objectivity, which, nevertheless, does not equal certainty. In principle, the serious historian can have access to enough documentary sources to base his or her claims on secure foundations. (As Austin said, "Enough is enough, enough isn't everything.")[48]

Historical interpretation—despite all the hopes and efforts to the contrary—cannot be formalized in a mechanical way. ("The dream of formalizing interpretation is as utopian as the dream of formalizing nonparadigmatic rationality itself.")[49] The historian might fail, even if he or she tries to be faithful to the two virtues of truth: sincerity and accuracy, which become essential virtues and guarantees of serious scholarly work, especially in the absence of easily formalizable rules of historical reconstruction. (Accuracy is the virtue of carefully investigating and deliberating over the evidence for and against a belief before asserting it. And sincerity is the virtue of genuinely expressing to others what one in fact believes—in the case of his-

[48] Hilary Putnam, "The Craving for Objectivity," *New Literary History* 15 (Winter, 1984): 230. Erich Auerbach perhaps went a little too far, when he asserted: "[I]n any random fragment plucked from the course of a life at any time the totality of its fate is contained and can be portrayed." *Mimesis: The Representation of Reality in Western Literature* (Princeton: Princeton University Press, 2003), 547.

[49] "Not only is interpretation a highly informal activity, guided by few, if any, settled rules or methods, but it is one that involves much more than linear propositional reasoning." Putnam, "The Craving for Objectivity," 237.

tory—on the basis of facts.)[50] It is difficult to accept that the skeptics are in a better position to deliver the truth about historical reconstruction than history is in delivering a truthful account about incidents of the past.

History writing—despite the legacies of the nineteenth century positivist credo—is not about recording what in fact happened exactly in the way it happened. Writing history, in my view, is radically different from the positivistic conviction. The historian, unlike the detective, the police officer, the investigative journalist, the prosecutor or the judge, is not supposed to reconstruct—beyond reasonable doubt—the incidents of the past. This would be a mistaken expectation. Rather, the historian, following accurate and professional research, should demonstrate the inherently uncertain character of any representation of the past. This claim has nothing to do with relativism: I am convinced that the historian should aim at unearthing historical truth. But the historical truth is that it is never possible to arrive at absolute reconstruction; uncertainty (in historical reconstructions) is an unavoidable part of the assertion of knowledge.

Historians can offer only afterthoughts, and as in the case of any afterthought, the historian's effort carries an unavoidable element of uncertainty; not only in the sense that historical argumentation can resort to conjectures and inferences: even the outcome of a historical investigation might, in fact should, remain, to a smaller or larger degree, devoid of absolute certainty. In consequence of this unavoidable element of historical reconstruction, the historian cannot usurp the role of the judge, and would do better to stay away from general moral judgment too. Still, accurately researched and sincerely stated uncertainties might provide protection from the dangers of unreflexive conviction of historical certainty, the mother of narrow-minded preconceptions and intolerance.

Skeptics about the possibility of making the recent past intelligible, surprisingly, do not hesitate to make strong assertions about heroic figures of the distant national past. They have no difficulty portraying and attributing motivations to Saint Stephen, the first Hungarian king, although the only surviving document of a more or less personal nature that could be connected to his person is his "Admonition" addressed to his son, and even in this case, the exact authorship of this *Libellus de institutione morum* that follows Carolingian models is highly questionable. Skeptics are more doubtful when the object of historical investigation is a figure of the recent past or a living person. The closer the historical actor in time,

[50] Bernard Williams, *Truth and Truthfulness: An Essay in Genealogy* (Princeton: Princeton University Press, 2002).

the more particular, the more complex, the less penetrable his or her motivations supposedly become; the task set for the historian is the more demanding, the closer we get to our present. Nevertheless, most of us, including the skeptics, living under the rule of law, accept the fact that judges, who deliver judgments of life and death, are entitled to administer justice although, as we know, not even the judge can ever be in possession of all the relevant facts. The courts, weighing the deeds and motivations of contemporaries, naturally make mistakes; justice is not exempt from occasional miscarriage, but if the possibility of ever arriving at an intelligible reconstruction of past events were denied to the court, as it is so often questioned in the case of historical reconstruction, none of us would have the chance to live under the rule of law.

Still, the assertions of the skeptics are not without merit. By definition, the historian is always late; he never arrives in time. The historian arrives on the scene when the action is already irreversibly over; after everybody has taken their bets, and the immediate consequences of the act are already in existence. As the historian comes after the fact, he is in no position to intervene in a direct way, to change the course of events, to tell the protagonists what they should or ought to do. As Hume formulated it in his *Treatise on Human Nature*: one cannot infer an "ought" from an "is."

Being too late, however, is the right time for the historian to arrive to the scene, as it is always the perceived endpoint of the chain of events, which defines the starting point of the historical narrative. The historian begins the story with the knowledge of its presumed end in mind.[51] This

[51] It follows from my reasoning that taking Foucault's neologism, "history of the present" in a literal sense—in the way Timothy Garton Ash uses it—is a misunderstanding. Foucault, on page 31 of *Discipline and Punish* (London: Penguin, 1991) introduces "history of the present" as a substitute or synonym of other similar neologisms of his, like "genealogy" or "archeology." What Foucault wanted to do was to show how the past structured the acts, the reflexes, the way of thinking of the present. Foucault's "history of the present" is not a presentist fallacy of projecting present meanings on the events of the past. *Discipline and Punish* aimed at identifying and isolating central issues of contemporary technology of power and tracing them back in time. "Many of Foucault's histories fall under the category he designated 'history of the present.' Of course, history is, by definition, about the past, but Foucault's histories typically begin from his perception that something is terribly wrong in the present. His motive for embarking on a history is his judgment that certain current social circumstances—an institution, a discipline, a social practice—are intolerable. His primary goal is not to understand the past but to understand the present [this is why Foucault is not considered primarily a historian]; or, to put the point more precisely to use an understanding of the past to understand something

claim has nothing to do with the teleological assertion that the end provides the meaning of an event. The presumed endpoint of the story stipulates the starting point for the historical narrative. "Completed events present themselves to us with a much greater clarity than those which are in the midst of unfolding," wrote Denis Foustel de Coulanges.[52] On the basis of the available documentary evidence the historian is entitled to narrate that which most probably happened. What ought to have happened—although it concerns the historian—is beyond his or her reach. The available (and always partial) sources attest only to what could have taken place. As the pragmatist philosopher, Hilary Putnam formulated it: "The purpose of the historian cannot be to perform a speech-act of condemning long-dead [or even still living] persons; rather his aim is to make the historical event intelligible, and to do this he employs a description which is itself made available by a moral point of view."[53]

In societies that have recently experienced political transition, especially in the former communist countries, there is a special breed of doubters. Long decades of mostly ideologically driven, centrally commissioned, and censored historical narratives in the service of continuously changing political needs have gravely undermined the credibility of historical work. The loss of belief in the possibility of authentic historical reconstruction affects primarily the work of historians working on modern and recent historical events, but even medieval studies—as countless attempts after 1989 of constructing new Middle Ages in all the East and Central European countries testify—have not been spared blunt and wholesale revisionism.[54] The opening (followed, in some countries by the renewed closure) of the archives after the fall of the Wall created the per-

that is intolerable in the present." Gary Gutting (ed.), *The Cambridge Companion to Foucault* (Cambridge: Cambridge University Press, 1999), ii.

[52] Quoted in Henry Rousso, *The Haunting Past: History, Memory, and Justice in Contemporary France* (Philadelphia: University of Pennsylvania Press, 2002), 30. Henry Rousso is the director of the *Institut d'Histoire du Tempts Présent* (IHTP). The name of the institute is a translation of the German *Zeitgeschichte*, and it deals with the history of what in English is called the recent past. "History," as Rousso said, "is supposed to bring the past into the present, but only to give us a better understanding of the distance that separates the two and an appreciation of the changes that have occurred in the interim." Ibid., 8.

[53] Hilary Putnam, *Ethics without Ontology* (Cambridge, MA: Harvard University Press, 2005), 74.

[54] In the fall of 2006 Gábor Klaniczay curated an exhibition, *Contagious Middle Ages*, in the OSA Archivum on post-1989 East, Central, and South-East European attempts of (re)creating and inventing a new Middle Ages. On-line version of the exhibition could be found at http://files.osa.ceu.hu/exhibitions/middleages (accessed 10 February, 2007).

ception that "facts" that might prove the opposite of any openly stated historical assertion, are just there, hidden in the depths of the so far well-guarded archives, awaiting discovery, rescue, and reworking. Anything, even a retroactive historical miracle, might be possible, based on newly discovered relevant facts; the past should not forget the people of the new world who are waiting for an appropriate prehistory. The example of suddenly born-again conservative historians who—based on the very same sources—publish books with diametrically opposed vignettes, labels, classifications and conclusions to their previous works—turning enemies into martyrs, counterrevolutionaries into revolutionaries, former protagonists into antagonists—contributed to the loss of the aura of historical authenticity. Probably, the most significant reason behind the epistemic doubts, however, is the newly experienced instability of the self. In the face of the unexpected changes that contradicted almost all existential expectations, everybody's life is now seen in a new light. Except for the few truly courageous members of the democratic opposition, almost everybody had to make his or her smaller or graver compromises during the long decades of a rule that mocked and undermined the respect and self-respect of human dignity.[55] To acknowledge the past is not an easy thing for most of us. It is in this context that one is tempted to accept Ian Hacking's over-paradoxical formulation: "It is almost as if retroactive redescription changes the past."[56] The rejection of any alleged attempt at moralizing should be understood from this perspective. Hiding behind the veil of historical particularism, the specificities of the (partly unknown and unknowable) historical circumstances that purportedly prevent any generalizable moral conclusion, is a byproduct of the post-transition predicament.

In the overpoliticized atmosphere of the former communist world, moral judgments about historical events have always been suspected either of being politically motivated or of having a hidden political agenda. Historical arguments, in East and Central Europe, were used in the twentieth century, and even earlier, in deciding highly contested political

[55] Even in the case of some of the most prominent members of the East and Central European oppositions posterity tried to change the past, as shown by the charges against Lech Wałęsa and Jacek Kuroń in Poland, Andrei Pleşu in Romania, Gábor Demszky and György Konrád in Hungary.

[56] Ian Hacking, *Rewriting the Soul: Multiple Personality and the Sciences of Memory* (Princeton: Princeton University Press, 1995), 243. See also by Hacking, "Indeterminacy in the Past: on the Recent Discussion of Chapter 17 of Rewriting the Soul," *History of the Human Sciences* 16 (2003): 117–24.

issues. Insistence on the privileged nature of historical particularities has served to keep the space for politically charged arguments and counter-arguments, accusations and counteraccusations, wide open. The issue of the former agent is an instructive case in point. Large segments of the political left, especially the supporters of the successor parties, who, in the face of revelations, usually feel, at least indirectly, implicated, customarily play down the political, social and moral significance of the detected act, especially if the person involved has remained—at least nominally— broadly faithful to his or her former political allegiance. In such cases, the case for the defense centers on the biographical particularities of the person (István Szabó was just nineteen years old when he was recruited); the relative and isolated nature of his deeds, notably in the light of his subsequent service to the country; the objectively patriotic nature of the act (as in the case of Péter Medgyessy, the Prime Minister, who had been a top secret counter-intelligence officer, who allegedly had to neutralize the Soviets at the time of Hungary's entry into the International Monetary Fund); the popularity of the person (as in the case of the popular radio broadcaster, who commentated live when Hungary famously defeated England by 6 to 3 at Wembley Stadium in 1953). When the accusations affect individuals who are directly or indirectly connected to the political right, as with the revelations about prominent figures of the ecclesiastical hierarchy, the arguments coming from the right either point at those groups which might have had a vested interest in the revelation (Jewish groups that supposedly conspired in the fall of Stanisław Wielgus, appointed archbishop of Poland); or, as opposed to the concrete deeds of the informer, they emphasize the role of the communist officers, who recruited the person in order to compromise him or his institution. The charged atmosphere turns ethical utterances into purportedly political propaganda. Nevertheless, as human beings with ethical sensitivity and as researchers who use documents in which description is intermixed with value judgment, the historian cannot avoid taking an ethical stance.[57]

In order to preserve the credibility of serious historical scholarship— especially in the *milieu* of extremely sensitive and self-destructively doubting post-transition societies—it is advisable for the historian to be particularly cautious with direct moral judgments—and also with claims

[57] In Putnam's words: "A being with no values would have no facts either." Hilary Putnam, *Reason, Truth and History* (Cambridge: Cambridge University Press, 1981), 201.

about the certainty of reconstruction. In the midst of a "memory epidemic" it is important to maintain and emphasize the distinction between historians and activists of historical memory. Historical memory operates in the present; it maintains that the past is not past but an aspect of the present that can and should be redressed. Historical memory craves for justice: either legal or moral or both. Historical memory is an inherently moralizing attitude to the events of the past. [58]

It is useful in this context to turn the classic question whether one can derive values from facts around and ask: is it possible to use sources without confusing descriptive facts with evaluative judgments? The question is particularly pertinent for the historian writing for a skeptical audience. "As Hume remarked, a person who makes mistakes in factual matters is at worst stupid or incompetent, but a person who is mistaken in evaluative matters—e.g. who prizes what properly deserves to be disdained—would for this very reason be deemed perverse and wicked. But if evaluations could be derived from facts, so that erroneous evaluations would be mere mistakes in inquiry and information-processing, then this line of differentiation would be breached." [59]

The truth of a historical proposition is determined on the basis of relevant facts pertaining to extra-linguistic reality. This assertion needs qualifications: as we know, unmediated access to extra-linguistic reality is unimaginable even in the natural sciences. Value-laden choice of theory, of experimental object, research method, and equipment mediate between observation, experimentation, and the formation of scientific hypotheses. Research (even in the natural sciences) presupposes epistemic values. [60]

[58] Rousso, *The Haunting Past*, especially chapter 1, "The Confusion Between Memory and History," 1–24.

[59] Hume, *Treatise*, Bk. III, Pt. I, Sect. I. Quoted by Nicholas Rescher, "How Wide is the Gap Between Facts and Values?" *Philosophy and Phenomenological Research* 1, Supplement (Fall 1990): 297.

[60] "While the natural objects of the natural sciences are determined extensionally and explained causally, the way in which a scientific theoretical apparatus supports such explanations cannot be causal. Each theory—and the selection of particular theory over and against its competitors—presupposes normative values, such as coherence, simplicity, explanatory power, and so on (…) Already in the 1930s Neurath had distinguished between what he labeled the 'domain of determination,' the level in which empirical evidence contributes to the theory selection, and the 'domain of underdetermination,' the level in which social and political factors contribute to the theory selection." Alexei Angelidis, "The Last Collapse? An Essay Review of Hilary Putnam's The Collapse of the Fact/Value Dichotomy and Other Essays," *Philosophy of Science* 71 (July 2004): 405. Hilary Putnam, *The Collapse of the Fact/Value Dichotomy* (Cambridge, MA: Harvard University Press, 2002), 31.

The skeptical insights of long decades of linguistic and cultural turn-arounds in the humanities and social sciences should further caution the historian. Although the claim that ontologically a historical fact pertains to extra-linguistic reality can, most probably, be defended, the historian is still not in an enviable position, being specifically in need of documents closely related to language—even in the case of images—in order to gain access to external reality.[61] Documents, broadly speaking linguistic sources that form the evidentiary base of historical scholarship, unavoidably contain both factual statements and value judgments. As Ayer remarked in his classic *Language, Truth and Logic*, an utterance or a sentence may at the same time make a descriptive statement and express an "ethical feeling."[62] Evaluation and description are mixed and often interdependent in the sources, which are usually overlooked by cautious positivists.

According to pragmatist philosophers, the distinction between facts and values is "at the very least hopelessly fuzzy,"[63] and one cannot easily be "disentangled" from the other. "The terms one uses even in *description* in history and in sociology and the other social sciences are invariably ethically colored" argued Hilary Putnam.[64] Although the radical positivist claim of a strict and clear fact/value "dichotomy" might be far-fetched, it would be difficult for the historian to overlook the fact/value distinction, especially since courts customarily distinguish two types of statements—facts and value judgments (opinions)—when deciding defamation cases against historians.[65]

[61] Counterfactual history, even if it is based on careful and reasoned argument, like Robert Fogel's *Railroads and American Economic Growth* (Baltimore: Johns Hopkins University Press, 1964) is outside my concern here.

[62] Alfred Jules Ayer, *Language, Truth and Logic* (London: Penguin, 2001), 111. (Originally published in 1936.)

[63] Putnam, *Reason, Truth and History*, 128.

[64] Putnam *The Collapse of the Fact/Value Dichotomy*, 63 (original emphasis).

[65] "Proving *facts* is dependent on at least three factors. First, *time*: in some countries, it is not legally possible to prove the truth of statements about facts from the distant past (in France, older than ten years). The idea behind this principle is probably that it is not desirable to keep dragging up the past. It implies, however, that proof of the non-defamatory nature of a given statement cannot invoke the facts themselves (...). *Opinions* (or "comments" or "value judgments") are not susceptible to proof because they do not fit a true/untrue scheme and therefore enjoy greater legal protection than facts." Antoon de Baets, "Defamation Cases against Historians," *History and Theory* 41 (2002): 347, note 5 (original emphasis). See also John Gilissen, "La Responsabilité civile et pénale de l'historien," *Revue belge de philologie et d'histoire* (1960): 1012–5.

After the advent of positivism, historians became more careful in stick-
ing to facts, and trying to suppress their unavoidable personal sympathies.
What a typical French judge, unfortunatelly, holds desirable about a histo-
rian, is in fact a not uncommon view: "In the judge's view, the image of
the 'good' historian [is]: meticulous, scrupulous, always moderate in opin-
ion and tone, apparently neutral, without avowed passion, or irritating
nerve. He resembles the good judge like a brother does."[66]

It would be quite difficult nowadays to imagine a serious historian
choosing Paul Pellisson-Fontanier, who preceded Racine in the office of the
historiographer of Louis XIV, as the model of the ideal historian. Around
1670 Pellison prepared a project about a planned historical work on the
king, which he sent to Colbert: "It is a fine field of speaking in abbreviated
form of all the King's virtues, and for enabling [the reader] to well conceive
of his greatness in all sorts of ways. (…) The Historian and not the lawyer
must explain the causes of the rupture and the King's just claims. (…) The
King must be praised everywhere but, so to speak without praise, by a nar-
rative of all that he has been seen to do, say, and think. It must appear disin-
terested. (…) In order to be better believed, it should not give him the mag-
nificent epithets and eulogies he deserves; they must be torn from the mouth
of the reader by the things themselves. (…)"[67] Even in the last third of the
seventeenth century, the prospective author of "great history," when trying
to get the commission, felt the need to emphasize that his panegyric—"in
order to be better believed"—would not obviously resemble a eulogy. But
as Pellison conceives it, "history"—in Louis Marin's words—"is the repre-
sentational effect (and not the referential origin) of narrative. (…) It is *by
avoiding* the panegyric that the panegyric extends its empire to the totality
of the narrative thing, that *it* is the narrative itself."[68] In contrast to Pelli-
son's ambition, historians nowadays strive to attain what Roland Barthes
called "reality effect," the appearance of facticity that lends the aura of au-
thority to historical narratives.[69]

[66] Jean-Denis Bredin, "Le Droit, le judge, et l'historien," *Le Débat* 32 (November 1984):
111. Quoted by de Baets, "Defamation Cases," 356, note 54.

[67] Paul Pellisson-Fontanier, *Oeuvres diverses* (Paris, 1735), vol. 2, 323–8. Quoted by Louis
Marin, *Portrait of the King* (Minneapolis: University of Minnesota Press, 1988), 39–40.

[68] Marin, *Portrait of the King*, 65, 70 (original emphasis).

[69] What Barthes meant by "reality effect" of literature was close to what is colloquially meant
by the creation of illusion. It is worth comparing "the reality effect" with Edwin Chargaff's
"intensity." "[T]he ability to concentrate one's powers of imagination and execution so as
to convey an overwhelming impression of reality." Edwin Chargaff, *Heraclitean Fire:
Sketches from a Life Before Nature* (New York: Warner Books, 1978), 175.

individual or of the society."[72] There are philosophers who question Williams's characterization of "thick concepts." Some disagree about the precise nature of "thick" concepts; about whether they can or should be "disentangled," about the nature of the fact/value dichotomy; how wide the gap is between facts and values; why "rich" descriptions are necessary and/or desirable; whether it is possible to provide a description from a moral point of view; whether the difference between fact and value is a difference between verifiability and meaninglessness, as the Vienna Circle held. All these concerns are not essential for the present discussion. Putnam argues that "thick" concepts "simply ignore the supposed fact/value dichotomy and cheerfully allow [themselves] to be used sometimes for normative purpose and sometimes as a descriptive term."[73]

These mainly, but not exclusively, technical disagreements among philosophers do not prevent the historian distinguishing between "thick" and "thin" ethical concepts. "Thick" concepts can be firmly attached to the description of events, making use of the factual basis of the sources, without resorting to mostly prescriptive concepts that cannot be factually verified by the documents. However, by using such concepts, the historian is capable of establishing his or her ethical position, without gravely undermining the factual foundations of the historian's effort.

Williams is preoccupied with the limits and grave problems of moralizing the possibility of a general ethical theory; his interest does not lie in the options available to the historian, but in the critique of moral philosophy. One of Williams' objections to existing theories of moral philosophy is that they neglect the specificities of the agent's project. In an essay that preceded his *Ethics and the Limits of Philosophy*, Williams argued that moral theories demand that we neglect our relationship to our projects, which "presents an insoluble problem to ethical theory."[74] The specificities of the projects and the actors' relationship to them are exactly what historians are after; what might pose a problem for ethical theory is a distinctive advantage for the historian.

[72] Bernard Williams, *Ethics and the Limits of Philosophy* (Cambridge, MA: Harvard University Press, 1985), 129–30. For a sympathetic but very critical reading of Williams's book, see Samuel Scheffler's review (who taught together with Williams in Berkeley) "Morality Through Thick and Thin. A Critical Notice of Ethics and the Limits of Philosophy," *The Philosophical Review* 96 (July 1987): 411–34.

[73] Putnam, *The Collapse of the Fact/Value Dichotomy*, 35.

[74] "The Point of View of the Universe: Sidgwick and the Ambitions of Ethics" in Bernard Williams, *Making Sense of Humanity and Other Philosophical Papers, 1982–1993* (Cambridge: Cambridge University Press, 1995), 170.

"Thick" concepts—Williams insists—are both "world-guided" and "action-guiding": "A concept of this sort may be rightly or wrongly applied, and people who have acquired it can agree that it applies or fails to apply to some new situation. (…) Some disagreement at the margin may be irresoluble, but this does not mean that the use of the concept is not controlled by facts or the users' perception of the world. (As with other concepts that are not totally precise, marginal disagreements can indeed help to show how their use *is* controlled by the facts.)"[75] "Thin" concepts can be imagined as being far away from everyday actions, residing in the abstract value judgments of (certain kinds of) moral philosophers, while "thick" concepts occupy a middle position, a stance somewhat above the uncritical, unreflexive acceptance of local practices (which leads to complex ethical problems in its turn).[76]

One would presume that Williams' formulation of the juxtaposition of "thin" and "thick" concepts comes from the work of his Oxford colleague, Gilbert Ryle, the philosopher of mind. Thick concepts have been mentioned in philosophy from the middle of the 1950s (in the works of Iris Murdoch, Philippa Foot, and John McDowell), but the distinction between "thin" and "thick" concepts came into circulation after the publication of Williams's *Ethics and the Limits of Philosophy* in 1985. We know from Williams himself that his "ethnographic stance" on the notion of "thin" and "thick" was influenced by the anthropologist, Clifford Geertz.[77] Geertz, for his part, admitted that he had borrowed the notion of "thick description" from none other than Gilbert Ryle. "Ryle's discussion of "thick description" appears in two of his essays: *Thinking and Reflecting* and *The Thinking of Thoughts*," Clifford Geertz wrote, revealing the source of his thick description.[78] The connection between "thick description" and "thick moral concepts" is not only philological and historiographical, but also theoretical, and this is what gives historians the chance to make exceptionally good use of them.

A parallel reading of Williams's and Geertz's texts—that to my knowledge no scholar has attempted so far—seems particularly useful for a histo-

[75] Williams, *Ethics and the Limits of Philosophy*, 141.

[76] Hollis, "The Shape of a Life," 176–7; and Williams, *Ethics and the Limits of Philosophy*, 148.

[77] "William's reply to Simon Blackburn," *Philosophical Books* 27 (1986).

[78] Clifford Geertz, "Thick Description: Toward and Interpretive Theory of Culture" in *The Interpretation of Cultures* (New York: Basic Books, 1973), 6. (The original title of the latter paper was "The Thinking of Thoughts: What is 'le Penseur' Doing?," originally "University Lecture no.18, 1968" at the University of Saskatchewan.)

rian. Geertz's idea of culture is compatible with Williams's notion of "thick" ethical concepts: both are, to a degree, descriptive and prescriptive. "[W]hat we call our data are really our own constructions of other people's constructions of what they and their compatriots are up to," claims Geertz,[79] emphasizing that the empirical facts are themselves mediated through the way in which the actors involved in the historical incidents perceived and—unavoidably—evaluated their experiences. Williams argues:

> How we "go on" from one application of a concept to another is a function of the kind of interest in what the concept represents, and we should not assume that we could see how people "go on" if we did not share the evaluative perspective in which this kind of concept has its point. An insightful observer can indeed come to understand and anticipate the use of the concept without actually sharing the values of the people who use it. (...) But in imaginatively anticipating the use of the concept, the observer also has to grasp imaginatively its evaluative point. He cannot stand quite outside the evaluative interests of the community he is observing, and pick up the concept simply as a device for dividing up in a rather strange way certain neutral features of the world.[80]

There are philosophers who argue that the nature of "thick" concepts, their saturation with descriptive elements, renders them non-transportable from one context to another, thus undermining moral universalism, and encouraging particularism.[81] For historians this is not an insurmountable weakness of "thick" concepts, as the historian tries to refrain from judging the historical events under reconstruction on universal moral grounds. The historian aims, rather, to grasp the specificities of the situation. "Thick description cannot be cashed out in culture- or context-neutral terms, but rather implicates a rich set of values and commitments, which inform, guide, and motivate action."[82] And this is exactly what makes them attractive and suitable tools for those historians whose ambition is to grasp the peculiarities of a particular situation.

It seems that Williams's "ethnographic stance" made him receptive to the concerns and approach of the anthropologist, whose primary task is to describe and make intelligible what has taken place, what has presumably been experienced by the actors themselves: "The sympathetic observer

[79] Ibid., 9.
[80] Williams, *Ethics and the Limits of Philosophy*, 141–2.
[81] O. O'Neill, *Towards Justice and Virtue: A Reconstructive Account of Practical Reasoning* (Cambridge: Cambridge University Press, 1996).
[82] Jay L. Garfield, "Particularity and Principle: The Structure of Moral Knowledge" in Brad Hooker and Margaret Olivia Little (eds.), *Moral Particularism* (Oxford: Clarendon Press, 2000), 180.

can follow the practice of the people he is observing; he can report, antici-
pate, and even take part in discussions of the use they make of their con-
cept. But, as with some other concepts of theirs, relating to religion, for
instance, or to witchcraft, he may not be ultimately identified with the use
of the concept: it may not really be his."[83]

More than a decade after the publication of *Ethics and the Limits of
Philosophy*, Williams wrote: "If we concentrate on thick concepts, we do
indeed have something like the notion of a helpful informant."[84] "Thick-
ness" thus is not just a style of narrating and focusing on the relevant de-
tails, not just concentrating on intentions, expectations, circumstances, and
purposes that supposedly provide actions with their meaning—as Ryle
asserted in his original papers[85]—but also the choice of appropriate
"thick" concepts in appropriate contexts. Those concepts are suggestive:
they keep the direction of the observation and description near the site of
the action, closer to the ground, while behaving almost as if a local in-
former aided the work of the outside observer, who tries to make sense of
the way in which the natives (of different localities or times or minds) are
trying to give meaning to the actions of their world. "Concepts," as Ian
Hacking argued forcefully, "are words in their sites. Sites include sen-
tences, uttered or transcribed, always in a larger site of neighborhood,
institution, authority, language."[86]

Contrary to Williams's implicit assumption, it is thus not automatic or
merely a matter of language whether a word could or should be treated as
a "thick concept"; "thick concepts" are made and determined by their site,
their location in the course of the reconstruction of the event. A descrip-
tive term, depending on the context and the intention of the user, may
behave as a "thick" concept, while a "thick" concept may be turned into a
moral concept if it is used in a specific "site." As Geertz writes: "Analy-
sis, then, is sorting out the structure of signification—what Ryle called
established codes, a somewhat misleading expression, for it makes the
enterprise sound too much like that of the cipher clerk, when it is much

[83] Williams, *Ethics and the Limits of Philosophy*, 142.

[84] Bernard Williams, "Truth in Ethics" in Brad Hooker (ed.), *Truth in Ethics* (Oxford: Blackwell, 1996), 27.

[85] Gilbert Ryle, *Collected Papers*, vol. 2. (*Collected Essays, 1929–1968*) (London: Hutchinson, 1971), 465–96.

[86] Ian Hacking, "Two Kinds of 'New Historicism' for Philosophers" in Ralph Cohen, Michael S. Roth (eds.), *History and Histories within the Human Sciences* (Charlottesville: University of Virginia Press, 1995), 313. See also his *Historical Ontology* (Cambridge, MA—London: Harvard University Press, 2002), 68.

more like that of the literary critic—and determining their social ground and import."[87]

At this point, it becomes really difficult to distinguish the words of the philosopher from the text of the anthropologist. "The point for now is only that ethnography is 'thick' description. What the ethnographer is in fact faced with (…) is a multiplicity of complex conceptual structures, many of them superimposed upon or knotted into one another, which are at once strange, irregular, and inexplicit, and which he must contrive somehow first to grasp and then to render. (…) Doing ethnography is like trying to read (in the sense of 'construct a reading of') a manuscript—foreign, faded, full of ellipses, incoherencies, suspicious emendations, and tendentious commentaries, but written not in conventionalized graphs of sound but in transient examples of shaped behavior."[88]

Writing about Geertz—without mentioning Bernard Williams and the issue of "thick moral concept"—Stephen Greenblatt argues: "As Geertz's famous essay deploys the term, however, thickness begins to slide almost imperceptibly from the description to the thing described. (…) Thickness no longer seems extrinsic to the object (…)."[89] It was not due only to Geertz's observational and analytic abilities that he was able to show that the complexities of the objects of his research were "actually inscribed in the textual fragments" he used. The fecund hybrid nature of those "thick" concepts he employed "helped to create as well as to disclose the effect of compression,"[90] and it also stipulates a strong ethical commitment. The advice given by Geertz—"for [anthropological] theory [it is necessary] to stay rather closer to the ground than tends to be the case in sciences more able to give themselves over to imaginative abstraction"[91]—finds an echo in the supposition of the philosopher that "the middle distance is critical (…) where people do their best with what they are given."[92] "Thick moral concepts" might help in keeping clear of the moral high ground, close to the scene of action, where reflection on historical events does not threaten to rob thick concepts of their power to guide. An important looping effect is at work here: it is not only with the help of the "thick" concepts that the historian is capable of credible, meaningful and sincere description, but by aiming at

[87] Geertz, "Thick Description," 9.

[88] Ibid., 9–10.

[89] Stephen Greenblatt, "The Touch of the Real," *Representations* 59, Special Issue: "The Fate of 'Culture': Geertz and Beyond" (Summer, 1977): 17.

[90] Ibid., 18.

[91] Ibid., 24.

[92] Hollis, "The Shape of a Life," 176–7.

sharply focused and intense historical reconstruction, it may also become possible to find the right conceptual tools. As Ian Hacking asserted: "Only by immersion in real-life complexities can one hope to get a clarification of language that fits lived experience."[93]

According to Geertz, one of the inherent characteristics of "thick" description is its "microscopic"[94] nature:

> the anthropologist characteristically approaches (...) broader interpretations and more abstract analysis from the direction of exceedingly extended acquaintances with extremely small matters. He confronts the same grand realities that others—historians, economists, political scientists, sociologists—confront in more fateful settings. (...) The methodological problem which the microscopic nature of ethnography presents is both real and critical. (...) It is to be resolved—or, anyway, kept at bay—by realizing that social actions are comments on more than themselves; that where an interpretation comes from does not determine where it can be impelled to go. Small facts speak to large issues, winks to epistemology, or sheep raids to revolution, because they are made to.[95]

It seems that anthropology, via moral philosophy, might offer a sort of solution for the historian caught in the web of the moral implications of past actions. Anthropology provides the bridge for the historian. "Anthropology has offered historians not only a series of themes largely overlooked in the past (...) but also something of much greater importance: a conceptual frame of reference, whose outlines we are only now beginning to make out," wrote the micro-historians almost thirty years ago.[96] The use of richly textured, intense, dense description, employing "thick concepts," is not the privilege of micro-historians who have been practicing thick description for long decades; the issue is not only the scale but also the focus; it is not only the object of the analysis but also the attention that should be intense, nuanced, and sustained;[97] the willingness to immerse oneself in the life of others might provide the language that, in turn, might help to find the concepts which, in the right place in the narrative, could assist the accuracy and sincerity of the historian's enterprise.

[93] Hacking, "Indeterminacy of the Past," 124.

[94] Geertz, "Thick Description," 21.

[95] Ibid., 21, 23.

[96] Ginzburg and Poni, "The Name and the Game," 4. In Geertzian fashion, Ginzburg and Poni state: "Microhistorical analysis therefore has two fronts. On one side, by moving on a reduced scale, it permits in many cases a reconstitution of 'real life' unthinkable in other kinds of historiography. On the other side, it proposes to investigate the invisible structures within which that lived experience is articulated." Ibid., 8.

[97] Greenblatt, "The Touch of the Real," 18–9.

István Szabó, not unlike Furtwängler, decided not to emigrate, but to work as an artist and influence the situation from the inside. He made twenty-three films between 1959 and 1988, before the fall of the Berlin Wall, was appointed director of one of the state-owned film studios, and professor at the Budapest Film Academy. He received the Kossuth Prize, the highest Hungarian decoration for an artist as early as 1975. Emigration has been a constant theme of Szabó's films. Already in *Lovefilm* (*Szerelmesfilm*, 1970) a Hungarian couple, who had been separated by the emigration of the young woman after the defeat of the 1956 revolution, meet in Paris and contemplate staying together, until finally the young man decides to leave his love and return to his home country, which is ruled by the restored communist regime. In *Mephisto*, Höfgen, the actor, also sees emigration as an alternative to the pact with the Devil, but he too decides to stay in Nazi Germany, giving up his artistic freedom, human autonomy, and dignity. Emigration and collaboration with the repressive regime play prominent roles in Szabó's *Sunshine* (*A napfény íze*, 2000), in which Szabó, himself a Jew, recounts the experience of three generations of Hungarian Jews from the end of the nineteenth century until the end of the twentieth, living under successive fascist and communist regimes.

Emigration, exile—one of the oldest punishments and sources of human suffering—seems to be a descriptive term, especially if understood merely as a change of place, *loci commutatio*, as Seneca described it for his mother, rather disingenuously, in his *Ad Helviam*. (Seneca hated Corsica, which he referred to in one of his epigrams as "*Corsica terribilis.*")[98] Seneca did not choose, but was forced into exile by Messalina, the wife of Claudius.

"When Gottfried Benn [the German writer and doctor, who never joined the Nazi party, physician of the writer, Carl Steinheim, Pamela Wedekind's first husband] was asked why he had remained in Germany even after 1934, he replied that the idea of emigrating had never occurred to him. (...) When members of his generation left Germany, Benn said, they were not taking the political action of emigration, they were just trying to escape personal hardships and unpleasant circumstances by traveling elsewhere. (...) There was an anti-Semitic tone in the rejection of emigration and exile: a German could not possibly adopt what had been the fate of the Jewish people for centuries (...)."[99] In July 1934, Thomas

[98] For a curious interpretation of the text of *Ad Helviam*, see Arther Ferrill, "Seneca's Exile and the Ad Helviam: A Reinterpretation," *Classical Philology* 61 (October 1966): 253–7.

[99] Lepenies, *The Seduction of Culture*, 50–1.

Mann speculated about the fate of the German people after the end of the Nazi regime: "Perhaps history has in fact intended for them the role of the Jews, one which even Goethe thought befitted them: to be one day scattered throughout the world and to view their existence with an intellectually proud self-irony."[100] In March 1934, Thomas Mann wrote in his diary: "The fact that I was driven away from that existence [the life he lived in Munich before emigration] is a serious flaw in the destined pattern of my life, one I am attempting—in vain, it appears—to come to terms with, and the impossibility of setting it right and reestablishing the existence impresses itself upon me again and again, no matter how I look at it, and it gnaws at my heart."[101]

Furtwängler, unlike Herbert von Karajan and Karl Böhm, was never a member of the Nazi party. As he said at the de-nazification tribunal: "It was my task to help German music, for which I felt responsible. That would not have been possible from abroad. (...) The people who once upon a time produced Bach, Beethoven, Mozart, Schubert, and others lived on under the surface of the national socialist Germany. (...) I could not leave Germany in her deepest misery."[102] In the film Furtwängler claimed: "I walked a tightrope between exile and the gallows." (A sentence—as one of the reviewers remarked—which nobody would dream of saying outside the bounds of a British stage.) In another memorandum, written in his defense in 1947, Wilhelm Furtwängler argued: "A single performance of a truly great German musical composition was by its nature a more powerful, more essential negation of the spirit of Buchenwald and Auschwitz than all words could be."[103] These words echo what Gründgens claimed in front of his de-nazification committee.

In *Taking Sides* Szabó had Furtwängler state that he did not emigrate because he was not forced to, as he was not a Jew. In 1924, the Hungarian émigré sociologist, Karl Mannheim, tried to define the genuine emigrant in his exile in Vienna: "Who then, is the genuine 'emigrant'? Only he who finds contradiction between his world view and that of the regime irreconcilable. Among these are also included individuals who were not persecuted, who could have remained at home, but who could not remain at

[100] Thomas Mann, *Past Masters* (New York: Alfred Knopf, 1933), 220.
[101] Thomas Mann, "Diaries, 14 March, 1934" in his *Diaries 1918–1939* (London: André Deutsch, 1983), 200.
[102] Furtwängler tribunal proceedings (in English), December 17, 1946. Zentralbibliothek, Zurich.
[103] Chris Walton, "Wilhelm Furtwängler Apologia pro vita sua," *Dissonanz* 51 (February 1997): 24.

home precisely because they found the contradiction irreconcilable."[104] In Mannheim's definition exile "thickens," and from a descriptive term, turns into a "thick" concept.

Mannheim would have considered Béla Bartók, the quintessential twentieth century Hungarian artist exile, a "genuine emigrant." When Bartók died in 1945 in New York, homesick and miserable, Paul Henry Lang bade farewell to him in an obituary on the pages of the *Musical Quarterly*:

> The philosophers are wont to say that a man can be characterized by the relationship of his intellectual and moral qualities, but they sometimes forget that mind itself, risen to a higher sphere, can become a moral quality, that the highest stature of mind can be synonymous with the greatest goodness, objectivity, and nobility. This noble mind was Bartók's: courage to speak the truth only and everywhere, to understand dispassionately, and to forgive—a just attitude towards friend and foe that all of us admired in him in his last trying years of self-imposed exile. (...) Among his fellow musicians there were perhaps some whose imagination and passion measured up to his, but their mind and intellect occupied only a secondary place on their altar and often beat a retreat before more powerful deities, and not a few of them were carried away by political events or acquiesced in what they took for a *vis major*. (...) There were artists and men of letters who placed political "social," and "national" slogans ahead of artistic and scholarly integrity, using such slogans to sit in judgment over the good reputation (and bread-earning) of their confreres. Even among the honorable exceptions there were many, in tortured Europe, who kept silent, rather than raise their voices in protest. (...) When all the furies of hell emerged from their hideous abode to plunge the world in misery and anguish, he voluntarily relinquished his prominent position, refusing to have commerce with the champions of hatred and destruction. Had he taken a passive attitude he could have remained the commanding figure of Hungarian—and European—music, for he could not have been denounced as a *Kulturbolschewik,* as a non-Aryan, or of inferior racial stock. But he could relinquish the eminent position due to him with a smile; he could leave it cheerfully, hand it over to someone unworthy of the honor...[105]

Bartók did not leave smiling and cheerful, but sad and desperately shaken, when he sailed to America after his last concert at the Budapest Music Academy.

The inflexible Adorno could barely believe his ears when listening to one of Bartók's last public talks: "But even Béla Bartók, from whom such

[104] "Levelek az emigrációból. I., 5 January 1924" [Letters from the emigration], *Diogenes* 1 (1924): 13. Quoted by David Kettler, "The Vicissitudes of Exile." Paper presented at a conference on "The Hungarian Revolution of 1956 and After: Impact and Contribution," Bard College, February 16, 2007.

[105] Paul Henry Lang, "Editorial," *The Musical Quarterly* 32 (January 1946): 131–6.

inclinations were very distant, began at a certain point to separate himself from his own past. In a speech given in New York he explained that a composer like he, whose roots were in folk music, could ultimately not do without tonality—an astounding statement from the Bartók who unhesitatingly resisted all populist temptations and chose exile and poverty when the shadow of Fascism passed over Europe."[106] For the elitist and uncompromising Adorno, the Bartók of the "late style," the Bartók of the "Ukrainian Folk Song" and the "Concerto for Piano and Orchestra," did not measure up to the ethical stand expected from a genuine emigrant. Bartók's last artistic and human gesture of reaching back to his roots, his beginnings,—his *Ansatzpunkte*, as Erich Auerbach would have called it— to Central European folk music, to tonality, was understood by Adorno as giving up basic moral standards.

Emigration, exile, for the exiled and homesick Adorno—who after the war, nevertheless, returned to Germany—was neither a descriptive category nor a "thick" concept, but a genuine moral concept. In the famous eighteenth passage of *Minima Moralia*, writing on the refuge for the homeless, Adorno stated: "The attempt to evade responsibility for one's residence by moving into a hotel or furnished rooms makes the enforced conditions of emigration a wisely-chosen norm (…) The best mode of conduct (…) still seems an uncommitted, suspended one (…) it is part of morality not to be at home in one's home."[107] Although in this passage—despite its widespread misreading—Adorno means what he says, speaking about homelessness and the homeless, the loss of one's house and private dwelling almost in a literal sense, the chapter from the first part of *Minima Moralia* is mostly quoted as a moral imperative addressed to the intellectual, who cannot be at home anywhere if he or she sticks to serious moral and intellectual commitments. This is how Edward Said, one of the most emblematic intellectual exiles of the past decades, understood and referred to it.

Said quoted Adorno's dictum, "it is part of morality not to be at home in one's home," several times. In his collection of essays, *Reflexion on Exile*, he refers to it twice.[108] In his 1993 Reith Lectures on BBC radio

[106] Theodor W. Adorno, "The Aging of the New Music" in *Essays on Music* (Berkeley: University of California Press, 2002), 184.

[107] Theodor W. Adorno, *Minima Moralia: Reflections from Damaged Life* (London: Verso, 1978), 38–9.

[108] Edward Said, *Reflections on Exile and Other Essays* (Cambridge, MA: Harvard University Press, 2002).

Said devoted a long segment to Adorno, once more referring to the eighteenth passage of *Minima Moralia*. According to Said, for Adorno the real intellectual is a permanent exile. "The *exilic* intellectual does not respond to the logic of the conventional but to the audacity of daring, and to representing change, to moving on, not standing still."[109] For Said, while exile is an actual condition, it is also "a metaphorical condition"; "the pattern that sets the course for the intellectual as outsider is best exemplified by the condition of exile, the state of never being fully adjusted, always feeling outside the chatty, familiar world inhabited by natives (…)" Wrong life cannot be lived rightly, warned Adorno in *Minima Moralia*, and according to Said, the life that can be lived rightly is the life of the exiled, the marginalized: "For the intellectual an exilic displacement means being liberated from the usual career. (…) Even if one is not an actual immigrant or expatriate, it is still possible to think as one, to imagine and investigate in spite of barriers, and always to move away from the centralizing authorities towards the margins (…)."[110] Words become particular concepts in their sites; in the context of Said's texts, the concepts of exile and emigration leave their descriptive character behind and take on forceful moral quality. Being out of place—the title of Said's autobiography—is not a spatial but an ethical status, "not a privilege but an *alternative* to the mass institutions that dominate modern life."[111]

Adorno was not Said's only exiled hero; three others appear in several of his writings: Hugh of St. Victor, Dante and Erich Auerbach. The three exemplary lives appear together in several of Said's works, among them in *Orientalism*.[112] The three figures, in fact, merge in one person: Erich Auerbach.

Hugh of St. Victor, the twelfth-century scholastic theologian who was born in Saxony but lived most of his life in the monastery of St. Victor in Paris, shows up in one of Auerbach last essays, *Philology and Weltliteratur*, which Edward Said translated together with his wife. Auerbach quotes a short passage from Hugh's *Didascalicon*: "It is therefore, a source of great virtue for the practiced mind to learn, bit by bit, first to change about invisible and transitory things, so that afterwards it may be able to leave

[109] "Intellectual Exile: Expatriates and Marginals" in Moustafa Bayoumi, Andrew Rubin (eds.), *The Edward Said Reader* (New York: Random House, 2000), 381. Originally published as Edward Said, *Representations of the Intellectual: The 1993 Reith Lectures* (New York: Vintage, 1996).

[110] Ibid., 373, 379–80, respectively.

[111] Edward Said, "Reflections on Exile," *Granta* 13 (Autumn 1984): 170.

[112] Edward Said, *Orientalism* (New York: Vintage, 1979), 258–60.

them behind altogether. The man who finds his homeland sweet is still a tender beginner; he to whom every soil is as his native one is already strong; but he is perfect to whom the entire world is a foreign land [*perfectus vero cui mundus totus exilium est.*]"[113] Said used and quoted (several times in different texts) this short passage of the mystic philosopher, via Auerbach, as his *ars poetica.*[114]

Auerbach wrote his first major work on Dante, the Florentine exile, to whom he devoted the most exalted parts in his *Mimesis.*[115] In the introduction written for the fiftieth-anniversary edition of *Mimesis,* Said claimed that Auerbach's book on Dante was his most exciting and intense work. Even in Auerbach's Dante what interests Said is the supposed tension between the Christian poet and the Jewish philologist, writing in exile, in the Orient, about the exiled seminal figure of the West:

> It is not hard to detect a combination of pride and distance as he [Auerbach] describes the emergence of Christianity in the ancient world as the product of prodigious missionary work undertaken by the apostle Paul, a diasporic Jew converted to Christ. The parallel with his own situation as a non-Christian explaining Christianity's achievement is evident, but so too is the irony that, in so doing, he travels from his roots still further. Most of all, however, in Auerbach's searingly powerful and strangely intimate characterization of the great Christian Thomist poet Dante—who emerges from the pages of *Mimesis* as *the* seminal figure in Western literature—the reader is inevitably led to the paradox of a Prussian Jewish scholar in Turkish, Muslim, non-European exile handling (perhaps even juggling) charged, and in many ways irreconcilable, sets of antinomies that, though ordered more benignly than their mutual antagonism suggests, never lose their opposition to each other.[116]

It is difficult to avoid the impression that what made Auerbach Said's hero in exile in the first place, was just a very short and modest passage, written as if in self-defense, on the last page of the Epilogue to *Mimesis.*

[113] Originally written in 1952. Translated by Edward and Maire Said, *Centennial Review* 13 (1969): 1–17. Hugh of St. Victor's words come from Book 3, chapter 19 of *Didascalicon.*

[114] In an interview Said gave to *Boundary 2,* he said: "I find myself, in a funny way, sort of living the way that passage describes—you know the passage I've quoted it many times—from Hugh of Saint Victor, where the person who is a stranger everywhere is somehow at home but not loving the world too much—you know—you're moving on." "The Panic of the Visual: A Conversation with Edward Said," *Boundary 2* 25 (Summer 1998): 23.

[115] Erich Auerbach, *Dante als Dichter der irdischen Welt* (Berlin: de Gruyter, 1929) and the "Farinate and Cavalcante" chapter in his *Mimesis,* 174–202.

[116] Edward Said, "Introduction" to Auerbach's *Mimesis,* xvii–xviii.

"(…) I should especially have liked to add a special chapter on German realism of the seventeenth century. But the difficulties were too great. As it was, I had to deal with texts ranging over three thousand years, and I was often obliged to go beyond the confines of my own field, that of the romance literatures. I may also mention that the book was written during the war and in Istanbul, where the libraries are not well equipped for European studies."[117]

Istanbul was not Auerbach's choice: when he was forced to give up his position at the University of Marburg in 1936, he received an invitation to teach Romance languages and literature at the University of Istanbul. It would be wrong to claim that Auerbach's move was merely a change of place, *loci commutatio*. For Said, the author of *Orientalism*, Auerbach's location is more than a historical accident or necessity; it is the appropriate condition for the engaged and critical intellectual, the precondition of meaningful intellectual work. "At this point then, Auerbach's epilogue to *Mimesis* suddenly becomes clear: 'it is quite possible that the book owes its existence to just this lack of rich and specialized library.' In other words, the book owed its existence to the very fact of Oriental, non-Occidental exile and homelessness. And if this is so, then *Mimesis* itself is not, as it has so frequently been taken to be, only a massive reaffirmation of the Western cultural tradition, but also a work built upon a critically important alienation from it, a work whose conditions and circumstances of existence are not immediately derived from the culture it describes with such extraordinary insight and brilliance but built rather on an agonizing distance from it."[118]

[117] Auerbach, *Mimesis*, 557.

[118] Edward Said, "Secular Criticism" (1983) included in his *The Word, the Text, and the Critic* (Cambridge, MA: Harvard University Press, 1983), 7–8. See also Aamir R. Mufti, "Auerbach in Istanbul: Edward Said, Secular Criticism, and the Question of Minority Culture," *Critical Inquiry* 25 (Autumn 1998): 95–125. In *The Word, the Text, and the Critic*, Auerbach is the central figure. On the page preceding my quote Said wrote: "To any European trained principally, as Auerbach was, in medieval and renaissance Romance literatures, Istanbul represents the terrible Turk, as well as Islam, the scourge of Christendom, the great Oriental apostasy incarnate. Throughout the classical period of European culture Turkey was the Orient, Islam its most redoubtable and aggressive representative. (…) The Orient and Islam also stood for the ultimate alienation from the opposition to Europe, the European tradition of Christian Latinity, as well as to the putative authority of ecclesia, humanistic learning, and cultural community. (…) To have been an exile in Istanbul at the time of fascism in Europe was a deeply resonating and intense form of exile from Europe." Ibid., 6.

I have not quoted the whole passage of Auerbach's "self-defense" in the Epilogue of *Mimesis*. The text continues: "International communications were impeded; I had to dispense with almost all periodicals, with almost all the more recent investigations, and in some cases with reliable critical editions of my texts. (…) The lack of technical literature and periodicals may also serve to explain that my book has no notes. Aside from the texts, I quote comparatively little, and that little it was easy to include in the body of the book. On the other hand it is quite possible that the book owes its existence to just this lack of a rich and specialized library. If it had been possible for me to acquaint myself with all the work that has been done on so many subjects, I might never have reached the point of writing."[119] Said understands Auerbach's words as a conscious attempt to turn necessity into virtue: the isolated existence forced him to find a method whereby he could rely only on the available classical texts, and still reconstruct whole lives and a whole world from the fragments. At this point, it is not only his life in exile that makes Auerbach an exemplary figure for Said, but also the method—which in Said's reading is directly connected to the state and life of the exile. Said's insight into Auerbach's method—independent of its relation to the exiled condition—is relevant for the larger theme of my essay.

In his introduction to *Mimesis* Said tried to summarize and understand Auerbach's working method. "In order to be able to understand a humanistic text, one must try to do so as if one is the author of that text, living the author's reality, undergoing the kind of life experiences intrinsic to his or her life (…)."[120] To make the past intelligible the researcher should get immersed in the world of the past, to reconstruct it by the help of appropriate dense description, in order to achieve intensity. Said emphasizes Auerbach's "extraordinary attention to the minute, local details," and even evokes the term "thick" when describing Auerbach's research method: "to accomplish a greater realism, a more substantial '*thickness*' (to use a term from current anthropological description)."[121]

The introduction reproduces a long passage from the main text of *Mimesis*:

> When people realize that epochs and societies are not to be judged in terms of a pattern concept of what is desirable absolutely speaking but rather in every

[119] Auerbach, *Mimesis*, 557.
[120] Ibid., xiii.
[121] Ibid., xxi (emphasis is mine).

case in terms of their own premises; (...) when, finally, they accept the conviction that the meaning of events cannot be grasped in abstract and general forms of cognition and that the material needed to understand it [must be sought] (...) in the depths of the workaday world and its men and women, because it is only there that one can grasp what is unique, what is animated by inner forces, and what, in both concrete and a more profound sense, is universally valid: then it is to be expected that those insights will also be transferred to the present and that, in consequence the present too will be seen as incomparable and unique, as animated by inner forces and in a constant state of development; in other words, as a piece of history whose everyday depths and total inner structure lay claim to our interest both in their origins and in the direction taken by their development.[122]

In his *Appendix: Epilegomena To Mimesis*, Auerbach attempted once more to explain his method:

My effort for exactitude relates to the individual and the concrete (...). The arranging must happen in such a way that it allows the individual phenomenon to live and unfold freely. Were it possible, I would not have used any generalizing expressions at all, but instead I would have suggested their thought to the reader purely presenting sequence of particulars. (...) It is in the nature of our subject that our general concepts are poorly differentiable and are undefinable. Their worth—the worth of concepts such as classic, Renaissance, mannerism, baroque, enlightenment, Romanticism, realism, symbolism, and so forth, most which originally designate literary epochs or groups, but which are also applicable far beyond those—accordingly, their worth consists in that they elicit in readers or hearers a series of ideas that facilitate for them an understanding of what is meant in the particular context. They are not exact (...). One must beware, it seems to me, of regarding the exact sciences as our model; our precision relates to the particular.[123]

Said pays particular attention to one of the most peculiar features of Auerbach's methodology: "In comparing himself to modern novelists such as Joyce and Woolf, who re-create a whole world out of random, usually unimportant moments, Auerbach explicitly rejects a rigid scheme, a relentless sequential movement, or fixed concepts as instruments of study. 'As opposed to this,' he says near the end, 'I see the possibility of success and profit in a method which consists in letting myself be guided by a few motifs which I have worked out gradually and without a specific purpose' (...)."[124] This insistence on a few seemingly insignificant and

[122] Ibid., xxvii–xxviii (originally from 443–4.)

[123] Ibid., 572–3. First published in *Romanische Forschungen* 65 (1953): 1–18. Translated by Jan M. Ziolkowski.

[124] Ibid., 548.

random motifs that Said emphasizes is precisely that aspect of Auerbach's method which made him important for Carlo Ginzburg, the conscious practitioner of "thick" description: "My approach to microhistory is strongly indebted to the work of scholars like Erich Auerbach (...) who developed interpretations of literary and painterly artifacts based on clues others had considered insignificant. (...) A life chosen at random can make concretely visible the attempt to unify the world, as well as some of its implications. In saying this I am echoing Auerbach."[125] In another piece, Ginzburg reasserts: "As Erich Auerbach wrote half a century ago, in a world like ours, which knowledge can no longer control, research should not proceed from broad conceptual categories but from concrete starting points (*Ansatzpunkte*), intuitively acquired and then thoroughly investigated: concrete points and, I would add, random."[126] I do not insist on randomness (nor does Ginzburg, who adds: "But of course I do not regard this as a rule"); what emerges as important for me from this long detour in Auerbach's company is the suspicion of broad, general conceptual categories, the insistence on the concrete, the individual that acquires its meaning in the particular historical context, the development from the starting point as defined by the perceived end-point of the complex historical incident.

In his introduction to *Mimesis* Said devotes a passage to Goethe—who figures prominently in Auerbach's book—where he writes affectionately about Goethe's cycle of intimate love poems, the "West-Östlicher Diwan," inspired by verses of the Koran and by the German translation of the Persian poet, Shams-od-Din Muhhamad Hafiz (or Hafez). Edward Said was an accomplished pianist; in his early years, he attended the Julliard School of Music. He published texts on music, collected in volumes of essays (*Musical Elaborations, On "Late Style"*). He befriended the Argentinian-born Jewish pianist and conductor, Daniel Barenboim, then the musical director of the Chicago Symphony Orchestra, which, in 1948 rejected Furtwängler for his Nazi past. (Their public conversations on

[125] Carlo Ginzburg, "Latitude, Slaves, and the Bible: An Experiment in Microhistory," *Critical Inquiry* 31 (Spring 2005): 665–83.

[126] Carlo Ginzburg, "Conversations with Orion," *Perspectives Online* 45 (2005), at: www.historians.org/Perspectives/issues/2005/0505/0505arc1.cfm (accessed 15 March, 2007).

music held at the Carnegie Hall in New York were published as *Parallels and Paradoxes*). Goethe's poem suggested the name for a musical ensemble—the "West-Eastern Divan"—founded by Said and Barenboim, comprising young Israeli and Palestinian musicians, who set up an international musical summer camp and gave concerts together all over the world, including Israel and the Palestinian territory. The project was originally conceived in Weimar near to Buchenwald on the 250th anniversary of Goethe's birth.

Both Barenboim and Said had formative experiences related to Furtwängler in their childhood. At the age of eleven Barenboim met and played for Furtwängler, who then wrote: "The eleven-year-old Daniel Barenboim is a phenomenon." Said, as a child, was taken by his parents to one of Furtwängler's concerts in Cairo: "This was *the* overpowering musical performance of my first twenty-two years of life, approached only when in 1958 I heard the opening measures of *Das Rheingold* rising out of the black Bayreuth pit," recalled Said in his memoirs.[127] Furtwängler conducted the Berlin Philharmonic, and he gave two concerts. The two-day program included, apart from Schubert's "Unfinished" symphony, Mozart's G-minor, and Beethoven's Fifth symphonies, Bruckner's Seventh (with the Adagio that had been played on German radio under Furtwängler's baton when Hitler's suicide was announced). "My parents drew the obvious conclusion that only the first program was suitable for me, and it may have been the unknown 'Bruckner' that put them off," remembered Said. Beethoven's Fifth had a lasting impact on Said. Said devotes three pages of his autobiography to his Furtwängler experience, which end with:

> On my fifteenth birthday in 1950, my parents had given me Percy Scholes' *Oxford Companion to Music*, which I still own, and which had a tiny entry for Furtwängler ("German conductor born in 1866; see Germany and Austria") that elaborated upon a bit in a general but very oblique discussion of music under the Third Reich, and Furtwängler's role in the *Mathias der Maler* case. This gave no sense of why he was so controversial a figure after the war, or that the question of morality and collaboration had so powerful a bearing on him.[128]

Daniel Barenboim lives in Berlin, where in the past years, he has conducted the Berlin Staatskapelle. On July 7, 2001 the Staatskapelle was scheduled to perform at the Israeli Festival in Jerusalem. Barenboim de-

[127] Edward Said, *Out of Place* (London: Granta Books, 1999), 102 (original emphasis).
[128] Ibid., 104.

cided to include the first act of Wagner's *Walküre* as part of the program; one of the singers would have been Placido Domingo. A public outcry forced Barenboim to change the original plans, and instead of Wagner, he included Schumann and Stravinsky. A week before the concert, Barenboim held a press conference, which was, it is said, interrupted by the ringing of a mobile phone to the tune of Wagner's *Ride of the Valkyries*. The following week, at the end of the Staatskapelle concert, Barenboim, supposedly influenced by the incident during the press conference, turned to the audience and offered a short extract from Wagner's *Tristan and Isolde* as an encore. As Edward Said described the event in a piece he wrote for *Le Monde diplomatique*: after the scandal that erupted following the concert, Barenboim "opened the floor for discussion [that lasted for half an hour]. In the end, Barenboim said he would play the piece but suggested that those who were offended could leave, which some did. By and large, the Wagner was well received by a rapturous audience of about 2800."[129] Ehud Olmert, the future Prime Minister, then the mayor of Jerusalem, denounced Barenboim as "brazen, arrogant, uncivilized, and insensitive." Barenboim had to apologize. In the piece written in defense of his friend, Said returned to Adorno, and his Auerbach thesis: "Barenboim is at home everywhere and nowhere. (...) One can imagine that for many Jews for whom Germany still represents what is most evil and anti-Semitic, Barenboim's residence there is a difficult [issue to accept], especially as his chosen area of music to perform is the classical Austro-Germanic repertory, in which Wagner's operas are at the centre (in this he follows Wilhelm Furtwängler, the greatest German conductor of the 20th century, also a complex political figure)."[130]

In March 2003, Barenboim and the Berlin Staatskapelle were honored with the Wilhelm Furtwängler-Preis. In December 2004 Barenboim, leading the Berlin Philharmonic, conducted Furtwängler's symphony No.2. When asked about the choice of the program, Barenboim said: "Furtwängler understood sound in a way no other interpretive musician had managed to achieve. He understood music as something that integrates everything—intellect, sentiment and sensuality. Furtwängler was not a Nazi."[131] In István Szabó's *Taking Sides* the investigator asks Furt-

[129] Edward Said, "Why Barenboim was Right to Conduct Wagner in Israel: Better to Know," *Le Monde diplomatique* (6 October 2001).

[130] Ibid.

[131] "Barenboim Pitches into Blair over Handling of Middle East Peace Deals," *Guardian Unlimited* (30 November 2004).

wängler: "Why didn't you get out in 1933, when all the others, Bruno Walter, Klemperer, Max Reinhardt left? They were right to leave," Furtwängler answers, "they were Jews. I am a German; I stayed in my homeland." At this point Furtwängler decides to leave the room. Major Arnold's assistant, the German–Jewish-born, American-raised Lt. David Wills, whose parents were left behind in Gemany and perished in a concentration camp, runs after the conductor. When he catches Furtwängler in the corridor, he says: "When I was a child, my father took me to one of your concerts. I remember, you conducted Beethoven's Fifth Symphony. I was deeply moved. I have loved music ever since. I was grateful to you. And I admired you. How could you, how could you serve those criminals?" The film ends with an archive recording of Furtwängler conducting Beethoven's Fifth.

Communist Secret Services on the Screen

The Duna-gate Scandal in and beyond the Hungarian Media[1]

RENÁTA UITZ

The visual record of Hungary's transition to democracy is marked with comfortably familiar (if not canonical) images of key events and personalities. No visual representation of the Hungarian transition which takes its topic and itself seriously is complete without the black-and-white film of Imre Nagy, the prime minister of the 1956 revolt, listening to his death sentence, followed by the images of the immense crowd at his reburial ceremony before the catafalque on Heroes' Square. The story of the Roundtable Talks cannot be presented properly without the requisite images of the Opposition Roundtable meeting in the building of the Law faculty at Eötvös Loránd University.[2] Whether the participants (re)presented will include János Kis, László Sólyom, Viktor Orbán or Péter Tölgyessy much depends on the editors' discretion.

[1] The idea of this paper emerged while I was teaching a course with Oksana Sarkisova at CEU, Budapest on the representations of the transition to democracy in documentary films. A research paper written by Fruzsina Orosz (LEGS class 2005/06) for this course enabled me to articulate some of my points. While I owe a lot to their insights, I remain fully responsible for any errors and misunderstandings in this piece. All translations from the Hungarian are mine.

[2] The Hungarian Roundtable Talks were conducted between the Communist Party, the Opposition Roundtable and the so-called Third Side (*Harmadik Oldal*). For an informative introduction to the Hungarian Roundtable Talks see András Sajó, "The Roundtable Talks in Hungary" in Jon Elster (ed.), *The Roundtable Talks and the Breakdown of Communism* (Chicago: The University of Chicago, 1996). On the question of the reorganization of the secret police at the Roundtable Talks see the record on the appearance of Ferenc Pallagi, the deputy minister in the Ministry of the Interior, responsible for state security services (head of Division III in the Ministry of the Interior) on September 6, 1989 before the Roundtable's experts' subcommittee no. I/6 (the negotiating forum entrusted with developing measures to prevent aggressive solutions) in András Bozóki (ed.), *A rendszerváltás forgatókönyve. Kerekasztal-tárgyalások 1989-ben* [The script of transition. Roundtable talks in 1989] (Budapest: Új Mandátum Könyvkiadó, 2000), vol. 6, 659, 663–4. For an exchange at a mid-level political coordination meeting, see also *A rendszerváltás forgatókönyve*, vol. 4, 302, 323.

Over the years a characteristic iconography has developed around all the major traumas, dilemmas, regrets and victories of Hungary's transition to democracy. In the public debate about these issues rhetorical panels are accompanied by standard visual panels, generating an air of reassuring familiarity. Among the visual accounts which reflect the dilemmas about the fate of the archives of the communist secret services is the footage on the Duna-gate[3] scandal shot by the Black Box (*Fekete Doboz*) crew. This footage contains telltale signs that the communist secret services were deeply engaged in inappropriate and illegal activities following the conclusion of the Roundtable Talks and even after the declaration of the Republic on October 23, 1989. The Black Box crew filmed hard evidence of continuing illegal secret surveillance of the emerging political opposition and events suggesting the destruction of files on the premises of the communist secret police. As preserved in (distorted) public memory, the central image associated with the Duna-gate scandal is that of a giant shredder wiping out the paper trail of the communist regime.

For several years afterwards, the short documentary about the "Duna-gate scandal" popped up in the Hungarian media whenever it hosted the hesitant but increasingly intricate public debate about the fate of the personnel and the files of the communist secret police.[4] This was a long proc-

[3] Duna-gate was named after Watergate. *Duna* is the Hungarian name of the river Danube. I decided to keep the Hungarian throughout the text. In the discussion below I follow László Varga, "Gergő és az ő árnyéka, avagy amikor a jog a politika ügynökévé válik" [Gergő and his shadow, or when law becomes the agent of politics], *Beszélő* 7 (September–October 2002): 30, available at http://beszelo.c3.hu/02/0910/07varga.htm (accessed 10 February, 2007); Béla Révész, "Dunagate I, Előzmények és botrány a sajtó tükrében" [Dunagate I, the antecedents and the scandal as reflected in the press], *Beszélő* 9 (December 2004): 46, available at http://beszelo.c3.hu/04/12/08reveszb.htm (accessed 10 February, 2007); Béla Révész, "Dunagate II, A rendszerváltás forgatókönyvei és állambiztonság" [The scenarios of transition and state security], *Beszélő* 10 (January 2005): 40, available at http://beszelo.c3.hu/cikkek/dunagate-ii (accessed 10 February, 2007) and Béla Révész, "Dunagate III, A jogállam árnyékában" [In the shadow of the constitutional state], *Beszélő* 10 (February 2005): 46, available at http://beszelo.c3.hu/cikkek/dunagate-iii (accessed 10 February, 2007). The references below are to the electronic versions of these articles.

[4] Throughout the paper I am using the phrases "communist secret services" and "communist secret police" interchangeably, as the secret services were a unit in the communist police force within the framework of the Interior Ministry. The most infamous unit in the Hungarian communist secret police was Subdivision III/III, the department dealing with internal intelligence. Over the years it became more and more clear that the various departments within the secret police (i.e. counter-intelligence, foreign intelligence and internal intelligence) worked together, so that in the long run the Hungarian polity's ini-

ess, in the course of which not only would the Hungarian polity gradually learn about the compromised past of several public figures who were involved with the secret police, but those who cared to pay attention would also acquire the ability to distinguish between individuals involved in the operations of the security police and thus tell a networker from a rank-and-file security police officer. Eventually those who followed all the inquiries and the legal and political developments would also accept that instead of expecting a complete and definitive list of agents to emerge, or waiting for the dossier of a suspected agent to surface, it was better to accept that secret police paperwork broke down into a number of different genres. While there is no such thing as an agent-list, there existed a network roster (*hálózati nyilvántartás*) and instead of one agent file there are dossiers on enrolling agents (*beszervezési dosszié* or "*B*" *dosszié*), accompanied by personal information sheets (the so-called form no. 6, or "*6*"-*os karton*) and agents' work dossiers (*munka dosszié* or "*M*" *dosszié*). In addition to such documents, the communist secret service regularly produced various types of reports in the course of their activities.[5] Whether intricately technical, deeply emotional or simply defamatory, any contribution on secret police personnel, lustration or file access will take note of the fact that the secret police documents preserved and currently available are compromised, as many files are missing. While some of the missing files appear to be available, at least for blackmailing, many are believed to have been destroyed in the last days of the communist regime in a major house-cleaning campaign undertaken at the secret services.[6]

tial preoccupation with pinpointing officers and agents in Subdivision III/III turned out to be more misleading than useful in coming to terms with the communist past.

[5] For an overview, see Béla Révész, "Ellenzékiek megfigyelése a kerekasztal-tárgyalások idején" [Surveillance of the opposition during the roundtable ralks], available at www.rev.hu/html/hu/ugynok/munka/revesz2.html (accessed 10 February, 2007); R. Müller, "Napi Operatív Információs Jelentések, 1979–1989" [Daily operative information reports, 1979–1989] in György Gyarmati (ed.), *Trezor 1. A Történeti Hivatal Évkönyve* [Trezor 1. Yearbook of the agency for history] (Budapest: Történeti Hivatal, 1999), 251–82. Furthermore, documents were not only produced but also destroyed in the course of the regular operations of the secret police, as in any other bureaucratic organization. Internal rules required records to be kept of the fate of files wiped out.

[6] Police major-general Horváth, the chief of Subdivison III/III on October 16, 1989 proposed a wholesale review of operative records, with reference to the changed political circumstances. The task was to destroy all security police files which were not compatible with the current legal regulations. Deputy minister Pallagi authorized the destruction of files on November 21, 1989. Accordingly, Horváth prepared a proposal, dated December 8, 1989, which called for a "comprehensive review of the operative records" of

In this article I will examine how the familiar images of the Duna-gate scandal changed as they accompanied the Hungarian debate about lustration and access to the files of the communist secret police.[7] As the years of transition slowly faded into the past, the documentary record bearing the ultimate visual evidence of illegal secret police activities went through a curious transformation before our eyes.

My article will demonstrate the dilution of the original footage as it was committed to public memory. During the early years the short fragment recorded on the premises of the communist secret services served as the standard illustration of anything to do with lustration. At a curious, tense moment in 2004 fragments of the visual record were merged in the evening news with extraneous fragments which—although they belonged to different events—conformed better to the public memory of Duna-gate. This mélange of images was then used to challenge the credibility of the original recording, sometimes even by individuals whose own identity shifted significantly within the same period. As a result, the once compelling visual evidence of the abuse of governmental power was replaced by far less unsettling images.

This article tracks the many lives of the original Duna-gate footage in the Hungarian media and beyond. It will discuss how these few minutes of a video journal recorded and edited by the Black Box studio defined the reference points of the story of the communist state security services and how these symbols were transformed among other myths and legends in the making. The analysis follows the Duna-gate footage from the moment when it served as the ultimate visual evidence of the illegal activities of

the state security services. This proposal, signed by Pallagi on December 18, 1989, authorized a sweeping destruction campaign with the deadline of December 31, 1989. The destruction order covered those current operative files still with the state security personnel, archived operative files and the so-called network files (i.e. files on agents and other contacts of the services). On December 22, 1989 a circular from the secretariat of the deputy minister for state security services ordered that no records of the destruction of files should be kept. These documents are available in György Markó, "Állambiztonsági iratok a Történeti Hivatalban. A Duna-gate egy belügyminisztériumi jelentés tükrében" [State security documents at the agency for history. Duna-gate in the light of a Report of the Ministry of the Interior], *Kritika* 31 (October 2002): 20, available at www.th.hu/html/hu/aktualitas/irat_megsemmisites.html (accessed February 10, 2007).

[7] In its broadest sense, lustration is a method of exposing and/or removing former secret service personnel (officers, agents and informers) from elective public offices and public employment. Solutions in different countries differ in scope and vehemence. The pages below will summarize the most important features of the Hungarian approach to lustration, without providing a detailed comparative analysis.

the communist secret police, through the years when it became an indispensable illustration in accounts of Hungary's transition to democracy, to the point where, due to an unfortunate editorial decision, it appeared as a false collage of itself.

In January 1990, the Duna-gate scandal was one of the first real shocks to test the durability of the compromises behind the new constitutional arrangements established in the transition to democracy in 1989. The first part of the article introduces the Duna-gate scandal briefly. It is important to point out at once that the scandal was not only the subject of the documentary whose afterlife is to be discussed in the following pages. It was also the key event which started the ongoing legislative effort to manage the files of the communist secret police, first predominantly in the context of lustration, and subsequently in ensuring that both the victims of secret police abuse and researchers obtained meaningful access to whatever was preserved of these files. Since the media-life of the Duna-gate fragment is so intricately tied up with the twists and turns of the lustration and file access saga, the rest of the article will attempt to account for those key events in the political and legislative record which left their mark on the public life of the Duna-gate footage.

In tracing the somewhat unfortunate career of the original footage my main concern is not the plasticity of visual evidence in the midst of the storms of democratic transition, as one might expect. Instead, I regard the fate of the Duna-gate footage as the best diagnostic tool for exploring the Hungarian context, which has been unable to produce an appropriate lustration law or a legal framework allowing victims and researchers proper access to the preserved files of the communist secret services.

THE DUNA-GATE FOOTAGE AS EVIDENCE OF SECRET POLICE ABUSES

In Hungary, the fate of the communist secret services and the future of the files they accumulated in the course of their operations were not settled during the early days of the transition to democracy. It is now known that key figures of the fledgling political opposition had been under secret police surveillance during the last days of the communist regime, and it is suspected that some of them were under surveillance even during the Roundtable Talks. Nevertheless, while the rightful owners wanted their confiscated copies of *samizdat* literature back, along with the printing press that had also been seized by the authorities, the abolition of the state security services and the opening of their

archives was not a key item on the agenda of the dealmakers of the democratic transition in 1989. The Opposition Roundtable pointed out the need for a reorganization of the communist secret services, a suggestion that was rejected both by the Communist Party[8] and by the Third Side at the national Roundtable Talks. In the end, the closure of the communist secret services did not become an opposition demand at the Roundtable Talks. The transition to democracy was crowned by the declaration of the Republic on October 23, 1989 and the entry into force of a set of constitutional amendments which introduced the constitutional framework for a multi-party democracy based on constitutionalism and the rule of law.

Before the democratic elections in which the freshly formed opposition parties were to compete for the votes of the electorate, as the first newsworthy event of the new year, on January 5, 1990, four prominent opposition figures, Bálint Magyar and Gábor Demszky of the Alliance of Free Democrats, and Gábor Fodor[9] and József Szájer of the Alliance of Young Democrats, revealed their recent discovery in a press conference held at the *Graffiti* cinema. Showing a short film allegedly recorded inside a building of the Interior Ministry, they claimed that the communist secret services were still keeping opposition parties and their members under illegal surveillance and using reports based on this surveillance for their subsequent operations.

The short, black-and-white film is not too spectacular. First the camera shows steel cupboards which, a whispering male voice explains, are empty, due to the fact that "forty tons of secret documents were destroyed." Then we see sheets of paper, one saying "Strictly confidential" (*Szigorúan titkos*) in the top right corner and "Report" (*Jelentés*) in the middle. From there the camera slowly moves downwards, with a different male voice reading the document aloud. The typed text itself gives an account of various meetings attended by prominent members of the emerging political opposition in late December, 1989.

[8] Hungarian Socialist Workers' Party (*Magyar Szocialista Munkáspárt*), to give it its proper name, commonly abbreviated as MSzMP. The Hungarian Socialist Party (*Magyar Szocialista Párt*, commonly abbreviated as MSzP) referred to in the text is the offspring of the Communist Party, formed during the regime change, which was also elected to the first democratically elected Parliament and subsequently became a governing party in 1994, and also in 2002 and 2006 (forming a coalition with a small liberal party, the Free Democratic Alliance [*Szabad Demokraták Szövetsége*, or SzDSz].

[9] Gábor Fodor later transferred to the Alliance of Free Democrats and remains an active advocate of unrestricted access to files.

These unappealing images, recorded by a shaky hand, served as first hard evidence that the communist secret services had not abandoned their surveillance of the members of the political opposition. In addition, this was the first tape to emerge as proof of the mass destruction of secret police files: the Black Box footage shows images of bags and steel cupboards which a narrator identifies as signs of the mass destruction of documents, explaining that all this is taking place at the Interior Ministry, on the premises of the secret police. It was this tape that unleashed the Duna-gate scandal with plenty of evidence of illegal secret service surveillance, but with not much more than strong hints of the mass destruction of secret police papers.

After introducing this footage, these leading members of the political opposition demanded the criminal prosecution of key state security officials by the metropolitan chief prosecutor. An hour before the press conference, János Kis and Gábor Fodor of the opposition approached Prime Minister Miklós Németh with a petition demanding an explanation and the instant reorganization of the secret services.[10]

The claim made by the opposition politicians was straightforward. While before the declaration of the Republic on October 23, 1989 one could still explain the surveillance of opposition figures as a sign of the unrelenting communist regime exercising its powers to the utmost, this explanation became inadequate as of that day. The major constitutional revision which had been agreed upon during the Roundtable Talks was now in effect,[11] a revision which turned Hungary into a constitutional democracy. As expected, the scandal of Duna-gate exploded when opposition figures discovered that they were under illegal surveillance and decided to use the press to demand the prosecution of those responsible.[12]

The footage which set the events in motion was recorded in exactly the sort of conspiratorial circumstances that one might expect in a story revolving around the communist secret police. According to the partici-

[10] The letter is available in Hungarian in Révész, "Dunagate I" in his note 34.

[11] Béla Révész, "Az Ellenzéki Kerekasztal es az állambiztonsági szervek" [The Opposition Roundtable and the State Security Services] in *A rendszerváltás forgatókönyve*, vol. 7, 420.

[12] Varga, "Gergő és az ő árnyéka" and Révész, "Dunagate I" in note 48. The investigation of the alleged crimes of the secret services fell under the jurisdiction of the military prosecutor. Following the press conference Ferenc Kőszeg, a prominent opposition figure, was approached by another police officer, Lieutenant István Bajcsi, to request his presence at the military prosecutor's office where Bajcsi was planning to hand over further evidence on the illegal surveillance of opposition figures. Bajcsi did not know Kőszeg before.

pants' accounts, on December 25, 1989 Gábor Roszik, an Evangelical pastor and a well-known MP on the opposition side at the time, was approached by a man in the crowd in the middle of an open-air ecumenical service held at Heroes' Square in Budapest. The man, who was unknown to him, asked to be introduced to a journalist who would be willing to go to the premises of the Ministry of the Interior to report on the misdeeds of the secret police. Roszik directed the mysterious bespectacled man to journalist Zoltán Lovas. Lovas first asked a few key opposition figures, among them Ferenc Kőszeg, for advice about the proposed leak.[13]

Subsequently, accompanied by a cameraman, Lovas was led by the bespectacled man, Major József Végvári, a state security officer, to one of the buildings of the state security services, exactly as he had been promised on Heroes' Square. The journalist and the cameraman did not meet any resistance at the secret police premises.[14] While they were filming, they were shown a set of documents proving the continuing surveillance of opposition figures after October 23, 1989, and also some signs of the destruction on a massive scale of state security documents.

In response to the Duna-gate scandal both the Interior Ministry and the outgoing (still communist) Parliament started investigations.[15] An *ad hoc* committee was established in the Interior Ministry to investigate the opposition's claims and the request for prosecution filed by the opposition in January 1990. In its report, dated January 16, 1990, the committee found the state security service documents accessed by the political opposition to be authentic, and also confirmed that some of the information contained in the reports appearing in the Duna-gate footage could only have been obtained through secret surveillance measures. As the report shows, the central concern of the Interior Ministry's *ad hoc* committee was to establish who had ordered the surveillance, upon what legal grounds and for what purpose. This was a particularly challenging task as the secret services'

[13] Kőszeg (himself a favorite object of surveillance games) was a participant in the Roundtable Talks (on experts' subcommittee no. I/6), but he did not attend the meeting in which deputy minister Pallagi was heard about the activities of the communist secret services.

[14] Despite the lack of resistance, as Lovas explains, at that time this was a most stressful assignment and the intruders were not entirely sure whether they were safe. His panic and fear caused serious physical symptoms. See his early account in Zoltán Lovas, *Jöttem, láttam, győztek* [I came, I saw, they conquered] (Budapest: AB-Beszélő, 1990), 201, and later in the documentary *Hero or traitor?* (*Hős vagy áruló?* Dir: Róbert Kiss, 2004). The title of the film refers to Major József Végvári.

[15] The reports of these investigations were published as an appendix to Révész, "Dunagate III" at www.beszelo.hu/05/02/095reveszfugg.htm (accessed 10 February, 2007).

operational rules stated that once the surveillance of an object was terminated, the order authorizing the surveillance had to be destroyed. The *ad hoc* committee rejected the contention of the services that surveillance was necessary to protect the leaders of the opposition, and found that the purpose of the surveillance was an inquiry into the plans, activities and connections of the individuals in question.[16]

Following the report of the Interior Ministry's committee, Interior Minister István Horváth ordered the seizure of the files of Subdivision III/III and prohibited further surveillance; on January 18, 1990—five days before his resignation—he ordered the complete winding up of the internal security services and a halt to the destruction of their files. In January, 1990 the outgoing communist Parliament passed an act concerning the interim regulation of the use of surveillance measures[17] and on January 31, 1990 a parliamentary committee was set up to investigate the operations of the state security services.

The parliamentary committee investigating internal security operations for the outgoing communist Parliament included two members from the opposition: Miklós Tamás Gáspár and József Debreczeni.[18] The committee was astonished by the web of secret regulations and internal orders under which the state security services operated. The communist secret services' last-minute destruction of the files in December 1989 was successful to the extent that the committee was unable to identify exactly

[16] The report of the *ad hoc* committee is available at Markó, "Állambiztonsági iratok a Történeti Hivatalban" and also as an appendix to Révész, "Dunagate III."

[17] Act no. 10 of 1990 on the interim regulation of permissions on special surveillance measures and techniques. Note, however, that this act did not contain any comprehensive regulations for the national security establishment. Instead, in the spring of 1990 the outgoing Communist Cabinet passed a Cabinet decree in connection with the act on the interim regulation of surveillance measures concerning the interim regulation of national security tasks. (Cabinet decree 26/1990. (II. 14.) Korm. on the interim regulation of the performance of national security tasks.) This interim cabinet regulation provided the grounds for establishing the bulwarks of the currently existing national security establishment in the form of two civilian, *Nemzetbiztonsági Hivatal* [Agency for National Security] and *Információs Hivatal* [Information Agency], and two military intelligence offices, opening on March 1, 1990. The final regulation of the new Hungarian democracy's national security services was passed in 1995 (Act no. 125 of 1995), during the second Parliament with an overwhelming majority of the Hungarian Socialist Party.

[18] The report of the parliamentary committee is available in 29/1990. (III. 13.) OGY határozat a Belügyminisztérium belső biztonsági szolgálatának tevékenységéről [29/1990. (III. 13.) OGY resolution on the operations of the state security services of the Ministry of the Interior].

which members of the political opposition were under surveillance for how long and on whose orders even after October 23, 1989.

It seems that the primary source of information on these surveillance activities before the parliamentary committee was a set of daily operative information reports (*napi operatív információs jelentés*, i.e. documents similar to the ones flagged by opposition politicians in their Duna-gate press conference) and various internal informational reports (*tájékoztató jelentések*) by the secret services. The parliamentary committee wrongly concluded that the campaign of destruction in December 1989 had almost completely destroyed the files (archives) of subdivision III/III, thus preventing posterity from learning about the ways of the communist regime. The committee established the political responsibility of Minister István Horváth, deputy minister Ferenc Pallagi and police Major-General József Horváth; by then all three had resigned. There seems to be no hint in the committee's final report about the preservation of the surveillance or other files of Subdivision III/III in the archives of the continuing intelligence services.

Presenting the findings of the parliamentary committee in the plenary session, Miklós Tamás Gáspár read out the names of those high-ranking politicians who were the recipients of the secret services' regular reports, copies of which were filmed by Black Box inside the Ministry. He stressed that from the reports themselves it was not obvious that the information they contained had been collected by illegal means. Nonetheless, he suggested that all politicians who were recipients of such reports should resign from political life. In response, Prime Minister Miklós Németh—himself one of the recipients—confirmed that a recipient of the reports could have no idea of how the secret services had gathered the information they contained. Németh went on to flatly reject any calls for his resignation. He explained that in the interests of state security any prime minister would have to rely on the work of the security services, and therefore this whole matter should be left undisturbed. As the immediate consequence of the eruption of the Duna-gate scandal, Major Végvári was suspended, though in the end he was not indicted by the military prosecutor. On January 23, Minister István Horváth resigned. Prime Minister Németh continued to make promises about the reorganization of the secret services in conformity with the rule of law.

A few days after the Duna-gate press conference, the deputy interior minister responsible for the secret services, Ferenc Pallagi, in a radio interview flatly denied the surveillance of opposition parties, declaring that he had never before seen the documents exhibited at the Duna-gate press

conference. He also submitted, "being fully cognizant of [his] responsibility, that the Minister of the Interior and the Cabinet had never seen these documents, which could only appear in one, internal area of state security."[19] As the parliamentary investigation of 1990 established, however, such daily operative information reports on matters of state security were addressed, among others, to the Minister of the Interior, the Secretary of State and also to the deputy minister responsible for state security (Ferenc Pallagi).[20] Deputy minister Pallagi's denial is typical of the reaction of the contemporary establishment as mirrored in the press. Subsequently it was established that a number of high-ranking political office holders were among the recipients of daily operative information reports even after the declaration of the republic on October 23, 1989.[21] The list includes, among others, the temporary President of the Republic (Mátyás Szűrös), the Prime Minister (Miklós Németh), the Minister of State (and aspiring President, Imre Pozsgay), the then-Foreign Minister (and later Prime Minister, 1994–1998, Gyula Horn), the then-Deputy Prime Minister (and later Prime Minister, 2002–2004, Péter Medgyessy).[22]

Today, it is generally agreed that the opposition parties at the time had no idea about the structure and procedures of the state security services. As a result, the opposition's bargaining position was significantly impaired during the Roundtable Talks. As historian László Varga bitterly remarks, the communist state security services managed to hide even from the eyes of the parliamentary investigation committee.[23] After the first

[19] Interview with "168 óra" [168 hours], a radio talk-show, the interviews of which also appear in a weekly paper, entitled *168 óra* [168 hours] on January 9, 1990. Quoted by Révész, "Dunagate I" in note 30.

[20] See Appendix "Bizottsági jelentés a BM belső biztonsági szolgálatának tevékenységéről" [Committee report on the operations of the Internal Security Services of the Ministry of the Interior], (3 January), attached to 29/1990. (III. 13.) OGY resolution. Révész, "Ellenzékiek megfigyelése a kerekasztal-tárgyalások idején." Minister Horváth intended to broaden the scope of recipients of daily operative information reports in November 1989. Rolf Müller, "Belügyi információs jelentések" [Internal informational reports] in *Trezor 3. Az átmenet évkönyve* [Trezor 3. Yearbook of transition] (Budapest: Állambiztonsági Szolgálatok Történeti Levéltára, 2004), 147, 162, note 34.

[21] Daily operative information reports were a genre of regular reports prepared by the state security services. For a general description, see Müller, "Napi Operatív Információs Jelentések." Also explained in Révész, "Ellenzékiek megfigyelése."

[22] The list of recipients was made available recently in "Olvasókör, Politikusok, akik az állambiztonsági jelentéseket kapták" [Reading group club, politicians who received state security reports], *Hvg.hu* (March 24, 2005), available at http://hvg.hu/itthon/ 20050323olvasomozgalom.aspx (accessed 10 February, 2007).

[23] Varga, "Gergő és az ő árnyéka."

democratic elections in the spring of 1990 it became the task of the new
Parliament to regulate the fate of these archives, to provide for disclosure
of their ties with the communist secret services and to achieve the infor-
mational restitution of victims.[24] By that time, narratives emphasizing the
need for security were deeply imbedded in the public debate on the fate of
the personnel and files of the secret services.

THE DUNA-GATE FOOTAGE:
THE CANONICAL ILLUSTRATION REFRAMED

In the early and mid-1990s documentaries and documentary collages on
the transition to democracy were in fashion.[25] When Duna-gate appeared
on screen, it usually accompanied another topos: the portrait of Major
József Végvári, the man who had led the Black Box crew towards their
fine discovery on the premises of the Interior Ministry.[26] According to
Végvári's own account he was so upset, confused and disappointed by
the disgraceful practices of the secret police that he could no longer con-
tain himself and decided to turn the tables on the "Firm." This account
was recorded by many cameras in many settings over the years, in tele-
vision studios when the scandal was still fresh but also in more private
settings with Végvári sitting for portrait interviews with documentary
filmmakers.

Végvári's account of the events and his role in the exposure of these
malpractices does not change much. In the earliest recordings he appears
rather nervous, often speaking in the jargon of the secret police, while the

[24] On the political forces behind various alterations in the scope of the lustration law in
English, see M. C. Horne and M. Levi, "Does Lustration Promote Trustworthy Govern-
ance? An Exploration of the Experience of Central and Eastern Europe," Prepared for
Trust and Honesty Project, Budapest Collegium, Second draft, October 2002, available
at www.colbud.hu/honesty-trust/horne/pub01.doc (accessed 10 February, 2007).

[25] The most famous ones are the documentary series *Rendszerváltó évek* [Years of Transi-
tion]. See especially episode *Televíziós leletek, 1989 őszétől 1990 tavaszáig* [Television
recordings from the Autumn 1989 till the Spring of 1990] (László B. Révész and Pál Er-
dőss, 1997) and *Hős vagy áruló?*, mentioned above.

[26] The first major portrait film on Major Végvári was made by Black Box in 1989/1990,
entitled *T.E.D. 23 Charlie* (by Márta Elbert, István Jávor, Zoltán Lovas and László Pe-
sty), 50 min., released in 1990. Segments of this film were included in the Black Box
video journal *Magyar Változások* [Hungarian transformations] by Márta Elbert, István
Jávor, Zoltán Lovas and László Pesty.

unofficial parts appear in less articulate Hungarian.[27] As time passes, he becomes more composed before the camera and his narrative more coherent.[28] Nevertheless, there is something unsettling about him. He seems haunted and slightly disturbed.

The more interviews were conducted, and the more time passed, the less suitable Végvári became as the face associated with the public inquiry into the misdeeds of the communist secret police. More and more participants and commentators began to question the genuineness and sincerity of his efforts to expose the surveillance scandal and the destruction of the secret police files. After a decade it was hard to find anyone familiar with the details of the story who did not believe that Végvári's efforts were in fact an assignment from his superiors, and that what appears in the films is one of the numerous legends fabricated by the secret services themselves.

Police Major-General József Horváth,[29] the chief of the internal intelligence unit of the secret police (Subdivision III/III), claims that he was informed of the December 1989 break-in into the premises of the secret police and its consequences not by internal intelligence, but by the television coverage of the press conference in the *Graffiti* cinema.[30] This latter statement may be untrue, but it is not entirely implausible. It reflects the state of utter confusion in which the communist security services existed and operated during the second half of 1989. Indeed, the level of internal confusion in the secret police was not concealed too long even by the Interior Ministry. Tomaj Barsi, the ministerial spokesperson, openly said on a late-night news broadcast in the wake of the Duna-gate scandal that the secret services were trying to adopt a philosophy which suited a "pluralistic constitutional state," but that the actual practices did not always match this philosophy.[31]

Thus, both J. Horváth's and Végvári's stories fit an emerging master narrative, irrespective of whether the former, the latter, or neither is telling the truth. The only thing that is clear is that over the years, as the ways of the secret police became more familiar to the public, the portrait of the nervous man with the glasses became less and less appropriate to epito-

[27] This contrast between the layers of the presentation is probably the sharpest in the Black Box interview included in the video journal *Magyar Változások*, following the footage recorded in the secret police building with Végvári's aid.

[28] Especially in the documentary film *Hős vagy áruló?*

[29] Not to be confused with Interior Minister István Horváth.

[30] Varga, "Gergő és az ő árnyéka."

[31] *Napzárta*, studio round table with György Baló, available in the collage *Rendszerváltó évek: Televíziós leletek.*

mize the uncovering of the misdeeds of the communist secret services. As time went on, it became increasingly easy to drop the figure of Major Végvári from the pantheon of visual topoi illustrating the never-ending quest for the heritage of the communist secret police. From the early surveillance scandal of 1989 attention shifted to the search for a decent lustration law and proper access to files. This shift happened when grave scandals involving prominent and not-so prominent secret service officers and agents took the media space over from gestures of remembrance and occasional, half-hearted legislative efforts to introduce, and later to reform, legal norms on lustration and file access.

DEALING WITH SECRET POLICE FILES AMIDST NEW SCANDALS: THE DUNA-GATE FOOTAGE MEETS ITS FATE

This is not the place for a detailed account of all the stages of legislation affecting the fate of the archives of the communist secret police: the following overview will concentrate only on the key events of this saga. In order to understand the Hungarian context it is important to bear in mind that in Hungary the issue of access to the files of the communist secret police was separate from that of lustration. The Duna-gate scandal triggered legislative attempts to expose the former agents of the communist internal secret services, or at least to exclude them from elected office through lustration. The first bill on lustration was passed in 1994, during the last days of the first democratically elected Parliament, setting off an ongoing game of public ping-pong between the Parliament and the Constitutional Court, which seemed to have more or less settled down by 2000.[32] Legislation allowing victims and researchers access to the files of the communist secret services and creating the Agency for History (*Történeti Hivatal*) was adopted as an afterthought, forced upon Parliament by the Constitutional Court. Thanks to legislative amendments in 2001, which brought major changes in the rules governing access to the files of the former secret services, the victims of the communist intelligence appara-

[32] The lustration law was passed in 1994 as the "Act on Background Checks to be Conducted on Individuals Holding Certain Important Positions," Act No. 23 of 1994. Available in Neil Kritz (ed.), *Transitional Justice, How Emerging Democracies Reckon with Former Regimes*, vol. 3 (Washington, D.C.: United States Institute of Peace Press, 1995). 418. The Constitutional Court found the central provisions of the act unconstitutional in 60/1994 (XII. 24.) Constitutional Court decision. After numerous further rounds, Parliament passed Act no. 93 of 2000.

tus also gained more or less meaningful access to files containing information on their lives.[33]

While exposures of top elected officials and public figures did not cease during the first decade of the fledgling Hungarian democracy, the summer of 2002 brought a major and uncomfortable surprise when the leading conservative daily *Magyar Nemzet* published a set of documents asserting that Péter Medgyessy, the newly elected Prime Minister and member of the Hungarian Socialist Party, had served as a counter-intelligence officer between 1977 and 1982.[34] The Medgyessy scandal of 2002 confirmed the weaknesses of the existing legislation on lustration and enforced the reconsideration of lustration and informational reparation.

The constantly changing legal framework has proved unable to expose agents and collaborators of the communist state security services, but it continues to fuel further argument, prompting the revision of a legal framework which—despite all the changes already introduced—has remained ultimately incapable of fulfilling its noble aims. First of all, the rules on lustration fell short of signaling with sufficient certainty which players in the post-communist political elite had worked for the communist secret services. The most painful aspect of the Medgyessy scandal was the fact that the Prime Minister had passed the process of lustration, which cleared him of ever having worked for the internal intelligence division of the communist secret services (i.e. Subdivision III/III), while not revealing that he had indeed been an officer of the counter-intelligence division of those services. This traumatic revelation, which could not have been prevented even by the most careful lustration review, was the result of the parliamentarians' lack of information concerning the structures and procedures of the communist secret services at the time when they drafted the lustration law.

In the spring of 2003 a new law on access to the archives of the former secret services came into force, transforming the Agency for History into the Historical Archives of the Hungarian State Security (*Állambiztonsági*

[33] Act no. 67 of 2001. This act did not affect the scope of lustration. Instead, it introduced a number of clarifications in the act which made it somewhat easier for victims to access their files deposited with the Agency for History. Furthermore, it was the first in the series of lustration bills to define such terms as "person under surveillance," "career employee," "network person," and also "third party" and "relative."

[34] "Titkos ügynök a kormány élén, A D–209-es számú elvtárs kiemelt főoperatív beosztásban" [A Secret agent heading the government, comrade no. D-209 on a special high operative rank], *Magyar Nemzet* (18 June 2002), available at www.mno.hu/index.mno?cikk=84914&rvt=2 (accessed 10 February, 2007).

Szolgálatok Történeti Levéltára).[35] This overhaul was meant to remedy numerous shortcomings in the slow transfer of files from the new security services to a research archive, and also to pave the way for meaningful file access.

Despite all these efforts, the autumn of 2004 turned up more former communist state security officers among elected officials and public figures, while various lists of agents of doubtful credibility started to emerge on the internet and in newspapers even during the spring of 2005.[36] The approaching final deadline which would bring an end to mandatory lustration and the emergence of these lists of agents prompted a new interest among parliamentary circles in amending the legislation on exposing the agents of the former communist secret services and on access to their files. Completely unexpectedly, Prime Minister Ferenc Gyurcsány of the Hungarian Socialist Party took the lead in advocating the full disclosure of state security service collaborators. While his vague initial policy statements were met with approval by all four political parties, the more concrete the Socialist proposal became, the further it fell short of four-party consensus.

The most important components of the major amendment to the law on access to files, passed in 2005 on the initiative of the Socialist govern-

[35] Act no. 3 of 2003 on the disclosure of the activities of the secret services of the communist regime and on the establishment of the Historical Archives of the Hungarian State Security, available in English at the website of the Historical Archives at www.abtl.hu/html/en/acts/ABTL_4_2003_evi_III_tv_e.pdf (accessed 10 February, 2007).

[36] Not long after the Medgyessy scandal a so-called "agent list" was posted at www.angelfire.com/zine2/szakerto90/ under the pseudonym "Szakértő 90" (Expert 90), including the names and personal identification data of 219 persons. The availability of the list was first reported by the online news portal, Index, on February 27, 2005 as "Interneten az Antall-féle ügynöklista" [Antall's agent list on the web], www.index.hu/politika/belfold/ugynoklist22/ and the news media followed suit. News accounts, interviews, analysis and further agent lists were collected at numerous portals devoted solely to the agent issue (see www.nincstobbtitok.hu, http://hvg.hu/ugynok.aspx and www.hetivalasz.hu/showcontent.php?chid=10927 all accessed 20 February, 2007). Initially the public debate focused on whether or not this list was The Agent List, which according to one of the founding myths of the Hungarian democracy had been handed over by the outgoing Communist government to the first democratically elected Prime Minister. The list included the names of numerous public figures who were not subject to the lustration laws, thus fuelling a string of accusations and denials. Note that at the time the 1956 Institute launched an interesting on-line initiative to provide easily accessible information on matters related to secret police agents and files at www.rev.hu/html/hu/ugynok/_ugynok.html (accessed 20 February, 2007).

ment, were found unconstitutional in the Hungarian Constitutional Court in October 2005 upon the petition of the outgoing president of the republic (who was acting at least in part upon the request of the faction leaders of parties in the governing coalition).[37] While amendments to the laws are still constantly being prepared, more and more revelations about agents emerge. There were reports even in the international media when the world-renowned film director István Szabó's recruitment as an informer was exposed in the press early in 2006.

It was in the context of one of the scandals around the flood of agent lists that the Duna-gate footage reached the most recent stage in its career. In December 2004, the Hungarian television's evening news program, *Az Este* [The Evening], invited the eminent historian János Kenedi to comment on the credibility of the emerging lists of agents and secret police files.[38] As an illustration, the editors of the program prepared short spots on the fate of agents and agent lists in various post-communist democracies. This was followed by a live studio conversation with Kenedi, who explained how far the known and officially archived files of the communist secret police could be trusted. The conversation revolved around the credibility of the emerging agent lists, and whether any of them was identical to "The List" which according to one of the strongest myths of the Hungarian transition had been prepared by the services in the early days of democracy and handed over to the first democratically elected Prime Minister, József Antall.

The other topic of conversation was the fate of the missing secret service files and, in general, the integrity of the remaining records. Kenedi explained that in the archival system of the communist secret police it is impossible to destroy complete dossiers at random, as many cross-references exist in other rosters. Thus, if a dossier is removed, other rosters and indexes reveal that a dossier or some documents from the dossier are missing from the preserved record. In saying this, Kenedi was not revealing any new discoveries about the nature of the preserved files: by this time the facts were known to the narrow audience that followed the less scandalous (and therefore more boring) parts of parliamentary debates and read historical publications on file access and agenthood.

[37] "Ügynöktörvénystart" [Start of an Agents' law], *Hvg.hu* (1 June 2005) at http://hvg.hu/hvgfriss/2005.22/200522HVGFriss19.aspx (accessed 10 February, 2007).

[38] *Az Este* [The Evening] aired on MTV1, the main Hungarian public television channel, on 10 December, 2004.

What makes this television interview with Kenedi interesting is what happened after the first part of the studio conversation. The conversation was interrupted by a spot introduced as the Black Box footage on the Duna-gate scandal. This included the familiar images of typed secret service documents accompanied by Lovas's whispering voice, followed by the scenes of the mass destruction of papers—among them red folders going down a conveyor belt, right into a huge paper shredder, a scene previously unseen in the classic Duna-gate footage.[39]

After the spot a visibly perplexed Kenedi appeared on the screen, saying that "this is exactly the type of recording which has the potential to expose disinformation." He was immediately challenged by the program presenter, who had noticed his reaction. The presenter pointed out that, contrary to what Kenedi claimed, there were folders being destroyed before the very cameras. Kenedi, while acknowledging that he was puzzled by what was described as the Duna-gate footage recorded by Black Box, maintained that what he had seen in the spot were unbound sheets and nothing that resembled secret police dossiers. When asked about the red folders, he said that was not what a secret police dossier looked like. The unbound sheets he could identify from the recording were most probably daily information reports (which were produced in about half a dozen copies by the services) or some other kind of departmental (in-house) papers. By the end of the interview it had become clear to the average television viewer that Kenedi could not provide an expert opinion which would suffice in the circumstances: the red folders remained much more attractive than a makeshift explanation about some irrelevant sheets of paper produced by daily office routine.

With this short episode, the Duna-gate footage credited to the Black Box crew suddenly became the center of media attention for a second time, now in its own right. Three days later the same evening news program, *Az Este*, invited Balázs Horváth, the Interior Minister of the first democratically elected government, to share his expertise on the most recent round of the lustration and file-access scandal. The former minister's studio appearance was introduced by a short clip of János Kenedi's reaction to what was credited as Black Box's original recording on Duna-

[39] The conveyor belt and the shredder were filmed by Black Box in the paper mill at Újpest, and appear in a different film, on the destruction of Communist Party papers. The title of that documentary is *Pártiratok zúzdában* [Party records in the paper mill]. Excerpts also appear in the documentary collage *Magyar Változások* [Hungarian transformations] edited by Black Box, in which the scenes from the Újpest paper mill are followed by the excerpts on Duna-gate.

gate, with a commentary questioning the authenticity of the footage about the destruction of secret police files.[40]

According to the announcer, Kenedi, the expert, had said that the footage was "capable of spreading disinformation." The announcer declared that the papers destroyed in the shredder were not secret agent reports as previously claimed by Black Box, but only departmental papers—in other words, not secret police files proper, as the audience had previously been led to believe. Before moving to the studio interview, it was announced that representatives of Black Box had declined to appear to comment.[41]

Kenedi's puzzled reaction is understandable, for the Duna-gate footage credited to Black Box had been reedited for use in the news program. The red folders which were such an attractive feature of the short excerpt actually came from a different body of material, also recorded by Black Box in 1989, about the destruction of Communist Party documents rather than secret police papers. This editorial intervention was revealed by an open letter in a leading newspaper by István Jávor and Márta Elbert, who still run Black Box and its archive.[42] Although in purely legal terms the reputation and good name of the Black Box crew may not be in doubt, this editorial incident is symptomatic of the media representation of the entire political and constitutional conundrum over the fate of the files of the communist secret services.

It should be noted that at the time when the Duna-gate footage was prepared hardly anybody outside the secret police, perhaps nobody at all, was in a position to identify the documents shown on the camera while

[40] According the István Jávor and Márta Elbert, writing on behalf of Black Box, by the time the collage was aired on *Az Este* for the second time, the editors of the news program were aware that the Black Box studio had lodged a protest against this particular montage made out of Black Box material with the chairman of the television channel. See their article, "Gátlástalan este" [Unscrupulous evening], *Népszabadság* (18 March 2005), available at www.nol.hu/cikk/355641/ (accessed 10 February, 2007). Jávor and Elbert accused the editors of the newsprogram of purposely discrediting Black Box's documentary material. The response of the news program's editor appeared as a letter in *Népszabadság* (1 April 2005), available at www.nol.hu/cikk/357176/ (accessed 10 February, 2007).

[41] According to some accounts, the journalist Zoltán Lovas was approached by the editors of the news program. Márta Elbert, on behalf of Black Box, told newspapers, that she had never received an invitation. See www.index.hu/politika/belfold/mtvdob0318/ (accessed 10 February, 2007).

[42] Jávor and Elbert, "Gátlástalan este." In addition to the problem of the reediting of the Black Box footage, there is a dispute about copyrights and royalties which is not covered by this paper.

being read out, or the papers seen in the shredder. These papers were much later identified by experts as copies of daily operative information reports containing surveillance information on the democratic opposition. In the original Duna-gate footage by Black Box, while mentioning the mass destruction of secret police files, the filmmakers did not claim to know what kind of secret police papers were being destroyed at the time. It is the commentary added to the reedited version of the Black Box materials in the news program, merging two different sets of footage, which makes claims about what is being destroyed and accuses the Black Box crew of misleading the audience. As István Jávor and Márta Elbert make clear in their open letter, "at the paper mill they were destroying party documents from district party committees, and there is no visual evidence of the destruction of Duna-gate files."[43]

One has to admit that in the maze of parliamentary investigative committees, expert opinions and dozens of forgotten or abandoned parliamentary bills, the whole issue of lustration and file access has become disturbingly complicated. It is not particularly newsworthy if yet another parliamentary session passes without a meaningful vote on lustration or file access. What makes news is the exposure of agents who have received lustration clearance, as happened most prominently with Prime Minister Péter Medgyessy. Another event that can make headlines in a news-hungry media is the exposure of former agents independently of the lustration process, a matter that might also become problematic (and therefore newsworthy) because the laws on file access, and especially on the publication of the results of such access, are murky, to say the least. This material, even when it is newsworthy, is not too telegenic. Had the Duna-gate footage recorded by Black Box been more "attractive," it would most probably have survived without being spiced up with images of red folders cut and pasted from another collection. It is unfortunate that this editorial zeal in a news room has the potential to destroy the reputation and credibility of the richest visual archive of the Hungarian transition. It seems that the need to please viewers takes precedence over the black, white and gray shades associated with reality.

In this respect it is worth noting that essentially the same accusation against Black Box, of misleading practices in the coverage of the Duna-gate scandal, was aired again by *Az Este* in March 2005. This particular broadcast was of interest solely because it featured not only a remastered, and thus falsified, visual record but also an individual who had undergone

[43] Jávor and Elbert, "Gátlástalan este."

a remarkable metamorphosis. This time, the reedited footage introduced the studio appearance of probably the most popular media celebrity on all matters constitutional, György Kolláth, who was invited to comment on the fate of agents and files.[44]

Dr. Kolláth's expertise in matters of communist state security is truly extraordinary. As a high ranking official (departmental head, or *minisztériumi főosztályvezető*) of the Interior Ministry in 1990, he was a member of the in-house investigation committee established by the Ministry in response to the appearance of the Duna-gate footage in January 1990. In the studio interview in March, 2005 he hastened to explain that, as a member of the investigative committee in 1990, he was the only "civilian" among the professionals. He stated even more categorically that even back then he had not understood much of the ways of the secret police or state security, as he had never been an expert on such subjects.[45] He skillfully avoided commenting on the substance of the agent scandals and on the integrity of the remaining secret police files, and resorted instead to repeating well-known generalities.

This remastered self-definition of a former official of the communist Interior Ministry was nothing new: Dr. Kolláth had explained his role in similar terms before.[46] He has since then also authored numerous expert opinions in which "civilian" is defined as a person who does not wear a uniform or carry a gun. Thus, in a major item of news commentary on file access, the Hungarian media audience is left with some documentary footage reedited beyond recognition[47] and a "civilian" dispensing amusing aphorisms, who by his own admission is not an expert on anything to do with state security.

[44] *Az Este*, aired on MTV1, the main Hungarian public television channel, on March 3, 2005.

[45] Dr. Kolláth mentioned that in response to this internal investigation of the secret services an act was passed that re-organized the secret services in 1990. To give him the benefit of the doubt, he may at best be referring to a set of interim measures passed in 1990, mentioned above. The act of parliament reorganizing the secret services was not passed until 1995.

[46] See György Kolláth, "Utóirat a Dunagate-ügyről—egy civil szemszögéből" [Postscript on the Duna-gate scandal—from a civilian perspective], *Belügyi Szemle* 33 (1995): 13. See also his contribution to the documentary *Hős vagy áruló?*

[47] As an illustration before Dr. Kolláth's studio appearance, a longer version of the Duna-gate mix was shown. There the Black Box camera crew's entry into the premises of the Communist Interior Ministry was dated mistakenly as of November 30, 1989 by the narrator of the news show.

CONCLUDING REMARKS

The short, shaky and rather dark footage of Duna-gate, with its whispering voiceover, raises endless questions about the operations of the communist secret services and the fate of its agents and files. In the early accounts of the Duna-gate scandal the images of secret police documents providing evidence of the illegal secret police surveillance of leading figures in the emerging opposition and the hints at the mass destruction of secret police files were accompanied by the comments of players who contributed to placing the issue of agents and file access on the political agenda of the new democracy. Over the years, however, once the excitement over the surveillance scandal of 1989/1990 had started to fade, and many drafts of lustration laws and regulations on file access had come and gone, some people have disappeared from the visual record, while others have changed profoundly on screen, before our very eyes.

In the post-transition and post-modern discourse the story-hungry news coverage of exposed agents and developments in the file access saga is finding it more and more difficult to settle on safe, canonical images. While the Hungarian public can still be excited by accounts of former agents, the focus of the high political debate about the fate of the files of the communist secret police has shifted from lustration to file access. Keeping up with the spirit of times, after an unfortunate glitch, the images of the Duna-gate picture book have been abandoned for new visual topoi. As the reputation of the key players in the agent-saga becomes increasingly questionable and other familiar faces appear in new roles, news editors are left with one firm visual reference point to capture the essence of the problem of the communist secret police: the image of a gigantic paper shredder. Firm, that is, until the founders of Black Box studio remind us that the wrong footage of the wrong monster shredder appeared as a casual background illustration to the news of the day in the coverage of the lustration and file access saga in the evening news.

When file access is discussed in the press, the favorite illustration of the day now shows the endless shelves of former secret police files stored in the Historical Archives of the State Security behind the locking wheel of an armored door. The endless shelves send the message that at last all is clear: the sinister files are kept in a well-guarded archive accessible under transparent conditions. The locking wheel on the closing steel door suggests that the archives are properly secured and access is granted only to those who are truly entitled to it.

The peaceful calm of dusty files is disturbed only by the noise of former agents being exposed once in a while, and by reports surfacing regardless of, or outside, the strictures of legality. They constitute a sobering reminder both to victims of the communist secret services and to historians eager to replace our many myths and legends about the communist past with the truth. But whatever has survived the alleged shredder is still kept in a safe place behind the locks of legislation, sealed by rules of access which have been constantly improving since 1990—at least according to the longest surviving legends of Hungary's constitutional democracy.

Façades

The Private and the Public
in Kádár's Kiss *by Péter Forgács*

BALÁZS VARGA

More than fifteen years have passed since the change of the political re-
gime in Eastern Europe, but the countries of the former Soviet bloc still
face the fundamental challenge of how to deal with the events of their
recent past, how to come to terms with the legacy of Socialism and its
local versions. There are countless ways of approaching these issues, but I
will focus on the possibilities of interpretation provided by creative docu-
mentaries. The material for my analysis is Péter Forgács's film *Kádár's
Kiss* (1997, the original Hungarian title is *Csermanek csókja*, meaning
Csermanek's Kiss), which by its unconventional treatment of the "private"
and the "public" offers a provocative and subversive interpretation of the
most exciting period of the Kádár regime, the first half of the 1960s, often
referred to as the establishment of "goulash Communism" or the post-
1956 consolidation. This unique audiovisual collage unveils the dichot-
omy of appearances and the world behind them. This effect is enhanced
by the juxtaposition of amateur films and archival footages through splen-
did sequences of montage.

PRIVATE FILMS, PRIVATE STORIES

Contemporary newsreels and amateur footages constitute the visual
source of Péter Forgács's film. Amateur films are important documents
of the period in question because of their role within society, their visual
energy, and the wide range of possible ways of using them. Amateur
films are also called family footages, private films, non-professional
films, and home movies. These terms are frequently used as synonyms,
and not always wrongly so, but it is important to note that they often
highlight different aspects of the same phenomenon: one refers to the

field of use, the other to the manner of application, the function of a medium or the technique. Amateur film is not a genre or theme, nor is it necessarily a technique-specific category. Moreover, as we will soon see, the dividing line between amateur films and the film industry (professional filmmaking) cannot always be accurately drawn. This is not only because of the usual problems of "categorization" but also due to rapid technological development which can turn a device used previously only by professional film-makers into a tool available to the general public, and thus part of "amateur" technology. Strange as it may sound, this also works vice versa. However, for pragmatic reasons, I would like to start by defining the social embeddedness of amateur film through binary oppositions, in order later to demonstrate their inadequacy; I will then analyze the possibilities of defining amateur film from a technical point of view.

When considering the field of "use," a very tangible opposition emerges: it contrasts the public/professional sphere with the private sphere defined by family and private life. In this opposition everything that is left out from the public sphere belongs to the private: rationality versus emotions, efficiency versus freedom, impersonality versus the personal/intimacy, uniformity versus personality, impersonal versus personal expression/creativity.[1] Yet another opposition can be found in the use of amateur films and their role in social communication: amateur in this case is connected to free time as opposed to working hours, which in those days also implied the contrast between commercial and non-commercial usage. We can thus speak of amateur films only after filmmaking became institutionalized and the film industry was established—in the first decade of the last century. Amateur films and non-professional films have been traditionally synonymous and the distinction between amateur films and professional films seems clear.

However, if we consider these binary oppositions thoroughly we discover that they are not sustainable for several reasons. Avant-garde filmmaking, for instance, annuls the opposition of commercial/non-commercial use, as well as the opposition of the field of use. Since its economic importance is minimal, its publicity is also limited. Considering the rapid development of technology, it is hardly possible to make a distinction between *amateur* and *professional*. Let us consider only the digital, network culture, where—in the world of YouTube—the division be-

[1] Patricia Rodden Zimmermann, *Reel Families: A Social History of Amateur Film* (Bloomington–Indianapolis: Indiana University Press, 1995), 2–4.

tween amateur and professional becomes meaningless. For this reason amateur film is practically a historical category.

The aspects of technological change unveil the constant interaction and reciprocal influence between amateur film and professional filmmaking. The history of technology is at the same time a history of style, so that by examining it we will have the opportunity to look also into the aesthetics of amateur films. Amateur film constantly aims toward professional filmmaking in its technical and stylistic instruments. While in the film industry, technical and stylistic norms (35 mm technology, narrative fiction, genres) were already standardized by the 1910–1920s, the same process took place at a much slower pace in amateur film. The first cameras for private use were appearing on the market as early as around 1900, but during the following decades countless companies, norms and formats were in competition. For example the Super 8mm format, one of the most widespread and popular formats even today, became popular in the 1930s. It was also during those years that the "institution" of amateur filming and the network of international festivals, clubs and professional magazines was established. Some amateurs were shooting their footages on 35 mm film even in the 1920s while film magazines dedicated to amateur filmmaking were full of questions like "how to make more professional films?"

One of the possible ways was to adopt the technical and stylistic norms. Meanwhile other initiatives deliberately tried to separate amateur film from professional filmmaking. In the 1920s, for example, a new spring-driven hand camera appeared that offered a wider range of possibilities and much easier use, sometimes going against professional standards, plans and editing norms. Thus, often it was not amateur film that strived to follow the film industry; in fact, amateur film was an incubational, experimental field for professional filmmaking. This view emphasizes a developmental trend which is contrary to the conventional one: amateur technology, codes and style tend to appear in professional filmmaking rather than the other way round. World War II brought with it the standardization of the 16 mm technology used earlier by amateurs (newsreels on the front lines were generally shot with such equipment because it was handier than traditional 35 mm cameras). Hi-8 video technology was originally developed for amateurs, but due to its relatively high (almost broadcast) quality it quickly became popular among media professionals. Jump-cuts, a special narrative instrument of avant-garde and amateur films in the 1920s became standard features in commercials, music videos and fiction films from the 1980s onwards. And the voyeuristic, self-representing character of amateur, private films is often regarded as an

important precursor of the reality shows aired by the television of the millennium.[2]

Technological development was an important factor in generating the new cult of amateur films, and after the advent of the video image there was a nostalgic revival of Super-8 mm film because of its unique visual quality, suggesting something different, special, exotic, strange and old. From the technical and the stylistic point of view the Super-8 technology adds a special atmosphere to amateur films, facilitating their contemporary "recycling." The quality of Super-8 footages, the scratchy, pixel-like texture of the images, is easily identifiable and creates an extremely exciting visual world. This explains why old amateur films shot at the beginning and in the middle of the last century have become so fashionable during the past two decades. In an era when digital footage is accessible in limitless quantities, low in price and improving in quality, old Super-8 films hold an outstanding atmosphere and visual energy. The aesthetic imitation of silent and amateur films—the stylization of the digital image by scratching it and making it look old—has also become very common and popular. This process started in the 1980s, with the spreading of video technique. At the same time the emergence of new media based on video technology provoked a debate centered around its main advantages: how low prices and accessibility actually work against selection. Since hours of footage are now easy to produce and everything can be recorded at any time, film themes are losing their value. In the video era of "here-and-now," the epoch of the floating signifier of Baudrillard, Super-8 films raise the nostalgia of "there-and-then."[3]

While amateur film can be separated from professional films by its social embeddedness and technical parameters, this is by no means an essentialist distinction: there is considerable interaction and communication between the two. Amateur film is not a generic category. Within the category of amateur/non-professional films we can distinguish fiction films, avant-garde exercises and documentaries, or travel and ethnographical films just as we can do among the professional ones. Péter Forgács's film, the subject of my analysis, uses the methods of amateur film to focus on a family's private world.

One of the most important characteristics of family footages is their lack of a traditional plot, their open narrative structure. Filmmakers shoot-

[2] James M. Moran, *There's No Place Like Home Video* (Minneapolis–London: University of Minnesota Press, 2002), 66.
[3] Ibid., 33.

ing a home movie do not intend to create a work of art, but to immortalize some moments of their own life which they consider important. Family events, celebrations, everyday occasions are organized to form some kind of a series (through thematic and/or chronological editing), but the events recorded do not form a causal chain. Therefore one of the two pillars of the traditional narrative structure (temporality and causality) is missing— instead, the history of the family, an external form of knowledge which is not coded into those images, establishes the framework for its own inter- pretation. But although causality in the traditional sense of the word is absent, there is still an order that can be interpreted as causal. Posterity (the grandchildren or a filmmaker passing by) can recreate this self- constructing causal order by reediting, or remixing the footages. The story recreated in this way can be strengthened by the filmmaker's or his/her relatives' confessions, recollections or anecdotes, which always give the film a special, nostalgic flavor.

Family films differ from other kinds of amateur film by their topics (events of everyday life and celebrations; personal and family legends). The amateur filmmaker shoots to preserve his/her and his/her family's best memories. From the moment of their conception these films mobilize nostalgia for the past, an atmosphere of *déjà disparu* (the aesthetics of disappearance). They guide us to the private sphere and its intimate, happy moments, which is why they are often considered as micro-history or part of counter-history. Because of their particular theme, their special structure of causality, the stunning visual energy that derives from their technique, and their atmosphere of nostalgia, amateur family films can be described as "history from below."

PRIVATE FILMS IN HUNGARY

When interpreting private film remixes, we have to consider both the ep- och when the original footages were made and the time when these foot- ages were collected and re-edited. It is even more so when both periods are marked by particular political contexts e.g. the consolidation of Hun- garian Socialism, or the Kádár era on the one hand and the change of the political regime and transition on the other. Péter Forgács's *Kádár's Kiss* is a creation of this kind.

Péter Forgács is an independent filmmaker and media/video artist. He attended the Hungarian University of Fine Arts in Budapest, but did not take a degree. During the 1970s he participated in Hungarian neo-avant-

garde art performances, undertook research in the social sciences, and engaged in psychodrama and psychoanalysis. He made his first short films at the end of the 1970s. At the beginning of the 1980s he established the Private Photo and Film Foundation, a unique collection of twentieth-century Hungarian amateur films. The basis of the collection is about five hundred hours of amateur footages, complemented by another forty hours of interviews with the films' authors and/or their relatives.[4] Forgács initiated his series, called *Private Hungary* (*Privát Magyarország*), more than twenty years ago, inspired among others by the key figure of Hungarian experimental filmmaking, Gábor Bódy, and his 1978 film *Private History* (*Privát Történelem*).[5] *Private Hungary* won Forgács a national and international reputation. This project is a re-orchestration of family footages, a kind of special archival remix, or a series of experimental documentary films.[6]

It is important to point out that Forgács turned towards amateur films and started his research before the political transition. Whether on purpose or by accident, the first pieces in the series had serious political connotations for their time. The names of the foundation and the film series (Private Photo and Film Archive and *Private Hungary*) are not coincidental. In the middle of the 1980s, Hungary was a special field for different kinds of memory politics and their evolution. Research into the history of mentalities, micro-sociology, the analysis of everyday culture had already gained some space in the scientific sphere. However such work could not appear in mainstream academia, which was ideologically aligned with the system (Forgács himself was also working in what was officially regarded as a "second-rate" institution, the Hungarian Cultural Research Institute).

In the 1950s, Hungarian Stalinism tried to dig deep into the private sphere, destroying the refuge people could find in private life. This in-

[4] The description of the collection is available on www.osa.ceu.hu/db/fa/320-1-2.htm (accessed 10 March, 2007).

[5] The first piece of the *Private Hungary* series, called *The Bartos Family* (*Bartos család*, 1988), is based on the same amateur footages as the above mentioned-film by Gábor Bódy (the family footages are shot by Zoltán Bartos, merchant and composer, between the 1920s and 1960s). For a comparative analysis of the two films, see András Forgách, "Zárt kertek pusztulása. Forgács Péter és a film" [The Destruction of Closed Gardens: Péter Forgács and film], *Metropolis* 2 (1999): 58–74.

[6] On Péter Forgács's *Private Hungary*, see Ernst van Alphen, "Towards a New Historiography: Peter Forgacs and the Aesthetics of Temporality," available at www.forgacspeter.hu/eng/main/press/articles/ernst%20_van_alphen.html (accessed 6 March, 2007); and Catherine Portuges, "Home Movies, Found Images, and Amateur Film as a Witness to History" in Jan-Christopher Horak (ed.), *The Moving Image* (Minneapolis: University of Minnesota Press, 2001), 107–23.

volved the obliteration of certain existing subcultures and alternative politics of remembrance. Almost all privately-owned 16 mm cameras were confiscated and the amateur film movement effectively suppressed. The Hungarian amateur film association was not re-established till the beginning of the 1960s, in the consolidation period of the Kádár regime. During this time, the public sphere expanded slowly but gradually, and everyday life and private life escaped from the imprisonment of ideology. Nevertheless, the interwar "bourgeois world" could not be revived but remained a closed, untouchable chapter of the past.[7]

When in the middle of the 1980s Forgács started to collect amateur films from the 1920s and 1930s and to make unique audiovisual collages out of them, the word "private" had various political connotations. The first pieces in the series can be interpreted as a sort of getaway, presenting new values, introducing some kind of ideal within the still existing world of State Socialism—faded pink and riddled with dry rot as it was.[8] These films evoke the life of middle class families: it is not by chance that the words "bourgeois" (*polgár*) or "gentleman" (*úr*) often appear in his titles or subtitles. Nevertheless, I do not intend to present Forgács's work in terms of an underground romanticism or of nostalgia for the lost interwar "bourgeois" and "private" worlds. Another important point to bear in mind when defining the context of the genesis of the *Private Hungary* series is that in exactly the same period, the second half of the 1980s, just before the political changes, new themes appeared in Hungarian social research and the arts. Apart from the new wave of the history of mentalities these novel themes focused on the Austro-Hungarian Monarchy, the turn of the century, the bourgeoisie and *Mitteleuropa*—in fact the same private/bourgeois world that is evoked by Forgács. However, the recognition of *Private Hungary* and Forgács's work with amateur footage did not start until the mid-1990s. Thus his pioneering work in researching and preserving certain values can be described only as a parallel process to the political transformations, and not as a direct reflection of contemporary social/historiographical trends.

[7] On the history of Hungarian amateur film-making, see Márton Kurutz, "Pergő képek" [Revolving Pictures], *Metropolis* 2 (1999): 92–101; and István Dékány, "Az amatörfilm-mozgalom története Magyarországon" [The history of amateur film-making in Hungary], *Pergő Képek* 5 (2000): 3–29.

[8] Benedek Balázs Vasák, "Határesetek" [Borderline cases], *Metropolis* 2 (1999): 108–28.

PRIVATE HUNGARY

Two main strategies can be observed in the later use of amateur family films: the nostalgic reconstruction of family history, and the associative montage film. The first strategy is in fact an experiment in a new kind of narrative reconstruction: the re-evocation of past times often accompanied by added voice-over narration, where amateur footages often serve as mere illustrations. The second, in contrast, does not aim to retell the past through a life story, to rehearse family legends using traditional narrative instruments. Instead it relies on the atmosphere and visual energy of images, creating montage sequences of free association by the creative treatment of family history or life history. This second strategy is characterized by the refusal to use amateur footages in an illustrative manner, so that images are not subordinated to commemorative, nostalgic commentaries. Instead of using voice-over narration, the author adds music, noises, sound collages, attempting an associative audio-design that evenly balances visuals and sound. Péter Forgács, whose entire life is in one way or another linked to amateur film, is not interested in family amateur films as a family history writer or an "associator," that is an avant-garde/montage filmmaker. For his remarkable family archival remixes he does not choose any of the obvious paths, but creates instead a combination of these two peculiar, extreme strategies, characterized by narrative reconstruction and the use of the visual energy of amateur films.

There are copious internal rhymes and connections between the different parts of the *Private Hungary* series, including some that deal with different chapters of the history of the same family. The episodes, structured as a kind of patchwork, offer a unique *roman fleuve*, articulating the history of Hungary in the past century in micro histories from the beginning of the 1900s to the 1970s. This stream has an inner dynamic of its own. The family footages which constitute each piece of the series differ significantly from each other. Among the authors some strive to document family scenes, others shoot fiction film (like László Dudás, the hero of *D-Film*, 1991 and *Photographed by László Dudás* (*Fényképezte Dudás László*) 1991), some even took the camera with them to the war front (László Rátz, the protagonist of *The Land of Nothing* (*A semmi országa*) 1996) followed and filmed the catastrophe of the Second Hungarian Army in the Ukraine during 1942). While reconstructing and elaborating the archival footages, Forgács's and his crew's approach, attitude and attention undergo constant changes. It makes a great difference when the original footages were filmed: in the "happy peacetime" of the 1920–30s (*Dusi*

and Jenő, 1989), during World War II and the persecution of the Jews (*The Land of Nothing; Free Fall* (*Örvény*) 1996), the post-war coalition years (*Class Lot* (*OsztálySORSjegy*) 1996–97), the Hungarian Stalinism of the 1950s (*The Bishop's Garden* (*A püspök kertje*) 2002) or the post-1956 "consolidation period" of the Kádár regime (*Kádár's Kiss*).

The heroes of the films are usually ordinary people: entrepreneurs, clerks, civil servants, engineers. Most come from middle-class families, only occasionally do we find a baroness, a philosopher-scientist who has an important role in politics, a Calvinist bishop, or the like. *The Bishop's Garden* and *A Bibó Reader* (*Bibó breviárium*, 2001) are novelties in the series because they explore the lives of two key figures of mid-twentieth century Hungarian history. The public and the private sphere, the world of politics and a family's everyday life, are contrasted more directly, but at the same time in a more sophisticated manner compared to the earlier middle-class stories.

The Calvinist bishop László Ravasz (who was a member of the Upper House of Parliament) played an important part in voting for the first two discriminatory "anti-Jewish laws" in 1938–39, but raised his voice against the persecution of the Jews in the 1940s. After the war, when the Communists came to power, Ravasz went into internal exile. István Bibó (the bishop's son-in-law) was a political philosopher, jurist, social researcher and Peasant Party politician. During the 1956 Revolution he was the Minister of State in Imre Nagy's government. On the day of the Soviet occupation in November he was the only member of the government to stay in the Parliament; he was also the author of the manifesto stating the aims and legitimacy of the 1956 Revolution. After several years of imprisonment he was amnestied at the beginning of the 1960s and worked as a librarian during the Kádár regime. Although his most important essays could not be published in socialist Hungary, he decisively influenced the thinking of the Hungarian opposition during the 1970s.[9] Incidentally, the life stories of both families were shot by the son of László Ravasz.

[9] Tibor Huszár, György Litván, Katalin S. Varga (eds.), *Bibó István (1911–1979). Életút dokumentumokban* [István Bibó (1911–1979): A life in documents] (Budapest: 1956-os Intézet, 1995); István Bibó, *Democracy, Revolution, Self-determination: Selected Writings* (Boulder: East European Monographs, 1991). On the relationship of Bibó and Ravasz, see László Tóth, "Ravasz László és Bibó István szellemi viszonya (Kapcsolódási pontok)" [The intellectual relationship of László Ravasz and István Bibó (Points of contact)] in Iván Zoltán Dénes (ed.), *Megtalálni a szabadság rendjét: Tanulmányok Bibó István életművéről* [To find the order of freedom: Studies on the work of István Bibó] (Budapest: Új Mandátum Könyvkiadó, 2001), 265–90.

Both *The Bishop's Garden* and *A Bibó Reader* show the ruptures and connections between the private and the public by means of stories of internal exile; and by quoting Bibó's essays they reveal the multiple, metaphorical interaction of text and visuals, life and thought.[10] Forgács's films in *Private Hungary* are always re-compositions, constructed out of minute fragments. They are audio-visual remixes of the past. In the author's own words:

> the past is something that in a sense I make out of the bits and pieces, that I construct (…) Most filmmakers use archive material and home-movie to illustrate an idea, a problem, a sociological or historical fact for their film. For me it's the opposite: it's the message of the film fragments themselves that is important and my challenge is to put together a new story. The home movie-makers, creating these naive self-anthropology films, proving for themselves and for later times that they exist. Their film approach—perception—is completely different from that of a "professional," and from mine. I want to compose something that could be called a private history in front of the curtain of public history. This dynamic relation between the elegy (of private saga) and the structure (of a historic perspective) with Hitchcockian melody is my message.[11] The bits and pieces of old home movies are more like parts of a dream work. My re-contextualizing construction is more a kind of restructuring of the dream work and not an illustration with or by their lives. My aim is more to open up the secret vaults of a personal, private history memory archive of those lives (…) Reading a dream means that you offer a reading, which could have been replaced by a different reading, which is—or could be—just as true, as right as other, earlier readings. So you peel off the meanings—or the attributions of meaning—and the music helps, opens up The Gate in that way. It's a kind of fluid in this procedure that helps you to rethink your own remembering. The music connects the mood and the structural elements, and bridges these gaps.[12]

Forgács's method goes back to the avant-garde filmmaking of the 1920s, the Soviet montage school, the eccentric style, the surrealistic, grotesque stylization and attraction montages of early Eisenstein films and the FEKS group, which aimed at contrasting images of differing emotional content and meaning. In *Private Hungary*, Forgács applies the con-

[10] Tamás Fehérvári, János Weiss, J. A. Tillmann, "Képtudat és önismeret" [Image and self-knowledge], *Filmvilág* 6 (2002): 17–9.

[11] The Hitchcockian melody is the suspense deriving from the fact that we, the audience, know better than the amateur film-makers themselves. We know their destiny.

[12] "At the center of Mitteleuropa," Péter Forgács interviewed by Sven Spieker at http://subsol.c3.hu/subsol_2/contributors3/forgacstext.html (accessed 23 February, 2007).

trapuntal structure on both the micro- and the macro-dramaturgical level, in short sequences as well as in the narrative construction of the entire film. Private (family) stories are contrasted to dramatic historical events such as World War II or the Holocaust. More precisely, Forgács shows family stories that end in historical traumas, which is why it is important to have some knowledge of the filmmakers' and their families' fate. Tiny slices are carved out of personal, local time and history, and the ordinariness of everyday life is contrasted to, and modified by, the "big" historical events. Private joy, passion, lost days gain emphasis in this way. The contrast creates the double effect of intellectual distance and emotional intimacy. The interruption of the emotional/narrative process obliges the viewer to reflect upon what she or he sees, and in the process new connotations, associations and allusions are created. Consequently, instead of adopting a passive, nostalgic attitude, the viewer is expected to play an active and reflexive role.

"Making it visible" is the key element of Forgács's work. His films bring to the surface experiences and memories not seen or felt before. They give a sense, a meaning and significance to those everyday experiences that otherwise would remain in an invisible and meaningless realm. This might explain why Forgács constantly highlights the importance of dream work and dream decoding in relation to the recreation of amateur films. Private footages need to be transformed and reshaped for such a creative reinterpretation/recreation. The audience undergoes a kind of initiation because it lacks information or insight (unless the outsiders' voyeuristic energies are mobilized). Forgács re-orchestrates the private footages by emphasizing certain details and manipulating fragments, with the use of slow-down, freeze frames, collages and image-text inserts.

Kádár's Kiss not only changes, removes and betrays the expectations and standard solutions of private films, but also offers a new approach compared to the structure of previous films within the *Private Hungary* series. *Official* versus *non-official* gains a particular connotation in this film. As I mentioned before, the traditional use of amateur films is unveiling: under or behind the public façade the *private* is shown; behind or under the big history the everyday experience is uncovered. Forgács's film does not concentrate on individual/private/family stories, but on the big events of the Kádár era, particularly on the 1960s' "consolidation." It differs from the personal/individual character; it leaves behind the closed, linear narrative, and replaces nostalgia with irony. There is no standard, conventional narrative typical of the nostalgic portrayals made out of fam-

ily stories. *Kádár's Kiss* is not a linear story, but a diffuse, associatively constructed audio-visual collage, a deconstructive interpretation of the epoch.

THE TIME OF THE ORIGINAL SHOTS: THE EARLY KÁDÁR REGIME

The original footages of *Kádár's Kiss* were made in the strange period—especially strange for those who were not alive then—of the Kádár era.[13] The 1956 Revolution and its repression belong to the first year of this period. The entire period referred to as the "Kádár regime" covers thirty-three years, between 1956 and 1989, but the three decades do not form a homogeneous episode. As the theory of narrativity emphasizes, a story is usually defined by the perspective of its terminus. The terminus—in this case 1989, the year of the regime change—obviously refers back to the beginning, the Revolution of 1956. The reburial in 1989 of Prime Minister Imre Nagy and other martyrs of the Revolution is a symbolic moment. It highlights questions of continuity and rupture—the crucial problem of the Kádár regime. We could also ask: what do we consider the core of the system? The continuity with the Rákosi regime, the Hungarian version of Stalinism (this interpretation treats all four decades of the Hungarian "communist experiment" as a homogeneous, common history)? Or the relative calm of the reformist consolidation period, when Hungarians enjoyed "goulash Communism" in the "happiest barracks in Eastern Europe" (in this case the efforts aiming at changing the regime would be preponderant; some say that Kádár and his colleagues slowly and secretly fulfilled the demands of the 1956 Revolution)? Which moment, which phase is the essence of the Kádár era: the brutal reprisals and bloodshed after the Revolution or the period of consolidation and reform?

This question is obviously provocative. The Kádár regime never realized either of the main goals of the Revolution—national independence and democracy—but the most important element of its self-image was cautious and half-hearted change. In order to have this "amended version" accepted by the people, the authorities had to make them forget the beginning, the reprisal that followed the Revolution. 1956 is the origo of

[13] On the historical interpretation and characteristic of the Kádár-era, see János Rainer M., "The Sixties in Hungary—Some Historical and Political Approaches" in János Rainer M., György Péteri (eds.), *Muddling Through in the Long 1960s: Ideas and Everyday Life in High Politics and the Lower Classes of Communist Hungary* (Budapest—Trondheim: 1956 Institute, 2005), 4–26; and Ignác Romsics, *Hungary in the 20th Century* (Budapest: Corvina, 1999).

the Kádár era and the goal of this "system without an ideology" was to forget 1956. The thirty-three years between 1956 and 1989 are marked by this paradox.

During the years of repression after the Revolution, in the period of establishment and reprisal, one of the core elements of the demonstration of power was to repeat that 1956 was a counterrevolution. Political brochures, resolutions, novels and films were produced to justify this thesis. At the beginning of the period of consolidation, however, after the 1963 amnesty, the aim became political neutralization. The slogan in Kádár's time, "who is not against us is with us," allowed everyday experiences and private life to escape from the sphere of politics and ideology. After the devastation of World War II, the agitated coalition years, the Rákosi dictatorship, the Revolution and the reprisals, the 1960s represented a period of tranquility, offering a chance to look back and make an assessment. Kádár and his colleagues learned that relative peace and collective forgetting can be most easily achieved and bought by concessions, above all by raising the standard of living and by reigning in the ideological offensive ("buying" in this case can be understood literally: from the 1970s onwards the system obtained social tranquility by financing the "happiest barrack" with Western loans). *Kádár's Kiss* unveils the falsehood of the early Kádár era, both the consolidation and the amnesia.

WHOSE KISS? THE TITLE

The reading of the film and the interpretation of its meanings should start by decoding the connotations of the title. The discrepancy between the Hungarian and the English title, which do not evoke the same associations, from the start draws our attention to the interchangeability of "private" and "public." The English *Kádár's Kiss* keeps the alliteration of the Hungarian, but the use of Csermanek in the Hungarian title is deliberate. It was the politician's original surname, Kádár being an alias he received in 1943 when the Communist Party was still illegal. Calling him Csermanek instead of Kádár bears multiple sarcastic and provocative connotations. It is also characteristic of Forgács, who in several interviews refers to Stalin simply as Dzhugashvili. He demotes Kádár, almost ignoring him as a communist politician: stripping him of the name and image of the public figure, he shows him instead as an ordinary person. This is particularly relevant because a central element of Kádár's public image was his everydayness, the emphasis that the politician was also a human being, "one of

us." That is also why the Kádár myth could operate as one example of the classical "good king—bad court" story.

However, the title also alludes to the common form of greeting used by communist politicians, the kiss—which appears in an archival sequence of the film, reminding us of a central element of communist choreography and rituals. Politics and pornography, public rituals and private lust are associated in a grotesque way. The next association is obviously the kiss of Judas, pointing to betrayal, which, as already mentioned, is the suppressed secret and essence of the genesis of the Kádár regime: the betrayal of Imre Nagy and the Revolution of 1956 by Kádár.

COLLAGES AND MONTAGES

Kádár's Kiss shows the motionless world of the Kádár regime of the 1960s, turning it around and upside down. It takes us back to the construction of the regime, the "Hungarian road to Socialism," the period of (relative) openness accompanying the local "Thaw." At the very beginning of the film we see images of the destruction of a building, and later the collapse of the National Theatre. We are also shown shots of new blocks of flats going up. What is being built and what is collapsing? What is hiding under the surface? What is behind the motionless, ornamented façades? Forgács's film comprises several audio-visual layers. This eccentric and grotesque structure shows the inner frustration and falseness of the apparently tranquil Kádár regime. The film is built out of private footages and photographs, news reels and film reportages, the radio broadcast of a theatrical performance and other radio materials such as news, excerpts from Kádár's speeches and musical hits. On the macro-dramaturgical level Forgács uses collages and montages to assemble a structure of varying themes and motifs, while on the micro-dramaturgical level he resorts to counterpoint and "eccentric" montages.

The structure of thematic variation is based on abstract binary contrasts: private and public (everyday events recorded in amateur footages versus official celebrations and marches), above and below (the political elite mentioned in Kádár's speeches versus the home-movie makers), popular/contemporary and elite/traditional culture (frivolous hits versus performances at the National Theatre). The most important themes of the film can be organized in various combinations and contrasts according to these opposites. There are four different basic relationships in the combination and montage of image with image, text with text, or audio material

with visual. The two layers may strengthen each other (the banality of contemporary musical hits paralells the empty clichés of Kádár's speech) or form a provocative contrast (a radio announcement of the death of Mátyás Rákosi, the former party secretary and a leading figure of Hungarian Stalinism in the 1950s, runs parallel with images of women dancing and smoking). The relationship between the two layers may be neutral (a weather report accompanies footage of a family vacation). Finally, the two layers may have an associative/metaphorical relationship (amateur footage of a construction site is "commented on" by a literary text about a "colossal garbage heap"). The audiovisual collages of *Kádár's Kiss* tend to use counterpoint and associative/metaphorical montage within one image (a naughty amateur recording of a naked woman posing in a living room is brought together with Kádár giving a speech in an archived newsreel on the TV screen), or within highly variegated montage sequences. A key motif in amateur films as well as in official propaganda productions is bringing together banality and ordinariness (the ancient peasant ritual of pig slaughtering and a newsreel report on a peasant successfully raising pigs). These sequences do not follow each other in direct counterpoint, but appear relatively far from each other in different scenes of the film.

Another leitmotif is the series of feasts taking place in a private atmosphere (Christmas dinner, the family toast, vacation at Lake Balaton), or in public, official rituals (May 1st, a festive dinner with Gypsy music for a Soviet delegation visiting Hungary). These visual motifs are contrasted by different audio collages: Kádár, being greeted on his birthday, makes a speech on how he was raised without the celebration of wedding anniversaries, name days, or birthdays. He claims to be embarrassed by his own anniversary. The contrast between construction and deconstruction also appears in different combinations, from a very direct and concrete montage (the footage of the demolition of the National Theatre and the building of a new block of flats that we have already mentioned), to more complex, metaphorical allusions (quotes from Kádár about "laying the foundations of Socialism," or making fun of people who like rhymeless poetry, and cannot bear short rhythmical poems).

The associative/metaphorical structure is very important in the film because of another leitmotif: "mistakes" and "errors." These turn up in both the audio and the visual materials: the radio newscaster muddles up the text of the news and starts laughing when she has to pronounce the name of a man accused of murder (which means blood in Hungarian). This theme is underlined by the text of some banal hits ("An old song says that if you tell a lie your voice will falter") and amateur photographs, which

according to traditional codes are "incorrectly set" and wrongly exposed (thus gaining the aura of non-professional, private, incidental *objets trouvés*). The dream-like visual interpretation of mistakes points to repressions and traumas, and smaller or bigger amnesias. This leads us to the core motif of the film, the topic of lies and betrayal. Variations on this theme move on the widest and richest scale, from the method of direct contrapuntal montage (the "comrade-like" kiss of Kádár and Brezhnev at the airport is accompanied by a contemporary hit: "You promised never to lie to me") to the method of associative allusion which reappears throughout the film. Perhaps the most striking example of the dissonant use of the private and the public, of elite culture and ordinariness, is the radio broadcast of the Hungarian national drama *Bánk Bán* contrasted with archetypical amateur photos.

József Katona's tragedy was written in the first half of the nineteenth century and quickly became a key work of Hungarian national romanticism. *Bánk Bán* is a canonized national classic, subject to contradictory interpretations, part of the obligatory secondary school curriculum even during the Kádár era. *Bánk Bán* is a drama set in the thirteenth century, which can be read both as a story of Hungarian noblemen conspiring in order to protect their country against foreigners or as a complaint of the repressed peasantry/nation (the monologue of a peasant named Tiborc, one of the main characters, had to be learnt by heart by all pupils) or again as the conflict between loyalty and honor. This overrated, hackneyed piece of national self-pity and self-absolution allows completely opposite interpretations and could thus be used to support both Kádár's self-absolving myth (we must choose the "least of evils," being at the mercy of a foreign power), and a call for national resistance. One aria called *Hazám, hazám* [My Homeland, My Homeland] became the favorite song of many who requested it again and again on radio and television programs during the 1970s and 1980s.

The radio coverage of *Bánk Bán* is the most solid pillar supporting the audiovisual collage of *Kádár's Kiss*. Most famous performances of this classic national drama took place at the National Theatre. By quoting the text of *Bánk Bán* the film, on the one hand, strengthens the motif of betrayal/lies (the kiss of Csermanek/Kádár/Judas). On the other hand, it alludes to the ambivalent character of the Kádár period of consolidation and modernization, whose public sphere was characterized by an advanced elite culture and a high level of education. It refers to the moment when the mass media (mainly television) suddenly redefined the relationship between *public* and *private*. The amateur footage mentioned above, in

which Kádár's speech appears on the living-room television screen, high-lights this gesture of modernization, with the mass media entering the private sphere, and changing the pattern of amateur filming by including the past as an outworn play. All this creates feelings of destruction, ruin, the powerlessness of decaying traditions (the demolition of the National Theatre in the city centre in 1965 to make way for the construction of the Budapest underground; the counterbalancing of the high-flown drama by down-to-earth amateur photos), which is reinforced by the other central audio material, the performance by Tibor Szemző[14] of a text by the eso-terical writer-philosopher Béla Hamvas:

> It is said there is a celestial body in the universe, one of its kind, Sirius Beta: a cold, dead star, a lusterless, heatless motionless body. Where the atoms are tossed about and piled on one another, in disarray, as on a colossal junk-heap, the rest perished. This is Sirius Beta, material par excellence. (…) When man becomes a materialist, or in other words, begins to believe that the world was and is of matter and he adheres to this material, and clings to it, and to him the material means gravity, environment, desire, religion, then man begins to feel obscurely that he is also a fallen and discarded, degraded and broken, being tossed aside and on a junk-heap, stripped of contact with the spiritual forces of nature, detached from the cosmos, aborted through some terrible catastrophe, his spiritual concern lost, and so he reverts and sinks.[15]

The "colossal garbage heap" of the Hamvas quote suggests the melan-choly of the brutal contrast between banality and monumentality. In For-gács's words, it is as if this text were looking down "from outer space" on Kádár's world, on the monumental utopia of the construction of Socialism in the 1960s and on everything that emerged from it all. While *Kádár's Kiss* is a grotesque, sarcastic and eclectic film, behind the deconstruction and the rhetoric we can observe the intention to unveil the uniqueness of private lives, to show individuality and individual ordinariness, to dis-cover the unique and unrepeatable lives of human beings, to search for a lost world. That is where the film finds its deep, inner melancholy. This melancholic tone also characterized earlier pieces of the *Private Hungary* series, but in this case it carries further connotations. Kádár's system is the country of nothingness, the eternal present tense. An empire based on

[14] Szemző is a musician, composer, independent filmmaker, and author of soundtracks. He has been a long-time collaborator on Forgács's films. As a musician, he was the founder of the acclaimed Hungarian modern ensemble *Group 180* and *The Gordian Knot Com-pany.*

[15] www.forgacspeter.hu/eng/main/films/kadar/kadar.htm (accessed 23 February, 2007).

appearance, outer shells and banality. That is why Forgács so frequently uses excerpts from the speeches of Kádár—the recollection of banality, cheap and empty jokes.

The most important challenge the film faced was how to depict the banality and prudishness of the system. This was also the central issue of the Czech New Wave films: the cheerfully bitter images of Miloš Forman, Jiří Menzel, Ivan Passer uncovered the poetry of everyday life and its great charm.[16] They told simple stories of lost teenagers and puzzled fathers. These stories were revolutionary not because of their narrative style but because their authors understood the impossibility and absurdity of the social utopia and realized that one does not have to portray "existing Socialism" in openly political dramas and exciting critical parables, but may show it through the most ordinary and banal moments of everyday life. That is why they told stories of well-meaning but hidebound secretaries, absurd meetings of factory committees, celebrations drowning in beer and chaos, or firemen's balls: their stories uncovered the unlivable, collapsed foundations of the system and at the same time offered strategies for survival, tiny adventures of happiness in everyday life as opposed to colossal banality, the banality of stupidity and the banality of a system devoid of ideology.

Forgács's film does not (or not only) operate with the silent irony of "intimate lighting," but with the instruments of sharp and grotesque contrast. The tension, connection and controversy between the prudishness of official norms and practices and the joys of everyday life is created by the interaction between politics and eroticism, the public and the private spheres, the constant game of interpretation and reinterpretation of the desexualized public sphere (where a kiss is nothing more than the sign of socialist politicians' fraternity) and the eroticism of the private worlds.

The most important signification principle of montage is the exchange or transposition of the signifier and the signified. An example for this is the motif of sex: the naked, private images are sweet, innocent, they are found footages—while the political pornography of the public sphere propagating asexuality becomes visible. The use of amateur films and newsreels along with official propaganda texts suggests the inseparability of the private and the public. Forgács's film shows the private *within* the public, and highlights this as the essence of the regime. The central message is the impossibility of getting through the banality, the

[16] Peter Hames, "The Czechoslovak New Wave: A Revolution Denied" in Linda Badley, R. Barton Palmer and Steven Jay Schneider (eds.), *Traditions in World Cinema* (Edinburgh: Edinburgh University Press, 2006), 67–79.

façade, because the core does not lie *behind* it—banality *is* the core itself. A chain of associations of the mistakes and errors uncovers the big lie of the regime: the building of Socialism is destruction; the basis of social peace is betrayal and suppression; behind the stillness there is frustration.

BEHIND THE FAÇADES OF CONSOLIDATION

Fig. 1 Kádár's Kiss. Courtesy of Péter Forgács

Forgács's film does not offer a representative image of the 1960s in Hungary, the consolidation period of the Kádár regime. The time frames are not clear: with most of the images and texts dating back to the first half of the 1960s, but some coming from the turn of the 1960–70s. There is no inner chronology since that is not the goal of the film: it does not matter which years are represented by more or by less material. Hungary at the beginning of the 1960s, (including 1963, a key date, the year of the amnesty granted to the majority of those imprisoned after the Revolution, which was the symbolic overture of the Kádár consolidation) and Hungary in the late 1960s and early 1970s (the time of the peak and subsequent slowdown of

the economic reform) represent two different eras, raising questions about homogeneity of the period. However, this question is irrelevant from the perspective of the film, since Forgács's aim is not to talk about periodization in terms of any historical analysis. Rather, he presents the Hungary of the 1960s as a timeless epoch, an everlasting present.

Kádár's Kiss uses a variety of themes, values, spheres and source materials in order to produce a contrapuntal narrative and a montage structure. It does not have a certain group or social class in its centre. In contrast with other films in the series, the amateur filmmakers, family members or friends appearing in the footages cannot be identified. No personal stories, destinies or family legends are connected with the images. The heroes rarely have names, and at most we know their forenames. This further highlights the fact that Kádár appears under both his names—his real name and the name he adopted during the clandestine period.

By viewing the amateur footages, the places where they were most probably made, and the objects surrounding the people, we experience the petit-bourgeois *milieu* of the socialist regime of the Hungarian 1960s. For the middle or lower-middle class Kádár's consolidation and the ambivalent modernization of the time meant extended opportunities, a change in lifestyle and an improvement of living standards (television, car, weekend cottage), which gave this period the nickname "refrigerator Socialism." The images of the film reflect a pragmatic world, free of politics and ideology, with a happy and peaceful consumerist society: vacations spent at Lake Balaton and anniversaries celebrated in front of the television—a tacit pact of philistines not wanting to break with their ordinariness and politicians insisting on their own average, ordinary character. This interpretation is further strengthened by several Kádár quotes that appear in the film, in which he insists that Communists are not "extraordinary people": they too are simple, average members of society, who sometimes make mistakes or take wrong decisions.

This peace and banality as well as the reciprocal compromises are based on forgetting and the fading or downright disappearance of traditions and values. In a beautiful and metaphorical piece of amateur footage, beneath the ruins of the National Theatre, the workers are carrying an old ornament, a statue, once the pride of the building. From the external point of view of Hamvas's text ("the colossal junkheap") the world of Kádár's consolidation seems like a cheap victory of materiality; while from the point of view of the 1956 Revolution and the reprisals against it—the starting point of the system itself—it is just a monotonous, grey and false period of betrayal and forgetting.

Kádár's Kiss unveils the falseness of the consolidation period under Kádár. It exposes the shallowness of a system devoid of ideology, where deleting the past, amnesia ("let's forget about the genesis of the system") and blindness towards the present (consolidation, neutralization) all mean self-betrayal. The crux of these lies and self-delusions is the distinction between the public and the private. The separation itself (when politics and ideology abandon everyday life), indeed the very possibility of separation, were only illusions; as such, they could only be kept up for a limited time. Forgács's grotesque, sarcastic and deeply melancholic film shows the Hungary of the 1960s, an empty façade living its eternal present. As a saying of the time put it: the Kádár regime was like honey. Sweet, but it made you get stuck with it.

The Experiences of a Filmmaker

Reconstructing Reality from Documents in Communist Archives

ALEXANDRU SOLOMON

THE PUBLIC INTEREST. DO WE HAVE A DUTY?

The results of a poll recently published in Romania indicated that 50% of the population is not interested in understanding the activities of the political police under the communist regime.[1] The poll also showed that 67% do not want to find out if somebody in their family worked for the *Securitate*.[2] These figures only confirm what we already knew: there is an obvious refusal to take responsibility for the criminal activities of the regime. More than half of Romanian society wishes to forget the socialist past. One must admit that this is not very encouraging for a documentary filmmaker, working mainly on recent history.

I have long accused the media—especially the TV stations—of causing this kind of attitude. But I am probably not alone in thinking that the political establishment is just as responsible for burying our recent past. It stands to reason that most politicians in my country were, to some extent, involved in the political structures of the communist regime. It is obviously not in their interest to encourage people to reevaluate the past and establish responsibilities. On the contrary, amnesia is their best ally. As a result, archives have remained closed too long since 1989.

Knowing all this, I have never been able to accept the extent of public indifference to something that, in my naive belief, is of capital importance

[1] The poll was made by the Social Studies Office (*Biroul de Cercetări Sociale*) between April 26 and May 4, 2006.

[2] The *Securitate* (Romanian for "Security"; official full name: *Departamentul Securității Statului* [State Security Department]), was the secret police force of communist Romania. Previously the Romanian secret police was called *Siguranța statului* [Safety of the State]. The *Securitate* was, in proportion to Romania's population, the largest secret police force in the Eastern bloc. For more on *Securitate*, see Dennis Deletant, *Ceaușescu and the Securitate: Coercion and Dissent in Romania, 1965–1989* (London: C. Hurst, 1995).

for building an "honorable" society in the future. There is no future without reconciliation with the past. Nevertheless, I am aware that this kind of reaction is human and that in Germany the discussion about the Holocaust did not start until 1960s. Last year, while I was in Spain, I was surprised to find that no films about Franco's political victims have been made till recently. It has taken thirty years to start.

In Romania, some of the reasons for this lack of interest probably lie precisely in the media representation of the recent past. Immediately after Ceauşescu's downfall, the communist regime began to be portrayed in the same black-and-white, propagandistic way as the old system had used against its enemies. For years, TV programs and newspapers have been depicting Communism in the darkest terms. They have made it look like a natural catastrophe which had come from abroad, from the Soviet Union—and to which individuals, in particular Romanians, made no active contribution.

One result is that today, for instance, to call somebody "a Communist" is an insult. The word has become a substitute for senile, or describes a generic malfunction of the human brain. This linguistic habit confirms that new stereotypes have by now successfully replaced the old ones. At the same time, there is a paradox: a large section of the population is nostalgic about those times, while the younger generations have no idea of the real living conditions in Romania before 1989.

In these circumstances, between lack of interest and a strongly stereotyped mind-set, "rememorizing" the past appears even more important. It seems to me that if there is a mission or a duty left for intellectuals, then it is to remember and to make sure things are not swept into oblivion. But this is not so simple. Although the socialist past is not that distant in history, it has become very difficult to grasp its significance. Not only are we working amidst misconceptions, but the sources that we can use are not trustworthy. We rely on archive documents—be they written or filmed—and on people. And we all know that there is no reason to trust either people or documents. I would like to write about how I learned to doubt everything while I was making an archive-based film *Great Communist Bank Robbery* (*Marele jaf comunist*, 2004).

THE STORY AND MY MOTIVATION

My *Great Communist Bank Robbery* is a film about the reconstruction of a true case—a robbery—and how difficult it is to get a clear picture of what happened. In 1959, the National Bank of Romania was held up and a

large amount of money stolen. This was exceptional in Eastern Europe. No one kept money in the bank; you couldn't even use money in those days, because there was almost nothing to buy. Besides, the police state was so strict that you could bet anyone who held up the National Bank would be easily caught. However, on July 28, 1959 a robbery took place in broad daylight: five people raided the National Bank and got away with the equivalent of a million dollars.

The event shocked the whole country and, more importantly, the communist leadership. The robbery seriously undermined the credibility of the regime. Two months later, six people were arrested and charged with the theft. They were ex-Communist Party and *Securitate* officials, all of them Jews. They were tried in court, for a crime that was considered as a political offence. At the end of the investigation, the Party leadership decided to reconstruct the robbery in a film in which the real defendants would play their own parts. During the trial, which was filmed live, five out of six were sentenced to death and by the time they were executed, *Reconstruction* was ready. It was screened for Party members and produced a strong impression throughout the country.

When I saw *Reconstruction*, I decided that I wanted to tell this story again. Not only was I dealing with a unique affair: an American-style heist executed in a communist country by Jewish communist activists; but I was immediately fascinated by what seemed to me a masterpiece of manipulation. Although it pretends to be a documentary and—in a way—it was made with the ingredients of documentary filmmaking, *Reconstruction* is so obviously lying, mixing real facts into a transparent fabrication, that it cannot be used as a source of information on the bank robbery. On the contrary, it hides the truth and was made to take us far away from the reality of those events. In my proposal I wrote down what seemed to me the goal of my film: to de-construct *Reconstruction*, unveil the multiple layers of propaganda, and get closer to the truth. I was going to perform a cleaning-up operation.

There was more to it. The robbery itself was a mystery: why would some Communists attack the same system they'd been fighting for, and why would they do it in this strange way—by robbing the National Bank? *Reconstruction* stated that they were simply driven by lust for money; they wanted to live in luxury. But this was completely unreasonable in those historical circumstances. And my characters knew very well what kind of a world they were living in. So I had to solve this enigma, too.

THE WRITTEN WORD

If the truth didn't lie in the archive film, then there must have been some-thing hidden in the *Securitate* archives. To my surprise, my application to examine the files on the robbery was approved quite quickly. I went there, in the autumn of 2001, with a sort of religious feeling. A set of twenty-seven volumes, containing about 10,000 pages, was waiting for me. There were transcripts of the interrogations of the robbers and other witnesses, declarations made by informers sharing the cells of the accused; reports from the police and conclusions by the investigators, documents issued by the tribunal as well as prison files and much more. Even the script of *Reconstruction* was there, in more than one version, with handwritten anno-tations of the Minister of the Interior.

Fig. 1 Great Communist Bank Robbery: The filmbox of *Reconstruction*
Courtesy of Alexandru Solomon

Whom could I trust, among all these? I was sure I couldn't trust the in-vestigators and the way they transcribed the interrogations and drew their conclusions. But could I believe what my main characters—those five men and one woman charged with the robbery—stated about their motives

in front of the *Securitate* officers? Weren't they trying to present their own deeds in a favorable light, so that their lives would be spared? Maybe they insisted on their political motives in order to give the bank robbery a positive, "cleaner" relevance. While reading and comparing their declarations, I learned that these people also liked to invent stories—another factor I had to take into account (Fig. 1).

Furthermore, could I trust the informers who shared the cells of the defendants? Weren't they trying to distort what the robbers said, in order to win the officers' favor? I was, however, inclined to believe these informers' reports, because they were handwritten and seemed less contrived. They looked like accurate accounts of what my characters said when they thought—naively—that nobody was listening to them. Only towards the end of the investigation did the robbers realize that their cell mates were regularly reporting on them.

When you plunge into such archives, it is like diving into the darkest, most hidden parts of the human soul. You are surrounded by suffering, treachery and viciousness. Nonetheless, one thing was clear: I had no right to condemn these people. And the fact that in this story there were no heroes, no characters driven by their ideals, attracted me even more. It took me weeks to read and make notes and then more weeks to organize all the material. I tried to hunt down any irregularity, to compare the testimonies and find discrepancies; I made a chronology of the investigation and tracked the way the investigators forced the defendants to make whatever statements suited the propaganda machine. But there were always grey areas and pieces missing in the puzzle.

At the end of this research, it looked as if I had understood some of the motives that led six former activists to raid the National Bank. It seemed to me that I could also detect the intentions of the *Securitate* and how the communist regime took political advantage of the bank robbery. I thought I could spot where the secret police had misled the investigation, where they added lies or distorted the facts. By reading different versions of the script of *Reconstruction*, I learned how they abandoned the idea of making an overtly anti-Semitic film and turned it into a hymn to the repressive authorities. However, all these were deductions; there was no proof, no certainty, only several explanations. I was soon to discover how relative these were and how the same archival documents could be deciphered differently.

The universal conspiracy theory

Two years later, when I started shooting, I invited the son of one of the defendants to Bucharest. Years before, he had applied for permission to look through the files, but had never received an answer. We decided together that he should come to Bucharest, and even if he did not get a permit, we would go together to the archives, where I would film him being refused access, and do an interview on the spot. We applied for a permit to film at the archives. Alex came to Bucharest, we met for a brief planning session and he left our production office. Half an hour later he received an invitation from the archives to start studying the files about his father (Fig. 2).

Fig. 2 Great Communist Bank Robbery: Reading the files
Courtesy of Alexandru Solomon

We were stunned; we couldn't find any explanation for this sudden approval of his application. Had they listened to our conversation and decided to appease us? We began to suspect that our offices were bugged and we had become part of the same comedy. At the same time, I thought that there was at least one human benefit from the fact that I was making this film: Alex would see these files and get to know his father better. The

robbery had happened when Alex was eight years old and he had never seen his father again.

Alex spent two difficult weeks in the archives, writing down and comparing, going through the same ordeal as I had. He was much more personally involved than I. At the end of this experience, he told me that he had reached a conclusion: everything had been set up. He believed that the robbery might not have taken place at all and doubted that his father had taken part in it in any case. He thought that all these files were just fiction, part of a more general script written by a dark spirit. To support his theory, he referred to some details that I hadn't noticed. Above all, he pointed out that the serial numbers of the supposedly stolen banknotes were not listed anywhere in the files. He suggested that this amount of money was never taken from the bank. I replied that of course, the *Securitate* files are full of gaps and lies, but this could not justify his belief that 10,000 pages, including statements by hundreds of people, were simply made up by a diabolical mastermind. But I had to admit that archival documents are no solid ground and that one single lie could cast doubt over the whole story.

THE MEMORY OF LIVING WITNESSES. PEOPLE ARE NO BETTER THAN ARCHIVES

The essence of information in a Stalinist society was rumor. As the media were strictly controlled and there was no real news, just propaganda, everybody relied on gossip. I combed through the press of the months that followed the robbery, and found nothing about the case. Nonetheless, while talking to people I realized that everybody knew about it. With no information in the press, rumor spread, combining things said by the witnesses with fantasies to create something that resembled mythology. I will mention one particularly long-lasting myth. It was said that the robbers had built a film set, with cameras and lights, to make passers-by believe that the raid on the bank was just a scene from a movie. They told people who approached the bank: "Go away; we're shooting a film!" I heard this story from many witnesses, and I was—of course—seduced by it. It was like a metaphor, or maybe a premonition, of the whole production of *Reconstruction*. But it was too beautiful to be true.

While I was going through the files, I read about some filming that had taken place at the hospital opposite the bank two days before the robbery. Then I found statements by women being treated in the hospital who, looking out of the window and seeing the robbery, thought that the film

crew had come back. I realized that the imagination of these women had been stimulated by the coincidence—on the same street—of the filming with the robbery.

This story is—for me—a perfect example of how easily people confuse what is in their heads with their real experiences. With many of my witnesses, I had to make an effort to separate rumors and faulty recollections from genuine memories. Most of them were certain that they held the key to the whole story, and that they alone knew it. But I also met an astonishing case of amnesia. I was delighted when I located the woman who had edited the *Reconstruction* film. I was sure that she could tell me more about the choices made by the director, e.g. what scenes were left out, and so on. She agreed to meet me and I traveled 300 kilometers to the town where she lived. I showed her the film: she was on the credits and she acknowledged working with the director on other films. But she kept saying—as she had already told me on the phone—that she couldn't remember anything; she even supposed that somebody else had edited *Reconstruction*.

Fig. 3 Reconstruction: The group
Courtesy of Alexandru Solomon and Libra Film

After a while, an image came back to her from the past: she had been editing at night for three nights; she couldn't get out into the corridor, which was patrolled by a *Securitate* officer. She was exhausted and told the director that she couldn't go on and the director replied: just splice these three shots and it's done. That was all she could remember. No pictures, nothing else. Either because it was safer, or because she was traumatized, she had erased this film from her memory. Later on, I found in the archives a note of the destruction of all the unused rushes from *Reconstruction*. It was dated 1966. If oblivion coincides with the removal of evidence, there's nothing more to be done.

Working with communist archives involves a great deal of moral responsibility. But interviewing people who acted in those times is even more complicated. I had to convince all sorts of individuals to cooperate on my film. I could not deceive them, but they had to see some advantage in embarking on such a risky trip. They learned to trust me; however I could not trust that their answers truly reflected their knowledge and feelings. Being involved with some of them—becoming a *partner*, a *comrade* of the *Securitate* officers for instance—was a real burden.

When interviewing people, I usually confronted them with other witnesses and with archival documents. I did this not only during the interviews but also through editing. At one point one of the interviewees, a former senior *Securitate* officer, told me to stop behaving as if I was interrogating him. It was he who was the investigator—not me. Although I never acted as if I were prosecuting my witnesses, it is true that the position of a documentary maker is that of *putting on trial* all his sources. Even having to use the word *witness* is significant. After showing my film to these people, the fact that most of them were disappointed was, for me, a guarantee. It confirmed that I had managed to place myself somewhere in the middle. Finding the right distance and the appropriate point of view is crucial in making documentaries. But it also meant that I wasn't able to solve the enigma.

BACK TO RECONSTRUCTION

After so many years, propaganda and faked documents have replaced the reality. Many of my witnesses referred to *Reconstruction* as evidence that things happened that way. When I went into editing, I had to resist the temptation to use the pictures of the robbery as staged in *Reconstruction* to illustrate the event (Fig. 3, Fig. 4). I had to frame them so that the audi-

ence would not take them for granted but be aware that this was just a *quote*. I screened the pictures in a cinema, to emphasize this quotation procedure and I played the same images several times to decode the manipulation. I brought the cameraman of *Reconstruction* back to some of the sets and gave him a camera, to reestablish the way all this was arranged (Fig. 5.) In general, bringing these people back to the locations where they *acted* forty-five years ago gave me—and them—a distance from which to reflect. The English word *re-enactment* is very appropriate for this kind of ritual. When the police take a suspect to the scene of the crime or confront him with the weapon, they don't want him to perform for art's sake; they are trying to break down his denial. Indeed, we are talking about a crime in our case. Sometimes, propaganda kills. This is not just an intellectual argument: the *Reconstruction* film, along with the *Securitate* files, was used as criminal evidence to convict six people.

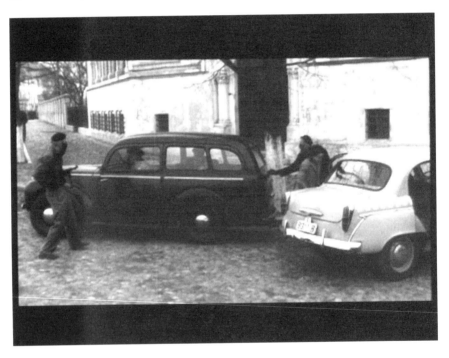

Fig. 4 Reconstruction: The robbery
Courtesy of Alexandru Solomon and Libra Film

Finally, as I had to give up on my attempt to crack the mystery, I realized that I could achieve a greater goal through my film. To confront people with their common past and let them establish their own contribution is the kind of process of coming to terms with the past that we need in our countries. So I decided to bring as many of my witnesses together in a hall where I would screen *Reconstruction* for them. I didn't want to be the one to point out who was guilty; I didn't have the right to do that. All I could do was to stir their memories and let them make up their own minds. I had to abandon my ambition to provide a clue to the story and solve the enigma. I was not the director of *Reconstruction*, who gives a single answer and tells—even forces—the people to think what he wants them to think. But I was happy with my role.

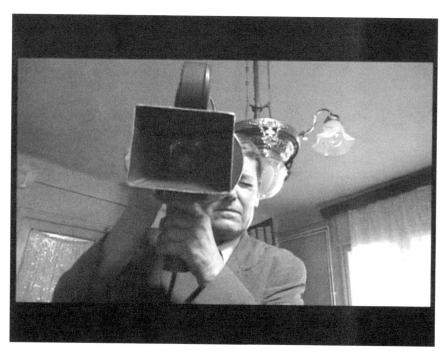

Fig. 5 Great Communist Bank Robbery: The cameraman
Courtesy of Alexandru Solomon

Subjects of Nostalgia: Selling the Past

Out of the Past

Memories and Nostalgia in (Post-)Yugoslav Cinema

NEVENA DAKOVIĆ

> *...history-as-problem has much less of an audience than history-as-dream, history-as-escapism, than History.*[1]

This article explores the ways the national past of ex-Yugoslavia is cine-matically remembered, with particular focus on the role played by the com-bination of documentary[2] and fictional material in the creation of diverse cinematic memories in mainly but not exclusively post-Yugoslav cinema. The primary issue I address is the role of documentary "interventions,"[3] the use of remembrance and memories within fictional structures, in shaping the past. I specifically concentrate on how documentary shots—whether obtru-sively inserted or seamlessly incorporated—rewrite the master narrative of a past whose very existence confirms the cinema as a privileged form of repre-sentation. This privilege is twofold, since cinema is able both to create a persuasive master narrative and to rewrite it, by revealing the hidden, elu-sive, latent meanings that cannot be expressed in any other way. In other words, cinema is imbued "with a particular sensitivity to groundswells of feelings and to changing sensibilities" and thus "films also lend themselves to the expression of sentiments that have yet to assume verbal form, or that resent clear articulation."[4] This sensitivity allows combinations of documen-

[1] Marc Ferro quoted in Naomi Greene, *Landscapes of Loss: The National Past in Postwar French Cinema* (Princeton: Princeton University Press, 1999), 11.

[2] The term "documentary" will be interchangeably used with "docu," "documentary mate-rial," "documentary (sometimes archive) footage," implying the quality of being true to reality, authentic, being based upon true events or things. It also refers to the facts in the sense of information about a particular subject, about something actual as opposed to invented. The notion of "faction" colloquially signifies work that is an amalgamation of fiction and documentary: it is thus a convenient term for the whole group of works ex-plored in this essay.

[3] The term "interventions" broadly refers to the presence and work of documentary mate-rial in the fictional structure and is close to the notions of insertion, combination, amal-gam, intrusion or even contamination and the resulting effects.

[4] Greene, *Landscapes of Loss*, 5.

tary and fiction to function as agents of nostalgia; signifiers of memory, emotions and the past; expressions of *Zeitgeist* or *Weltanschauung*; genre constituents or bearers of new meanings. Their manifold effects include the re-evaluation of the past, the correction of official public and collective history through metaphorical and symbolic restructuring, the emphasis on the repetitive model of events and the circular temporal regime, as well as the mapping of nostalgic individual and private remembrance.

My analysis focuses on the interplay of diverse cinematic materials as what "set the stamp on the representations of the past"[5] and not on the correlation between films and changes in the political, historical, or intellectual context—a well-explored topic in the broader fields of sociology, history or political studies.[6] My text-centered approach demands a widened notion of documentary material which includes quotations from, references to and imitations of, fiction. The fiction is understood to be contextually endowed with docu-credibility, as the text that mediates and testifies about the past in a "second degree," that is as testimony already refracted through media fiction. Considered as the material products of the past, in this paper the fiction films themselves are approached as "documents" of their times, i.e. documentary fiction.[7] This inclusion allows us to talk about metacinematic moments (for example film within the film) that help the creation of the cinematic remembrances of reality. Regardless of the tone—ironic, re-evaluative or nostalgic—the narratives are further enriched by references to world cinema history.

The films chosen for case study belong to two groups. One group, including titles like *Tito and I* (*Tito i ja*, 1992), *Underground* (1995), *Dust* (2001), consists of films from the post-Yugoslav era (i.e. after 1992), which directly record the changes in the social context that influence the (re)interpretation of the socialist past. The second group includes titles

[5] Andrew Dudley uses the term *optique*, which "suggests the ocular and ideological mechanisms of perspective." Andrew Dudley, *Mists of Regret: Culture and Sensibility in Classic French Cinema* (Princeton: Princeton University Press, 1995), 19. The mode of fiction/docu intertwining might be seen as the optique/mechanism of perspective for memories and the past in general.

[6] Dušan Bjelić, Obrad Savić (eds.), *Balkan as Metaphor: Between Globalisation and Fragmentation* (Cambridge, MA: MIT, 2002); Ivo Banac, *Eastern Europe in Revolution* (Ithaca: Cornell University Press, 1992); David Norris, *In the Wake of the Balkan Myth: Questions of Identity and Modernity* (New York: St. Martin's Press, 1999).

[7] The hybridity of documentary fiction is partially expressed by the term faction as the text intermingling facts and fiction, in which fictional material takes on the function of, and is treated as, documentary or archival footage.

made before 1992, such as the TV series *Unpicked Strawberries* (*Grlom u jagode*, 1974)[8] and the film *The Marathon Family* (*Maratonci trče počasni krug*, 1982),[9] which are either closely linked to impending political crises (*The Marathon Family*) or are great nostalgic stories setting a pattern to be repeated in the future (*Unpicked Strawberries*).[10]

The exploration is based upon Pierre Nora's concept, *le lieu de mémoire*,[11] which argues for a tradition of national memory that we feel has been lost or has disappeared. Nora's idea of "memory sites" bears particular resonance in the case of film texts. The interpretation of film text as a memory site, constructed of intertwined images/imagining of personal, collective, public pasts and eventually of a dialectical play of documentaries and fiction, vividly encapsulates the object of this analysis. Films that try to "come to terms" with the socialist past, I would argue, follow the model of "historiographic metafiction." The notion of historiographic metafiction refers to works which consciously problematize the making of fiction and history, posing questions about whose "truth" prevails, and exploring ways in which we can distinguish the past from the present.[12]

Early examples of the mixture of documentary and fiction in ex-Yugoslav cinema are found in the Eisensteinian montage of the socially critical and revisionist works of the Black Wave[13] classic Dušan Makave-

[8] The sequel, entitled *A Throatful of Strawberries* (*Jagode u grlu*, 1984), will be barely mentioned since it does not contain any documentary footage.

[9] However if the beginning of the disintegration is set right after Tito's death in 1980 then even these films belong to the post-Yugoslav era.

[10] The analysis of cinema as a nostalgic mode is based upon the theories of Vladimir Jankelevitch and Frederick Jameson. Vladimir Jankelevitch, *L'Irreversible et la Nostalgie* (Paris: Flammarion, 1973); Frederick Jameson, *Postmodernism or the Cultural Logic of Late Capitalism* (Durham, NC: Duke University Press, 1993).

[11] Pierre Nora (ed.), *Les Lieux de mémoire*, vols. 1–3. (Paris: Gallimard, 1984–1992). Greene quotes the definition of "*lieu de mémoire*" as a "significant entity, whether material or non-material in kind, that has become a symbolic element of the memorial heritage of a given community, as a result of human will or work of time." Greene, *Landscapes of Loss*, 4.

[12] Linda Hutcheon claims that "[t]he past is something which we must come to terms with and as such a confrontation involves an acknowledgment of limitation as well as power." Linda Hutcheon, "Telling Stories: Fiction and History" in Peter Brooker (ed.), *Modernism/Postmodernism* (Harlow: Longman, 1992), 239.

[13] Ginette Vincendeau (ed.), *Encyclopedia of European Cinema* (London: Cassell—BFI, 1999), 457 states that the term refers to "radical Yugoslav films of the late 1960s/1970s," directed by Želimir Žilnik, Živojin Pavlović, Dušan Makavejev and Aleksandar Petrović. The films were critical of Yugoslav society and criticized many of its problems, such as corruption, hypocrisy, state bureaucracy and the communist ruling class.

jev, from *Innocence Unprotected* (*Nevinost bez zaštite*, 1968) to *Gorilla Bathes at Noon* (*Gorila se kupa u podne*, 1993). The documentary "quotes" add further meaning to, and open up additional interpretative options within, his ingenious fictions. According to Makavejev the dialectics of densely intertwined facts and fiction challenge existing historical accounts of the past, rather than promoting individual nostalgia. The clustered documentary segments establish significant parallels across different layers of time (*Love Affair, or the Tragedy of a Switchboard Operator/Ljubavni slučaj ili tragedija službenice PTTa*, 1967), when "Makavejev wittily juxtaposes tender and erotic scenes between Isabelle and Ahmed with pedantic lectures by an elderly and distinguished sexologist, Professor Kostic,"[14] as well as across spatial borders (linking both sides of the Ocean, as in *WR: Mysteries of the Organism, WR: misterije organizma*, 1971). The film is "divided in two sections. The first intersperses a documentary on Wilhelm Reich's life, work, persecution and death in a Pennsylvania prison with examples of the bioenergetic and primal scream therapies employed by contemporary Reichian practitioners and various scenes and interviews reflecting contemporary America of 1969–1970. The second section is a fictional story set in Yugoslavia,"[15] which helps to articulate new contextually-determined meanings growing out of the apparently axiomatic factual layer. The following case studies offer a number of variations and elaborations of the initial documentary-fiction model established by Makavejev—of redistributed meanings, reconceptualized notions, rediscovered facts and rewritten fiction.

REMEMBRANCE OF THINGS PAST

The past is reconstructed as a function of the present just as much as the present is explained by the past[16]

Undoubtedly history is the ultimate subject matter of the films made after 1992. Problematizing the official version of the socialist past taught in schools and the popular versions advanced by the "national cinema classics," these films invest in new truths. Investment in new truths means at

[14] Daniel J. Goulding, *Liberated Cinema: The Yugoslav Experience, 1945–2001* (Bloomington—Indianapolis: Indiana University Press, 2002), 124.

[15] Ibid., 124.

[16] Jacques Le Goff quoted in Greene, *Landscapes of Loss*, 19.

the same time investment in new genres of "historiographic metafiction."[17] The film texts are equally involved in reshaping history and in researching the history of representation. The intricately related topics materialized in two strands within the film—historiographic and metafictional—that rely largely on the use of documentary clips.

One of the first films to revive Makavejev's cinematic amalgam, coincidentally the last film from ex-Yugoslavia, made in 1992, is *Tito and I.* It recalls Tito's era from a subjective point of view—as indicated in the title—and offers personal(ized) memories in a hybrid genre of family chronicle, *Bildungsfilm* and comedy.[18] Goran Marković ironically comments on the 1950s personality cult through the stylized use of documentary footage inscribed in the obsessive dream sequences of the boy hero (Dimitrije Vojnov). The oneiric framing produces a particularly ironic stance toward Tito and his time by creating the necessary critical and "de-realizing" distance. The documentary sequences are structured around Tito as the most prominent historical figure and mark the beginning of the dream episodes. Since the archive footage performs a twofold function—of providing the framework for the nation's present and past public (hi)stories and of giving a particular hue to the individual, intimate world and oneiric years of growing up—it is ascribed equally to the collective and the individual domain. In other words, the docu shots support the realist portrayal of everyday life and the specificity of a child's perception. The cinematic displacement of Tito's era and Tito himself from real remembrance into an ironic oneiric realm is paralleled by the disintegration of Yugoslavia in reality at the very moment of filming. In 1992, Slovenia became independent and the Second or ex-Yugoslavia began to be remembered as an irrevocably lost dream.

The docu images of Tito's journeys around the world and his visits to exotic countries are accompanied by Latino arrangements of Yugoslav folk melodies.[19] The lively music provides Bakhtin's carnivalesque optique, implying that Yugoslav Socialism was a political masquerade en-

[17] Hutcheon, "Telling Stories," 233.

[18] A point-of-view shot anchors "the image in the vision and perspective of one or another character" and is "marked by greater or lesser degrees of subjective distortion." Robert Stam, Sandy Flitterman Lewis, Robert Burgoyn, *New Vocabularies in Film Semiotics* (London: Routledge, 1992), 167.

[19] The archive documentary material is taken from the well-known state-produced newsreels called *Filmske novosti*—the same ones as Dragojević paraphrases at the beginning of *Pretty Village Pretty Flame* (*Lepa sela, lepo gore*, 1996)—a Serbian version of the *March of Time*.

joyed by the political elites. The hybridization of original footage and music made unfamiliar by new rhythms and arrangements has a dual implication. It underlines both the similarities between Tito and Latin–American dictators and those between Yugoslavia and a banana republic. The latter point is underlined by labeling the newly emerging, unstable and turbulent states (of ex-Yugoslavia) "tomato republics."

The concern with recent history, devastating wars, ethnic cleansing and "balkanization" became the main thematic obsession of films produced in the mid- and late 1990s. From *Underground* to films such as *Pretty Village Pretty Flame, Premeditated Murder* (*Ubistvo s predumišljajem*, 1996), and *Country of Truth, Love and Freedom* (*Zemlja istine, ljubavi i slobode*, 2000), the writers and their narratives venture into a rearticulation of the past aimed at providing new explanations for the turbulent present. The past (hi)stories "reflect the attitudes and needs, the uncertainties and fears of the present."[20] To explain the recurrent disasters of the Yugoslav past, the films' narratives reach for myths, fate and ghosts that haunt the nation, and present them in paraphrased docu sequels.

The idea of war as an endemic Balkan phenomenon is already explicit in Dušan Kovačević's work. In his scripts, considered to be among the best in the Yugoslav cinema, *The Marathon Family, Who Sings Over There?* (*Ko to tamo peva?*, 1980) and *Underground*, Kovačević provides a loose chronology of the events that signaled and led to the final disintegration of the second Yugoslavia: *The Marathon Family* opens with the assassination of King Alexander in Marseilles in 1934; *Who Sings Over There?* ends with the devastation of Belgrade on April 6, 1941, and the same event is the point of departure for *Underground*, which follows subsequent developments until 1992. His most recent film, *Professional* (*Profesionalac*, 2003), further chronicles the years of Milošević's rule, with protests, NATO bombing, elections, the 5 October democratic revolution and the end of Milošević's era. Kovačević, who also directs the film, uses an abundance of documentary shots, shown on the TV screens and video walls in the interiors and identified within the story as police surveillance material or "revolution live" seen by the protagonists.

In many ways, the key to understanding the past and history is supplied by *Underground*, which institutionalized the genre of historiographic metafiction. Historiographic aspects are treated mainly from the point of view of the national community, with the focus on the translation of the

[20] Greene, *Landscapes of Loss*, 3.

"reality" of the perplexing 1990s into history and film, and vice versa.[21] The metafictional perspective is created through a self-referential, narcissistic discourse about film history, popular culture and the making of fiction. The narrative makes references to half a century of Yugoslav history but refuses to verify either the official version of the past or our remembrances of it. *Underground* is the subtle expression of grief for a "country that was once upon a time" and of the growing awareness that the past should be blamed for the present, all of which is articulated by way of a strong criticism of communist regimes.[22] The underlying presumption is that all Yugoslav wars are reincarnations of the *Ur*-conflict or *Ur*-antagonism. Thus even the core conflicts of (the fairly recent) World War II were never really resolved, but only concealed by the political mantras of Brotherhood and Unity, Socialism and Self-Management.

The film's title is also a metaphor—both in spatial and temporal terms—for past history. *Underground* constantly emphasizes that the unfortunate heroes cannot escape from a vicious circle: they literally cannot get out of, or stop wandering through, the labyrinth of corridors with blood dripping down the walls.[23] The cellar which imprisons the multiethnic group becomes a symbol of the nation's past: an agonizing incarceration within a communist regime and a microcosm of multiethnic ex-Yugoslavia. *Underground* also alludes to the illegal communist movements (as the illegal Communist Party meetings were literally held underground) which reinforces the idea of the revolutionaries being portrayed as gangsters of the underworld.[24] Finally, the references could equally

[21] Nevena Daković, "Remembrance of the Things Past" in Guido Rings, Morgan Rikki (eds.), *European Cinema: Inside-Out. Images of the Self and the Other in Postcolonial European Film* (Heidelberg: Universitätsverlag, 2003), 243–59.

[22] The emphasis placed on past-present-future relations determines the complex temporal regime of the narratives. From *Underground* to films such as *Pretty Village Pretty Flame, Premeditated Murder* and *Balkan Rules* (*Balkanska pravila*, 1997), the authors elaborate past/present relations through visibly maintained constant and ironic dialogue, conditioning even the narrative organization. See, for example, the three parts of *Underground*, the four narrative strands in *Pretty Village* or the prolaptic construction of *Balkan Rules*.

[23] The web of underground tunnels which connect European capitals and are full of armies, victims and refugees is regarded as the work of international communist or orthodox alliances. Tony Rayns, "Underground," *Sight and Sound* 6 (1996): 54; Misha Glenny, "If You Are Not For Us," *Sight and Sound* 6 (1996): 13.

[24] An atypical and amusing revolutionary image equally evolves from filmic prototypes such as *General della Rovere* (*Il Generale della Rovere*, 1959) or *Balkan Express* (1982), with brigands and hoodlums as accidental war heroes.

well be considered as mythical or epic since *Underground* presents, similarly to *Gilgamesh*, the *Odyssee*, the *Aeneid* and the *Divine Comedy*, a world of the dead that the hero must visit in order to perform an extraordinary deed.[25]

The treatment of time is dual: realistically linear on the one hand, and mythically circular on the other. In the closed circle of time the traumas of the past are relived in the present. The present also serves as a mediating point for the mapping of the future through the past. The story is structured in three parts: each has war as the key word in its title: War (1941–1945); Cold War (1946–1960); War (1980–1995). All contain the rhythmical repetition of dramatic events such as death, childbirth, marriage and victory in battle. The linear progression of fictional weddings and funerals is intercut with authentic historical events: Tito's death provides an unmistakable focus, and Marko Dren (Miki Manojlović) appears as Tito's closest associate. The end marks the return to the beginning, to the lost paradise and its myth, bending the linear into the circular mythical time.

Rereading history in multiple time perspectives disrupts the unity and coherence of its official versions, unexpectedly bringing a touch of nostalgia. The film does not recognize World War II in ex-Yugoslavia as a dignified and progressive socialist revolution. Rather, war and revolution are depicted as brutal, manipulative struggles and as the consequences of a passionate infatuation with personal power. Tito's era is represented as part of the eternal procession of tyrants and their totalitarian regimes through the linking of the musical motif of the famous Nazi song *Lili Marleen* with two edited sequences of archive material. It accompanies the scenes of the 1941 German invasion of Yugoslavia.[26] When German troops marched into Slovenia (Maribor) and Croatia (Zagreb) they were welcomed and greeted in the streets by the population, while in Belgrade they were met by the silent ruins of a bombed and devastated city: the contrasting footage underlines the ongoing disintegration of the country.

The song also accompanies the scenes of Tito's funeral. A train carrying Tito's dead body travels along the same route as the National Socialist

[25] In this sense, Natalija (Mirjana Joković), who belongs to one man above ground and to another underground, could be regarded as a contemporary Persephone.

[26] *Lili Marleen* provides the connection with real history since the song was broadcast for the first time by Radio Belgrade on April 11, 1941. Rainer Werner Fassbinder replays this event in his film *Lili Marleen* (1981), while Hark Bohm, who plays the song's composer in Fassbinder's work, appears at the end of *Underground* as a hospital doctor.

armies did in the occupation of Yugoslavia. It might be symmetrically and symbolically read as the disappearance of the last traces of totalitarian regimes. The ensuing funeral ceremony is attended by the greatest political figures of the time, from Margaret Thatcher to Willy Brandt, Jimmy Carter, Nicolae Ceauşescu, and leaders of the non-aligned countries.[27] The group portrait of the people who left their mark on the turbulent century, enveloped by the sentimental tones of the German soldiers' ballad, provokes nostalgic sentiments. It introduces a complex feeling of loss and regret for what—in spite of tyranny and incarceration—is seen by many as a golden era, especially in contrast to what followed. For many who faced the break-up of the country, the wars, the economic crash of the 1990s and eventually the NATO bombing, Tito's era became a period of wealth, stability and happiness. The Janus-faced remembrance announces the inscription of history into myth and fairy tale, further reinforced by the end of the film, which is ambivalently trimmed with both criticism and nostalgia. On their floating island, the film's heroes begin the "epilogue" with "once upon a time there was a country" (i.e. Yugoslavia), mimicking the oral tradition of fairy tales but also articulating the sentiments of Serbian audiences about the country and the past they would remember with smiles, sorrow and tears.

Kusturica's distinctive style of dense intertextuality, saturated with homage, wide-ranging references and socio–political debates with the socialist realist heritage, confirms the self-conscious metafictional dimension of the film text. His de-naturalization "of the conventions of representing the past in narrative,"[28] established a model that was followed by numerous subsequent Yugoslav films. Some of the most important points are made by the use of documentary material incorporated into the fictional structure as well as by its parodic comments. The invented personal film history—thanks to the use of "docu-fiction"—is established as a genuine way of coping with the past.[29] There are clear references to a host of influential films by Vigo, Wajda and Tarkovskii. Scenes which verge on Rabelaisian grotesque evoke the legacy of anti–war comedies such as

[27] Many of the specific national signifiers are lost on a foreign audience. However, Tony Rayns brilliantly pinpoints the film's underlying oxymoron as "nostalgia for a national identity which is simultaneously exposed as skillfully manipulated illusion." Rayns, "Underground," 53.

[28] Greene, *Landscapes of Loss*, 240.

[29] The documentary fiction also includes quotations from other forms of art and culture. There are allusions to the Bible (the cellar as Noah's ark of salvation), painting (Gericault's or Breughel's compositions), comics and literature.

*M*A*S*H** (1970), *Catch–22* (1970), *To Be or Not to Be* (1942 together with its 1973 remake) and *Dr. Strangelove or: How I Learned to Stop Worrying and Love the Bomb* (1964).

The culmination of the metacinematic and metafictional approaches is a self-referential parodic segment of the film-within-a-film, in which events of the first part of the film are transformed into the (re)constructed narrative of the inner sequence "Spring Comes on a White Horse." At the end of the episode, the captives break out of their cellar and find themselves on the set of a movie[30] based upon the memoirs of the character called Marko.[31] This film-within-a-film satirically reviews Yugoslav cinema history as an array of polished revolutionary spectacles determined for thirty years by the dominance of socialist realism. The spectacular battle scenes, daring rescues, and unabashed heroism rehash the popular clichés of partisan epics. One famous director of the genre—Veljko Bulajić—even "recognized" himself in the role of the film director played by Dragan Nikolić, and threatened to sue Kusturica and his collaborators, thus confirming the factual nature of the fictional allusions.[32]

Underground completed the rethinking of the first years of the country's disintegration and escalating nationalism. Its success coincided with a turning point in the Yugoslav understanding of war: the signing of the Dayton agreement. From the pre-Dayton perspective, Serbia was not at war. The wars fought by Serbian diasporas in other republics were seen by Belgrade as justifiable crusades for their Yugoslav heritage, national dignity and self-protection. An even stronger attitude of total denial of the

[30] The generic model is provided by a series of partisan films, "celluloid monuments" to the war and revolution in former Yugoslavia, culminating in the expensive ecstatic spectacles *Battle on the Neretva* (*Bitka na Neretvi*, 1969) and *Sutjeska* (1973). From the 1960s onwards their aesthetic simplicity, total ideological loyalty, psychological and emotional schematism, political homogeneity and increasing budget were aimed both at glorifying the socialist revolution and at silencing the uproar of social criticism.

[31] The well-known story of *Underground* is about a group of people led by Popara who are kept in an underground cellar for many years after the end of World War II. Their imprisonment is orchestrated by Popara's comrade Marko, who has become a prosperous politician in a high position. For his personal profit he makes the group believe that the war is still in progress. At one point Popara and his son break out of the cellar. Coming to the surface they run into the shooting of a film version of Marko's war memoirs. The film set confirms the illusion of continuing devastation that Marko created for them. Film and reality conveniently intertwine, as Popara and his son take the cinematic illusion to be reality.

[32] The segment is both film as history and history made as film-within-a-film, supported by the combination of extradiegetically/intradiegetically framed narrations.

war characterized the post-Dayton period. As a consequence of the latter, Milošević's official politics began to clearly separate "Serbian Serbs" from Serbs who lived on the other side of the river Drina, and to distance one group from the other. Instead of being presented as a war which had been fought for nationalist reasons, it simultaneously appeared as a conflict orchestrated by metaphysical powers beyond human control and as the inevitable gloomy Balkan destiny, the work of corrupt politicians.

In *Underground*, Kusturica thus manages to embrace both a nationalist interpretation of the war, as best understood by a local audience, and the concept of a doomed Balkan/Yugoslav destiny, which would be understood by an international audience. But international audiences and critics all too easily overlook the explanatory concepts that he provided (intended in any case for the national audience) and which triggered heated debates about whose side Kusturica was on.[33] Some critics read the film as pro-Serbian and symptomatic of Yugo-nostalgia; others, particularly in Slovenia, regarded it as a shameless manipulation of history. While the story's mythical concept to some extent indeed neutralizes the nationalist explanation of the war, the centrality of the friends/rivals contrast—at least for the local audience—clearly challenges interpretations of the film as a "Serbian ego trip" and "propaganda for Milošević." Despite being best friends, which in Serbia means more than being blood brothers, the heroes turn against each other in immoral and evil ways just as civil war is generated by a split within one nation (the Serbian) and not mainly between nations (of ex-Yugoslavia).

In spite of the heroes' bitter acknowledgment that "there is no war till brother turns against brother," the audience—especially the international—may fail to notice the fact that both characters are Serbs.[34] Through the names of Popara (Lazar Ristovski), a peasant dish, and Dren, a hard and durable kind of wood, nicknames (Blacky as the mysterious, dangerous conspirator, and comrade Marko as the political opportunist, pillar of the Communist Party), make-up (Popara with a stiff Balkan moustache and Marko with a fancy Hollywood one) and characterization (the populist rural guerrilla leader and the urban career politician), the director is clearly signaling that one is a "Serbian Serb" while the other is a Serb from outside Serbia. In the context of the 1940s, within which the narra-

[33] An extensive recapitulation of the polemic is given in Dina Iordanova's book *Cinema of Flames* (London: BFI, 2001), 111–36.

[34] Even Stojan Cerović labels them as Serb and Montenegrin (Iordanova, *Cinema of Flames*, 116).

tive unfolds, these characters personify opposing types of revolutionaries; in the 1990s they turn the film into a treatise on post-Dayton political instrumentalization.

Underground, with its generic hybridization and referentiality, reveals the dark side of history, rewriting and ironizing "History with a capital H" as "fabricated by historians."[35] Kusturica questions every myth and the very existence of truth, taking everything to the point of annihilation and overwhelming skepticism. The film text searches for meaning and struggles to reread the history that the nation would remember.

DUAL REVISIONISM: HISTORY AND CINEMATIC HISTORY

In *Underground,* metafiction is subsumed in, and made to serve, the construction of the historiographic layer. However, a comparison of *Underground, Dust* and *The Marathon Family* reveals and maps the fine gradation in the relationship between the two layers. In the latter cases the metafictional (and eventually metacinematic) layer gradually strengthens until it becomes of equal importance with the historiographic one.

Milčo Mančevski's most recent film *Dust* widens the rethinking of Balkan history (the historiographic strand) by rewriting it in terms of a western (the metafictional strand). The partisan epics, with their lavish production, their clear moral polarization, their mythologization of national history and their reliance upon the genre formula were alternatively labeled "Red westerns." *Dust* straightforwardly uses the formula and the authentic components of the genre and can only be regarded as a variation of it. A real cowboy comes to the Wild East, and the local history turns into a multicultural and intercultural version of the authentic American film genre. A system of intertextual and multimedial references knits together the historical explorations of the western with cinematic imaginings and representations of the Balkans and Balkan history.

Dust has a two-layered narrative. One narrative is set in present-day New York and the other in pastoral Macedonia at the beginning of the twentieth century. In the contemporary beginning, a young African-American named Edge (Adrian Lester) robs an apartment in New York. Angela (Rosemary Murphy), the old lady who owns the apartment, unexpectedly wakes up. But instead of calling the police, she begins to tell Edge her life story, holding him at gunpoint. When she ends up in hospi-

[35] Dudley. *Mists of Regret,* 294.

tal, Edge keeps visiting her and the storytelling continues. Angela dies and Edge carries on telling her story. In the "Wild, Wild West" in the very last years of the century, two brothers, Luke and Elijah (Joseph Fiennes) fall in love with the same woman, Lilith (Anne Brochet). The Cainesque Luke runs away from the family *ménage à trois* and ends up in Macedonia, becoming a bounty hunter, but instead of hunting for rebels and money, he joins the Macedonian freedom fighters in their struggle against the Turks. Elijah, the "Abel," follows Luke in search of revenge. Luke dies saving the rebels, while Elijah takes the Macedonian baby girl with him to New York. The baby is Angela, the storyteller. Back in the present, Edge finishes telling the story and finds himself inserted into the same ongoing process of remembering.[36]

The tangled narrative unravels as the road veers from New York—the "Wild West"—across the Atlantic to Macedonia—the "Wild East." In temporal terms, it leaves the present and goes back to the late nineteenth and early twentieth centuries, ending in the realm of myth.[37] In terms of genre, it weaves together the road movie and the western. *Dust* features the "West of the East," presenting the Balkans as the genre's last frontier. The rearticulated and restructured collective memory is punctuated by archive shots that provide temporal and spatial points of reference. Arriving in Paris, Luke goes to the cinema and watches newsreels. The part about exotic countries and people includes the short film *The Visit of Sultan Rašid V to Kumanovo and Skopje* (*Poseta Sultana Rašida V Kumanovu i Skoplju*, 1905) about the visit of the Ottoman Emperor to the "colonial" Balkans. Made by the Manaki brothers, the Greek–Macedonian cinema pioneers, it is one of the earliest films preserved from their legacy—the same legacy that Harvey Keitel tries to locate in *Ulysses' Gaze* (*To Vlemma tou Odyssea*, 1995). The narrative relocation in the twentieth century is underlined as the hero encounters historical figures. The insertion of fictional characters into a verified historical context is done in an

[36] Answering questions about the past and remembrance, the film provides a complex storytelling introduced by the motto: "Where does your voice go when you are no more? What do we leave behind? Is it the story of our lives? Is it how others remember us? Is it the children we leave behind? Or the material records such as movies and photographs? Is it only the ashes in the urn? Is it the Dust?" (*Dust*).

[37] Mančevski's concept of time in *Before the Rain* (*Pred dozhdot*, 1994) is already circular, "The circle is not round, time never dies." In *Dust*, it is explained: "The centuries do not follow each other but coexist like parallel universes." Linear time bends and buckles into a circle. Its trajectory is paved by the repetition of the *déjà vu* events and rituals in different contexts.

elegant way, similar to *Zelig* (1983), *Forrest Gump* (1994) or *Underground*. On the ocean liner, in pseudo–authentic footage which is made to resemble old black-and-white newsreel, Luke meets Freud and Einstein. Upon arriving in Paris, he sees Picasso. A while later, the audience sees photos of Angela with Tito.

In the revised western *Dust*, the borrowed and reworked elements are subsumed into the rewriting of national history. The inserted documentary material enhances the credibility and verisimilitude of the restaged and reinterpreted past. The rediscovered Balkan past is made into a "perennial" phenomenon that "resonates across borders and cultures,"[38] combining tropes of rebellion against colonizers and the postcolonial gaze on the Other. Guerrilla freedom-fighting in South-Eastern Europe resembles the Third World independence movements and is also recognized as being close to the struggle of Native American tribes for liberation as shown in *Indianer* films and post-revisionist westerns.[39] In *Dust* documentary fiction is employed to create a new version of history: ideological recontextualization for the creation of a self-referential genre text. The Balkan past is revised according to the command from another great western, *The Man Who Shot Liberty Valance* (1962): "when history becomes myth, print the myth!"

The mythologizing perspective, typical of westerns, is ensured by Luke's bewildered gaze and identifies the Balkan skirmishes and battles in terms of the Armageddon between good and evil. The director reframes this from the perspectives of Marxist class-revolution, colonial rebellion or endless Balkan freedom fighting (for the common holy cause), into the ethically less clear distinction between good guys and bad guys of late American westerns. Macedonian heroes are heroes on the ethical borderline, driven by ambivalent personal codes and eager to repent (*Shane*, 1953; *The Magnificent Seven*, 1960 or *The Wild Bunch*, 1969). They are painfully aware that their time is inevitably passing as they sink into despair and melancholy. Balkan warriors are equally driven by the lust for gold (*Duck, You Sucker!/Giù la testa*, 1971) and prone to violence without firm principles or codes, as they are zealous freedom fighters (*Viva Zapata!*, 1952). Arriving in Macedonia, Luke sides with the rebels and their

[38] Mette Hjort, "Themes of Nation" in Mette Hjort, Scott MacKenzie (eds.), *Cinema and Nation* (London—New York: Routledge, 2000), 106.

[39] Post-revisionist westerns (*Dance with Wolves*, 1990, *Silverado* and *The Ballad of Little Joe*, 1993) "have sought to modify the ways in which some of these dimensions have been handled." See Steve Neale, *Genre and Hollywood* (New York: Routledge, 2000), 142.

nominal moral imperative "do not kill for gold, but kill for ideals," while Angela proudly claims that "Luke never killed a man without good reason." The revision of genre history helps the ideological reworking of history.

The next case study allows the concern with genre history to change into a broader rethinking of the history of national and also world cinema as well as of the history of film technique (the change from silent to sound cinema). Director Slobodan Šijan is a great connoisseur of national and world film history and his films engage in double revisionism: of political history and the national past as well as of national cinema history. The film texts thus acquire a complex self-conscious, metacinematic dimension. The film *The Marathon Family*, based on the eponymous play by Dušan Kovačević, is the bizarre story of a family of funeral parlor owners and gravediggers in provincial 1930s Serbia. The family's (hi)story, concerning their fight over jobs and inheritance, parallels the country's social and historical turmoil, underlined by the approaching shadows of World War II and the Third Reich. The youngest member of the family, Mirko (Bogdan Diklić), is in love with Kristina (Jelisaveta Sabljić), the daughter of the family's enemy and rival. She is in love with the traveling projectionist and cinema owner Djenka (Bora Todorović). The plot develops as an absurd comedy, ending in the final duel, death and destruction, including the burning of the film in the projector. An ingenious excuse for inserting all sorts of original film material is provided by making the character of Djenka into a traveling projectionist (in the play he is simply an adventurer). Thus the film contains film ads, scenes from Machati's 1929 *Erotikon* (first as the film shown in Djenka's cinema and later parodied when Djenka shoots his film with Kristina swimming in the lake), and Yugoslav feature and documentary films.

The opening consists of sequences from the documentary film about the assassination of the Yugoslav King Alexander in Marseilles in 1934, his funeral in Serbia at Oplenac and the national mourning. The images of the Marseilles shooting are organically associated with the family's business. Furthermore, they symbolically paint Serbian/Yugoslav history as a procession of deaths and wars that rhythmically mark tumultuous centuries. They prepare the key line of the film, "In Serbia, death is the job that pays," that articulates the film's thematic nexus of death, funeral rituals and funeral processions.

Many varieties of death appear in *The Marathon Family*: the death of the country, the individual, the family, the way of life, the whole era, or natural death, political assassination, crime of passion, cold-blooded mur-

der, and finally the death of the silent cinema. The ending of the film as a
whole closes both the revised national history and the story of the silent
cinema by inevitable death (the ruined film in the projector) and disap-
pearance (the projection of the first talkies). The deadly history of the
country is emphasized by three symbols of destruction: the parallel history
of the silent cinema which is bound to vanish, the film which is bound to
be destroyed, and the family which is doomed to face death.[40]

In terms of Jakobson's communication paradigm, the opening per-
forms three functions: phatic, referential and poetic. The phatic function
"corresponds to the contact or the channel" and "is specially geared to
establishing an initial connection and ensuring a continuous and attentive
reception."[41] In this case the very beginning of the film's opening (the
intertitle "1934" and "Balkan Film presents") signals two connections: to
the film *The Marathon Family* (whose story begins in 1934 and could also
be understood to be presented by "Balkan film") and to the possible film-
within-a-film (the documentary shown in the cinema that depicts a 1934
event and is presented by the same company). Performing a referential
function—oriented toward the context—it informs us about the historical
and social context of the narrative and its diegesis. The introduction of the
multi-level diegetic space framed as the space of cinematic projection
itself is made possible by Šijan's textual structuring. The first intertitle,
"1934," refers both to the main story and to the documentary shots. It is
designed in the typography of an obituary, on a black background with a
recognizable frame. It is followed by the logo "Balkan film presents,"
naming the producer of the documentary shots, but possibly also of the
main film.

The title *The Marathon Family*, in the same obituary-style typeface,
appears over the shot of a hearse. The documentary shots continue but do
not retain their original ending. The whole opening sequence ends with
the censer "burning" the opening of the black-and-white film straight into
the color that we recognize as the cinematic reality of the main diegesis.
Seen over these "reality" shots, the intertitle "six months later, a provin-
cial town in Serbia" rounds off the information about the chronotope of
this new diegetic layer. The ending of the whole film is positioned sym-

[40] The wider claim about Serbian history as a chain of deaths and assassinations is sup-
ported by the totality of the oeuvre of Dušan Kovačević. Every film chapter of the spon-
taneous chronicle of Serbian and Yugoslav history in his oeuvre ends with death, assas-
sination and devastation.
[41] Stam, Flitterman Lewis, Burgoyn, *New Vocabularies in Film Semiotics*, 16.

metrically to the ending of the documentary prologue with the burning censer. The shot preceding the end credits is the ruined film in the projector signaling the end of the showing of the possible film-within-a-film and of the film projection as the diegesis. But it is only the closing credits, again in obituary format, that mark the end for the extradiegetic audience. The third function in Jakobson's paradigm is the poetic function which "focus[es] on the message for its own sake; art as (…) defined by its self-referentiality."[42] Šijan's film begins with a quote and develops into the metacinematic story. *The Marathon Family* is above all a metacinematic work; it is about cinema in Serbia, traveling cinematographers, their repertoire, and the moment of the "death" of silent and the arrival of sound cinema.[43]

IN SEARCH OF PROUST AND NOSTALGIA

Apart from being employed for the revision of the public past, the amalgam of documentary and fiction also serves a Proustian attempt at the search for lost time, evoked through pop-cultural idioms. The intimate, emotional use of documentary shots in a largely politically and ideologically neutral context leads to the manifold changes—of their identification as such (they are no longer documents of public but of personal lives); of the performed effects; and eventually into the emphasis of the similarities of different social and temporal contexts. Frederick Jameson defines such an attempt in the cinema as a "nostalgia genre" that "consists of the films about the past and about specific generational moments of that past."[44]

Nevertheless, nostalgia films differ from broadly defined historical films in that they do not "reinvent a picture of the past in its lived totality"; they do not reconstruct the past but rather invent "the feel and shape of characteristics of art objects" in order to evoke feelings of the past.[45]

[42] Ibid., 16.

[43] As the film develops, after a long time Djenka comes to the town. Kristina—who also plays the piano for silent film shows—is eagerly waiting for him to continue their clandestine affair. Djenka simply wants to show the first talky. Announcing the first talky he publicly renounces silent cinema and his relationship with, and love for, Kristina. Both love and passion are relegated to the past. The film chosen for the gala screening is the *Story of One Day or the Unfinished Symphony of One Town* (*Priča jednog dana ili Nedovršena simfonija jednog grada*, 1941) produced by Balkan film, whose logo we have already seen.

[44] Jameson, *Postmodernism*, 168–70.

[45] Ibid., 170.

The textual elements and *mise-en-scene* "reawaken a sense of the past associated with those objects"[46] which work, among other things, through metonymy, pastiche and parody. Metonymy and pastiche refer to the "crystallized image" of the past that contains factual errors (some details, including music and other elements, do not correspond to the reality of the evoked past).[47] Among a number of definitions of pastiche, which is inseparable from *mode retro*, Jameson opts for the following: "pastiche is, like parody, the imitation of a peculiar or unique style, the wearing of a stylistic mask (...) but it is a neutral practice of such mimicry (...) pastiche is blank parody."[48] It further implies imitation through patched hybridized quotations, homage, references, and styles which are all typical of popular rather than high culture. In return, the fiction(s) of popular culture and its signifiers, apart from being sources of citations and imitations, are seen as new kinds of documents of the past. Documents are not only documentary films but documentary fiction in films, music, fashion, and even literary quotes. The various documents are a set of signifiers emptied of the real references to the actual past and filled with references to a specific media past and mediated history.

More importantly, the uses of documentaries both in historiographic metafiction and nostalgia films relate to the past and describe human attitudes toward and relations with the past. Nostalgia as an elusive sentiment includes the Fitzgeraldian *fêlure*: an eternal open wound, pain over a desire that cannot be fulfilled or realized.[49] The desire is related to the past in diverse ways—it is for the object from the past; for (re)living another time; for paradise lost.[50] The fulfillment of desire is relegated to the past

[46] Ibid., 170.

[47] Jameson describes the case of *Body Heat* (1981) where "nostalgia works as a narrative set in some indefinable nostalgic past, as eternal 1930s, say, beyond history." In ex-Yugoslav cinema a great example is *Hey Babu Riba* (*Bal na vodi*, 1986), where the fragments from *Bathing Beauty* (1944) and *One Summer of Happiness* (*Hon dansade en sommar*, 1951) are used to create the effect of the eternal late 1940s of the nostalgic narrative.

[48] Jameson, *Postmodernism*, 166–7.

[49] Jacqueline Simon, *La "fêlure" dans le cinéma romanesque américain des années 40 et 50* (Paris: Masson, 1989).

[50] This eternal longing and similar temporal regimes emphasize the similarities of nostalgia films and melodrama as having a certain romantic quality. Melodrama revolves around emotional frustration and whether or not there is a happy ending, the very presence of longing, desire or memories entails sweet nostalgia. For more about melodrama, see Nevena Daković, *Melodrama nije žanr* [Melodrama is not a Genre] (Belgrade and Novi Sad: Prometej, 1995).

or is obstructed during the narrative by the merciless flow of time, which becomes the universal obstacle. The heroes (like the audience) cannot stop or reverse the flow of time or alter the past events and thus have to face the lack of fulfilled desires from/of/for the past. Nostalgia is nurtured by the sense of irrecoverable loss that is experienced as time goes by[51] and that makes us constantly run away from the present into the past, as Jameson elaborates: "The very style of nostalgia films [is] invading and colonizing even those movies today which have contemporary settings: as though, for some reason, we were unable to focus on our own present, as though we have become incapable of achieving aesthetic representations of our own current experiences."[52] The escape into the past further legitimizes the use of documentaries, both real and fictional.

The revival of the past—through narrative (flashback), style, documentary interventions—changes nostalgia. The nostalgic sentiment is intensified as the relived past forces us once again to (re)experience the loss.[53] It is weakened, as the ability to relive golden moments partially redeems the emotion of loss. Finally, it is multiplied: nostalgia for the past is complemented by nostalgia for the created memories of that past, as experienced and "relived" through the "original" and its "representation" in a process which erases the differences between (real) memories of the past, fictional memories and memories of the fiction.

The ten episodes of what has become a cult TV series, *Unpicked Strawberries* (1974), narrate the growing up of Bane Bumbar (Branko Cvejić) and his friends in 1960s Belgrade. The series follows them from their formative, late teens until the full maturity of twenty-something. It forms a paradigmatic Belgrade middle-class family chronicle, and depicts the Oedipal trajectory of acquiring social and emotional identity. The scenario—written by Srdan Karanović and Rajko Grlić—is based on the personal memories of the actors and members of their families. In a few cases the names of the characters are actually the real names of the actors. An-

[51] In *Casablanca* (1943), one of the greatest melodramas of all times, the main musical theme is "As Time Goes By." In the Koran it is written that time is the only true witness to the fact that we are all eternal losers.

[52] Jameson, *Postmodernism*, 173.

[53] Simon, *La "fêlure,"* 21–2. She claims that the nostalgia for the past as relived through texts of popular culture (and constructed memories) is a secondary feeling which is not the same as the primary experience. The second time round one feels something one knew the first time and now recognizes and the second experience leaves a feeling of *déjà vu*. The partially recognized and satisfied desire generates further nostalgic longing.

other layer of the film is the shared social history which became part of the collective memory of generations of Belgrade's spectators. The nostalgic mood of the series is created by carefully placed flashbacks, a multilayered narrative structure and the intermingling of documentary and fiction segments that develop in a complex temporal regime.

Every episode is structured according to the same pattern of intertwined past and present segments. The credits—immediately conveying the themes of the past and remembrance—appear after sepia images in a blurred, hectic motion that matches the musical rhythm. The opening credits in the present are followed by the past story—introductory biopics of family members, friends and finally Bane himself—mimicking old newsreels and home movies. Blending documentary shots with fictional parts stylized in black and white to fit in with the epoch, the segment fully corresponds to the "faction" form. The ensuing comments from "nowadays" switch the narrative to the present, only to relapse again into the past in the main segment. The epilogue, beginning with Bane's comments on the story, ends with a short edited documentary sequence of the events that marked that year. The past is shown in black-and-white, while the main body of the story (the "historic present") is in color. The pattern of switches is supported by the diegetic/mimetic alternation. The recounted past is given in diegetic voice-over while its disappearance signals the change to mimetic mode. Dedicated to the visualization and imagining of the individual and collective memories (the autobiography of a generation) the text is saturated with the most important pop-cultural experiences of the era (the first jeans, open-air dancing on Kalemegdan, escape over the border and so on).[54]

The series also uses the style of old movies of the 1940s and 1950s to awaken the emotions associated with watching these films. The personal past is narrated in the mode, visual style, fashion of the era when it really happened (*mode retro*). This induces the audience's nostalgia and regret for the past, which is often remembered through movies. Offered as a pastiche of music, iconography, jargon and films, the hybridized memories resurrect the bitter-sweet taste of the past in its full richness, while the versatile constituents of media memory impose a widening of the notion of documents and facts. The objects, real persons, authentic still-existing scenery, quoted films, books and music become the factual material holders of the past. They appropriately signify the emotional hybridity as sad-

[54] The documentary/authentic elements of background and setting, the still existing city topography and recollections of the real popular figures of the 1960s who appear as themselves make it a successful example of constructed urban mythology.

ness and misfortune. A "happy unhappiness" or "pleasurable unhappiness" is more persuasive, engaging and impressive than a happiness without shadow. In the series a certain *je ne sais quoi*, something elusive, inexplicably and destructively sad, is inscribed in and emanates from the visual softness of the memories of youth, the languid sounds of musical memory, the hazy point of view from the present and the documentary ending that puts the final touch to the "mists of regret."

In pre-1992 Yugoslavia, the series *Unpicked Strawberries* was a rare example of the nostalgia genre. It is oriented towards personal, intimate lives and the loci of nostalgia are the 1960s, which in Yugoslavia were the moment of the breakthrough of Western popular culture. Due to this coincidence, the series literary puts into practice the reliance of *mode retro* or nostalgia films upon pop cultural idioms. A different kind of nostalgia marks a number of films of the 1980s which are collectively identifiable as rock'n'roll films. Although Ljubljana, Sarajevo and Belgrade were equally important centers of the flourishing rock sound, the New Wave in music was followed by a cinematic New Wave only in Belgrade. Rock film as endemic for Belgrade was a unique token of a new urban sensibility; of a time when rock really became part of the culture. "In these parts of the world, rock confirmed, as its most important feature, the urban character."[55]

This wave of films begins with the symptomatic title *The Fall of Rock'n'Roll* (*Kako je propao rok'n'rol*, 1989) and ends somewhat symmetrically in 1995 with the *Package Arrangement* (*Paket aranžman*, 1995)—also made as a three-part omnibus and named after the 1980 rock album that marked the beginning of the New Wave in music.[56] Loci of nostalgia in rock films are created as clusters of rock music—which appeared to be the authentic sound of the West in the 1960s—of Hollywood genre film references and of the urban atmosphere of the cosmopolitan, dynamic and open Belgrade of the 1980s. The nostalgic feeling is therefore related to the things that the generations always longed to possess and which are finally inscribed in the texts at the moment of realization. Nostalgia as longing is thus, paradoxically, about nostalgia experienced in or from the past. The film texts are the confirmation of the eventually fulfilled wish, full of the *joie de vivre* that is characteristic of both the urban and the rock atmosphere. The sealed bond between rock, urban and popular culture, given in the developing metacinematic structure and self-

[55] David Albahari, "Paket aranžman" [Package arrangement], *Vreme* 537 (3 May 2001), 27.
[56] The rock album contained music of three bands: *Idoli*, *Šarlo akrobata* and *Električni orgazam*.

referentiality, reappears in the postmodern comedies of Srđan Dragojević or Raša Andrić[57] in the 1990s. Dragojević's *We are no Angels* (*Mi nismo anđeli*, 1992) is a paradigmatic text with its postmodernist preference for pastiche and light irony, its directors' subscription to *politique d'auteurs* principles and adoration of Hollywood.

It presents a wide array of quotations from teen comedy, Hawksian adventure story, musical, and action films. Non-cinematic references and allusions involve both high and low culture (Frank Zappa, Sam Peckinpah, Gabriel Garcia Marquez, Jorge Luis Borges, Thomas Mann, Barbara Sidney). Both *Angels* and Andrić's subsequent films choose to ignore harsh reality; not to be concerned with war and social problems but rather to escape into the constructed world of popular culture, entertainment and Western-style images. But the very denial of and abstinence from comments upon reality is a powerful political (oppositional) stance. Withdrawal from reality into a dreamy world similar to the Yugoslav 1980s and regrets for the loss of a great and better past endow the nostalgia with a politicized tone. The generational nostalgia in post-Yugoslav and postmodern comedies is for Hollywood, for popular culture and the "glorious 1980s" of the Socialist Federal Republic of Yugoslavia that dwindled and finally vanished.

The diversification of nostalgia films follows the dynamics of historical change. It is in turn politicized and depoliticized as its center moves between the 1960s and the 1980s or around Hollywood and the West. Regardless of its lost object or era it is consistently linked with the popcultural domain and self-referential texts—based on quotations from documentary fiction, that is fiction films, rather than documentaries. Documentary fiction is revealed to have a metacinematic dimension equal to that found in historiographic metafiction.

MISTS OF REMEMBRANCE

The case studies analyzed above demonstrate that the role played by cinema—in the combination of documentary and fiction—in the representation and reconstruction of the (national and other) past and history is versatile and complex, both active and passive. On the one hand the films actively examine and (re)write the collective past or national history (*Underground, Dust*). On the other hand, they passively write out individual, private

[57] *Three Palms for Two Punks and a Babe* (*Tri palme ta dve bitange i ribicu*, 1998), *Thunderbirds* (*Munje*, 2001) and *When I grow up I will be a Kangoroo* (*Kad porastem biću kengur*, 2004).

(hi)stories through the selection and combination of ready-made elements already codified through popular culture (*Unpicked Strawberries*). To borrow Naomi Greene's powerful metaphor, cinema helps us to fill the "landscapes of loss" as well as to recreate the lost landscapes—collective, historical, individual, generational and emotional. The article focused on the landscapes of socialist Yugoslavia that are diversely shown and imagined in the films. The films are distinguishable according to their thematic concern with history and the public or private past, their modes of the representation ([meta]historical or metacinematic forms) and finally their genre models (historiographic metafiction, nostalgia film). Their orientation toward the examination of history resulted in the perfection of the model of historiographic metafiction (*Underground* or *Dust*). They deny the official version of history and of the past imposed by a dominant ideology striving for a (national) (hi)story that can only be told in images. As early as in *The Marathon Family* the interest in film history equals the interest in public history, paving the way for the full self-referentiality and postmodernism of the 1990s. The interest in private remembrances resulted in nostalgia films that try to recover the private past.

The dialectical relation of remembrance and nostalgia explains their interdependence and the role played by documentaries. The past is evoked through the use of documentaries. In the rearticulation of history their role could also be described as metahistorical, since the historical documents of one era are used to explain another history. In *Underground*, documentaries from World War II explain the wars of the 1990s. Documentary fiction is used to evoke the history of fiction and representation (genre history in *Dust*) and eventually to evoke and comment upon the history of cinema (*The Marathon Family*). In nostalgia films documents of history parallel and enrich the private (hi)stories.

A feeling of nostalgia accompanies every remembrance of the past, regardless of whether it is history or private past, or of how traumatic that past might be. The most private remembrances presented through pop cultural references—including documentary fiction—inevitably tackle national or public history, acquiring political references and a critical edge. The documentary footage, regardless of its brutality, is softened and nostalgically intoned by fiction. Documentaries veil the naturalistic representation of the past with "mists of regret." Linking past and present, this inevitable nostalgia confirms the Žižekian need "to dream the past in order to remember the future."[58]

[58] Thomas Elsaesser and Warren Buckland, *Studying Contemporary American Film: A Guide to Movie Analysis* (London: Arnold, 2002), 248.

FILMOGRAPHY

A Throatful of Strawberries (*Jagode u grlu*, Srdan Karanović, SFRY, 1984)

American Graffiti (George Lucas, USA, 1973)

Balkan Express (Branko Baletić, SFRY, 1982)

Balkan Rules (*Balkanska pravila*, Darko Bajić, FRY, 1997)

Bathing Beauty (George Sidney, USA, 1944)

Battle on the Neretva (*Bitka na Neretvi*, Veljko Bulajić, SFRY, 1969)

Before the Rain (*Pred dozhdot*, Milčo Mančevski, Republic of Macedonia/France/UK, 1994)

Body Heat (Lawrence Kasdan, USA, 1981)

Casablanca (Michael Curtiz, USA, 1943)

Catch 22 (Mike Nichols, USA, 1970)

Country of Truth, Love and Freedom (*Zemlja istine, ljubavi i slobode*, Milutin Petrović, FRY, 2000)

Dr. Strangelove or How I Learned to Stop Worrying and Love the Bomb (Stanley Kubrick, USA, 1964)

Duck, You Sucker! (*Giu la testa*, Sergio Leone, Italy, 1971)

Dust (Milčo Mančevski, UK/Germany/Italy/Republic of Macedonia, 2001)

Erotikon (Gustav Machati, Czechoslovakia, 1929)

Forrest Gump (Robert Zemeckis, USA, 1994)

General della Rovere (*Il Generale della Rovere*, Roberto Rossellini, Italy, 1959)

Gorilla Bathes at Noon (*Gorila se kupa u podne*, Dušan Makavejev, Germany/FRY, 1993)

Hey Babu Riba (*Bal na vodi*, Jovan Aćin, SFRY, 1986)

Innocence Unprotected (*Nevinost bez zaštite*, Dušan Makavejev, SFRY, 1968)

Lili Marleen (Rainer Werner Fassbinder, West Germany, 1981)

Love Affair, or the Tragedy of a Switchboard Operator (*Ljubavni slučaj ili tragedija službenice PTTa*, Dušan Makavejev, SFRY, 1967)

*M*A*S*H** (Robert Altman, USA, 1970)

Mysteries of the Organism (*WR: misterije organizma*, Dusan Makavejev, SFRY, 1971)

One Summer of Happiness (*Hon dansade en sommar*, Arne Mattsson, Sweden, 1951)

Package Arrangement (*Paket aranžman*, Srdan Golubović, Ivan Stefanović, Dejan Zečević, FRY, 1995)

Premeditated Murder (*Ubistvo s predumišljajem*, Gorčin Stojanović, FRY, 1996)

Pretty Village Pretty Flame (*Lepa sela, lepo gore*, Srdan Dragojević, FRY, 1996)

Professional (*Profesionalac*, Dušan Kovačević, Serbia and Montenegro, 2003)

Shane (George Stevens, USA, 1953)

Star Wars (George Lucas, USA, 1977)

Story of One Day or the Unfinished Symphony of One Town (*Priča jednog dana ili Nedovrsena simfonija jednog grada*, Maks Kalmič, Kingdom of Yugoslavia, 1941)

Sutjeska (Stipe Delić, SFRY, 1973)

The Fall of Rock'n'Roll (*Kako je propao rok'n'rol*, Vladimir Slavica, Goran Gajić, Zoran Pezo, SFRY, 1989)

The Magnificent Seven (John Sturges, USA, 1960)

The Man Who Shot Liberty Valance (John Ford, USA, 1962)

The Marathon Family also known as *The Marathon Lap of Honor* (*Maratonci trče počasni krug*, Slobodan Šijan, SFRY, 1982)

The Visit of Sultan Rashid V to Kumanovo and Skopje (*Poseta Sultana Rašida V Kumanovu i Skoplju*, Brothers Manaki, Macedonia, 1905)

The Wild Bunch (Sam Peckinpah, USA, 1969)

Three Palms for Two Punks and a Babe (*Tri palme ta dve bitange i ribicu*, Raša Anrić, FRY, 1998)

Thunderbirds (*Munje*, Raša Andić, FRY, 2001)

Tito and I (*Tito i ja*, Goran Marković, SFRY, 1992)

To Be or Not to Be (Alan Johnson, USA, 1973)

To Be or Not to Be (Ernst Lubitsch, USA, 1942)

Ulysses' Gaze (*To Vlemma tou Odyssea*, Theo Angelopoulos, Greece, 1995)

Underground (Emir Kusturica, France/FRY, 1995)

Unpicked Strawberries (*Grlom u jagode*, Srđan Karanović, SFRY, 1974)

Viva Zapata! (Elia Kazan, USA, 1952)

We are no Angels (*Mi nismo anđeli*, Srdan Dragojević, FRY, 1992)

When I Grow Up I will Be a Kangaroo (*Kad porastem biću kengur*, Raša Andrić, FRY, 2004)

Who Sings Over There? (*Ko to tamo peva?*, Slobodan Šijan, SFRY, 1980)

Zelig (Woody Allen, USA, 1983)

Long Farewells

The Anatomy of the Soviet Past
in Contemporary Russian Cinema

OKSANA SARKISOVA

> *One can look back at the footprints left in the sand*
> *and see them as a road.*
> Zygmunt Bauman, *From Pilgrim to Tourist*

From a growing temporal distance, the Soviet historical "episode" seems to entail an emphatic beginning and a somewhat less spectacular but equally distinguishable end. The present article sets out to review the films of the last twenty years dealing with the Soviet period. Despite the declared break with the past, characteristic of transitional societies, a closer look at the social and cultural fabric of "post-Communism" reveals that the simplistic opposition of "before" versus "after" is subverted by recurrent long-term intellectual frameworks, narrative devices, and visual imagery, employed to make sense of the world "here and now" as well as "there and then."

The liberated post-Soviet film market seemed to promise the emergence of a "new Bombay" for the film producers.[1] The first units of film production and distribution organizations independent of the state appeared as early as the autumn of 1988, at the same time as non-state investment in cinema was allowed.[2] The consequences turned out to be contradictory: initially mounting, production figures plummeted within a few years; Russian films disappeared from the shrinking distribution network, and a new chapter in the debate on the "crisis of cinema" unfolded. The market-oriented rationality that had just arrived faced a long tradition of approaching cinema as art, shared by filmmakers and functionaries alike. The opposition of "money" to "culture" sometimes took the form of op-

[1] Sergei Lavrientiev, "Tuman posle peizazha" [Fog after the landscape], *Iskusstvo Kino* 10 (1991): 113.

[2] Daniil Dondurei, "Kinodelo: na puti k rynky" [Film business: On the way to the market] in *Rossiiskoe kino: paradoksy obnovlenia* [Russian cinema: Paradoxes of renewal] (Moscow: Materik, 1995), 126–40.

posing Russia to "the West."[3] The slow adjustment of the film industry to the new social and economic realities provoked increasingly anxious debates about the seemingly gloomy prospects of Russian cinema.[4]

All the setbacks notwithstanding, the decay of the ideological confines promised to many a long-awaited leap into the "kingdom of freedom." Freedom was the "carrot" of changes, and liberation from the shadows of the past was expected to be a shared experience. The imagery of liberation facilitated the establishment of a symbolic rupture with the Soviet past in politics, history, and economics. In the first post-socialist years numerous filmmakers worked with the recurrent metaphor of escape from a closed repressive "zone." Over the last twenty years, however, the representation of the troubled Soviet past has evolved from concentration on social and individual traumas to the gradual emergence of a nostalgic modality. The withering away of the motif of rupture between the past and the present over the post-Soviet decade points to the gradual stabilization of the new order, bearing witness to the acceptance and routinization of social changes. Arguably, the disappearance of one of the constitutive discursive elements of the "post-communist condition" suggests the emergence of a new cultural configuration in contemporary Russia, including a *mélange* of the motifs of individual survival intertwined with the themes of collective security, paternalism and patriotism. I intend to trace how in a growing number of mainstream and art films the Soviet past turns from a repressive space into a routinized flow of everyday life. Being offered a growing number of examples of how "simple Soviet (wo)men" abused, exploited, resisted, and adjusted to the changing "rules of the game," the audience is occasionally given a chance to be proud of their collective achievements. Yet, while opening up the discursive space to multiple interpretations, most directors choose not to challenge the audience with too many disturbing questions.

[3] Daniil Dondurei, "Beshenye den'gi" [Exorbitant sums], *Iskusstvo Kino* 1 (1991): 61.

[4] "Nashe kino segodnia: vzgliad iz-za granits. Kruglyi stol v redaktsii Kinovedcheskie Zapiski" [Our cinema today: a look from abroad. Round table in the journal *Kinovedcheskie Zapiski*]. *Kinovedcheskie Zapiski* 4 (1989): 4–21; "Kak ozhivit' dinozavra? Rossiiskii kinemtograf v zerkale mezhdunarodnoi festival'noi politiki" [How to revive a dinosaur? Russian cinema in the mirror of the politics of international festivals], *Iskusstvo Kino* 12 (1993): 24–41.

TRAPPED BY THE HAMMER AND SICKLE: MOTIFS OF ZONE AND ESCAPE

> *I have discovered a fascinating similarity*
> *between life in the camp and at liberty...*
> *Almost any prisoner could be a security guard.*
> *Almost any warder deserved to be imprisoned.*
> Sergei Dovlatov, *Zone*

Liberation discourse flourished with the coming of *glasnost'* and can hardly be used as a chronological marker of the post-Soviet period.[5] Yet *perestroika* cinema, in the loosening grasp of state censorship, tended rather to thematize the experience of unattainable freedom, of striving for a better world located "elsewhere." As the sunset of Socialism approached, freedom gradually came to be relocated to the amorphously defined and unreachable "outside"; the ever-failing search for a desired condition of liberty introduced a persistent motif of escape as an attempt to break through to some other—free—existential space. The image of the "zone" as a space where rules radically different from those in the outside world are in operation became a metaphysical topos with Andrei Tarkovskii's famous *Stalker* (1979). His vision gained its strength from the multiplicity of possible significations, as the spatial metaphor opened up the geography of the soul. The weakening grasp of the regime made endowed the immediate connotation of the zone with concrete geographical references, confronting the audience with the inhuman conditions in the camps and prisons on the peripheries of the Soviet Union. The proliferation of traumatized narratives further expanded the meaning of the zone to stand symbolically for the entire territory of the Soviet Union, while the Solzhenitsian metaphor of an "Eternal Inmate, (...) looking at a normal world from behind bars" was projected onto society as a whole.[6]

Recurrent references to the imposed and unavoidable constraints presented escape as the only way out, often opposing the individual to the pressure of the group. In the parable-like *Zero City* (*Gorod Zero*, 1988), Karen Shakhnazarov depicted a Kafkaesque Soviet town, where a tight community circle forcefully embraces the protagonist, excluding all possibilities of departure, save a desperate escape. Another "accidental escape" appears in an absurd tragicomedy, *Cloud-Paradise* (*Oblako-Rai*,

[5] Andrew Horton and Mikhail Brashinsky, *The Zero Hour: Glasnost' and Soviet Cinema in Transition* (Princeton: Princeton University Press, 1992).

[6] Alexander Shpagin, "Sotsrealism umer. Da zdravstvuet?" [Socialist realism is dead. Long live...?], *Iskusstvo Kino* 3 (1991): 27.

1990). The main protagonist dreams of leaving a deeply provincial town and announces his desire to all his acquaintances living nearby. The inspired neighbors channel their fascination with the idea of escape into really "helping" the hero, whom they eventually force to set off on an unexpected voyage—into the wide open world.

Fig. 1 Freedom is Paradise
Courtesy of *Iskusstvo Kino*

The motif of escape often appears coupled with that of imprisonment, occurring in the most diverse genres ranging from drama to comedy. Sergei Bodrov's *Freedom is Paradise* (*S. E. R.*, 1989) tells the story of an uncouth but vulnerable teenager, whose only desire is to break out from the all-embracing penitentiary system. (Fig. 1) The hero keeps trying to escape from the camp for juvenile delinquents, searching for a never-seen father who turns out to be an inmate in a remote prison on the other side of the Soviet "Gulag Archipelago." As the two protagonists meet, the film turns from a private story into a societal metaphor of the unavoidable ties—symbolized by the heavy chain—binding times and generations. Freedom—a paradise, according to the young hero's tattoo—belongs to an unattainable, "unearthly" world which one can only long and strive for. The heavenly metaphor was used differently in Elena Tsyplakova's directorial debut.

Reed Paradise (*Kamyshovyi rai*, 1989) contrasted an attractive surface with the infernal essence, as a labor camp in the Central Asian desert turns out to be hell for those attracted by the promise of easy earnings. Faced with the brutal practices of this new, market-oriented Gulag, filmed with merciless naturalism, escape is the only (and unfulfilled) hope of the protagonists.

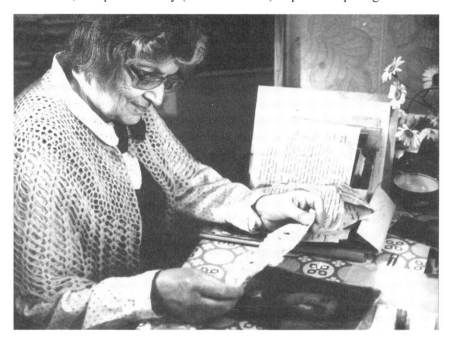

Fig. 2 Solovki Power
Courtesy of *Iskusstvo Kino*

By the end of its lifespan, the Soviet regime had firmly established the connection between prison and the Soviet rule. The belief in the boundless possibilities of molding (*perekovka*) human beings, inherited from early Soviet times, gradually turned into its tragic opposite. The contrast comes to the fore when we compare the groundbreaking *perestroika* documentary *Solovki Power* (*Vlast' solovetkaia*, 1988) with the long-forgotten Soviet propaganda film *Solovki* (1928). In both films the camp represents the Soviet world in miniature. The early Soviet propaganda film presents Solovki as an ideological shop-window, where a forced labor camp looks like a sanatorium, in which the inmates are spoiled by regular meals in a clean canteen with white tablecloths and lavish free time. By the 1990s, the propaganda images have been subverted by the oral history of the survivors, who speak of the territory under the Soviet regime as one spacious zone. (Fig. 2)

A paradigmatic connection of political regime and imprisonment emerges in Yurii Il'ienko's *Swan Lake: Zone* (*Lebedinoe ozero: Zona*, 1990). Sergei Paradzhanov's script, based on his personal experiences in a Soviet labor camp, offers a captivating visual metaphor: the protagonist, running away from the camp just before his release, hides for days in a huge hammer and sickle installation, trapped literally and symbolically by the system. The failed escape triggers the cruel retribution of his fellow inmates, forcing the hero finally to choose suicide as an ultimate form of escape from the vicious circle of brutality.

The modalities of referring to the Soviet regime ranged from original plots to kitsch, recycling the Soviet clichés. Many of them appear in an unsophisticated burlesque called *Strict Regime Comedy* (*Komedia strogogo rezhima*, 1992), where the inmates of a prison stage a revolutionary play, internalizing the roles of the Soviet "founding fathers" to the point of carrying out a real uprising and putting back into service a train resting "on the sidetrack," evoking a line from a popular Soviet song. In the closing shot, the camera moves from a close-up of the escaped inmates to a bird's-eye view of a train circling around the camp at full speed. A similarly dubious salvation appears in the tragicomedy *The Promised Heaven* (*Nebesa obetovannye*, 1991), which makes a euphemistic escape into the sky (parodying the famous ending of Vittorio de Sica's *Miracle in Milan*, 1951) seem the ultimate "liberation" for those who are unable to accommodate to the pace of change.

One of the much anticipated consequences of the dismantling of the Soviet control system was the gradual opening of the borders and the possibility to visit the countries previously hidden behind the Iron Curtain. In the Soviet period, escape abroad equaled a transfer to another world, making the notion of commuting between the two worlds virtually impossible, since sooner or later everybody was forced to make an "either-or" choice. In the 1990s, the concept of "abroad" began to acquire material characteristics, appearing in post-Soviet cinema as a desired final destination, bringing its inhabitants ultimate happiness, freedom, and satisfaction—but often appearing as a "reward" for crimes or betrayal. In a symbolic competition with the "West," Russia appeared at one and the same time as the West's temporal and spatial periphery and as a space of close proximity, "allowing" one to step out of a Petersburg window straight onto the roofs of Paris or to visit any world capital through the back door of an old house. (*To See Paris and Die*, 1992; *Window to Paris*, 1993; *Patriotic Comedy*, 1992).

Among the directions of escape, a traditional lifestyle also appeared as an alternative "paradise lost." Nikita Mikhalkov's *Urga* (1991) plays

on the birth control rules in Inner Mongolia, creating a nostalgic saga where freedom is slowly receding under the advance of aggressive civilization. The longing for an "organic" coexistence with nature is comparable to the retrospective attempts to find the golden age in history, where ideological claims are masked by the emphasis on the reconstruction of historical "truth." Searching for a "lost" Russia, Stanislav Govorukhin's *The Russia that We Lost* (*Rossia, kotoruyu my poteriali*, 1992) uses a documentary form to represent pre-revolutionary times, creating an eulogizing image of arcadian Imperial Russia contrasted to the demonic Soviet past. The escape into the past sought to restore the stable order of things by erasing more than seventy Soviet years from Russian history.

Used in a growing number of contexts, the escape metaphor occasionally complicated the original intention to break out of the imposed confines by offering numerous directions. The categorical "either-or" framework was challenged most often by the younger generation of filmmakers. They included Alexander Khvan, whose *Dyuba-Dyuba* (1992) is built on the familiar motif of liberation from prison but whose dramaturgy turns the linear structure of "liberation-escape-freedom-satisfaction" into something more complicated. The main protagonist returns to the town of his youth to save his first love from imprisonment for stealing drugs from the hospital where she works. The social gulf between the resident of the capital and his ex-classmates, who stayed in the provincial town and turned into alcoholics and drug-addicts, seems unbridgeable. To find the money needed for the escape, the hero ventures into a Dostoevskian undertaking of "expropriating" money of a *nouveau riche*, organizing a series of elaborate tortures. Despite a "successful" financial outcome, to the hero's distress his beloved refuses to leave the city, preferring a crass lover along with the chances of landing again behind bars. The lonely protagonist ends up reviewing his own story from a distance with the estrangement of a spectator. Its sentimental pathos notwithstanding, the film is built on the ambiguities of imposed liberation, formulated in opposition to the motif of desired escape.

Despite the elaborate critique of the Soviet system, the directions for further development remained vague; the liberation from the past laid bare an unstructured present. In the 1990s, an initial increase in film output was followed by a significant fall in production: in 1992, 172 films were made, in 1993 152, in 1994 sixty-eight, in 1995 forty-six.[7] Evaluations of the

[7] "Segida-info." *Iskusstvo Kino* 4 (1996): 76.

changes ranged from "fall, catastrophe, collapse" to "liberation and re-
newal."[8] The transformation of the film industry coincided with the per-
ception of an ideological void, which disturbed a growing number of
filmmakers and film critics. The blurred sense of direction evoked per-
sistent attempts to redefine the state of the art. One of the attempts to
unearth new ideological frameworks was a roundtable at the 19th Mos-
cow International Film Festival (July 1995) entitled "Post-Soviet Art in
Search of a New Ideology" and described by one film critic as a "volun-
tary search for a new illusion."[9] Although many participants—film crit-
ics, social scientists, philosophers—cautiously restrained from sketching
a path of future development, most of the presentations tacitly implied
the assigned moral "burden" of the art as well as the authorial "mission"
towards the audience.[10]

Many of those present at the round table mentioned the loss of a sense
of orientation as the political constraints vanished. The apathy of the audi-
ence was found to be most distressing. Nevertheless, some participants
attempted to formulate a "new ideology." Stating that Soviet cinema was a
product of "imperial consciousness," film director Alexander Mitta could
only envision its survival as a client of the state. On behalf of the film
industry, he offered the state a "fair deal," promising "a chance of rebirth,
of the reestablishment of its glory with the help of cinema."[11] Genre cin-
ema was seen both as an answer to the needs of the audience and as a way
out of the crisis of the "authorial" model. Daniil Dondurei, chief editor of
the leading film journal, *Iskusstvo Kino*, argued for the cinema's "psycho-
therapeutic" role, offering "livable models of the future." Its success was
described as depending on the positive image of the hero, since "one can-
not seriously think that cripples, neurotics, and aggressors are the real
heroes of our times."[12]

Structural changes in the reading and viewing preferences of the mass
audience facilitated the upsurge of a new industry of pulp fiction and tele-
vision programs offering light entertainment, which marginalized "thick"

[8] A. Dubrovin, Mark Zak (eds.), *Rossiiskoe kino: paradoksy obnovlenia* [Russian cinema:
 Paradoxes of renewal] (Moscow: Materik, 1995).
[9] Presentation of Alexander Troshin at a Symposium "Post-Soviet Art in Search of New
 Ideology," *Iskusstvo Kino* 2 (1996): 167.
[10] Symposium "Post-Soviet Art in Search of New Ideology," *Iskusstvo Kino* 6 (1996): 172.
[11] Presentation of Alexander Mitta at the Symposium "Post-Soviet Art in Search of New
 Ideology," *Iskusstvo Kino* 2 (1996): 163–4.
[12] Presentation of Daniil Dondurei at the Symposium "Post-Soviet Art in Search of New
 Ideology," *Iskusstvo Kino* 2 (1996): 155.

journals and art cinema.[13] Faced with the decreasing interest in Russian cinema, filmmakers were busy learning genre conventions, choosing rewarding themes according to Hollywood's popular blueprint. In this context, adventure cinema rethematized the motifs of escape, liberation, and criminality by placing the ever-present mafia—"a symbol of absolute and omnipotent evil"[14]—in the focus of attention. The mafia on the screen gradually emerged as ubiquitous and eternal, penetrating all spheres of life and holding everybody within its reach. It was "rediscovered" in Soviet times (*Bodyguard*, 1991; *Clan*, 1991; *Murder on Zhdanovskaia*, 1992), and penetrated various spheres of the present, at once resisting the regime and growing out of its depths (*Eastern Corridor or Racket à-la...*, 1991; *Rats, or Night Mafia*, 1991; *American Boy*, 1992; *To the Last Limit*, 1991; *A Day Before...*, 1991; *Crusader*, 1995).[15]

The previously established connection between the motifs of prison and liberation was losing its political connotations. The overwhelming presence of the criminal world on the screen began to provoke a counter-reaction to what came to be perceived as a thematic dominance: "today, when (...) the most influential part of society lives according to the law of thieves, central television shows a musical clip with the burial of a bandit, (...) the press reports the latest news from the life of outlaws, journalists go to prison to hear the revelations of crooks about the meaning of existence, one feels as if the most important social group were locked up, and those who are free were only rejoining or taking their leave from it."[16] The image of abroad gradually ceased to appear as a desired space of freedom, for which the cinematographic heroes of late *perestroika* longed, and came to be treated with a degree of detachment and criticism. The cross-Atlantic melodramatic love stories could have very different outcomes, but the us/others opposition no longer promoted a straightforwardly escapist motif (*Groom from Miami*, 1993; *Wild Love*, 1993; *House on Stone*, 1994). Among the clear-cut attempts to oppose the imagery of the "West as paradise" was Dmitrii Astrakhan's melodrama *You Are My Only Love*

[13] Boris Dubin, "Slovesnost' klassicheskaia i massovaia: literatura kak ideologia i literatura kak tsivilizatsia" [Classical and mass *belles-lettres*: Literature as ideology and literature as civilization] in his *Slovo-pis'mo-literatura* [Word-writing-literature] (Moscow: Novoe literaturnoe obozrenie, 2001), 306–23.

[14] Natalia Sirivlia, "Temnye sily nas zlobno gnetut" [Dark forces are menacing and oppressing us], *Iskusstvo Kino* 11 (1991): 41.

[15] Natalia Sirivlia, "Mafia—nash rulevoi!" [The mafia is leading us], *Iskusstvo Kino* 5 (1993): 26–33.

[16] A. Titov, "Seans" zony" [Session in the zone], *Iskusstvo Kino* 2 (1996): 143–4.

(*Ty u menia odna*, 1993). Its protagonist refuses to go to America with a millionairess who loves him and stays with his wife in a small apartment, preserving a traditional set of gender roles rather than accepting a position as a kept partner.

With the disappearance of the escape motif, the imagery of the zone became connected with the criminal underworld, losing the overtones of political or ideological liberation. The syncretic image of a romantic gangster proved to be a mixture of old and new characteristics. The most successful attempt to create a new hero in the 1990s appeared to be Danila Bagrov, the main character in Alexei Balabanov's *Brother* (*Brat*, 1997), played by Sergei Bodrov. Winning over the sympathies of the young and particularly female audience with his aura of the lonely, handsome outcast, Bodrov's hero performs acts of social justice in his spare time between contract killings. The fusion of vitality, physical power, and unshakeable conviction of moral righteousness reminds us of an ideal revolutionary hero—an unintended parallel further enhanced by Danila's lack of interest in financial rewards, which is somewhat ironic for a professional killer. "The power is in truth, not in money"—with this paraphrase of Alexander Nevskii's words, the new hero extends his symbolic genealogy back into the depths of national history.

The sweeping popularity of *Brother* made the producers rush out the sequel *Brother 2* (*Brat 2*, 2000), which further nourished expectations of a strong and confident hero. The existence of recognizable "bad guys" and the hero's avoidance of too much "unphotogenic" reflection on the screen seemed to be two important ingredients of success. In the sequel, Balabanov sends the hero to the U.S. to apply his ideas of justice and truth. No longer a dream world, America becomes the context for stating the hero's ideas of social order, and the extension of a familiar mafia space. Destroying the myth of the trans-Atlantic paradise, the film replaces it with another—that of the homogeneity of space, where Danila's reading of the world becomes a universal system of references. In this context the motif of spiritual liberation becomes utterly redundant, being replaced by those of unity, justice, and the triumph of might.

ANATOMY OF HISTORY: DISSECTING THE POWER(FUL)

The widely shared perception of the communist regime as a spacious repressive zone facilitated the initial repudiation of the Soviet past, seen as incompatible with basic human dignity and freedom. An accompanying sense of dissolving orientation blurred the coordinates of collective memory, making film critic Miron Chernenko describe the cinema of 1989 as a world in which "it is absolutely unclear, where we came from and where we are going."[17] At the same time, everyday life remained saturated by the intensive "consumption" of history. Public concern with historical material in the late 1980s and early 1990s had less to do with the work of devoted cabinet historians than with mass media accounts reacting with heightened interest to previously tabooed topics.

The desire to fill in the white spots and to uncover the truth behind official lies motivated historians and filmmakers alike. The settling of accounts connected past and present, history and politics, reality and remembrance. In the years of *perestroika*, cinematography played a pivotal role in reformatting historical narratives by creating new paths through the labyrinths of collective memory. Starting with *Repentance* (*Pokaianie*, 1986), late-Soviet and post-Soviet cinema was at once concerned with and troubled by historical themes, seeing in Soviet history a decaying, unburied corpse, to be neither forgotten nor forgiven. Like Tengiz Abuladze's heroine, who continuously unearthed the dead body of the buried dictator, demanding a public trial, the filmmakers originally sought to bring to light the yet unaddressed crimes of the past. The anatomical lessons of post-Soviet cinema were set in the most traumatic episodes of recent history.

Liberation from the constraints of censorship made "plunging" into history equal to "reshooting" the past. Seeking distance from Soviet bluster, the epic was turned into the grotesque, deheroizing previously canonized figures and subverting established chronologies and hierarchies. The form was challenged along with the content in mocking remakes of canonized Soviet cornucopias (*Tractor Drivers 2*, 1992) or by pseudo-scientific historical accounts, where an absurdist fictional (hi)story was constructed by using non-fiction material (*Two Captains 2*, 1993; *Comrade Chkalov Crossing the North Pole*, 1990).

Among the historical references that saturated the cinema, the imagery of Stalin appeared most frequently. As the hero of Sergei Soloviev's bur-

[17] Quoted in Daniil Dondurei, "Novaia model' kino: trudnosti perekhodnogo perioda" [New model of cinema: difficulties of transitional period] *Kinovedcheskie Zapiski* 3 (1989): 9.

lesque, *Black Rose—an Emblem of the Sorrow, Red Rose—an Emblem of Love* (1989), who woke up every morning to the recorded radio announcement of Stalin's death, the audience was constantly offered details—documentary as much as invented—from the life of the dictator. The emphasis on the purely bodily existence of the tyrant aimed to destroy the Soviet mythology of the untouchable political body. Against the anticorporeal tradition, which altogether deprived the leaders of any physical deficiency or bodily needs,[18] post-Soviet cinema attempted to show the previously hidden areas of privacy (*Inner Circle*, 1991; *How I Worked Under Stalin or Songs of the Oligarchs*, 1990), subverting the imposed understanding of "high" and "low," "witnessing" the nocturnal orgies in the Kremlin (*Balthazar's Feast or a Night with Stalin*, 1989), emphasizing bodily deficiencies (*Black Rose...*), and even asserting the duplication of Stalin's body for public occasions (*Comrade Stalin Goes to Africa*, 1991).

Looking back from 1989 at the Soviet period and its cinematographic reflection, film critic Mikhail Iampol'skii referred to it as a "sadomasochistic culture," consisting of "desexualized bodies, unfamiliar with pleasure and satisfaction."[19] The ensuing search for Soviet subjectivity both extended and challenged this claim, seeking to dissect the fabric of everyday life and to see "everyday Communism" in its daily anti-monumentality under the gloss of official rhetoric, colossal architecture, and loud official declarations of achievements. What was portrayed behind the façade of the monumental ideology was the world of sexual *simulacra* and physical aggression. Not only gender roles, but gender itself became an adjustable category in a world that despised any conventional ideas of normality. The levels of such "adjustment" varied—from turning a mare into a stallion with cardboard genitals as part of the preparations for a pompous Red Square parade (*Moscow Parade*, 1992) to a travesty of the heroine, who is turned into a hardworking male to take up the burden of constructing the new world (*Hammer and Sickle*, 1994). The latter experiment becomes the ultimate embodiment of the Soviet project, creating a never-tiring yet deeply unhappy male *Stakhanovist*, the pride and foundation of the system. The bodily imprint of the Soviet ideology linked

[18] Lidia Mamatova, "Model' kinomifov 1930h godov" [The model of film myths of the 1930s] in Lidia Mamatova (ed.), *Kino: politika i lyudi, 30e gody* [Cinema: Politics and people, 1930s] (Moscow: Materik, 1995), 52–78.

[19] "Nashe kino segodnia: vzgliad iz-za granits. Kruglyi stol v redaktsii Kinovedcheskie Zapiski, iyul' 1989" [Our cinema today: a look from beyond the borders. Round table in Kinovedcheskie Zapiski, July 1989] *Kinovedcheskie Zapiski* 4 (1989): 6.

social and biological levels and approached revolutionary dreams as a grotesque experiment with the very basics of human existence.

Sexuality was seen as both a weakness and a weapon, serving as a mechanism of social coherence and as fuel for social conflict in a compact and remote military unit in Petr Todorovskii's *Encore, Once More Encore!* (*Ankor, eshe ankor!*, 1992), where various female characters appear as the main agents of change. A military garrison, penetrated by the agents of the Soviet military secret police SMERSH,[20] forms an artificially bounded unit from which the inhabitants dream of escaping. Communal life produces no unity or freedom, but gossip, mutual hatred, and dependency, with friendship and love being cynically used for career-building. Both pleasure and repression reappear in Todorovskii's subsequent portrait of late Stalinism in *What a Wonderful Game* (*Kakaia chudnaia igra*, 1995), where a "joyous" world is ruined by a seemingly innocent joke, as the university students play out the mock radio broadcast of a governmental decree that never existed, announcing the fulfillment of the most wanted needs: lower vodka prices and freedom of speech.

The Great Terror prompted very diverse visual and intellectual cinematic interpretations. Nikita Mikhalkov's *Burnt by the Sun* (*Utomlennye solntsem*, 1994) became a successful borderline case between intellectual and mass cinema, which opposed an old-style intellectual to the charismatic, masculine, and simple revolutionary hero Kotov, played by the director himself. Presenting a contrast between two worlds, Mikhalkov made History an active protagonist, presenting melodramatic relationships as a tragedy with hagiographic overtones. The year 1936 is more than a background; time itself is clothed in the garments of a dramatist, turning the refined intellectual and musician Mitia into an NKVD agent, who is sent to arrest the legendary commander Kotov. But Kotov is far from being a passive victim, as at an earlier point he himself recruited Mitia to work for the secret services, before sending him away on a foreign mission and marrying his love, Marusia. As the opposition of the old and the new worlds becomes blurred, both protagonists perish, physically destroyed by the rising System.

[20] SMERSH is an abbreviation made up of two Russian words *SMERt' SHpionam* (meaning "death to spies"). The department was formed at the height of World War II (April 1943) with the original mission of identifying spies and conspirators in the army and among returning prisoners of war, as well as preventing any subversive activities within the Red Army and by anti-Soviet civilians, particularly in the territories returning under the control of the Soviet authorities. Freely using terror and purges, SMERSH left painful memories.

Fig. 3 Concert for a Rat
Courtesy of *Iskusstvo Kino*

A visual contrast to the sunny summer countryside forming the background to Mikhalkov's drama appears in Oleg Kovalov's historical fantasy *Concert for a Rat* (*Kontsert dlia krysy*, 1995). The closed space of a Leningrad communal flat, through the aestheticized ascetic purity of black and white contrasts, carries a similar message of pulpable physical aggression. (Fig. 3) The merging of reality and fiction finds its high point in the year 1939, with the signing of the Molotov–Ribbentrop pact and the appearance of Daniil Kharms's *The Old Woman*, both bearing witness to the ultimate fluidity of "normality" as a concept.[21] Following the "rules of the game" does not protect the heroes from ultimate destruction. According to the inherent logic of purges, a cavalry officer, having diligently removed every new "enemy" from a group photo of his friends, finally sticks the scissors in his own throat, cutting himself out of the historical landscape.

Bodily references permeate the sinister world of "Stalin baroque" in Alexei German's *Khrustalev, the Car!* (*Khrustalyov, mashinu!*, 1998).

[21] For more on Kharms' *The Old Woman*, see Mikhail Iampol'skii, *Bespamiatstvo kak istok* (*Chitaia Kharmsa*) [Delirium as source: reading Kharms] (Moscow: Novoe Literaturnoe Obozrenie, 1998).

The life of the protagonist, a surgeon, accustomed to cutting into human flesh, is itself dissected as he meets—in the density of the decaying Big Style—his own *Doppelgänger*. The subsequent infernal odyssey of the hero runs parallel with the physical decomposition of the state power, where identity is an ever-evasive notion. But the parallel existences intersect in the non-Euclidean space of the film, with Stalin's death as their crossroads. The further—and ultimate—dissolution of the very foundations of the Soviet "body politic" and its memory appears in Sokurov's *Taurus* (*Telets*, 2000). The physical decay of the agonizing Lenin and the dissolution of his dense visual mythology becomes not simply a farewell to a passing epoch, but constitutes the passing away of an "imagined community" held together by a recognizable imagery. The past, embedded in the eye of the beholder, disappears with the transformation of each single viewer.

Towards the late-1990s, the heated debates of the period of "historical intoxication" gave way to the reestablished image of various epochs, where the complexities of history replaced the maximalist positions of the first truth-seekers. The public became the most sensitive barometer of changes: interest in the "terror of history" gradually declined, while the scope of portrayed epochs became more variegated. The emerging historical hierarchy replaced the insecurities of the post-communist period, reopening the possibility of using historical material to legitimize various national projects. The decay of the Soviet Union stimulated the reestablishment of national histories over the whole post-Soviet space, involving cinematography in the building of nation-states by constructing popular versions of normative historical memory. These attempts could be more or less subversive in the different successor states, ranging from Yurii Il'ienko's openly provocative *Prayer For Hetman Mazepa* (2002) in the Ukraine to the monumental *Amir Temur the Great* (1997) and *The Lands that Belonged to my Father* (1998) in Uzbekistan. Similarly, filmmakers in Russia sought to put the past to the service of the contemporary state-building process, fusing pre-Soviet Russian and post-Soviet imperial cultural missions (*The Barber of Siberia*, 1998; *The Romanovs: An Imperial Family*, 2000; *The Captain's Daughter*, 2000). However, none of the attempts to ascribe new values to different historical episodes included the obliteration of the major constitutive element of the Soviet period—the memory of the Great Patriotic War.

THE TIMES OF THE WARRIORS: THE IMAGERY OF WAR

One of the central integrative historical memories in the Soviet period was the Great Patriotic War (1941–1945), a term used in Soviet and post-Soviet public discourse almost interchangeably with World War II.[22] Thematized in literature, the plastic arts, and the cinema as an experience at once liberating and unifying, war memories from the early post-war years were shaped under close state supervision, which secured substantial material resources for numerous monumental displays and public performances. The war was introduced as "a moment of truth," which made it possible to ascribe an unquestionable and uncontested meaning to the total subordination of individual interests to the well-being of the state. A Russian was considered to be "always a little bit of a soldier, who is most organic in the context of war and unfreedom."[23]

Up to the present, the state has remained involved in the production of cinematographic war imagery, supporting film studios and sponsoring new "patriotic" film festivals specialized in the production and promotion of such images.[24] While active state involvement in the politics of war memory also remained characteristic of the post-Soviet years, the cinematography of the 1990s tried to revise even this most monolithic and rigid myth of the Soviet times. In the last Soviet years this cornerstone of So-

[22] Denise Youngblood, *Russian War Films: On the Cinema Front, 1914–2005* (Lawrence: University Press of Kansas, 2007). Lev Gudkov, "'Pamiat' o voine i massovaia iden-tichnost' rossian" [War "memory" and Russians' collective identity], *Neprikosnovennyi zapas* 2–3 (2005).

[23] Ilia Alekseev, "Boinia # 6" [Massacre # 6], *Iskusstvo Kino* 5 (1993): 5–8.

[24] One such festival, for example, is the International Forum Zolotoi Vityaz' established in 1992. In his introductory address, the president of the festival invited the audience to "learn to appreciate a unique spiritual culture of the Slavic Christian world in the world of cinema, theater, music, arts, and Russian martial arts" www.zolotoyvityaz.ru/#1 (accessed 10 January, 2007). According to the festival's statement, the "steady activities of Zolotoi Vityaz' led to the emergence of a new phenomenon in world culture—a positive Slavic Orthodox cinema and theater. (…) Zolotoi Vityaz' became a real spiritual alternative to the soulless business of the contemporary film market." Available at www.zolotoyvityaz.ru/content35_58_43.html (accessed 10 January, 2007). In 2003, there emerged a Festival of Military Cinema named after Yu. N. Ozerov. The festival sees as its goal "not only to show the latest cinematographic achievements in military cinema as the brightest and most dramatic kind of cinematography, but also to raise among all our countrymen and the young in particular an interest in history and love of our country and its traditions, which were mainly shaped by the primary aim—the defense of the Fatherland." See the opening statement at the official festival's site, www.warcinema.ru (accessed 10 January, 2007).

viet identity was challenged by the release of new data on human losses and official decision-making. An opinion poll conducted in Moscow in 1994 concluded that a significant percentage of the population questioned the image of World War II created by the Soviet cinema.[25] Going against the "martial, male, Russian"[26] war image which was dominant in the Soviet Union and has survived up to the present day, alternative discourses gradually emerged alongside the "officially promoted" imagery.

The Soviet model of a hero-liberator was first consistently subverted in Pavel Chukhrai's *Thief* (*Vor*, 1997), where the audience was faced with a crook behind the façade of an attractive officer. Himself the son of film director Grigorii Chukhrai, whose *Ballad of a Soldier* (*Ballada o soldate*, 1959) became a paradigmatic anti-monumental treatment of war, the filmmaker attempted to challenge the dominant discourse of heroism by looking at the father-son relationship. The father figure in *Thief* contradicts the representative tradition of sacralized patriotism, sacrifice, and communalism. The story is presented as one long flashback told by the narrator, a little boy at the time the story takes place. His father, using the fake identity of a military hero, cynically exploits the openness and trust of his gullible neighbors in order to fleece them. Masquerading the body, the film contests both the monumental self-representation of late Stalinism and the attempts to present the surface as the essence, revealing the omnipresent cult of brute force, struggle for survival, and mistrust of everyone around. The closing scene shows the grown-up boy as a colonel in Chechnya, himself caught up in a vicious circle of violence and militancy.

Although the 1990s opened up the arena for multiple agencies involved in shaping the war memories, their public appearance remained politicized. Heated debates demonstrate a high degree of resistance to

[25] According to the quoted data, 49% of the respondents stated that their understanding of World War II had changed in the last few years, 40% believed that fascism was misrepresented in the Soviet cinema, while 32% claimed that the war films of the 1960s–1980s do not create an adequate image of the war. Although the formulation of the questions allows for different interpretations, and the principles of sampling remained unclear, the mere occurrence of the poll demonstrates the importance of the issue. See V. Dubitskaia, "Komu nuzhno razrushit' mif o voine" [Who wants to ruin the war myth], *Iskusstvo Kino* 10 (1994): 66–7.

[26] T. G. Ashplant, Graham Dawson, Michael Roper, "The Politics of War Memory and Commemoration: Contexts, Structures, and Dynamics" in T. G. Ashplant, Graham Dawson, Michael Roper (eds.), *The Politics of War Memory and Commemoration* (London: Routledge, 2000), 27.

different forms of deviation from the imagery shaped during the Soviet post-war decades. Among the most debated examples are *Our Own* (*Svoi*, 2004) and *Polumgla* (2005), made by filmmakers of a younger generation. While these works received partial support from the state-funded Cinematography Committee, their message differs markedly from the "war mainstream." Visually and conceptually they draw on the heritage of the Thaw cinema of war, which, paradoxically, included not only official propaganda works, but also the first attempts to subvert Soviet bluster and monumentality.[27] Characteristically, the films seeking to explore yet untouched dimensions of the war choose off-battlefield locations, concentrating on the stories away from the front line, and include figures that are often missing from the conventional "patriotic" accounts: collaborators, women, or prisoners of war.

Artem Antonov's *Polumgla* is a directorial debut. *Polumgla* literally means "dusk," but in the film it is the name of a northern Russian village, far away from the front line, where German prisoners of war are sent to build a tower declared to be an important military project. The village women, losing hope of ever seeing their husbands alive, initiate interaction with the captives, which evolves into a bitter-sweet coexistence. When the tower nears completion, the villagers and the POWs prepare to celebrate the new year. At night, masked dancing figures emerge from the darkness around the Germans' barracks, arousing mixed feelings of surprise and fear in them. As the villagers in their carnivalesque clothes draw the stunned Germans into the whirlpool of their merriment, the seeming unity and happiness is disturbed by an anxiety that fills in the air. Only one day after the death-mocking ritual tragic news breaks: the Soviet military leadership announces the uselessness of the construction and decides to "liquidate" the POW unit. In a sudden twist, the young men turn from enemies into victims, whose lives are taken away on the orders of some anonymous, invisible, irrational, yet omnipresent power that is not interested in individual stories and personal details. The carnival remains a false subversion that can never reverse the hierarchy of power. Any occasional delay becomes a strengthening element of the oppressive system.

[27] Alexander Shpagin, "Religia voiny. Sub'ektivnye zametki o bogoiskatel'stve v voennom kinematografe" [Religion of war. Subjective remarks on God-seeking in war cinema]. *Iskusstvo Kino* 5 (2005): 56–68 and *Iskusstvo Kino* 6 (2005): 72–89. On-line version available at www.kinoart.ru/magazine/05-2005/review/shpagin0505/ and www.kinoart.ru/magazine/06-2005/review/spagin0905/ (accessed 26 January, 2007).

It was exactly this provocative ending that sparked the scandal around the film. The director used a script written by Igor' Bolgarin and Viktor Smirnov—writers whose career started with rather mainstream Soviet scripts.[28] The screenplay of *Polumgla* was originally entitled "And the Earth was Covered in Snow…"[29] and featured a somewhat implausible final scene of the villagers bidding farewell to the German war prisoners whom they have befriended in the spirit of the late-Soviet internationalism. Having learned of the change in the script, the writers started a campaign against the film, without anticipating the final outcome. To the surprise of many critics, who welcomed the debut work, the director was accused by the script-writers of nothing less than creating an "anti-Russian" film.[30] For some time the distribution of the film in Russia was delayed—an event unprecedented since the end of the Soviet regime.[31] The festival success of the film, screened in Montreal, Vyborg, and Vologda, finally shifted the balance in the director's favor and the film was released; however, the resurrection of the late-Soviet "patriotic" discursive ghost in new garments gave rise to concerns among professionals.

Dmitrii Meskhiev's *Our Own* also uses a rural setting, this time in the Pskov area, in the territories occupied by the Nazi army. Three Soviet military men—a political commissar, an NKVD-officer, and a young sniper—escape from captivity and head for the native village of the sniper. However, the young man's father has accepted the position of village elder under

[28] Igor' Bolgarin started his script-writing career in 1957 with the adventure drama *On the Count's Ruins* (*Na grafskikh razvalinakh*, 1957), where a little boy helps the Cheka officers to find and neutralize some bandits. He also co-authored one of the most popular films on the Civil War in the Soviet Union, *His Excellency's Adjutant* (*Ad'yutant ego prevoskhoditel'stva*, 1969). Bolgarin initially cooperated with Viktor Smirnov in 1969. They jointly wrote the script for the adventure story *Tough Kilometers* (*Surovye kilometry*, 1969) and continued working together on dramas set during the Civil War and World War II, as well as on contemporary adventure stories. Their last joint film made in the Soviet Union was devoted to Dmitrii Ulianov, Lenin's brother, and his activities in creating Soviet sanatoriums in the Crimea (*It's not Always Summer in the Crimea, V Krymu ne vsegda leto*, 1987).

[29] The script is published in *Kinostsenarii* 2–3 (2004).

[30] Igor' Bolgarin, "Rezhisser rezal nashu pravdu. I dobavlial mnogo svoei lzhi" [The Director cut our truth. And added his lies], *Novaia Gazeta* (8 September 2005) http://2005.novayagazeta.ru/nomer/2005/66n/n66n-s22.shtml (accessed 29 January, 2007); Ilia Smirnov, "Polumglisty," *Skepsis*, on-line version at http://scepsis.ru/library/id702.html (accessed 29 January, 2007).

[31] Valerii Kichin, "Polumgla slepit glaza" [Polumgla blinds], *Rossiiskaia gazeta* (1 December 2005). On-line version available at www.rg.ru/2005/12/01/kino.html (accessed 29 January, 2007).

the Nazi occupation and a number of his fellow-villagers are serving in the German police. One of them is in love with the old man's daughter and uses every means to force the family to agree to their marriage. The destinies of the three soldiers are mixed up with the complex power struggle in the village, where betrayal and loyalty are only inches apart. Even though it went against the war clichés, the film was perceived by some critics as a "military-rural thriller" (Roman Volobuev), a "quality western with pseudo-patriotic underlying motives" (Boris Khlebnikov), an "existential western made from the partisan discoveries of the Soviet multi-national cinema" (Andrei Plakhov), and even as "the first Russian 'American' war film" (Yurii Gladil'schikov).[32] This polarization of opinions, albeit somewhat less radical than in the case of *Polumgla*, points at once to the surviving resistance to the on-going revisionism of war representations and the growing desire to see even more "radical" treatments of the familiar theme.

It is not only the younger generation of filmmakers who venture into films revising war experiences. A recent film by an established filmmaker, Petr Todorovskii, whose works were already mentioned above, is a case in point. *The Taurus Constellation* (*V sozvezdii byka*, 2003) is the somewhat artificial story of the rivalry of a village shepherd and a city show-off over a girl. Living in a village close to Stalingrad, the two become friends in the course of an adventurous foray to find hay for the bulls during the decisive battle. On their journey, the two are almost killed by German soldiers, but finally capture a medic whom they eventually befriend in their "run-for-your-life" journey in the snowy plains around Stalingrad. The film uses the familiar dramaturgical devices: everyday village life, the mutual dependency of the prisoner and the locals, the ability to understand the each other's most basic needs despite the lack of a common language, and most of all a mildly sympathetic portrait of a German medic. Similar motifs of linguistic barriers overcome by humanity appear in Alexander Rogozhkin's *The Cuckoo* (*Kukushka*, 2001), where an unexpected triangle—a Finnish kamikaze sniper, a captain in the Soviet Army, escaping from SMERSH, and a Lapp woman—try to make sense of their existence during September 1944, a few days before Finland dropped out of the Second World War.

These works remain exceptions among the conventional reproductions of heroic struggle and sacrifice, such as, for example, *The Star* (*Zvezda*,

[32] Roman Volobuev, "Na neitral'noi polose" [On the neutral line], *Seans* 21–22 (2005), on-line version available at http://seance.ru/n/21–22/films2004/svoi/ripley-svoi/ (accessed 27 January, 2007); "Seansu otvechayut," *Seans* 21–22 (2005), on-line version available at http://seance.ru/category/n/21–22/films2004/svoi/mnenia (accessed 29 January, 2007).

2002), a recent remake of the 1949 adaptation of Kazakevich's epony-mous novel. At the same time, there is a growing number of films which use war as a pretext for telling adventure stories, using historical details as "decorations" of the storyline. One such is the crime drama *In August 1944* (*V avguste 44-go*, 2002), where the role of the "good guys" is as-signed to SMERSH agents, fighting heroically against Polish and Ukrain-ian Nazi collaborators.[33]

Given the rigidity of the memory of World War II, other occasions of military conflict provide space for experiments with the existential border-line of life and death. Before the tragic outbreak of military violence in Chechnya, the film critics formulated a conceptual framework, using war situations as an exemplary model ground for existential questions. This potential was explored in the early 1990s in reflections on the war in Af-ghanistan (*Leg*, 1991; *Afghan Breakdown*, 1991; *Peshawar Waltz*, 1994). Vladimir Bortko's *Afghan Breakdown*, for example, shows the last days of the Soviet military presence in Afghanistan. Everything is permeated by the anticipation of withdrawal: morale is low, the bullying of youngsters is rife, the inhabitants of the military town are completing their last shopping rounds, weapons are being traded in exchange for safe withdrawal, the longing for and the fear of life in peace pervade the daily conversations. The news of the growing lack of everyday goods, the environmental cri-sis, and the devaluation of savings, as well as growing criticism of Soviet interventionist military campaigns, arouses confusion and concern. But the fighting goes on—and the fate of the last victims makes the war even more meaningless.

Characteristically of the "times of change," the leading role of a brave and honorable military commander is played by the Italian actor Michele Placido, who starred in the mid-1980s Italian TV series *La Piovra* (*Octo-pus*) on the struggle between the mafia and the police, which was highly popular in the late Soviet Union. However, instead of a victorious hero image, he is assigned a tragic halo in the film: having accidentally killed a friendly Afghan mediator with his wife and children, he allows himself to be killed by the only survivor of the family, a teenage boy. His death does

[33] Current revisionism is visible not only in cinema: recently published archival materials, selected by the current Federal Security Agency (FSB), similarly glorify their mission and activities. See *"Smersh": Istoricheskie ocherki i arkhivnye dokumenty* ["Smersh": Historical essays and archival documents] (Moscow: Izdatel'stvo Glavarkhiva Moskvy, OAO "Moskovskie uchebniki i kartolitografii," 2003). Not surprisingly, the album re-ceived a positive review on the Russian Federal Security Service's web-site: www.fsb.ru/history/book/smersh/recenz.html (accessed 29 January, 2007).

not represent a heroic martyrdom, but stands as a metaphor for expiating the sins committed by the Soviet Union. Ironically, it was the close cooperation with the military authorities that allowed for an impressive emphasis on the futility of the military presence and responsibility for the violence in the closing scene, where dozens of Soviet military helicopters dominate the Afghan sky.

It is instructive to compare this early post-Soviet film to a recent Russian blockbuster: *The 9th Company* (*9 rota*, 2005). While the war in Afghanistan is a rare cinematographic topic, particularly since the outbreak of the war in Chechnya, a comparison of the two films reveals a clear discursive shift in the representation of war in post-Soviet cinema—war in general, as well as the Soviet presence in Afghanistan in particular. *The 9th Company* was directed by Fedor Bondarchuk, whose father Sergei Bondarchuk was a prominent Soviet actor and filmmaker known for his film adaptations of Mikhail Sholokhov and Leo Tolstoy. Bondarchuk junior took after his father in many ways: his high-budget production, which cost $9,000,000, became a record in contemporary Russian filmmaking, the shooting included mass scenes comparable with those of Bondarchuk senior, and the director also played one of the leading roles in his film.

Although it drew on the accumulated experience of numerous Hollywood blockbusters, *The 9th Company* was cheered for its "patriotic" stance in many reviews and audience responses.[34] Nevertheless, it contains some ambiguities, including recognizable tropes from earlier treatments of this war: the traces of the arms trade, the soldier brutality, and the mounting insecurity about accommodating to "life in peace" seemingly repeat similar themes in *Afghan Breakdown*. At the same time, the war business remains an exceptional episode and the humiliating treatment of soldiers is presented as learning "survival skills." Both the reasons for Soviet intervention in Afghanistan and the political context of the war are bracketed off: nothing provokes the audience to reflect on what exactly makes this war "ours"—except the official slogans about the "international duty of the Soviet soldiers to our brother nation under the threat of imperialist intervention," chanted by newcomers as part of their training program.

The film seeks to replace both history and politics with a timeless epic of brotherhood, loyalty, sacrifice, and comradeship. An inevitable aes-

[34] Most of the reviews are available on the film's official web-site at www.9rota.ru/ flashindex.html (accessed 10 January, 2007). See also supplementary documentary materials on the released DVD.

theticization of war takes place not only on the visual level, achieved with spectacular pyrotechnics, careful color correction, and fast-pace montage, but is also straightforwardly verbalized in the film by one of the protagonists, a painter. He explains his reason for volunteering to come to Afghanistan by paraphrasing Freud: "There is only life and death in war. War is beautiful." Despite his declared principle of verisimilitude in portraying historical realities, the director seems to subscribe to a timeless and metaphorical view on the war. While this position might be explained by the intention to create another spectacular show with a schematic historical background, Bondarchuk sees the film as a "generational" stance, and also accepts its educational mission.[35] This disturbing ambiguity intensifies in the closing episode of the film: after the final bloody fight, where most of the unit perishes, it turns out that the boys were simply forgotten at a post which not longer needed to be defended; nevertheless, the unit survivor proudly declares that they "won their war." The utter meaninglessness of these sacrificial deaths even within the Soviet logic of war recalls Antonov's solution in *Polumgla*, but Bondarchuk refuses to deheroicize the 9th company's death, emphasizing the ambivalence of "war truths," which not only rehabilitate the veterans' pride, but also seek to serve as a model for a young audience.

This brief overview of war films in contemporary Russia demonstrates the role of the cinema in the complex dynamics of war memory created by an interplay of different agencies, including "those of individual memory, remembrance in civil society, and national commemorative practices organized by the state."[36] Both the war films and their reception reveal an unbroken continuity in the perceptions of the war experience as a constitutive part of contemporary identity constructs.

A LIVABLE PAST: THE TRIUMPH OF SOVIET EVERYDAY LIFE

The original break with the Soviet system of references became paradoxically transformed into its own opposite over the post-Soviet decade.[37] The growing longing for the past, simplified and stripped of its deep contradic-

[35] Interivew with Fedor Bondarchuk and Elena Iatsura on the 9th company's official site: www.9rota.ru/flashindex.html (accessed 29 January, 2007).

[36] T. G. Ashplant et al., "The Politics of War memory," 10.

[37] Yuri Levada, *Ot mnenii k ponimaniyu. Sotsiologicheskie ocherki. 1993–2000* [From opinions to understanding. Sociological essays. 1993–2000] (Moscow: Moskovskaia Shkola Politicheskih Issledovanii, 2000).

tions by the nostalgic gaze, gradually became a pervasive characteristic of the new cultural context.[38] The reemerging interest of the audience in Soviet cultural products, including first and foremost the cinema, resists attempts to make the Soviet worldview an object of rational analysis, appearing on most occasions rather as a form of emotional co-experience.

The crucial link in the new "chain of times" was provided by the desired new ideology, the absence of which so troubled the filmmakers in the mid-1990s. The round table at the 2005 Moscow Film Festival focused on patriotism as a "(re)discovered" normative pillar.[39] The discussion itself, however, demonstrated a broad range of divergent views, as the participants spoke about diverse issues, including artistic mission, environmental conditions, history textbooks, the Russian soul, and the growing xenophobia. At the same time, round table participants pointed to the gradual emergence of prioritized historical themes and periods, which were markedly different from the "totalitarian" paradigm of the first post-communist years.

A prominent role in reshaping historical priorities was and is played by television. The growing number of Soviet films on TV screens in the late 1990s–early 2000s made it possible not only for the broadcasters to save on royalties and other fees but also to return the audience to the universe of the "common Soviet (wo)man"—a feeling which was met with enthusiasm by many. At the same time, attempts to critically assess the Soviet "blockbusters" and "masterpieces" were often discarded as unnecessary or irrelevant. The short-lived television program *Kinopravda*, which sought to create an analytical framework for viewing the films by contextualizing them with the help of historians, filmmakers, and other public figures, was quickly replaced by an ever-growing number of nostalgic documentaries in investigative guise, seeking to present the cult pop figures, as well as journalists, scientists, and politicians—as "survivors" and "subverters" of the regime.[40] A number of television projects in the 1990s fused private

[38] Svetlana Boym, *The Future of Nostalgia* (New York: Basic Books, 2001). Maya Nadkarni and Olga Shevchenko, "The Politics of Nostalgia: A Case for Comparative Analysis of Post-socialist Practices," *Ab Imperio* 2 (2004): 487–519.

[39] Round Table "Searching for Meaning: New Patriotism" [V poiskakh smysla: novyi patriotizm], *Iskusstvo Kino* 1 (2006). On-line version of the debate is available at www.kinoart.ru/magazine/01-2006/now/roundtable06012/ (accessed 29 January, 2007).

[40] Among such TV documentaries are the recently produced *Julian Semenov. Information for Thought* (*Julian Semenov. Informatsia k razmyshleniyu*, Alexander Pasechnyi, 2006), *Ivan Brovkin's Drama* (*Drama Ivana Brovkina*, Irina Il'ina, 2006), *Spartak Mishulin. The One who Could Fly* (*Spartak Mishulin. Umeyushii letat'*, Andrei Grachev, 2006), *The Land is Empty Without You... Maia Kristalinskaia* ("*Opustela bez tebia zemlia...*"

recollections and material *souvenirs* creating a collage of historical anec-
dotes (*Old Appartment, Lately*).[41] The New Year programs of the past
years have consistently evoked the memory of Soviet musical programs.[42]
The shift of priorities bears witness to the continuing captivation by the
Soviet ideological machine and the wariness of any alienating mediators.

The cinema also turns to private memories and recollections, demon-
strating a wide range of possible interpretations of multiple private histo-
ries. Paradigmatic in this respect is a work by Vitalii Manskii, *Mono-
logue: Private Chronicles* (*Monolog: Chastnye Khroniki*, 1999). Manskii
uses the home archives of countless anonymous contributors, merging
their personal, individual and utterly private stories into the generic story
of a collective Soviet self. Speaking on behalf of the last Soviet genera-
tion, an off-screen voice tells the viewers the story of a "simple Soviet
man," born on April 11, 1961, one day before Gagarin's flight into the
cosmos—at once keeping an ironic distance from the narrative and deeply
internalizing it. The mosaic reconstruction of a Soviet *Bildungsroman*
seeks to embrace the most generic generational experiences, as well as to
present the history of private ups and downs behind the monochrome So-
viet façade. The rehabilitated past emerges devoid of any extremes, ap-
pealing to experiences which are recognizable by the largest possible au-
dience.

In his macro-reflection, the narrator appears as both a contemporary
and a historical figure, and his commentary on pioneer life and the 7 No-
vember demonstrations combines the complicity of a participant with the
deconstructive view of an outsider. The Orwellian year of 1984, for ex-
ample, contains the imagery of peaceful Volga landscapes, accompanied
by a commentary on Reagan's statement about the "empire of evil." Re-
stating on behalf of his generation that the Soviet Union was "indeed an
empire, but not an evil one," the narrator fuses the rhetoric of the times

Maia Kristalinskaia, Svetlana Stasenko and Alexander Gromov, 2006), *The Unbending
Cohort. Thomas Kolesnichenko* (*Kogorta nesgibaemykh. Tomas Kolesnichenko*, S.
Kraus, A. Chernov; 2005), *Suslov. The Grey Cardinal* (*Suslov. Seryi kardinal*, Viktor
Beliakov, 2005) and many more, produced and shown on a weekly basis. More on the
current and earlier programs at www.rutv.ru (accessed 29 January, 2007). Furthermore,
a whole new channel, Nostalgia TV, is currently in operation, although available only to
paying subscribers via satellite. See www.nostalgiatv.ru (accessed 29 January, 2007).

[41] The two programs are titled "Staraia Kvartira" (first shown in 1996) and "Namedni:
1961–1991. Our Era" (first shown in 1997), respectively.

[42] Kirill Razlogov, "Vpered v proshloe" [Forward to the past], *Iskusstvo Kino* 3 (1997),
available at http://old.kinoart.ru/1997/3/5.html (accessed 12 December, 2006).

with a contemporary reevaluation of the imperial legacy in an ironic, detached tone. Although the author drowns his alter-ego at the onset of *perestroika*, it was exactly his generation that later partook in remolding the image of Soviet history, ascribing to it the nostalgic gaze of participant observers.

The on-going transformation of the post-communist decade moved away from the *Trauerarbeit* of addressing past traumas, to the growing prominence of everyday life with the primary goal of survival among the most absurd or oppressive circumstances. The shift of historical epochs and genres further contributes to the reestablishment of the broken "chain of times." Recent years have witnessed a growing number of films on the Brezhnevian and Andropovian epochs. Not only do the sheer numbers demonstrate the changing perspective; the evaluation of the times too has changed dramatically. For most of the 1990s, the Brezhnevian period appeared dull and repressive. It suffices to compare a *Totalitarian Romance* (*Totalitarnyi romans*, 1998) or *Russian Ragtime* (*Russkii Regtaim*, 1993) with the controversial TV film *Brezhnev* (2005).

Fig. 4 Russian Ragtime
Courtesy of *Iskusstvo Kino*

Both *Totalitarian Romance*, featuring a love affair between a Moscow intellectual and a provincial girl, and *Russian Ragtime*, where the hero's emigration becomes possible through his betrayal of his closest friends to the KGB, are devoid of any nostalgic glow and penetrated by the obsessive desire of their protagonists to escape from the oppressive regime. (Fig. 4) The protagonist of *Totalitarian Romance* escapes from Moscow to a small town after becoming involved in the protests against the Soviet intervention in Czechoslovakia. There he starts a relationship with a woman who is an archetypal product of the Soviet system, with a firm belief in the advantages of Socialism and pity for the suffering inhabitants of the brutal capitalist world. Their relationship is quickly spotted and monitored by local KGB agents. Trying to turn the girl into an informer, they ultimately open her eyes to the problems which she had long preferred to interpret according to the party directives. *Russian Ragtime*, where the protagonist has to convince the security services to let him emigrate, features a panorama of different "accommodating" strategies towards the regime, grounded in the ethical, professional, public, and private compromises that citizens were forced to perform.

A conscious attempt at remolding the image of the period was undertaken in a recent TV project entitled *Brezhnev*. The four episodes, produced and sponsored by the state television Channel 1 in 2005, were directed by Sergei Snezhkin. They are set in 1982 and concentrate on the last days of Brezhnev, as the aging and ailing state secretary is gradually sinking into his own past. His dreams bring back the early years of his career, his first encounter with his wife, his work with Khrushchev, later a plot to remove him from his ruling position, and finally World War II. In his dreams, Brezhnev is potent and active—when awake, he is hardly able to concentrate for a few minutes. In contrast to Sokurov's *Taurus*, physical deficiencies here do not become a marker of the decaying regime; rather, the aging physical "surface" is shown as containing a still potent spirit. It is not by chance that the top party leadership is worried—most of the aged functionaries who have survived numerous rounds of purges are afraid to take any initiatives while the General Secretary is still alive. The official reasoning conveys at the same time the main message of the film: "The country needs calm and stability, and calm and stability is you!"

Further ambiguities in reconstructing a well-remembered Brezhnevian regime follow suit. The film director sought to distance himself from the image of the late Soviet regime as corrupt, oppressive, and unviable: in his reading, Brezhnev stands alone against a background of stupidity and incompetence as a benevolent tsar, whose best intentions are simply never

realized. The film opens with the nocturnal appearance of a troubled petitioner whose son was unjustly sent to prison. Secretly climbing into Brezhnev's country residence at night, the man with tears in his eyes tells his story to the General Secretary, who has been awakened against the will of the confused security guards. Brezhnev immediately starts to solve the problem—but the man cannot bear his happiness and drops dead at the feet of the warm-hearted ruler.

The contrast between good intentions and non-complying realities remains a recurrent motif throughout the four episodes. Brezhnev visits a village store to discover to his great surprise that despite the party's decree that "Soviet toilers shall have all they need on their tables" the shop is virtually empty of goods. Nevertheless, excited customers cheer the leader, assuring him that they all live very well. While his meetings with "the people" demonstrate the open heart and good will of the party leader, within his own family he is portrayed as strict and uncompromising, refusing to get involved in his son-in-law's troubles, and unwilling to extend a helping hand to his daughter. At the same time, he is presented as a self-sacrificing figure, who has devoted his whole life to serving "his people": "I was worn out before I should have been. Land improvement is my problem, the Constitution is my problem, disarmament is my problem, sausages in the shops—also my problem. But I don't have two lives!" he cries in despair. The ambiguity of Brezhnev's image is based on the shifting distance between the author's position and the protagonists' performance. While the film allows us to play with double optics—we are free to see Brezhnev as a lunatic remote from any reality or as a concerned leader, giving his life for others—this new ideological construct also serves the very practical goal of strengthening popular nostalgia for the years of "stability."

The re-evoked interest in Brezhnev's times also gave rise to new topics, some of which at a closer look appear to be forgotten old ones. Among them is the (re)emerging interest in the workings of the secret police and spy stories, abundantly manufactured during the Cold War. Along with the cinema, the book market contributed to the shift in reading priorities, demonstrated both by the rocketing number of titles and by the size of print-runs.[43] Among the recent cinematographic representations of

[43] Contrary to the mid-1990s fascination with Stalin and his close collaborators, in the 2000s an increasing number of publications came out on Brezhnev, Andropov, and the workings of the secret police—often resurrecting the cold-war rhetoric: S. Semenov, *Leonid Brezhnev* (Moscow: Eksmo, 2005); B. Sokolov, *Leonid Brezhnev. Zolotaia*

the KGB one rarely finds the straightforwardly negative accounts common in the 1990s. Moreover, while in *Totalitarian Romance* and *Russian Ragtime* the agents were malevolent figures relegated to the background, a number of recent films put the secret agent into the focus, often creating ambiguous statements about the "grey cardinals" of Soviet life. Such is, for example, *Illegal* (*Nelegal*, 2005), directed by Boris Frumin and Yurii Lebedev. The main character, a KGB agent in Finland, is called back to the Soviet Union as his mission is on the verge of being discovered. Upon his return, the KGB builds him a civilian career, intending to make him work at the airport customs to secure the safe transit of agents and secret materials across the border. Played by Aleksei Serebriakov, the agent is a peculiar melancholic version of James Bond: in spite of his immediate success with all the women he meets, he is portrayed as a victim of the system, removed from his family and deprived of any deep personal relationship.

Illegal is set in 1979. Somewhat ironically, director Boris Frumin emigrated from the Soviet Union in 1978, after his films (*Diary of a School Director*, 1975; *The Errors of Youth*, 1978) were shelved and his further career obstructed.[44] The historical "markers" in the film are confusing: critics immediately picked on Brezhnev's and Andropov's portraits as Party General Secretary, on the contemporary brand of old cigarettes the protagonist smokes, and other minor but disturbing inconsistencies about times that are still vivid in the memories of many viewers.[45] Both the

epokha [Leonid Brezhnev. The golden age] (Moscow: AST-Press Kniga, 2004); Leonid M. Mlechin, *Brezhnev* (Moscow: TK Velbi, 2005); Alexander Maisurian, *Drugoi Brezhnev* [The other Brezhnev] (Moscow: Vagrius, 2004); Vladimir Musael'ian, *Gensek i fotograf. 100-letnemy jubileyu posviashaetsia* [General Secretary and photographer. To Brezhnev's 100th anniversary.] (Moscow: Kuchkovo pole, 2006); Sergei Chertoprud, *Andropov—KGB* (Iauza: Eksmo, 2004); Sergei Chertoprud, *Yurii Andropov: tainy predsedatelia KGB* [Yurii Andropov: Secrets of the KGB chief] (Iauza: Eksmo, 2006); Leonid M. Mlechin, *Andropov* (Moscow: TK Velbi, 2006); Roy Medvedev, *Andropov* (Moscow: Molodaia Gvardia, 2006).

[44] Boris Frumin, "Konspektirovat' nastoiashee" [Summarizing the present], *Iskusstvo Kino* 2 (2006), on-line version at www.kinoart.ru/magazine/archive/02-2006/ (accessed 26 January, 2007).

[45] Roman Volobuev, "Nelegal. Sovetskoe ekzistentsial'noe retro pro shpiona" [Illegal. Soviet existential retro about a spy] at http://msk.afisha.ru/cinema/movie/?id=14110033 (accessed 26 January, 2007); Mikhail Trofimenkov, "Oshibki rezidentov. Sovetskaia shpionskaia klassika v "Nelegale" Borisa Frumina" [Mistakes of the residents. Soviet spy classics in Boris Frumin's *Illegal*], *Kommersant* (19 September 2005). On-line version available at www.kommersant.ru/doc.html?path=\daily\2005\175m\28520745.htm (accessed 26 January, 2007).

hero's goals and his means of achieving them remain petty and devoid of any of the romantic excitement typical of crime drama. On the contrary, his life is pitiful and empty: he is a minor cog in the complex machinery, whose existence is justified by the rhetoric of "keeping up with the enemies." An ambiguous message sent by the film fuses an anti-heroic narrative with a theoretically "noble mission" which itself is at no point challenged.

Another recent attempt to look into the KGB's everyday life was undertaken by Konstantin Khudiakov in a four-episode TV film called *The One from Leningrad. The Lives of the Others* (*Leningradets. Chuzhaia zhizn'*, 2005). Khudiakov's film included some well-known actors and mixed cinema and TV-series aesthetics. The story centers on an eccentric family of Soviet engineers, who for generations have worked on top military projects. It opens in 1962, when the youngest generation is assigned to build the most advanced atomic warship. The family itself is an aggregate portrait of the Soviet technical intelligentsia—well-educated servants of the regime, who do not always hide their critical opinions, but who enjoy abundant privileges although they live under permanent supervision by the secret services. In fact, a KGB agent is almost part of their family—he lives under the same roof, goes shopping with them, consoles an aging aunt, offers his services to a jilted bride, saves a talented engineer and an unlucky suitor from suicide, and even idyllically plants potatoes together with the whole family at their *dacha*. Meanwhile, he eavesdrops, searches through private belongings, and installs bugs in the house—all to misguide the omnipresent enemies. The master plot, revealed to the stunned family at the end of the film, is that their whole existence was only a diversionary project to distract the attention of Western spies from the real engineering breakthrough of the Soviet Union. A dubious *modus vivendi*, constructed by the filmmaker, avoids either straightforward glorification or any ethical issues: the symbiosis seems to function perfectly, and the only thing that upsets the hero is that his work on the most destructive atomic project ever was in vain.

The rural theme seldom appears among cinematographic retro topics. In the 1980s, village life on the screens was presented in terms of an aging population and abandoned spaces, but it was not devoid of spiritual potential. In 1991, Lidia Bobrova's debut *Hey You, Geese* (*Oi vy, gusi*) reworked these tropes into a dramatic story set in 1980 in a small Cossack *stanitsa* (settlement) in the Russian South. Evolving around the lives of three brothers—one handicapped, one alcoholic, and one a criminal recently released from prison—the film shows the penury and hypocrisy of

the Soviet rural world. The family of the handicapped protagonist, for example, struggles with poverty, since the authorities forbid him to take any of the available jobs in order to "protect" his health and at the same time offer him a pension which is not enough to keep his family. The slow village life is set against the backdrop of the Olympics; and the bombastic media reports further expose the multi-layered falseness of the regime. Her later work—*In That Land* (*V toi strane*, 1997), set in contemporary Russia—shows how little the rural world has changed since.

Bobrova's films stand in sharp contrast to a recent village retro in the comic genre, *Kolkhoz entertainment* (2004). Set in 1989, introduced as "*Perestroika*," the film takes place in the "Red Rebel" kolkhoz. Reprimanded for lacking "culture," the kolkhoz director decides to shoot a movie in the village to prove that the kolkhoz is culturally advanced and worthy of an annual bonus. Finding no support in the capital, the director decides to involve villagers and inmates from the nearby prison, and brings in an alcoholic script-writer whose main dilemma is whether the film should be nominated for an Oscar or a Cannes prize. Choosing World War II as a time frame, the villagers create a parodistic cocktail of war film clichés, including brutal enemies, wicked collaborators, and self-sacrificing heroes. Gradually the fiction spills over into reality as the inmates start to harass the local villagers, confiscate their possessions and terrorize the population with explosions. But finally, in prison, where the whole crew has ended up by the close of the shooting, they receive the news that their film has indeed been nominated for an Oscar. This bitter-sweet cinematographic "fast food" fuses stigmatization and self-glorification, creating a fully virtual atmosphere of the most recent past.

Among other recent attempts at "national hits" is Ivan Dykhovichnyi's *The Kopeck* (*Kopeika*, 2001). At the center of the story is the first Zhiguli model, released in 1970. (Fig. 5) Throughout the film people from all social groups, occupations, and locations, partake in owning this loyal though chronically unreliable car. Passing from party elite to market sellers, engineers, and dissidents, the vehicle ultimately connects the whole of society not only spatially, as it travels from Moscow beyond the Urals, but temporally as well, with a lifespan up to the present day. The value of the Zhiguli only grows with time: it bridges both the Soviet and the post-Soviet world, entering contemporary times as a precious retro-object bought at an auction by entrepreneurs, before they perish one after another in the insecure "new-Russian" business world.

Fig. 5 Kopeck
Courtesy of *Iskusstvo Kino*

Social coherence is further strengthened by the participation in universally accepted achievements. Along with World War II, expansion into the cosmos emerges as another motif arousing collective pride. In recent years, filmmakers have turned to exploring the first years of space travel, creating works that successfully combine art-house characteristics with the appeal to a broad audience. Among such works are Aleksei Uchitel's *Dreaming of Space* (*Kosmos kak predchuvstvie*, 2005) and Aleksei Fedorchenko's *First on the Moon* (*Pervye na lune*, 2005). Both films are interesting examples of the sophisticated merging of fictional and documentary material, which makes it possible to support the artificial construct with the viewers' embedded trust in non-fiction footage.

Dreaming of Space is set in 1957 in a small port on the edge of the Soviet empire. The main protagonist is another "simple Soviet man," a cook with the nickname Konjok (little horse), who has his work, his girlfriend, and his settled life. (Fig. 6) His alter-ego, friend-enemy, the mysterious Gherman with the strange name and even stranger behavior appears out of nowhere and is clearly—albeit only for us, the viewers, and not for the naïve and somewhat short-sighted Konjok—preparing to escape from the Soviet Union. He practices sports, swims in icy water, learns a single Eng-

lish phrase about political asylum, and finally seduces Konjok's girlfriend in order to gain access to foreign ships. His actions, seen through the eyes of the enthusiastic and childlike hero, do not have the halo of resistance that such a figure would have received a decade earlier. In this narrative, it is Konjok, not Gherman, who is the main character. Following Gherman's disappearance, Konjok is upgraded, moves to Moscow and on the way meets another enthusiastic young man, Yurii. In the final scene, together with Konjok the audience will recognize this young man as Yurii Gagarin, a new and a much more attractive role model than the disappearing friend. In this new system of coordinates, Gherman with his struggle to escape is marginalized, written off, and easily forgotten.

Fig. 6 Dreaming of Space
Courtesy of *Iskusstvo Kino*

First on the Moon is a conscious manipulation of archival footage, deliberately aimed at blurring reality and fiction. Stylized into an investigative documentary, this film is a phantasmagoric story of an NKVD-supervised experiment in which a special group is trained to fly to the moon. (Fig. 7) However, the first spaceship explodes, the astronaut disappears, and everybody involved in the project is purged. Fedorchenko creates an entertaining piece of fiction stylized into the form of "secret police footage" recently "discovered" in the KGB archives. This mock-documentary is

shot in black-and-white in the style of the 1930s, and includes short fragments of original archival footage. The rest of the material was artificially aged and deliberately edited to make the story look credible.

This "documentary fantasy" was premiered at the Mostra film festival in Venice in 2005, where it received a prize in the panorama program "Horizons." The audience remained both entertained and perplexed: while the story is obviously from the realm of science fiction, one needs a high degree of visual literacy to be able to identify the very professional "visual stitches," playing on the "authenticity" of the archival footage. The cosmos emerges as a space of competition—albeit an imaginary one—and also as a space of pride and positive identification. The dislocated hero—according to the plot after the spaceship exploded Kharlamov, the first cosmonaut, landed on an island in the Pacific—crosses oceans and continents to return to his native empire, even if he eventually ends up in a mental asylum. The centrifugal movement typical of early post-Soviet cinema is slowly but steadily replaced by a centripetal movement. While the twenty-first century directors are giving free rein to irony and ambivalence in making their statements, the change of landmarks is paradigmatic.

Fig. 7 First on the Moon
Courtesy of *Iskusstvo Kino*

A symbolic temporal marker appears most pronounced in the recent adventure comedy *Soviet Period Park* (*Park sovetskogo perioda*, 2006), which seeks to settle accounts not only with the Soviet past, but also with the growing nostalgia for it. Director Yulii Gusman creates a virtual Soviet Disneyland where Socialism is a primary commodity. Saturated with references to Soviet film history, featuring old-time stars from *kolkhoz* melodramas and revolutionary "action films," making ample use of remaining Stalinist architecture as well as new attractions such as a miniature Kremlin at a Turkish resort, the film looks at the past through a rosy veil of conspicuous consumption. All the visitors who have paid their fee are free to choose their own roles in the Soviet "paradise," from the top party leader to the protesting dissident. The trained staff of this unusual sanatorium eagerly complies with the most eccentric wishes of the visitors—provided they are willing to abide by the rules. As soon as the main character transgresses the imposed regulations, the system starts to repress the rebel, showing the not-so-silver lining of this "idyllic" world.

By parodying the final episode of *Repentance* (1986)—the film which according to many critics "ended" Soviet cinema—Gusman tacitly exposes the long after-life of the alleged dead. Abuladze's film closed with the quest for a road leading to the Temple, in search of repentance, absolution, and spiritual renewal. "Who needs a road that does not lead to the Soviet Period Park?"—Gusman asks himself in the guise of a driver on an endless road in the closing scene of his film.[46] After twenty years, history returns as farce, replacing the hopes for a successful escape from or a peaceful burial of the troubled past, which were still available "at the beginning of the end" of the Soviet period, with an ambiguous grin from the pragmatic "nostalgia-makers."

[46] In an interview following the release of the film, the director exposed the eclectic post-Soviet mythology which creates a "cocktail of epochs," calling for collective "cleansing and repentance. And to finally start living and working." Interview with film director Yulii Gusman by Nadezhda Krasilova "*Ia ne budu sidet' v norke i umirat' ot strakha*" [I will not burrow and die of fear] on June 2, 2006. Available at www.newizv.ru/news/2006-06-02/47483 (accessed 26 January, 2007).

FILMOGRAPHY

A Day Before... (*Za den' do...*, Oleg Boretskii, Alexander Negreba, Russia, 1991)

Afghan Breakdown (*Afganskii Izlom*, Vladimir Bortko, USSR/Italy, 1991)

American Boy (Boris Kvashnev, Russia, 1992)

Amir Temur the Great (*Velikii Amir Temur*, aka *Buyuk Amir Temur*, Isamat Ergashev, Uzbekistan, 1997)

Ballad of a Soldier (*Ballada o soldate*, Grigorii Chukhrai, USSR, 1959)

Balthazar's Feast or a Night with Stalin (*Piry Valtasara ili noch so Stalinym*, Yurii Kara, USSR, 1989)

Black Rose—an Emblem of the Sorrow, Red Rose—an Emblem of Love (*Chernaia roza— emblema pechali, krasnaia roza—emblema lyubvi*, Sergei Soloviev, USSR, 1989)

Bodyguard (*Telokhranitel'*, Anatolii Ivanov, Russia, 1991)

Brezhnev (Sergei Snezhkin, Russia, TV-film, 2005)

Brother (*Brat*, Alexei Balabanov, Russia, 1997)

Brother 2 (*Brat 2*, Alexei Balabanov, Russia, 2000)

Burnt by the Sun (*Utomlennye solntsem*, Nikita Mikhalkov, Russia, 1994)

Clan (*Klan*, Alexander Voropaev, Russia, 1991)

Cloud-Paradise (*Oblako-rai*, Vladimir Dostal', USSR, 1990)

Comrade Chkalov Crossing the North Pole (*Perehod tovarisha Chkalova cherez severnyi polyus*, Maksim Pezhemskii, USSR, 1990)

Comrade Stalin Goes to Africa (*Puteshestvie tovarischa Stalina v Afriku*, Iraklii Kviri- kadze, Russia, 1991)

Concert for a Rat (*Konzert dlia krysy*, Oleg Kovalov, Russia, 1995)

Crusader (*Krestonosets*, Mikhail Tumanishvili, Alexander Inshakov, Russia, 1995)

Diary of a School Director (*Dnevnik direktora shkoly*, Boris Frumin, USSR, 1975)

Dreaming of Space (*Kosmos kak predchuvstvie*, Aleksei Uchitel, Russia, 2005)

Dyuba-Dyuba (Alexander Khvan, Russia, 1992)

Eastern Corridor or Racket à-la... (*Vostochnyi koridor, ili reket po...*, Bolat Omarov, Russia, 1991)

Encore, Once More Encore! (*Ankor, eshe ankor*, Petr Todorovskii, Russia, 1992)

First on the Moon (*Pervye na lune*, Alksei Fedorchenko, Russia, 2005)

Freedom is Paradise (*S. E. R.* aka *Svoboda eto rai*, Sergei Bodrov, USSR, 1989)

Groom from Miami (*Zhenikh iz Miami*, Anatolii Eiramzhan, Russia, 1993)

Hammer and Sickle (*Serp i molot*, Sergei Livnev, Russia, 1994)

Hey, You Geese (*Oi, vy gusi*, Lidia Bobrova, Russia, 1991)

House on Stone (*Dom na kamne*, Aleksandr Khriakov, Russia, 1994)

How I Worked Under Stalin or Songs of the Oligarchs (*Ia sluzhil v apparate Stalina, ili pesn' oligarkhov*, Semen Aranovich, USSR, 1990)

Illegal (*Nelegal*, Boris Frumin, Yurii Lebedev, Russia, 2005)

In August 1944 (*V avguste 44-go*, Mikhail Ptashuk, Russia/Belarus, 2002)

In That Land (*V toi strane*, Lidia Bobrova, Russia, 1997)

Khrustalev, the Car! (*Khrustalyov, mashinu!*, Alexei German, Russia/France, 1998)

Kolkhoz Entertainment (*Kolkhoz Interteinment*, Maxim Voronkov, Russia, 2004)

Leg (*Noga*, Nikita Tiagunov, Russia, 1991)

Miracle in Milan (*Miracolo a Milano*, Vittorio de Sica, Italy, 1951)

Monologue: Private Chronicles (*Monolog: Chastnye Khroniki*, Vitalii Manskii, Russia, 1999)

Moscow Parade (*Prorva*, Ivan Dykhovichnyi, Russia/France/Germany, 1992)

Murder on Zhdanovskaia (*Ubiistvo na Zhdanovskoi*, Sulambek Mamilov, Russia, 1992)

Our Own (*Svoi*, Dmitrii Meskhiev, Russia, 2004)

Peshavar Waltz (*Peshavarskii val's*, Gennadii Kayumov, Timur Bekmambetov, Russia, 1994)

Polumgla (*Polumgla*, Artem Antonov, Russia, 2005)

Prayer For Hetman Mazepa (*Molitva za Hetmana Mazepu*, Yurii Il'ienko, Ukraine, 2002)

Rats, or Night Mafia (*Krysy, ili nochnaia mafia*, Yurii Muzyka, Evgenii Vasil'ev, Russia, 1991)

Reed Paradise (*Kamyshovyi rai*, Elena Tsyplakova, USSR, 1989)

Repentance (*Pokaianie* aka *Monanieba*, Tengiz Abuladze, USSR, 1986)

Russian Ragtime (*Russkii Ragtime*, Sergei Urusliak, Russia, 1993)

Solovki (A. Cherkasov, USSR, 1928)

Solovki Power (*Vlast' Solovetskaia*, Marina Gol'dovskaia, USSR, 1988)

Soviet Period Park (*Park sovetskogo perioda*, Yuli Gusman, Russia, 2006)

Stalker (Andrei Tarkovskii, USSR, 1979)

Strict Regime Comedy (*Komedia strogogo rezhima*, Vladimir Studennikov, Mikhail Grigor'ev, Russia, 1992)

Swan Lake: Zone (*Lebedinoe ozero: Zona*, Yurii Il'ienko, USSR/Canada/Sweden, 1990)

Taurus (*Telets*, Alexander Sokurov, Russia, 2000)

The 9th Company (*9 rota*, Fedor Bondarchuk, Russia, 2005)

The Barber of Siberia (*Sibirskii Tsiryul'nik*, Nikita Mihalkov, Russia, 1998)

The Captain's Daughter (*Russkii Bunt*, Alexander Proshkin, Russia, 2000)

The Cuckoo (*Kukushka*, Alexander Rogozhkin, Russia, 2001)

The Errors of Youth (*Oshibki yunosti*, Boris Frumin, USSR, 1978)

The Inner Circle (*Blizhnii Krug*, Andrei Konchalovskii, USSR/Italy/USA, 1991)

The Kopeck (*Kopeika*, Ivan Dykhovichnyi, Russia, 2001)

The Lands that Belonged to my Father (*Zemlia predkov* aka *Otamdan Kolgan Dalalar*) Shurhat Abbasov, Uzbekistan, 1998)

The One from Leningrad. The Lives of Others (*Leningradets. Chuzhaia zhizn'*, Konstantin Khudiakov, Russia, TV-film, 2005)

The Promised Heaven (*Nebesa obetovannye*, El'dar Riazanov, Russia, 1991)

The Romanovs: An Imperial Family (*Romanovy: Venzenosnaia Sem'ia*, Gleb Panfilov, Russia, 2000)

The Russia that We Lost (*Rossia, kotoruyu my poteriali*, Stanislav Govorukhin, Russia, 1992)

The Star (*Zvezda*, Nikolai Lebedev, Russia, 2002)

The Taurus Constellation (*V sozvezdii byka*, Petr Todorovskii, Russia, 2003)

The Thief (*Vor*, Pavel Chuhrai, Russia/France, 1997)

To See Paris and Die (*Uvidet' Parizh i umeret'*, Alexander Proshkin, Russia, 1992)

To the Last Limit (*Za postlednei chertoi*, Nikolai Stambula, Russia, 1991)

Totalitarian Romance (*Totalitarnyi roman*, V. Sorokin, Russia, 1998)

Tractor Drivers 2 (*Traktoristy 2*, Igor' Aleinikov, Gleb Aleinikov, Russia, 1992)

Two Captains 2 (*Dva Kapitana 2*, Sergei Debizhev, Russia, 1993)

Urga (Nikita Mihalkov, USSR/France, 1991)

What a Wonderful Game (*Kakaia chudnaia igra*, Petr Todorovskii, Russia, 1995)
Wild Love (*Dikaia Lyubov'*, Villen Novak, Russia, 1993)
Window to Paris (*Okno v Parizh*, Yurii Mamin, Russia/France, 1993)
You Are My Only Love (*Ty u menia odna*, Dmitrii Astrakhan, Russia, 1993)
Zero City (*Gorod Zero*, Karen Shakhnazarov, USSR, 1988)

The Economics of Nostalgia

Socialist Films and Capitalist Commodities in Contemporary Poland

KACPER POBŁOCKI

While the very first non-communist government in Polish post-war history "demonstrated the truism that only revolutionaries are able to impose austerity,"[1] its executives declared that austerity measures would bring fruits only when all links with the past were broken. The Prime Minister announced in his inaugural speech the need to draw a "bold line" between the inglorious past and the brighter future, and the technocratic finance minister justified the drastic dismantling of socialist industry by his belief that a market economy could be built only on completely new foundations. This revolutionary ambition to make a radical break with the past was never realized: sociologists and other observers soon noticed that the new order was not being built *on* the ruins of state Socialism, but *with* those ruins.[2]

Between 1987 and 1994 dozens of feature films critical of the socialist regime were made. Most of them were still financed by the socialist economy until the "austerity measures" introduced in January 1990 cast the film industry into dire financial straits. The latest among them— Kazimierz Kutz's *Death as a Slice of Bread* (*Śmierć jak kromka chleba*, 1994), describing the violent confrontation between Silesian strikers and police at the *Wujek* coal mine after the imposition of Martial Law in December 1981—was already co-financed by private investors including the workers who were determined to put their tragedy on celluloid (Fig. 1).[3] The political climate changed after the elections that brought a post-communist party to power in 1993. The post-Communists embraced the

[1] Stanley Aronowitz, *The Politics of Identity: Class, Culture, Social Movements* (New York: Routledge, 1992), 48.

[2] Lászlo Bruszt, David Stark, *Post-Socialist Pathways: Transforming Politics and Property in East Central Europe* (Cambridge: Cambridge University Press, 1998).

[3] Kazimierz Kutz, "Mordęga" [The Grind], *Kino* 5 (1994): 4–8.

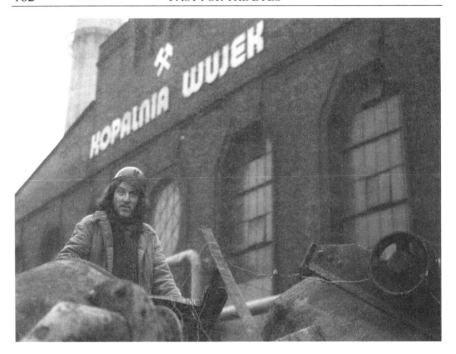

Fig. 1 Kazimerz Kutz's *Death as a Slice of Bread* came out when the ethos of Solidarity
was at its lowest point (courtesy *Studio Filmowe TOR*)

"bold line" approach, and preferred to "choose the future."[4] What their
critics described as "the politics of amnesia"[5] soon turned into the politics
of nostalgia. Public television started broadcasting old socialist series and
comedies, and the emerging private channels followed suit. In many cases
such "recycled" films were more popular than those in the very same
genre produced after 1989.[6] While some films acquired cult status, attract-
ing millions of viewers who knew parts of them by heart and referred to
them in daily conversation, only two "nostalgic" films were made.[7] The
period of "nostalgia" (roughly from 1994 to 2003), when the socialist hits

[4] Aleksander Kwaśniewski's campaign slogan in 1995.

[5] Michał Głowiński, "PRL-owskie mity i realia" [Myths and the truth about the people's
Poland] in Michał Głowiński (ed.), *Dzień Ulissesa i inne szkice na tematy niemitologic-
zne* [Ulysses's day and other essays] (Cracow: PiW, 2000).

[6] Karolina Wajda, "07 wciąż się zgłąsza" [07 still on duty], *Kultura Popularna* 10 (2004):
41–9.

[7] Monika Talarczyk-Gubała, "Kultura popularna i nostalgia za komunizmem" [Popular
culture and nostalgia for Communism], *Kultura Popularna* 10 (2004): 33.

regained their popularity, partially overlapped with the rule of the post-communist Aleksander Kwaśniewski, who won the elections of 1995 by a small margin, but whose support never fell below 80% in the last four years of his presidency.[8]

The post-Communists began to lose the upper hand in symbolic politics in late 2002, when a major corruption scandal broke out and a Parliamentary commission was formed to investigate it. Its sessions were broadcast live and followed by millions, as if they were a top-rate television series.[9] Moreover, the Institute of National Remembrance – Commission for the Prosecution of Crimes against the Polish Nation, established in 1998 and holding exclusive rights over the archives of the communist secret services, initiated a wide debate on the role of the secret police before and after 1989 by a variety of publications, documentary films, and especially by documents brought to the attention of the public through the media. These were the main instruments employed by the political right in making a case that Communism was a crime and post-Communists were criminals.[10] When in 2005 a right-wing government was formed it already had a clear vision of the "historical politics" it wanted to pursue. The newly appointed president of public television declared that *Four Troopers and a Dog* (*Czterej pancerni i pies*, 1966–1970), a highly popular socialist series about the liberation of Poland from the Nazi occupation by the Red Army with the help of Polish soldiers, would never again be broadcast by public television, which would sponsor an alternative series showing the "historical truth" instead.[11]

Since the novelty in politics after 1989 was the immense influence of the mass media, it is no wonder that the way Socialism was portrayed can be easily correlated with the distribution of political power. This is especially the case because public television, traditionally loyal to the government, was the most important institution financing the production of films and documentaries in post-socialist Poland.[12] The farewell to traditional politics and the growing power of the electronic media, or in Alek-

[8] Kacper Pobłocki, "Europe, the Pope and the Holy Left Alliance in Poland," *Focaal. European Journal of Anthropology* 43 (2004): 130.

[9] Kazimierz Kutz, "Śląsk jest, Rywina nie ma" [Silesia exists and Rywin does not], *Przekrój* 28 (2003): 28–31.

[10] Karol Modzelewski, "IPN: kto historyk, kto trąba?" [Who works at the institute for National Remembrance?], *Gazeta Wyborcza* (13–15 August 2005): 12.

[11] Renata Radłowska, "Szarikowi uciąć ogon" [Cutting Szarik's tail off], *Gazeta Wyborcza* (24 July 2006): 6.

[12] Marek Haltof, *Kino polskie* [Polish cinema] (Gdańsk: Słowo, obraz/terytoria, 2004), 218.

sander Kwaśniewski's words, the replacement of (political) vision by television, was a bitter consequence of the way modern liberal democracy worked. When the populace turned into an electorate in 1989, the political elite had to communicate with it, and popular tastes, often despised by the highbrow establishment, suddenly had to be taken into account. Those who appreciated this change, like Kwaśniewski who during his 1995 campaign danced to the allegedly "crass" *disco polo* music, triumphed.

Just as the uncompromising anti-Communism of the late 1980s and the films that severely criticized the regime were clearly a political project closely associated with the Solidarity movement, the moment of "nostalgia" came as a grassroots reaction to it. Nostalgia was a late "rebellion of the masses," formerly repressed by the socialist system that tried to steer television from above, as Teresa Bogucka argued.[13] Already in 1997 she regretted that young people found socialist comedies amusing, arguing that Socialism was "more sinister and destructive than what emerges from the hodgepodge served today on television. Entertaining people with images of how ridiculous People's Poland was is a further humiliation for those who had been repressed by it."[14] Despite some efforts to understand the roots of nostalgia, most intellectuals simply deplored it.[15] The highbrow media sounded the alarm, for example, at the results of a survey which demonstrated that over half the Polish population thought that Edward Gierek, the 1970s socialist leader, had accomplished more for Poland than Lech Wałęsa, the legendary head of Solidarity; soon after Gierek's death in 2001, statues of him were erected and streets named after him.[16] The recent "historical politics" of the right-wing government is clearly a reaction to the alleged collective amnesia, or a penchant for "history without guilt."[17] Yet despite the efforts of the right-wing elite to teach the masses about "true" Polish post-war history and to remind them of the communist crimes, for example by commemorating the 25th anniversary of the imposition of Martial Law in Poland, over half

[13] Teresa Bogucka, *Triumfujące profanum. Telewizja po przełomie 1989* [Triumphing *profanum.* Television after 1989] (Warsaw: Wydawnictwo Sic!, 2002).

[14] Bogucka quoted in Talarczyk-Gubała, "Kultura popularna i nostalgia za komunizmem," 36.

[15] Filip Modrzejewski, Monika Sznajderman, *Nostalgia. Eseje o tęsknocie za komunizmem* [Nostalgia: Essays on longing for Communism] (Wołowiec: Wydawnictwo Czarne, 2002).

[16] "Komuno wróć" [Who wants Communism back?], *Gazeta Wyborcza* (26 May 2004): 1; Waldemar Kuczyński, "Dlaczego tęsknimy do Gierka i PRL" [Why do we long for Gierek and People's Poland?], *Gazeta Wyborcza*, (4 June 2004): 16.

[17] Talarczyk-Gubała, "Kultura popularna i nostalgia za komunizmem," 36.

the adult Polish population still regarded the decision to declare Martial Law as correct.[18]

This contrast partially boils down to a difference between political and private history. Jacek Kuroń argued in 1995 that the "history of People's Poland is not only the history of anti-communist struggle, but it is also the history of the people who built post-war Poland with their day-to-day toil."[19] Oskar Kaszyński confessed that the idea for his nostalgic *Segment '76* (2003) had emerged from conversations with his father, who would not complain about the secret police or the curfew, but rather told stories about daily coping with economic shortages.[20] It was not a coincidence that private history focused mainly on the early 1970s—the heyday of State Socialism—and, in a sense, filled in the pages of history written, with little enthusiasm, by professional historians.[21] Political historians and filmmakers associated with Solidarity clearly preferred the Stalinist era, which fitted the anti-communist template best. The contemporary Polish historiography of Socialism can also be divided according to the political/private dichotomy. Many of the established historians affiliated with the well-subsidized Institute for National Remembrance focus on political history-writing even in the genre of crime fiction,[22] whereas a younger generation, born predominantly in the late 1970s and early 1980s, gathered mainly around Professor Marcin Kula and since 2000 has published over thirty volumes (mostly Masters' and some doctoral theses) on the cultural, social or even material history of People's Poland.[23]

MAKING SOCIALISM VISIBLE

Visual material is indispensable in the debates on the recent past. The very first attempt to write a comprehensive history of People's Poland—Jacek Kuroń's and Jacek Żakowski's *People's Poland for Beginners*—

[18] Małgorzata Solecka, "Pamiętamy tak jak chcemy" [We remember what we like], *Rzeczpospolita* (13 December 2006): 1.

[19] Jacek Kuroń, Jacek Żakowski, *PRL dla początkujących* [People's Poland for beginners] (Wrocław: Wydawnictwo Dolnośląskie, 1995): 280–2.

[20] See his interview in a documentary by Piotr Boruszkowski and Sławomir Koehler, *The Fashionable 1980s* (*Moda na Obciach*, 2003).

[21] Krzysztof Burnetko, "O jaką przeszłość walczymy?" [What sort of past are we fighting for?], *Polityka* 47 (2006): 10.

[22] Andrzej Paczkowski, "Śmierć rewizjonisty" [Death of a revisionist], *Polityka* 41 (2006): 80.

[23] Burnetko, "O jaką przeszłość walczymy?" 14.

put visuals and text on an equal footing. Its over 300 pages featured more than 500 color illustrations, ranging from photographs of the people, places, or events described, through reproductions of posters, cartoons, archival documents, money, newspaper articles, manuscripts, stamps, and book covers to photographs of commodities and material objects. It was supposed "not to be a memoir, nor a school book, but a kind of illustrated guidebook" that would constitute "the very first step towards building a museum about People's Poland" where Żakowski, who "remembered only half of People's Poland's history personally," could bring his children.[24] As a "critical witness" to the entire socialist period, Jacek Kuroń presented himself as an ideal guide through such a virtual museum. The book and the visuals it contained thus intended to provide a bridge between three generations who had spent their respective childhoods in the interwar period (like Kuroń, born in 1934), during or just after Stalinism (like Żakowski, born in 1957) and during the final years of Socialism (like Żakowski's children, born in the 1980s).

Images served as epistemic bridges and constituted "testimonies" of Socialism as important as those provided by its eyewitnesses. As early as the 1980s the generation of filmmakers making political cinema, too young to remember Stalinism personally, created a vision of it anchored in socialist realist iconography. Socialist realism was extremely "photogenic" with its banners, red flags and stars, huge portraits, mass parades, rallies of enthusiastic youth, monumental construction sites, and black limos carrying secret police in black coats, as was confessed by Robert Gliński, the author of *Sunday Pranks* (*Niedzielne igraszki*, 1983, first screened in 1988) where the day of Stalin's death is seen through children's eyes. Gliński was one of the many directors from the "Martial Law Generation" who chose to set their films on Socialism in the years of their own childhood. They did so partly because Stalinism had been "closed" and they were officially allowed to criticize it, and partly because Stalinism could serve as a powerful metaphor for Poland in the early 1980s.[25] The youngest generation of filmmakers who grew up under Martial Law, however, did not set their films in the gloomy early 1980s. Both *Sztos* (*Sztos*, 1997) by Olaf Lubaszenko (born in 1968) and *Segment '76* by Oskar Kaszyński (born in 1978) were set in the mid-1970s. Although this period was the heyday of Socialism, neither film

[24] Kuroń, Żakowski, *PRL dla początkujących*, 2.
[25] Haltof, *Kino polskie*, 268, 259.

glorified it. Rather, they sought to reject the language of political revisionism, and embraced a wholly different critical aesthetic.

It would be misleading to call these films nostalgic, as critics did.[26] It was not nostalgia, but fetishism—a concept germane to nostalgia but belonging to economic theory—that constituted them. Just as in Kuroń and Żakowski's quasi-museum, "Socialism" in both films was communed with by "objects." Both films were "economic comedies" and starred things as well as people. *Sztos* shows how two swindlers make easy money: they cheat Western tourists while changing their hard currency into Polish złotys. Desire for a fashionable furniture item known as *segment* is the reason why a young graduate embarks on "economic tourism" in *Segment '76*. Neither Lubaszenko nor Kaszyński intended to meticulously reconstruct the economic realities of People's Poland, but rather mocked them.[27] The low-key *Segment '76* seemed not to feature actors, but merely today's twenty-somethings who "dressed up" as their parents when they were in their twenties. The acting in *Sztos* was criticized for not being convincing enough. This lack of realism only strengthened the impression that both films were fakes. Both films were first and foremost pastiches of Western movies—*Sztos* was a tribute to George Roy Hill's *The Sting* (1973) and *Segment '76* drew heavily from Guy Ritchie's *Snatch* (2000). It could be argued that *Sztos* does not even use "real" locations, but takes the audience on a guided tour through old socialist comedies. It bristles with intertextuality and allusions to places from other movies and even uses their original soundtracks, as it does in the crucial scene in which the two protagonists, trying to fall asleep in a hotel room, hear a famous conversation from Andrzej Kondratiuk's *Uplifted* (*Wniebowzięci*, 1973).[28] Even though the two characters from *Uplifted* indeed had that conversation in a hotel corridor, this "quote" in *Sztos* was doubly false: first, it consisted of sentences from two different dialogues, and second, such a virtual meeting could never have taken place, because the heroes of both films visited hotels in different cities.[29] Just as the Western tourists were left with fake cash in *Sztos*, the viewers face a "counterfeit Socialism" in these two films.

[26] Andrzej Kołodyński, "Nostalgia bliższego stopnia" [A closer look at nostalgia], *Kino* 7 (1997): 42; Talarczyk-Gubała, "Kultura popularna," 33–8.

[27] Talarczyk-Gubała, "Kultura popularna," 37.

[28] Kołodyński, "Nostalgia bliższego stopnia," 42.

[29] Maciej Łuczak, *Wniebowzięci czyli jak to się robi hydrozagadkę* [Uplifted or how to make a hydro-puzzle] (Warsaw: Prószyński i Spółka, 2004), 15–6.

People's Poland for Beginners, *Sztos*, and *Segment '76* were all at-
tempts to build "quasi-museums" of People's Poland, where fetishes of
Socialism were gazed at. Why was Socialism suddenly put on public dis-
play? The invasion of audiovisual culture that surprised and often irritated
commentators in the early 1990s, to which Kuroń and Żakowski's book
was a clear response, and the post-modern intertextuality of *Sztos* and
playfulness of *Segment '76*, deplored by the critics of "nostalgia" were
actually the harbingers of an emerging economic order where signs,
commodity fetishism, the commercialization of culture, and advertising
played key roles[30] and which manifested itself in the "replacement of poli-
tics by economics."[31] Similar changes were affecting the cinema, where
commercial films of mainly North American provenance quickly replaced
the local productions. Film directors, who were used to high social es-
teem, after the change of the regime were deprived of their romantic mis-
sion to illuminate and guide the nation. If in 1991, 18% of all films dis-
tributed in Polish cinemas were Polish, in 1995 this number fell to 10%.
The Polish films' share of all the profits derived from ticket sales was
even more modest: 9.4% in 1991 and 5.2% in 1995.[32]

Succor to the "national pride," damaged by the domination of Hol-
lywood, came from old socialist comedies, watched by millions—when
the public television broadcast Stanisław Bareja's *Teddy Bear* (*Miś*,
1980) on 26 January 1998, it was watched by over 22% of all television
viewers.[33] While films by erstwhile giants of national cinema such as
Andrzej Wajda and Krzysztof Zanussi were largely ignored—Zanussi's
At Full Gallop (*Cwal*, 1996), showing how a former aristocrat lived
through Stalinism, was watched in cinemas by a mere 5000 people[34]—
Bareja's comedies were cherished in retrospect as the "best documenta-
ries and archival sources on the socialist era"[35] and works that "tell
more about People's Poland than lofty volumes."[36] The notion of

[30] Jean Baudrillard, *For a Critique of the Political Economy of the Sign* (St. Louis, MO:
Telis Press, 1981); David Harvey, *The Condition of Postmodernity: An Enquiry into the
Origins of Cultural Change* (Oxford: Blackwell, 1990), 284–307.

[31] Haltof, *Kino polskie*, 219.

[32] Haltof, *Kino polskie*, 217–9.

[33] Maciej Łuczak, *Miś czyli rzecz o Stanisławie Barei* [Teddy bear or the story of Stanisław
Bareja] (Warsaw: Prószyński i Spółka, 2001), 91.

[34] Haltof, *Kino polskie*, 263.

[35] Bożena Janicka, "Misior" [The Teddy bear], *Kino* 3 (1997): 19.

[36] Rafał Ziemkiewicz, "Miś nieśmiertelny" [The immortal Teddy bear], *Cinema Polska* 12
(2003): 23.

Bareizm, coined in the early 1970s by Bareja's colleague at the Łódź Film School to denote kitsch and formal mediocrity, now stood for a perfect depiction of the absurdities of the socialist system. Interviewed for a documentary entitled *Bareizm* (1997), figures like Wajda and Zanussi admitted that Bareja had been unfairly criticized and marginalized before 1989, and in fact the formal mediocrity of his films (partly because he did not have the resources to re-shoot scenes, and partly because he did not care) perfectly captures the chaos of the socialist economy.[37] In 1998, a glossy magazine declared that Bareja's films were fetishes of the 1980s, consigned them to the same "fetish" basket as socialist commodities and advertising slogans, and hailed his television series *Taxi Drivers* (*Zmiennicy*, 1986) as a "ballad about Turkish jeans."[38] "Original" socialist comedies constituted better showpieces for the quasi-museum about People's Poland than any films made in the 1990s. That was how the television set became a private virtual "museum" of sorts, where Socialism was directly accessible via its many fetishes. Socialist comedies were broadcast on television in the 1990s as a cheap and very reliable method of attracting wide audiences and raising TV rates for commercials. When in January 2007 a ski-jumping contest was suddenly cancelled, public television broadcast Bareja's *Teddy Bear* instead, and still three million sport fans found watching it worthwhile, although *Teddy Bear* had been shown on public television alone nineteen times since 2000.[39]

After over a decade of such visual "recycling," film critics have gathered enough material to identify the new role of commodities in writing history. Rafał Marszałek's *The Cinema of Found Objects* is a compelling attempt to trace how Poland's twentieth century history, especially its socialist period, was recorded in its cinematography.[40] Marszałek envisioned a "Bureau of Lost Objects" where he placed various imponderables culled from Polish films. By describing how selected props "acted" in Polish films over the last century, Marszałek excavated the history of Polish everyday life and traced how dress code, interior design, and sexual habits were transformed. Material objects, commodities,

[37] Łuczak, *Miś*, 27, 87–8, 139.

[38] Ibid., 126.

[39] Krystyna Lubelska, "Kochany Pan Tym" [The beloved Mr. Tym], *Polityka* 5 (2007): 62.

[40] Rafał Marszałek, *Kino rzeczy znalezionych* [The cinema of found objects] (Gdańsk: Słowo, obraz/terytoria, 2006); see also Dorota Skotarczak, *Obraz społeczeństwa PRL w komedii filmowej* [The image of People's Poland and its society in film comedy] (Poznań: Adam Mickiewicz University Press, 2004).

and even money were at once the starting points and the protagonists in his story. However, in order to understand the intertextuality of *Sztos*, the playfulness of *Segment '76* and the mesmerizing "fetish" qualities of socialist comedies, we need to go a step further and turn to the economic theory that reveals the circumstances under which socialist commodities were made *visible* after 1989.

Before the fall of Socialism, as Frances Pine has argued, labor was the main measure of value, and work done for the state, unlike work done "privately," was considered exploitative and hence downgraded.[41] As a consequence, commodities produced in the state sector were devalued, and social status was measured by one's access to, and possession of, rare Western goods, acquired outside the state economy. This socialist "cargo cult,"[42] an incarnation of commodity fetishism that usually occurs when the production and consumption of commodities are geographically separated, was possible because the actual process of production of the Western goods was *invisible* to the socialist consumers.[43] When the post-1989 order clearly started privileging Western goods, undercutting Polish producers, it was viewed by many as a betrayal of the promises pinned upon the demise of State Socialism. Consumers tried to unite the domains of consumption and production that had been so painfully divorced by the new economic order and began valuing goods produced by well-known and *visible* processes, which led them to favor "intrinsically" Polish goods over imported ones. Socialism was re-envisioned as a system where Poles produced accessible goods for the domestic market, and the two domains of production and consumption were reunited in the mythical body of the family, the nation, and the socialist past. These were, Pine suggested, the roots of both that recurrent banal nationalism and the nostalgia for Socialism, the two being opposite sides of the same coin.[44]

[41] Frances Pine, "From Production to Consumption in post-Socialism?" in Michał Buchowski (ed.), *Poland beyond Communism: "Transition" in Critical Perspective* (Fribourg: University Press Fribourg, 2002), 209–24.

[42] Pine, "From Production to Consumption in post-Socialism?" 210.

[43] Arjun Appadurai, "Introduction: Commodities and the Politics of Value" in Arjun Appadurai (ed.), *The Social Life of Things: Commodities in Cultural Perspective* (Cambridge: Cambridge University Press, 1986), 48; Pine, "From production to consumption," 210.

[44] Michael Billig, *Banal Nationalism* (London: Sage Publications, 1995).

CONTRASTING SOCIALISM AND CAPITALISM

Before Socialism was watched "ritually" on TV screens,[45] it became a key element in restructuring labor, for example in the Polish socialist firm Alima, which was sold in 1992 to the multinational Gerber. Even though labor had been commoditized in Socialism,[46] the most novel thing about the post-1989 order was a free market that restructured the exchange of commoditized labor for money between employees and employers. Facing the constant threat of "redundancy," Alima-Gerber's Polish employees, as Elizabeth Dunn described, made tremendous efforts to transform their erstwhile socialist "selves" into "capitalist persons."[47] They did so to prove, both to their American employers and to the colleagues with whom they competed on the emerging labor market, that their labor had a higher value, because it was "capitalist." That is how both Socialism and Capitalism became "things" one could sell as part of one's commoditized labor, or "identity." Therefore, local managers "managed" their new personalities by consuming Western prestige goods, and slick salesmen imagined themselves as living advertisements, believing that their private penchant for "movement" in life ensured a swifter market circulation of the commodities they sold. White-collar workers established their "capitalist" identity in opposition to the manual workers, who were labeled "socialist" and not allowed to participate in consuming the fruits of Alima-Gerber's market success on the grounds that they were relics of the "socialist past" rather than important elements of the capitalist machine.[48]

The enormous success of Alima-Gerber's soft drink *Frugo* was a telling example of the use of such dichotomies in advertising. *Frugo* television spots featured a hip teenager dressed in baggy clothes, spray-painting a "gray" world populated by "socialist" talking heads openly outraged by his joyfulness and dynamism. The four flavors of the soft drink featured four versions of "socialist" adults admonishing the teenager's unfettered consumption. In the "red" *Frugo* advertisement, for example, a fat old lady in a black suit shouts at the camera: "today's unruly youth should realize that we often lacked beets and could not even dream about fruits!"

[45] Monika Talarczyk-Gubala, "Kino kultu po polsku" [Polish cult cinema], *Kultura Popularna* 13 (2005): 23–8.

[46] Martha Lampland, *The Object of Labor: Commodification in Socialist Hungary* (Chicago: University of Chicago Press, 1995), 5.

[47] Elizabeth Dunn, *Privatizing Poland: Baby Food, Big Business, and the Remaking of the Polish Labor* (Ithaca: Cornell University Press, 2004), 59.

[48] Dunn, *Privatizing Poland*, chapter 3.

This advertisement from 1996 sought to reconstruct the "ambience" of Socialism by presenting some of its fetishes—furniture, interior decoration, clothes, the staple foods of the shortage economy, and especially the image of an infuriated communist talking head. However, there was not a speck of nostalgia in it. *Frugo* glorified the new market economy and its central protagonist—the possessive individual—and soon became for many journalists the epitome of aggressive and unforgiving "young" Capitalism.[49]

The authors of the *Frugo* campaign did not invent the stark contrast between Capitalism and Socialism, but exploited a construct that had emerged in the 1980s.[50] Even though it has been argued that Socialism was conceived as the "anti-world" to Capitalism,[51] it was the crisis years of the late 1970s and early 1980s, at least in Polish cinematography, that first gave birth to a dichotomy that reified Socialism and Capitalism as two distinct worlds. Films critical of Socialism had been made and screened ever since the "Thaw" period of the late 1950s, and after 1976 the criticism accelerated and was codified by critics and filmmakers as "cinema of moral anxiety." It is regarded as having made its appearance in 1976, the year of the first outbreak of the series of economic crises within the planned economy and the emergence of the radical opposition group, KOR. It was curbed in 1981, when Martial Law was imposed, the Solidarity trade union banned, its major figures detained and the screw of censorship tightened. It criticized the growing rift between official propaganda and everyday life under "really existing Socialism," presenting the (im)moral choices that people—especially young intellectuals in provincial towns—faced in their everyday lives. However, as Maria Kornatowska argued, the "cinema of moral anxiety" provided only constructive criticism from within, not due to limits imposed by censorship, but rather because of its "intellectual naivety and formal poverty."[52] It never actually portrayed Socialism as fundamentally evil, but only showed how minor cogs in the socialist machine—such as its provincial executives—"got it wrong." This limitation could also be a consequence of the time-lag in-

[49] Marcin Meller, "Pokolenie Frugo" [The Frugo generation], *Polityka* 14 (1998): 6–8.

[50] Michał Buchowski, "The Specter of Orientalism in Europe: From Exotic Other to Stigmatized Brother," *Anthropological Quarterly* 79 (2006): 463–82.

[51] Susan Buck-Morss, *Dreamworld and Catastrophe: The Passing of Mass Utopia in East and West* (Cambridge, MA: MIT Press, 2000), chapter 1; Stephen Kotkin, *Magnetic Mountain: Stalinism as a Civilization* (Berkeley: University of California Press, 1997), 29–31.

[52] Maria Kornatowska, *Wodzireje i amatorzy* [Top dogs and amateurs] (Warsaw: Wydawnictwa Artystyczne i Filmowe, 1990).

trinsic to film production in socialist Poland—for example, Andrzej Wajda's *Man of Marble* (*Człowiek z marmuru*, 1976), which told the bitter story of a 1950s *Stakhanovite* who lost his initial enthusiasm for Socialism, was written in 1962, but it took fifteen years of struggle with Party officials to make the film.[53] The "cinema of moral anxiety" addressed the issues that were significant before 1976 and failed to respond to the unfolding economic crisis. Only the commercial cinema of the early 1980s did so, and that is why the highbrow cinema of the 1970s and early 1980s collected dust on archival shelves, whereas socialist comedies, formerly looked down on, triumphed in the 1990s.[54]

These comedies rested on the dichotomy between "abnormal" and "normal" worlds. The concept of "normality," as Jacek Kurczewski argued, emerged in the 1980s and served as a template for the envisioned postsocialist order.[55] It was central to both the popular rejection of "really existing Socialism" in the 1980s and the initial support for economic restructuring in the early 1990s. The desire to live in a "normal world" disguised the criticism of socialist economic reality. In part, it was a return to the socialist governments' policy of "normalization," a rhetoric that in the 1980s urged the population to reject the Solidarity "anarchists" and "madmen," and to revert to the stability and order of early 1970s Consumer Socialism.[56] It grew out of the everyday experience of Martial Law, which had suspended the previous order and created a new reality literally overnight,[57] urging people to reject "Polish surrealism," as one of the Solidarity leaders did in the late 1980s in Maria Zmarz-Koczanowicz's *History of a camera* (*Historia pewnej kamery*, 1993). The "everyday surrealism" of Martial Law grew out the economic crisis that struck Poland between 1976 and 1981, when—with the foreign currencies being the only "real" money in the country—everyday routines were turned upside down.[58]

[53] Andrzej Wajda tells the story in Stanisław Janicki's documentary *Dreams are More Interesting* (*Marzenia są ciekawsze*, 1999).

[54] Janicka, "Misior," 19.

[55] Jacek Kurczewski, *The Resurrection of Rights in Poland* (Oxford: Clarendon Press, 1993), 351–68.

[56] Kuroń and Żakowski, *PRL dla początkujących*, 252; Jolanta Muszyńska et al. (ed.), *Obraz codzienności w prasie stanu wojennego: Gdańsk, Kraków, Warszawa* [Everyday life in the martial law press: Gdańsk, Cracow and Warsaw] (Warsaw: Trio, 2006), 248. See also the propagandist film *Dignity* (*Godność*) by Roman Wionczek, 1984.

[57] Muszyńska, *Obraz codzienności*, 69.

[58] Marszalek, *Kino rzeczy znalezionych*, 86; Kuroń, Żakowski, *PRL dla początkujących*, 147.

Already under Martial Law some people experienced conditions as "surreal" and amusing. For example, the Krakow Automobile Club organized "rallies of economical driving," where prizes were given to those who used the least petrol. In 1982 one such rally was won by a Polski Fiat owner, who used only 3.31 liters of petrol per 100 kilometers (much less than on official test drives).[59] Such festivities ridiculed the 1970s "catching up" project (with Polski Fiat as its supposed miracle product). In the 1980s the "normal world" of unlimited consumer goods was usually located beyond the Iron Curtain. The two worlds appeared ontologically different: an "ersatz state" Socialism was plagued by notorious shortages, while Capitalism seemed from afar a land of plenty safeguarded by a "natural" (a metonym for "normal") order.[60]

Such a dichotomy between the "natural" and "artificial" worlds was first captured in Juliusz Machulski's *Sexmission* (*Seksmisja*, 1983). It was a cathartic anti-utopia, watched by over thirteen million Poles just after Martial Law was lifted.[61] Its two main characters decide to become guinea pigs, placed in hibernation to be brought back to life three years later. However, when they wake up they discover that many more years have passed and a nuclear holocaust has wiped out all life on the Earth's surface, including all male human beings. The underground society consists only of women, who have mastered the methods of artificial reproduction. Eventually the two heroes escape and realize that the underground world is a fake. The head of the women's council turns out to be a man who has always been afraid of women. They join him in his comfortable cottage in a breathtaking natural surrounding, together with two Amazons, who quickly turn into pliant kittens, as the men teach them the basics of conventional reproduction.

Although Machulski's film was one of the cult comedies of the 1990s, it was Bareja's *Teddy Bear* that, for most people, captured the essence of the socialist world in a nutshell.[62] The ironic science-fiction language deployed by Machulski was transparent enough already in the 1980s: the scene in which the two heroes walk across a post-nuclear wasteland, discovering that it is a fake, was an intelligent pastiche of socialist science fiction, except that here the astronauts faced "neither good or bad Com-

[59] Muszyńska, *Obraz codzienności*, 266.
[60] Philip Mirowski (ed.), *Natural Images in Economic Thought: "Markets Red in Tooth and Claw"* (Cambridge: Cambridge University Press, 1994); Łuczak, *Miś*, 13.
[61] Haltof, *Kino polskie*, 206.
[62] Janicka, "Misior," 19.

munism" but a natural order, based upon patriarchal relations.[63] As Agnieszka Graf argues, *Sexmission* rested on the popular 1980s myth that Socialism, commonly referred to by the feminine word *komuna*, symbolically castrated Polish men, who ceased to be the real breadwinners and economic heads of families as women became the "hunters" who stood in endless queues for long hours. The men could regain their masculinity only by engaging in anti-communist politics.[64]

Unlike Bareja's *Teddy Bear*, *Sexmission* could never provide a relevant representation of the "absurdities" of Socialism[65] because its vision of a natural order was political and not economic. *Teddy Bear* opens with a scene in which socialist traffic policemen set up dummy cardboard houses next to a highway, so that they can fine drivers for speeding in a "built-up area." While the police officers explain to the drivers why they have to pay, one of the three dummy houses falls apart when somebody accidentally pulls out one of the pegs that held it upright. Since two houses do not count as a built-up area, the fines are null and void. Socialism, Bareja suggests, is a system designed for exploitation, but does not actually work very well.

The person who accidentally ruins the police's wicked plan is Ryszard Ochódzki—the manager of a second-rate sports club on his way to a tournament abroad—who just stopped for a pee. At the border it turns out that somebody has torn several pages from his passport. He realizes that it was his former wife, who hoped to stop him going to London, where they have a large sum of money in a joint bank account. Since she has married a high party official, Ochódzki cannot get a new passport. He therefore contrives a complicated intrigue in the hope of withdrawing the money before she can. He tells a film director whom he has befriended that an English aunt has been sending him money ever since he was a child. His parents, in order to get more, once told her that he had a twin. After many years, the aunt now wants to come for a visit, and Ochódzki needs a look-alike to pose as his non-existent brother. He promises his friend the money the generous aunt is bringing for his twin. He is given a small role in a film and pretends to fall ill, providing the excuse to search for a double. When they find one, Ochódzki gets a naïve actress to seduce him and steal the passport that Ochódzki has meanwhile arranged for his look-alike. She

[63] Andrzej Sapkowski and Witold Bereś, *Historia i fantastyka* [History and fantasy] (Warsaw: Supernowa, 2005), 34.

[64] Agnieszka Graf, *Świat bez kobiet. Płeć w polskim życiu publicznym* [A World without women: Gender in Polish public life] (Warsaw: WAB, 2001), 22–5, 268–72.

[65] Łuczak, *Miś*, 35.

believes that Ochódzki needs the passport so that they can leave for London together and act in a Polański movie, but he goes alone, and arrives just in time.

Ochódzki is cunning, guided by crude self-interest, and the only person who actually knows what the entire intrigue is about.[66] The resources needed to pull it off are enormous—Ochódzki and the film director spend large sums of public money only to draw a small private profit from it. But, as Ochódzki says in a crucial scene, when he persuades his friend to participate in the scam, "we should not be *Pewex*es and mix up two systems of thought," that is, mix up the state socialist economy with the real economy based upon foreign currency.[67] *Pewex* was the trademark of "internal export," a franchise where Poles could buy both Western goods and Polish "export" commodities for hard currency; it was designed to drain the population of the precious Western cash that the government urgently needed to pay back foreign loans. The universe of Bareja's *Teddy Bear* is saturated with the schizophrenic division between the fake socialist economy that all its characters have the misfortune to live in and the capitalist world that they apparently all long for.

Ochódzki is a classic anti-hero of the cinema of moral anxiety, very much like the main character in Bareja's earlier *What Will You Do When You Catch Me? (Co mi zrobisz jak mnie złapiesz?*, 1978). In that film, however, Socialism is portrayed as a system ruined by the managers' greed but otherwise worth living in. It is not the same world of scarcity as in *Teddy Bear*, which we see in the scene of the employees rushing to munch tasty snacks after listening to an upbeat speech by their CEO. When the CEO and his deputy travel to the West they do not find it fundamentally different from socialist Poland, apart from some oddities, such as the French habit of eating frogs, that make them laugh. Although, as Krzysztof Toeplitz noted in 1978, Bareja had already coined his unique visual register in this film, it was only with *Teddy Bear* that he transcended the conceptual framework of the cinema of moral anxiety by showing Socialism and Capitalism as two wholly incommensurable worlds.[68]

[66] Ziemkiewicz, "Miś nieśmiertelny," 23.
[67] Marszałek, *Kino rzeczy znalezionych*, 86.
[68] Łuczak, *Miś*, 35, 84–5.

FROM NORMALITY TO ANTI-POLITICS

It was not merely the contrast between Socialism and Capitalism as eco-
nomic systems, but rather the contrast between Socialism and Capitalism
as icons and modes of visual expression that explains the success of the
Frugo campaign in the mid-1990s. As Iga Mergler has argued, the *Frugo*
ad heavily relied on the video-clip MTV aesthetics that in the early 1990s
were perhaps the most uncommon approach seen on the "traditional" tele-
vision channels available to the Polish public. As the first "stream televi-
sion" that was not organized around a narrative principle and had no tradi-
tional programming, it was MTV that prepared the ground for *Frugo*'s
astonishing success.[69] The Frugo "capitalist" teenager lived in a "video-
clip" world of unfettered consumption, where limitations were imposed
only by boring "socialist" adults. However, he could spray-paint the
screen from the inside, thus making adults disappear—in the same way as
a young viewer can easily zap channels. Unlike the adults, the teenager
behaves as if being on television were wholly natural for him, and he ob-
viously enjoys it. In other words, two modes of television—a "Capitalist"
and a "Socialist,"—are contrasted. "Socialist" television, however, fea-
tured not only socialists: among the allegedly "socialist" talking heads
only one is a communist activist. The remaining three could just as well
be right-wing propagators of austere Catholic morality. The indifferent
teenager, therefore, seems to be as weary of communist propaganda as he
is bored by the Catholic rhetoric of austerity. The Socialism and anti-
Socialism of the 1980s merge into one mode of "traditional television,"
contrasted to the new video-clip universe.

The "traditional" iconography was derived from the 1980s pastiches of
socialist realism. The new video aesthetics appeared in Magdalena
Łazarkiewicz's *The Last Schoolbell* (*Ostatni dzwonek*, 1989), a story set
in 1988 which features a group of high-school students setting up a theatre
group. They prepare a play called "History Lesson," in which they criti-
cize the official historiography and offer their own symbolic vision of it—
a surreal mixture of distorted images derived from socialist realist iconog-
raphy. The school principal tries to stop them going to a festival, but they
get round his authority by making a video clip that they send secretly to
the festival committee. They qualify, and during their actual performance
they screen their clip in the background. Video technology came to Poland

[69] Iga Mergler, "Chodź, pomaluj mój świat" [Come and paint my world], *Kultura
Popularna* 14 (2005): 54.

in the 1980s mostly with Western "humanitarian aid" and offered the op-
portunity to bypass the state monopoly of information. Not only were
tapes of Western action films privately exchanged, but Polish films
banned by censors were also watched on illegal video copies. The under-
ground Video Studio Gdańsk even started making documentaries that
were envisioned as an alternative to official production.[70] Łazarkiewicz
signaled the expressive potential that this new medium had for the
younger generation and embraced the video-clip aesthetic that dominated
the depictions of Socialism after 1989.[71]

 This new aesthetics was part and parcel of "anti-politics"—a crucial
aspect of the neo-liberal governance in post-socialist countries and argua-
bly in the world at large.[72] Soon after the "shock therapy" the meaning of
"anti-politics" in Poland changed. If in the early 1980s it brought hopes of
a more just social order based on civil society that was outside the state and
the market, achieved by a strategy of social openness, commitment to dia-
logue, political self-restraint and eschewal of force, its neo-liberal version
embraced the "market" and conflated "democratization" with "marketiza-
tion."[73] The spirit of neo-liberal anti-politics virtually dominated the Polish
popular culture of the 1990s. Its emblematic literary figure—Geralt the
Witcher from Andrzej Sapkowski's fantasy sagas—was a "professional"
whose greatest desire was to eschew the petty political quarrels of his con-
temporaries and simply "do a good job." As many critics have noticed, he
closely resembled Franz Maurer, the cynical former secret police officer in
Władysław Pasikowski's *Dogs* (*Psy*, 1992), who was "beyond the good and
evil" of contemporary Polish politics and eliminated "baddies" irrespective
of their political affiliation (Fig. 2).[74] Pasikowski's scandalous film was
iconoclastic towards both the previous system and those who fought against
it. It mocked a famous quasi-documentary scene from Wajda's *Man of Iron*

[70] Aired on "Kino Polska" TV channel on 23 September, 2006.

[71] Kuroń, Żakowski, *PRL dla początkujących*, 259–60.

[72] James Ferguson, *The Anti-politics Machine: "Development," Depoliticization, and
 Bureaucratic Power in Lesotho* (Minneapolis: University of Minnesota Press, 1997);
 Jean Comaroff, John Comaroff, *Millennial Capitalism and the Culture of Neoliberalism*
 (Durham: Duke University Press, 2000); David Harvey, *A Brief History of Neoliberal-
 ism* (Oxford: Oxford University Press, 2005).

[73] David Ost, *The Defeat of Solidarity: Anger and Politics in Post-communist Europe*
 (Ithaca: Cornell University Press, 2006), 94–106, 190–3; Gil Eyal, "Anti-politics and the
 Spirit of Capitalism: Dissidents, Monetarists, and the Czech Transition to Capitalism,"
 Theory and Society 29 (2000): 49–92.

[74] Sapkowski, Bereś, *Historia i fantastyka*, 53–7.

(*Człowiek z żelaza*, 1981) where workers solemnly carry their dead co-striker on their shoulders. Pasikowski showed how secret police officers, on their way to burn the police files at night, carry their drunken colleague and sing the very same protest song as the workers in *Man of Iron*.

Fig. 2 Politics of amnesia - burning archives in Władysław Pasikowski's *Dogs* (courtesy *Studio Filmowe Zebra*)

The characters of socialist cinema brought back to grace in the 1990s were marked by their a-political attitude. To some extent the post-1989 success of *Teddy Bear* can be attributed to its 1991 sequel *Controlled Conversations* (*Rozmowy kontrolowane*, 1991), where Ryszard Ochódzki suddenly changed sides and—partly guided by opportunism and partly by accident—became a leading Solidarity resistance fighter, which showed what little regard he had for the ideals of either side. Konrad Szołajski's *Man of...* (*Człowiek z...*, 1993) was an open mockery of Wajda's diptych, the story of how a "man of flesh and blood" embarks on a risky anti-communist venture to prove his masculinity to a girl who is only willing to love a hero. Even though Szołajski started working on the film as early as 1989, he had trouble financing it; he claimed that the post-Solidarity elite had rejected his project on political grounds and that socialist censorship *à rebours* ruled supreme in post-1989 Poland, though with economic

rather than political instruments.[75] After a few years of Hollywood hegemony in Polish cinemas, *Man of...*, together with Marek Piwowski's *The Hijacking of Agata* (*Uprowadzenie Agaty*, 1993), attracted audiences to Polish films.[76] The latter film was based on the true story of the escape of the daughter of the vice-chairman of Parliament, who could not tolerate her autocratic father. He was the same politician who in 1988 was still giving speeches on the need to reject "Polish surrealism." Maria Zmarz-Koczanowicz confessed in 1994 that she now found this scene from her own *History of a Camera* amusing, and that Agata's father was as "surreal" as his political opponents seemed back in 1988.[77] When *Man of...* was shown on French television in 1995, a famous Polish actor explained to the foreign audience that the very fact that politics could be laughed at meant that Poland was "finally a normal country."[78] By the mid-1990s, anti-politics and "normality" had become synonymous.

ENVISIONING THE NATIONAL CHARACTER

The anti-political laughter was directed at the socialist period and the timeless "national character" at the same time.[79] Marek Piwowski's *The Cruise* (*Rejs*, 1970) or Bareja's *Teddy Bear* were extraordinarily popular in the 1990s, not only because they ridiculed Socialism, but because their humor was ripe with "inside jokes" that were said to be funny only for Poles and unintelligible to outsiders.[80] Polish comedies of the 1970s, as Anita Skwara postulated already in 1990, became the basis for envisioning a commercial alternative to Hollywood productions. It was the "third way" that reached beyond the propagandist socialist realism and the lofty neo-romanticism of the Polish film school engaged in a deadly battle.[81] If

[75] Wiesław Kot, "Czkawka" [Hiccup], *Wprost* 37 (1993): 76.

[76] Zygmunt Kałużyński and Tomasz Raczek, "Sprawiedliwość śmiechu" [Laughter as a judge]. *Wprost* 41 (1993): 78–9.

[77] Maria Zmarz-Koczanowicz, "Wolę się śmiać" [I prefer to laugh], *Kino* 5 (1994): 9.

[78] Aired on "Kino Polska" TV channel on 2 February, 2006.

[79] Barbara Kosecka, "Ciało i dyscyplina. Rejs jako próba pewnej strategii syntezy" [Body and discipline: The cruise as an attempt at a certain synthesis], *Kwartalnik filmowy* 18 (1997): 36–7; Talarczyk-Gubała, "Kino kultu po polsku," 27–8.

[80] Kosecka, "Ciało i dyscyplina," 34; Sławomir Mizierski, "Jeśli już oglądaliście, zobaczcie koniecznie" [If you have seen it already, watch it again], *Polityka* 17–8 (2006): 76.

[81] Anita Skwara, "Między socrealizmem a romantyzmem" [Between Socialist Realism and Romanticism], *Kino* 3 (1990): 21.

the "spontaneously neo-romantic" films from the "Polish school" of the 1950s and 1960s "became a large-scale educational project disseminating the knowledge of national mythology and cultural tradition" to complete the nineteenth century romantic national project, Polish comedies watched in the 1990s on television promoted a new national identity.[82] Reified "Socialism" became a central component of this new national culture as did the belief that being a Pole is a joke, that "life is a comedy."[83] *Frugo*'s success, according to most commentators, lay not in the way it criticized Socialism, but in the way it combined the latest "Western" aesthetics with the local cultural content. It was supposed to be the very first thoroughly Polish yet highly professional advertising campaign, and its authors have been hailed ever since as innovative bridge-builders who succeeded in combining global trends with local meanings.[84]

"Nostalgia" for socialism was often accused by its highbrow conservative critics of being equivalent to "amnesia," because it departed from, and even criticized, narrative-based history-writing in favor of an MTV "hodgepodge" style. It may be argued that in the 1990s the socialist films were viewed not as narrative representations, but rather as a post-modern "assembly" of largely independent scenes.[85] This explains the phenomenon of cult films, which were so well-known to their fans that it made no difference whether they were watched from the beginning, the middle, or the end. Piwowski's *The Cruise* was inspired by Umberto Eco's idea of the open text and comprised a series of skits that constituted a loose plot: seemingly random people meet on a cruise on the Vistula river and decide to stage a performance to celebrate the Captain's birthday.[86] The characters were mainly played by amateurs, accompanied by a handful of professional actors who were there to "provoke" the amateurs and incite "happenings." Even though in the 1990s *The Cruise* was regarded as a freestyle improvisation provoked more by vodka than by Piwowski's arrangement, it had a very detailed albeit open script written by three authors. The scenes that

[82] Skwara, "Między socrealizmem a romantyzmem," 21.

[83] Łuczak, *Miś*, 153.

[84] Krystyna Lubelska, "Dwugłowy smok—Iwo i Kot" [A Double-headed dragon: Iwo and Kot], *Polityka* 34 (2005): 62–3; for the uses of local knowledge in the 1990s see Don Kalb, "The Uses of Local Knowledge" in Charles Tilly and Robert Goodin (eds.), *The Oxford Handbook of Contextual Political Analysis* (Oxford: Oxford University Press, 2006), 579–96.

[85] Mergler, "Chodź, pomaluj mój świat," 54.

[86] Maciej Łuczak, *Rejs czyli szczególnie nie chodzę na filmy polskie* [The cruise or I do not go for Polish movies] (Warsaw: Prószyński i Spółka, 2002), 24–6.

eventually appeared in the film were carefully selected from a massive corpus of material gathered over several months of shooting. The result looked like a low-key production, and in the 1990s was often compared to Danish Dogma films, but was actually quite expensive to produce. Piwowski's mentor from the elder generation regretted that *The Cruise* resembled "scattered beads." Some, he argued, were beautifully polished, but Piwowski had failed to string them on a thread that could make up the necklace that a comedy as a genre must constitute.[87] Some other cult comedies also used a "serial" structure, such as Andrzej Kondratiuk's *Hydro-Puzzle* (*Hydrozagadka*, 1970), a comic-book-like mockery of socialist superheroes, or Bareja's comedies that consisted of independent gags.[88]

Piwowski's critical mentor did not appreciate what many others noticed later: that *The Cruise* established the national Polish comedy.[89] As early as 1970 Andrzej Wajda wrote that he was extremely surprised when he saw how the audience reacted to this "badly acted and terribly shot" film. "No previous Polish comedy filmmaker, including myself, had managed to establish such an instant and intimate relationship with the audience. There was no *such* laughter and *such* applause at the screenings of the films we had made before. It turned out that what I initially took for playful intellectualism corresponds to people's daily experience and is in high social demand. Its authors discovered what the contemporary audience wants to laugh at. The capital they have collected is priceless, and should soon be invested in a new, equally important and desired film."[90] *Teddy Bear* further developed the style used by Piwowski (even though he drew copiously on the Czech New Wave).[91] Bareja made slapstick comedies *à rebours*. His 1960s operetta-like films were still immersed in prewar comedy aesthetics. In the 1970s, however, he turned his eyes towards everyday life.[92] As Krzysztof Toeplitz put it, initially Bareja found showing how people throw cream pies in each other's faces funny. "When Bareja started making comedies about how we can no longer produce such cream," wrote Toeplitz, "he finally found his own, unique register."[93] This style was gaining popularity in the 1980s—*The Cruise* was hardly

[87] Łuczak, *Rejs*, 24, 31, 38.

[88] Łuczak, *Miś*, 80–1.

[89] Ibid., 53.

[90] Andrzej Wajda quoted in Łuczak, *Rejs*, 115 (original emphasis).

[91] Karolina Dabert, "Świat chaosu czy chaos świata?" [A world of chaos or chaos of a world?], *Kwartalnik filmowy* 18 (1997): 39.

[92] Łuczak, *Miś*, 34, 42–4.

[93] Jerzy Toeplitz quoted in Łuczak, *Miś*, 35.

ever screened before 1980, and received full acclaim only after 1989 when it became the local response to the "deluge of Hollywood productions."[94]

This anthropology of the "national character" drew on a panoply of sources. Funny gags notwithstanding, *Teddy Bear* is a film about the working class, allegedly the apple of the Party's eye, needing to regain its own tradition and history.[95] Ochódzki's double works as a coalman and is, like his buddies, so uprooted that he does not know what the very word "tradition" means. One of his friends hears a radio announcement that "a new lay tradition was born." He assumes that "tradition" is a proper name and wants to give it to his daughter. "Tradition" remains an empty signifier throughout the film until the very last scene, in which a "wise man" explain in lofty words: "You cannot give your daughter that name. Nothing can simply be called tradition. Nobody can declare a tradition or establish it by decree. Those who think they can, shine like a dim candle in daylight. Tradition is a thousand-year-old oak. Our cultural tradition is a fortress. It is the Christmas carol, the Christmas dinner, folk songs, it is our forefathers' tongue, it is our history that cannot be changed." Then a giant straw teddy bear, which was bought earlier in the official "folk souvenir" shop and which embodies national culture perverted by the Communists, explodes. That is why Maciej Łuczak compared Bareja's film to the acclaimed theatre performance *Description of Customs* (*Opis obyczajów*, 1990), where actors dressed in contemporary costume recite lines from an eighteenth-century diary by Jędrzej Kitowicz, one of the most important sources used by historians and anthropologists to describe everyday life in early modern Poland. Both Bareja's films and Kitowicz's diaries reveal, Łuczak argues, what "contemporary Poles are really like. The whole truth about contemporary Poles lurks behind the historical costume. The world as Bareja saw it did not perish when Socialism came to an end, because absurdity is an integral part of every society."[96]

Piwowski was the other ethnographer, described by Łuczak as a contemporary Kitowicz, whose sequel to *The Cruise*, he suggested, should be titled "The Poles' self-portrait."[97] Piwowski did his "fieldwork" in the Praga district of Warsaw, where he spent long hours socializing with the proletarian fringe of the socialist society. Praga seemed to him and to other Warsaw intellectuals to be the place where "Socialism had no ac-

[94] Łuczak, *Rejs*, 105.
[95] Janicka, "Misior," 19.
[96] Łuczak, *Miś*, 137–8.
[97] Łuczak, *Rejs*, 138–9.

cess," being its "anti-thesis," "governed by other rules."[98] Amateur actors who came from society's margins were, for Piwowski, more "authentic" than professional actors who could not speak "the same way people speak in real life."[99] That is why Piwowski's stars were the duo Jan Himilsbach—a Praga gravestone mason and occasionally a writer—and Zdzisław Maklakiewicz—a second-rate heart-throb who gave superb performances for friends in bars but always lost his extraordinary acting faculties when confronted with the camera lens. Before 1989 their genius was appreciated only by Piwowski and Andrzej Kondratiuk, and in the 1970s screenplays written for them were rejected by film associations. Both actors became "cult figures" in the 1990s, because they were the most suitable folk heroes for post-socialist times. *Sztos* is actually a tribute to *Uplifted*—both are quasi-road movies where two male friends embark on a journey that seals their friendship. In both, the decisive moment is the "test of money," when the men have to show that they value each other more than material goods or women. In *Uplifted,* Maklakiewicz and Himilsbach win the lottery and decide to spend the money flying planes: they waste the money in order to realize one of their dreams. In *Sztos* two petty criminals go on a journey around Poland's coast, cheating German tourists; they do so not to "make money" but to set up a spectacular revenge on a disloyal friend. Both films tell the story of how male friendship survives commercialization. Maklakiewicz and Himilsbach were perfect anti-bourgeois heroes, who were worshipped not because they were "on top" like regular film celebrities, but because they were sympathetic losers who cared as little about money and the conspicuous consumption it offered as they cared for work. If they lived today, Andrzej Kondratiuk claims, they would be even more marginalized than they were in the 1970s, when the post-1989 commodity cult had already started.[100]

DIFFERENT SHADES OF NOIR

Marek Hłasko, a central figure of the "Polish October" of 1956, regretted in 1966 that even though history was generous towards Poles with the countless tragedies they had to endure, none of these was transformed into

[98] Ibid., 77.
[99] Łuczak, *Rejs,* 116.
[100] Łuczak, *Wniebowzięci,* 151–3, 161, 172.

world-class literature. Instead, he argued, Beckett, Ionesco, and Kafka had become favorite authors in Polish intellectual circles (Ionesco was actually the most important inspiration for Stanisław Tym, who co-authored *Teddy Bear* and played the main role).[101] Polish intellectuals preferred blissful ignorance, believing that they lived in a "land of absurdity," rather than in a hell. Gombrowicz's *Ferdydurke* became their "Bible," he recalls, and the elite refused to see what everybody else saw with the naked eye. "They found refuge in laughter only so as not to see that they were laughable: it is better to be a jester attracting wide audiences than a Hamlet talking to empty seats."[102] He argued that Polish literature lacked realism: daily life, especially in its economic dimension, was taboo. Unlike with the great European classics, Hłasko regretted, future readers would not be able to infer the value of money from reading contemporary Polish novels.[103] It seems that he pinned more hope on film, on which his own writing drew deeply and which it mimicked. Hłasko, dubbed the East European James Dean, was obsessed with the *cinema noir*, which he knew extremely well, regarding Humphrey Bogart, next to Dostoyevsky, as one of his idols, and when socialist realism ruled supreme, he, like many other Poles, found refuge and inspiration in watching Western films.[104] He authored scripts for the "Polish School," and even tried writing for Hollywood, but died prematurely.

The Polish post-war cinema was largely structured by the conundrum of the Stalinist terror. Historical debates after 1989 hinged upon the controversy as to whether Socialism was a tragedy or a farce. Those who thought it a tragedy, envisioned it as a *political* tragedy, those who thought it a farce, envisioned it mostly as an *economic* farce. The former conceived characters like the light-hearted cabaret actress in Bugajski's *Interrogation* (*Przesłuchanie*, 1982), who discovers that there is nothing funny about a Stalinist jail. It was Bugajski's *Interrogation,* and not works by Wajda and the other filmmakers of the "cinema of moral anxiety," that became known as "the most anti-communist film in the history of the Polish cinema."[105] Even though *Interrogation* was shot in 1981 and edited in 1982, it was shelved for seven years. Its 1989 release marked the coun-

[101] Tym also wrote a play titled "Dear Mr. Ionesco!"

[102] Marek Hłasko, *Piękni dwudziestoletni* [The Beautiful 20-year olds] (Warsaw: Da Capo, 1966), 165.

[103] Ibid., 167–8.

[104] Ibid., 122–4: Marszałek, *Kino rzeczy znalezionych*, 149.

[105] Jacek Szczerba et al., "Cztery perły w tym 'Psy'" [Four pearls including *Dogs*], *Gazeta Wyborcza* (3 November 1999): 18.

try's transition to post-socialism. In a speech introducing *Interrogation* at its first public screening, Wajda declared that "this première ends the film history of People's Poland. Tomorrow will be the very first day of free Poland's cinematography."[106] *Interrogation* tells the story of a cheerful cabaret actress, hailed by one critic as the "new Antigone,"[107] who is unjustly arrested and undergoes a brutal interrogation in a Stalinist jail, in order to manufacture false charges against somebody she once knew. It is the story of her psychic transformation from recklessness and ignorance to stony defiance. When she is eventually freed, she is reunited with her daughter, who was fathered by one of her interrogators and born in jail. Just as the jail scenes were read as an allegory of Poland in the 1980s—it was not by chance that the première took place on 13 December 1989, the anniversary of the declaration of Martial Law—so the final scenes offered a spark of bitter hope for the future. The film perfectly suited the role Wajda envisioned for it—to be a cathartic moment that separated the difficult past from the brighter future, and to serve as the foundation on which Democratic Poland could bring to light a "secret truth" about communist crimes. Before *Interrogation* was first screened in 1989, it was watched on illegal video copies or read in printed samizdat versions throughout the 1980s.[108] Prevented by censorship from being publicly shown, the further it was kept out of sight, the more powerful its impact became. This role was confirmed by the avalanche of prizes it received at the Polish Film Festival in 1990, and by the Golden Palm awarded to Krystyna Janda as female lead in Cannes in the same year.

Initially a commercial success, *Interrogation* virtually disappeared from public memory and sight soon after 1990. While socialist comedies ruled supreme, modest visual productions showed Stalinism by "localizing" Hollywood clichés. Some action movies, like Jacek Bromski's *Polish Cuisine* (*Kuchnia Polska*, 1991), were inspired by the success of *Interrogation* and starred its main actress, Krystyna Janda. Others, like Janusz Kijowski in *State of Fear* (*Stan Strachu*, 1989), chose a dramatic actor as their hero. Reciting Hamlet's monologues to empty theatre seats, he plans to flee abroad, but is against his will entrusted with a suitcase full of money intended for the Solidarity underground. He decides to deliver it, even though the secret police are constantly on his back and break every-

[106] Andrzej Wajda quoted in Maria Brzostowiecka, "Nowa Antygona" [The new Antigone], *Ekran* 4 (1990): 6–7.

[107] Brzostowiecka, "Nowa Antygona," 7.

[108] Muszyńska, *Obraz codzienności*, 222.

body except him with beatings and intimidation. In Wojciech Wójcik's early film *Kill me at the End* (*Zabić na końcu*, 1990) two factory workers decide to carry out a bank robbery inspired by the script of a Hollywood action movie. Even though they find the script perfectly realistic and follow it meticulously, Polish reality proves entirely different from the film clichés. The robbery fails, and the film's refrain drives the point home: "*Casablanca* will never happen here." It was black comedy, and not black crime fiction, that turned out to be the more appropriate representation of Socialism for the wider population. It was not a political tragedy, but an economic farce told in the language cobbled together by Bareja and Piwowski (whose sense of humor Bareja exploited and continued) that turned out to be a more credible rendering of Socialism for both the population and critics of different political preferences.[109]

This victory was short-lived. Banal nationalism in a nostalgic mode was soon replaced by a slightly less benign nationalism in its neo-conservative version. Marcin Meller, who in 1998 coined the phrase "*Frugo* generation" and rebuked the superficial video-clip youth culture for its historical amnesia,[110] confessed in Maria Zmarz-Koczanowicz's documentary *Generation '89* (*Pokolenie '89*, 2001) that because of the crime prevailing in the streets, Poland needed its Giuliani, and neo-conservatism was the only way forward. A Giuliani duly arrived in the person of Lech Kaczyński, first an uncompromising minister of justice, then the "sheriff of Warsaw," and since 2005 the President of Poland. Still in the late 1990s, the old socialist TV crime series *Calling 07* (*07 zgłoś się*, 1976–1987) was more popular than professionally-made "capitalist" films such as Wojciech Wójcik's *Extradition* (*Ekstradycja*, 1995). The socialist TV series featured, as Katarzyna Wajda argued, only petty and mildly dangerous crime that seemed more realistic and appealing than the international mafia networks, exorbitant sums, ruthless characters and spectacular explosions that were the substance of new crime films.[111]

The neo-*noir* aesthetic has gradually gained realism, however, and it has done so by putting on historical costume. The plot of Wójcik's *There and Back* (*Tam i z powrotem*, 2001) virtually copied his earlier *Kill me at the End*. It too is set in the city of Łódź, but this time in 1965, where a bank robbery is organized for the purpose of buying fake passports and

[109] Ziemkiewicz, "Miś nieśmiertelny," 23.

[110] Meller, "Pokolenie Frugo," 8.

[111] Wajda, "07 wciąż się zgłasza," 41–2.

fleeing the country. If Hollywood clichés seemed unsuited to Polish reality in *Kill me at the End*, *There and Back* was saturated with a *noir*-like aesthetic: the malicious secret police in black leather coats were omnipresent, the machine-like system ruined individual talents, and the positive hero was separated from the outside world and his own family. Around 2001 the biggest private television channel TVN changed its profile and turned to portraying crime virtually non-stop. TVN journalists became masters of sensational news, and interventionist TV programs and documentaries were interwoven with crime series, Hollywood films, and reenacted court hearings; recently TVN produced a feature film about the Polish mafia.[112] It also sponsored a spectacular documentary series called *The Great Escapes* (*Wielkie Ucieczki*, 2005), partly reenacting and partly narrating real stories of people who attempted to flee socialist Poland to live a "normal" life beyond the Iron Curtain.

The vision of socialist Poland as a police state was most powerfully realized in *One day in People's Poland* (*Jeden dzień w PRL*, 2005) by Maciej Drygas, who was called by one critic "the George Orwell of Polish documentaries."[113] This film is a compilation of socialist documentaries, archival TV footage, amateur movies and socialist newsreels, edited with masterly precision and accompanied by a soundtrack of voices reading out fragments of letters, official correspondence, police reports, and even radio programs with weather forecasts. Drygas takes the viewer on a dawn-till-dusk tour through 27 September 1962, the date of a private conversation between a high party official and a Catholic bishop, of which he had found a secret recording, although eventually he did not include it in the film. The documentary is structured upon the juxtaposition of banality and terror: stories of mundane daily activities intersect with images of police surveillance (Fig. 3). Although Drygas's crew researched that day's events in various state archives, it was in the archives of the secret police, stored at the Institute for National Remembrance, that he found his key data: "Initially, I did not have a thesis to prove," he said in an interview, "but the more I immersed myself in the Institute's archives, the more I was stunned by the scale of police surveillance."[114]

[112] I owe this point to Iga Mergler. See also Bianka Mikołajewska, "Szklana Temida" [TV justice], *Polityka* 6 (2007): 89–91.

[113] Jacek Hugo-Bader, "Jeden dzień w PRL" [One day in People's Poland], *Gazeta Telewizyjna* (11 November 2005): 10.

[114] Maciej Drygas, "Ciężar prawdy" [The heaviness of truth], *Film & TV Kamera* 4 (2006): 10.

Fig. 3 An Orwellian "antidote for nostalgia" in Maciej Drygas' *One Day in People's Poland* (courtesy *Drygas Production*)

In order to show the "true image" of People's Poland Drygas, like many historians associated with the Institute for National Remembrance,[115] reproduced the secret police point of view. Unlike the authors of *The Lost Archives of the Secret Services* (*Tajne taśmy SB*, 2002), who in 2001 found a handful of "operational" footage of the main Warsaw dissidents made by the secret services and not only showed it in their documentary but also interviewed its authors and thus unveiled some fascinating aspects of the "relationship" the secret services developed with the people under surveillance, Drygas in his documentary tried to reproduce the gaze that the secret services were supposed to have trained on society at large. *One Day in People's Poland* has no individual hero, but shows Socialism as a Polish collective tragedy, sometimes with elements of farce. The jury of the Krakow Documentary Film Festival commended *One Day in People's Poland* as "a convincing account of the absurdities of a totalitarian system,"[116] and one critic recalled that even though he had

[115] Modzelewski, "IPN: kto historyk, kto trąba?" 12.

[116] http://filmpolski.pl/fp/index.php/4221231, accessed 1 February, 2007.

burst out laughing while watching it, on second thoughts the absurdities of Socialism were not funny at all.[117] Drygas's "time travel" was received as the best therapy against nostalgia.[118] It subverted the "realism" of Bareja's comedies by concentrating on the very mundane realities of everyday life and put some classic tropes from Piwowski's *The Cruise*—such as a police investigation into an anti-socialist slogan on a toilet wall, or criticism of a poem that was not "optimistic enough"—into an Orwellian account of a police state.[119]

Those who praise Drygas's documentary as the first "anti-nostalgic cure" forget that Bareja was actually the pioneer of crime cinema in Poland and had made the first Polish criminal series in the mid-1960s. It seems, however, that Bareja deliberately abandoned this genre, although police officers appear in all his comedies. The central character of his series *Alternatywy 4* (*Alternatywy 4*, 1983) is a housing-project caretaker called Stanisław Angel (*Anioł*) who tries to observe, control and terrorize the entire community he is actually supposed to help. Rather than emphasizing his power, Bareja reveals its limits, and shows how the community gets rid of him.[120] When Szołajski's *Man of...* was attacked by right-wingers Zygmunt Kałużyński wrote that they were behaving as if "they had walked into a cabaret and made a fuss that they were unable to pray there;" instead, he argued that "the filmmaker who understands that our national condition is hilarious will be a master."[121] Szołajski's film was a tribute to the tradition initiated by the prematurely dead Andrzej Munk, who was first to show the Polish tragedy tongue-in-cheek.[122] Against Kałużyński's expectation, it was not a young director, but a dead one—Stanisław Bareja—who became the post-1989 master of irony and whose popularity supported Kałużyński's opinion that, in the long run, laughter is a fairer judgment than any attempt to moralize over politics.

[117] Hugo-Bader, "Jeden dzień w PRL," 10.

[118] Tadeusz Szyma, "Koniec świata PRLu" [The end of People's Poland], *Kino* 12 (2005): 44–5; Krystyna Lubelska, "Wycieczka do PRL" [A journey to People's Poland], *Polityka* 45 (2005): 67.

[119] Wojciech Szacki, "Jeden dzień w PRL" [One day in People's Poland], *Gazeta Wyborcza* (15 November 2005): 2.

[120] Łuczak, *Miś*, 119–22.

[121] Kałużyński and Raczek, "Sprawiedliwość śmiechu," 79.

[122] Aired on "Kino Polska" TV channel on 4 February, 2005. Mirosław Przylipiak, "Kim jest dla nas Andrzej Munk" [Who is Andrzej Munk for us], *Kino* 5 (1994): 18–9; Łukasz Dziatkiewicz, "Andrzeja Munka Portret niepełny" [Andrzej Munk's incomplete portrait], *Gazeta Wyborcza* (21 January 2007): 22.

POLAND'S PROTRACTED TRANSITION

It could be argued that the cinema that turned Socialism into a fetish was in fact part and parcel of a novel genre of the Polish commercial cinema of the 1990s, often dubbed by critics as "personal," "private" or "nostalgic."[123] Its major representatives—Jan Jakub Kolski, Andrzej Barański, and Andrzej Kondratiuk—shot art-house films which praised the "slow" life of the Polish countryside, far away from the centers of power and politics. Their blend of the spirit of anti-politics with attempts at pinpointing the national character drew on the peasant lifestyle and re-valued folk culture. Even though some of their films were set in the 1950s and 1960s, any reference to the historical context was usually bracketed. For example, Kolski's *Jańcio the Water Man* (*Jańcio Wodnik*, 1991), tells the story of a folk "philosopher-errant" who is tempted to market his healing powers but finally comes to realize that material gains and physical pleasures are transitory and it is more worthwhile to search for one's private metaphysics. The only "marker" of the time is a car produced in the 1950s—a gift by some people whom Jańcio has healed.[124] Such "escapism" from the post-socialist commercial world produced a counter-reaction in the form of "socially engaged cinema."[125] However, rather then being a mere "documentation" of post-socialist realities, it drew heavily on Hollywoodian aesthetics. Krzysztof Krauze's acclaimed *Debt* (*Dług*, 1999) was a psychological thriller, based on the true story of two young businessmen murdering a psychopath who terrorizes them by demanding the return of a non-existent debt. Robert Gliński's *Hi, Tereska* (*Cześć, Tereska*, 2000), a black-and-white quasi-documentary feature on an innocent teenage girl from the Warsaw Praga district who becomes a mindless killer, was hailed as an accurate portrayal of life in the post-socialist "urban ghetto." Yet, as Marek Radziwon wrote in a devastating review, Gliński's film had grown out of a provincial desire for a "Polish Bronx" and was as inadequate as a depiction of Polish realities as the Hollywood-inspired action movies.[126] The phenomenon of post-socialist crime and the media-induced "fear"

[123] See for example Tadeusz Sobolewski, "Liczy się kino robione z pasją" [Only cinema made with passion counts], *Gazeta Wyborcza* (5 January 2004): 13.

[124] Marszalek, *Kino rzeczy znalezionych*, 102.

[125] Andrzej Kołodyński, "Wrzeciono czasu" [Time spindle], *Kino* 7–8 (2002): 44–6; "Niezapomniane, 1991–2001: polskie kino naszych czasów" [The unforgettable: Polish cinema 1991–2001], *Kino* 9 (2002): 33.

[126] Marek Radziwon, "Nie wierzcie Teresce" [Do not believe Tereska], *Dialog* 5–6 (2002): 120–8. See also the film *The Blokers* (*Blokersi*, 2001) by Sylwester Latkowski.

made it easier to ascribe all the present problems to the socialist past and the doings of post-communist criminals.

The cinematography of the 1990s and the first half of the 2000s cannot be looked at separately from the films made in the 1980s. There is a sense in which post-socialist cinematography began in 1981 with Stanisław Bareja's *Teddy Bear*. Although the 1980s are usually perceived as "stagnant," Poland was undergoing a protracted transition towards flexible capitalism, reflected also in the symbolic regime with its stark contrast between reified Socialism and Capitalism, later to become central to the 1990s order. Erstwhile party officials, strongly resembling Ryszard Ochódzki, took to the seemingly "new" capitalist reality like fish to water. 1989 was neither the end, nor the beginning, but a middle point in this "protracted transition." Even though 1989 was a breakthrough, the 1976–2006 period saw numerous continuities. As the economist Kazimierz Poznanski argued, it was Edward Gierek, the first independent Polish socialist leader, who by taking loans from Western banks and governments triggered the Polish "protracted transition."[127] Although initially Gierek's modernization project seemed to work, in 1976 his government began to lose control over it, and the concomitant crisis years pulled socialist Poland into the orbit of global "casino Capitalism," where fluctuating exchange rates became a prime factor determining the stability, or otherwise, of local economies.[128]

The bizarre economic regime of 1980s Poland, where the only real value—"hard" currency—was officially banned and where the pockets of "capitalist" private entrepreneurship gradually prevailed over the official state economy, was an example of a classic post-Fordist restructuring and devaluation of industrial spaces that took off in the early 1970s in the world at large.[129] Even though the socialists and the alternative elites promoted by the Solidarity trade union were officially engaged in a deadly symbolic strife, their goals were quite convergent—both sides hoped to end the "surreal" situation and restore "normality."[130] Commodity fetishism and the consumer culture that was so painfully experienced in Poland

[127] Kazimierz Poznański, *Poland's Protracted Transition: Institutional Change and Economic Growth 1970–1994* (Cambridge: Cambridge University Press, 1996).

[128] Susan Strange, *Casino Capitalism* (Oxford, UK: Blackwell, 1986).

[129] Harvey, *The Condition of Postmodernity*, 284–307.

[130] Kurczewski, *The Resurrection of Rights in Poland*, 117–8, 351–2; Dariusz Grala, *Reformy gospodarcze w PRL w latach 1982–1989. Próba uratowania socjalizmu* [Economic reforms in Poland between 1982 and 1989. An attempt to rescue Socialism]. (Warsaw: Trio, 2005).

in the early 1990s had first taken root in the early 1970s and dominated the "occult" economy of the 1980s. The post-Fordist aesthetics and new national culture, reflected in the films of Piwowski and Bareja, received full acclaim in the 1990s, becoming part of an emerging regime that sought to reinvent the local "culture" in order to find a stable anchor for value.

FILMOGRAPHY

Alternatywy 4 (*Alternatywy 4*, Stanisław Bareja, Poland, 1983)

At Full Gallop (*Cwał*, Krzysztof Zanussi, Poland, 1996)

Bareizm (*Bareizm*, Agnieszka Arnold, Poland, 1997)

Calling 07 (*07 zgłoś się*, Krzysztof Szmagier, Andrzej Jerzy Piotrowski, Kazimierz Tarnas, Poland, 1976–1987)

Controlled Conversations (*Rozmowy kontrolowane*, Sylwester Chęciński, Poland, 1991)

Death as a Slice of Bread (*Śmierć jak kromka chleba*, Kazimierz Kutz, Poland, 1994)

Debt (*Dług*, Krzysztof Krauze, Poland, 1999)

Description of Customs (*Opis obyczajów*, Mikołaj Grabowski, Poland, 1990)

Dignity (*Godność*, Roman Wionczek, Poland, 1984)

Dogs (*Psy*, Władysław Pasikowski, Poland, 1992)

Dreams are more interesting (*Marzenia są ciekawsze*, Stanisław Janicki, Poland, 1999)

Extradition (*Ekstradycja*, Wojciech Wójcik, Poland, 1995)

Four Troopers and a Dog (*Czterej pancerni i pies*, Konrad Nałęcki, Andrzej Czekalski, Poland, 1966–1970)

Generation '89 (*Pokolenie '89*, Maria Zmarz-Koczanowicz, Poland, 2001)

Hi, Tereska (*Cześć, Tereska*, Robert Gliński, Poland, 2000)

History of a Camera (*Historia pewnej kamery*, Maria Zmarz-Koczanowicz, Poland, 1993)

Hydro-Puzzle (*Hydrozagadka*, Andrzej Kondratiuk, Poland, 1970)

Interrogation (*Przesłuchanie*, Ryszard Bugajski, Poland, 1982)

Jańcio the Water Man (*Jańcio Wodnik*, Jan Jakub Kolski, Poland, 1991)

Kill me at the End (*Zabić na końcu*, Wojciech Wójcik, Poland, 1990)

Man of... (*Człowiek z...*, Konrad Szołajski, Poland, 1993)

Man of Marble (*Człowiek z marmuru*, Andrzej Wajda, Poland, 1976)

Man of Iron (*Człowiek z żelaza*, Andrzej Wajda, Poland, 1981)

One day in People's Poland (*Jeden dzień w PRL*, Maciej Drygas, Poland, 2005)

Segment '76 (*Segment '76*, Oksar Kaszyński, Poland, 2003)

Sexmission (*Seksmisja*, Juliusz Machulski, Poland, 1983)

Snatch (Guy Ritchie, United Kingdom, 2000)

State of Fear (*Stan Strachu*, Janusz Kijowski, Poland, 1989)

Sunday Pranks (*Niedzielne igraszki*, Robert Gliński, Poland, 1983)

Sztos (*Sztos*, Olaf Lubaszenko, Poland, 1997)

Taxi Drivers (*Zmiennicy*, Stanisław Bareja, Poland, 1986)

Teddy Bear (*Miś*, Stanisław Bareja, Poland, 1980)

The Blokers (*Blokersi*, Sylwester Latkowski, Poland, 2001)

The Cruise (*Rejs*, Marek Piwowski, Poland, 1970)

The Fashionable 1980s (*Moda na Obciach*, Piotr Boruszkowski, Sławomir Koehler, Poland, 2003)

The Great Escapes (*Wielkie Ucieczki*, Grzegorz Madej, Radosław Dunaszewski, Wojciech Bockenheim, Poland, 2005)

The Hijacking of Agata (*Uprowadzenie Agaty*, Marek Piwowski, Poland, 1993)

The Last Schoolbell (*Ostatni dzwonek*, Magdalena Łazarkiewicz, Poland, 1989)

The Lost Archives of the Secret Services (*Tajne taśmy SB*, Piotr Morawski, Poland, 2002)

The Sting (George Roy Hill, USA, 1973)

There and Back (*Tam i z powrotem*, Wojciech Wójcik, Poland, 2001)

Uplifted (*Wniebowzięci*, Andrzej Kondratiuk, Poland, 1973)

What Will You Do When You Catch Me? (*Co mi zrobisz jak mnie złapiesz?*, Stanisław Bareja, Poland, 1978)

"We Have Democracy, Don't We?"

Czech Society as Reflected in Contemporary Czech Cinema[1]

PETRA DOMINKOVÁ

The "Velvet Revolution" in November 1989 brought about enormous changes in the political and social environment: the communist regime was abolished and after forty-one years democracy was reestablished in Czechoslovakia. In art, the most important change brought by the Revolution was the end of censorship. Since 1989 artists have been allowed to do as they wish—as long as they can find the funding. Film in socialism was funded exclusively by the state, but since about 1990 the state has not been responsible for what is produced and, not surprisingly, the authorities have cut the subsidies of the costly film industry. Compared to other arts, cinema has faced greater challenges, for even the most independent production needs *some* money for filming.

Miloš Forman, the Czech director who has been living in the U.S. since 1968, once perceptively observed that Czech film in the early 1990s was in transition between a greenhouse and a jungle.[2] Filmmakers had to get used to the free market, to competition and, above all, to the new situation in financing. The average cost of a Czech film today is about thirty million Czech Korunas (CZK) (approximately USD 1.5 million) and due to the limited possibilities of distribution it is extremely difficult to cover expenses.[3] The only state subsidy comes from the State Fund of the Czech Republic for the Support and Development of Czech Cinema[4]

[1] I would like to thank John Fackenthal for his indispensable help with the first version of this article, his many useful suggestions and his infinite patience.

[2] Boca Abrhámová, "Czech Film in 1992" in *Filmová ročenka/Film Yearbook 1992* (Prague: NFA, 1993), 20.

[3] Details about the impossibility of covering the expenses of Czech films and about their distribution in the Czech Republic can be found in T. Dvořáková, "Rozhovor s Janem Bradáčem" [Interview with Jan Bradáč], *Cinepur* 12 (November 2003): 37–8.

[4] Further information available at www.mkcr.cz/statni-fondy/fond-pro-podporu-a-rozvoj-ceske-kinematografie/default.htm (accessed 19 January, 2006).

(Státní fond ČR pro podporu a rozvoj české kinematografie) which has an annual budget in the tens of millions CZK. This amount is distributed to dozens of projects: feature films, short films, festivals, and support for local cinemas.[5] Considering that over the last decade about twenty new features per year have been produced, it is obvious that funding must have come mainly from other sources.[6]

The situation was particularly critical in the first couple of years after the "Velvet Revolution." While twenty-nine features were produced in 1989,[7] and twenty-eight in 1990 (the majority of which were shot before November 1989), in 1991 only four features were made.[8] The next year eight films were completed and in 1992 there were fifteen.[9] From that moment on there have been approximately twenty films produced annually in the Czech Republic. Between 1990 and 2006 about 300 fiction features have been produced altogether.

Czech critics regularly express doubts about the quality of post-1989 cinema. For instance, Stanislava Přádná complained that she had found it difficult to pick Czech films to write about since she had grown "intensely skeptical because of the blandness and mediocrity of most of the Czech film production in the past decade. Was there anything of universal interest, something that transcended the merely local, if not provincial dimension?"[10] The contributors to the November 2003 issue of *Cinepur*, which was devoted to Czech contemporary cinema, were more specific. For ex-

[5] For example, in June 2006 70,953,520 CZK were distributed to forty-three projects, and in January 2006 41,160,000 CZK to forty-six projects. See www.mkcr.cz/scripts/detail.php?id=225 (accessed 19 December, 2006).

[6] For further details on the financing of Czech films, see A. Danielis, "Proč na tom jsme právě takhle" [Why we are in this situation], *Film a doba* 44 (Spring-Summer 1998): 4–6.

[7] Since 1991 the Audiovisual Producers' Association (*Asociace producentů v audiovizi*, or APA) has published a yearly catalog of Czech films. Information about film production from the year 1991 and forward is taken from these catalogs. The older data are taken from V. Březina, *Lexikon českého filmu* [The encyclopedia of Czech cinema] (Prague: Cinema, 1996). Information on how many films have been produced each year varies according to which source one uses. For example, Václav Březina claims that in 1991 ten films were produced. APA, however, listed some of them among the films made in 1992.

[8] It is interesting that a similar drop in production had already occurred once in the history of Czech cinema—after World War II. While nine films were produced in 1944, only three were completed in 1945. The following year the number rose to twelve. V. Březina, *Lexikon.*

[9] According to V. Březina, nine films were produced in 1992 and nineteen films in 1993.

[10] Stanislava Přádná, "The Czech Cinema," available at www.artmargins.com/content/cineview/padna20020130.html (accessed 20 February, 2007).

ample, one of them argued that the "recipe" of today's film is the following: "The narration is exclusively restricted to personal relationships. Real society—political, economic, social issues—does not exist in the world of Czech films; if something like that appears, it is just inessential background. Thus, there are no film characters who would take a stance on politics, who would have any problem—either existential or social. (...) As a rule, our protagonists do not work (...), they do not study (...), they do not do business and they have no 'higher aims.' They are not committed to anything."[11] Although I may have reservations about both assertions—there are certainly *some* films that transcend the provincial dimension and there are certainly *some* protagonists who work and care—I have to admit that these claims definitely apply to the majority of Czech contemporary cinema, whether it deals with the past or the present.

Contemporary Czech cinema is sometimes compared to the so-called Czechoslovak New Wave (CNW)[12] in an attempt to prove the mediocrity of post-1989 cinema. Peter Hames, discussing a few contemporary examples, claims that in these films "[t]here is none of the critical angle."[13] He believes that the New Wave films better convey the national past: "One cannot help but feel that the 1960s New Wave would have come up with films on the collective experience that were much more critical and analytical."[14] The same point is made in the above-mentioned work by Přádná; nevertheless, she also points out the most significant difference between the 1960s and the post-1989 cinema: financing. State subsidies during the communist period meant that directors were not concerned with

[11] Martin Švoma, "Je umělej!!! aneb Několik nejistých tendencí současného českého filmu" [It is Artificial!!! or Some Uncertain Tendencies in Contemporary Czech Cinema], *Cinepur* 12 (November 2003): 23.

[12] Czechoslovak New Wave is a term used for the films made in the 1963–1968 period by FAMU students and graduates such as Jiří Menzel, Věra Chytilová, Miloš Forman, Ivan Passer, Pavel Juráček, Drahomíra Vihanová, Evald Schorm, Antonín Máša, and others. The literature about CNW is quite extensive; the basic works are Peter Hames, *The Czechoslovak New Wave* (London: Wallflower Press, 2005); J. Žalman, *Films and Filmmakers* (Prague: Orbis, 1968); J. Škvorecký, *Všichni ti bystří mladí muži a ženy: Osobní historie českého filmu* [All the bright young men and women: A personal history of Czech cinema] (Prague: Horizont, 1991); S. Přádná, Z. Škápová, J. Cieslar, *Démanty všednosti: Český a slovenský film 60. let: Kapitoly o nové vlně* [Diamonds of common life: Czech and Slovak film in the 1960s: Chapters about New Wave] (Prague: Pražská scéna, 2002).

[13] Peter Hames, "The Ironies of History: The Czech Experience" in Anikó Imre (ed.), *East European Cinemas* (London: Routledge, 2005), 148.

[14] Ibid., 149.

the box-office success of their films. Since 1989, "*auteur* cinema" has been replaced by "producers' cinema," and producers need at least to cover their expenses, if not make a profit. The dependence upon the audience may be one reason why contemporary films are less challenging in terms of their portrayal of the past. However, society has changed as well. It is no coincidence that when censored films from the 1960s were released after the "Velvet Revolution" (some of them for the first time, some re-released) they did not receive much attention from the audiences. As Přádná stated, New Wave films "had become out-of-date and obsolete."[15] I will discuss some of the CNW films later in comparison with contemporary Czech films. I will further review and analyze the attitudes towards Czechoslovak Socialism in films in past settings as well as contemporary ones. This article is divided into two parts—in the first I focus on how directors portray the socialist period and in the second I discuss the breakthroughs and continuities in representing contemporary society.

RETRO-FILMS IN CONTEMPORARY CINEMA

The number of films set in the communist past is quite limited—only about twenty were made after the change of the regime. Five of them, all comedies, were highly successful in the Czech box office: *The Tank Battalion* (*Tankový prapor*, 1991), *The Black Barons* (*Černí baroni*, 1992), *Kolya* (*Kolja*, 1996), *Cosy Dens* (*Pelíšky*, 1998), and *Pupendo* (2003). Although the others referred to below were not commercial hits, some of them were well received by the critics and deserve mention.

Box office figures from the years 1991–2001 show that the most successful film released in this period was *The Tank Battalion*,[16] directed by Vít Olmer, which was seen during the first decade after its release in what was then Czechoslovakia by more than 2,000,000 people (that is, almost twice as many as those who watched *Titanic* in the same period).[17] Second on the list is *The Black Barons* by Zdenek Sirový with 1,471,000 specta-

[15] Přádná. "The Czech Cinema." It seems that similar experiences were shared by many East European countries. See for example Dina Iordanova, *Cinema of the Other Europe: The Industry and Artistry of East Central European Film* (London, NY.: Wallflower Press, 2003), 36.

[16] *The Tank Battalion* is considered the first Czech private film made since the nationalization of cinema in August 1945.

[17] *České filmy: katalog 1991–2001* [Czech Films: Catalogue 1991–2001] (Prague: APA, 2002), 243.

tors. Both are comedies that depict obligatory military service in the 1950s. Both feature jolly young men who "intelligently resist the stupidity and constant harassment of communist brass-hats, and think only of their life in civvy street, women and hard liquor."[18]

While *The Tank Battalion* shows "normal" military service, *The Black Barons* focuses on the so-called *Pomocný technický prapor* (PTP, or Technical Collateral Battalion). PTPs were the special battalions in the period between 1950 and 1954, designed for young men believed to be dangerous to the communist regime. Altogether about 60,000 men were forced to join this branch of the military. For one reason or another they did not match the official image of a devoted member of communist society: they were the sons of factory or farm owners (seen as "exploiters"), priests, students of theology, or *kulaks*. The conditions in PTPs were difficult: the men were forced to work hard in mines, forests, or quarries and unlike "normal" service, which lasted two years, were drafted for four years. Casualties were common. Under the communist regime the PTPs hushed up; their existence was not made public until 1989. During the 1960s, there was only one film on the subject: Jaromil Jireš's *The Joke* (*Žert*, 1968), based on Milan Kundera's novel, was almost immediately banned and not seen by ordinary viewers until 1989.

The Joke narrates the bitter story of a man who is expelled from the Communist Party and from university because of a harmless joke. He spends some time in a PTP, experiencing ceaseless harassment and bullying by the officers. In contrast to *The Joke*, *The Black Barons* shows a PTP as a slightly ridiculous, but not really bad, battalion where the men had a lot of fun and the officers were idiotic, but harmless. Surprising as it may seem—but in fact not at all rare—since the "Velvet Revolution," Czech directors have preferred comedy to other genres and have chosen to show even the most tragic episodes from Czech history as situations in which nothing discourages people having fun. As Peter Hames points out, "[p]eople continue to live, have relationships, and raise families, often responding to the situations in which they find themselves with irony and humor."[19]

Another taboo subject before 1989 (with the exception of the short period in the 1960s) was the communist-run prison camps. Between 1948 and 1989 there were altogether about 200,000 people in these camps. About 4,500 died for various reasons: 248 were executed, a few hundred committed suicide, others died due to work injuries or illness, some were

[18] Ibid., 55.
[19] Hames, "The Ironies," 137.

killed by the guards; most of the casualties occurred during the 1950s.[20] One political prisoner who spent seven years in prison was Jiří Stránský (born in 1931). After 1989, he became a freelance writer; three of his novels were turned into films, all of them set in the 1950s. Two take place in prison camps: *Boomerang* (*Bumerang*, 1997) by Hynek Bočan and *A Little Piece of Heaven* (*Kousek nebe*, 2005) by Petr Nikolaev. Both films treated the topic seriously and both received only moderate audience response. *Boomerang* shows the story of male prisoners working in a uranium plant, while *A Little Piece of Heaven* focuses on the relationship between a male and a female prisoner. The latter recalls *Larks on a Thread* (*Skřivánci na niti*, 1969) directed by Jiří Menzel, which due to its critical stance was not released until 1990. In both films the romance of a couple inside the prison walls appears rather implausible, considering the harsh conditions that political prisoners were forced to live under. *Larks on a Thread* focuses on the relationship between Pavel, a cook and political prisoner, who did not want to work on Saturdays for religious reasons, and Jitka, a woman imprisoned for attempting to flee the country. Although male and female camps are strictly divided, Pavel and Jitka always somehow manage to meet. Eventually they even get married thanks to the kindness of a prison guard. The couple in *A Little Piece of Heaven*— Luboš, who is in prison mainly because he is the son of an executed "enemy of the state," and Dana, whose crime is not clear—also manage to see each other quite often, raising objections from critics. Finally, they are even allowed to spend a night together when a prison guard is bribed by sex with another female inmate.

In both films the 1950s period is only the background for a love story that could happen anywhere where restrictions are imposed on people—be it a concentration camp, any prison at any time, any kind of asylum, any single-sex college, and so on. In *A Little Piece of Heaven* in particular, the "markers" of the 1950s are inserted into the story quite artificially. They include a fight between an inmate who appears in the film only for this purpose, and a former ambassador of Czechoslovakia to the UN, who proudly states that there are no political prisoners in the country. The scene is not connected to the rest of the story and could have been cut completely without affecting the plot. A trustworthy and competent film about 1950s Czechoslovakia is yet to be made.

[20] Zdenek Mihalco, "Komunistická vězení: 4500 mrtvých" [Communist prisons: 4,500 dead], available at http://aktualne.centrum.cz/domaci/zdravi-skola-spolecnost/clanek.phtml?id= 276127 (accessed 20 February, 2007).

One topic that was not exactly taboo in pre-1989 cinema, although its depiction was highly biased, is the invasion of Czechoslovakia by the Warsaw Pact forces on August 21, 1968. A number of films from the 1960s that attempted to portray the events of 1968 in a complex and critical way were banned shortly after they were made—among them *The Seventh Day, the Eighth Night* (*Den sedmý, osmá noc*, 1969) by Evald Schorm, not shown until 1990. The mainstream cinematographic interpretations of the 1970–80s tended to give the events of 1968 an "officially approved" reading. These films are sometimes set in small villages with the honest folk threatened by the "rightists" and "capitalists" who are only out for their own profit, sometimes in cities where Prague Spring sympathizers are usually involved in criminal activities. For example, *Where the Storks Nest* (*Tam kde hnízdí čápi*, 1975) by Karel Steklý tells the story of the head of a successful cooperative struggling with the "anti-socialistic elements" who attempt to infiltrate the county offices. In the same year Vojtěch Trapl directed *The Knell Won't Be Tolled* (*Tobě hrana zvonit nebude*), about a lady who was attacked in the summer of 1968 by a group of people because of her husband, a devoted member of the Communist Party of Czechoslovakia.

While one might have expected these unlikely stories to be replaced after November 1989 by more plausible narratives attempting an unbiased representation of the events of 1968—the Prague Spring and the invasion—nothing of the sort happened. In fact, there are only two contemporary films set in the 1960s, *The Rebels* (*Rebelové*, 2001) by Filip Renč and *Cosy Dens* by Jan Hřebejk, and a few where the 1960s appear as only one historical episode within a longer time-frame (like, for example, *Wonderful Years that Sucked/Báječná léta pod psa*, 1997 or *Kolya*).

The Rebels is a musical about the relationship between two teenagers, Šimon and Tereza. Šimon deserts during his military service and wants to emigrate to the U.S. When the opportunity to emigrate appears, Šimon finally decides to stay in the Czech Republic because of Tereza. However, she does not know this and, believing that Šimon has left, joins her father who decides to emigrate to Germany as soon as he hears that the Warsaw Pact is invading Czechoslovakia. There is no happy ending: the audience is well aware that the couple may never meet again. Although the summer of 1968 is chosen as a time-frame, the overall mood—apart from the ending—is joyful. The emphasis is on the popular 1960s music, the colorful fashions, and of course the love story.

While *Cosy Dens* (seventh in the box office between 1991 and 2001 with over one million spectators) is not a musical, it is also richly accompanied by 1960s songs which contribute to the same joyful atmosphere

that we met in *The Rebels*. *Cosy Dens* tells the story of two neighboring
families, one loyal to the communist regime and the other opposed to it.
While the film is set in a tumultuous epoch "there is little reference to the
changes and debates of the period."[21] Instead, Hřebejk "presents the times
much more in terms of the everyday experience of fairly ordinary peo-
ple."[22] And as Přádná emphasizes, "[a]midst all the laughter, one almost
forgets that the character must have been a loyal servant of the totalitarian
regime with all its inhuman repression and atrocities."[23]

Interestingly, it is the period of "normalization"[24] which is treated in-
creasingly often in contemporary Czech cinema. For example, Vladimír
Michálek in *The Forgotten Light* (*Zapomenuté světlo*, 1996) focuses on an
issue that is very rarely discussed: the struggle between the clergy and the
communist state. Among the films appreciated by the broad audience are
two others (both seen by over one million viewers) that portray the epoch
of normalization—*Kolya* by Jan Svěrák (which won the Oscar for Best
Foreign Language Film in 1997) and *Pupendo* by Jan Hřebejk. *Kolya*
focuses on a sham marriage between a Russian woman and a Czech man.
Soon after the wedding she emigrates to West Germany and leaves her
son, the five-year-old Kolya, in the Czech Republic. The plot evolves
around the numerous difficulties that Kolya and his stepfather face.
Svěrák touches on a few issues connected with contemporary reality: the
presence of Soviet soldiers in the Czech Republic, the humiliation of peo-
ple who were not members of the Communist Party, the "Velvet Revolu-
tion," "changing coats,"[25] and so on. However, *Kolya* as a whole appears
to be little more than "an easily digestible formula that employs humor
and nostalgia," as Anikó Imre believes.[26]

The story of *Pupendo* is similar to that of *Cosy Dens*. Again we see the
problems faced by two families, one of them involved with the Commu-

[21] Hames, "The Ironies," 136.

[22] Ibid., 142–3.

[23] Přádná, "The Czech Cinema."

[24] "Normalization" is the name commonly given to the period from 1969 to about 1987. It
was characterized by initial restoration of the conditions prevailing before the reform
period led by Alexander Dubček (1963–1968) and subsequent preservation of this new
status quo.

[25] "Changing coats" (in Czech *převlékání kabátů*) is a term for a sudden change of loyal-
ties, usually with the aim of self-preservation, for example leaving the Communist Party
(KSČ) after November 1989 to avoid the troubles that might have resulted from mem-
bership.

[26] Anikó Imre, "Introduction: East European Cinemas in New Perspectives" in Imre (ed.),
East European Cinemas, xvii.

nist Party, the other not. Bedřich, once a successful sculptor, is prevented for political reasons from working freely. Instead of making real sculptures, he produces kitsch ceramic pigs and money boxes shaped like buttocks with ears. The whole family is involved in his "business" and none of them have anything to do with politics. Míla and Magda Břečka, the other family, are both members of the Communist Party and hold respectable positions: Míla is a headmaster and Magda, Bedřich's former student, has an important post in the artists' union. The two families are brought together when Bedřich is given a chance to create a mosaic and later on a statue of the Soviet World War II military commander Marshal Rybalko. There are some contemporary references, for example to the radio broadcasts of the Voice of America that were widely listened to in reality. However, the portrayal of Communism and Communists, in Hames's words, "does not extend beyond stereotypes—the featureless, characterless man who heads the union, the 'fellow travelers' like the Břečkas, who seek to protect the children and do a little good along the way. Significantly, they do not take any major initiatives themselves."[27]

The transformation of the regime in November 1989 rarely emerges as a subject in Czech cinema. The few films that show archival footage or a reconstruction of the happenings date from the early 1990s. Later on, filmmakers rarely felt the need to return to the "Velvet Revolution" and subsequent events. Some references to 1989 are found in *The Little Hotel in the Heart of Europe* (*Hotýlek v srdci Evropy*, 1994), *Kolya, The Small Town* (*Městečko*, 2003) and *The Beginning of a Long Autumn* (*Začátek dlouhého podzimu*, 1990). The most extensive representation of transformation, however, is to be found in *It's Better to Be Wealthy and Healthy than Poor and Ill* (*Lepšie byť bohatý a zdravý ako chudý a nemocný*, 1992). The story begins before a demonstration on 17 November, 1989. We witness the gatherings, the singing of the anthem, the speeches by all kinds of speakers, including archival footage. The two heroines of the film meet during one of the demonstrations: Nona is a photojournalist and Esther is one of the anonymous figures who have the opportunity to make a speech on stage. Surprisingly, this is the only film where the motif of the "destruction of barriers" appears literally, when the wire fence that used to separate the Czech Republic from its western neighbors, Germany and Austria, is severed. In another episode Soviet officers are trying to sell machine guns to the heroines. Although it was common knowledge that the Soviet soldiers who were forced to leave

[27] Hames, "The Ironies," 147.

the Czech Republic in the 1990s tried to sell anything they could at bargain prices, this is the only scene in Czech cinema that deals with the issue.[28]

A brief overview of contemporary cinema, then, demonstrates that there are not many references to the Czechoslovak past in Czech films, and that those that do appear are seldom more than superficial hints or background for melodramas or comedies. Can it be that Czech society, together with Czech film directors, is experiencing a sort of amnesia towards its recent history? A discussion of contemporary society as portrayed in recent films may help to answer this question.

CONTEMPORARY SOCIETY: A NOT-SO-BRAVE NEW WORLD

The post-1989 cinema illustrated the advantages and disadvantages of a new political situation in comparison with the communist regime. This was particularly the case with the films made during the first five years after the "Velvet Revolution," and sometimes later. When the benefits of the transition are portrayed—the possibility of travel, the chance to run one's own business, freedom of speech—they are presented as obvious and natural. At the same time the filmmakers are at pains to point out that for each advantage there must always be some disadvantage: true, people travel but do not have enough money and do not know the languages; yes, many run their own business, but they do not know how to do it and are constantly cheated and trapped; indeed, there is freedom of speech, but the fear of the old days when "the walls still had ears" remains deeply embedded in many. In fact, the downsides of the new regime, including increasing unemployment, homelessness, the rising prices, and "coat-changing" are shown constantly.

The films intended to depict contemporary society (about 150 in total) are usually comedies or satires.[29] These genres were always prominent in Czech cinema, and as mentioned above, even a topic like the PTP, which

[28] In 1990 there were still about 92,000 Soviet soldiers and officers in the Czech Republic, and another 45,000 of their relatives. After 1989 it was decided that they would have to leave Czechoslovakia. However, it was not until June 21, 1991 that the last Soviet soldier left the country.

[29] Talking about Hungarian, Polish, Czech, Slovak, and Eastern German cinema, Iordanova stated: "Many of these films [that dealt with new social problems] were satires, as it seemed that satire was the most appropriate tone which would reflect the situation." Iordanova, *Cinema of the Other Europe*, 151–2.

is anything but funny, was shown in comedy instead of drama. Although it may seem strange for directors who have overnight been freed from censorship to miss an opportunity to provide a serious portrayal of their society, it is still understandable, considering the strong Czech tradition of treating any topic, even the most tragic, in a comic manner. For instance, in 1947, two years after the end of World War II, Josef Mach directed a comedy set during the German occupation of the Czech lands, called *Nobody Knows Anything* (*Nikdo nic neví*), in which two tram drivers who believe that they have killed a Nazi try to hide the body. Finally it turns out that their "victim" was drunk and simply passed out. This comedy is still popular today. When reading about contemporary cinema we rarely find films classified simply as "comedies"—the word is usually accompanied by adjectives like "musical," "nostalgic," "period," "bitter," "bittersweet," or given the prefix "tragi-". If it is not a comedy, it is an "ironic story" or a "grotesque reflection."[30] It sometimes feels as if the Czechs have invented a few sub-genres in order to make the majority of films fit somehow into the broad genre of "comedy."

Even if some of the comedies did not win praise from the critics, many were great popular hits. For example, by the end of 2001 *Sun, Hay and Eroticism* (*Slunce, seno, erotika*, 1991) and *The End of Poets in Bohemia...* (*Konec básníků v Čechách...*, 1993) had both been seen in ex-Czechoslovakia by nearly a million spectators, *The Inheritance or Fuckoffguysgoodday* (*Dědictví aneb kurvahošigutntag*, 1992) by about 810,000 and *She Picked Violets with Dynamite* (*Trhala fialky dynamitem*, 1992) by almost 740,000. In comparison, during the same period, of two American blockbusters shown, *Jurassic Park* attracted approximately 1,160,000 spectators and *Titanic* approximately 1,060,000.[31]

These films treated the "Czech common man" in a far from flattering tone. Yet, as Přádná argues, "viewers were not in the least offended by this unflattering portrayal. On the contrary, they were amused and delighted, without feeling any need to identify with this distorted portrait."[32] In most of these films the Czechs are portrayed as incompetent, clumsy, but harmless creatures who have no particular gifts, but who are still able to achieve their goals in whatever way they choose.

This concept of seemingly idiotic but in fact cunning characters reminds us of "the good soldier Švejk," the protagonist of Jaroslav Hašek's

[30] All these epithets have been used in APA catalogues, see note 7.
[31] *České filmy*, 243.
[32] Přádná, "The Czech Cinema."

novel first published in 1912. He is often believed to represent the "typical Czech": being smart, he often chooses to play the imbecile, because it makes his life much easier—when he does not want to do something, he just pretends he does not understand what he is supposed to do. However, while in some respects we might find that the characters in the films discussed below resemble Švejk, the ones above unfortunately do not show any sign of cleverness.

Sun, Hay and Eroticism was directed by Zdeněk Troška, who so far has made exclusively fairy tales and comedies. His films are popular with audiences but less warmly received by the critics. *Sun, Hay and Eroticism* is the third in a series; the previous two—*Sun, Hay and Strawberries (Slunce, seno, jahody)* and *Sun, Hay and a Couple of Slaps (Slunce, seno a pár facek)*—were made in 1984 and 1989 respectively. While the earlier two comedies, set entirely in a small village in south Bohemia, depict the relationships between neighbors and colleagues, the third is about an exchange trip between Italian and Czech cooperatives. In fact, the title itself reveals that this is a post-1989 film: "eroticism" in a title was quite unimaginable for a "socialist" film. Furthermore, this film added a new motif to the trilogy: travel to the "West."

At the beginning of *Sun, Hay and Eroticism* a group of Czechs visit an Italian town to discuss modern work methods. In return they invite the Italians to the Czech Republic. As love affairs develop between Czech women and Italian men, the representations of the "locals" suggest that the Czechs are uncouth people who have no manners. According to the story, the only way the Czechs can entertain the Italian visitors is by putting on an erotic performance, and the only thing that any Czech woman desires is to marry a foreigner.

She Picked Violets with Dynamite is so similar to *Sun, Hay and Eroticism* that for many people the two films blend into one indistinct compound. Both comedies depict a simple-minded suburban family challenged by contact with foreigners. The female leads of both films are played by the same actress, Helena Růžičková. Some thirty years ago she played Mrs. Homolka in a trilogy about a suburban family of the 1960s. *Behold Homolka (Ecce homo Homolka,* 1969), *Dandy Homolka (Hogofogo Homolka,* 1970) and *Homolka and Pouch (Homolka a tobolka,* 1972) were all directed by Jiří Papoušek, who often worked with Miloš Forman in the 1960s. His "Homolka" series is still very popular and the *Sun, Hay...* trilogy and *She Picked Violets with Dynamite* are attempts to continue this tradition of "ordinary family" stories. The latter centers on a family from a small town who decide to open a travel agency. They or-

ganize a trip to France, where they plan to find customers interested in going to the Czech Republic. Even though they succeed, the way in which they behave and handle the business is shameful. For example, when they arrive back in the Czech Republic, they realize that no accommodation has been prepared and they put the French guests up in a stable, pretending that this was the original plan.

The End of Poets in Bohemia... is a sequel to a very successful series about "poets"—young men who occasionally write verses to attract a girl— from the 1980s. Šafránek, the protagonist, has completed his medical training but cannot find a job. He decides to open his own clinic but the banks refuse to give him a loan. He is well aware of consumerism in the new society, but is nevertheless shocked by the porn magazines in the newsstands, the slot machines in restaurants, and the advertisements everywhere. However, overcoming his initial aversion to advertising, he ends up working in the field of marketing. Over the past decade advertising has penetrated daily life; film protagonists are no longer surprised by its omnipresence (*Accumulator I*, 1994; *Little Otík*, 2001; *The Trash*, 2002), and the hero's job is sometimes that of an ad man (*Traps*, 1998; *From Subway with Love*, 2005).

Political life and proliferating political parties are also used as a noticeable "marker" of the new times. Some parties appearing in films are non-existent: in *The Little Hotel in the Heart of Europe* a man played by Jiří Krytinář (a well-known dwarf actor, who has appeared in numerous Czech films) claims that he founded The Party of Lilliputians. In other cases the parties are real, however incredible they may sound: in *Small Town* a few men join the Independent Erotic Initiative (*Nezávislá erotická iniciativa*, or NEI)[33] and win the country's first free election. References to the Civic Democratic Party (*Občanská demokratická strana*, or ODS), currently the most successful political party in the Czech Republic and the winner of the parliamentary election in July 2006, appeared only twice in films made after 1989. In *Still a Bigger Noodle Than We Hoped for* (*Ještě větší blbec, než jsme doufali*, 1994), the speaker addresses the non-party members as: "Ladies and gentlemen, dear ODS," and in *Small Town*, the citizens, mostly members of the NEI, make jokes about the ODS poster featuring a blue bird as a symbol of the party. Since "bird" (*pták*) in Czech is a vulgar expression for a penis, this scene obviously ridicules the ODS.

[33] NEI was founded in February 1990. It was characterized by an open approach to eroticism and was also involved in the sex industry. In a European Parliamentary Election in 2004 it was represented by porn-star Dolly Buster and won 0,71%: one of its best results ever.

The scene could also be read as a comment on a bizarre situation in recent politics: having won the election in 1998, the ODS made a deal with its biggest rival, The Czech Social Democratic Party (*Česká sociální demokracie*, or ČSSD), unpleasantly surprising its own voters. The agreement applied to the whole period from 1998 to 2002 and cost the ODS many of its supporters. Consequently, the party lost the 2002 election to the ČSSD.

High-level politics appears in *Traps* by Věra Chytilová. As Přádná pointed out, in this film Chytilová "acutely perceives the evolution of Czech society, as well as its moral decay."[34] In fact, Chytilová has been doing so throughout her career. She has always portrayed contemporary society and dealt with issues that were overlooked or tabooed, often focusing on gender issues. *Traps* is no exception. It tells the story of a girl who is raped and in revenge castrates the rapist and his helper. However, instead of being seen as a victim, she is condemned by society, including her friends. This is mainly due to the fact that the rapist, Dohnal, holds considerable power as a deputy to the Minister of Ecology and uses his position to present himself to the media as a victim of assault. The other issue addressed by Chytilová is corruption in high-level politics. Dohnal has close links with the businessman Bach, who persuades him to change the route of a planned highway in order to profit from building a motel and a petrol station next to it. The easily corrupted Dohnal ignores the interests of his office, preferring to cultivate a good relationship with a *nouveau riche*. Dohnal is also portrayed as a careerist, who moves from one political appointment to another without holding proper qualifications for any. In one scene he complains: "I shouldn't take this ecology thing. When I was in the Ministry of Industry, we had a much better time."

All the films discussed in this section deal with the new issues that were brought by the new regime: private property, enterprise, travel to western countries, the clash with foreign cultures, and so on. All were made by middle-aged directors, most of whom had experience in film or television. They all focused on "simple" Czech people of limited education (with the exception of doctor Šafránek in *The End of Poets in Bohemia...*) and none of them was particularly surprising in form. The time for young directors to introduce new topics—sexual and racial minorities, the life of young people in the cities, the issue of drug addiction—and (sometimes) original forms, often influenced by their experience in advertising, was yet to come.

[34] Přádná, "The Czech Cinema."

FORWARD INTO THE PAST

How is the past referred to in contemporary settings? Surprisingly enough, instead of criticism we often find praise for different aspects of the former regime. The comparison between the past and the present makes the praise seem genuine, for example, in *It's Better to Be Wealthy and Healthy than Poor and Ill*, which portrays the lives of two heroines in the years following the 1989 "Velvet Revolution." In one scene one of the protagonists is asked by a customer in a bar: "Did you really have such a bad time during Communism? Isn't it true that you had meat every day? Isn't it true that you had a job?" This seemingly insignificant remark in fact encapsulates the worries shared by many people at the beginning of the 1990s. Work was no longer guaranteed and prices were rising faster than salaries, making many long for the predictable past.

At other times the praise is meant ironically (by the directors, not necessarily by the characters): the villagers in *Sun, Hay and Eroticism*, expecting the Italian delegation, try to tidy up their village. Everyone begins painting his or her house, and at one point one of the elderly ladies comments: "The Communists were great, they never expected anything." From the point of view of this "simple" woman, involved neither with Communists nor with dissidents, the past in retrospect appears as a reasonably happy time.

In post-1989 Eastern Europe the communist censorship contributed to the creation of a peculiar production style. Even the filmmakers sometimes voiced their disappointment with the present in comparison with the clear "rules of the game" of the past. For example, Kazimierz Kutz, a well-known Polish director, once pointed out that "there were some positive aspects to political censorship, which motivated the best artists to work harder and to speak in purely visual terms."[35] In the Czech context similar sentiments about censorship were expressed by folk singer Jiří Dědeček in his 1989 song *Give me Back My Enemy* (*Vraťte mi nepřítele*) with the refrain: "Give me back my enemy and go to hell." The Hungarian director Márta Mészáros also pointed out the difficulties of transformation of the film industry: "When Communism collapsed and the system changed, it wasn't easy because essentially the administration didn't have any idea of what it should change into. They believed the old system wasn't good, and so they destroyed the entire studio infrastruc-

[35] Marek Haltof, "A Fistful of Dollars: Polish Cinema after the 1989 Freedom Shock," *Film Quarterly* 48 (Spring 1995): 16.

ture. But the old system was good—for a small country like Hungary—in the sense that we didn't have private producers or private distributors."[36]

The issue of censorship and artistic freedom was not only talked about, but films were also made in which the protagonists were artists challenged by various restrictions. For instance, Tomáš Vorel's *The Stone Bridge* (*Kamenný most*, 1996) conveys doubts about the position of the artist in today's society. To some extent, it is the autobiographical story of a film director in his "Christ years" who suffers an existential crisis. His mother produces and sells kitsch dwarf dolls on Charles Bridge (one of the most prominent sights in Prague). His father, once a successful sculptor, complains: "During Communism life was wonderful. No tourists, cops everywhere, people hidden at home. (…) Everything was falling apart and we were in our heyday."

In comparison, however, retro films show an even less optimistic picture of the artist's life in communist society. As was already mentioned, the figure of an artist forbidden to work during the period of so-called "normalization" is crucial in two films: *Pupendo* by Jan Hřebejk and *Kolya* by Jan Svěrák: "in *Kolya*, a professional musician (…) has been expelled from the Czech Philharmonic; in *Pupendo*, a monumental sculptor (…) has refused his obligatory obeisance to the regime."[37] The same topic is shown in the less well-known *That Czech Song of Ours 2* (*Ta naše písnička česká 2*, 1990) by Vít Olmer. A gifted violinist loses his job after the Warsaw Pact invasion of 1968 and from that moment he struggles with the monopoly agency for the employment of artists, which refuses to provide him with any work suited to his virtuosity. To do what he knows best, playing the violin, he is willing to accept the most humiliating jobs: performing for drunks in night clubs or providing the musical background for a communist official's night-time swim. This film shows the compromises that were all too common under the previous regime.

The anonymous agency in the film bears a clear resemblance to Pragokoncert—the monopolistic agency under the control of the Ministry of Culture that had the power to distribute positions without regard to professional qualifications. Pragokoncert was founded in 1958 to control and organize, particularly but not exclusively, performances by Czech and

[36] Horton, "Ordinary Lives," at www.sensesofcinema.com/contents/02/22/meszaros.html (accessed 20 February, 2007).

[37] Hames, "The Ironies," 144.

Slovak musicians, bands, and orchestras in foreign countries.[38] The similarities between the fictional agency and the real one were noticed by the censors, and the preparations for the film, which had begun before November 1989, were "stopped provisionally." Shooting could restart only after the change of the regime. Considering both the reality and the fictional world of films, it seems that the artists who were successful under the previous regime and able to work, although by no means without encountering obstacles, now take a rather balanced stance in evaluating pre-1989 society, to the extent of even seeing certain advantages in working within a system that was not geared to the market. On the other hand, those who were banned from working, or faced harsh censorship and humiliation, would hardly admit that there were any advantages to creating art at the time of the communist regime. But does it really matter what regime we live under? In contemporary Czech cinema we find a few movies which show that after November 1989 nothing actually changed. *Nudity for Sale* (*Nahota na prodej*, 1993), an attempt at a thriller, focuses on human trafficking: a gang forces a couple of girls into prostitution and a journalist tries to uncover their activities. When a corrupt magazine editor refuses to publish his article, one of the characters comments: "So it will be the same as it was during Communism: a few untouchables and the rest of us." When Šafránek in *The End of Poets in Bohemia...* learns that someone has informed on him he says: "I see that denouncers still exist." In the epilogue of *Corpus delicti* (1991), which takes place shortly after the "Velvet Revolution," an unsuccessful scriptwriter complains: "A new totalitarian regime has just begun."

Communist characters rarely appear in films, being relegated to the periphery of the filmmakers' interest. At the beginning of the 1990s, Communists were mostly portrayed as comical figures, but since 1995 they have been largely absent. The common "clues" helping to identify a Communist are the greeting *čest*[39] and the address *soudruhu* (comrade). In *The Inheritance*, one of the first films to reflect the new situation, the manager of a brickyard momentarily forgets about the change of regime and greets Bohouš: "Čest... I mean good afternoon." In *Sun, Hay and Eroticism* a committee from a cooperative visits a family and the daughter says to her mother: "Don't worry, the comrades are not here because of

[38] For more information about the history of Pragokoncert, see www.graddo.com/index.php?id=132 (accessed 25 January 2007).

[39] *Čest* is an abbreviation of *čest práci*, meaning "homage to work." It was a common greeting among members of the Communist Party.

you," to which the leader of the committee replies: "C'mon, there are no
comrades any more…"

Communists are often ironically referred to as "Comanches," a com-
mon nickname for the members of Communist Party, as in *The Inheri-
tance*, *The New Breed* (*Sametoví vrazi*, 2005), and *The Little Hotel in the
Heart of Europe*. The story of the last film begins in the U.S., where Otík
Kocián, a Czech emigrant, is watching the news on television and sees
footage of the November 17th 1989 demonstration. With the fall of Com-
munism the hotel that his family used to own is returned to him and he
decides to go back to the Czech Republic to manage it. Otík happens to be
an ethnographer who is doing research on the Native Americans. Advising
him to return home, his mother adds: "They don't have Comanches,
though…" Her words obviously bear a double meaning.

A deeper and more tragic portrayal of Communists is found in Juraj
Jakubisko's[40] *It's Better to Be Wealthy and Healthy than Poor and Ill*.
Ester, one of the heroines, meets a member of the StB, the Czech secret
police, shortly before November 1989 and falls in love with him. During
one of the demonstrations following November 17th she takes the stage
and tries to defend some Communists: "They are not all the same. Some
of them are exactly like you and me." Shortly afterwards a newspaper
publishes an obituary with the information that her lover has committed
suicide. Although it is never made clear whether it really was a suicide,
this is a highly dramatic moment. The audience is invited to sympathize
with Ester and her lover, even if he was obviously a wrongdoer.[41]

Reflecting on the post-socialist changes, the motif of "changing coats"
often appears, usually in stories about those timeserving members of the
Communist Party who left after November 1989. Occasionally films were
made about "dissidents" who in fact were secret agents of the Czechoslo-
vak Secret Police (StB). The portrayal of this kind of character is identical

[40] Juraj Jakubisko, a native Slovak, is an important figure of the Slovak New Wave of the
1960s. His film *It's Better to Be…* was produced during the existence of Czechoslova-
kia, which is why it is discussed here. Since the 1990s Jakubisko has been living in Pra-
gue. His most recent films have been made in the Czech language and produced by the
Czech Republic, and are thus considered here as part of the Czech cinema.

[41] The director Jiří Krejčík in his documentary *Graduation in November* (*Maturita v lis-
topadu*, 2000) portrays a similar case. In November 1989 he filmed a debate in a local high
school in which students discussed political events and expressed their feelings about
them. The school principal—a Communist—could not handle the confrontation with the
students and committed suicide shortly after the filming. It is only speculation, but we may
suppose that Juraj Jakubisko was aware of this particular case and found inspiration in it.

across the genres: the motif is presented in the same way in the thriller *Nudity for Sale* and in the comedy *The Inheritance*. One of the characters in *Nudity for Sale* says: "The biggest bastards changed their opinion just after November 1989." In *The Inheritance* a couple of lumberjacks are talking about who was and who was not a Communist. One of them claims that he was, is and will always be a Communist. Another admits that he left the Communist Party after November 1989. The devoted communist observes: "As a Communist, I wouldn't mind if you hadn't joined, but I do mind that you left."

The "invisible" continuity is exposed in another comedy with similar characters, entitled *Wild Beer* (*Divoké pivo*, 1995). The film centers on the privatization of a brewery which produces a magic beer that makes its drinkers tell the truth. The characters who drink the beer confess all their sins because they are no longer able to lie. For example, the mayor of a town reverts in his speech to familiar clichés, such as "Long live the Communist Party of the Czech Republic!" The viewers, who are likewise under the influence of the magic beer, applaud him.

We might also see the "changing coats" motif in the first film to portray the post-1989 situation, *The Beginning of a Long Autumn*. The story centers on an event in a small village: a statue of the first Czechoslovak president, Tomáš Garique Masaryk,[42] which was removed from the main square in the late 1960s as a consequence of the 1968 invasion, is to be re-installed. One of strongest supporters of the re-installation is the chairman of the county council, a Communist who twenty years earlier had favored its removal.

In *It's Better to Be Wealthy and Healthy than Poor and Ill*, it becomes obvious that a man who was believed to be a dissident in fact cooperated with the StB. He denies the accusation, claiming that it is merely an attempt to discredit him. Similarly, one of the characters in *Corpus delicti*, who informs on his friends and causes the death of his own wife who was an active dissident, gains an influential position after November 1989 when, instead of admitting his own faults, he accuses his dead wife of cooperating with the StB. Although many similar cases were discussed in the Czech media, it seems that these two films are the last to deal with the "false dissidents."

[42] Tomáš Garrigue Masaryk was president of Czechoslovakia from the beginning of its existence until 1935 (he died in 1937). He was extremely popular, and often addressed as "daddy." In November 1989 T. G. Masaryk became one of the symbols of the "Velvet revolution." The re-erection of his statues symbolized to many people the re-installation of freedom in the Czech Republic.

In this context it is interesting to recall the malevolent portrayal of dissidents, "*kulaks*," priests and other "enemies of the state" in pre-1989 cinema. They were mostly presented as people who cared only about their own wellbeing in the pursuit of money and power. This kind of hateful characterization is absent from post-1989 cinema. Those people who might have been the immediate targets—the Communists—are instead presented as comical, harmless characters. Contemporary Czech cinema prefers to make the audience laugh at the Communists and their regime rather than induce hatred or fear.

THE SINS OF THE PAST AND HOMO ECONOMICUS TODAY

Correcting the "sins" of the communist regime for the population in the Czech Republic implied first and foremost the restitution of property. Some films chose to concentrate on restitution or inheritance, often featuring a fairy-tale pattern in which a lazy boy suddenly obtains a fortune. However, unlike fairy tales, they usually have a problematic ending. A happy hero is a fool who is totally incompetent; by chance he acquires great wealth or property but has no idea what to do with it. The same pattern is often used by the creators of Czech contemporary television series. The most famous of these—*Life at the château* (*Život na zámku*), *Sleeping Beauty* (*Šípková Růženka*), *Seven of Spades Ranch* (*Ranč u zelené sedmy*) and *Hotel Herbich*—share the same basic plot, which turns on some surprising information about a fortune. "The protagonists usually did nothing to get it," says Irena Reifová, author of a comprehensive essay on Czech TV series.[43] Comparing films with TV series, we can, however, find an important difference: while the TV series usually focus on whole families, the films concentrate exclusively on individuals. In Czech cinema the *nouveau riche* character is most often a lonely middle-aged man who does not find a girlfriend until he has be-

[43] Irena Reifová, "Kryty moci a úkryty před mocí: Normalizační a postkomunistický televizní seriál" [Shelters of power and hiding from power: TV series during the "Normalization" period and in post-communist times] in Jakub Končelík, Barbara Köpplová, Irena Prázová (eds.), *Konsolidace vládnutí a podnikání v České republice a v Evropské uni (Příspěvky z konference konané ve dnech 31.10–2.11. 2002). II, Sociologie, prognostika a správa médií* [Consolidation of governance and business in the Czech Republic and European Union: (Contributions to a conference 31.10.–2.11.2002). II. Sociology, Prognosis and Regulation of the Media] (Prague: UK FSV, Matfyzpress, 2002), 370.

come rich, as for instance the heroes of *The Inheritance* and *Still a Bigger Noodle Than We Hoped for.*[44]

The Inheritance focuses on the story of Bohouš, a middle-aged man from a small village, who spends most of the day lying in bed. When he inherits a couple of houses, a brickyard, some land, and a large sum of money he is unable to manage his possessions wisely and does not know how to communicate either with the authorities or with the buyers. He spends most of his money treating his friends to drinks and dinners, building a luxury swimming pool behind his house, and going to the brothel. After buying a merry-go-round, he discovers that he is broke. Life in post-1989 Czechoslovakia is depicted here as chaos ruled by money and consumerism. In the last scene Bohouš learns that he inherited even more money from his father than he originally believed. He looks straight into the camera and challenges the audience: "And now I will buy all of you." This Chytilová film stands as a harsh criticism of "early capitalism" in the Czech Republic. It ends with a feeling common in the Czech Republic at the beginning of the 1990s: if you have money you can buy anything you want.[45]

At the beginning of *Still a Bigger Noodle Than We Hoped for*, Vít has lost both his job and his apartment. When his grandfather dies, Vít inherits a luxury hotel in Karlovy Vary, a spa with an extensive clientele. At first, the simple-minded Vít has no idea what to do, but soon develops enough savvy even to defeat some conmen who try to trick him out of his property. But this success ultimately comes to naught when he marries a gambling addict who spends all his money in the casinos.

She Picked Violets with Dynamite, one of the first Czech films to reflect the post-1989 social environment, also focuses on business, this time on a travel agency. It begins with a melody that parodies the famous theme of *Once Upon a Time in the West* (1968), implying that the

[44] The authors of an article about contemporary Czech Cinema in *Cinepur* coined the term "businessman's comedy" for a "genre" in which they include these two titles and *The Little Hotel in the Heart of Europe*. According to them, "businessman's comedies" "contain two common traits—nationalism and the distrust of business." See Jan Křipáč, Rudolf Schimera, "Pokus o zločin: Český žánrový film 90. let" [Attempt at a Crime: Czech Genre Cinema in the 1990s], *Cinepur* 12 (November 2003): 24–6.

[45] A well known song sung by Richard Müller at the beginning of the 1990s implies that happiness has no value: "Happiness is such a beautiful and fancy thing but you cannot exchange it for dough..." The song comes from the album *Pension svět* [Pension World], released in 1988.

Czechs have entered the (Wild) West of capitalism.[46] The Karafiáts, the protagonists of the movie, share the same feeling. They decide that "the free market has been established," and that they should be a part of it. They manage to procure an old bus, paint cheerful motifs on it, and borrow folk costumes. Having installed a gramophone which plays Smetana's *The Bartered Bride*, they set off to Paris to charm the French.

In the first half of the 1990s protagonists of Czech films are seen trying to start their own businesses, but their naive attempts usually fail. Sometimes they are unable to raise the necessary funds: Šafránek in *The End of Poets in Bohemia...* cannot even get a bank loan to establish his own office. In another instance the protagonist's business is soon destroyed: Švanda's farm in *Which Side Eden* (*Návrat ztraceného ráje*, 1999) burns down even before being insured. In some films the real estate that the protagonists receive becomes more of a burden than a blessing, as in case of a dilapidated hotel (*The Little Hotel in the Heart of Europe*), a disused factory (*The End of Poets in Bohemia...*), or a neglected farm (*Small Town*).[47]

In the last decade, however, Czech cinema has tended to portray much more sophisticated and successful private enterprises. After 1995 we can finally find prospering businessmen in Czech films (*Bringing up Girls in Bohemia*, 1997; *Traps*). However, their activities often remain dubious. For example, in *The New Breed* all the businessmen are connected to the underworld; sometimes they are involved in downright criminal activities. One of the characters considers opening a brothel for a "foreign clientele"; another runs a sadomasochist salon. In *One Hand Can't Clap* (*Jedna ruka netleská*, 2003), the character Zdeněk opens a vegetarian restaurant with a basement in which he organizes macabre parties serving eagle, bear meat, and even human flesh, while he makes passionate speeches à-la Hitler.

Positive portrayals of businessmen are almost absent from Czech films. The current cinema thus continues in the tradition that was established before 1989: businessman, *kulak*, factory owner, in short anyone

[46] We can find a similar western motif in the film *Once There Was a Cop 2* (*Byl jednou jeden polda 2*, 1997). At the beginning of the film a policeman named Meisner returns to Prague from New York dressed in a western outfit (ten-gallon hat, cowboy jacket, leather boots). Repeatedly we hear a "western" musical motif, and to make it quite clear, one of Meisner's admirers says, "You look exactly like a cowboy."

[47] The situation is identical in the Czech TV series: "An average family gains a huge possession as a result of a sudden miracle. It is never money, but always a valuable but run-down property or firm." See Reifová, "Kryty moci," 369.

who runs his own business, no matter what it is, is never a positive figure. Before the Velvet Revolution the entrepreneur was usually shown as the biggest villain who needed to be expelled from society. For example, in *Rough Wine* (*Bouřlivé víno*, 1976), which depicts a small village in southern Moravia in 1968–69, we find a couple of traders who want to establish their own wholesale wine business.[48] A 1986 publication gave them a surprisingly familiar "contemporary" evaluation: "As soon as they have the chance to exercise their greed, to get rich easily, to live off society, they eagerly pursue profits. Anything that brings in money is ethical for them, and devoted to this unethical 'ethic' they will send their own daughters to the conman's bed if they believe he has the dollars, and they keep counting how much they can earn."[49]

Although attitudes towards businessmen are often similarly critical in pre-1989 and post-1989 cinema, today it is virtually impossible to find an equally hateful description of private initiative. The businessmen in contemporary cinema are not exactly heroes, indeed they are often criminals, but hardly any of them are presented as such despicable "enemies of the state" as the heroes of *Rough Wine*. Contemporary businessmen appear problematic because of the way they handle business, and not simply because they run a business, as was the case in the majority of mainstream socialist production.

Apart from inheriting or going into business, there is one more way to get rich, mainly available to women: to have an affair with a wealthy foreigner. Czech girls in contemporary cinema marry Germans (*Lovers and Murderers*, 2004), or have affairs with French (*She Picked Violets with Dynamite*) or Italians (*Sun, Hay and Eroticism*). Sometimes it is enough to have a relationship with a rich Czech emigrant living in Canada (*It's Better to Be Wealthy and Healthy than Poor and Ill*) or in Italy (*Beauty in Trouble*, 2006).

Otherwise, women usually do not have access to fortunes and serve merely as entertainment for successful men. In post-1989 cinema, sex is treated openly. In addition to erotic scenes, Czech contemporary films are replete with brothels and prostitutes. The brothels are portrayed either as a form of enterprise (*The Fountain for Susan 2*, 1993; *Nudity for Sale*; *The End of Poets...*; *The Little Hotel in the Heart of Europe*; *Seizing the Day*,

[48] For a short period in the late 1960s private enterprises were possible.

[49] *Kinematografie bojující: 65 let bojů a vítězství KSČ ve filmu* [Embattled cinema: 65 years of struggle and victories of the Communist Party of Czechoslovakia in film] (Prague: ČSFÚ, 1986).

1996; *Bad Joke*, 2002; *Lovers and Murderers*; *The New Breed*; and *Play-girls*, 1995) or as places where the hero finds relaxation (*The Inheritance*; *Still a Bigger Noodle Than We Hoped for*; *Small Town*; *Post Coitum*, 2004).

In *It's Better to Be Wealthy and Healthy than Poor and Ill*, the two heroines are not prostitutes, but pretend to be, in order to rob their "customers." And if there is no brothel in the movie there is at least a nudist beach (*Sun, Hay and Eroticism*) or a sex shop (*Traps*). Sometimes film-makers go as far as to imply that the new social order actually requires this kind of business. For example, in *It's Better to Be Wealthy and Healthy than Poor and Ill*, one of the characters says: "Just look around: advertisements, sex... So this is freedom..." In *Nudity for Sale* somebody claims that the girls who are forced into prostitution are a "democracy tax." Nevertheless, it is important to remember that the brothel as such is by no means a new arrival in Czech cinema. Brothels were often part of the setting in earlier films that featured the First Republic.[50] Of course, a hidden parallel lurked in the background of the socialist films: the First Republic, so highly appreciated by the opposition as a democratic state, was actually "rotten." As an example we may mention *The Angel or the Devil* (*Anděl s ďáblem v těle*, 1983), set entirely in the *Rivière* brothel where a prostitute becomes a madame.

While many of the issues discussed in this section are not new to Czech cinema, contemporary Czech films discovered new facets of them. The businessmen, although not exactly moral heroes, are no longer rare examples, as in pre-1989 cinema. Furthermore, private enterprise *per se* is no longer the morally unacceptable activity it used to be before the "Velvet Revolution." Interestingly, however, even in today's cinema we do not find an independent businesswoman; whenever portrayed in connection with some enterprise, women feature almost exclusively as the object of "business," often involved with the sex industry. In the rare cases in which women run their own business we often find the same pattern repeated: for example, in *Playgirls* the ladies run their own brothel.

[50] The First Republic existed in Czechoslovakia from 1918 to 1938, until 1935 under the presidency of Tomáš Garrigue Masaryk.

US AND OTHERS: FOREIGNERS IN CZECH CINEMA

Another topic we find quite often in post-1989 cinema is that of foreign (usually western) tourists in the Czech Republic. The frequent visits by foreign tourists to the Czech Republic (mainly to Prague) was something that the citizens were not used to under Socialism. That is not to say that there was no tourism before 1989; however, its scale was incomparably smaller than after the "Velvet Revolution." This new situation found its reflection in the cinema. Despite being a significant economic resource, tourists are depicted almost exclusively in a negative light. Bublina in *The Stone Bridge* puts her disgust with tourists into the words "When I see Charles Bridge it makes me puke. The noisy tourists, the psychos. They think they can do whatever they want when they have money." Nine years later, a similar disgust is conveyed by Laura in *From Subway with Love*. In an English lesson one of the students gives a clue for the word "seal": "I am fat and spend all day lying on the beach," at which she immediately exclaims: "German tourist."

German tourists particularly often appear in contemporary Czech cinema, frequently associated with World War II. For example, Bohouš in *The Inheritance* comments on a group of horse-riding Germans: "It's two years since the Velvet Revolution and the Germans are everywhere just like during the war." In *She Picked Violets with Dynamite*, one of the characters refuses to go to Germany because he was forced to work there during the War. Germans are also often connected with the sex industry. In *Mandragora* (1997), homosexual prostitutes are hired mainly by Germans and a blue movie that is being shot towards the end of the film is also intended for a German clientele. In *Seizing the Day*, the majority of clients for the female prostitutes are again Germans, which is why the heroine, Valentýna, learns their language.[51]

Despite all the negative feelings the Czechs display towards tourists, they also profit from their presence. The mother of Tomáš in *The Stone*

[51] In his review Jaromír Blažejovský mentions an incongruity between the language of diplomacy and the portrayal of Germans in this film, "While the diplomats meet in palaces to declare an optimal version of an agreement between the Czechs and the Germans, Zdeněk Tyc [the director] flippantly brings into this film the odious character of a perverse German (Otto Ševčík), who represents and says the worst that ever these two nations might think about each other. In drastic, offensive humor we get a genuine look at the Czech-German animosity (amplified by the context of 'selling love') that was brushed under the diplomatic carpet." See Jaromír Blažejovský, "Tycova (ne)nahota na prodej (O jedné *dis*kontinuitě)" [Tyc's (un)nudity for sale (About one *dis*continuity)], *Film a doba* 42 (1996): 78–9.

Bridge sells gnome dolls on Charles Bridge and in one shot we see an English-speaking customer, implying that most of the people who are interested in these kitsch products are tourists. In *Small Town*, one of the heroes wishes to run a hotel because he believes that "The Germans are everywhere," and he sees an excellent opportunity for profit. Foreigners who come to the Czech Republic on business are also often portrayed negatively in films.[52] Bohouš (*The Inheritance*) uses a vulgar expression for the Japanese who wish to buy his brickyard while in the recent *City of the Sun* (*Sluneční stát*, 2005) Italian entrepreneurs appear as ruthless sharks, dismissing the local workers as soon as they have purchased a factory in Ostrava.

The topic of migration is also often discussed in Czech contemporary cinema. Unlike in other Eastern European countries, this issue was not really dealt with under the communist regime. Dina Iordanova insists that this topic "has claimed a constant presence in East Central European film-making, even though at times it was suppressed by censorship as a subject matter better left untouched."[53] She mentions Polish and Hungarian films as examples. In pre-1989 Czechoslovakia the situation was different and the emigration issue was usually restricted to stories of brave border guards who did not hesitate to kill "enemies of the state" who were illegally trying to cross into Austria or Germany. The Czech emigrants who return to their homeland after the change of the regime thus provide a new topic. They come back for various reasons: sometimes for a short while just to see their friends (Robert from Canada in *It's Better to Be Wealthy and Healthy than Poor and Ill*); sometimes for longer periods to manage their suddenly acquired property (Otík Kocián from the U.S. in *The Little Hotel in the Heart of Europe*), to try to sell an inherited house (Evžen Beneš from Italy in *Beauty in Trouble*), or to gain some work experience (Nancy from the U.S. in *Nudity for Sale*).

In Vojtěch Jasný's *Which Side Eden* (1999), the topic of emigration is central. Jan Poutník, a film director who left Czechoslovakia after the 1968 invasion, returns to his home village to meet his friends, mostly also returning emigrants. One of them, who decides to stay in the Czech Republic after twenty-one years spent abroad, says: "America is America, but home is home." The protagonist's wife makes another point: "Exile is

[52] "A typical character in Czech comedy is the covetous and ruthless businessman, often German or Japanese. This is particularly the case with the foreign investor who wants to buy as much Czech property as he can." Křipáč, "Pokus," 25.

[53] Iordanova, *Cinema of the Other Europe*, 39.

sometimes even worse than prison." Although the returning emigrants are seldom disappointed by the new order and are often happy to be back, they generally do not return to the Czech Republic for good, preferring to stay in the countries that provided them with asylum. Poutník's friend is one of the rare exceptions. However, it is important to note that while *Which Side Eden* focuses on emigrants in their late fifties or early sixties who return to the country to "die at home," other films mentioned above portray people in their forties who are often shown as having successful careers and decent incomes and not feeling any need to return to the Czech Republic.

Earlier we discussed the topic of the artist in Czech cinema. *Which Side Eden*, where Jan Poutník is obviously an alter ego of the director Vojtěch Jasný, sheds light on another aspect of this issue. Jasný was one of the New Wave directors, whose films were very successful both with broad audiences and with the critics. Among them was *All My Good Countrymen* (*Všichni dobří rodáci*, 1968), which tells the story of seven friends in a Moravian village after the Communist coup in February 1948. Believed by many to be the best Czech film ever made, it was banned "for ever" immediately after the August 1968 invasion. Jasný emigrated to Austria in the early 1970s and later to the United States, and like the protagonist of his latest film he has not been able to create any significant films since. Instead, he has focused on teaching. The majority of the directors who emigrated from Czechoslovakia after 1968 faced similar problems, including world-famous filmmakers such as Jan Němec and Jiří Weiss.

The issues of tourism and migration are very complex and cannot be covered completely in this restricted space. We would have to consider other topics: the differences between the portrayal of "western" and "eastern" tourists and between their portrayal in contemporary and pre-1989 cinema; the motif of people who came to the Czech Republic as tourists, but decided to stay and the motif of Czech emigrants who fell in love with their "host" countries and decided not to return to their homeland; the portrayal of minorities and the difference between their portrayal today and before the Velvet Revolution. However, all this would require much more space than we can offer.

CONCLUSION

This overview of contemporary Czech cinema has highlighted the most common themes in the films that portray the last sixty years of Czech history. Each of these would deserve a study on its own. Our aim was to introduce the recurrent motifs rather than to offer a comprehensive analysis. We saw that the majority of contemporary films focus on present-day issues, while the representation of historical periods—such as the 1950s—remains weak, especially in comparison with the films of the Czech New Wave. It is important to point out the scarcity of portrayals of the 1960s and the fact that that decade has not yet been the subject of deep reflection. Tellingly, it is the period of "normalization" that is emerging more frequently than other periods in contemporary films; however, most films concentrate on "universal" everyday life, usually eschewing general statements about political or economic realities. The representation of the contemporary social environment in Czech cinema also remains centered on anti-political everyday life, most often reduced to private dilemmas and choices. Both historical and current events are shown mainly through the lives of "ordinary people." Czech contemporary films have a tendency to overlook grave historical truths, and national psychological traumas are often trivialized. Film directors frequently downplay the theme of opportunistic loyalty to the communist regime. We are still waiting for a drama that will portray the past regime truthfully; at the moment, laughter seems to be the only "weapon" that Czech cinema has to offer for dealing with the past.

FILMOGRAPHY

A Little Piece of Heaven (*Kousek nebe*, Petr Nikolaev, Czech Republic, 2005)
Accumulator 1 (*Akumulátor 1*, Jan Svěrák, Czech Republic, 1994)
All My Good Countrymen (*Všichni dobří rodáci*, Vojtěch Jasný, Czechoslovakia, 1968)
Bad Joke (*Kameňák*, Zdeněk Troška, Czech Republic, 2003)
Beauty in Trouble (*Kráska v nesnázích*, Jan Hřebejk, Czech Republic, 2006)
Behold Homolka (*Ecce homo Homolka*, Jiří Papoušek, Czechoslovakia, 1969)
Boomerang (*Bumerang*, Hynek Bočan, Czech Republic, 1997)
Bringing up Girls in Bohemia (*Výchova dívek v Čechách*, Petr Koliha, Czech Republic, 1997)
Corpus delicti (Irena Pavlásková, Czechoslovakia, 1991)
Cosy Dens (*Pelíšky*, Jan Hřebejk, Czech Republic, 1998)
Dandy Homolka (*Hogo-fogo Homolka*, Jiří Papoušek, Czechoslovakia, 1970)
From Subway with Love (*Román pro ženy*, Filip Renč, Czech Republic, 2005)

Graduation in November (*Maturita v listopadu*, Jiří Krejčík, Czech Republic, 2000)
Homolka and Pouch (*Homolka a tobolka*, Jiří Papoušek, Czechoslovakia, 1972)
It's Better to Be Wealthy and Healthy than Poor and Ill (*Lepšie byť bohatý a zdravý ako chudý a nemocný*, Juraj Jakubisko, Czechoslovakia, 1992)
Joke (*Žert*, Jaromil Jireš, Czechoslovakia, 1968)
Jurassic Park (Steven Spielberg, USA, 1993)
Kolya (*Kolja*, Jan Svěrák, Czech Republic, 1996)
Larks on a Thread (*Skřivánci na niti*, Jiří Menzel, Czechoslovakia, 1969)
Little Otík (*Otesánek*, Jan Švankmajer, Czechoslovakia, 2001)
Lovers and Murderers (*Milenci a vrazi*, Viktor Polesný, Czech Republic, 2004)
Mandragora (Wiktor Grodecki, Czech Republic, 1997)
Nobody Knows Anything (*Nikdo nic neví*, Josef Mach, Czechoslovakia, 1947)
Nudity for Sale (*Nahota na prodej*, Vít Olmer, Czech Republic, 1993)
Once Upon a Time in the West (Sergio Leone, Italy, USA, 1968)
One Hand Can't Clap (*Jedna ruka netleská*, David Ondříček, Czech Republic, 2003)
Playgirls (Vít Olmer, Czech Republic, 1995)
Post coitum (Juraj Jakubisko, Czech Republic, 2004)
Pupendo (Jan Hřebejk, Czech Republic, 2003)
Rough Wine (*Bouřlivé víno*, Václav Vorlíček, Czechoslovakia, 1976)
Seizing the Day (*Už*, Zdeněk Tyc, Czech Republic, 1996)
She Picked Violets with Dynamite (*Trhala fialky dynamitem*, Milan Růžička, Czechoslovakia, 1992)
Small Town (*Městečko*, Jan Kraus, Czech Republic, 2003)
Still a Bigger Noodle Than We Hoped for (*Ještě větší blbec než jsme doufali*, Vít Olmer, Czech Republic, 1994)
Sun, Hay and a Couple of Slaps (*Slunce, seno a pár facek*, Zdeněk Troška, Czechoslovakia, 1989)
Sun, Hay and Eroticism (*Slunce, seno, erotika*, Zdeněk Troška, Czechoslovakia, 1991)
Sun, Hay and Strawberries (*Slunce, seno, jahody*, Zdeněk Troška, Czechoslovakia, 1984)
That Czech Song of Ours 2 (*Ta naše písnička česká 2*, Vít Olmer, Czechoslovakia, 1990)
The Angel or the Devil (*Anděl s ďáblem v těle*, Václav Matějka, Czechoslovakia, 1983)
The Beginning of a Long Autumn (*Začátek dlouhého podzimu*, Peter Hledík, Czechoslovakia, 1990)
The Black Barons (*Černí baroni*, Zdenek Sirový, Czechoslovakia, 1992)
The City of the Sun (*Sluneční stát*, Martin Šulík, Czech Republic, Slovakia, 2005)
The End of Poets in Bohemia... (*Konec básníků v Čechách...*, Dušan Klein, Czech Republic, 1993)
The Forgotten Light (*Zapomenuté světlo*, Vladimír Michálek, Czech Republic, 1996)
The Fountain for Susan 2 (*Fontána pre Zuzanu II*, Dušan Rapoš, Czech Republic, 1993)
The Inheritance or Fuckoffguysgoodday (*Dědictví aneb Kurvahošigutentag*, Věra Chytilová, Czechoslovakia, 1992)
The Knell Won't Be Tolled (*Tobě hrana zvonit nebude*, Vojtěch Trapl, Czechoslovakia, 1975)
The Little Hotel in the Heart of Europe (*Hotýlek v srdci Evropy*, Milan Růžička, Czech Republic, 1994)
The New Breed (*Sametoví vrazi*, Jiří Svoboda, Czech Republic, 2005)
The Rebels (*Rebelové*, Filip Renč, Czech Republic, 2001)

The Seventh Day, the Eighth Night (*Den sedmý, osmá noc*, Evald Schorm, Czechoslovakia, 1969)

The Stone Bridge (*Kamenný most*, Tomáš Vorel, Czech Republic, 1996)

The Tank Battalion (*Tankový prapor*, Vít Olmer, Czechoslovakia, 1991)

The Trash (*Brak*, Karel Spěváček, Czech Republic, 2002)

There Once Was a Cop 2 (*Byl jednou jeden polda 2*, Jaroslav Soukup, Czech Republic, 1997)

Titanic (James Cameron, USA, 1997)

Traps (*Pasti, pasti, pastičky*, Věra Chytilová, Czech Republic, 1998)

The Trash (*Brak*, Karel Spěváček, Czech Republic, 2002)

Where the Storks Nest (*Tam kde hnízdí čápi*, Karel Steklý, Czechoslovakia, 1975)

Which Side Eden (*Návrat ztraceného ráje*, Vojtěch Jasný, Czech Republic, 1999)

Wild Beer (*Divoké pivo*, Milan Muchna, Czech Republic, 1995)

Wonderful Years that Sucked (*Báječná léta pod psa*, Petr Nikolaev, Czech Republic, 1997)

Objects of Memory: Museums, Monuments, Memorials

The Redistribution of the Memory of Socialism

Identity Formations of the "Survivors" in Hungary after 1989

ZSOLT K. HORVÁTH

THE UNFINISHED PRESENT: INTERPRETATIVE CONFLICTS OF MEMORY AND HISTORY

"Budapest is a city without time. If you visit here, you will not feel that you are in the nineties. (…) Here the politicians want to win World War I in Parliament."[1] This remark by Jenő Menyhárt, underground musician and emblematic figure of the 1980s in Hungary, uttered in his subjective, sarcastic style, explicates the symbolic battle for possession of the past in post-socialist Hungary. Labeling the historical consciousness and political uses of the recent past of Hungary, he talks about a country which defines itself through its earlier historical conflicts, and not through current political, economic and cultural problems. At the same time, his statement provides an opportunity to focus our attention on the significance and motivations of this symbolic fight for the past: why, in what way, and to whom has the past become important? More precisely, which past gained significance after 1989?

Most Hungarian historians consider the "socialist period"[2] exclusively as a politico-historical period, as a subject of contemporary history (*Zeitgeschichte, l'histoire du temps présent*), and there have been complaints about the existence of a scholarly consensus in contemporary historical writing. At first glance, this is not a problem: history as an academic dis-

[1] Anna Szemere, *Up from the Underground: the Culture of Rock Music in Postsocialist Hungary* (Pennsylvania: Pennsylvania State University Press, 2001), 193.

[2] Following János Kornai, the term "socialist" (and not "communist") will be used. As he argued, this term refers to the realised form of the system, while the notion "communism" would be applied to the idea as a utopia. See János Kornai, *The Socialist System: The Political Economy of Communism* (Oxford—Princeton: Clarendon Press, 1992), 35–6.

cipline has the right to talk about the past, even the recent past, applying the authority of institutionalized knowledge. However,—and this seems unique to the study of contemporary history—the history of the socialist period is far from being the exclusive intellectual property of professional, academic historians. Since there are many people still alive who lived through this historical era, the persecution suffered or, in contrast, the phenomenon of nostalgia simultaneously form part of "communicative memory" (based on intergenerational communication) and of systematic "cultural memory" (commemoration), as well as of history (as an academic discipline).[3] Thus in this instance the role of historical consensus is quite ambiguous, and the authority of academic knowledge more fragile and more controversial than, for example, in the case of historical data from the eighteenth century. As the Hungarian historian László Karsai wrote in a newspaper article, historical "truth is more complicated,"[4] in other words the consensus of professional historians about the past is more complex than an emotionally loaded judgment, and consequently more difficult to communicate to a broader public.[5]

The reason for this is not the relative unavailability of historical sources. On the contrary, the difficulties of interpretation are caused by an abundance of radically different types of records, which is unusual for other historical periods and which, with respect to the recent past, is further complicated by the specific emotional expectations of those who lived through the period. For instance, a person sent to prison in the 1950s in Hungary could be rightly called both a "witness" and a "victim" today. In this case, even such a simple definition goes beyond the remit of academic history and becomes a public political, moral and aesthetic problem. As the French historian François Hartog argued, this is the "extended role" of the historian of the recent past.[6] There is certainly no suggestion here that the survivors of persecution should be denied moral respect in the name of academic

[3] The distinction between these forms of social memory has become a widely used conceptual tool following the synthesis of Jan Assmann. See his *Das kulturelle Gedächtnis: Schrift, Erinnerung und politische Identität in frühen Hochkulturen* (Munich: C. H. Beck, 1992).

[4] László Karsai, "Az igazság bonyolultabb" [The truth is more complicated], *Népszabadság* (6 March 2002): 10.

[5] This challenge for history is discussed by Giovanni Levi, "Le passé lointain. Sur l'usage politique de l'histoire" in Jacques Revel, François Hartog (eds.), *Les usages politiques du passé* (Paris: EHESS, 2001), 25–37.

[6] François Hartog, "L'historien et la conjoncture historiographique," *Le Débat* 102 (1998): 4–10.

knowledge, but at the same time, it should be pointed out that the simultaneity of history and memory is an inevitable issue for a historian. In fact, the researcher is always embedded in an actual historical tradition, and thus sees the recent past as part of the memorial space created by survivors, historians and all remembering persons or institutions. According to Paul Ricœur, "we are members of the field of historicity as storytellers, as novelists, as historians. We belong to history before telling a story or writing history. The game of telling is included in the reality told."[7]

The French historian Pierre Nora, the leader of arguably the most influential collaborative study on memory, contends that the recent wave of investigation into the various forms of remembrance has contributed to the development of a clear distinction between history and memory. Nevertheless, the definition of the notion of memory itself is far from unambiguous. According to Nora, its interpretation changed significantly in the course of the last century. In France, at the end of the nineteenth century, memory was understood as a term close to history as a new academic discipline. Nora points out that Ernest Lavisse, the editor of the twenty-seven-volume *Histoire de France*, which also appeared in a shortened popular edition known as the "Petit Lavisse" and sold about a million copies, was a teacher of the nation, as well as an "evangelist of the republic." In publishing his historical work, Lavisse's goal was to confirm and consolidate the Third Republic in France. Nora's essay concludes that nowadays, contrary to its classic function, history has become a purely academic discipline and lost its ability to construct national identity. The important implication of Nora's argument is that professional history ceased to be the dominant means of producing interpretations of the past as socially constructed processes of remembering effectively penetrated this field. The sites of the complicated interaction of history and memory are the *lieux de mémoire* where representations of the past take shape in contemporary societies.[8]

This article will focus on four of these sites in contemporary Hungary, where the image of the socialist past has been re-shaped as a result of various social, political and cultural developments. It will be argued that this

[7] Paul Ricœur, "The Narrative Function" in his *Hermeneutics and the Human Sciences* (Cambridge—Paris: Cambridge University Press—Maison des Sciences de l'Homme, 1981), 294.

[8] Pierre Nora, "Entre mémoire et histoire. La problématique des lieux" in *Les Lieux de mémoire*. Vol. 1: *La République* (Paris: Gallimard, 1984), xvii-xlii. The project was published in three volumes: Pierre Nora (ed.), *Les Lieux de mémoire*, vols. 1–3 (Paris: Gallimard, 1984–1992). See also Nora, "Lavisse, instituteur national" in *Lieux de mémoire*, Vol. 1: *La République* (Paris: Gallimard, 1984).

process should be understood as a predominantly symbolic struggle for the ability to define the meanings of the history of the socialist period. As was observed by a few political scientists, some of them active participants (as intellectuals or opposition politicians) in the Hungarian transition, the replacement of the communist regime was not marked by a conceptual ideological controversy between the classical traditions of Liberalism, Socialism and Conservatism, but by a veritable battle of metaphors. The Hungarian political scientist Márton Szabó argues that "(...) there is no ideological fight going on among the political actors of the transition, but rather a symbolic linguistic one. The citizen does not have to choose between overall ideological visions, but between 'fairly little words.'"[9] Szabó claims that this symbolic struggle was a characteristic feature of the new democracies. He connects this phenomenon to the fact that the relatively underdeveloped democratic institutions in these countries, together with the legacy of dictatorial politics, endowed the symbolic field of political representation with extraordinary importance. Social interests and political identities were easier to articulate by ritual re-interpretations of the past than by formalized institutional processes. In 1989, the year of the transition, the politics of symbols played a crucial role. Political meetings and manifestations organized by the opposition to the Hungarian Socialist Workers Party (MSzMP) took place on important dates and holidays. These actions started on 15 March (the anniversary of the 1848 Revolution), when the existence of an open democratic opposition became manifest. They were followed by similarly important historical ceremonies on 16 June (the reburial of Imre Nagy, Prime Minister of the 1956 Revolution, on the anniversary of his execution in 1958) and on 23 October (the anniversary of the first day of that Revolution and the proclamation of the new Hungarian Republic in 1989). According to Tamás Hofer, the democratic opposition arranged its demonstrations to coincide with these emblematic dates of the past and used strong symbolic language against those in power.[10] Nonetheless, after the transition, during the first years of democracy, symbolic politics appeared only sporadically. This fact was connected to the attempt of the political elite to bring the making of politics predominantly within the bounds of the democratically-based institutions.

[9] Márton Szabó, "A rendszerváltozás szemantikája" [Semantics of the transition], *Politikatudományi Szemle* 4 (1993): 178.

[10] Tamás Hofer, "Harc a rendszerváltásért szimbolikus mezőben. 1989. március 15-e Budapesten" [Symbolic battle for the transition: the 15th of March 1989 in Budapest], *Politikatudományi Szemle* 1 (1992): 29–51.

In 1998, the new, young right-wing Alliance of Young Democrats—Hungarian Civic Party (*Fidesz Magyar Polgári Párt, Fidesz–MPP*) established the new government after winning the general elections. This government started a wide-ranging campaign to re-define political identities in the country on the basis of a well-defined politics of history. The adaptation of the newly emerged European term "cultural heritage" (*patrimoine*), taken from the French and British contexts and based on the appreciation of historical monuments, was among their first measures. They also planned to revive and finance the second "Millennium celebrations"—the first had taken place in 1896, ten centuries after the Hungarian conquest of the Carpathian basin—in order to commemorate the thousandth anniversary of the baptism of István, the first king of the Hungarians. The transfer of the Sacred Crown from the National Museum to the Parliament building was another of their projects. The same government also sponsored a large exhibition entitled "Dreamers of Dreams," popularizing Hungarians who had acquired world-wide recognition. Last but not least, Fidesz's most debatable project was the creation of the House of Terror, in downtown Budapest, which was a direct attempt to re-interpret the history of the communist system. I will examine the transformations of this symbolic struggle for the interpretation of Socialism in connection with four sites of memory: the Pantheon of the Labor Movement, the 1956 memorials in the Rákoskeresztúr cemetery, the Statue Park, and the House of Terror itself.

THE PANTHEON AND THE NOSTALGIC MEMORY OF THE KÁDÁR ERA

The Pantheon of the Labor Movement came into existence in 1959, so strictly speaking, it has nothing to do with the appraisal of the socialist past. (Fig. 1) Nonetheless, although the Pantheon is completely neglected by politicians, personal attachment to the socialist past still flourishes at this site. Situated in the Kerepesi Cemetery, officially called the National Graveyard on Fiume Road, the Pantheon's first aim was to integrate the communist movement into the symbolization and self-representation of the nation. Following the model of the French Pantheon, the cemetery was built to preserve the memory of the "great historical figures of Hungary" (among others Batthyány, Kossuth and Deák).[11]

[11] Vilmos Tóth, "A Kerepesi úti temető másfél évszázada" [One and a half centuries of the Kerepesi Cemetery], *Budapesti Negyed* 7 (Spring 1999), Special Issue on the Kerepesi Cemetery, vol. 1, 3–126.

Hungarian Communists started to capitalize on its symbolic uses in the 1950s. In May 1956, the Council of the City of Budapest closed the cemetery and declared it a National Pantheon (decree 608/20 of the City Council of Budapest). Although the idea was first mooted in 1947, it was not until 1957 that the Central Committee decided to build the site for the martyrs of the communist movement, including the soldiers who had died during the Revolution in the autumn of 1956.[12] The idea of creating such a place, and the date chosen for its inauguration, were not accidental. The Pantheon of the Labor Movement was inaugurated in 1959, on the 40th anniversary of the first Hungarian Soviet Republic. It consists of a number of different elements. The mausoleum, the central building containing urns with the ashes of cremated bodies, was built first. Later it was complemented by six pillars, designed to commemorate those who were buried outside the cemetery. In front of the central building is the so-called "main street," which is considered the most prestigious burial site for those who were not cremated. Those buried here include, for instance: the philosopher György Lukács; Máté Zalka, a veteran of the Spanish Civil War; Erik Molnár, one of the most important historians and ideologists of the Party; and the victims of the biggest show trial put on by the Stalinist Rákosi regime, András Szalai, György Pálffy, Tibor Szőnyi and László Rajk. After the Revolution of 1956, which was suppressed by the new Kádár government with the help of the Red Army, the regime had to redefine itself and, at the same time, prove its discontinuity with the former Stalinist leadership that had left traumatic memories behind. The effect of this "interpretative pressure"[13] over the past was the construction of a historical continuity encompassing the labor movement of the first Hungarian Soviet Republic in 1919, as well as the "heroic" illegal activities of Communists during the inter-war period.[14] In the years that followed, the fate of the Pantheon did not change radically: the burial ground was enlarged to accommodate the other communist leaders and workers of the

[12] Péter Apor, "The Eternal Body: the Birth of the Pantheon of the Labor Movement in Budapest," *East Central Europe* 31/4 (2004): 23–42; and Tóth, "A Kerepesi úti temető," 93–4.

[13] The notion is from Melinda Kalmár, *Ennivaló és hozomány: A kora kádárizmus ideológiája* [Food and dowry: The ideology of early Kádárism] (Budapest: Magvető, 1998); K. G. Faber, "The Use of History in Political Debate," *History and Theory* 17 (4 1978): 19–35.

[14] Péter Apor, *Corpus Communismi Mysticum: History, Politics and Continuity in Communist Hungary* (unpublished PhD dissertation), Florence, European University Institute, 2002.

movement, and a new, modest, standardized design appeared: black marble graves, bearing the name of the deceased and a little star.

Fig. 1 The Pantheon of the Labor Movement
(photo: Zsolt K. Horváth, 2006)

The last communist addition to the Pantheon, the tomb of János Kádár, provided a paradoxical completion of the site and transformed the building into a memorial of the Kádár era itself. It is true that in 1989 there was no revolution in Hungary, not even a "velvet" one as in Prague, but the slow actions organized by the opposition led to the most important symbolic event of the transition: the official reburial on 16 June 1989 of Imre Nagy, Prime Minister of the 1956 Revolution, hanged by the subsequent Kádár regime in 1958.[15] The ceremony took place in Heroes' Square, in front of the Millenary Monument and the Hall of Arts (*Műcsarnok*). At that time János Kádár, First Secretary of the Party between 1956 and 1988, was already very ill; he died one month later. "It is worth mentioning," writes István Rév, "that János Kádár died in exactly the hour when Imre Nagy was legally rehabilitated by the Supreme Court of Hungary. On television one could see a slip of paper with the news of Kádár's death

[15] Hofer, "Harc a rendszerváltásért," 29–51.

on it being passed down the benches of the courtroom."[16] It was obvious that Kádár should be buried in the Pantheon and it was also clear that a central location had to be found for him within the complex. Nonetheless, the time of his death also marked the beginning of the demise of his political personality as the regenerator of the country after the crisis of 1956. The reburial of Imre Nagy, in particular, had suddenly led to his name being associated with the murder of the leader of the Revolution. The last general secretary of the Hungarian Socialist Workers' Party, Károly Grósz, had the idea of placing Kádár's tomb in a new location, practically next to the mausoleum. Thus, the remains of the leader lie alone, set apart from the others, with the result that his tomb is part of the Pantheon, but at the same time keeps a distance from it.

Nowadays, the Pantheon is a site of nostalgic memory of the Kádár era which focuses on the calm period of the late 1960s and the 1970s. The political urban legend in Budapest holds that there are always flowers on Kádár's grave. As a matter of fact, observation confirms the rumors. During my research, I met elderly people putting flowers and wreaths on his grave, and mostly older women sitting on the bench in front of the grave, eating and talking. It is not surprising to see elderly people spending long hours and even eating in a cemetery: in private life, they will often visit the grave of their deceased partner. In fact, this is a sign of their emotional attachment to and a confirmation of their union with their partner—even beyond death. But in the case of a much-praised politician, the same morphological act, the visit, suggests not only a sentimental union, but also a political identification: the act of the visit and the rite of commemoration confirm a political conviction, a persuasion inscribed in one's own life history. Its institutionalized form is the celebration of the anniversary of János Kádár's death, which suggests that the Hungarian Workers Party (*Munkáspárt*), the known descendant of Kádár's Hungarian Socialist Workers Party, does not commemorate János Kádár, the human being, but János Kádár, the political figure. His grave in the Pantheon is a political sign, a site of memory treasured by the last believers in Kádárism.

[16] István Rév, "Parallel Autopsies," *Representations* 49 (1995): 15–39. Republished in his *Retroactive Justice: Pre-History of Post-Communism* (Stanford: Stanford University Press, 2005), 19–51.

THE CULT OF HEROES VERSUS THE POLITICAL ONTOLOGY OF DEATH:
THE RÁKOSKERESZTÚR CEMETERY

After the ceremony of the reburial of Imre Nagy and his companions, another site, the so-called "plot no. 301" in the Rákoskeresztúr cemetery (*Újköztemető*) came into the focus of public discussions about the recent past. In fact, one should talk about three plots: numbers 298, 300 and 301. These sites have a very controversial meaning: according to the official version plot no. 298 contains the remains of the "victims" of the fabricated Stalinist show trials of the early 1950s, while numbers 300 and 301 were used to bury the corpses of the revolutionaries executed after 1956. However, on closer examination of the names one recognizes several dubious individuals among these victims. They include, among others, one of the most disreputable men of the inter-war period, a cruel police officer, Tibor Wayand, and Mihály Francia Kiss, the "white terrorist" who was involved in the mass killings after the defeat of the first Hungarian Soviet Republic in 1919/1920.[17] Nevertheless, these three plots in the Rákoskeresztúr cemetery are considered in the collective and political memory exclusively as the resting place of the heroes of the 1956 revolution.

After the publication of the sentence in 1958 in *Népszabadság* (at that time the official daily paper of the Party) and the execution of Imre Nagy and his companions, nobody, including the relatives of the executed, had any information about where the corpses were buried. According to rumors, they were laid in unmarked graves next to the last plot in the largest Hungarian cemetery situated on the outskirts of Budapest. In the spring of 1988, on the occasion of the 30th anniversary of their execution, the widow and the daughter of József Szilágyi, once a companion of Imre Nagy, officially asked the Hungarian authorities about the exact location of the remains without, however, receiving an adequate answer.[18] To make up for the lack of a more appropriate opportunity to honor the mem-

[17] Magyar Országos Levéltár [National Archives of Hungary] M–KS–276–65–341.

[18] The copy of this letter is available in János Rainer M. (ed.), *Tetemrehívás: 1958–1988, Párizs–Budapest* [Autopsy: 1958–1988, Paris-Budapest] (Budapest: Bibliotéka, 1989), 68. Until the clandestine archival research of historian János M. Rainer conducted at the beginning of 1980, and published in *samizdat* under a pseudonym, even the exact number of those executed was unknown. Elek Fényes [= János M. Rainer], "Adatok az 1956-os forradalmat követő megtorláshoz" [Data on the persecution following the 1956 Revolution] (1986), republished in Fanny Havas et al. (eds.), *Beszélő Összkiadás*, vol. II (Budapest: AB-Beszélő, 1992), 649–63.

ory of Imre Nagy and his companions, Ferenc Fejtő, an emigré writer and historian living in Paris, organized a commemoration in 1988 in the Père Lachaise cemetery, where Ernő Nagy had prepared an installation based on an original conception by László Rajk. At the same time, in Budapest, the Hungarian police broke up a celebration organized by the democratic opposition.

In the same year, Károly Grósz went to the United States, where he was requested to declare that the Hungarian authorities would respond to relatives wishing to know the exact location of the deceased. Thus, by a slow melting of the great taboo fabricated by Kádár, an opportunity appeared in 1989, and on 29 March of the same year, the remains began to be exhumed.[19] A few months later, on 16 June, the official reburial of Imre Nagy and his companions took place in Heroes' Square in central Budapest. After accepting the alternative political celebrations organized by the democratic opposition on 15 March, the Party and the government eventually supported this ceremony as well, and a huge audience was able to experience the event, as it was broadcast live on Hungarian television.

Still in 1989, the decision was taken to erect a memorial on plot no. 300, where victims of the post-1956 communist repression were buried. György Jovánovics, a well-known avant-garde sculptor, won the design competition.[20] His idea was to erect a site for personal mourning and not for political ceremonies. His avant-garde background enabled him to create something "original" in a period when celebrating the memory of the heroes became practically obligatory (a real heyday of memorial building),[21] and the personal dimension became irrelevant. Aliz Halda, the companion of Miklós Gimes, who had been executed in 1956, complained that she was unable to empathize with the official, empty commemoration organized by the Hungarian state. According to Halda, the confrontation of political celebration and personal mourning resulted in ostentatious rituals: "Everything is transformed into a ceremony, with soldiers, orches-

[19] It is typical that some days later Szilveszter Harangozó, Deputy Minister of the Interior at the time, prohibited the release of even the slightest details to the relatives. *1956-os Intézet* [Institute for the History of 1956], Oral History Archives No. 261, interview with József Pajcsics conducted by András Hegedűs in 1991, 91.

[20] For the history of the competition and the debates surrounding it see, Péter György, *Néma hagyomány. Kollektív felejtés és kései múltértelmezés: 1956 1989-ben* [A silent Tradition. Collective oblivion and belated interpretation of the past: 1956 in 1989] (Budapest: Magvető, 2000), 281.

[21] Géza Boros, *Emlékművek '56-nak* [Memorials to 1956] (Budapest: 1956-os Intézet, 1997).

tra, measured steps and official floral tributes. For one or two years, nota-
bles arriving [in Hungary] paid their respects to plot no. 301 [the resting
place of Imre Nagy and his companions]: the Swedish King and his wife
came here, Václav Havel and others as well. I was, of course, touched by
these events, but they also made me nervous."[22]

Jovánovics's innovation was to build a counter-memorial to the Revolu-
tion of 1956. As he said, "what I built there is not a political monument; it is
a memorial to the dead."[23] For him, the main question was how to erect a
"good memorial" of aesthetic value in a period when a tribute to the revolu-
tionaries was almost obligatory. A memorial, on the one hand, talks about
the importance of time and space, and on the other hand, organizes the
mnemonic use of public space. Thus, its social and political (ab)use can
result in a meaning which was not intended by the sculptor. According to
art historians András Rényi and László Beke, Jovánovics's answer to this
challenge is the construction of a paradox: erecting a memorial and, at the
same time, trying to avoid direct political abuse through a hidden symbolic
language.[24] As the sculptor said in an interview, "the memorial and the
statue situated in a public space is something that is absolutely foreign to
me, because it is exactly a representation of the dominant use of an idea
suggested by the authorities."[25] Jovánovics re-defined the concept of memo-
rial-building. The very material that he used could be considered as a para-
dox: the main component of all his monuments and memorials is a mixture

[22] Eszter Rádai, "Szövetkezni a jóra. Interjú Halda Alizzal" [Alliance for the good: An
interview with Aliz Halda], *Élet és Irodalom* 43 (2003): 7. In connection with this ques-
tion, see also her novel entitled *Magánügy* [Private issue] (Budapest: Noran, 2002) and
Gimes's biography: Sándor Révész, *Egyetlen élet. Gimes Miklós története* [Only one
life: The story of Miklós Gimes] (Budapest: 1956-os Intézet–Sík, 1999), especially 417–
26. Additional information can be found in the documentary film directed by the
younger Miklós Gimes entitled "*Mutter*" (2003).

[23] Zsófia Mihancsik, "'Amit ott építettem az nem emlékmű, hanem halálmű.' Interjú
Jovánovics Györggyel" ["What I built there is not a political monument: it is a death
memorial": An interview with György Jovánovics], *Budapesti Negyed* 3 (1994): 203.

[24] László Beke, "Polisz és nekropolisz. Szempontok Jovánovics György 1956-os emlék-
művének értékeléséhez" [Polis and necropolis: Perspectives in the interpretation of the
1956 memorial by György Jovánovics], *Magyar Építőművészet* 85 (1994): 6, 24–9; and
András Rényi, "A dekonstruált kegyelet. Jovánovics György 1956-os emlék/műve és a
posztmodern szobrászat" [Deconstructed piety. The memorial of 1956 of György
Jovánovics and post-modern sculpture] in his *A testek világlása. Hermeneutikai ta-
nulmányok* [The light of bodies: Studies in hermenutics] (Budapest: Kijárat, 1999), 173–
217.

[25] Mihancsik, "Interjú Jovánovics Györggyel," 203.

of white cement and quartz sand that makes up a kind of white concrete resembling gypsum. Gypsum, a fragile, ephemeral, and short-lived substance, is a fundamental medium in Jovánovics's earlier work and in this context it works against the monumental, eternal and solemn function associated with a "normal" memorial. (Fig. 2)

Fig. 2 György Jovánovics's "Thanato-plastic"
(photo: Zsolt K. Horváth, 2006)

The memorial to the dead is divided into three parts: the open grave with a pillar exactly 1956 millimeters high (the only allusion to the political context); the path leading the visitor to the "altar," a site for personal mourning; and behind it, the "great rustic stone" which is a reference to the testimony by István Angyal, one of the most emblematic revolutionaries of 1956, who wrote in prison before his execution on 1 December 1958: "Let a great rustic stone be the memorial of the anonymous mob with which we shared a common fate, and with which we die. But brooding over the past is always stupid. Rather, forget us, forget us, it will be better."[26] Jovánovics, by using the great rustic stone behind the altar as a quotation of sorts and trying to be faithful to this message, is in fact creat-

[26] Quoted in István Eörsi, *Emlékezés a régi szép időkre* [Remembering the good old days] (Budapest: Holnap, 1989), 178.

ing another paradox, that is to say, a memorial based on the idea of forgetting. This memorial, as a work of art, is placed into a natural environment based on the careful organization of space: a bird's eye view would show the little paths leading visitors into the symbolic church (the altar). While considering the plot in its entirety, Jovánovics's work is a piece of land art, the memorial itself could be seen as an instance of conceptual art.[27] In terms of its reception it could be identified as a counter-memorial. Despite the highly positive reaction of the experts, most of the former revolutionaries found Jovánovics's work incomprehensible, abstract, obscure, and—as the art historian Géza Boros writes—they longed for another, a "real" memorial, because they felt unable to identify with the already existing one.[28]

The other plots also constitute sites of confrontation in aesthetic terms, but in a completely different manner than Jovánovics's work. Plot no. 301 was re-designed in a thoroughly distinctive fashion by a team of artists called *Inconnu*. This group, whose previous artistic activity had aimed at eliminating the bond between political and aesthetic creation, constructed a conspicuously separate space in the cemetery by using special wooden grave markers (*kopjafa*) in an imagined Transylvanian Magyar style. (Fig. 3) In aesthetic terms—generating a sense of pathetic heroism—this part of the cemetery is radically dissimilar to and incongruent with the visual representation of Jovánovics's work. Plot no. 298 was reconstructed only two years later. In 1991, members of the new Hungarian anticommunist, nationalist extreme right proposed and, subsequently, carried out the re-building of this plot. The simplest solution seemed to be for them to copy the design of plot no. 301, thus they too decided to erect wooden grave markers. But while the *Inconnu* group represented, from a bird's eye view, a spiral, visitors are now faced with the uniform, clean-cut geometric arrangement found in military cemeteries in plot no. 298. A different concept of how to deal with the dead is implied here: while Jovánovics's counter-memorial is dedicated to the singular, unrepeatable and irreplaceable character of the human being, in the "military conception" of plot no.

[27] L. Földényi suggests the term "thanato-plastics" for Jovánovics's work. László F. Földényi, "Séta a 301-es parcellában. Jovánovics György thanatoplasztikája" [Walk in plot no. 301: The thanato-plastics of György Jovánovics], *Jelenkor* (November 1992): 900–15.

[28] Géza Boros, "'Igazi' emlékművek" ["Real" memorials] in his *Emlék/mű. Művészet—köztér—vizualitás a rendszerváltozástól a Milleniumig* [Memory/al: Art—Public space—Visual conceptions from 1989 to the millenium] (Budapest: Enciklopédia, 2001), 53–5.

298, a dead person is no more than a cynically used occasion for political demonstrations. When, in the same year, the right-wing extremists erected a so-called Transylvanian gate (*székelykapu*)—widely used in the 1980s to symbolize the Hungarian demand for Transylvania—in front of plots no. 298 and no. 301, they retrospectively constructed a historical continuity between the revisionist nationalism of the inter-war years and the revolt of 1956, ignoring the socially and politically diverse composition of the participants in the events of October and November 1956. Though the gate has since been re-located to another side of the same plot, the inscription—"do not enter through this gate, if you are not Hungarian"—still recalls the radical message. Nonetheless, this form of radicalism divides even the conservative right-wing. Miklós Melocco, a well-known Hungarian sculptor and an emblematic figure of Hungarian right-wing politics, whose father is buried here, described plot no. 298, with its wooden grave markers, as a "disgusting puppet cemetery."[29]

Fig. 3 Plot no. 301 in the Rákoskeresztúr cemetery
(photo: Zsolt K. Horváth, 2006)

[29] Melocco quoted by György, *Néma hagyomány*, 145.

IRONIC READING AND THE POSSIBILITY OF SELF-ANALYSIS: THE STATUE PARK

Prompted by the damage to and the destruction of some socialist statues located in public squares during the transition years, the literary historian László Szörényi proposed in 1989 that statues of Lenin should be preserved in a place outside the city.[30] His article, entitled "Lenin Garden," was the original idea on which the concept of the Statue Park was based.[31] The proposal rapidly found favor with the authorities, and in 1992 the Gallery of Budapest announced a design competition. It was won by the architect Ákos Eleőd, who adopted a sensitive approach embodied in a plan for a clear structure for the Park with a relatively easily intelligible symbolism.[32] His main idea was to avoid taking any physical revenge on the statues and to place them instead in a radically different, but still meaningful context. Neither a "park of shame" nor a place of ethical retribution, the moral impact of the design is based on irony.[33] On the one hand, Eleőd's proposal suggests both self-irony and self-control, because, as he says, everybody lived silently among these "propaganda objects" situated in the public spaces of Budapest until the transition years, so that there is no real reason to take symbolic revenge. If the Park were to join the revenge movement, it would become an instrument of counter-propaganda. On the other hand, if these de-contextualized representations can make visitors laugh at these statues, as elements of an ideological environment located in public spaces, they can laugh at the former socialist power and, partly, also at themselves.[34]

[30] Éva Kovács, "Terek és szobrok emlékezete, (1988–1990)" [Memory of squares and statues, 1988–1990], *Regio* 1 (2001): 68–91.

[31] László Szörényi, "Leninkert" [Lenin garden], *Hitel* 10 (1989): 27–8.

[32] Ákos Eleőd, "Szoborpark (műleírás)" [Statue Park: Description of the oeuvre], *2000* (July 1993): 60–1.

[33] See Anne-Marie Losonczy, "Le patrimoine de l'oubli. Le parc-musée des Statues de Budapest," *Ethnologie française* 29/3 (1999): 445–52; and "Deux figures muséales de la mémoire en Hongrie postcommuniste: muséification du passé récent entre deux régimes" in B. Jewsiewicki Koss (ed.), *Travail de mémoire et d'oubli dans les sociétés postcommunistes* (Bucharest: Editura Universităţii din Bucureşti, 2006), 64–81; Péter Apor, "Le 'socialisme à visage humain': le Parc des statues de Budapest," *La Nouvelle Alternative* 20 (October–December 2005): 189–93.

[34] Júlia Váradi, "Szoborpark-történet. (Beszélgetés Eleőd Ákossal)" [A History of the Statue Park. An Interview with Ákos Eleőd], *Magyar Építőművészet* 85/2 (1994): 19–23; István Schneller, "Szoborpark: egy korszak lezárása, egy új korszak kezdete" [Statue Park: the end of a period and the beginning of a new period], *Magyar Építőművészet* 85/2 (1994):

Fig. 4 The entrance of the Statue Park
(photo: Zsolt K. Horváth, 2006)

Entering the park, one sees a huge socialist realist façade with statues of the Marx-Engels duo and of Lenin. But behind the façade there is nothing: it remains an empty promise. (Fig. 4) According to Géza Boros, it can be understood as a genuine metaphor of Socialism: at first sight, a great, enticing promise, but never to be fulfilled; a monumental but empty construction. On the gate, there is an extract from a poem by Gyula Illyés, written in 1950, published for the first time in October 1956 under the title "One Sentence on Tyranny." The poem's most important line is: "everybody is a link in the chain," meaning that the dictatorship was present everywhere. This highlighted use of the quotation from the poem implies a confrontation of the former "I" with the present one, and excludes the possibility of symbolic revenge or the shifting of responsibility onto others. (As demonstrated by Tony Judt, the sentence "they did it" was the key motive of the appraisal of Nazism.)[35] After entering the Park, the visitor is

23–4; Tibor Wehner, "Nyilvános, idényjellegű szobortemető" [A public and seasonal statue cemetery], *Balkon* (April 1994): 16–7.

[35] Tony Judt, "The Past is Another Country: Myth and Memory in Postwar Europe," *Daedalus* (Autumn 1992): 83–118; Reinhart Koselleck, "Diskontinuität der Erinnerung," *Deutsche Zeitschrift für Philosophie* 47 (1999): 213–22. Henry Rousso, "L'épuration en France: une histoire inachevée," *Vingtième Siècle* 33 (1992): 78–106.

led by a main avenue to a great wall, representing the "end station" of Socialism, which is completed by three subsequent paths, forming a sign of infinity, where the statues are placed.

Fig. 5 Communist heroes in the Statue Park
(photo: Zsolt K. Horváth, 2006)

Ákos Eleőd's artistic conception combines three main themes. The first is the friendly relationship between Hungary and the USSR during the socialist period, and the expression of the gratitude of the Hungarian people for the liberation of their country. Among others, this aspect can be seen in the statue of the Soviet soldier with a flag at the moment of liberation; in a bas-relief representing the joy of liberty; or in the statue of friendship featuring a Hungarian worker and a Soviet soldier as representative figures of their countries. The second theme deals with the heroes of the communist movement: among others, Endre Ságvári, a clandestine communist activist killed by a policeman in 1944; or one of the greatest figures of the labor movement's mythology, Béla Kun, the leader of the first Hungarian Soviet Republic in 1919. One sculpture, considered to be one of the most valuable in the Statue Park, shows Béla Kun giving commands to the soldiers of the Hungarian Red Army. All the elements of the installation confirm the "revolutionary" ambience: guns, a street lamp beside Kun, the strength of the army, and so on. Another work stresses the

heroic role of Kun; here he can be seen in an intellectual pose as he ex-
plains the strategy of the Communist Party to the workers in Csepel. The
third theme encompasses all the important events and key terms of the
communist movement: for example, Memorial to the Spanish Civil War,
which was, of course, one of the most important myths of the labor
movement (not only in Hungary but for all Communists throughout the
world); a conceptual work of art, Provision for Humanity; one example of
the hundreds of statues of Lenin, which stood in the main square of practi-
cally every town; and a three-dimensional embodiment of the well-known
political recruitment poster *Fegyverbe! Fegyverbe!* ("To Arms!") made in
1919 by Róbert Berény. (Fig. 5)

The symbolic logic of the Statue Park is simple but efficacious, as it
gives visitors the opportunity to laugh at the remnants of the socialist sys-
tem. It aims at generating an instance of Bakhtinian "laughter,"[36] a
weapon for powerless people, as well as a space for self-analysis. Since its
inauguration in 1993, the Statue Park has remained incomplete—a few
architectural elements have never been built—because, as its architect
recently explained, there is no longer the political will to emphasize and
develop this ironic perception of the memory of Socialism.[37] Usually, the
competition between different memories is not an accidental, innocent
event, but is embedded in a given political situation. Indeed, whereas the
next subject of my analysis, the House of Terror, benefited from excep-
tionally generous government funding, the unfinished and deteriorating
Statue Park barely scrapes by.

TRAGIC REPRESENTATION AND THE MEMORY OF VICTIMS: THE HOUSE OF TERROR

According to Katalin Sinkó and Ákos Kovács, the birth of memorial
building is tied to two specific events in modern Hungary: firstly to the
celebrations of the Millennium in 1896 and secondly to World War I.[38] In

[36] Mikhail Bakhtin calls grotesque laughter the weapon of the powerless in turning hierar-
chies upside down. Mihail M. Bakhtin, *Rabelais and his World* (Bloomington: Indiana
University Press, 1984).

[37] Géza Boros, "Szoborpark. Interjú Eleőd Ákossal" [Statue Park: Interview with Ákos
Eleőd], *Élet és Irodalom* (19 December 2003): 6.

[38] Katalin Sinkó, "A nemzeti emlékmű és a nemzeti tudat változásai" [The National
monument and the change of national consciousness] in Ákos Kovács (ed.), *Monumen-
tumok az első háborúból* [Monuments from World War I] (Budapest: Corvina, 1991), 9–

1915, to help the government's war propaganda, the National Committee for Preserving the Memory of Heroes (HEMOB) was founded and later, at the beginning of 1917, the Hungarian Assembly passed a law about "preserving the memory of heroes who fought for the country during this war." After the war, in 1924, the Assembly officially founded the Memorial Day of Heroes.[39]

Arguably, World War I was a traumatic experience, and the loss of fathers and brothers who died in battle could be as painful as it was to be twenty years later. It is also evident that the Second World War was bloodier and thus more terrible than the First, but the proportionate increase in casualties (soldiers and civilians included) alone does not explain the radical change in the uses of the term "victim." Why, after 1918, did the survivors and relatives of fallen soldiers commemorate the heroes, and not the victims? According to Reinhart Koselleck, before and shortly after World War I, monuments and memorial days were created for heroes, and if a soldier was named on a monument as a victim, this meant an actual sacrifice (e.g. "fallen *for* the country"). After World War II this view changed radically. The notion of victim began to signify a passive person suffering from an aggressive action.[40] This semantic change extended the connotations of the concept of victim(hood): after 1945, anyone could have become the victim of Nazism, and according to the same logic this kind of retrospective judgment was extended to the victims of Communism after 1989. The silence about the past or the transformation of the past according to personal interests—which are characteristic of the uses of collective memory—results in certain interpretative conflicts: if everybody is considered as a victim, then who were the executioners?

It is in this particular context that decree no. 58 was passed in 2000, establishing the Memorial Day for the Victims of Communist Dictatorships (sic).[41] On 24 February 2002, the eve of the second Memorial Day of the Victims of Communist Dictatorships, Viktor Orbán, Prime Minister of the

45: Ákos Kovács, "Emeljünk emlékszobrot hőseinknek!" [Let us erect a commemorative statue to our heroes!] in *Monumentumok az első háborúból*, 104–24.

[39] Kovács, "Emeljünk emlékszobrot hőseinknek!," 109–10 and 116–7.

[40] Reinhart Koselleck,"Diskontinuität der Erinnerung," 213–22.

[41] Decree of the Hungarian Parliament on the Memorial Day for Victims of Communist Dictatorships, 58/2000 (VI. 16.) számú Országgyűlési Határozat "A kommunista diktatúrák áldozatainak emléknapjáról," *Magyar Közlöny* 58 (16 June 2000): 3360. There are at least two hidden messages in the title: its date, i.e. the anniversary of the execution of Imre Nagy and his companions, and the plural of the communist dictatorships. The second is an allusion to the first Hungarian Soviet Republic of 1919.

right-wing government, inaugurated the House of Terror Museum with the following words,

> We closed the museum door on the long, pompous and awful twentieth century at the last moment. At the last moment, because it threatened to continue as before. (...) Now, we are putting the pain, the hatred behind bars, because we want them to have no longer any place in our lives and in the future. We put them behind bars, but we will never forget them. The wall of the house that, until now, was the boundary between the interior and the street, from now will become the wall between the past and the future. (...) What is inside belongs to the past and we shall become part of the future.[42]

It is not by chance that the essence of this speech is based on the juxtaposition of the "past closed up in the museum" and "the perspective of the future." The moral surplus of the construction of the House of Terror, as the Prime Minister said, is the fact of "regaining the independence of the nation and the liberty of our citizens" without any bloody, aggressive action. During the parliamentary elections of the same year, the past/future contrast became the central theme of the rhetoric of the right-wing party. Remarks such as "you have a choice not between two parties, but between two worlds," or "where does the past end, and where does the future start?" or expressions like "forces of the past," were closely bound up with the right-wing election strategy. The entire process began with the opening ceremony of the House of Terror. Subsequently, the main campaign slogan of Fidesz–MPP (Hungarian Civic Party), "The future has begun," contrasted sharply with "forces of the past," which was an allusion to the Socialist Party (MSzP). In an article entitled "The future cannot begin," the sociologist Niklas Luhmann considers the past and future as time horizons, whose starting points are always, and necessarily, in the present. In these terms, the future always remains inaccessible because it is constantly "slipping" from the actual present. In this sense, the future is *by definition* unreachable.[43] In the Fidesz-MPP conception, the reference to the future is a representation of wishes and aspirations, and the usage of present perfect tense (past perfect tense in the original Hungarian) suggests the real possibility of reaching it.

On 24 February, for the occasion of its inauguration, practically all the political parties in Parliament formulated statements concerning their rela-

[42] Available at www.orbanviktor.hu/old/index2.html, accessed 23 August, 2002.
[43] Niklas Luhmann, "The Future Cannot Begin," *Social Research* 43 (1976): 130–52.

tionship to the site in open street demonstrations.[44] The extreme right-wing group, the Party of Hungarian Truth and Life (*Magyar Igazság és Élet Pártja*, MIÉP) organized a demonstration in front of the headquarters of the Hungarian Socialist Party (a descendant of the former state party) which they regarded as "the real house of terror." The placards they brought to the demonstration, containing the names of the enemies of "real Hungarians," evoked a historical continuity from Mihály Károlyi via László Rajk, Stalin, and Ferenc Münnich to the contemporary socialist Prime Minister, Péter Medgyessy. Later on, marching with their placards from the socialist headquarters, they arrived at the House of Terror in order to unify the forces of the right-wing parties. Thus, they produced a continuity not only of names, but also of sites. According to this political symbolism, if one displays the names of the enemies and victimizers then their victims should be revealed as well. Three days after the opening of the House of Terror, the State Secretary for Foreign Affairs delivered a speech in Budafok in front of a memorial erected to the 1956 revolution: "The most horrifying thing of all is not even the number of victims, but the silence. That is why *we are also victims*, because we did not know what was happening to us."[45] Thus, everyone is or can be a victim, even those who did not live at the time of Socialism.

The project of the House of Terror is even more radical: there is a database on its official website where anybody can sign in and add a description of the suffering inflicted on them, as well as the name of the perpetrator. In this sense, it is could be seen as the exact opposite of the Statue Park: as a site for symbolic revenge. On the other hand, the responses to the inauguration of the museum of the two left-wing parties in Parliament, the Alliance of Free Democrats (*Szabad Demokraták Szövetsége*, SzDSz) and the Socialist Party, are also interesting. These parties refused to articulate their opinion about the right-wing interpretation of the socialist past even in symbolic terms. The Free Democrats organized a farewell party for the right-wing government in Heroes' Square, some 200 meters from the House of Terror. The Socialists arranged no public meetings, but asked their supporters to stay at home and not to participate in these demonstrations. What is remark-

[44] Julianna Bodó, Zoltán A. Biró, "Szimbolikus térfoglalási eljárások" [Symbolical occupations of space] in Márton Szabó (ed.), *Szövegvilág: Írások a szimbolikus és diszkurzív politikáról* [A world of texts: Studies on symbolic and discursive politics] (Budapest: Scientia Humana, 1997), 305–32.

[45] "Az áldozatok emléke" [The memory of victims], *Magyar Nemzet* (26 February 2002): 1, 3.

able here is that the opposition concentrated on current practical issues of politics, leaving the political representation of history to the ruling conservative right wing.

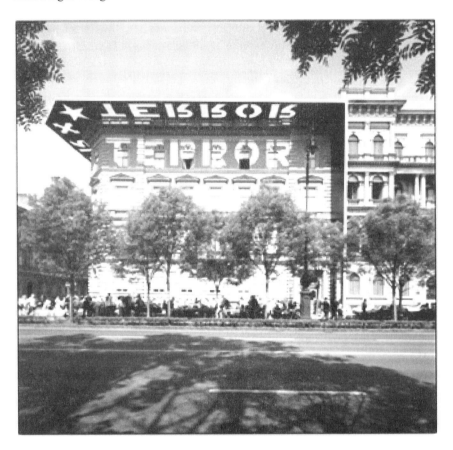

Fig. 6 The House of Terror
(photo: Zsolt K. Horváth, 2006)

The building of the House of Terror, located at 60 Andrássy Avenue, used to be the headquarters of the Hungarian Nazi Arrow Cross Party until the end of World War II, and after the liberation of Budapest in 1945 became the command center of the political police of the Hungarian Communist Party.[46] During the war, a large number of Jews were killed on the

[46] This part of the present article summarises an earlier, much longer analysis: Zsófia Frazon, Zsolt K. Horváth, "A megsértett Magyarország. A Terror Háza mint tárgybemu-

banks of the Danube by Arrow Cross men, and after the war many people were tortured and killed within the walls of this building by Communists. Thus, the building itself is associated with traumatic memories of lived experience. (Fig. 6)

Although the House of Terror as an institution is formally a museum, its reputation and political significance are not the same as those of an ordinary museum exhibition.[47] According to the German museologist Gottfried Korff one should ask whether history needs to be conserved in a museum.[48] The task of a museum is to collect, keep, look after and present its objects. In fact, preserving, accumulating and keeping the traces of the past, along with their classification, presentation and finally their interpretation, permit the process of remembering. This whole process of archival collection constitutes the institutionalized basis of the museum.[49] That is the reason why the *authenticity* of the exhibited objects should be guaranteed. Authenticity in this regard is seen as an intellectual relationship between the "reality" of the past and the artificial context of the museum. The authentic object must be considered as a fragment of an earlier world's reality which, in a museographic context, by its mimetic function, is able to produce a general meaning.

The House of Terror lays claim to the realistic and faithful representation of the socialist past in a neo-positivist understanding of historical studies.[50] The exhibition displays three different categories of objects. The first group includes authentic historical material, the second consists of copies of original historical items, and the last includes actual objects of contemporary everyday life, whose role, meaning and place in the context of the exhibition remains unclear. The museum in general uses even its authentic materials in a way that further increases the uncer-

tatás, emlékmű és politikai rítus" [The injured Hungary: The House of Terror as presentation of objects, monument and political rite], *Regio* 4 (2002): 303–47.

[47] Gábor Csillag, "Little house of terror. The premises and practices of the 'House of Terror' Museum, Budapest," *Transversal* 1 (2002): 18–46; Mark Pittaway, "The 'House of Terror' and Hungary's Politics of Memory," *Austrian Studies Newsletter* 1 (Winter 2003): 16–7.

[48] Gottfried Korff, "Läßt sich Geschichte musealisieren?" *Museumskunde* 60 (1995): 18–22.

[49] Barbara Kirshenblatt-Gimblett, *Destination Culture: Tourism, Museums, and Heritage* (Berkeley: University of California Press, 1998), 18–34; Gottfried Korff, Martin Roth, "Einleitung" in G. Korff, M. Roth (eds.), *Das historische Museum: Labor, Schaubühne, Identitätsfabrik* (Frankfurt/M: Campus, 1990), 9–37.

[50] Ferenc Donáth, "(T)error iratok" [(T)error documents], *Élet és Irodalom* 67 (21 March 2003): 8–9.

tainty concerning their interpretation. Typically, there is so little information attached to objects that it is often very difficult to decide whether they are really the genuine remnant of an actual historical moment or simply objects that represent a historical interpretation. This transforms the exhibited material into mere illustrative accessories of a dramatized story. In addition, the museum constantly blurs the distinction between real and fabricated objects as it displays them in the same installation, without any further explanation. The profound lack of historical contextualization, of clarity and of methodological consistency ultimately undermines the credibility of the representation of the past. Thus, the museum fails to satisfy the critical role of history as an academic discipline. According to József Ihász, a distinguished interior designer, "this paucity of objects is compensated for by the artistic installations" made by the architect, Attila Ferenczffy Kovács.[51] Ferenczffy Kovács's conceptions are deeply influenced by one of the most celebrated contemporary French artists, Christian Boltanski, above of all in the Wall of Victims.[52] But what suffices for Boltanski in an exclusively artistic context is not enough for Ferenczffy Kovács in a historical museum which could rather be defined as a memorial representation with a teleological function, whose main purpose is the affirmation and confirmation of a political identity.

What is at stake in this fight for the past and in the importance of the term "victim" as the basis of a new self-representation? It is well known that during the nineteenth century, the representation of a nation by a symbolic figure, usually a woman, was common throughout Europe. Pictures of Bavaria, Helvetia, Bohemia, Polonia and Hungária as national geniuses were common. According to Katalin Sinkó, these women were sometimes portrayed in a tortured pose, sometimes in full dignity and

[51] István Ihász, "Gomb és kabát. A profán valóság bemutatásának kísérlete a Terror Háza Múzeumban" [Button and coat: The attempt to display mundane reality in the House of Terror Museum] in János Pintér (ed.), *Történeti Muzeológiai Szemle. A Magyar Múzeumi Történész Társulat Évkönyve* [Review of historical museum studies: Annales of the Hungarian Association of Museum Historians] vol. 2. (Budapest, 2002), 100.

[52] Rényi András, "A retorika terrorja. A Terror Háza mint esztétikai probléma" [The terror of rhetoric: The House of Terror as an aesthetic problem], *Élet és Irodalom* 47 (4 July 2003): 3, 11–2; Sándor Radnóti, "Mi a Terror Háza?" [What is the House of Terror?], *Élet és Irodalom* 67 (24 January 2003): 15 and 20. For the critique of the simplifying concept of history by Radnóti, see Zsolt K. Horváth, "Über 'Lieu de Mémoire,' 'Trauma' und ihre Bedeutung in Ungarn. Gedächtnisforschung aus begriffsgeschichtlicher Sicht" in Amália Kerekes et al. (eds.), *Leitha und Lethe. Symbolische Räume und Zeiten in der Kultur Österreich-Ungarns* (Tübingen–Basel: Francke, 2004), 37–49.

well-being, representing the actual political situation of the nation in question.[53] The presentation of a mutilated national figure always signified territorial occupation by another power. In Hungary, in the nineteenth and at the beginning of the twentieth century, until the Trianon treaty, the so-called "Hungária enthroned," representing the grandeur of the nation, was the predominant form of pictorial representation of the country. After 1920, a radical change took place: Hungária, the national genius, began to disappear from visual representations and, at the same time, a cartographical representation of Greater Hungary became more frequent. This process is connected to the spread of the sacralized concept of the territory, soil and landscape. During the inter-war period "anthropogeography" and "cultural morphology" played a predominant role in the formation of Hungarian identity. For instance, the schoolbooks of the time contain the picture of Greater Hungary covered with flowers and a sword representing the struggle for the country; the prayer for Greater Hungary is represented as a halo around a little girl's head. The concept of a sacred country and, at the same time, the impression of menace are both equally present here. Katalin Sinkó maintains that there is a strange continuity relating to the self-representation of Hungary, because around the transition years the horrifying and self-tortured conceptions appeared again.[54] On the occasion of a popular design competition entitled "Hungary can be yours," organized by the Artpool Art Research Centre in 1984, most of the Hungarian artists' entries were based on tragic cartographic representations of the country, while foreigners tended to use puns ("Buddha-pest" for Budapest, "Hungry" for Hungary, etc). These associations clearly show the widespread stereotypes or patterns relating to the representation of the country.[55]

The House of Terror renewed the cultural tradition of tragic self-representation, including the conception of mutilation. The first room in the museum is the so-called "Occupation Room," which implies that everything that happened in Hungary after 1920 was due to the influence of foreign countries and powers. In this regard, one can see how the sacred territory of Greater Hungary was mutilated by the Western Powers in

[53] Katalin Sinkó, "A megsértett Hungária" [The injured Hungária] in Tamás Hofer (ed.), *Magyarok Kelet és Nyugat közt. A nemzettudat változó jelképei* [Hungarians between East and West: The changing symbols of national identity] (Budapest: Néprajzi Múzeum–Balassi Kiadó, 1996), 267–82.

[54] Ibid., 278–9.

[55] Ibid., 279.

1920, how the Third Reich occupied Hungary on 19 March 1944, and how the USSR took over the country a year later. This point of view supports the innocence of the Hungarian population, and thus automatically rejects any responsibility for what happened. In fact, the House of Terror is not really a museum of the communist period, but rather a tragic self-representation of the recent past. On the other hand, it is true that the suffering caused by Communism is the leitmotif of the exhibition; indeed, it could be maintained that the House of Terror with its cultural, symbolic context is a political allegory of Hungary injured by Communism. It keeps the structure of the former representation of the suffering nation; according to its content, suffering and victimhood have become the two keywords of this conception. The previous *religion civile* has been changed by the image of a demonized Communism.

CONCLUSION

These four sites of memory established particular links with the recent past, manifested in a political cult of heroes or victims, personal mourning, or an ironic attitude to objects. The moral relationships which were generated through the interaction of these sites and the past included irony, active forgiveness, accusation and tragedy, which could be expressed in either a majestic or a rather mundane style. The study of memorials, and in more general terms the anthropology of politics as such, usually presupposes that the initiative for a communication with the past comes exclusively from the realm of high politics. This understanding, however, ignores those forms of popular remembering that exist outside the frame of reference of political consensus, but are kept alive by the will of successors. For instance, the nostalgic memory manifested in the cult of the dead Kádár is an actual attitude towards the recent past, even if no political party or credible political force is inclined to come to terms with it. The analysis of a politics of symbols, therefore, must not be limited solely to the field of high politics, for if it is thus confined, it will fail to register other significant means of identifying with the past generated by social practices.

Nonetheless, the degree to which a mode of remembering is able to shape the broader arena of social memory depends to a great extent on its potential to become institutionalized. These four sites of memory have radically differing opportunities in this respect. The antiquated symbolism of the Pantheon of the Labor Movement is equal to its profound physical

deterioration, while the cult around Kádár's grave, exclusively by elderly people, presages that this site will not be able to go beyond the limits of generational communicative memory because the experiences it conveys are irrelevant outside this group. The memorial designed by Jovánovics and the Rákoskeresztúr cemetery are incorporated into a broader context and form part of the general process of remembering and forgetting the 1956 Revolution. Although it is still uncertain today whether the political legacy of the Revolution can continue, as is reflected in the mixed nature of its representations in the cemetery, the site remains important due to the legitimacy it obtained in 1989. Nevertheless, its effects are weakened by the constant political controversies about the memory of 1956 and by its location on the outskirts of the city. The spatial situation also seems to determine the status of the Statue Park. From a significant form of re-membering connected to a cultural community, it has been gradually transformed into a tourist attraction, and thus marginalized as a site of memory. The concept of the past represented by the Statue Park, the self-irony taking responsibility seriously, is being excluded by a politics of national identity based on injuries, which is inscribed into a more tradi-tional concept of the nation. This is embodied in the House of Terror, whose central location and ability to attract political rites provides a cru-cial role for the space of memory and history in contemporary Hungarian politics.

Raising the Cross

Exorcising Romania's Communist Past in Museums, Memorials and Monuments

GABRIELA CRISTEA AND SIMINA RADU-BUCURENCI

Exhibitions on the communist[1] past are scarce in Romanian museums. In contrast to this scarcity, the commemoration of the "communist tragedy" through memorials, monuments and the hybrid species of memorial-museum is disproportionately present. Only a very skilled and determined museumgoer will be able to discover the few places where aspects of the communist past are permanently exhibited in Romanian museums.[2] In Bucharest, the visitor should be prepared to go underground to find the only permanent exhibition dedicated to Communism, in the unexpected location of the Romanian Peasant Museum.[3] Outside Bucharest, he or she will have to travel 700 kilometers to the Sighet Memorial Museum, located near the Ukrainian border. This former political prison is the most elaborate visual discourse on Romanian Communism, with its fifty rooms dedicated to the victims of Communism, a memorial in the courtyard and a cemetery outside the city of Sighet. A visitor who is unfamiliar with Romanian public discourse, will probably be struck by the abundance of crosses and other religious symbols and metaphors embedded in or framing the visual discourse on Communism.

[1] Unlike many other Central and Eastern European countries, Romanians (academics included) prefer to call the pre-1989 period Communism, disregarding alternative denominations such as Socialism, "Real Socialism" or "actually existing Socialism."

[2] This paper is concerned only with permanent exhibitions on the communist regime. Temporary exhibitions were organized in the 1990s, although rarely. Their number has recently increased as the topic of Communism is becoming almost fashionable. Another important spot where Communism is visually represented is the Leisure Park near Craiova, where the businessman Dinel Staicu built a hotel called RSR (Romanian Socialist Republic) near a swimming pool and a football field. In the same location there is a church and a memorial dedicated to the tragic death of the Ceauşescu couple.

[3] The National History Museum has not been able so far to organize a permanent exhibition on Romania's recent history. At the time of writing (2007) the museum offers access only to the historical treasury and a replica of Trajan's Column, the rest of the building being under reconstruction.

We will argue that these discourses about Communism are actually discourses about anti-Communism, that is: the struggle against Communism in Romania.[4] One of the main characteristics of the discourse on the communist past has been the attempt to distance, or alienate, this past and to avoid integrating it into a coherent history of the country. The fact that Communism has so far been a strongly marginalized topic only assisted the initial drive towards distancing its history. We will explore the methods through which this "distancing" or "alienation" has been accomplished in visual representations of Communism. This article will dwell mainly on those exhibitions and the monuments erected to the victims of Communism, arguing that what was marginal for more than fifteen years, the anti-communist approach to Communism, is now becoming mainstream discourse in Romanian public life. At the core of this discourse is the assertion that the communist regime was a foreign body introduced by force into the national history, a devilish undertaking to be finally defeated by proper exorcism. Thus, the anti-communist discourse and the public discourse of the Romanian Orthodox Church became strongly allied since both appealed to national feelings and frustrations.

AGORAS OF PLURAL NARRATIVES VS. TEMPLES OF UNIQUE TRUTH[5]

As public services and "educational centers,"[6] museums play a very important role in the "construction of consciousness."[7] In Eastern and Central Europe, museums, memorials and monuments about Communism are among the most important places where societies develop a new type of "collective self consciousness"[8] by dealing with and interpreting their own recent past. The fact that they initiate debate rather than simply represent public opinion on the controversial past brings their discourses into the

[4] "Romania doesn't need a museum of Communism, but a museum of the fight against Communism," Adrian Iorgulescu, the Romanian Minister of Culture declared at the opening of the temporary exhibition "The Golden Era. Between Propaganda and Reality." The exhibition is housed in the National History Museum and was opened in 2007 on the symbolic day of January 26th, Nicolae Ceauşescu's birthday.

[5] The distinction between agora museum and temple museum is discussed in Michael M. Ames, *Cannibal Tours and Glass Boxes: the Anthropology of Museums* (Vancouver: University of British Columbia, 1992).

[6] Ames, *Cannibal Tours*, 26.

[7] Pierre Bourdieu and Hans Haacke, *Free Exchange* (Cambridge: Polity Press, 1995), 98.

[8] Ames, *Cannibal Tours*, 111.

political arena. Above all, monuments, memorials and museums are important because they work with visual stimuli. The public space of debate nowadays is no longer a place of discourse, but rather a "place of gaze."[9]

Abbé Henri Grégoire, an important figure in the French Revolution, called the museum of the time a "temple of the human spirit."[10] This title implies some important assumptions: that those who work inside the museum are performing some kind of priestly function, that the visitors' attitude is one of reverence, and that the objects inside are sacred. In the nineteenth century, at the time of nation-making, modern museums inherited the same type of authority. At that moment, existing private collections were appropriated by the state and, subjected to its aims and ambitions, became modern state museums. As central spaces in supporting the construction of the nation-state, during the nineteenth and twentieth centuries they were turned into Temples of the Nation.

According to Ihab Hassan the specific elements representative of modernity are collection (accumulation), sincerity, reality, exemplarity (uniqueness), while post-modernity is marked by waste, irony, virtual worlds, mass production.[11] Consequently where we speak of "postmodern" museums, Wolfgang Ernst and Michael Fehr have written about "museums of Waste," "virtual museology," "museum, media and archaeological gaze," "ironic museum."[12] These are not museums which the visitor enters like a Temple, to receive a single Truth, Reality, uniqueness, and accumulation of information for the better identification with an ideal, but museums seen as agoras—places of meeting, discussion and confrontation with different variants of what is perceived as being the truth.

Museums, monuments and memorials of (anti-)Communism in post-1989 Romania mainly function as "temples of Truth," confined to National History. Raised after 1989, their anti-communist discourse is shaped by national values and uses modern means of visual representation. No postmodern techniques and functions of museum discourse are used: the mu-

[9] Richard Sennett, *Flesh and Stone: The Body and the City in Western Civilization* (London: Faber and Faber, 1996), 358.

[10] Stephen E. Weil, *A Cabinet of Curiosities: Inquiries into Museums and their Prospects* (Washington and London: Smithsonian Institution Press, 1995), 7.

[11] Ihab Hassan, "POSTmodernISM" in Lawrence E. Cahoone (ed.), *From Modernism to Postmodernism: An Anthology* (Oxford–Cambridge, MA: Blackwell, 1996), 4.

[12] Wolfgang Ernst, "Archi(ve) Textures of Museology" in Susan A. Crane (ed.), *Museums and Memory* (Stanford: Stanford University Press, 2000), 17–34; Michael Fehr, "A Museum and Its Memory: The Art of Recovering History" in Crane (ed.), *Museums and Memory*, 35–59.

seum is not seen as an "agora" where the conflicting memories of the past could, ironically and fragmentarily, face each other. Nowadays, any attempt to create an "agora museum" of Romanian Communism is made more difficult as it would go against the existing anti-communist victimizing discourse, currently endorsed by the President of Romania.

ROMANIAN ANTI-COMMUNISM

19 December 2006: "Parliament was hell yesterday. Our representatives were yelling, whistling and stamping." This sentence opens an article entitled "Exorcising an Era."[13] The same day similar articles covered the front page of newspapers: "The solemn meeting to condemn Communism was transformed into a cheap circus reminiscent of a group exorcism."[14] Leading the "exorcism," with perfect calm and determination in the growing chaos, Romania's President, Traian Băsescu, delivered his forty-minute speech on the crimes of the Romanian Communist regime, seventeen years after its overthrow. Meanwhile, members of the ultra-nationalist Greater Romania party (*România Mare*) were trying to stop the speech or at least to disrupt the desired solemnity of the moment.

> As head of the Romanian State, I condemn explicitly and categorically the communist system in Romania, from its establishment, on dictatorial basis in 1944–1947 to its collapse in December 1989. Taking into account the realities presented in the Report, I state with full responsibility: the communist regime in Romania was illegitimate and criminal.[15]

The President of Romania based this statement on a report issued by the Presidential Commission for the Analysis of Communist Dictatorship

[13] Laura Gafencu, Anca Simina, "Exorcizare unei epoci" [Exorcising an era], *Evenimentul Zilei* (19 December 2006). Available at www.expres.ro/article.php?artid=284959 (accessed 10 January, 2007).

[14] Lia Bejan, Luminita Castali, "The solemn meeting to condemn Communism has been transformed into a cheap circus reminiscent of group exorcism," *Gardianul* (19 December 2006). Available at www.gardianul.ro/2006/12/18/politica-c7/scandal_in_parlament-s88149.html (accessed 10 January, 2007).

[15] Speech by Romania's President, Traian Băsescu, on the Occasion of Presenting the Report of the Presidential Commission for the Analysis of Communist Dictatorship in Romania (Romanian Parliament, 18 December, 2006). Available at www.presidency.ro/?_RID=det&tb=date&id=8288&_PRID (accessed 10 January, 2007).

in Romania. The Commission itself was established in April 2006, with the precise purpose of delivering a report on the basis of which President Traian Băsescu could, whole-heartedly, condemn "Communism."[16]

However, the idea of the communist regime being a criminal one was totally alien to Romanian public discourse as recently as just two years ago.[17] One can hardly imagine the shock and wonder of the Romanian voter when, during the presidential elections in 2004, Traian Băsescu, the candidate of the anti-communist opposition challenging the Party of Democratic Socialism (PDSR), the successor of the Romanian Communist Party, made this remark on television: "What a curse for Romanian people to be forced, fifteen years after the Revolution, to choose between two Communists!"[18] Having based his campaign on accusing his opponents as the heirs of the communist dictatorship, Băsescu, after winning the elections, launched a systematic policy to re-write the history of Communism centered on the condemnation of communist crimes. Up to that moment, the anti-communist discourse had been restricted to a small group of intellectuals and former political prisoners who had been trying for years to make their ideas heard. In the early 1990s they were labeled "hooligans" and "fascists" by the then Romanian President, Ion Iliescu, for claiming exactly what has now become the official position of the same institution, the Romanian Presidency. Since then, their voices have gained authority in intellectual circles, while remaining marginal in Romanian society at large. At the same time their discourse has remained radical in its Manichaeism and lack of nuances.

One of these radical elements is the attempt to distance and alienate the past as a nightmare, a horror film whose scenario somehow imposed itself on Romanian society. In his latest book Stelian Tănase, political scientist, self-appointed but quite famous historian, media personality and member of the aforementioned Presidential Commission, tries to depict the communist *nomenklatura* by tracing its roots in the years of illegality. His

[16] Even though the President condemned the communist regime, the headlines were all about the "condemnation of Communism." The synonymy between Communism and communist regime is considered perfectly valid in Romanian everyday and public speech.

[17] Adrian Năstase, ex-Prime Minister of Romania, declared in 2004 that "anti-Communism is obsolete" and "graves should be left in peace." Quoted in Edward Kanterian, *Knowing Where the Graves Are: How Romania Has Begun to Deal with its Communist Past*. Available at www.draculacastle.com/html/cgulag1.html (accessed 2 February, 2004).

[18] See the reaction of political analysts in "Political analysts appreciate Băsescu's move." *Ziua* (10 December, 2004). Available at www.ziua.net/display.php?id=164648&data=2004-12-10 (accessed 22 January, 2007).

argument is as much historical as it is psychological. Tănase tries to convince his readers that living in illegality had such lasting effects on the members of the communist elite that they continued to act throughout their political careers as if they were still in the cellars. "The underground meant dehumanization, alienation; it was a laboratory for producing *human hybrids, monsters* that would prove themselves after seizing power."[19] These people, Tănase claims, "have run the country for decades from the underground that they never actually left. They remained hidden in a bunker, far away, alien to society, continuously conspiring against it. They never managed to come to the surface, to gain legitimacy, not even for one day in almost half a century during which they were running the Romanian world. They remained condemned to their condition of *eternal creatures of darkness*."[20]

Stelian Tănase is a talented writer of novels and history books.[21] He gained access to archives that other historians never saw and is one of the contributors to the Report that led to the official condemnation of the communist regime in Romania. Thus he is no longer a marginal voice, as he was in the early 1990s. And what does this voice tell us now? That Communism was brought upon an innocent society by some sort of monsters, creatures of darkness, human hybrids who never became part of Romanian society. It is not very hard to see how, in this framework, a denunciation of Communism becomes very easy, and indeed necessary.[22] After all "we," the normal people, the society had nothing to do with it. It was "them," the aliens, the human hybrids, that brought this curse upon us.[23]

This is precisely the discourse that the official condemnation of the communist regime is now reproducing: "The exported Communism that

[19] Stelian Tănase, *Clienţii lu Tanti Varvara. Istorii clandestine* [Aunt Varvara's clients. Clandestine histories] (Bucharest: Humanitas, 2005), 71 (original emphasis).

[20] Ibid., 493 (original emphasis).

[21] An English translation of a chapter from Stelian Tănase's book is available on-line in the journal *Archipelago*. As announced by the journal, the chapter belongs to the novel *Aunt Varvara's Clients*, translated with the financial support of the Romanian Cultural Institute. Available at www.archipelago.org/vol10-12/tanase.htm (accessed 22 January, 2007).

[22] The President's speech assesses the establishment of the Communist regime in Romania along the same lines, calling it "exported Communism," "imposed through foreign dictate." Speech by Romania's President, Traian Băsescu.

[23] Andrei Pleşu expressed the same idea of the non-responsibility of the Romanian people, by a metaphor. "If one brings a brothel to high school boys, who is responsible for what happens next?" *Cultura Libre*, TV show on Romanian National Television TVR1, May 25th, 2006. Available at http://cultura--libre.blogspot.com/2006/05/25-mai-andrei-plesu-si-marius-oprea.html (accessed 1 June, 2006).

we lived through for five decades is a wound in Romania's history, an open wound whose time has come to be closed forever."[24] Seen as a wound, or as a place of darkness and death, the communist past had to be closed or distanced with an equally powerful symbol. Those involved in the "exorcising" of Communism thought that the cross had the appropriate symbolic power, through its mixed Christian-traditional (even pagan) symbolism. The distance between the world of the living and the world of the dead is one of the most radical distances one can think of. In Romanian Orthodox and popular tradition, the cross usually marks this line. The cross stands at the border and keeps the two worlds from contaminating each other. The Romanian language retains this understanding in the expression "to put the cross (on something)"[25] which means to finish something definitively. This is precisely what President Băsescu is now prescribing. In the visual discourse on (anti-)Communism, the cross is one of the most powerful and widely used distancing techniques, meant to reformat the public discourse on the past by introducing a series of binary oppositions such as nightmare vs. reality, bad vs. good, fake vs. authentic and finally death vs. life.

WHY THE CROSS? AN ALLEGORY

The Association of Former Political Prisoners in Romania, led by Ticu Dumitrescu since 1990, supported the construction of the first monuments dedicated to the sacrifice, suffering and struggle against Communism.[26] Eighty-two monuments were built between 1991 and 2004 from private funds, with no support from any state institution. In 2004, the Association published an anniversary memorial album with pictures of all these monuments. The introductory text claims that "during the forty-five years of communist terror (1945–1989), Romania became a country of organized crime, of torture chambers, of detention and extermination camps. During this period, an entire nation lived in terror, humiliation, lies and

[24] Speech by Traian Băsescu.

[25] The idea of "putting a cross at the end of something" will recall to many English-speaking readers the old habit of letting an illiterate sign a document with an X. However, in the Romanian context the expression is certainly related to the cross as a Christian symbol.

[26] Constantin Grigore Dumitrescu, b. 1928, is the initiator of the 187/1999 law granting each Romanian citizen free access to his/her own *Securitate* dossier and denouncing the *Securitate* as political police.

fraud. If Moscow had not sustained the Romanian Communist Party, all these things would not have happened."[27]

The overwhelming majority of these monuments, some of them humble constructions, others great works of art, are based on structures of marble, stone or wood shaped in or marked with the form of a cross.[28] Some of them represent the map of "Greater Romania"[29] as it used to be between the two World Wars. On the monument in Insula Mare, Brăila, all the places of detention and labor camps from the communist period are represented by the symbol of the skull and crossbones on a map of Romania. The map is dominated by the image of Jesus on the cross, creating an overall strong sense of intense religious feeling. (Fig. 1) The stylized crosses often recall the crosses on tombs. Some are placed in parks, others at crossroads, where communist statues once stood, and most of them in graveyards or near churches, as if the bodies of the victims were actually there. These monuments seek to operate as symbolic reburials, since the victims of the struggle against the establishment of Communism were buried without religious services in unknown places or in large common graves. The monument in Bistriţa-Năsăud is described as "an obelisk of marble, six meters high, surmounted by a white cross, and with a bas-relief that symbolizes Golgotha on the main facade."[30] The monument in Calaraşi is a combination of four crosses, one for each façade. The first façade is dedicated to those who fought, suffered and sacrificed themselves against Communism; two other façades are dedicated to the veterans of the First and Second World Wars. The fourth commemorates those who fought during the Revolution of 1989. This last example shows that in the anti-communist imagination the communist period is incorporated into the history of national suffering, the victims of which are comparable to those of the First and Second World Wars.

[27] Constantin Ticu Dumitrescu (ed.), *Album Memorial. Monumente închinate jentfei, suferinţei şi înptei împotriva comunismului* [Memorial album: Monuments dedicated to the sacrifice, suffering and fight against Communism] (Bucharest: Ziua, 2004), 6.

[28] There are four monuments which are not constructed in the form of a cross, or where the cross symbolism is not so evident. It is interesting to note that all these exceptions are inside the Szekler region of the country where the majority of the population is Hungarian.

[29] "Greater Romania" refers to the country's expanded territory encompassing Transylvania, Bessarabia (nowadays Republic of Moldova), Bukovina and Dobrouja in 1918.

[30] Dumitrescu, *Album Memorial*, 28.

Fig. 1 Inscription on the monument in Brăila,
"The Horrors of the Communist Regime"

Most of these monuments were inaugurated with a religious service, in the presence of political leaders who gave speeches and priests sprinkling holy water and burning incense. The inscriptions on these monuments further illustrate the discourse that they sustain:

> [h]ere as everywhere in the country, during the times of the Soviet-communist devastation, sons of the Romanian people, fighters for the defense of the national being, were murdered. Honor their self-abnegation and sacrifice by bearing its fruits for tomorrow![31]
>
> The monument of the anti-communist resistance in the Banat belongs not to those who raised it, but to those who sacrificed their lives under the sign of communist torture, which destroyed the country and the nation. This [monument] is a modest "symbol" from those who survived the prisons of the red devil.[32]
>
> They sacrificed themselves for Christ, for dignity and for national freedom. If we die here in chains and torn garments it is not we who honor the Roma-

[31] Ibid., 146.
[32] Ibid., 147.

nian people, but the Romanian people who have honored us for dying for them.[33]

These inscriptions on the monuments are typical of the way Communism was represented in Romania between 1993 and 2004, although it remained a marginal voice of the ardent anti-communist minority. However, what was marginal for more than fifteen years is gradually becoming mainstream discourse in Romanian public life. For the Association of Former Political Prisoners, and the regional leaders of the Association, who supported the construction of these monuments,[34] the period from 1945 to 1989 was a time of "Soviet devastation," when the country was led by a political regime metamorphosed into a "red devil." Those who fought against it, the victims, "sacrificed themselves for Christ, for dignity and for national freedom."[35] It seems that only Christian symbols are powerful enough to oppose "the red devil." This nationalist and victimizing discourse, radical in its simplistic Manichaeism, is shaped on a religious dichotomy: Christ vs. the devil, order vs. disorder, light vs. darkness.

In April 2004, it was decided overnight that the monument to the Communist Heroes in Freedom Park (Carol Park), which had been erected in 1963 and contained urns with the ashes of the major party leaders, Stefan Gheorghiu, I. C. Frimu, Dr. Petru Groza, Gheorghe Gheorghiu-Dej, should be destroyed. The fences round the memorial were removed, the interior heating system dismantled, and bulldozers expected to come and destroy the monument any moment.[36] The entire affair was not the outcome of a public decision about the communist past. It was neither the state nor civil society that was trying to break the silence that had surrounded the monument for those forty years, but the Church. The Orthodox Patriarchy wanted to build the Cathedral of National Redemption on the very spot where this

[33] Dumitrescu, *Album Memorial*, 146.

[34] In 2003, the Association of Former Political Prisoners began a project for the construction of a monument dedicated to the victims of the anti-communist resistance co-financed by the Romanian Minister of Culture. The monument, called "Wings" (by artist Mihai Buculei), will be finalized in 2007. It will be placed in the Square of the Free Press (former Piața Scânteii), where the statue of Lenin used to stand before 1989.

[35] Dumitrescu, *Album Memorial*, 146.

[36] The Carol Park is the creation of the French architect Edouard Redont. It was opened in 1906 on Filaret Hill and named after Karl Eitel Friedrich Zephyrinus Ludwig von Hohenzollern-Sigmaringen, known as Carol I, the first king of Romania, who reigned from 1866 to 1916. When the Communists came to power the name of the park was changed into Freedom Park. Adrian Majuru, "De la Gradina Filaret la Parcul Regele Carol" [From the Filaret garden to the Carol park], *Cultura* 7 (April 2004): 21.

"unfortunate" monument stood.[37] Only in this indirect way did Romania's recent past and its memory enter the public arena: in a scenario where the communist ruins and their physical presence were opposed to the virtual presence of the Cathedral of National Redemption. This was one of the actions that pitted Communism against religion, or rather, Communism against "national" redemption through religion.

A lot of people gathered in front of the monument to demonstrate.[38] The vast majority wanted to keep the monument either because they wanted to preserve an important and historical green oasis in Bucharest, or because they considered the building of an Orthodox cathedral inappropriate, or even because they were against the demolition of a socialist monument. Others supported the demolition plan as a way of erasing the traces of an awful communist past. A minority argued that the communist monument should be transformed into a monument dedicated to the heroes who fought against Communism. There were even some who maintained that the monument should be preserved in its present form and transformed into a future Romanian tourist attraction.

There was no large-scale public debate in Romania about the construction of the anti-communist monuments. This could mean that symbolizing the anti-communist struggle by using religious symbols was accepted and taken for granted by both public opinion and art critics; it might also mean that both public and critics were largely indifferent to this commemorative urge.[39] All these monuments seem to correspond to the common imagery

[37] The project of building the Cathedral of National Redemption was conceived in 1878–1879, after the War of Independence against the Ottoman Empire. The subject was re-opened in the interwar period. At that time, Patriarch Miron Cristea gave his agreement for this cathedral to be built in Bucharest. In 2000, after fierce debates the winning project was designed by architect Gheorghe Bratilaveanu. The cathedral will cover 1,800 square meters and will be 95,60 meters high. After considering many locations finally Arsenalului Hill, near the Parliament House (ex-House of People) was chosen. In the end, the monument remained in the same place since another location for the cathedral had been chosen.

[38] The Association Solidarity for the Freedom of Consciousness was established to stop the building of the cathedral in Carol Park. Association site is available at www.humanism.ro/articles.php?page=62&article=131 (accessed 19 February, 2007).

[39] In 2005, in Revolution Square, Bucharest, a monument was raised to the Victims of the 1989 Revolution. It was heavily criticized by many important names in the field of art in Romania: for its "kitsch" style (it was called "the olive on the stick," or "the potato on the stick"), for its lack of harmony with the surrounding buildings and for the price that was paid for it from public funds. Alexandru Ghilduş, the artist who built it, was paid fifty-six billion Lei (approximately 1.6 million Euro).

of the fight against Communism. Very recently, at the beginning of 2007, the Romanian architect and theoretician, Augustin Ioan claimed that the religious symbolism suffocates the memory discourse of the monuments and memorials of Communism.[40]

COMMUNISM UNDERGROUND. THE ROMANIAN PEASANT MUSEUM

The Romanian Peasant Museum is one of the rare examples of a communist museum (i.e. an official museum of the communist regime) transformed into a museum about Communism. Despite its name but in accordance with its history, the Romanian Peasant Museum is still the only institution in the capital to have a permanent exhibition on Communism. It is also the location of the ongoing battle of Orthodoxy versus Communism, presented as truth versus lies, authenticity versus fakery, recent history versus atemporality.

The Romanian Peasant Museum was re-established in 1990. The building assigned to it was originally built at the beginning of the twentieth century as an ethnographic museum. The Museum of National Art had been removed from the building in 1952, and the Lenin-Stalin Museum installed in its place. It was successively renamed the Lenin Museum, the Museum of the Romanian Communist Party and, finally, the History Museum of the Communist Party and Revolutionary and Democratic Movement of Romania, which occupied the building until 1990.

The Romanian Peasant Museum was to construct its identity in sharp contrast with its predecessor. It was not only a question of institutional succession; the distance to be established was between two eras, two worlds, two regimes. The team at the Peasant Museum chose to establish this distance in a very peculiar way. On a museographical level, the basic concepts in dealing with the heritage of the old museum were fakery and truth. The former communist museum was considered a "fake museum"; therefore its objects were "fake objects." The new museum was built through a dialogue with the objects, but this very dialogue was denied to the "communist" objects. On a discursive level, the distance taken was even sharper: the old museum was a "ghost" still haunting the building of the Peasant Museum, which needed to be exorcised.

The idea of this basic opposition was present from the first moment of the re-establishment of the museum, in February 1990. Andrei Pleşu, the

[40] *Arhitectura ortodoxa* [Orthodox architecture], TV show on Romanian Public Television, 19 February 2007, from www.tvr.ro/webcast/emisiuni.php (accessed 19 February, 2007).

Minister of Culture at that time, explained his decision: "The idea of reestablishing a museum of ethnography in the building on the boulevard[41] was not the result of an effort of imagination, but of memory. That building was designed by Ghika-Budeşti[42] especially to be an ethnography museum. (...) It seemed symbolically useful *to exorcise the ghosts of a fake museum* such as the Museum of the Romanian Communist Party with a museum belonging to the local tradition."[43] Andrei Pleşu announced in this statement the two basic lines of thinking about the former communist museum: however, what they claimed to be a "fake museum" was lively enough to produce its own "ghosts" after its officially announced death. The only way to make sure the ghosts will not bother you again, is to make sure that the dead are really dead. Or, even better, that they were never alive.

The links connecting the Romanian Peasant Museum and the former Communist Party Museum were more powerful than just inheriting/reoccupying the building. The museum inherited the exhibitions, the entire collection, the library and, not least important, the staff of the communist museum. The story of the Peasant Museum is told by the new staff as the story of a struggle: a physical struggle with the transformations that the building had undergone as a communist museum and with all the objects that had lost any purpose or meaning, and a spiritual struggle with the ghosts of Communism.[44] The physical struggle did not take too long: only a few months for dismantling, cleaning the exhibition rooms and transferring the objects to other institutions (such as the National History Museum). Ioana Popescu, head of the research department and a visual anthropologist at the museum, who had been a member of the new museum team since 1990, told us the story of the rediscovery of the exhibition rooms: "On the outside, the building has arches in neo-Romanesque style. On the inside, we were surprised to discover no cupolas, no arches. There were long rooms, some square-ish, some like wide halls that you walked through, with straight walls on each side. Then we realized that the walls

[41] Before World War II, the museum was known as the "museum on the boulevard" since it was located on the main promenade of Bucharest, Kiseleff Boulevard.

[42] Famous Romanian architect, representative of the "neo-Romanian" architectural style. The museum was built according to his plans between 1912 and 1938.

[43] Irina Nicolau, Carmen Huluţă, *Dosar sentimental* [Sentimental dossier] (Bucharest: Ars Docendi, 2001), 17–8.

[44] Among the new people, the most important is the director appointed in 1990: Horia Bernea, the famous Romanian painter and artist. He continued to run the museum until his death in 2000.

were not real: they were only fake walls hiding the splendid interior archi-
tecture."[45]

The same company that had installed the earlier exhibitions was hired
to dismantle them. They discovered that the panels and the fake walls
were so solidly made that it took an enormous amount of time, money and
work to get rid of them. The researchers of the museum actively partici-
pated in this process. "We float in the red works of Ceauşescu and in the
blue volumes of the *Soviet Encyclopedia*. The panels of the earlier exhibi-
tions are deeply embedded in the walls, meant to last for eternity. They
leave holes like craters after they have been removed."[46]

Another part of the physical struggle was against the old collections,
which were considered "trash" by the researchers and museographers of
the new museum.

> At first, we wanted to throw everything away. Then we realized that we
> couldn't do that because we could be attacked when it was noticed that we
> had thrown away communist books. The political moment was still not very
> clear (…) So we discussed it with the Museum of National History and with
> the State Archives and we tried to throw over to them most of this trash, what
> we called "trash." What nobody wanted to take we put in the basement, in a
> room that we still call the Chamber of Horrors. Later, we received offers from
> abroad, from private persons or institutions that wanted to buy communist ob-
> jects from us. But they were no longer here, so we answered loftily that we
> would not sell our country.[47]

Irina Nicolau has different memories of how the difficult heritage of the
Communist Party Museum was handled.[48] She recalls that they treated the
collections of the old museum carefully since they were a part of recent his-
tory and they did not want to do what the Communists had done: to erase the
past.[49] However, most of the exhibits of the earlier museum were not re-
garded as having even patrimonial value. The former Communist Party Mu-
seum was thought of as a museum of fake photographs and words.

Exorcising the communist ghosts is a recurrent metaphor in the narra-
tive of the museum, and also of post-communist Romanian society at

[45] Ioana Popescu, tape-recorded interview by Simina Radu-Bucurenci, Bucharest, Roma-
nia, April 26, 2004.

[46] Nicolau, *Sentimental dossier*, 32.

[47] Popescu, interview.

[48] Irina Nicolau, writer and ethnologist, was Bernea's right-hand in conceiving and build-
ing the museum. She was the center of an informal group of mostly young people who
were co-opted into the museum's projects.

[49] Nicolau, *Sentimental dossier*, 22.

large. "Exorcism" became more than a metaphor when Horia Bernea de-
cided, in the spring of 1991, to call on the clergy to chase away these spir-
its in a religious ceremony.

> While the dismantling took place, Horia Bernea had the idea that we needed
> to clean the space not only of fake walls and fake objects, but also of the bad
> spirits that must have sneaked in and lived among us. (…) He brought some
> prelates who came to sprinkle the holy water (*aghiasmă*), to clean the whole
> museum. They entered every storage room, every little corner; we have pic-
> tures of that. And it is interesting to see that we were all there. We were all
> there because we all had to be sprinkled with holy water. (…) And the priests
> who came with huge buckets of holy water were sprinkling with all the
> strength in their muscles. It seemed that their arms were going to break off
> their shoulders when they were sprinkling. They flooded everything in holy
> water. When they found themselves in front of that famous sculpture of the
> heads of Marx, Engels and Lenin—there was one in almost every room—they
> drenched, flooded it with water as if this would destroy it. One of these triple
> busts ended up in the interior courtyard of the museum. It was huge, so we
> couldn't send it anywhere, we had no money for special transport, so finally it
> was dragged to the museum's courtyard and it is still there among the rubbish
> and the debris, surrounded by a square metal fence.[50]

Conquering the space of the museum was thus one of the first tasks of
the team gathered around Horia Bernea and Irina Nicolau. In the early
phase they were not even allowed to enter the exhibition halls. They felt
surrounded by a hostile environment, which included not only the build-
ing and the "fake objects" of the communist collection, but also the old
museum staff. "They received us with a clearly stated, declared hatred.
We finally managed to greet each other but it was clear that we were tak-
ing their place and they would have to leave, one way or another. That
they would not find a place in the framework we were contemplating for
our museum. It was very hard for us to get to know them by name."[51]

However, in the middle of all these mundane problems, the museum
began to organize small events and exhibitions,[52] to produce unconven-
tional little booklets, most of them hand-made, and to establish its reputa-
tion as an innovative institution, which put patrimony objects on show,
and hired traditional bands (*lăutari*) to play music on the streets of Bucha-
rest. They began to think of permanent exhibitions, searching for a theme

[50] Popescu, interview.
[51] Ibid.
[52] The first temporary exhibition organized by the museum in 1990 was "Clay Toys,"
followed by displays of icons, painted Easter eggs, an exhibition called "Chairs," all ex-
perimental and daring in terms of exhibiting techniques and message.

that would give meaning to the new name of the museum. The outcome would have to be both a "healing museum," as Irina Nicolau wanted it, and a "testifying museum," as Horia Bernea wished. And it did become, in our view, both a healing and disturbing museum, thought-provoking, irritating and beautiful, fundamentalist and delicate. In 1996, it was chosen to be the European Museum of the year.

The "healing" component of the museum was obviously aimed at the traumatic memory of the communist regime. Paradoxically, the initial reaction to this past was a total indifference, a deliberate refusal to make any reference to recent history. This was reflected in the first permanent exhibition, entitled "The Cross," which was inaugurated on April 19, 1993. The French anthropologist Gérard Althabe observed that the exhibition probably told more about the communist past by its total lack of reference to it.[53]

Actually, it told rather about how the communist past was viewed in the early 1990s by the Romanian intelligentsia: as a black hole that had to be forgotten, in order to make it easier to reach back to the interwar period where the "real" Romanian history and identity were supposed to be found. As Irina Nicolau put it: "There is in Romania a huge emptiness that one has to fill in with one's own body, in order to build upon it. Or maybe it is better to build a bridge over it, with one pillar in Samurcaş's[54] times and the other in the place where the future starts. But are we wise enough to make that bridge? Are we working fast enough?"[55]

After cleaning the museum and removing the traces of the communist past, it seemed necessary to the new staff to reinstall a sense of normality and truthfulness in the previously abused image of the peasant. And this normality could only be reached by keeping silent, for a time, about everything that had been mystified and altered under communist rule. As Ioana Popescu remembers: "We started with the idea that the discourse on the cross must not be a vindictive discourse. Horia Bernea did not want to use "The Cross" either as a cover for the horrors of Communism or as a weapon. He simply wanted to try to induce a certain normality, a normality that he could not imagine in the Romanian world in the absence of the cross. A cross that he saw was an element of balance and order. (...) So he started by trying to make peace. A calm and normal speech. We did not

[53] Gérard Althabe, "Une exposition ethnographique: du plaisir estéthique, une leçon politique," *Martor: The Romanian Peasant Museum Anthropology Review* 2 (1997): 144–58.

[54] Al. Tzigara Samurcaş was the director of the museum from 1906 to 1948.

[55] Nicolau, *Sentimental dossier*, 37.

think for a moment that in the exhibition "The Cross" there should be the victory of the cross over Communism."[56]

However, the idea of such a victory is implied, for example, in a case described by both Ioana Popescu and Gérard Althabe. One of the museum's façades had been decorated with a huge socialist realist mosaic, which the museum staff was not allowed to remove because it was considered a work of art. Their first solution was to cover it with a wooden structure. After a small, old village church was reassembled in the courtyard they suddenly realized that the church had become the main point of interest, while the mosaic had become almost invisible. So the covering was removed and the mosaic with its workers and socialist mothers surrounded by happy children is still there. Ioana Popescu claims that, even though it is there, one no longer sees it. Gérard Althabe considers this "the *mise en scène* of the victorious resistance of Christianity over Communism."[57]

As the analysis of monuments dedicated to the victims of Communism shows, the cross was a typical symbol of anti-Communism in the 1990s. However, it would be an over-simplification to say that this is the reason why the cross became the organizing principle of the museum. Vintilă Mihăilescu, a sociologist and director of the museum since 2005, wrote a critical article analyzing the "conservative revolution" that the Romanian Peasant Museum proposed in the 1990s.[58] He explains the choice of the cross as an attempt to put the Romanian peasant on a European Christian map, to transform nationalism into Eurocentrism. The museum, in this view, is not a museum of the peasant and much less of the Romanian peasant; it is a museum of the "traditional man," of the "real Christian," as he existed before the Great Schism. Christianity and its symbols are thus much more than anti-Communism. They may be very effective in the anti-communist ghost-hunt but their value is ultimately eternal, profound and a-historical.

One must not, however, underestimate personal choices. Horia Bernea had a life-long commitment to the symbol of the cross. As he remembers in an interview, in the 1970s he was dreaming of designing a huge cross over the Carpathians that would be visible from the Moon (together with the Chinese Wall, the only other human-made construction visible from there). "Through an act of megalomania, I wanted to affirm the Cross. Again the Cross! Only now do I realize that It has al-

[56] Popescu, interview.

[57] Althabe, "Une exposition," 155.

[58] Vintilă Mihăilescu, "The Romanian Peasant Museum and the Authentic Man," *Martor: The Romanian Peasant Museum Anthropology Review* 11 (2006): 15–29.

ways followed me."[59] Horia Bernea's father, Ernest Bernea was active in
the interwar period as an ethnologist in Dimitrie Gusti's sociological
school of Bucharest. He wrote extensively on the Romanian peasantry,
its views on time, space and causality.[60] He was also active in the Iron
Guard, the extreme-right wing political movement of interwar Romania,
which he joined in 1935. His name is not often mentioned in connection
with the visual discourse of the museum, but his ideas about the peasant
world are there.[61]

The Christian dimension that was suddenly re-discovered in the Ro-
manian peasant can thus be traced to an interwar (extreme) right-wing
tradition.[62] However, the discourse that the Peasant Museum was propos-
ing, at least at the time of the opening of "The Cross," was very much a-
historical. Time stood still in the halls of the museum, while its space ex-
panded beyond the Romanian borders. It is a museum about the European
traditional man, "profoundly Christian, formed in continuation of ancient
civilizations, organically bound to the Mediterranean world, to civiliza-
tions that can be traced back from India to Brittany," as Horia Bernea
explained.[63]

What could make this timeless, profoundly European and Christian
peasant, "a relic of European Middle Ages elsewhere lost,"[64] step back
into history? The visual discourse of the Romanian Peasant Museum
states very clearly: it was Communism. While many East European intel-

[59] Horia Bernea, interviewed by Mihai Sârbulescu. Mihai Sârbulescu, *Despre ucenicie* [On apprenticeship] (Bucharest: Anastasia, n. d.), 120.

[60] Recently republished, for example, Ernest Bernea, *Spatiu, timp si cauzalitate la poporul roman* [Space, time and causality for the Romanian people] (Bucharest: Humanitas, 2005).

[61] The inter-war concept of *rânduială* (translated as "order" and refering to a special, tradi-tional way of relating to life and nature, in which everything has its place and outside which the "good" cannot be achieved) was used as one of the structural principles of the Peasant Museum. It was also the name of the journal that Ernest Bernea was editing back in the 1930s.

[62] Some of the ultra-nationalist writers of the interwar period were rehabilitated during Romania's national-communist period. Most of these writers, like Ernest Bernea or Constatin Noica, were reedited in the 1970s and 1980s with the Christian dimension carefully deleted. Their vision would be fully rehabilitated, Christianity included, after 1989. See Katherine Verdery, *National Ideology Under Socialism: Identity and Cultural Politics in Ceausescu's Romania* (Berkeley: University of California Press, 1991).

[63] Horia Bernea, *Câteva gânduri despre muzeu, cantități, materialitate și încrucișare* [A few thoughts on museum, quantities, materiality and crossing] (Bucharest: Ars Docendi, 2001), 21.

[64] Nicolau, *Sentimental dossier*, 102.

lectuals claim that Communism, i.e. "Real Socialism," was a step out of history for these countries,[65] the Romanian Peasant Museum asserts the contrary. The timeless existence of the peasant, in perfect harmony with God and nature, was abruptly pushed into history through the installation of the communist regimes. The only rooms in the Romanian Peasant Museum where the time component is very present are those concerned with the collectivization process.[66]

The idea of an exhibition on Communism was Irina Nicolau's; however, the concept was worked out together with Horia Bernea. The exhibition opened in 1997 under the title "The Plague—Political Installation." (Fig. 2) It is housed in a small room in the basement, just before one reaches the toilets. The only explanation given to the visitor is the brief notice at the entrance: "A memorial of the pain and suffering collectivization caused to the peasant world." The upper parts of the walls show red hammers and sickles, which "painted in oils on a strip of blue (…) still look like drops of blood,"[67] while the lower parts are covered with issues of the communist newspaper *Scânteia*, bearing lists of peasants imprisoned for resisting collectivization. The walls, painted in red, are lined with busts of Lenin and Stalin (Fig. 3, Fig. 4) and crammed with large portraits of Gheorghe Gheorghiu-Dej. The center of the room is occupied by a huge vase with the inscription: "To comrade I. V. Stalin, a sign of love and gratitude from the Romanian Association for Tightening Relations with the Soviet Union." To read the inscription, one has to go round four times. The cord surrounding the vase is supported by four huge ashtrays. A green board entitled "The collectivization class from child to adult" features poems and short compositions that children were forced to learn and write about the benefits of collectivization and hatred of the *kulaks* (*chiaburi*). The exhibition was accompanied by a booklet, *The Red Ox*, consisting of the testimonies of peasants who suffered through the collectivization process.

[65] Traian Băsescu stated in his speech for the condemnation of the communist regime: "It was an oppressive regime, which deprived the Romanian people of five decades of modern history." Speech by Romania's President, Traian Băsescu.

[66] The little room called *Time*, which thematizes the peasant understanding of (cyclical) time is as timeless as the rest of the permanent exhibition.

[67] Nicolau, *Sentimental dossier*, 137.

Fig. 2 The permanent exhibition *The Plague—Political Installation*
(© Roald Aron and the Romanian Peasant Museum)

Horia Bernea explains the symbolism of colors in the *Plague* exhibition. For example, the board was a reminder of the early years of Communism. During its retreat from Romania the German army abandoned several wagons of green paint made by I.G. Farben. The Soviet troops used it to paint everything from public benches to public toilets, from offices to kindergartens. So, for Bernea, green was the color of Communism.[68] The contrast between this room and the rest of the museum could not be sharper. While everything in the museum was meant to breathe harmony and beauty, "The Plague" made an immediate impact by its ugliness. Walking through it, the visitor is assaulted by the strong, violent colors and the "fake objects" (mainly communist kitsch) on display. One of the slogans of the Romanian Peasant Museum is "a real museum is one that you come back to." "The Plague" seems to contradict this by making you want to climb back up the stairs, to get out of that basement.

[68] Horia Bernea and Irina Nicolau, "L'installation. Exposer des objets au Musée du Paysan Roumain," *Martor: The Romanian Peasant Museum Anthropology Review* 3 (1998): 226.

Fig. 3 Detail with Lenin painted red from the exhibition
The Plague—Political Installation
(© Roald Aron and the Romanian Peasant Museum)

Fig. 4 Detail with two identical Lenin statues from the exhibition
The Plague—Political Installation
(© Roald Aron and the Romanian Peasant Museum)

One of the strongest points of the new museographic discourse pro-
posed by the Peasant Museum was dialogue with the objects: letting the
objects speak for themselves, letting them "conquer" the space and find
their most appropriate place in the display. Horia Bernea claims that "The
Romanian Peasant Museum was born out of dialogue with the objects, an
accepted, alert, always attentive dialogue, without any preconceptions."[69]
In the case of "The Plague" exhibition, he confessed, the freedom of the
object had been totally ignored. The objects in this exhibition had origi-
nally been exhibited in the Communist Party Museum. They were, by
necessity, objects of a fake past, of an unreal reality. "As opposed to the
dialogue with the patrimonial objects, where I forbade myself any precon-
ceived ideas, here we absolutely needed a political bias. As we couldn't
exhibit the lies of the regime, we tried to exhibit its ugliness."[70]

It seemed more urgent for Bernea's team, in the early 1990s, to bring
into the museum what was beautiful and harmonious about the Romanian
peasant, what was timeless about him. Only after the permanent display
was more or less finished, did the need for a discourse on ugliness become
urgent. The museum that they had composed was "a serene museum, a
museum of peasant balance, in which you didn't notice that you were in
fact walking on bones, walking on dead people, dead peasants who had
everything taken away from them."[71] From this point of view, it was itself
becoming fake and misleading and it needed, Irina Nicolau thought, a
counter-balance to all its serenity. This counter-balance would be "The
Plague." Irina Nicolau was thinking about it as early as 1990. "I was
dreaming of an exhibition set up in the technical basement, where we
could isolate four small, damp rooms and a former bathroom with broken
tiles, a steamy mirror and a dirty bath-tub. I imagined the bath-tub filled
with water in which old newspapers would float among the sunken bronze
busts of Lenin, Stalin and Gheorghiu-Dej."[72] "The Plague" is not very far
from what Irina Nicolau imagined in 1990. The toilets next to it are not
dirty, but they do smell like toilets through the permanently open door.

The troubling thing about this "political installation" is that it is not
necessarily only about collectivization. It is a discourse on the years of
Communism, on the ugliness, absurdity and fakeness of the first decades
of communist rule in Romania. In a published conversation between Irina

[69] Bernea and Nicolau, "L'installation," 225.

[70] Ibid., 225.

[71] Popescu, interview.

[72] Nicolau, *Sentimental dossier*, 58.

Nicolau and Horia Bernea about this exhibition, the main theme is repre-
senting Communism, not collectivization: "Pasternak said that a talented
writer should describe those years so that the blood of the readers freezes
and their hair stands on end. This is the reaction we should have aimed
for, but we obviously did not succeed. We could have obtained it only if
we had locked up the visitors in the exhibition room among all the aggres-
sively ugly objects and kept them there without water, food or sanitation
for a week."[73] A small sheet of paper kept and later published by Irina
Nicolau makes the intentions behind the display even clearer. It contains a
list of possible titles for the exhibition on collectivization imagined by
Horia Bernea. "The Plague" could as well have been entitled "The Break-
ing of the Silence," "Essay on Death," "Essay on Murder" or "The
Plague—the Breaking of the Silence."[74]

To talk about Communism in 1997 was indeed "breaking the silence."
To this end Horia Bernea used harsh metaphors in the booklet accompa-
nying the exhibition: "Communism is a disease of society and the soul; it
is opposed to the life-giving convention; an ideal stupidity, totally ori-
ented against life; a destructive atheist sect; orientation against the spirit,
comfortable to the lower qualities of man; the exaltation of shameful evil;
absolute hatred, affirmed with no reservations; an attempt to destroy the
multimillenary attempt at spiritualization; a sinister utopia."[75]

NATIONAL CALVARY: THE SIGHET MEMORIAL MUSEUM

Vladislav Todorov in the introduction to *Red Square, Black Square: Or-
ganon for Revolutionary Imagination*[76] describes the dilemma that the ex-
communist countries face in front of the ruins of their recent communist
past: whether to conquer the ruined space by force or to ask for the Grand
Ruin to be kept as a ruin. After its opening in 1993, the Memorial Mu-
seum of the Victims of Communism and of Resistance functioned as a

[73] Bernea. "L'installation," 224–5. The idea of keeping the visitor "prisoner" for a while, in
 order to make him not only understand but feel, occurred to other museum curators as
 well. The House of Terror in Budapest keeps visitors for three long minutes in a slowly
 descending elevator, watching and listening to stories about how people were hanged in
 that very building.

[74] Nicolau, *Sentimental dossier*, 140.

[75] Horia Bernea quoted in Nicolau, *Sentimental dossier*, 140.

[76] Vladislav Todorov, *Red Square, Black Square: Organon for Revolutionary Imagination*
 (New York: State University of New York, 1995), 2.

ruin of Romania's past for five years. The building where the museum is located used to be a major political prison in Sighetul Marmației, in the far north of the country, two kilometers from the border with the Ukraine, that is, the previous USSR border. The prison operated between May 1950 and July 1955 as an extermination centre for the political, religious, economic and administrative leaders of interwar Romania. After 1955, it was transformed into a common prison, all the political prisoners being transferred to other places in the country. In the 1970s it was entirely empty. The prison museum today is the most important institution in Romania that presents in visual terms the forty-five years of Communism. In 1997 the government funded the final stages of the restoration process—the roof was repaired, the interior painted white—and "in 1998, the Council of Europe designated the Sighet Memorial as one of the main memorial sites of the continent, alongside the Auschwitz Museum and the Peace Memorial in Normandy."[77] Nevertheless, the first funding forthcoming in 1994 was not from local, national or international sources, but from private funds.[78] The creation of this memorial museum was the most important enterprise of the Civic Academy Foundation, founded in 1993. In 2006, some of its members became important contributors to the Report of the Presidential Commission for the Analysis of Communist Dictatorship in Romania. It is only recently that the Civic Academy Foundation's effort has become part of the mainstream discourse in Romanian public life, since before 2006 its visual discourse was totally alien to Romanian society at large.[79]

The museum started by exhibiting one room of torture (*Neagra*—the black room) and the cells where major political and intellectual figures of the interwar period used to be imprisoned, starved and then killed. Some of the cells were named after the famous political leaders who were imprisoned—and sometimes died—there (e.g. Iuliu Maniu and Gheorghe Bratianu). In three cells only those objects that were "origi-

[77] Speech by Romania's President, Traian Băsescu. Official museum site: www. memorialsighet.ro/.

[78] An English businessman of Romanian origin, Mr. Misu Carciog, paid all the costs of the restoration and the architectural plans.

[79] On 14 January 2007, one month after Traian Băsescu made his speech in the Parliament on the crimes of the Romanian Communist regime, he visited for the first time the Sighet Memorial Museum. He declared on television that, having visited this Memorial, he was even more convinced that he had been right in sustaining the efforts for an encyclopedia and a manual of Communism to be published in Romania. Retrieved from *Realitatea* TV, 14 January, 2007.

nally" found there were exhibited (the iron beds, the heating installation, sometimes the bed-cover, some iron pots where the prisoners received water). In 1997 the place still contained only the empty cells of the ex-political prison, the memorial, and the Space of Meditation and Prayer, erected in the courtyard.[80] After 1997, the museum of the prison turned into a museum of the victims of Communism and of Resistance.[81] The cells on the ground floor were transformed into exhibition rooms displaying different aspects of Communism: detention and Gulag, *Securitate* and demolition, resistance and repression, fake elections, Ceauşescu's "Golden Era." Summer schools and conferences began to be held here and the International Centre for the Study of Communism started to function.[82]

The sensation of fear provoked by this place is intensified by the rectangular and enormously high black iron façade, that was built at the entrance to the museum. Iron was used also to construct stairs inside the prison, which did not exist before 2002, but which were built in the style of the prison building. (Fig. 5) While entering the museum, the visitor immediately notices the Maps Room off the entrance corridor. On the walls, over 230 places of imprisonment, forced labor and forced residence, as well as psychiatric institutions with a political character, places where fights and executions took place, and common graves are marked by crosses on a large map of the country. Six smaller maps present in detail each of these categories. On the floor, beneath the big map, there is a

[80] The Space of Meditation and Prayer was built by the architect Radu Mihailescu, in a modernized antique style (referring to the Greek *tholos* and the Christian catacomb). On the walls there were engraved in smoky andesite the names of almost 8,000 people who died in prisons, camps and deportation places throughout Romania. Extremely meticulous, the operation of gathering the names of the dead took ten years of work within the International Center for the Study of Communism, yet the figure is far lower than the total number of victims of communist repression. Most of the names were established by Cicerone Ionitoiu and the late Eugen Sahan, both historians by vocation and former political prisoners.

[81] The curators of the exhibitions are also the members of the Center of Research, headed by Romulus Rusan. Since 2001, the director of the museum is Gheorghe Mihai Barlea.

[82] The executive scientific board of the International Center for the Study of Communism includes Thomas Blanton (N.S. Archives, George Washington University), Vladimir Bukovsky (Cambridge University), Stephane Courtois (C.N.R.S., Paris), Dennis Deletant (London University), Helmut Muller-Enbergs (The Federal Office for the Study of STASI Archive, Berlin), Pierre Hassner, Acad. Serban Papacostea and Acad. Alexandru Zub.

cluster of the barbed wire used in constructing prison fences. After this "accommodation room" one can enter the former prison itself. From this spot, the entire building, with its two floors with many cells on both sides, is clearly visible.

Fig. 5 The façade of The Memorial of the Victims
of Communism and of Resistance
(© The Memorial of the Victims of Communism and of Resistance)

The first exhibition cell is called "Fake Elections." It exhibits a double-bottomed wooden box for ballot papers. It is not an original artifact, but it shows how elections were faked. In the room "Repression against the Church," among documents testifying to the repression of Orthodox, Greek and Roman–Catholic Churches, a big white cross is painted on the floor, with handcuffs and striped prisoner's clothes thrown on it. The room "Collectivization: Repression and Resistance" exhibits the terror and impoverishment that peasants suffered during the thirteen years of the collectivization process. It is stated here that 96% of the agricultural area of the country and 3,201,000 families were brought into collective farms. On the front wall there is a map of Romania and in the middle of the room

a permanently green piece of turf. This last installation "stands for both the land, alive and free, and for the grave of those who sacrificed themselves for it."[83]

Thick plastic panels with texts and images are on the walls of other rooms (e.g. Workers' Movements in the Jiu Valley and Braşov). In the room "The Golden Era or Communist Kitsch" the viewer will find two statues representing Nicolae Ceauşescu and his wife. Other objects represent Ceauşescu's cult of personality by portraits and clothes he used to wear on special occasions. In 2004 the voice of Ceauşescu making speeches could be heard throughout the prison: as soon as the visitor entered the room, the sensors started the audiotape. The second soundtrack in the museum was played in the *Securitate* room evoking sounds and voices heard during interrogations.[84] The museum exhibits a teleological understanding of the communist regime: from the original sin, namely the forged elections, the subsequent crimes of repression and terror followed logically up to Ceauşescu's cult of power, ending in the emergence of resistance and the victory of anti-communism. The museum has special exhibition rooms dedicated to anti-communist movements in Eastern Europe: 1956 in Hungary, the Prague Spring, Charta 77, Solidarity, the Velvet Revolution.

In 2004, many empty cells could still be seen on the first and second floors. On one door was written: "exhibition under construction." It seemed that the memory of Communism itself was under construction. The empty cells seemed even more powerful than the completed ones. The blank spaces served as markers of forgetting and remembering, as "ruins" of one's past. The dilemma of processing the past has its model in the drama of Hamlet. While Fortinbras wants to remove the dead bodies (the ruins) in the final scene, Horatio needs them to be kept on stage because only through them can he re-collect the story of the past. Todorov considers that the second variant is the appropriate way of dealing with the past: collection of ruins, re-collection and (re)narration. Ruins construct a public space of sight and of reflection.

After 2004 the empty spaces in the Sighet Memorial disappeared. They were seen as imperfections to be removed, not as inevitable gaps between the memories of the past. Nowadays the museum contains approximately fifty exhibition rooms on the ground, first and second floors.[85] Time and

[83] www.memorialsighet.ro/en/sala.asp?id=9 (accessed 10 January, 2007).

[84] We do not know if the voices were authentic or just "mise en scène."

[85] The current rooms of the memorial museum are (numbers refer to the former cell numbers):

money have resuscitated "History." "History is the reconstruction of something that does not exist any more," says Pierre Nora; "[h]istory belongs to everyone and to no one and therefore has a universal vocation. (...) History was holy because the nation was holy. The nation became the vehicle that allowed French memory to remain standing on its sanctified foundation (...) Memory is life, in permanent evolution, subject to the dialectic of remembering and forgetting."[86] The president of the Foundation of the Civic Academy, Ana Blandiana, claimed that the main purpose of this Foundation is "the rescue of memory (...) Everything that happened in politics and public life after 1990 showed that the memory of the last fifty years had been deleted. At that moment I found it very important to recover history as a way of refurnishing our brains and as a way of building a minimal point from which to begin a normal life. What happens in Sighet is not necessarily a way towards the past but rather a way towards the future."[87] To "rescue memory" and to "refurnish our brains,"

Ground Floor: Room 5: The maps room; Room 8: Elections of 1946; Room 9: The Room where Iuliu Maniu (1873–1953) died; Room 10: Ilie Lazar, a hero of Maramures; Room 11: Destruction of the political parties; Room 12: The year 1945 from Yalta to Moscow; Room 13: Repression against the church; Room 14: *Securitate* between1948 and 1989; Room 17: Forced labour; Room 18: Collectivization. Resistance and repression; Room 19: The year 1948—Romania's sovietization; Room 20: Communism versus the Monarchy; Room 21: "Bessarabians in the Gulag"; Room 22: Bessarabia in the Gulag; Room 23: The countries of Eastern Europe (1945–1989); Rooms 25–26: The Exhibition "A Cold War Chronology."

First floor: Room 37: "Black"; Room 38: Dignitaries' Room; Room 39: The Penitentiary regime; Room 40: Destruction of the Academy; Room 41: Ethnic and religious repression; Room 43: Repression against culture; Room 44: Solidarity, 18 days that shook the world; Room 47: Deportations in Baragan; Room 48: Anti-communist resistance in the mountains; Room 49: 1956—Student movements in Romania; Room 50: Pitesti phenomenon; Room 51: Poetry in prison; Room 52: Women in prison; Room 53: Daily life in prison; Rooms 54–58: "Gheorghe I. Bratianu (1898–1953)."

Second floor: Room 73: Cell where Gheorghe I. Bratianu died; Room 74: The Visovan Group; Room 75: Demolitions in the 1980s; Room 77: Opponents and dissidents in the 1980s–1990s; Room 78: "The Golden Era" or communist kitsch; Room 79: Workers movements in the Jiu Valley and Brasov; Room 82: Prague Spring (1968)—Charta 77 (1977)—The Velvet Revolution (1989); Room 83: Revolution in Hungary (1956); Rooms 84–87: "Iuliu Maniu (1873–1953) the father of democracy."

[86] Pierre Nora (ed.), *Realms of Memory: Rethinking the French Past* (New York: Columbia University Press, 1996), 3–5.

[87] Armand Gosu, "A Memorial about the Past for the Future," *Revista* 22 (July 2002): 645. Ana Blandiana (literary pseudonym of Otilia Valeria Coman), born in 1942, winner of the Herder Prize for poetry in 1969, Romanian dissident during the last years of communist dictatorship, today executive manager of the Civic Academy Foundation and di-

paradoxically, are actions that are not specific to the way in which memory functions, but to the way history does. That is why this museum does not play with different types of memories about the past, or search for competing interpretations, but accepts oblivion by simply affirming a single victimizing version of the past: suffering and death on the altar of the Nation. Consequently, the Sighet Memorial Museum is constructed as a holy place of the Romanian nation, and not one that comes from debate between individual memories. The Memorial of the Victims of Communism and of Resistance is a memorial for those who fought the communist system and who became its victims.

The cemetery of the Memorial is called the Cemetery of the Poor. It is situated outside the city, two and a half kilometers away. Since the prisoners' graves could not be identified among the thousands of graves prior and subsequent to the 1950s, a landscape project was developed. On the 14,000 square meters of the cemetery, the outline of the whole country was marked by planting mainly coniferous trees. "The idea is that, in this way, the country will keep its martyrs in its arms and mourn them through the repeated generations of vegetation. From a viewing point which will be placed on a raised area, actually on the bank of Tisza (the current frontier with the Ukraine) visitors to the Memorial will be able to see this symbolic drawing more and more distinctly as nature perfects the project."[88] Chris Rojek claims that "death sites and places of violent death involving celebrities or large numbers of people, almost immediately take on a monumental quality."[89] Choosing to talk only about victims, and placing a memorial camouflaged as a museum about Communism in a former political prison, accompanied by a monument-like cemetery, makes the discourse about the past radical, combative and, accordingly, lacking in nuances.

rector of the Sighet Memorial Museum. *Revista 22*, an independent weekly magazine of political and cultural analysis. The first number was issued on 20 of January 1990, edited by the Group for Social Dialogue (GDS). "The members of GDS are main figures of public and cultural life in Romania, most of them ex-dissidents of the Communist Party." Available at http://gds.ong.ro/, (accessed 1 October, 2006).

[88] www.memorialsighet.ro/en/istoric_muzeu_memorial.asp (accessed 20 December, 2006).

[89] Chris Rojek, "Fatal Attractions" in his *Ways of Escape: Modern Transformations in Leisure and Travel* (London: Macmillan, 1993), 136–72, reprinted in David Boswell, Jessica Evans (eds.), *Representing the Nation: A Reader. Histories, Heritage and Museums* (London and New York: Routledge, 1999), 185–207.

ONLY ANSWERS

Leon Wieseltier considered monuments and memorials as spots that paradoxically interdict memorization. In public places, when people see monuments, "they say only: once there was someone who wanted something remembered here. In front of these figures and markers nobody stops any longer, or thinks or shudders. They are bulwarks against thought, devices for the prevention of any intrusion of the past into the present."[90] This can happen not only to monuments built centuries ago, but also to new ones. Wieseltier is referring to the monuments for Holocaust victims. But with all of them—whether for wars, the Holocaust, Communism, Revolution—the same thing happens: they are seen, recognized, and then forgotten.

"There is nothing in this world as invisible as a monument," says Robert Musil. "They are no doubt erected to be seen, indeed, to attract attention. But at the same time they are impregnated with something that repels attention, causing the glance to roll right off, like water droplets off an oilcloth, without even pausing for a moment."[91] The creation of anticommunist monuments and memorials brought about a kind of obtuseness of sight and of understanding. Wieseltier suggests that this obtuseness was caused by their unique message, which "was so central for our life that it did not play any kind of role in our consciousness."[92] The result was another kind of distance, an alienation of one's past. Between total forgetting and total remembering in a museum (about Communism) a very subtle equilibrium should to be found. In "A Museum and Its Memory," Michael Fehr says, "any place defined only by memories or relics, like many museums, will cause death by suffocation. (...) Memory and amnesia have to be related, and have to work together; otherwise, separated from each other and fixed absolutely, they both lead by different paths to chaos and death."[93]

Nonetheless, Romanian museums often seek to imitate the convincing power of memorials and monuments. Appealing to nationalist and religious feelings and fears, memorials and monuments proclaim a single victimizing version of history. Instead of aiming to become agora museums, places of discussion and debate, Romanian museums dream of be-

[90] Leon Wieseltier, "After Memory," *New Republic* 208 (1993): 7.
[91] Quoted in Ibid., 5.
[92] Wieseltier, "After Memory," 5.
[93] Fehr, "A Museum and Its Memory," 75.

coming memorials. In the speech that condemned the communist regime on 18 December 2006, Romania's President made recommendations about the memorialization of Communism. Among them was the creation of a Museum of Communist Dictatorship that "like the Holocaust Memorial in Washington, would be both a place of memory and an affirmation of the values of the open society."[94] The future Museum of Communist Dictatorship is to be a memorial museum. It will be curated, among others, by the Civic Academy Foundation, the makers of the Sighet Memorial, and the Association of Former Political Prisoners, the makers of the monuments to the victims of the communist regime. One does not have to be a fortuneteller to predict fairly accurately what this museum will look like and what it will attempt to convey to the public. A place where demons are exorcised, visitors are frightened to death, victims become martyrs and no third way is offered between victim and perpetrator; no questions, no dilemmas, no doubts, only answers.

[94] Speech by Romania's President, Traian Băsescu.

The "Unmemorable"
and the "Unforgettable"

"Museumizing" the Socialist Past in Post-1989 Bulgaria

NIKOLAI VUKOV

About 60 km from Bulgaria's capital, Sofia, lies a small town which cur-rently represents the primary case of what can be described as a "museum of Socialism in the country." The town has nothing that can be compared to Budapest's Statue Park, nor is it a place where the heritage of the so-cialist period is put on display, decontextualized and recontextualized in a post-socialist mode. It would be wrong to suggest that the town was once the location of a labor camp or a prison for the socialist regime's oppo-nents. The town is not, or at least not directly, related to people and fami-lies who were persecuted by the regime; it is not a place where political opponents were executed after the socialists came to power, nor is it a place where demonstrations were held by dissidents. However, both be-fore and after the fall of the socialist system, the town has been known to every Bulgarian and its name has become an emblem that one can hardly dissociate from those times. The special feature of this town, which until 1980s was only a village, is that it was the birthplace of the man who from the mid-1950s until the end of the regime in 1989 was the General Secre-tary of the Communist Party and the Head of State of the People's Repub-lic of Bulgaria: Todor Zhivkov.[1] An important detail, one would say, es-pecially bearing in mind the old joke from the last years of Communism, that while Marx had the idea of Communism being victorious in a well-developed capitalist country, Lenin attempted to realize it in an underde-veloped one, Honecker in a divided country, Ceauşescu in one family, and Zhivkov in his own birthplace: Pravets. Joking apart, if there was one place in Bulgaria where most of the socialist dreams were largely realized, it was in Pravets. There is no need to list the many benefits that the social-

[1] With Decree no. 2190 of the State Council of the People's Republic of Bulgaria of 16 October 1981, Pravets was declared a town and in the same year a History Museum was created in it.

ist regime showered on the village, the most conspicuous being that a university was actually built there in the period—to the envy of many larger towns. But the benefits were by no means only educational and the citizens of Pravets have innumerable reasons for feeling nostalgic about the socialist era.

The purpose of starting the present chapter with this example is not to pay tribute to the efforts made to establish Communism in at least one town in Bulgaria, but rather to point out that this town's decision to re-open the previous museum exhibition devoted to the socialist leader is in fact the main example of a "museum of Socialism" being initiated in Bul-garia.[2] Other projects for museums have existed; indeed there are numer-ous examples of such initiatives; but none of them were ever realized. Already in the first years after 1989, when many socialist monuments (mostly those to socialist leaders) fell from their pedestals, there were suggestions about gathering them in a museum exhibition.[3] During the intensive debates about the fate of the Soviet army monuments in the larg-est Bulgarian cities, ideas about their possible preservation were voiced, but on condition that a museum of Communism would be created nearby.[4] After the edifice which served as a monument of the Party (a huge con-

[2] The museum of the communist leader (including the house of his birth and an exhibition building dedicated to his achievements) was established soon after Pravets had received the status of a town. The museum was a regular destination for visits until the end of the communist rule in Bulgaria. Soon after the political changes of 1989, the museum was closed, to be reopened again in the 1990s at the initiative of the local community to commemorate Todor Zhivkov as a major figure in national and local history.

[3] Ideas for creating museums of communist statues were raised in relation to Sofia, Plovdiv, Dimitrovgrad, and Montana, but no real steps were taken towards putting these ideas into practice. About the theoretical implications of the museumization of socialist monuments see Svetlana Boym, "Totalitarian Sculpture Garden: History as a Pastoral" in her *The Future of Nostalgia* (New York: Basic Books, 2001), 83–108; Beverley James, "Fencing in the Past: Budapest's Statue Park Museum," *Media, Culture and So-ciety* 21 (1999): 291–311; Nikolai Vukov, "Monuments beyond the Representations of Power: Monuments of the Socialist Past in post-1989 Bulgaria" in Arnold Bartetzky, Marina Dmitrieva, Stefan Troebst (eds.), *Neue Staaten—neue Bilder? Visuelle Kultur im Dienst staatlicher Selbstdarstellung in Zentral- und Osteuropa seit 1918* (Cologne: Böhlau, 2005), 211–9.

[4] Such was the case with the monument to the Soviet army in the center of the Bulgarian capital. In the whirlpool of discussions about its destruction or preservation, in 1993 the government proposed a project (unaccomplished, however) for creating a museum of totalitarian art in the spacious area around it, Todor Varchev, "Kabinetat podlozhi de-montazha na pametnika" [The cabinet postponed for a while the dismantlement of the monument], *Express* 7 (4 May 1993).

struction on the mountain peak of Buzludja) lost its function, there were suggestions that the grand building should be used for a museum of the recent past.[5] None of these ideas bore fruit, largely because of the polemics that they provoked, the scarcity of funds, and the lack of a real will to carry out such projects. Monuments to the victims of communism and to those oppressed by the totalitarian regime were raised in many towns in the mid-1990s,[6] but, apart from the texts on memorial plaques and inscriptions, historical information or museum exhibits seldom accompanied them. The major (and for a while, the most plausible) option for the creation of such a museum was the mausoleum of Georgi Dimitrov in Sofia, a large building which could have housed a museum display inside, in place of Dimitrov's body, or could even have preserved the body as an exhibition object.[7] But, in 1999, as is frequently reported in presentations on Bulgaria's post-socialist transition, the mausoleum was blown up and a flower garden laid out in its place.[8]

[5] Thus, for example, the municipality in Haskovo intended to open a museum of totalitarian art on the peak to collect busts, monuments, pictures, and brochures from the entire country, as well as to reinstall the destroyed mosaics with the images of socialist rulers that existed in the edifice. About the media announcements of this project, see *24 chasa* 14 (18 January 1993); *Duma* 132 (8 June 1995); *Duma* 138 (15 June 1995). More about the Buzludja monument and its fate after 1989, see in Nikolai Vukov, "Les métamorphoses du corps de la pouvoire: le Buzludja maison-monument de la Partie," *La Nouvelle Alternative* (Numéro spécial "Politiques symboliques en Europe Centrale") 20 (October–December 2005): 183–8.

[6] Taken up by the raising of commemorative signs to the so-called "Revival process" of the mid-1980s, when the communist state organized a campaign to forcibly rename Bulgarian Muslims, the process also involved erecting monuments and memorial plaques at former labor camps and at sites where the victims of the regime were persecuted and murdered. By the end of the 1990s collective monuments to the victims of communist repression had been built in most large towns in Bulgaria.

[7] On July 18, 1990, 41 years after being placed on public display, Dimitrov's body was removed from the mausoleum and cremated. The decision was taken after a series of public calls for the proper burial of Dimitrov as an act that would symbolize the end of one-party rule in Bulgaria. With the removal of the body the empty sepulcher became the focus of various projects for its reutilization, some of which included installing a museum of the history of Socialism in Bulgaria, establishing a gallery of modern art, or housing a section of the National Museum in it. About the various transformations of Dimitrov's mausoleum see Lilyana Deyanova, "The Battles for the Mausoleum: Traumatic Places of Collective Memory" in Jacques Coenen-Huther (ed.), *Bulgaria at the Crossroads* (New York: Nova Science, 1997); Vladimir Gradev, "Le Mausolée de Dimitrov," *Communications* 55 (1992): 77–88.

[8] In 1999, the government of the Union of Democratic Forces took the decision to destroy the mausoleum and to reconstitute the former royal garden that existed before its con-

Thus, in spite of several random attempts on a regional level, the "most modern" period of Bulgarian history failed to find presentation and interpretation in a museum and remains, even in historical museums with a more general profile, a relatively "blank" period. Several short-term exhibitions have appeared in some regional museums,[9] but they have not been systematically carried out and cannot be considered as serious attempts to investigate the issue. Novel historical materials on the socialist period have been produced and new emphases in the public discourse about the past have developed, but they have not been embodied in any museum exhibition. So far, the town of Pravets is the prime example of a community that has united its efforts to open a museum reflecting on the socialist past (Fig. 1, Fig. 2), and it seems that this situation is unlikely to change in the near future. The current article approaches this characteristic situation of museum displays in Bulgaria after 1989, when the earlier network of meanings and discourses has been dissolved and new ones have not gained sufficient justification to embody post-socialist visions of history in museum narratives. Throwing light on the reshaped nature of socialist museum displays after 1989 in Bulgaria and on the emergence of new topics and events in the modern history of the country, I will discuss the new concepts applied to the construction of historical legacies and the discourse of "difficulty" surrounding historical representations in a post-socialist mode.

Before approaching the problem of the shift away from committed museum practice in the post-socialist era, an explanation of the interpretative distinction offered in the title of this chapter is needed. While exploited in both the classical and the modern traditions, the opposition between memory and forgetting is one that frequently ignores a third component in the processes related to memory: the "unmemorable."[10] The latter does not

struction. The decision was enacted in a swift and uncompromising way and within days no trace remained of the huge building. About the fate of the mausoleum and the memory after its disappearance, see Maria Todorova, "The Mausoleum of Georgi Dimitrov as *lieu de mémoire*," *The Journal of Modern History* 78 (2006): 377–411; Nikolai Vukov, "The Destruction of Georgi Dimitrov's Mausoleum in Sofia: The "Incoincidence" between Memory and Its Referents," *Octogon* 10 (2003).

[9] For example, Tinka Bozova, Zlatka Antova, "Vruzkite na savremennia muzei s jivota" [The links of the contemporary museum with life] in Krassimira Cholakova (ed.), *Moderniat muzei—modeli za adaptacia* (Veliko Tarnovo, 2004), 144.

[10] On the theoretical elaboration of the relationship between memory and forgetting, see Aleida Assmann, Dietrich Harth, *Mnemosyne, Formen und Funktionen der kulturellen Erinnerung* (Frankfurt: Fischer, 1991); Mary J. Carruthers, *The Book of Memory: A Study of Memory in Medieval Culture* (Cambridge: Cambridge University Press, 1990);

designate things that memory cannot hold and has relegated to the realm of forgetting, but rather things that are not "worthy" of remembrance and that, although remembered, never enter the realm of representation. The "unmemorable" refers to experiences that are well-known and can be revived by an act of recollection, but are generally not treated in that way.

Fig. 1 The museum of Todor Zhivkov in Pravets, front view
(photo: Nikolai Vukov, 2007)

Patrick Geary, *Phantoms of Remembrance: Memory and Oblivion at the End of the First Millenium* (Princeton: Princeton University Press, New Jersey, 1994); Maurice Halbwachs, *On Collective Memory* (Chicago: The University of Chicago Press, 1992); Jacques Le Goff, *History and Memory* (New York: Columbia University Press, 1992). Attention to memory traces that do not enter the realm of representation can be found in the abundant literature on traumatic memory. For example, Paul Antze, Michael Lambek (eds.), *Tense Past: Cultural Essays in Trauma and Memory* (New York: Routledge, 1966); Dominick LaCapra, *Writing History, Writing Trauma* (Baltimore: Johns Hopkins University Press, 2000); K. Hodgkin, S. Radstone (eds.), *The Politics of Memory: Contested Pasts* (London: Routledge, 2003). Taking a different course, in this chapter I direct my attention to realms of memory that are not necessarily associated with trauma, but that remain unrepresented and "unremembered" rather because of the complex intertwining of nostalgia, uncertainty about the grounds of interpretation, and the attitude to what is "unworthy" to be remembered.

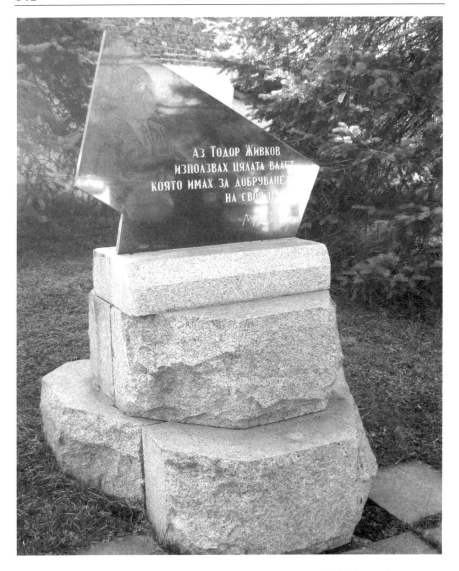

Fig. 2 The monument to Todor Zhivkov in front of the museum in his honor in Pravets
(photo: Nikolai Vukov, 2007)

They are not forgotten, but on the contrary they can sometimes be re-
membered much better than anything else that the storehouse of memory
preserves. They are retained in the memory but are prevented from being
displayed; well-known and shared by many individuals at the same time,
but wrapped in silence; present in the mind, but hidden from view; they

have undeniable presence but are denied materialization. The factors and conditions that lead to this field of memory being held "in reserve" can be diverse and can result from different psychological processes and narrative constraints. Among them, a central criterion for understanding the nature of the "unmemorable" is "worthiness," which determines that certain acts or events should neither reach the level of expression, nor be entirely omitted from the realm of memory. The "worthiness" of certain events (and the "unworthiness" of others) serves to legitimize the logic of hiding certain remembered things from view, and is susceptible to such legitimation due to its highly selective and discriminative character.

What is probably more important to emphasize here is that the "unmemorable" is a fighting ground not so much between memory and forgetting (because, I insist, it needs to be considered as a separate category), but rather between memory and representation, thus constituting the "limits of representation" that historians such as Saul Friedlander have tried to probe.[11] It is therefore the nature of the "unmemorable" that, in my view, is especially applicable in approaching the issue of museum representations of recent history in post-socialist Bulgaria—as a concept that denotes things that are not subject to forgetting but face restraints in representation, that are stored in the mind but not employed in narratives, that are preserved as memory traces but not embodied in materialized forms. To approach the logic of this case of simultaneous remembering and forgetting in a post-socialist context, it may prove useful to revisit the history of museums in socialist times.

MUSEUMS AND MEMORY IN SOCIALIST BULGARIA

As early as the first years after the establishment of the socialist regime in Bulgaria, decisive steps were taken to reorganize the historical museums and to create special departments dedicated to the socialist and revolutionary movement in the country. The first indicative example was the National Museum of the Revolutionary Movement, built after a decision of the Central Committee of the Bulgarian Communist Party (BKP) in 1948. It was preceded in 1947 by a National Exhibition of the Resistance in Sofia, which brought together materials about the antifascist struggle of the working people of the entire country. This exhibition served as a basis

[11] Saul Friedlander (ed.), *Probing the Limits of Representation* (Cambridge MA: Harvard University Press, 1992).

for the museum, which was opened on 23 September 1950. It held over 3,000 photos, objects, weapons, documents, maps and works of art that recreated "the struggle of the working people under the guidance of the BKP against Capitalism and Fascism."[12] During the 1950s and 1960s several branches of this museum were opened in regional museums in the larger towns of the country (Plovdiv, Varna, Burgas, etc.).[13] Several of the former prisons where Communists were detained and tortured were turned into museums.[14] The art galleries that were opened at the time (Plovdiv, 1952; Varna, 1950) also directed much of their activity to exhibitions on the topic of the resistance movement. Furthermore, in that period, many "house museums" dedicated to prominent leaders of the socialist and resistance movements were created in the places where they were born or lived. In Sofia alone, such museums were established to Dimitar Blagoev, the founder of the Bulgarian Socialist Party, to the prominent leader of the international socialist movement, Georgi Dimitrov, to Dimitrov's main collaborator in the socialist movement, Vassil Kolarov, and to many less prominent figures from the history of the Party.[15] Special museums were created in Mihailovgrad—to the 1923 September uprising (1953), and in Dimitrovgrad—to socialist construction (1954). Another addition to the development of museums was the creation of the National Museum of Bulgarian–Soviet Friendship (opened in 1958), which also provided a pattern for similar units in regional museums elsewhere in the country.

[12] Mihail Raichev, *Muzei, starini, pametnitsi v Bulgaria* [Museums, antiquities and monuments in Bulgaria] (Sofia: Nauka i izkustvo, 1981), 16.

[13] In Plovdiv, the Museum of the History of Capitalism, the Workers' Revolutionary Movement and Socialist Construction was built in 1948 and opened to visitors in 1954. In Pernik, the Regional Historical Museum was created in 1952 as a specialized museum about mining work in the region, but both its first exhibition in 1957 and its subsequent function defined it as a "museum of the revolutionary movement in the region." A notable detail is that the exhibition ended with an original pantheon—a photographic installation of images of local heroes who died in the struggles for national and social liberation.

[14] In Burgas, for example, the island of "Bolshevik" (former "St. Anastasia"), previously a camp for political prisoners, was turned into a permanent exhibition about the revolutionary struggles in the region. In Veliko Tarnovo a special prison museum was created at the place where Communists and resistance fighters had been held prisoners.

[15] Such museums were also built and dedicated to Georgi Kirkov (a prominent journalist and socialist tribune), Alexander Stamboliyski (a leader of the Bulgarian Agricultural Union and Prime Minister after World War I, murdered in the June 1923 uprising), Nikolai Hrelkov, Hristo Smirnenski, and Nikola Vaprsarov—poets with unconcealed sympathies for socialist ideas.

At the beginning of the 1960s, in line with enhanced attempts to trace the local roots of the antifascist and resistance movements, many "house-museums" to partisans and fighters were opened in towns throughout the country, and a series of "hut-monuments" (tourist complexes with museum displays dedicated to partisan troops) established along the tourist routes in the mountains. In addition the Culture Houses (*chitalishta*)–characteristic establishments dating back to the nineteenth-century Revival period which exist in almost all towns and villages in Bulgaria–played the role of housing museum exhibitions wherever regional museums or specially developed venues were not available. What is more, all the regional museums made efforts to develop memorial sites related to the history of the revolutionary movement, which they used as branches of their museum activities. Thus, for example, following a decision by the Politburo of the Central Committee of the BKP, the "Garrison Shooting Ground" Memorial, where many political prisoners were executed in the early 1940s, was turned into a department of the Museum of Sofia in 1969.

Although the pace of these developments varied in different parts of the country, by the late 1960s the majority of museums dedicated to the socialist and revolutionary movement had been created and their status and functions were firmly outlined. They were institutions financed by the state, with a fixed structure and two levels of governance: one involving museum specialists and the other (often more important) of Party secretaries affiliated with these institutions. This structure applied to most museums in the country, whose number was estimated in the 1980s at about 200.[16] The characteristic mode of shared governance had a significant impact on the procedures leading to opening a museum exhibition and on the very nature of museum display itself. The rules demanded that every exhibition or permanent display relating to modern history must be approved by the Regional Committee of the Bulgarian Communist Party. As a result, museum departments dedicated to "Modern" and "Contemporary" History were labeled "Workers and the Revolutionary Movement" and "Socialist Construction," and they interpreted history in the light of the Communist Party's ideology.

The permanent exhibition was the obligatory core of museum displays at the time, and its structure also followed a specific pattern. Thematic museums were not popular, because they were considered as a result of

[16] Mihail Raichev, *Muzei, starini, pametnitsi v Bulgaria*, 5.

bourgeois, Western and decadent thought.[17] With the exception of those dedicated to individual figures or events of national history, museums generally had to present history chronologically from antiquity up to the present time. Thus, no matter what possible variations might appear on a regional basis, or depending on the chosen focus of an exhibition, they would all have rather similar, or even identical, structures. All had to go back as far as possible to traces of antiquity and, more importantly, all had to include substantial sections dedicated to the antifascist resistance and to socialist construction in the country. The exhibitions strictly followed the Party doctrine and were synchronized with the political holidays in the calendar—the October Revolution, the Anniversaries of the Socialist Victory, the Days of Bulgarian-Soviet Friendship, and so on. In the majority of cases they were standard photographic exhibitions with an emphasis on their documentary value and clear propaganda overtones. Exhibitions with a more historical (rather than ideological) profile, dedicated for example to the local historical and cultural characteristics of towns and regions, were generally an exception.

The guidelines that each museum was supposed to follow were determined on the one hand by the ideological vision of "the progressive development from prehistoric times until the socialist victory," and on the other hand along the axes of the "national history" paradigm, which attributed a relatively firm set of points around which "museumized" historical narratives could evolve. While largely ignored during the first two decades after the establishment of the socialist order, in the late 1960s and 1970s national history regained its proper place for historical investigation and representation, largely thanks to the possibilities that it provided for the ideology to "recover its roots" far back in the past.[18] Apart from revealing the glory of the Medieval Bulgarian Kingdoms, the Middle Ages, for example, provided a useful occasion to remind people of the social rebellions that were predecessors to the socialist revolution. The nation-building struggles and the nineteenth-century revolutionaries against Ottoman domination were shown as prefiguring the antifascist struggle, and the Russian-Ottoman War of 1877–78 was interpreted as a model on

[17] Bozova-Antova, "Vruzkite na savremennia muzei s jivota," 144.

[18] On the main lines of interpreting national history in Bulgaria before and after 1989, see Nikolai Vukov, "Representing the Nation's Past: National History Monuments in Socialist and Post-Socialist Bulgaria" in Seventh Annual Kokkalis Program Graduate Student Workshop, Harvard, 2005. Available at www.ksg.harvard.edu/kokkalis/GSW7/Nikolai%20Voukov%20_paper_.pdf (accessed 20 November, 2006).

which the "second liberation" of the country would take place in 1944. Thus, while in the first years after the socialists came to power the museums of the revolutionary movement were among the most important conditions for the ideology's self-legitimation, in the decades that followed they became instruments for reshaping the entire context of the production and narration of history. They not only radicalized the historicization and propagation of the ideology's own history, but also reworked the retrospective historical visualizations of previous centuries. Tracing historical identities back to times immemorial, they also succeeded in reshaping the entire image of the past—not only in terms of concrete visualizations, but also as a settled and "permanent" display of "indisputable" events and characters.

An important issue in this respect concerns the activities in which museums and museum workers were involved at the time, and how the "appeal" of these exhibitions was sustained despite the expected danger of boredom with the redundant narrative. A good illustration of such activities is provided by the yearly meetings of museum specialists that were held in the 1970s and 1980s. The content of the publications that resulted from such meetings did not differ much, as the reports generally stressed the important role of museums in "popularizing and propagating the history of the revolutionary movement and the victorious march of the Bulgarian people along the road of Socialism." They were all guided by the belief in "mass-political work, which gives an enormous opportunity to contribute to the class-party and the patriotic and international education of the working people and youth." [19] What is especially impressive in such reports is the experiences that people shared through the abundant museum activities at the time: "Every day in the halls of the National Museum of the Revolutionary Movement there are overviews and thematic lectures, mass cultural activities: meetings with veterans, participants in the revolutionary struggles and in the war, with excellent production workers and prominent representatives of literature and art, with outstanding party and social activists; party and Komsomol membership cards are distributed, there are seminars, conferences, solemn meetings, pioneers' clubs, etc." [20] The museums were special places for carrying out

[19] Tania Burova, "Masovo-politicheskata rabota na Natsionalnia Muzei na Revoliutsion-noto Dvijenie s trudovite kolektivi" [The mass-political work of national museum of revolutionary movement with working collectives] in *Problemi na kulturno-masovata rabota na muzeite s trudovite kolektivi* (Sofia, 1986), 17.

[20] Ibid., 17.

political education and for organizing political rituals: "Often in the halls of the museum and in the "Workers' club" department membership cards were distributed. In the period of four years about 2,000 young Communists and 4,000 Komsomol members were admitted in the department."[21] An interesting area of museum work was the organization of various sporting activities, such as the annual "Marathon for Freedom," dedicated to the 9th September socialist revolution.

Certain forms of museum activity went far beyond the walls of the museums. A widespread idea was that of displaying museum materials (personal belongings of socialists and antifascists, documents, photos) in specially arranged windows in schools, enterprises and institutions, or in central locations of the city. In a new approach, the activities of the museums took place among the collectives, the territory of the workers' enterprises. In 1985, eighteen such activities were organized in the Kremikovtzi steel production plant, half of them related to the rituals of giving names to eleven workers' brigades in the plant. A specially prepared window displayed the personal belongings of the heroes the brigades were named after.[22] In less than two years, in 1984–85, ten thematic exhibitions and about twenty museum windows were arranged in the plant, which was one of the largest in the country at the time: "Behind the bars of the fascist prisons," "The beginning [of the antifascist struggle])," "Partisan everyday life," "Parachutists and submariners," "Bulgarians who took part in the Great Patriotic War of the USSR," "Relics from the collection of National Museum of the Revolutionary Movement," and so on. The materials in the "Partisan everyday life" exhibition included 100 objects and over 200 "Relics from the collection of the National Museum of the Revolutinary Movement." Five exhibitions were mounted in the Trade Union House of Culture in the plant, and five directly along the production lines.[23] In 1984 the number of complex mass-political activities organized in or outside the halls of the Museum of the Revolutionary Movement in Sofia reached 490. In the first half of 1985 an activity involving a working collective took place in the museum almost every hour. The lecturing activity of museum workers in plants and factories was also impressive. As reported, in three years the regional historical museum in the town of Pernik held 1,292 thematic talks and lectures, often accompanied by exhibitions.

[21] Ibid., 18.
[22] Ibid., 18.
[23] Ibid., 21.

The radical way in which this mass-political work was carried out by museums in the last two decades of the regime comes as no surprise. It was clearly defined in documents as a necessary step to be taken in order to increase the people's awareness of the rich historical traditions of the Communist Party and of all working people. As one museum specialist admits, "Many of the work collectives did not want to visit the museum just to attend a lecture. That is why we had to find the most suitable form of mass culture work with them. In this respect we were greatly helped by the contracts signed in 1981 for joint activities with enterprises, institutes, institutions, departments of the Ministry of the Interior and the Ministry of Education, teachers' collectives, etc."[24] In order to fulfill the terms of these contracts the museum specialists had to provide these various enterprises and institutions with regular exhibitions, photographic displays, and other visual materials related to important dates and events. If the institutions specially requested it (and it seemed that they did, since they were guided in these requests by party secretaries, Komsomol, and social organizations), museums facilitated them in organizing and carrying out festive meetings and conversations with veterans, as well as many other activities related to anniversaries and special days. Convenient occasions for this fell 100 years after the birth of Dimitrov, 60 years after the creation of the USSR, 65 years after the October Revolution, 40 years after the victory over Fascism, and so on. An especially "interesting" form of project with working collectives were the complex activities named "Veterans narrate." These were considered "appropriate for all social groups—workers, intellectual workers, clerks, army workers, teachers, students, etc."[25] and organized again on those (as well as on many other) occasions.

THE RESHAPING OF MUSEUM PRACTICES AFTER 1989

It is not surprising that, given this overexploited encounter between museums and the population in the socialist period, a critical lack of interest in museums with historical collections became dominant after the change of regime. As if following a hidden agreement, all the activities related to "mass cultural work" among working people ceased immediately after 1989. The task of maintaining a contact with the exhibited objects of the past was swiftly left to the initiatives of enterprises,

[24] Ibid., 35.
[25] Ibid., 35.

schools, and other institutions, which, obviously overfed with the decades of ideological work, seemed no longer to take any special interest in museum visits. However, the real problem was not *whether* to visit museums but rather *what* to see there. Large parts of the historical exhibitions in all the museums in the country (with the exception of the museums of Natural History) were suffused by socialist doctrines, and their permanent displays had to be demolished or completely reshaped to suit a post-socialist context. But how to carry out this reshaping when, at least in the early 1990s, it was not quite clear whether the stage was already a "post-socialist" one and whether the transition was irreversible? How to achieve the rearrangement of historical narratives when the old patterns of conceptualizing history were still the only ones that museum specialists and the public had at their disposal? How to create new visualizations of the past, when the attempt to root out the all-encompassing socialist narratives came close to destroying the very notion of the past?

In the face of these dilemmas the easiest step to take was to close the museums of the revolutionary movement and to place a large part of the regional museums' collections in storage, from which they would not reappear for public view again. Occupying a central location in the city, about two minutes' walk from the National Parliament, the building of the Museum of the Revolutionary Movement in Sofia became the subject of debate about its re-appropriation and reutilization after the closing of its permanent exhibition. After it had stood empty and abandoned for several years, a theater was opened on its premises in the mid-1990s, and subsequently parts of it were occupied by a bank and a number of private firms. Next to the still gaping old windows of some of its exhibition rooms, now one of the biggest night clubs in the capital operates. Though less "successful," the fate of other similar museums was not very different, as they all became the targets of property debates and restitution activities. The collections that were accommodated in the closed museums, and the material objects that circulated for display in enterprises and institutions, no longer hold the potential to command esteem, care or even attention. The objects that were previously on display would not recreate any past, and their association with the previous networks of representation condemned them to a symbolic death, overtly expressed in the refusal of state or other institutions to consider them as cultural and historical heritage.

More important and complicated processes affected those museums that did not focus exclusively on the revolutionary movement, but rather

addressed regional and national history. Though in many of them the sections dedicated to the socialist movement and post-war construction were closed, the traces of the past narratives were not so easy to eliminate. While in technical terms there were enormous tasks associated with the preparation of new catalogues and a different classification of the existing objects, the challenges at the level of interpretation were no less serious. The need to produce alternative discourses on the recent past was met with a "sense of disorientation"[26]: on what possible grounds could the new historical evaluation be established, and how could the recent past be represented in a strongly politicized field? It took a decade to settle (though debates still resurface) issues such as the role of the Soviet army in Bulgarian history in the 1940s, the nature of "Bulgarian Fascism" and the attitudes towards those who died in the partisan struggle of the late 1930s and 1940s. Many of the nineteenth century liberation fighters had to undergo a new interpretation of their historical role, usually in line with the nation-building process rather than with the history of the social struggle. In several cases, areas of national history which the socialist ideology had largely suppressed provided opportunities to fill the empty spaces left by the displays of the socialist and revolutionary movement. An increased interest in the Balkan wars and the First World War, attention to personalities and events related to the Third Bulgarian Kingdom and the revived memory of forgotten figures of the interwar period were all trends that marked postsocialist museum initiatives. However, in spite of the attempts at reworking historical representations, the major field of activity for museums after the changes was related to dissolving the historical presentations into ethnographic ones, following a pattern similar to the nineteenth century *Heimatsmuseen* with their emphasis on local cultural traditions at the expense of critical historiographic reflection.

The avoidance of the recent past is clearly demonstrated by the National History Museum in Sofia, in which the representation of Bulgarian history ends with the establishment of the socialist regime in Bulgaria without a separate section on the period after 1945. The lack of tangible material (objects, documents, photographs) is not a reason, since as early as the beginning of the 1990s the National History Museum (which already had its own collection from the socialist era) was enriched by the transfer of historical objects from the National Museum of the Revolu-

[26] Katherine Verdery, *The Political Lives of Dead Bodies: Reburial and Postsocialist Change* (New York: Columbia University Press, 1999), 35.

tionary Movement and the Museum of Bulgarian-Soviet Friendship. However, neither the earlier collection nor the new acquisitions were put on display, but remained in storage. This is all the more surprising if we remember that the new building which the museum took over in 2000 is the former principal residence of the communist leader, Todor Zhivkov.[27] As a site where the main ceremonies of state were held and the main decisions related to Bulgarian history were taken, the former residence in a curious way contradicts the limitation that the museum has evidently embraced: from 7000 A.C. until the mid-twentieth century. Although physically situated within the material framework of the socialist period, the museum refuses to narrate it, and has positioned itself entirely within a "national past" that preceded the socialist era—Prehistory, Ancient Thrace, the Middle Ages, the Bulgarian Lands in the eighteenth and nineteenth centuries, and the Third Bulgarian Kingdom (1879–1946). The only case of an exhibition including explicit references to the socialist period is the collection of aviation objects dating from Bulgaria's membership in the Warsaw Pact (1955–1989). Apart from the display of these objects, the representation of national history simply stops with the Second World War and no intention to overcome this self-imposed boundary has been announced. The appropriation of the former communist leader's residence by a museum of national history and the elimination of the socialist period from museum display become emblematic of the politics of forgetting that surrounds this museum exhibition. The reluctance to reflect about the powerful *milieu* that hosts the exhibition itself disrupts the legitimacy of this museum project and raises legitimate suspicions about the political implications of the "unmemorable."

This overt "innocence" of the museum displays is shared by the other regional museums in the country, where the pattern of exhibitions generally comprises sections on archeology (including Prehistory, Antiquity, the Middle Ages, and Numismatics), the Bulgarian Lands of the fifteenth through the nineteenth centuries (with the periods of the "National Revival" and "Ethnography"), and "Modern History" (covering the period from the National Liberation until the Second World War). Almost without exception, in regional and local museums the turbulent 1940s, the

[27] Created in 1973 and holding its first representative exhibition in 1984, in honor of the 1300th anniversary of the Bulgarian State, for almost three decades the National Museum occupied the grand building of the Law Courts in Sofia. When the building was reappropriated by the courts and regained its previous functions, the museum was moved to the former residence on the outskirts of the capital.

antifascist resistance, and the socialist period are denied representation and limited to brief allusions to the establishment of the socialist regime in 1944. A more tangible set of references to the socialist period can be found in the National Military History Museum, where the exhibition of military technology and documents about the history of the Bulgarian army extends from the Middle Ages until today. However, despite this openness to the period after 1945, the thematic specificity of the museum and the focus on military problems allow relatively limited attention to be paid to the socialist period *per se*. Almost without exception, the rule for all the regional and national museums across the country is the avoidance of the socialist period. The empty space left by the discarded socialist regime's representations was not utilized for creating alternative representations on the most recent period of Bulgarian history, but rather for extending the museum narratives about figures and events across the large span of pre-socialist times. Although sometimes it served to re-legitimize areas of history which previously stood in the shadow of the ideological master narratives, the exclusive concentration on the period before the 1940s is a symbolic act that circumscribes the socialist times, denying the possibility of a meaningful reflection on that period.

This symptomatic feature of historical museums after the changes leads us to another important point. As an extension of the earlier period, the space in these museums cannot be a heterotopic one. It fails to testify to the existence of alternative orderings, meanings and practices, but rather prolongs the inertia, excluding from display everything on which there is no official policy of visibility. Heterotopia, as identified by Foucault, refers to places that are "capable of juxtaposing in a single real space, several sites that are in themselves incompatible."[28] It is "necessarily a relational phenomenon: no site is heterotopic by itself, it only becomes so through its juxtaposition with other sites around it."[29] In the post-socialist situation of the socialist museums in Bulgaria, this relation and juxtaposition seem to have been impossible to implement. While in the first years after the changes the representations of the heroic socialist struggles and the supreme achievements of the socialist order were

[28] Zeynep Kezer, "If Walls Could Talk. Exploring the Dimensions of Heterotopic at the Four Seasons Istanbul Hotel" in Dana Arnold, Andrew Ballantine (eds.), *Architecture as Experience: Radical Change in Spatial Practice* (London: Routledge, 2004), 214. On heterotopy, see also Kevin Hetherington, "The Utopics of Social Ordering—Stonehenge as a Museum without Walls" in Sharon Macdonald, Gordon Fyfe (eds.), *Theorizing Museums* (Cambridge, MA: Blackwell—The Sociological Review, 1996), 153–60.

[29] Kezer, "If Walls Could Talk," 214.

dropped from visibility, in the years that followed the policies on their relations, both to the present and to the other museum narratives that remained, were vague and unsettled. Even so, their attempts to reach back to the realm of visibility were doomed, at least in the light of the unaltered understanding that a history museum should be a stage where only historically firm, crystallized, and more or less uncontestable narratives would be permitted. The problematic and the arguable, the multivocal and contradictory would not be represented, would be left without a say, or—at most—would be limited to a brief label statement. In a tradition that reaches back before the socialist rule, but that gained its ultimate expression during that period, the museum space is expected to be one where only what is publicly embraced and officially sanctioned will find representation. The physical and temporal adjacencies between objects belonging to different discursive realms seemed not only inadequate, but hard to justify in the severe policies of inclusion and exclusion after 1989.

As illustrated by these examples, a "museumized" representation of the socialist era has not found a place in the previous museum forms—both because of the "earthquakes" that museum institutions encountered after 1989 and because of the impossibility of replacing the previous monolithic discourse by a heterotopic and polyphonic one. At the background of this virtual atrophy of the existing museums, a way to represent the socialist period was sought mainly by creating a separate museum about that era. Since the early 1990s discussions have been taking place on the possibility of creating a separate museum of Socialism in Bulgaria, but, as I have already mentioned, these have not borne fruit. One of the most intensive debates about such a museum was held in the late 1990s with the participation of prominent writers, architects, historians, and painters, but being both politically and economically inappropriate, the idea was doomed to failure. Since the beginning of the new millennium the issue of creating a museum of the socialist past has been transferred increasingly to the Internet, and this has led to the first versions of such a museum— the electronic forum "I Lived Socialism" and the exhibition "Inventory Book of Socialism," both of which appeared in book form in 2006.[30]

Initiated by the Bulgarian writer Georgi Gospodinov, the first project represented a forum where individual stories about the socialist era were collected and shared with the other participants. Welcoming participation

[30] Georgi Gospodinov (ed.), *Az zhiviah sotsializma. 171 lichni istorii* [I Lived Socialism. 171 Personal Stories] (Sofia, 2006); Yana Genova, Georgi Gospodinov, *Inventarna kniga na sotsializma* [Inventory Book of Socialism] (Sofia, 2006).

by people across the generational spectrum, the project succeeded in gathering eyewitness narratives from the 1950s through the 1980s and evoking diverse spheres of public life in those times. Avoiding the risk of superimposing historical narratives about the socialist period, the project gave predominance to personal narratives and private recollections. The goal was to extract the most immediate and expressive stories that people remembered and associated with Socialism, and to bring them out to the public, giving a voice to experiences that have remained unspoken and unshared for decades. Although differing in principle from conventional museum forms, the web forum and its book version undertook largely the functions which the previous museum forms have failed to perform. They preserve memories of the past that are otherwise destined to disappear, providing an open ground for reflection and self-reflection related to recent historical experience, and sustaining the freedom of expression and association which every museum object should ideally have. All the constituents of the project are essentially different from those involved in the "traditional" museum forms, indicating as they do that the "unmemorable," in order to transmit itself to the present, needs to find alternative forms of tangible recollection. In the project in question, it is the personal story that is turned into a museum object: each of the participants in the forum tells the most vivid and expressive story that he/she regards as representative of their personal experience in the socialist times, and relate it to the personal stories of the other people in the forum. The stories are not encompassed within a master narrative, either on the website or in the book, but joined together by the formal identifier of the decade that each story refers to. In that way, the multivocal and the dissonant, the incomprehensible and the inexpressible not only find their place in this forum, but provide alternative ways of overcoming the rigidity of the earlier museum discourse.

Inherently connected with the "I Lived Socialism" project, the "Inventory Book of Socialism" exhibition goes one step further in realizing the "museumization" of the socialist era. Initiated by Yana Genova and Georgi Gospodinov, the Inventory Book consists of material objects (and, in the book format, photocopy images), which were inherent parts of socialist everyday life: socialist brand TV sets and electric appliances, chocolates and candies with characteristic wrappers, cigarettes and soft drinks typical of those times, shoes and soap, and so on and so forth. The display traces the development of the design of over 500 everyday objects from the 1960s until the 1980s, and thus provides an account of areas of life that were not represented in any archive, record, or museum exhibit.

Collected from cellars, attics and storehouses, the objects are labeled with brief texts that situate them in the context of their use in the socialist era. Directly related to the private sphere, the exhibition reveals the extent to which the boundaries between private and public life were blurred under Socialism, and the high level of uniformity that marks the material heritage of those times.

The Inventory Book of Socialism is a good testimony in the debate on the willing forgetfulness about the socialist period. For many viewers the objects are easily recognizable as things that they once used, saw or were in contact with; objects that they have heard about; or objects that are still part of today's households. Despite the variations of age and lived experience among the visitors to the exhibition (and readers of the book), and despite the differences in taste and attitude to these objects, the Inventory Book serves to unveil memories about the material life that surrounded people and exercised a lasting impact on their senses and perception. The memories are retrieved and retroactively extracted, but they are also created, constructed, and implanted. For people of the generation that witnessed these objects directly, the inventory is an opportunity to look at them in a new way, as if exhibited in a glass case; it is a way of making these artifacts visible after many of them have stopped eliciting immediate associations with the socialist epoch. For the visitors of the youngest generation, the exhibition is an occasion to see some of these objects for the first time, to observe them as parts of the past and to be fascinated by them. They are "imagined memories" of a time that has not been lived through and as such they bring that time closer to the viewer than any of the other institutionalized forms of historical "museumization."

In the context of these examples, it should be much easier to understand the presence of the Todor Zhivkov museum in Pravets. Unlike the National History Museum in the former residence, where the ruler spent most of his life in power, the local museum in his birthplace relies on the link with his childhood and sustains this link in a way that is strongly reminiscent of the "museum houses" of the nineteenth century fighters for national liberation (Fig. 3). The small two-storey house preserves everyday objects from the first half of the twentieth century, surrounding them with an aura of authenticity. The kitchen and the dining room where the ruler's family had their meals, the crockery and cutlery that they used, the loom on which their home-made clothes were prepared, the fireplace, and so on—all insist on the idea of ordinary origins destined to give birth to "extraordinary" achievements (Fig. 4). The value of simplicity conveyed by the small house is combined with that of aesthetic sensitivity, as ex-

pressed by the neat arrangement of the rooms and by the small flowerbeds around the house. Upon reflection, however, the apparent harmony is disrupted—on the one hand we have the ideological sanctification that surrounded the leader before 1989, and on the other the amnesia after the end of his power, and especially after his death in 1998.

Fig. 3 The house where Todor Zhivkov was born in Pravets
(photo: Nikolai Vukov, 2007)

Recreating the everyday life of a poor family in the first half of the twentieth century, the house became an object of the care and attention of the Communist Party, a site where the humble origin of the leader was emphasized and affirmed as a precondition for "great deeds." Although sustaining the link with its sanctification in the socialist period, the house as an exhibition object acquired a different dimension at the post-1989 stage. The viewer is already aware of the post-socialist disavowal of the Party and its leader, and is thus guided by either opposition or allegiance to this process. Whereas in the socialist period the ideologically loaded implications of this museum site were coupled with the idea of the permanency of the political and representational order, in the period after the

changes this pair is challenged by the notions of discontinuity and rupture. To the political changes after 1989 and to the years when the museum was closed, yet another discontinuity was added—the death of Todor Zhivkov in 1998. While the other ruptures remain practically silenced in this museum, the death of Zhivkov (as evoked by the necrologues of the eight years after his death) adds a commemorative tone to the entire comlex.

Fig. 4 The dining room of the house where Todor Zhivkov was born
(photo: Nikolai Vukov, 2007)

This mode of solemn attention to an individual destiny, which began in this humble house, would have a better chance of success, if its message of simplicity and modesty were not overshadowed by the grand museum building nearby (Fig. 5), dedicated to Zhivkov's supreme achievements as a communist leader. Following the architectural fashion characteristic of the deliberately impressive residential and recreational buildings of late Socialism, the museum combines stylized elements of nineteenth century revivalist architecture with modernist approaches to external design. The exhibition is located on two floors—the first consisting of a hall that was obviously designed for hosting official meetings and small ceremonies,

and the second focusing on objects connected with the life of the leader. The interior and its decoration are preserved as they were at the time the museum was created, the most notable feature being the mural representing a flock of white doves flying across a background of red floral motifs. The exhibition hall concentrates exclusively on the gifts that the socialist leader received from statesmen and politicians all over the world in recognition of his role on the stage of world politics. If one can find a heterotopic experience in any museum dating back to the socialist era, it is surely in this exhibition, which brings together statues of elephants from India, pictures of elks from Northern Europe, ritual masks from African and South American countries, china, silverware, and copperware from all over the world. All these objects not only gather together distant geographical locations, but in the context of the museum also turn the lack of practical purpose that such gifts embody into an "absolute value." The supplementary information about these objects is also varied—only a few are accompanied by tags or labels, obviously leaving the task of further explanation to the museum curator.

Fig. 5 The museum of Todor Zhivkov in Pravets, side view
(photo: Nikolai Vukov, 2007)

The most peculiar aspect of this museum is that, although it was re-opened thanks to the initiative of the local community to commemorate the socialist leader, it operates without actual consideration for tourists who might be interested in visiting the site. There is no information about the museum's location or its opening hours—either in tourist bro-chures or on the internet—and it is by pure chance that a visitor will find it open. After three visits to the place, my own efforts to see the exhibi-tion from inside remained fruitless, since, despite the assurances of neighbors that the museum was officially functioning, the woman en-trusted with its maintenance never appeared to unlock the doors. The only way to establish a link with the exhibition is to peer through the museum windows, trying to recreate meanings that might carry a differ-ent resonance if observed at closer range. The tourists to the site are certainly not numerous (which explains the lack of care about keeping the exhibition open), but even those who occasionally turn up have to satisfy their curiosity mainly through the glass window.

Although the history of the museum before the political changes can-not be established, given the lack of information about its previous con-tents, it seems likely that the collection of gifts was not on display, or at least that it could not have formed the core of the exhibition as it stands today. It is more probable that in the whirlpool of transformations that occurred in all the museums after 1989, this one too dropped the bio-graphical account of the leader and of his achievements which certainly constituted the principal display. Zhivkov's gifts were a widely discussed topic in the mid-1990s and, as with similar objects belonging to other communist leaders such as Tito and Ceauşescu, the collection was put on temporary exhibition but later hidden from view. While Tito's collection of gifts was sent as a traveling exhibition to several European capitals, and Ceauşescu's are stored in the National History Museum in Bucharest, Zhivkov's hoard is wrapped in secret. The collection in Pravets is too small to represent the entire amount that the leader received during his three decades in power, but it is very likely that it is at least part of the gift collection that was famous in Zhivkov's lifetime.

As this somewhat sweeping overview has made clear, the case of the Pravets museum deserves attention not so much for the richness of the exhibition, or for the originality of its approach, but for the fact that such a display has been sustained in the general confusion surrounding museum representations of the socialist period. An expression of nostalgia for the days when the town was at the top of the scale of symbolic importance during the socialist era, the reopening of this museum bears overtones of

the local community's affection for the major contributor to its one-time prosperity. The monument to him in the town square, the streets, names and institutions named after him, the obituary on the 8th anniversary of his death—all these create a network of references to an individual whom the community has identified as its special patron. The local enthusiasm for commemoration is not, however, to be found on the nation-wide spectrum, where the general lack of museum representations of the socialist period in Bulgaria raises doubts about the very possibility of narrating the recent past in museum terms. It is an expressive indicator of the "fragmentation of memory politics"[31] after the collapse of Socialism and the strange results of the attempts at new re-compositions. Still standing in a period when the previous approach to historical representation has been demoted from legitimacy, the museum in Pravets embodies a nostalgic move beyond narrative fragmentation and an attempt to bridge the gap that opened up with the end of the socialist regime in the country.

In the context of the institutional and discursive shifts that occurred in museum representations after 1989, the basic lack of a museum to the recent past poses a series of questions related to the ways history is perceived, remembered, forgotten, and permitted or forbidden representation. Is the absence of such a museum due to a conscious policy chosen in Bulgarian society after 1989 that seeks to prevent the development of alternative (and revisionist) approaches to the forty-five years of Socialism, or is it rather the consequence of a deeply nurtured amnesia, after decades of indoctrination? Is it because we lack sufficient empirical and interpretative grounds to set up a coherent museum discourse on the socialist past in "post-socialist" terms; or is it rather because there is no will to recompose the dissolved narratives into new forms and visualizations? Is this lack of a museum to the socialist past due to the "short" temporal distance that prevents the creation of coherent historical narratives, or is it due to the general impossibility of narrating the recent period, at least in the forms that the ideology had appropriated before? Can we speak of a "crisis" in the museum as an institution in the post-socialist context, or is it rather a question of a psychological barrier preventing the embodying of the past in plausible narratives and messages that carry conviction?

Each of those suppositions has been a plausible option at one point or another during the seventeen years since 1989, and each has a certain legitimating potential. However, what I believe is of crucial importance in

[31] Andreas Huyssen, *Present Pasts, Urban Palimpsests and the Politics of Memory* (Stanford: Stanford University Press, 2003), 17.

this lack of a "museumized" experience of the recent past is a general revulsion against museum visualization that results from decades of perceiving museums as inseparable from ideological discourse. In the socialist period, museums served as radicalized forms of the expropriation of the past, where the symbolic defeat of collective memory by historicized visions of the past was systematically completed. Museums not only shaped collective memory within ideological contours, but also replaced the tangible sense of the past by an abstract ideological history, which strove to encompass historical experience and to become its virtual and only embodiment. Instead of creating a palpable connection to what had been before, this resulted in reliance on allegories about ideological postulates and abstract narratives, and in confusion between the actual and the represented, the authentic and the simulacrum.

As a result of these processes in historical representation, the communist museums seemed not to refer to reality, but rather to imaginary realms, which constituted the sense of the real and brought about its systematic exhaustion. An expected repercussion was that the illusion of "eternity" that they created did not merely stop time and forgetting (as the ideology insisted), but also obstructed the enlivening sources of collective memory and worked to disrupt its self-recreational capacity. In them, the ideologically sanctioned and firm representations of history precluded the possibility of its acquiring public and institutionalized "expression," prevented it from finding a way to narratives and visual forms, and kept it beneath the surface of the representable. The dissolution of the link between memory and representation that occurred in the socialist period, not only conditioned the characteristic relationship between truth and persuasion at the time, but also laid the basis of the special status of the "unmemorable"—as memory that is stored, but does not reach representation—in the period after 1989.

The discourses of truth, authenticity and legitimacy have been critical points in all East European countries. However, unlike, for example, the Hungarians, who could use the events of 1956 as a powerful basis for narratives of their history that were different from the socialist mode, and unlike the Romanians who could directly oppose Ceauşescu's regime as they took steps toward rewriting their recent history, the Bulgarians had difficulties trying to find a relatively firm ground from which to approach the past. Testimonies of the regime's crimes did appear[32] and memories of repression

[32] About the communist repression and the victims of the totalitarian regime in Bulgaria see esp. Ekaterina Boncheva (ed.), *Bulgarskijat Gulag: svideteli. Sbornik dokumentalni razkazi za konclagerite v Bulgaria* [The Bulgarian Gulag: Witnesses. Collection of

were vivid enough, but they still could not consolidate around an image of life in socialist Bulgaria as one of "terror." The denial of human rights and the limitations of freedom were accepted as a feature of those times, but the memories of a period when basic living standards were assured for everybody still hover in the air. The notion of the Soviet Union as an "external oppressor" is still impossible to imagine—both because of the widespread, popular and shared discourse of the historical brotherhood between the Bulgarian and the Russian peoples, and because of the awareness of the enormous benefits that Bulgaria reaped as a preferred partner of the Soviet Union in the socialist era. What is more, attempts to identify the "internal oppressor" were also doomed—neither Zhivkov nor anybody from his circle could be fitted into such a role, and even actions such as the forcible renaming of Bulgarian Turks in the 1980s and the terrifying silencing of the news about the Chernobyl catastrophe, are regarded today as politicized issues whose solution should be left to the future.

The memory of the communist camps, the repression and the bids for freedom constitute for many Bulgarians an experience that, introduced as a topic after 1989 but then hidden somewhere in the storehouse of memory, does not reach the realm of explicit public representation. On the contrary, the benefits of everyday life, with all the illusions of well-being that they created, are deeply inscribed in the memories of the witnesses, and in a curious way determine their general approach to the past.[33] It is notable how, whenever they come to the fore (for example in commemorative ceremonies around the so called "anti-totalitarian monuments" to the victims of the regime), the voices describing the crimes of the socialist regime are sharply contested by the protests of those for whom the regime provided "everything necessary." The approach to the socialist period thus appears problematic not so much because of a confessed trauma of the past, but rather because of a manifest trauma of the present, since for

documentary narratives about the concentration camps in Bulgaria] (Sofia, 1991); Stefan Bochev, *Belene, Skazanie za konclagerna Bulgaria* [Belene: An epic narrative about Bulgaria of the concentration camps] (Sofia, 1999); Lilyana Deyanova, *Ochertanijata na mulchanieto: Travmatichni mesta na kolektivnata pamet* [The contours of silence: Traumatic sites of collective memory] (Sofia, 1999); Tzvetan Todorov (ed.), *Voices from the Gulag: Life and Death in Communist Bulgaria*, (University Park: Pennsylvania University Press, 1999).

[33] For a detailed investigation about the disparity between the ideology's high dictum and the benefits of everyday life during socialism, see Gerald Creed, *Domesticating Revolution: From Socialist Reform to Ambivalent Transition in a Bulgarian Village* (Pennsylvania: The Pennsylvania University Press, 1998).

many Bulgarians the problems of the transition period have been much harder to bear than the restrained but "cozy" life that they had before. In itself an expression of nostalgia, it helps to explain the motives behind the initiative of the people of Pravets to reopen the museum of Todor Zhivkov and to commemorate the former Head of State as a major factor in the country's well-being. By reconstituting "worthiness" and establishing personalities and experiences of the socialist period as "unforgettable," this museum is an ironic response to the prevented representation of a past that is still remembered by the majority of the population.

The lack of museum realizations of the recent past in post-socialist Bulgaria may be an indicator of the processes related to "learning how to forget," after decades of instruction in "how to remember." It may be regarded as a reaction of the memory to discard some of the burden that was laid upon it for years and to relax from the obligation to be constantly wakeful. However, it also testifies to a process of keeping certain areas of memory out of representation and replacing them with discourses which are in fact contingent with those that were propagated before. Being an illustration of the difficulty of elaborating new discourses on the recent past, the relegation of the socialist experience to the realm of the "unmemorable" also helps to explain how the museum in post-socialist mode lost its capacity to effect a historical and moral "reanimation" of Bulgarian society, and how it continues to be a form of memory where the past and present are still not in an open dialogue. Between the two poles of the representational field—one the museum in Pravets, the other the dispersed artifacts of the former socialist museums (some of which are still offered for sale on antiquarian stalls)—lies the general lack of a critical and thoughtful approach to this period of Bulgarian history in museum terms. As exemplified by projects such as "I Lived Socialism" and the "Inventory Book," the discussions and visualizations of the recent past occur not in public museums, but exclusively in the media and on the Internet. The sites dedicated to the socialist heritage and the web forums of individual memories about those years have taken over many of the functions that museums once performed as institutions for preserving and representing the past. Their failure to do so with respect to the recent period leaves the field open and ready to be occupied by new methods of sharing and distributing knowledge, which will probably constitute the new ways of "museumizing" the past in the future.

Containing Fascism

History in Post-Communist Baltic Occupation and Genocide Museums[1]

JAMES MARK

Since the collapse of Communism, three major museums dealing with the recent past have been established in the capital cities of the Baltic states. Two of these—the Museum of Occupations (Tallinn, Estonia, established in 2003) and The Museum of the Occupation of Latvia (Riga, 1993)—linked the Nazi and Soviet periods together to present a history of continuous national subjugation and suffering at the hands of foreign powers, lasting from 1940 to 1991. The third—the Museum of Genocide Victims (Vilnius, Lithuania, 1992)—dealt solely with the terrors of the communist period, despite being placed in a building with a "double past" of both Soviet and Nazi persecution.[2]

These museums focused on national suffering, terror and occupation. However, it was the terrors of Communism, rather than those of Fascism, which took centre stage. This in part reflected the longer-lasting and more recent nature of communist influence in the region: the Baltic states were incorporated twice into the Soviet Union—in 1940–41, and then between 1944 and 1991; Nazi occupation was restricted to the years 1941–44. However, it also reflected the choices of those who founded these institutions. In the main, these were groups who had suffered under Communism rather than Fascism; the Occupation Museum (Tallinn) was mainly funded by an exile, Dr. Olga Kistler-Ritso, who had fled in the face of Red Army advances in 1944,[3] and is run by Heiki Ahonen, a prominent anti-

[1] I would like to thank both the British Academy for the small research grant which allowed me to carry out the primary research for this article, and the museum curators, directors and press officers who generously gave me interviews and guided tours around their museums and assistance in uncovering material connected with their sites. My thanks also to Meike Wulf for her comments and suggestions
[2] All research at the museums themselves was carried out in the summer of 2005. All information on displays is correct as of this date.
[3] In addition to this, her father was killed by the Soviet regime.

communist who was imprisoned in Soviet camps. The Vilnius museum was instigated by the Union of Political Prisoners and Exiles, an association of those who had suffered because of Soviet rule. By contrast, the Riga museum was "authored" by a member of the North American Latvian diaspora who wanted to challenge the exclusive indigenous focus on Soviet crimes by including both occupations; however, even this museum was strongly influenced by the greater emphasis on communist-era suffering found in post-independence Baltic historiographies.[4] These sites' focus on Communism was in part a product of the difficulties the curators faced in amassing their collections; frequently Soviet era items were gathered from the personal belongings of the founding groups themselves, whereas objects from the Nazi occupation were harder to obtain.[5] Moreover, this choice reflected wider cultural assumptions about the relative importance of these different terrors. Only in the late 1990s did it become common to accord weight to Nazi persecution alongside Soviet crimes. Even then, however, this new approach was often adopted only grudgingly and regarded as a foreign imposition associated with integration into European political and cultural norms, rather than as a domestic imperative.[6]

Fascism did not merely play a secondary role in these museums' accounts of twentieth century terror and suffering: the memory of it was often perceived to be in competition with that of Communism. Some curators expressed the view that Holocaust remembrance in Western Europe and North America drowned out an appropriate recognition of national suffering under the communist terror, while some felt that a focus on communist-era victimization was a necessary response to those groups both within their countries and in post-communist Russia who still exonerated the Soviets and considered them to be the "liberators" of the Baltics from Fascism. This article will consider how these museums attempted to "contain" the memory of Fascism so that it could not compete with stories of Soviet crimes, how narratives of Nazi occupation were in fact used to frame an anti-communist reading of history, and

[4] Dovile Budryte, *Taming Nationalism? Political Community Building in the Post-Soviet Baltic States* (Aldershot: Ashgate, 2005), 181–3.

[5] The director of the Tallinn museum used objects from the time of his own incarceration in a Soviet labor camp. See Heiki Ahonen, "Wie gründet man ein Museum? Zur Entstehungsgeschichte des Museums der Okkupationen in Tallinn" in Volkhard Knigge, Ulrich Mählert (eds.), *Der Kommunismus im Museum. Formen der Auseinandersetzung in Deutschland und Ostmitteleuropa* (Cologne and Weimar: Böhlau, 2005), 109.

[6] Budryte, *Taming Nationalism?*, 184.

how, at sites where Fascism was marginalized entirely, this exclusion was normalized.

In the late 1980s, nationalist opposition movements in the Baltics constructed new semi-public histories that were to provide the foundation for public narratives after independence in 1991. These rejected Soviet versions of the past which had emphasized the role that Baltic peoples and parliaments had played in voluntarily inviting the Soviet Union into the region in 1940, the depth of the suffering under the Nazi occupation which followed, and then the role of the Red Army as liberators of the Baltics in 1944–5. Against the background of *perestroika, glasnost* and Gorbachev's criticisms of Stalinist historiography, younger reform-minded Baltic historians, encouraged by revelations about the secret protocols of the Molotov–Ribbentrop Pact, created new histories which explored the Baltic states' forced incorporation into the USSR and presented the Soviets as occupiers.[7] At the centre of this new public history was the idea of the "Soviet genocide," a term which had been used by diaspora historians since the 1940s to describe the repression and deportation of Baltic peoples in the Stalinist era, but which was now taken up by nationalist historians and politicians in the region. Oral histories of the repressed, memoirs of deportees and research by new organizations such as the Commission for Research into Stalinist Crimes committed in Lithuania or Memento, the Association for the Illegally Repressed in Estonia, played a large role in constructing new public histories which delegitimized the Soviet Union as an unwanted, brutal dictatorship.[8] Only in the late 1990s did public interest in Stalinist repressions decline, although groups such as Nuremberg-2 in Lithuania continued to campaign to keep former injustices visible in the public arena.[9]

[7] For a detailed discussion of this in a Lithuanian setting, see Alfred Erich Senn, "Perestroika in Lithuanian Historiography: The Molotov-Ribbentrop Pact," *Russian Review* 49/1 (1990): 43–53.

[8] Budryte, *Taming Nationalism*, 181. On the importance of a restrictive set of life stories of the deported in establishing a new historical truth in Lithuania, see Neringa Klumbyte, "Ethnographic Note on Nation: Narratives and Symbols of Early Post-socialist Nationalism in Lithuania," *Dialectical Anthropology* 27 (2003): 281: "while many people were deported to Siberia after World War II, the experience of life there is communicated through books by selected authors (...) who become part of the school curriculum. They are personal and literal; the legitimacy and representativeness of personal memoirs are not questioned."

[9] Budryte, *Taming Nationalism*, 183. He also describes how June 14 ceremonies, which commemorated the beginnings of the mass deportations in 1941, were much better attended in the late 1980s and early 1990s. He cites a survey of Lithuanian teenagers, con-

Before the late 1990s, by contrast, the story of suffering under Nazi oc-
cupation was of much less importance to the public histories of the newly
independent Baltic states.[10] This absence was in part the result of the Soviet
regime's instrumentalization of Fascist crimes in order to legitimize its own
power. For many, talk of "Nazi atrocities" was still associated with Soviet
propaganda, and there was thus little appetite for the further uncovering of
Fascist crimes, even in accounts free from the distortions of Soviet histori-
ography. This post-communist silence was also due to the fact that some of
these crimes—in particular the Holocaust—had not received much specific
attention during the Soviet period. In Latvia, for instance, despite Jewish
communities' efforts to retain Holocaust memory and organize regular
commemorative events at sites of Jewish killings such as Rumbula,[11] there
was never sufficient political space to challenge the regime's silence before
the *perestroika* period. The term Holocaust was first used in Latvia in
1988.[12] In Lithuania, in the late 1980s, the nationalist opposition movement
Sajudis did try to promote the memory of the Holocaust alongside Soviet
crimes and to forge links and common historical understandings with the
Jewish community. Lithuanian Jews too used the greater political space
afforded by *glasnost* to commemorate the victims of the Panieri killings and
the Vilnius Ghetto,[13] and to re-open, in 1989, the Vilnius Jewish museum
the Soviets had closed in 1949. This new museum established a permanent
exhibition on the Holocaust called "Catastrophe" in a separate building in
1990.[14] After independence, some governments made efforts to support
Holocaust memory officially. In 1994, 23 September was declared the Na-
tional Memorial Day for the Genocide of the Lithuanian Jews, while the
state-sponsored "Holocaust Victims' Remembrance Day" was instituted in
Latvia.[15] Yet despite these initiatives "from above," there remained a very
low level of social awareness of the suffering of Jews. Immediately after

ducted in 2004, which suggested that many considered it important to remember the peri-
ods of repression, but that most were not attracted by official state remembrance (ibid.).

[10] Bella Zisere, "The Memory of the Shoah in Post-Soviet Latvia," *East European Jewish
Affairs* 35/2 (2005): 160.

[11] Ibid., 160.

[12] Ieva Gundare, "Overcoming the Legacy of History for Ethnic Integration in Latvia,"
Intermarium 5/3 (2002): 17.

[13] Dov Levin, "Lithuania" in David S. Wyman, Charles H. Rosenzveig (eds.), *The World
Reacts to the Holocaust* (Baltimore and London: Johns Hopkins University Press, 1996),
345.

[14] This remains the one Holocaust museum in the Baltics; it is small, difficult to find, and
poorly funded.

[15] Zisere, *Memory*, 156.

independence, the story of Nazi terror was often drowned out by new na-
tionalist histories which focused on communist crimes exclusively, viewed
the period of Nazi occupation as less severe than the Soviet, and valued
anti-Communism much more than anti-Fascism: hence those anti-
Communists who had fought alongside Nazi Germany were idealized by
certain nationalist groups.

These new national histories that foregrounded Stalinist crimes had a
powerful influence on the new museum and memorial landscape after
1991, leading to two particular developments. First, the history of the
recent past, as in many parts of the former Soviet bloc, was as commonly
displayed at sites of former violence and incarceration as it was in pur-
pose-built museums. Second, it was places of former communist terror
and imprisonment, rather than fascist ones, which were most often re-
stored and presented to the public, such as the reconstructed underground
prisons of the KGB Cells Museum in Tartu, Estonia, or the KGB prison in
Vilnius. Even where locations were chosen which did not have a violent
or oppressive communist past, they were often modeled on Soviet prisons
or Gulags: *Grüto Parkas* (dubbed "Stalinworld") near Druskinikai,
Lithuania, a statue park surrounded by fences, barbed wire and lookout
towers, was built to resemble a Siberian camp;[16] the occupation museum
in Riga began its display with the reconstruction of a Gulag barracks; the
display on Communism in the War Museum, Riga, placed its exhibits of
everyday life under Communism within cages, the frames of which ap-
peared to crumble away as the exhibition moved towards the end of
Communism, the emergence of a democratic opposition and national in-
dependence.

Yet the display of Communism at sites of former Soviet terror pre-
sented certain difficulties. Many of these locations did not have "pure"
communist pasts: frequently former camps and prisons were used for
criminal purposes during both the Nazi and the two Soviet occupations.
Thus in the immediate post-communist period new museums which
wanted to use these locations to highlight Stalinist crimes had to deal with
the Nazi past of these places. In some cases, museums addressed the site's
dual histories. The Ninth Fort outside Kaunas, Lithuania, for example,
was not only the site of the murder of 45,000 Jews and Russian prisoners
of war (mainly by local Lithuanian forces) under German occupation, but
was also a holding centre from which Lithuanian nationals were deported

[16] Its founder wanted to install railway tracks from the entrance to the statues in order to
recreate the experience of deportations to Siberia. He was barred from doing so.

to Siberia during the first Soviet occupation in 1940–1, and then func-
tioned as a Soviet prison between 1945 and 1948. In 1958, the fort was
opened as a museum dedicated to the "victims of Fascism." After 1991, its
displays were remade to address the victims of both occupations: one ex-
hibition addressed the period of German occupation, while others dealt
with the deportation of Lithuanians in 1940–1 and used the prison setting
to relate the experience of incarceration for various groups—the Lithua-
nian intelligentsia, the Freedom Fighters' Union and military officers—in
Soviet camps elsewhere. One author criticized the greater weight accorded
to exhibitions on the Soviet repression of Lithuanians at a site where the
larger tragedy was connected with the Holocaust and Nazism.[17]

However, many locations with a double past of both Soviet and Nazi
terror chose to deal solely with the crimes of the communist period. One
such site was the Museum of Genocide Victims in Vilnius,[18] which inhab-
ited a former political prison that was used by the NKVD and NKGB dur-
ing the first Soviet occupation, then by the Gestapo between 1941 and
1944, and by the KGB from 1944 until August 1991.[19] The project to turn
the prison into a museum was initiated by the Union of Political Prisoners
and Exiles, an association of those whose suffering was the result of the
Soviet occupation. It was then supported financially by the Ministry of
Culture. The cells of the former KGB prison were opened to the public on
14 August 1992, while the rest of the building was gradually transformed
into a research centre and archive which included former KGB collec-
tions. In 1997, the museum became part of the state-financed Research
Centre of Genocide and Resistance of the Inhabitants of Lithuania. In
1999, the decision was made to widen the scope of the public display. In
2000, an excavated communist-era execution cell was opened in the
basement. Since 2002, exhibits dealing with the two periods of Soviet

[17] Dov Levin, "Lithuanian Attitudes toward the Jewish Minority in the Aftermath of the Holo-
caust: The Lithuanian Press, 1991–1992," *Holocaust and Genocide Studies* 7/2 (1993): 249.

[18] In post-communist Lithuania in the 1990s, the term genocide was much more likely to
refer to Soviet era deportation and killing of Lithuanians than it was to the extermination
of Lithuanian Jews (despite the fact that 94% of them were killed in the Holocaust; ibid.,
247). Criticism of the use of the term to describe Stalinist policies came from the Lithua-
nian Jewish community, who suggested that the word should not be used to describe a
policy aimed at untrustworthy social classes; and from prominent exiles such as Tomas
Venclova. The common defense was that the Stalinist terror system defined whole na-
tionalities as untrustworthy; see Budryte, *Taming Nationalism*, 183–4.

[19] In fact, this building has an interesting pre-Soviet history too: it was a political prison under
the Russian Empire, the square it faces was a site for public executions before 1917, and
the road on which it is situated was called "Victim Street" before World War II.

occupation have been established on the upper floors.[20] However, there was no attempt to restore the Gestapo prison or provide exhibitions on the Nazi period; hence the chronological narrative of the main museum jumped from 1941 to 1944.

The exclusion of the history of Nazi occupation and victimization from the reconstructed prison was not considered problematic by the curators. Rather, it was presented as a necessary corrective to those one-sided "western" approaches to historical memory which placed far greater emphasis on the suffering caused by Fascism to the detriment of those who were persecuted under Communism. The former political prisoners who initiated the project which led to the museum tried to re-dress the balance:

> Of course it was important for them to show to the world that Communism was as bad as Fascism (...) Communism isn't condemned by everybody in public opinion (...) in Europe there is a little known about Communism and it is very difficult for them even to get permission from Europe for projects concerning Communism. It doesn't seem so important to them (...) mainly because, in the Second World War, Great Britain and United States were together with Russia, so, you know, they were against Fascism, so they don't want to (...)[21]

This was not seen as the deliberate exclusion of one part of the building's history. Rather, it was argued that the experience of Fascism would be more appropriately dealt with at a separate site such as the city's Jewish museum or at another former Gestapo prison.[22]

However, these sites drew their power from the presentation of their buildings as authentic places of terror which "spoke for themselves" about past evils and gave the visitor a direct encounter with their earlier hor-

[20] An exhibition on the period 1939–41 which mainly dealt with Soviet oppression and KGB activity was opened in 2002; displays on anti-Soviet resistance including the post-war partisan struggle, and on deportation and labor camps, were opened in 2004; in 2005, plans were made for an exhibition on dissidents and resistance from the 1960s to the 1980s.

[21] Interview conducted by the author with Virginija Rudienė, Museum of Genocide Victims, August 2005.

[22] For a fascinating exploration of a site where, in the early 1990s, two different guided walks—one which dealt with the victims of Fascism and one with the victims of the Soviets—gave the memorial site's two constituencies very different experiences of the former Nazi and Soviet camp, see Sarah Farmer, "Symbols that Face Both Ways: Commemorating the Victims of Stalinism and Nazism at Buchenwald and Sachsenhausen." *Representations* 49 (1995): 97–119.

rors.[23] The exclusion of Fascism threatened to undermine this, as it revealed the ideological interventions of the curators. Hence the decision to exclude Fascism had to be rationalized in the museum's explanations of the reconstruction to the visitor. In Vilnius, this marginalization was framed simply as a question about the museum's ability to reconstruct the cells "objectively," rather than as an ideological choice. A curator employed arguments about the availability of information, in particular stressing the absence of evidence for the fascist use of the prison (because the Communists destroyed it).[24] However, it was clear that there was, at first, an absence of evidence for the communist use of the prison as a location for terror. The prison had not been used as a site of torture and execution since the 1950s[25] and the Communists too hid their crimes very effectively. Yet the implications of these absences were presented differently in each case. The lack of evidence of communist-era suffering was used to illustrate the evil ability of the Soviets to cover up their crimes, and the capacity of post-communist reconstructions to uncover (and thwart) their suppression of the "historical truth."[26] In the case of Fascism, the absence of evidence was used as a justification for the absence of historical reconstruction.

This can be illustrated with reference to two rooms in the Vilnius museum: the reconstructed Soviet era execution chamber[27] (Fig. 1) and a cell which contained graffiti from the period of Nazi occupation. The decision

[23] The director placed a great deal of emphasis on the authenticity of the building: "even now you see the prison building, aside from a few exceptions, as the KGB left it in August 1991," quoted from Eugenijus Peikštenis, "Das Museum für die Opfer des Genozids, Vilnius" in *Der Kommunismus im Museum*, 132. Former prisoners from the communist era were used as guides to provide visitors with powerful recollections of the Soviet jail, to make their visit more "authentic."

[24] Interview conducted by the author with Vilma Juozevičiūtė (Press Officer), Museum of Genocide Victims, August 2005.

[25] In the late communist period, some cells were still used to hold political dissidents, but most had been converted to house the archives of the KGB.

[26] The narrative of uncovering hidden atrocities is of course a compelling story in many post-dictatorial societies; however, this narrative had a particularly strong appeal in Lithuania. During the *glasnost* period, the KGB revealed its willingness to disclose the locations of many mass graves in the Soviet bloc, including that at Katyn. Lithuania was an exception to this, as the Soviet elite feared that such revelations would stoke the nationalist independence movement. The KGB then destroyed documentary evidence of these sites in 1990–1: see Rokas M. Tracevskis, "A Grave Fit for Whom?" *Transitions Online* (3 October 2003).

[27] The director states that over 1000 prisoners were killed here under Soviet occupation. See Peikštenis, "Das Museum für die Opfer des Genozids, Vilnius," 138.

to restore the execution cell, and to make it the centerpiece of the museum, was of course an ideological choice informed by an approach which placed suffering under the Soviets above Nazi era crimes. Yet the power of displays at museums is in part determined by an audience's perception of them as objective and balanced. Hence curators needed to demonstrate that their interventions at these sites were merely the value-free bringing to light of the evidence of crimes that was already embedded in

Fig. 1 Excavated execution chamber (Museum of Genocide Victims)
(photo: James Mark, 2005)

the building, waiting to be discovered. The idea that they had made an ideological choice to excavate and renovate the Soviet prison, but not the Nazi one, needed to be sidelined. To this end, the display of the execution cell was concerned as much with the process of discovery as it was with the actual history of the cell itself. Focusing on the uncovering diverted attention away from their initial choice of what to uncover, and enabled the museum to frame their work as the objective revelation of a "true, hidden past."

First, the museum stressed that there was little evidence for the existence of the cell: it was marked as a kitchen on KGB plans; few warders were told of its existence; and no surviving prisoners ever knew of it (any who might have been taken there would have been shot).[28] Eventually, a possible site was identified by General Jurgis Jurgelis (a former director of the State Security Department), who himself had garnered the information from eye-witness reports of former KGB workers. Yet the paucity of evidence, and the difficulties with which it was located, were not used to explore the problems inherent in restoring sites of terror. Rather, they were employed to justify the legitimacy of the project. Focusing on the process of overcoming the former regime's evil, ingenious ability to cover up their own crimes enabled curators to present Communists as the devious destroyers of historical fact and thus the post-communist museum as the site that was recovering that truth, against all the odds. Moreover, this narrative presented the cell, not the curators, as the active agent in the process; it established a notion of hidden crimes that were merely waiting for the post-communist museum to uncover them. Thus the curator had not actively chosen to unearth the Soviet execution cell; it had merely presented itself for excavation.

Second, the exhibition was designed to demonstrate the objectivity of the process through which this past was uncovered, in order to confirm to the viewer that this was a simple case of stripping bare (through archaeology) Communism's hidden crimes to reveal the truth about the past. The execution room was presented as an archaeological dig: the dug earth and seemingly arbitrarily-placed objects, such as a pair of glasses and a small piece of barbed wire, were there to present the viewer with an apparently genuine scientifically-conducted excavation progress (Fig. 2). These objects did not in fact belong to the site at all: they were recovered from the mass graves found at Tuskulėnai Manor (a location which included bodies

[28] Interview conducted by the author with Vilma Juozevičiūtė, Museum of Genocide Victims, August 2005.

of anti-Soviet partisans, Nazi collaborators, and criminals).[29] However, they played an important role in providing an authentic frame for the central evidence of communist evil in the room: a drain where, it was

Fig. 2 Objects from the Tuskulėnai mass grave, displayed under a reinforced glass floor in the excavated execution chamber (Museum of Genocide Victims)
(photo: James Mark, 2005)

claimed, blood from the executed victim flowed away (Fig. 3); and bullet holes in the wall, covered by a piece of glass that protected the evidence of atrocity but also framed the crime for the viewer. Moreover, a reinforced glass floor laid over the earth allowed visitors to view the excavation and at the same time functioned as a symbol for the imagined transparency of the museum's approach to history.[30] By focusing the audience's attention on the

[29] The museum justified their use of these objects on the basis that many of the remains found at Tuskulėnai Manor were of individuals who had been executed in the KGB prison.

[30] According to a press officer from the museum, "the KGB destroyed it and maybe they hoped that nobody would find this place but now we can show where the KGB killed people. So this glass floor is here so that everything will be made transparent." The idea

Communists' attempts at concealment and the objectivity of the scientific methods used by the post-communist museum in the excavation, the curators effectively diverted attention away from the ideological choices which lay behind the reconstruction of only one of the prisons.

Fig. 3 Drain, displayed in the excavated execution chamber
(Museum of Genocide Victims) (photo: James Mark, 2005)

Whereas a paucity of evidence and the difficulties involved in reconstruction were used to add power to the presentation of "hidden" communist crimes, the lack of physical proof for fascist terror justified its marginalization. The evidence presented for fascist crimes was minimal and confusing. The only remaining sign of its use as a Gestapo prison was in one cell, otherwise unadorned and without explanatory texts, which contained the almost unrecognizable (and easily missed) graffiti of a swastika

of the post-communist democratic museum as a transparent window on the past was reflected in debates over the glass-dominated architecture used by the Occupation Museum in Tallinn, too. See A Student Fieldreport, "Kommunismus zum Anfassen? Museen zur Geschichte der kommunistischen Diktaturen in Ostmitteleuropa" in *Der Kommunismus im Museum*, 206.

and the name and date (1943) of imprisonment of a Polish partisan (Fig. 4). Those taking guided tours were shown the swastika as illustrative not only of the museum's Nazi past, but also of the impossibility of reconstructing it. It was used as a springboard to talk about the insufficient physical evidence of Fascism, and the absence of objects from the German occupation with which to construct an exhibition. Whereas inadequate evidence of Fascism was thus used to rationalize the impossibility of proper historical reconstruction, insufficient evidence of communist crimes was employed to justify the necessity of further research to uncover the truth. Hence the choice to reconstruct one experience, but not another, was framed as a question of the historian's proper and objective use of evidence in each case. The idea that this was an ideological intervention on the part of the curator was effectively sidelined.

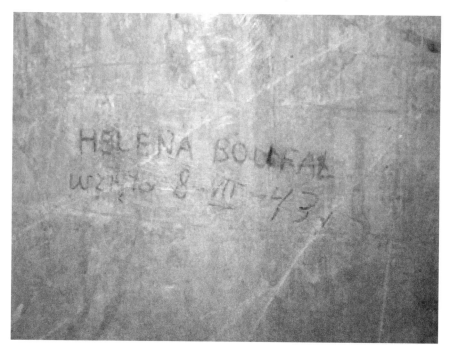

Fig. 4 Polish graffiti from 1943 on a cell wall, demonstrating the use of the prison by the Gestapo during the Nazi occupation of Lithuania (Museum of Genocide Victims) (photo: James Mark, 2005)

The museum's focus on the crimes of the Soviets at a location with an ambiguous past was also a feature of their engagement with the Tuskulėnai site, a Vilnius city park where, in 1994, a mass grave from the early Soviet

period was discovered. Many of those who had been killed in the above-mentioned execution cell were taken there to be buried.[31] This location initially appeared to be a more straightforward site than a prison with a double past: a memorial or museum here would allow a simple iteration of the crimes of the Soviet occupiers alongside a scene of mass killing that graphically illustrated their brutality. It was initially assumed that many of the bodies were anti-Soviet partisans and Roman Catholic priests. However, when the remains of some of the 717 victims were identified, they were found to include not only anti-Soviet resistors and criminals but also Nazi collaborators and members of a Polish partisan group who had murdered Jews, and were later shot by the Soviets.[32] The site's meaning was thus made more complex—it became capable of illustrating not only communist terror but also Nazi crimes and the role of Soviets in putting an end to them—and thus had the potential to undermine a simple anti-communist account.[33]

The museum too understood the tension inherent in the site, and wanted to cleanse it of its Nazi associations. However, it was not able to do so as the remains of the bodies could not be separated into neat piles of worthy and unworthy victims of the Communists: "[Our opinion] of the war criminals and Nazi collaborators [who were buried there] is unfavorable, but there was no question of separating out the remains as the bodies had been disfigured by lime and some other chemicals and so the identification of them was impossible."[34] Despite the impossibility of politically purifying the mass grave, the desire to turn this location into an anti-communist site meant that Nazi collaborators had to be co-opted into the role call of victims of the Soviets. A columbarium, now under the control of the Museum of Genocide Victims, was opened on the site in 2004 and contains most of the

[31] The Museum of Genocide Victims and its associated research centre were heavily involved with this site. One of the members of the commission for the commemoration of the Tuskulėnai victims was Dalia Kuodytė, director general of the Genocide and Resistance Research Centre. The museum's director, Eugenijus Peikštenis, participated in the preparation of information on the victims in the mass grave, and in the drafting of the basic concepts behind the educational information centre and museum at Tuskulėnai. From personal correspondence of the author with the museum in February 2007.

[32] Tracevskis, "Grave," 2–3. It has been suggested that a site within Vilnius was used for the mass burials because of fears about partisan activity outside the city in the immediate aftermath of World War II.

[33] "It is as if the NKVD made this "cocktail" and jigsaw for our generation with the intention of puzzling us. Completely innocent people and fighters for an independent and democratic Lithuania are mixed up with those who participated in the Holocaust" (Emmanuel Zingeris, quoted from ibid., 3).

[34] Personal correspondence of the author with the museum (February 2007).

victims' remains, including those of Nazi collaborators.[35] Some protested at the commemoration of Fascists in the name of anti-Communism; Emmanuel Zingeris, director of the Vilna Gaon Jewish State Museum, refused to support the project or attend the opening ceremony.[36] Despite these associations, the park became an important anti-communist site in Lithuania. It was used for commemorative events on 14 June, the "Day of Mourning and Hope," which recalled the beginning of the Soviet repression in Lithuania.[37] In addition, the buildings of the Tuskulėnai Manor,[38] which were used by both the KGB and the Association of Water Sports as a sanatorium under Soviet rule, are to be converted by the museum to house an exhibition on the "spiritual genocide" of the communist period, focusing on the attempts to turn Lithuanians into the "Homo Sovieticus."[39]

However, not all sites that dealt with the Soviet period marginalized the history of Fascism. The museums of occupation in both Riga and Tallinn adopted a comparative approach which addressed the experience of occupation under *both* the Soviets and Nazis. The Riga museum's focus on double occupation can be viewed as a reaction to the exclusion of the Nazi occupation and the Holocaust from Baltic collective memories in the early 1990s. The agenda of the museum was initially shaped by diaspora rather than indigenous perspectives; the Latvian state was at first ambivalent about such a museum, which in its first decade was funded for the most part by donations from diaspora social organizations and private individuals from North America.[40] Dr. Paulis Lazda, an

[35] The Catholic Church was asked to look after the remains before the columbarium was built; it refused because they contained the bones of those who participated in the Holocaust (and many non-Catholics). See Tracevskis, "Grave," 3.

[36] Ellen Cassedy, "A Controversy Exhumes Long-buried Memories," *Forward. The Jewish Daily* (12 November 2004) at www.forward.com/articles/a-controversy-exhumes-long-buried-memories/ (accessed 15 February, 2007).

[37] Baltic News Service (14 June 2006).

[38] The site contains two estates: one based around the Tuskulėnai manor (built 1825) and the other around the Walicki villa (built 1866). After 1944, both estates were nationalized and handed over to the security services of the Lithuanian SSR. The Walicki villa was turned into the summer residence for directors of the KGB, and later a kindergarten and a summer camp for children of security employees was established. KGB officers lived in three buildings of the manor until 1949, after which point part of the estate was transferred to the Association of Water Sports. From personal correspondence of the author with the museum (February 2007).

[39] Peikštenis, "Das Museum für die Opfer des Genozids, Vilnius," 138.

[40] Interview conducted by the author with Paulis Lazda (one of the founders of the museum), February 2007. Since 2000, however, the Ministry of Culture has begun to make

American Latvian history professor who left the Baltics with his parents in 1944 and lived in the United States from 1950, was the "author of the concept"[41] of the museum (alongside being one of its ten founding members). He insisted on the necessity of a comparative approach, despite some local opposition to the inclusion of Nazism and the Holocaust.[42] Since its opening in 1993, the museum has frequently been presented as a counterbalance to restrictive accounts of totalitarian violence that concentrate on one terror to the exclusion of the other. According to Valters Nollendorfs, the deputy director of the museum, "East Europeans must now come to terms with the Holocaust and everything connected with it. West Europeans must get to grips with the Gulag. That's the only way both sides can come to an understanding."[43] Indeed, the museum has taken the message of double terror to the West: since 1998 traveling exhibitions to Western Europe and North America have been organized.[44] Despite being a privately funded museum that initially attempted to challenge restrictive aspects of Baltic memory, it has, since the late 1990s, increasingly found itself in tune with a Latvian political elite that has embraced the idea of the "double genocide" under both Nazis and Soviets, and has become a site for official state visits.[45]

contributions to the museum. Helena Demakova, Latvian Culture Minister since 2004, has been particularly supportive. There have been very few private donations from within Latvia itself; Lazda ascribed this to an absence of a post-communist culture of charitable giving and a reluctance to donate on the part of some Latvian companies who fear that it might affect their economic relationship with Russia.

[41] This was Lazda's description of his role.

[42] According to Paulis Lazda, "that was a demand I made of people who were joining the effort [that they accept the double occupation concept]. There was a natural and strong push to make it a 'museum of repression' [i.e. just Soviet repression], and these were good, fine people who had suffered this and that, and the memory of the Nazis was not as strong, but I said that it could not be otherwise. And my colleagues generally agreed. That was something I insisted upon (...) there were differences (...) they argued in the quantitative sense, but I said, no, we should consider the qualitative aspect as well, in other words, the three or so years of Nazi occupation was relatively short, well, I said, that's true, and that is in some ways an ongoing debate in the museum. But there is not a really meaningful opposition to the occupation concept." Interview conducted by the author, February 2007.

[43] Stefan Wagstyl, "Peacetime Collaboration," *Financial Times* (7 May 2005).

[44] Interview conducted by the author with Richard Petersons (historian and curator of the museum), August 2005.

[45] For example, Queen Elizabeth II stopped at the museum on a state visit in October 2006. In 2000, Paulis Lazda himself was awarded Latvia's top civilian honor, Commander of the Order of Three Stars, for his work with the museum. The available annual visitor figures for the museum are as follows: 2001/2002: 40,000 visitors; 2004: 65,000; Gundega

The Estonian Occupation Museum was opened in 2003, a decade after its Latvian counterpart. Its inclusion of both occupations reflected broader shifts in mainstream historical memory in the Baltics in those ten years, from an almost exclusive focus on Soviet occupation and terror in the early independence period to an emphasis on the effects of both Nazi and Soviet occupation by the late 1990s.[46] Like the Riga Museum, it too was funded from abroad, in this case by the donations of an Estonian American exile Olga Kistler-Ritso. However, its periodization and focus on both occupations was decided by Estonian academics at "brainstorming sessions" and conferences in 1998.[47] The director (who had been an anti-communist dissident and imprisoned in Soviet camps) framed his institution in contrast to western Holocaust museums, which he argued, limited the museum experience through the use of dark and oppressive spaces combined with a hushed reverent tone that was almost church-like:

> In Holocaust museums you are told that you should not speak loudly, you should not make any noise, you have to behave in a certain way. [It's] what I call a "church atmosphere" which, I believe, doesn't support learning. You are just made to act in a certain way (...) Holocaust museums tend to have a dark and oppressive atmosphere, so you are dragged into some kind of environment where there should be no doubts (...) from my point of view, it doesn't provoke any thinking. It's all clear. It's all set. And I believe that especially the younger generation doesn't want that. They tend to try to question things and find answers by themselves. You know you type in something into the internet and you get thousands of answers then you have a choice. I believe that if people are given a choice, they usually make the right choice; at least this is what we want.[48]

Thus he wanted a light, open museum that dealt with both forms of twentieth century totalitarian occupation, and avoided the darkened atmosphere and "closed questions" of Holocaust sites. To this end, the museum scattered across the exhibition space a diverse range of objects which were designed to set off memories and provoke debate rather than guide the viewer to fixed answers: a line of battered suitcases by the entrance was used to represent the 70,000 Estonians who left the country in

Michel, Valters Nollendorfs, "Das Lettische Okkupationsmuseum, Riga" in *Der Kommunismus im Museum*, 122.

[46] For a more in-depth exploration of this shift, see Budryte, *Taming Nationalism*, 183–6.

[47] www.okupatsioon.ee/english/activities/index.html (accessed 1 February, 2007). Olga Kistler-Ritso donated 35 million kroons for its establishment.

[48] Interview with Heiki Ahonen (museum director), conducted by the author, Tallinn, August 2005.

the face of the advance of the Red Army in 1944, for instance.[49] When interviewed, the director also highlighted the importance of those objects that opened up questions and debate about the ambiguous and conflicting nature of the experience of two different occupiers:

> We have a wonderful thing, one photograph taken of two guys standing in uniforms, one is in a Waffen SS [uniform], another one is in Soviet uniform and they both were arrested for that photograph. It was taken after the war just like a mock photo. They were friends from the same village but they ended up on different sides. Fortunately, they didn't meet in combat, but they met after the war, dug out their uniforms and made a mock photo. (…) for us this was a dilemma, for Brits, well, generally Brits were serving in the British army. In Estonia it was, you know, some 30,000 on the Soviet side and some 60,000 on the German side and another few thousand on the Finnish side, so these were the choices.[50]

Both occupation museums deployed the rhetoric of equality of victimhood at the beginning of their displays, where they appeared to be according equal worth to the suffering caused by Fascism and Communism. The introductory panel at the Riga museum, encountered as one walked up the stairs to the main exhibition, stated: "During the periods of Soviet and German occupation, Latvia lost 550,000 people, or more than a third of its population. This is the number who were murdered, killed in battle, sentenced, deported, scattered as refugees, and who disappeared without a trace." Here differences between the two occupations were ignored in favor of an approach which absorbed all those who suffered into a national martyrology and did not draw attention to their relative merit as victims. The gateway to the Tallinn museum, framed by two trains adorned with a swastika and red star respectively (representing the deportation and killing brought by both systems) (Fig. 5), set up the expectation of a substantial exploration of the destructive capabilities of *both* systems. Yet despite the space accorded to displays on Fascism and this rhetoric of equality in representation, the terrors of the Nazi occupation were subordinated to the story of communist-era persecution and national suffering in both museums. Fascism was deployed where it had the potential to confirm the anti-communist script. Where it had the capacity to undermine this version of history, it was edited out, or framed in very particular ways.

[49] Many objects were therefore deliberately presented with minimal or no explanatory text.

[50] Interview with Heiki Ahonen conducted by the author, August 2005. The visitor figures for the museum are 2–3,000 per month; Ahonen, "Wie gründet man ein Museum?" 116.

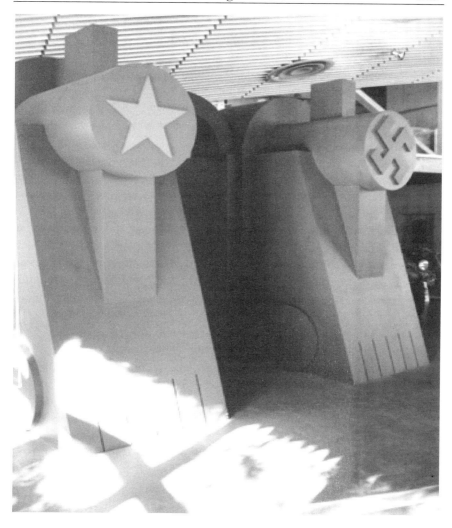

Fig. 5 Models of locomotives with the symbols of Soviet and Nazi occupation
(gateway to the exhibition at the Occupation Museum, Tallinn, Estonia)
(photo: James Mark,2005)

It was anti-Communism, rather than anti-Fascism, that principally structured these museums' narratives of the Nazi occupation of the Baltics (1941–44). The German occupation was subsumed within the account of the struggle against Communism. The Soviet occupation of 1940–41 that preceded the arrival of the Nazis was depicted as the first attempt of outside forces to destroy the nation. The Riga museum, for example, focused on the subjugation of national culture and deportations

of Latvian nationals to the Gulag. Both museums then displayed evidence of their citizens enthusiastically welcoming Nazi troops. It was assumed that support for Germans did not need to be excused or attributed to particular "collaborationist" groups. Rather, these images were employed to support a narrative in which the first Soviet occupation had been so terrible that entire Baltic populations were forced to turn to the Nazis for protection. This evidence of support was thus being used to illustrate anti-Communism, not collaboration. The arrival of the German troops was shown as a liberation from Communism and the ensuing occupation as a first doomed attempt to revive national independence (eventually condemned to fail because the Nazis would not allow any form of autonomy). The German occupation was then presented as far less brutal: the Tallinn museum narrated how the Nazis permitted the national flag to hang publicly (alongside the swastika); the Riga museum drew attention to the greater, albeit limited, forms of cultural expression that the German occupation allowed.[51] Although Fascism and Communism were both condemned, it was clear that aspects of the German occupation could be revived and celebrated in so far as they facilitated the struggle against Communism. Thus those who fought with Nazi Germany against the Bolsheviks were celebrated as national patriots and heroes in the Tallinn museum. A film recounted the German occupation primarily through the eyes of those who fought with the Nazis both to force the Soviets out in 1941 and to prevent their return in 1944. They were lionized for defending their land from the "Bolshevik avalanche." Later an enthusiastic narrator revealed that three times more men than called for volunteered themselves for military service in 1944 to prevent a second Soviet occupation that would "imperil the nation." Whereas in Western Europe alliances with Nazism—whether ideological or merely tactical—tend to be condemned as collaboration, sensitive and sympathetic stories were told which helped to frame the German alliance as a tactical necessity borne of limited choices to save the nation under constrained circumstances.[52]

[51] "The Nazi occupation and the war hinder the development of Latvian culture, albeit with fewer restrictions than during the year of Soviet occupation where the expression of inappropriate ideas most often ended in imprisonment or threat of death. Although subject to censorship, private publishing houses (...) are allowed to resume work (...)" (Museum of the Occupation of Latvia, Riga).

[52] This is not true everywhere in Western Europe. In democratic Spain, where the "pact of silence" after Franco's death meant that earlier Francoist historical narratives were not immediately challenged, it was possible to represent links between Nazi Germany and

This anti-communist framing also determined the sort of evidence deemed meaningful and convincing in these museums. Many types of contemporaneous data, so long as they dealt with the evils of Communism, could be used. Hence German wartime propaganda was employed as authentic evidence of Soviet atrocities. The Tallinn museum not only used German propaganda detailing torture, maiming and mass graves to condemn the first Soviet occupation, but also lent this material greater authority by using modern-day oral history voices to confirm these Nazi wartime accounts. It offered interviewees recalling their experience of being shown evidence of Soviet violence as schoolchildren under the Nazi occupation. Rather than being used to explore the ways in which the Nazis used atrocity stories to manipulate the local population into looking to them to defend the Estonian national interest, this was presented as the unproblematic eye-witnessing of the Soviet brutalization of the nation.[53] The Riga museum, by contrast, contextualized this evidence as politicized propaganda designed to attract support for the Nazis as the protectors of the Baltics from "Soviet-Jewish" perpetrators.[54] However, it also placed less ideological, emotionally appealing objects—such as hymn texts from wartime church services dedicated to victims of the communist terror—alongside Nazi atrocity material. This positioning suggested that the museum wished to reinforce the credibility of the Nazi material as evidence, despite simultaneously contextualizing it as propaganda. Moreover, the cumulative effect of viewing the numerous photographs collected by the German authorities about Soviet atrocities was to direct the audience to the evils of Communism even within the exhibit on the Nazi occupation.

The commemoration of those who fought alongside the Nazi army was a controversial development after 1991. Those who saw themselves en-

Spain in the Second World War in an uncritical manner. Until very recently, the Military Museum in Madrid, for example, had a relatively positive display on the Blue Division (those troops sent by Franco to fight alongside Nazi Germany to "save Europe from Communism"). My thanks to Tim Rees for this point.

[53] The testimony from this respondent was unclear. He announced that he was a schoolchild during the Nazi occupation before reeling off the range of evidence of Soviet atrocities that he saw: women with breasts cut off and pins under their fingernails, and bodies piled up in wells. It was possible that he saw the Soviets do this himself, although his framing suggests that he was taken to see it later under the Nazi occupation (Interview with Magnus Kald, director of *Liberation*, a documentary film show in the occupation museum, Tallin.)

[54] The museum display states: "Materials about Soviet terror and occupation are compiled in the biased 1942 publication *Baigais gads* (Year of Horror). Such propaganda is continued during the entire Nazi occupation."

gaged in the "struggle against Bolshevism" and chose the German occupiers as "the lesser evil" were given public space to articulate their anti-communist memories in the immediate post-independence period. In the late 1990s, however, these groups began to be viewed as an international liability by political elites, and have faced governmental attempts to silence them.[55] In 2002, for instance, a privately funded memorial depicting an Estonian soldier in a Waffen SS uniform was erected in Pärnu. An inscription dedicated the monument, "to all Estonian soldiers who fell in the Second World War to liberate their homeland and to free Europe 1940–45." It was taken from its original location following protests from the national government in 2002, removed after two weeks of public display from the village of Lihula (despite violent protests) in 2004, and was unveiled in the grounds of the privately funded small-scale Museum of the Struggle for Estonia's Liberation in the village of Lagedi outside Tallinn in 2005.[56] To nationalist groups—such as the Estonian Freedom Fighters' Association—such monuments expressed the realities of their struggle to free Estonia from Bolshevism. To foreign observers from both Western Europe and Russia, these statues represented collaboration or an unacceptable revival in Nazi ideology.[57]

Russian criticism was frequently associated with earlier communist caricatures of Estonians as fascists and had little influence. Western European incomprehension and criticism, by contrast, had a much greater impact. The repeated forced dismantling of the statue was linked to governmental fears about Estonia's international image as it integrated into western political and military structures; according to Kristiina Ojuland, the Foreign Minister, in 2004, "Estonia, as a small country that shares common European values and is building its future as a NATO and EU member, will not, in its approach to the past, rely on the memories of those, who view the past as linked to World War II German uniforms, which the democratic world identifies with Nazism. In today's global environment, Estonia must not isolate itself from the international community and damage its reputation. Local inappropriate actions can often result in very

[55] For this argument, see Meike Wulf, "The Struggle for Official Recognition of "Displaced" Group Memories in Post-Soviet Estonia" in Michal Kopeček (ed.), *Past in the Making: Recent History Revisions and Historical Revisionism in Central Europe after 1989* (Budapest: CEU Presss, 2008), 217–43.

[56] Baltic News Service (8 June 2006). In June 2006, the defense ministry provided the museum with its first state funding, in order to upgrade the building's security following threats connected with the installation of the "Lagedi" statue.

[57] Budryte. *Taming Nationalism*, 185–6.

serious and far reaching international consequences."[58] In February 2007, the Estonian parliament was presented with the "Forbidden Structures Act," which would enable the state to refuse permission for, or to remove, memorials that might incite "violations of the public order." This would allow the central government both to take down Soviet era monuments considered provocative, and to prevent politically problematic local memorialization projects.[59]

While those aspects of the Nazi occupation period which could be used to demonize Communism were played up in the Riga and Tallinn occupation museums, others which threatened this anti-communist reading of recent history were marginalized or "contained." Two versions of the German occupation were particularly threatening; first, the capacity of stories of the horrors of Fascism to justify attraction to the communist state or to evoke sympathy for the idea that the Soviet Union was the liberator of the Baltics; second, the potential for the memories of victims of Fascism to drown out the appeals of those who suffered under Communism.

These occupation museums aimed to destroy the power of the idea that Communism and the Soviet presence in the Baltics could in some way (however minor) be justified because of the experience of Fascism. This "anti-fascist" reading of history had been official state dogma prior to 1991 and a staple narrative of Soviet history museums and memorial sites. From the late 1950s, Soviet historians, influenced by a number of well-publicized war crimes trials, increasingly turned their attention to publishing works on Nazi atrocities in the region.[60] During the same period, sites of Fascist crimes were opened to the public (and increasingly became a required excursion for Baltic schoolchildren): the Ninth Fort (Kaunas), the site of the killing of 45,000 Jews and Soviet prisoners of war, was opened as a museum in 1958; Salaspils concentration camp near Riga, the location for medical experiments on, and the murder of, European Jewry, Russian prisoners of war, and Roma, became a memorial site in 1968. These loca-

[58] www.vm.ee/eng/kat_138/4791.html (accessed 21 February, 2007).

[59] Baltic News Service (1 February 2007). The introduction of this parliamentary act was also triggered by controversies over the Bronze Soldier in Tallinn, and plans by the municipal council of Narva (where the population is over 90% Russian-speaking) to erect a monument to Peter the Great.

[60] Romuald J. Misiunas, "Soviet Historiography on World War II and the Baltic States, 1944–1974" in V. Stanley Vardys, Romuald J. Misiunas (eds.), *The Baltic States in Peace and War 1917–1945* (University Park: Pennsylvania State University Press, 1978), 189–90.

tions were used to illustrate the depth of suffering caused by Nazi occupation (although the specificity of Jewish persecution at these sites was not highlighted; a memorial tablet to the 30,000 Jews who died at the Ninth Fort was constructed only in 1991). They also were employed to demonstrate the role that Soviets played both as liberators and continued protectors of the region from both foreign and indigenous sources of Fascism.

Curators were concerned that despite the collapse of Communism, these ideas continued to be powerful. Staff in both occupation museums thought that many in their remaining Soviet era settler population still believed in the former "colonial" rhetoric of Soviets as liberators of the Baltics from Fascism;[61] one curator in Riga commented that "they [the Soviet era immigrant population] don't like the word "occupation" and don't think that our [museum's] history is correct (...) They think that it was not occupation, that we wanted to be incorporated into the Soviet Union at the beginning of Second World War and there were no solutions other than to make an alliance against Nazism (...)"[62] This continuing fear of older anti-fascist narratives can be seen in the debates over the removal of Soviet memorials and statues, most notably the Liberation monument in Riga and the Soviet "Bronze soldier" in Tallinn. The Tallinn monument, which depicts a "liberating" Red Army soldier mourning his fallen colleagues, was erected in 1947 and survived the collapse of Communism as a relatively uncontested place of mourning.[63]

[61] Unlike Lithuania (6%), Russian language communities make up significant minorities in both Latvia (30%) and Estonia (28%). Curators usually distinguished between the "historical" pre-Soviet Russian minority who were less likely to hold to these views, and Soviet era "colonizers" who did. It is interesting to note that these occupation museums—the primary aim of which was to refute the narrative of liberation—only occurred in those Baltic states where large Soviet settler populations existed.

[62] Interview conducted by the author with Richards Petersons, August 2005. Divides in social memory between Soviet immigrant populations and local Baltic populations were frequently noted by both academics and journalists. In a survey of Russian and Latvian language school examinations, the political scientist Juris Dubrovskij noted: "The fact that problems still exist in Latvia can be attested to by final examinations in high schools. We can underline general tendencies in the answers of students studying in Russian or in Latvian. Whilst the former idealise the USSR and show today's Latvia as a country of apartheid, the works of Latvian-speaking schoolchildren present 'eternal Latvia' that is constantly being occupied (...) and Latvians were and still are victims of history." Juris Dubrovskij, *Kholokost v latviiskikh uchebnikakh istorii* [Holocaust in Latvian history textbooks] quoted in Zisere, *Memory*, 158.

[63] According to a late Soviet-era publication on Tallinn's monuments, "The Bronze figure of a soldier mourning his comrades is free of unnecessary pathos, full of courage and

Yet, since 2004, possibly in response to the forced removal of monuments to Estonians who fought alongside the German army, this monument has been vandalized frequently. Prime Minister Andrus Ansip, amongst many others, argued for the removal of the statue from Tõnismägi Square to a less prominent location, possibly a military cemetery or memorial park, and for the remains of Red Army soldiers under the monument to be reburied at one of these sites.

Concerns over residual anti-fascism were confirmed by the strength of the response to this proposal from Russian nationalists both in Estonia and Russia, and from the Russian state. Estonian Russian nationalists such as Dmitri Klenski, leader of the Constitution Party, have co-opted the statue as a symbol of Russian identity in Estonia and have presented the attempt to remove it as a revival of Fascism in Estonia.[64] The Russian Foreign Minister referred to its proposed removal as blasphemy against those who defeated Nazi Germany, thus confirming that important Russians still saw Soviet intervention in the region more in terms of liberation than occupation.[65] It should be noted that other representatives of the Russian community in Estonia suggested alternative plans that aimed to subvert the ethnic divisiveness of this debate: Sergei Ivanov of the Reform Party recommended a monument which would commemorate the victimhood of ethnic Russians and Estonians in Estonia in World War II jointly.[66] Indeed, there have also been left-wing Estonians—particularly those who fought with the Red Army—who have interpreted the statue not as a colonial monument but as one dedicated to all those, including Estonians, who fought to end Fascism. They thus argue that it should be left alone.[67] Yet debates over the statue have appeared to confirm the imagined power of a residual anti-fascist narrative of Soviet liberation for certain sections of the population; some of the advocates for its removal thus suggested that

confidence," Mart Eller, *Monuments and Decorative Sculpture of Tallinn* (Tallinn, 1978), 25.

[64] Olivier Truc, "Une statue soviétique sème la discorde entre nationalistes estoniens et russophones," *Le Monde* (17 January 2007). For a website that defended the Bronze Soldier and saw its removal as a victory for Fascism, see http://bronze-soldier.com/ (accessed 21 February, 2007).

[65] Steven Lee Myers, "Estonia sparks outrage in Russia," *International Herald Tribune* (24 January 2007).

[66] Wulf, "Struggle for Official Recognition." She notes that this is a similar solution to that found in the *Neue Wache* in Berlin, where a monument to the victims of all tyrannies and wars in modern German history was constructed in the wake of German reunification.

[67] Ibid.

if it could not be destroyed, then its power might be neutralized by remov-
ing it to a site, such as the Occupation Museum, where it could not be
interpreted as a valid monument to liberation.[68]

These museums were also shaped by an environment in which mem-
bers of the Russian political elite continued to valorize the Soviets as
liberators of the Baltic states. In the *perestroika* period in the late 1980s,
it had initially appeared that the Baltic liberation narrative had been fa-
tally undermined: the existence of the secret protocols of the Molotov–
Ribbentrop pact, which laid out plans for the forced incorporation of the
Baltics into Nazi Germany and the Soviet Union, was finally conceded
by the Soviet authorities.[69] In post-communist Russia, however, impor-
tant elements of the liberation narrative were retained or revived: it was
common for members of the Russian political elite to state that the Sovi-
ets were invited into the Baltics in 1940, and to dwell longer on their
roles as liberators of the Baltics in 1944 than as an occupying force that
remained.[70] The Russian foreign ministry attacked occupation museums
in Estonia, Latvia and Georgia for equating Communism with Fascism
and characterizing Soviet interventions solely as occupations in their
exhibitions.[71] Similarly, there was some evidence that Russian minorities
in the Baltics were alienated by these museums. One study on the recep-
tion of the Riga museum concluded that although the site attempted to
reach out to the Latvian Russian minority (with all texts translated into
Russian and a deliberate attempt to avoid blaming particular ethnic
groups), few Russian schoolchildren visited and the name of the mu-
seum evoked feelings of guilt from Russian visitors who identified

[68] "Estonians protest controversial memorial," *Baltic Times* (22 May 2006). This sugges-
tion was made in speeches at the protest at the Bronze Statue on 20 May 2006.

[69] For a detailed discussion of this see Senn, "Perestroika in Lithuanian Historiography,"
43–56.

[70] This is also true of post-communist Russian history textbooks. While now acknowledg-
ing the existence of the Molotov–Ribbentrop Pact and the Secret Protocols, they still
present World War II primarily as a story of the Soviet Union's heroic role in liberating
Europe from Fascism; James V. Wertsch, "Patching Up Blank Spots in History: Revis-
ing the Official Narrative of the Molotov–Ribbentrop Pact," paper presented at the
"Memory from Transdisciplinary Perspectives" conference, University of Tartu, Esto-
nia, January 2007.

[71] A museum of occupation opened in Georgia in 2006 on 26 May, the anniversary of
Georgia's declaration of independence from the Russian Empire in 1918. Russian presi-
dent Vladimir Putin criticized the establishment of the museum; BBC Monitoring, For-
mer Soviet Union, 10 July 2006.

themselves as the demonized "occupiers."[72] Few Estonian Russians visited the Museum of Occupation in Tallinn.[73]

In order to quell the idea that the advance of the Red Army into the Baltics in 1944 could in any way be considered a liberation, these museums needed to destroy the interrelationship between the two ideologies of the occupiers. Thus these museums did not provide space for the discussion of the potential appeal of Communism as an ideological reaction against Fascism. Rather, they favored a narrative of one brutal occupation followed by an even more brutal one. Ideology could be presented only in so far as it evidenced the evils of each system: in the Riga Museum, for instance, the racial ideology of Nazism and class-based principles of Communism were described in depth in so far as they explained the reasons for the terrors of both systems. However, no exploration was provided of how each system defined itself in relation to the other, how each presented itself as the negation of the evils of the other, or how this ideological battle impacted on the worldviews of citizens in the Baltic states. Rather, history was contained in a framework in which the Soviet presence after 1944 meant the continuation of occupation, a continuing absence of sovereignty, the renewed oppression of the nation, and the citizen as a victim of yet another occupier.

To maintain the idea that Latvians were simply victims of foreign occupiers, it was necessary to exclude accounts of political radicalization. Where Latvians supported or resisted these systems, they were never described as doing so on the basis of left- or right-wing convictions. Rather, they were only ever presented as Latvian citizens trying to defend their occupied nation in the best possible way: under Nazi occupation, this usually meant a limited accommodation with the occupier in so far as that allowed for the greater struggle against communist domination; under Communism, it meant resistance to the Soviet destroyers of the nation. Ordinary citizens were very seldom seen as having been politicized by any ideology other than Latvian nationalism. Thus battles during World

[72] Gundare, "Overcoming the Legacy," 24. Gundare quoted one comment in Russian from the guest book: "The exhibit concentrates on victims, not on perpetrators. We can only guess whom you are blaming for all the sufferings."

[73] According to its director, "[f]ew Russians come in. Actually you can say that very few older people come but the youngsters are fascinated. When we opened our home page, it was in Estonian, someone obviously Russian and not too elderly wrote us that we should also do it in Russian, because Estonians tend to accuse Russians and local Russians do not understand for what. Some would like to know." www.nma.gov.au/involve/friends/friends_magazine/past_articles/museums_of_occupation (accessed 21 February, 2007).

War II in which Latvians fought for both Nazi Germany and the Soviet Union were always presented as evidence of national tragedy—"Latvian fighting against Latvian." The possibility of Latvian soldiers on either side fighting for an ideology was never considered.[74]

The story of Fascism was also threatening in so far as it could provide potentially sympathetic narratives of those radicalized to Communism by the experience of Nazi occupation and terror. It was therefore necessary to quell the idea that some social groups might have felt themselves liberated by the Soviets. In the Tallinn Occupation Museum, even death camp survivors were shown to have rejected the idea of liberation. A film presented the point at which inmates were set free from the camp at Klooga by the Red Army. An oral history respondent then recounted how, when asked by a Soviet soldier whether she was grateful to have been liberated from the fascists, she had replied that her husband had been in Russia (it is not clear how he got there) and had not been heard from.[75] Thus even the victims of Fascism were co-opted to corroborate an anti-communist script: their experiences confirmed that suffering caused by the Soviets could be placed on a par with Nazi crimes and that, even for those who narrowly escaped death, the arrival of the Red Army in 1944 was not considered an unambiguous liberation. Both museums then began their account of the communist period with stories of partisan war and resistance to the new regime. It was thus the fear of the continuing power of the liberation idea, and the lack of certainty that the notion of occupation was sufficiently embedded in post-communist society, which led some curators to avoid displaying any ambiguities of the social response to the arrival of the Soviets in 1944.[76]

The curators of the Riga museum also needed to deal with the pro-Soviet and anti-fascist history of their building. In 1970, a Memorial Museum to the Latvian Red Riflemen, situated in a purpose-built structure in the form of an elongated cube raised off the ground on stilts on Latvian Red Riflemen Square, was opened as part of the centenary celebration of Lenin's birth.[77] This institution depicted the story of the Latvian Riflemen, a group who had served the Bolshevik cause during the Russian Revolu-

[74] The description of the battle of Kurzeme in the Riga Museum had "Latvian pitted against Latvian."

[75] The reason for her presence at Klooga was not made clear. It was a site where mainly foreign Jews were taken.

[76] Interview conducted by the author with Richards Petersons, August 2005.

[77] It was a branch of the Museum of the Revolution of the Latvian Soviet Socialist Republic.

tion and the ensuing Civil War. It was a propaganda museum that had represented the Soviets as liberators of Latvia and was used to emphasize the role that Latvians themselves had played in the establishment of the Soviet Union.[78] In 1991, it was closed and the building leased to the Occupation Museum by the state. Even since the collapse of Communism, it has, for those still ideologically attached to the former system, retained its symbolic significance as a site that formerly represented Soviet power and liberation: it has been used as a starting point for marches on anniversaries of Soviet days of remembrance (it has, in addition, been used as a starting point by nationalist organizations marching to the Freedom Monument as a location that, for them, now represents occupation).[79] Given the structure's continuing power to invoke politically undesirable responses, the new museum attempted to make a clean break with the past of its building. None of the old exhibits were retained (aside from a few busts of prominent Communists); most of the communist-era collections were deposited at Riga's War Museum, and new materials were acquired from individuals' donations, antiquarian shops and former secret police agents who wanted to sell KGB materials.[80] Moreover, the building itself, popularly known as the "black box" (the red oxidized copper of its exterior having darkened) and often viewed as a Soviet eyesore in the centre of Riga's restored old town, is to receive a simple, stark white extension to symbolize a break with a traumatic past.[81] There was no reference to Latvian riflemen—a group whose story had the potential to demonstrate the role that political ideology had on Latvians themselves—in the new museum. The museum's decision to forget the history of its building set it apart from nearly all other post-communist museums located at sites with remarkable communist pasts.

The memory of Fascism was also threatening because of the power of the stories of Holocaust victims to drown out appeals to Soviet era suffering. To a large extent, the growth of Holocaust awareness emerged not out

[78] According to a guidebook from the late Soviet period, "Latvian riflemen guarded the revolutionary headquarters, the Smolny Palace in Petrograd (now Leningrad), and when the government of the young republic moved from Petrograd to Moscow in March 1918 they guarded the Kremlin. They were always on the most crucial parts of the front in the Civil War against the external and internal enemies of the young Soviet country. Many soldiers and commanders were awarded high revolutionary honors." From Maria Debrer, *Riga: A Guide* (Riga: Europa Baltikum, 1982), 29–30.

[79] Michel and Nollendorfs, "Das Lettische Okkupationsmuseum," 119.

[80] Interview conducted by the author with Paulis Lazda, February 2007.

[81] Michel and Nollendorfs, "Das Lettische Okkupationsmuseum," 119.

of local initiatives but rather in the context of the Baltic states' integration into western political and economic structures and the consequent adoption of their cultural and historical norms.[82] There had been very little promotion of Holocaust awareness "from below" by the small remaining Jewish communities in the Baltics after independence.[83] Rather, the promotion of Holocaust memory started in the late 1990s and was state-led. Commissions were created in Estonia, Latvia and Lithuania in 1998 to investigate the crimes of the Nazi regime alongside those of the Soviet. Their establishment was closely connected to the emerging realization that the Baltic states were likely to enter NATO and the European Union, and that they needed to find an acceptable way of presenting their histories to an international audience.[84] Thus one of the primary aims of the Estonian commission was to produce Holocaust histories molded to the demands of the western political community, not a domestic audience.[85] The same has been intimated in the Latvian case: "This Commission has a strong external function—to satisfy Western demands by acknowledging the Holocaust in Latvia, and to counterbalance this demand by confronting the West with the crimes of the Soviet regime."[86]

In the domestic context, therefore, the presentation of the Holocaust was shaped through the interaction between powerful indigenous pressures to emphasize anti-communist histories and new international imperatives to foreground Jewish suffering. Hence the common western stance that the Shoah represented a uniquely terrible tragedy that stands alone was often rejected. Instead, the idea of placing the suffering of Jews under Nazi occupation, and Baltic peoples under the Soviets, together as a "double genocide" became a popular historical conception in the late 1990s.[87] Thus new transnational forms of Holocaust remembrance that were adopted in the

[82] The European Union has supported many continent-wide Holocaust initiatives, such as the Holocaust Memorial Day on 27 January, and has presented a newly unified Europe as growing out of the lessons of the Holocaust. German guilt is now much less emphasized; rather, the Holocaust is presented as a part of the collective heritage of all European nations out of which common lessons can be learnt to ensure a free, tolerant continent; Helga Embacher, "Britishness and ethnic counter-memories—Jewishness versus Muslim memories in Great Britain," paper presented at the "Memory from Transdisciplinary Perspectives" conference, University of Tartu, Estonia, January 2007.

[83] Zisere, *Memory*, 162–3. Some small-scale local initiatives such as the Holocaust museum in Vilnius came from below, however.

[84] Budryte, *Taming Nationalism*, 186.

[85] Wulf, "Struggle for Official Recognition."

[86] Gundare, "Overcoming the Legacy," 23.

[87] Budryte, *Taming Nationalism*, 186.

Baltics, such as Holocaust Day on 27 January, did not always concentrate solely on Jewish suffering. For instance, on January 27 2007, Andrus Ansip, the Estonian Prime Minister from the "libertarian conservative" Reform Party, used the horrors of the Holocaust as a springboard to talk about wider forms of suffering in his country: "Today on International Holocaust Remembrance Day we bow our heads in honor of its innocent victims (…) The understanding that no crime against humanity should ever be forgotten is self-evident to all of us—Estonia too suffered during and after the Second World War under totalitarian regimes and we paid for this with our independence. Their crimes will never expire and their perpetrators cannot be justified. Our thoughts are with all of the victims of the Holocaust."[88] This reluctance to foreground Holocaust memories was also connected with debates over the extent to which local Baltic collaborators were involved in killing.[89] These debates have the potential to undermine these countries' powerful perceptions of themselves as victim nations, and can often be read as revivals of Soviet era accusations that Baltic peoples were Nazi collaborators. An ambivalence with regard to Holocaust memory was, on occasion, also connected to Western Europe's perceived failure to reciprocate with an equal recognition of the crimes of Communism.[90] For these reasons, some suggest, there has been unwillingness at a local level to acknowledge the Holocaust as a vital historical topic.[91]

The presentation of the Holocaust at the Riga Occupation Museum reflected some of these conflicting pressures. On the one hand educating Latvians towards a greater Holocaust awareness was a fundamental aim of the museum; it was reported that some Latvian visitors were shocked to discover any displays on the Holocaust and Nazism at a museum of "occupation," as the term was for them almost exclusively connected with the Soviet presence and communist crimes.[92] In the museum itself, Latvia's

[88] U.S. Federal News (27 January 2007).

[89] Campaigners such as Ephraim Zuroff from the Simon Wiesenthal Centre have played significant roles in drawing attention to, and trying to uncover, Nazi collaborators in the Baltics.

[90] See, for example, the failure of Baltic Members of the European Parliament in 2005–6 to obtain a European-wide ban on the public display of Stalinist symbols, which would have placed them on the same legal footing as Nazi insignia.

[91] Gundare, "Overcoming the Legacy," 17. In a study on the attitudes of Latvian teachers, the author found that they were very defensive in response to the introduction of Holocaust history, seeing it as an attack on national history, and responding by emphasizing their own suffering: "Latvians also have suffered, to a large extent under the Stalinist regime, especially in the Gulag."

[92] Ibid., 24.

experience of the Holocaust was described in depth: the story of 70,000 Latvian Jews (and 25,000 Jews from elsewhere)[93] who were exterminated was well-documented and presented both elements of Nazi persecution from above and the mixed, complex nature of the social response of non-Jewish Latvians. It showed cases of assistance to Jews, but also stressed the passivity of the majority of the population and the role of Latvian extremist groups such as the Arājs Commando in the killings.[94]

In spite of the account of its horrors, the manner in which the Holocaust was framed within the museum meant that it could not compete with stories of Soviet crimes. The Holocaust was placed outside the story of the Latvian nation. It was given a separate set of panels, and was clearly divided from the main narrative of the German occupation where it was asserted that for the "Latvian nation" the experience of occupation was far less severe under the Nazis than it was under the Soviets: businesses were allowed to flourish, property was returned to farmers and a certain degree of cultural autonomy was granted. Such a (relatively) positive narrative was only possible through the complete exclusion of the Holocaust from the national story. Placing the Jewish experience outside the mainstream also allowed communist demographic policies to be presented as a worse form of ethnic cleansing than Nazi ones: the resettling of 800,000 Soviet citizens to Latvia was portrayed as a greater tragedy than the Nazi Ostplan which had planned to bring "only" 164,000 Germans over 25 years.

However, Jewish suffering was not always placed outside national history. Where it could be deployed as evidence of the Stalinist terror, it was incorporated. In the panels on the Soviet occupations of 1940–41 and 1944–91 in the Riga museum, the persecution of Jews was not related as a separate narrative but rather absorbed into the national story. In the course of the Soviet deportations of June 1941, for example, a far higher proportion of Jewish Latvians (compared to non-Jewish Latvians) were affected.[95] In the display, however, numbers of Jewish and non-Jewish de-

[93] These were the numbers provided in the museum display. For a discussion of these figures, see Aivars Stranga, "The Holocaust in Occupied Latvia: 1941–1945" in V. Nollendorfs, E. Oberländer (eds.), *The Hidden and Forbidden History of Latvia under Soviet and Nazi Occupations 1940–1991* (Riga: The Institute of History of Latvia, 2005), 161.

[94] It is estimated that they "directly killed" at least 26,000 civilians, and were "indirectly involved" in the murder of around 60,000. The membership of the organization probably constituted a few thousand. Ibid., 167.

[95] Andrew Ezergailis, *The Holocaust in Latvia 1941–1944: The Missing Centre* (Washington: United States Holocaust Memorial Museum, 1996), 70.

portees were conflated into one national figure and the particularity of the Jewish experience was ignored. The absence of the story of Jewish deportation under the first Soviet occupation meant that the museum provided no refutation to the historically inaccurate yet still commonly held prejudice that Jews, in league with the Soviet authorities, were responsible for the deportation of ethnic Latvians.[96] Hence Jews suffered as a minority outside the nation under the Nazi occupation, an interpretation which assisted in their presentation of the Latvian nation's experience of Fascism as far less severe. Elsewhere, however, Jewish persecution was co-opted into a story of national suffering, where it helped to emphasize national victimhood under Communism.

The representation of the Holocaust at the Estonian Occupation Museum was shaped by a different set of interactions between international pressures and domestic imperatives. At this site, the Holocaust was almost entirely absent in the section on the German occupation period, and, despite the museum's emphasis on striking objects from the three occupations, there were virtually no pieces connected with Jewish suffering. When asked about this absence. its director pointed to the impropriety of importing a "western" style of history that was of much less significance to Estonia than it was in other parts of Europe, and addressed the need to show to an international audience the validity of the specific and different nature of an Estonian story that did not need to foreground the Holocaust. When discussing the Shoah, the director presented the issue in terms of a dialogue between himself and westerners interested in Holocaust issues:

we were visited by a director of the Washington Holocaust Museum and she asked (…) some specific questions (…) 'what is here about the Holocaust?', and I said almost nothing because it didn't basically happen here physically [i.e. the apparatus of the Holocaust was on a much smaller-scale in Estonia] and I said because, yes, Estonia had refugees, and all who were left, all were killed, but a few survived (…) but Estonia never had a Jewish question and we just simply don't have any physical items from these people who were killed (…) we are never going to do what's done in some concentration camps, let's say they built the new crematorium and said that this is original (…).[97]

[96] For a discussion of the myth of Latvian Jews as "[Soviet] tank kissers," see Zisere, *Memory*, 158. The deportation of Baltic Jews by the Soviets in 1940 can be instrumentalized in other ways, too: according to Estonian historian Meelis Maripuu their deportation of 500 Estonian Jews can be described as the "first act of the Holocaust." In this instance, by contrast, the Soviets are demonized by association with the Holocaust. For a discussion of this, see Wulf, "The Struggle for official Recognition."

[97] Interview conducted by the author with Heiki Ahonen, August 2005.

A number of arguments were thus advanced for the very brief treatment of the Holocaust. First, that it was not really an omission; rather, the number of Estonian Jews killed was relatively small—900–1,000[98]—compared to 70,000 Latvian Jews[99] and over 225,000 Lithuanian Jews, and in contrast to the 122,000 Estonians who suffered repression under the Stalinist terror.[100] This position in part stemmed from the museum's nation-centered approach which regarded only suffering endured by Estonian citizens as significant and did not see fit to address national history in the context of the wider suffering caused by the war; hence the story of the approximately 15,000 foreign Jews who were deported to Estonia was not considered relevant. Second, that given the relatively small numbers involved, the foregrounding of the Holocaust story would be the result of politicized and distorting pressure from the international community to conform to artificially prescribed and (in an Estonian setting) empty Holocaust norms, rather than based on a historian's objective consideration of the importance of these events. Third, that these pressures should be resisted in the name of historical accuracy: to give undue attention to the Holocaust would be akin to the rebuilding of parts of concentration camps and claiming them to be authentic. Fourth, that nations needed to be allowed to tell their own story, and that the specificity of that national account should be respected. It was thus locally inappropriate to give undue weight or space to the Holocaust given its much smaller scale in Estonia.

In their construction of new national histories, these museums were caught between two powerful anti-fascist framings of European history. On the one hand, communist-era rhetoric—that presented the Soviets as the liberators of the Baltics from Fascism—was deemed still to be influential both among Soviet era settlers in their countries and in contemporary Russia. On the other, they were faced with a new, powerful Holocaust-

[98] For a discussion of this approximate figure, see Meike Wulf, "Historical Culture, Conflicting Memories and Identities in Post-Soviet Estonia," PhD dissertation, London School of Economics, 2005, 82.

[99] 70,000 native Latvian Jews, 20,000 from the Reich and 1000 from Lithuania were killed in Latvia; see Stranga, "The Holocaust in Occupied Latvia," 161.

[100] This figure is quoted in Budryte, *Taming Nationalism*, 180. For a detailed description of the different ways in which Estonians suffered, and the numbers involved, see Ahonen, "Wie gründet man ein Museum?" 116. See also *The White Book: Losses Inflicted on the Estonian Nation by Occupation Regimes 1940–1991* (2005), produced by the Estonian State Commission on the Examination of the Policies of Repression, for a detailed analysis of Estonia's population losses.

centered anti-fascist narrative that was an important part of Western European (and official European Union) memory. Facing the threat of these versions of history, these sites attempted to contain the memory of Fascism so that it could not drown out their primary focus on communist era suffering. In some cases, this meant that the story of Nazi occupation was marginalized from historical locations that would have appeared initially to demand its inclusion. Sites at which both Nazi and Soviet terror had occurred often restored only the physical space, and through it the memory, of communist criminality. Where the story of Fascism had entered the museum, it was narrated in such a way that it confirmed the dominant anti-communist script, and its crimes were not invested with the power ascribed to those of Communism.

How Is Communism Displayed?

Exhibitions and Museums of Communism in Poland

IZABELLA MAIN

It was a cold Monday in early December 2006. On the way to work I passed a tram stop. A black and white poster with heavy red lettering "Thou Shalt not Kill" hung on the wall of a tram shelter. It hung between two colorful posters, one with a girl saying "I am looking for a mummy and a daddy"—part of a social campaign for adoption—and another "Apocalypto by Mel Gibson"—a movie advertisement. My first idea was that the black and white poster must relate to the fairly controversial anti-abortion debate. Yet, a closer inspection explained everything: there was a large, blurred picture of a street with a tank and some people, alongside two small black inscriptions: "13 December 1981. Katowice" and "The Pacification of 'Wujek' Coalmine."[1] The quote from the Ten Commandments was in red ink—the color of blood, of the workers' movement and of Communism. It was a public exhibition about one of the most tragic events of Communist rule in Poland. In spite of many years of investigations and trials, nobody has ever been found guilty on the basis of the existing evidence. Interestingly, there was neither a caption nor an author's name. It was an anonymous public commemoration.

The end of Communism and the introduction of parliamentary democracy led to the transformation of symbolic spaces and the public sphere in Eastern Europe. In Poland, pre-war national holidays, such as 3 May and 11 November, were re-introduced, while the communist celebrations of 22 July and 7 November were erased from the calendar of state holidays. Furthermore, the names of streets and squares were changed throughout Poland, many monuments to Soviet leaders and heroes were removed, and new monuments and memorials commemorating previously neglected

[1] "Wujek" coal mine is in Katowice. On December 16, 1981, after the introduction of martial law, the workers on strike were brutally attacked by the army and riot police, who opened fire, killing nine and injuring twenty-one miners.

heroes were constructed.[2] The national coat of arms was changed by the new Constitution: the White Eagle was given a crown—a return to the pre-war emblem.[3] Members of former opposition and informal groups established a number of institutes and centers for the promotion of history and heritage by supporting research and publications as well as organizing educational programs and projects.[4] Historical research and studies about the period of the Polish People's Republic (PRL) flourished after the years of neglect, in part thanks to the fact that the archives were becoming more accessible. An enormous number of books, memoirs, and several new journals have been published, and many historical debates have taken place in newspapers and journals. It seems that history has become one of the best represented subjects in the media and on the Internet, although not necessarily reflecting the interests of a society which is often more concerned about the current economic and political situation.

There are many stories about Communism in Poland, and there are many places where these stories are visually represented.[5] These places were either created by the government, like the Institute of National Remembrance, or supported by the authorities of the city of Warsaw, like the History Meeting House and the SocLand Museum. Some sites, established originally for other purposes, such as the Zamoyski Museum and the Ethnographic Museum, presented objects from the communist period because these objects were already in their collections. There are also places created by organizations and groups: The Karta Center and, momentarily,

[2] Maria Bucur, Nancy M. Wingfield (eds.), *Staging the Past: The Politics of Commemoration in Habsburg Central Europe, 1848 to the Present* (West Lafayette: Purdue University Press, 2001); Marcin Frybes, Patrick Michel (eds.), *Po komunizmie: O mitach w Polsce współczesnej* [After Communism. About myths in contemporary Poland] (Warsaw: Wydawnictwo Krupski i S-ka, 1999); Marcin Kula, "Dlaczego Polacy dziś cenią Konstytucję 3 Maja" [Why do Poles think highly today of the constitution of May 3?], *Magazyn historyczny. Mówią wieki* 5 (1991): 16–21; Izabella Main, *Political Symbols and Rituals in Poland, 1944–2002: A Research Report*, Arbeitshilfe 2 (Leipzig: GWZO, 2003).

[3] Maria Woźniakowa (ed.), *Orzeł Biały. Godło Państwa Polskiego* [White eagle. The emblem of the Polish state] (Warsaw: Wydawnictwo Sejmowe, 1995); Wiktor Osiatyński, "A Brief History of the Constitution," *East European Constitutional Review* 5 (Spring 1997), at www.law.nyu.edu/eecr/vol6num2/feature/history.html (accessed 21 March, 2007).

[4] To mention only a few: Theatre NN in Lublin, Borderlands in Sejny, Borussia in Olsztyn, the Krzyżowa Foundation and The Karta Center.

[5] There are plans to open new museums related to the period of the Polish People's Republic: the Museum of the 1956 Uprising in Poznań and the European Center of *Solidarność* in Gdańsk.

exhibitions of the SocLand Foundation. Finally, there are sites owned by individuals, such as the Internet Museum of People's Poland and the Proletaryat Café. Apparently the number of ways of referring to, representing and displaying various objects—which correspond to events, persons, movements of the communist period—is increasing. The 50th anniversary of the Poznań Uprising observed in June 2006, the 25th anniversary of *Solidarność* in July and August of 2005 and the 25th anniversary of the introduction of martial law in December of 2006 were very conspicuous events. Public spaces in larger cities, for example, Poznań, Lublin and Warsaw, were covered with posters, billboards, open air exhibitions, and objects (for example, a tank in front of the castle in Poznań or a railway coach which travelled across Poland celebrating the anniversary of strikes in Lublin in July 1980).

The projects for exhibitions and museums represented two distinct types: some curators intended to create collections of objects which would allegedly speak for themselves (neglecting narrative, debates, definitions) while other curators proposed particular contexts for the objects and displays and, thus, narratives of Communism illustrated by selected items. Displaying authentic objects was not a precondition of many exhibitions and some curators created exhibitions consisting simply of panels with enlarged photographs and commentaries. At the same time the process of collecting objects representing the communist period seems just to have started: it is not being done on a large or organized scale.[6]

COMMUNISM AS ART

The oldest collection of art devoted predominantly to Communism is kept in the Gallery of Socialist Realist Art[7] created in 1994 in Kozłówka, a village in the Lublin region. The collection started as a storehouse of unwanted socialist realist sculptures in the 1970s, but the exhibition was created in the 1990s when other outdated monuments, sculptures and paintings were moved to Kozłówka. The collection was inaccessible to the

[6] I have faced several challenges and limitations when working on this project. The temporary nature of several exhibitions prevented me from actually seeing them, and I have therefore confined my analysis to press reports, published catalogues, and interviews with curators. The paper reflects the situation at the beginning of 2007, including temporary exhibitions and projects in making.

[7] Socrealism, another term for Socialist Realism, a style of art officially approved in the Soviet Union and other countries of the Soviet bloc.

general public before 1994, though it was used by journalists, art histori-
ans and film makers (director Andrzej Wajda used the collection as a film
set for his *Man of Marble*).[8] It is displayed in a coach house of the former
manor house of the Zamoyski family, known since 1944 as the Zamoyski
Museum. Although the Zamoyski Museum and the Gallery of Socialist
Realist Art are situated around 150 km from Warsaw in a village without
a rail link, they are well-known tourist destinations.

The permanent exhibition consists of sculptures, paintings and draw-
ings, which are accompanied by music from the period. In the surrounding
park, there are dismantled monuments to Bolesław Bierut (unveiled in
Lublin 1979 and removed in 1989), Vladimir Lenin (formerly in Poronin)
and Julian Marchewski (formerly in Włocławek).[9] On the 10th anniver-
sary of the Gallery, in 2004, a temporary exhibition, "Thrown Away Art,"
was organized. Several famous paintings and sculptures were borrowed
from the National Museums in Cracow, Warsaw, Wrocław and Łódź. In
2005, the permanent exhibition was re-arranged in order to offer the visi-
tors a better understanding of socialist realist art. The pictures, sculptures
and photos are organized according to leading themes, such as industry,
agriculture, the countryside, coal-mining, metallurgy. Jacek Szczepaniak,
the curator, has told me that the exhibition presented the art of the period
and explained what socialist realism was. Additional information about
the Communist period is provided upon request for guided tours and mu-
seum classes. There are plans to create a multimedia presentation about
the 1950s, based on original newsreels, currently "on hold" for financial
reasons. The curator also pointed out that one needs to know something
about the period to understand this art. Clearly, this small collection pre-
sents only art of the Stalinist period and its curators have limited possibili-
ties for extending the exhibition due to limitations of space.

The growing interest in socialist realism in recent years is exemplified
by another temporary exhibition, entitled "About a Happy Socialist Polish
Village. Socrealism in Folk Art" in the Ethnographic Museum in Warsaw.
This exhibition displayed colorful works of folk art, which represented the
struggle against illiteracy, work competition, the Stakhanovite movement
and gifts for Stalin on his 70th birthday. The curator, Alicja Mironiuk-
Nikolska, prepared the exhibition, using the collection of the museum,

[8] Personal communication with Jacek Szczepaniak, the director of the gallery and the
curator of the exhibition.
[9] Web page of the Zamoyski Museum: www.muzeumzamoyskich.lublin.pl/amainpage!.
htm (accessed 25 November, 2006).

which was created in the early 1960s. The goal was to restore the collection of socialist realist folk art in people's minds.[10] The opening ceremony took place on 22 July 2005, a state holiday in the communist period. The exhibition guide referred to the 50th anniversary of the opening of the Palace of Culture in Warsaw, neglecting the other meaning of this date. The curators either assumed that the visitors would know the date or that it was insignificant and did not need to be remembered. A journalist from *Gazeta Wyborcza* wrote that the curator failed to give a definition of socrealism, at the same time confirming that "defining socrealism would be very difficult."[11] His review of the exhibition was aptly entitled "Socrealism like pornography" because he argued that while it is as hard to define socialist realist art as it is to define pornography, everyone knows what it is.

On the poster of the exhibition, the name of the curator, Alicja Mironiuk-Nikolska, was accompanied by a phrase "a stakhanovite—300% workload," which suggests an ironic attitude to the ideology of the period. The meaning of the displays of socialist realist art in Kozłówka and the Ethnographic Museum in Warsaw for visitors from Eastern Europe who experienced life under the communist system is not primarily "art." When James Clifford described a consultation of elders in the Portland Art Museum displaying objects of the Tlingit authorities, he concluded that the objects of "art" were referred to as "history," "law" and "records."[12] Yet, the irony in these museums is readable only to those who are familiar with the propaganda heroes of socialist labor. The curators of the two Polish exhibitions left the audience alone with questions about history, representation and politics. Only the titles "Thrown Away Art" and "Happy Socialist Village" referred to the fact that there was a break between these objects and the present time: socialist realist works no longer decorate rooms in official buildings or public spaces, and are no longer created by artists. The curators offered no explanations as to how and why this happened because they were only interested in offering the possibility of seeing a collection which had been kept in storage.

Kevin Hetherington wrote in a short essay on the relationship between modernity and museum that articulating narratives of experience and iden-

[10] Interview conducted by the author with Alicja Mironiuk-Nikolska, the curator of the exhibition.

[11] Wojciech Orliński, "Socrealizm jak pornografia" [Socrealism like pornography], *Gazeta Wyborcza* (1 August 2005): 14.

[12] James Clifford, *Routes: Travel and Translation in the Late Twentieth Century* (Cambridge and London: Harvard University Press, 1997), 191.

tity is the main objective of museums of art, historical museums, specialist collections, and other collections in a modern world where the relationship between time and space is in doubt.[13] Currently, museums are attempting to place experience in a singular narrative space which makes sense of the modern world.[14] The exhibitions on socialist realist art were created on the basis of authentic objects, made by artists and folk artists in Poland, representing a particular style and themes. Displaying objects without commentaries, however, detaches them from significant questions of the relationships between these representations of life under the socialist regime and the history of the period as well as the memory of people. Also, the position of the creators (professional artists, folk artists, participants in a local competition organized to celebrate significant dates) is left without explanation. The museums of socialist realism fail to make clear that their objects on display were the outcomes of a specific historical period with certain political, social and cultural priorities and contexts. Thereby, they remain mere illustrations of a vague abstract "Socialism." Communism as a real, historically situated period appears unworthy of recall, and thus fit to be ignored.

COMMUNISM AS COMMODITY. THE PROLETARYAT CAFÉ IN POZNAŃ

The consumption of an assortment of products—alcoholic and non-alcoholic beverages, food, socialist realist art and objects made during the communist period—is the objective of another display site—the Proletaryat Café. It is not the only such site in Poland, as there are similar places in few other cities, but it is the one I had the opportunity to observe. The Proletaryat Café was opened in January 2004 in the center of Poznań. Its design is making ample use of communist symbols and everyday objects, both Polish and international. In the window there is a big bust of Lenin, inside there are pictures of Stalin, Marx, Dzerzhinsky and a recently unveiled bust of Gierek (the party leader in the 1970s Poland). The walls and the counter are red, there are red flags and posters from the epoch encouraging people to fight class enemies. Drinks are served in old glasses which were actually mustard containers. The menu lists many kinds of alcohol, Polish and foreign, but also a special beer labeled "Proletaryat." The music performed includes Polish revolutionary songs, but also Cuban and Soviet ones. There are many everyday objects displayed

[13] Kevin Hetherington, "Museum," *Theory, Culture & Society* 23 (2006): 600–1.
[14] Hetherington, "Museum," 600.

in glass showcases, such as food coupons, Soviet army uniforms, documents, money, matchboxes and so on. There is a shelf with forty-five volumes of Lenin's works. There are also old name-plates of streets and buildings, like Dzerzhinsky Street or Province Committee of the Polish United Workers' Party. Although there are many objects from the period, the design is actually modern (the sofas, armchairs and tables are new) and there are high-tech elements, such as a display board with slogans from the epoch. The place has a website with entries such as Speeches, News, Menu, Events, Rostrum, Gallery and Our Museum.

One of the owners, Sławomir Cichocki, in the interview he gave just before the opening of Proletaryat, stated that he was doing it "not for ideology but for fun." He continued that it was a fashion to collect objects from the communist period. "This place is for people who are in their thirties and forties, like the owners, who remember the last years of Communism, but who keep it at a distance and have a sense of humor."[15] The other owner believed that this place was needed because there is nostalgia for Communism in all former communist countries, including Poland. According to *Newsweek Polska* magazine, which awarded Proletaryat the first prize for design among Poznań cafés in 2004, "Proletaryat slightly mythologizes the Polish People's Republic but does it with good taste."[16]

Both journalists and a few guests whom I interviewed in 2005 focused on design and menu, neglecting the question of how Communism is represented in the café. Nevertheless, the place proposes a timeless and depersonalized version of Communism. There is a mixture of gadgets, music, slogans from different periods and countries without any additional information. The experience of people who lived under Communism is reduced to a few funny artifacts. Many visitors are too young to remember Communism, or were never interested in learning about it, and the place offers them a simple—almost fairy-tale—version. Communism is limited to examples of the cult of personality, slogans from the *Communist Manifesto*, such as "Workers of all countries, unite!" and the predominance of the color red. There are no artifacts related to prisons, camps, oppression, social change or opposition. The objects in the café serve to create an atmosphere of absurdity and fun rather than a serious reflection about Communism. There is a huge poster, saying "The Museum of Communism" on the wall but it is an unjustified claim. The place uses objects from the Communist period and

[15] "Proletaryat. Rozmowa ze Sławomirem Cichockim" [Proletariat. An interview with Sławomir Cichocki], *Gazeta Wyborcza. Poznań* (16 January, 2004): 2.
[16] Information from www.proletaryat.pl (accessed 5 December, 2006).

the nostalgia of some Poles as a commodity to attract customers. Although it is neither a museum nor an exhibition, the café offers its visitors an ambiguous representation of the communist past—the display can be read as funny, ironic, nostalgic or trendy. The Proletaryat Café creates a sense of distance towards the communist past and avoids any individual or collective reflection about it.

THE INTERNET MUSEUM OF PEOPLE'S POLAND

The most comprehensive collection of objects—photos, sounds, texts—is available on the Internet at www.polskaludowa.pl. The Internet Museum of People's Poland started in 1999. It is the most popular such collection in the country: the site has so far been visited by over 1,200,000 people. It was established by a group of individuals who placed items from their own collections as well as items sent by others on the Internet. The curators are anonymous, that is, they do not list their names online and refuse to reveal their identity. The only way to contact them is by e-mail, but my own messages were never answered.

The first goal of the curators was to gather items depicting everyday life in the Polish People's Republic and to make them available to everybody on the Internet. Everybody was welcome to send in their own mementos of the Polish People's Republic. In 2003, the curators announced that their popularity had exceeded their expectations and that the team working on a voluntary basis was not able to place all the objects received on the net immediately. The second objective was to gather the material without any attempt at historically assessing the period of the PRL. The viewers were invited to make the assessment themselves. The aim of the curators was to keep the memory of the PRL alive, "hoping that the PRL will never happen again."[17] The curators went on to say that the exhibits were presented in order to inform, to allow explanation, critical analysis and education. They also explained that the Museum was a non-profit organization and not connected to any institution.

The exhibition is divided into five parts: The Collection, The Documents of Opposition, Documents, Sound Recordings and The Curator's Office. The museum is a virtual labyrinth, with many hyperlinks and numerous pages. For example, in "The Collection" one of the fifteen links is called "Objects of everyday life," leading to eighteen topics with thou-

[17] Kilka słów od kustosza... [A few words from the curator...], www.polskaludowa.com/kustosz/od_kustosza.htm (accessed 24 November, 2006).

sands of scanned photos of objects: from a piggy bank to a paper bag with a May Day slogan. There are many museum aids: information, calendar, biographical entries, quiz and sounds of decades. Finally there are links to other Internet sites related to the PRL and Communism. Other internet projects are usually shorter, smaller and often limited in theme.[18] However, what is missing in the Internet Museum is the narrative aspect, since objects are clustered according to themes or form separate entities.

The International Council of Museums (ICOM) defines the museum as "a non-profit making permanent institution in the service of society and of its development, open to the public, which acquires, conserves, researches, communicates and exhibits, for purposes of study, education and enjoyment, the tangible and intangible evidence of people and their environment."[19] The specific principles concern preservation, maintaining the collection in trust for the benefit of society and its development, providing opportunities for the appreciation, understanding and promotion of the natural and cultural heritage, holding resources for other public services and benefits. Further, ICOM states that "interaction with the constituent community and promotion of their heritage is an integral part of the educational role of the museum." While most of these principles are fulfilled in the Internet Museum, it limits the audience to people familiar with the Internet. Another restriction springs from the unusual choice of only one language. The curator writes that it is maintained in Polish only as it is mainly intended for a Polish audience. Interaction is rather imaginary: visitors and donors must write messages to the curators and patiently wait for the answer, since there is no other way of reaching them.

The Internet Museum of People's Poland cannot replace a collection in a building, though internet pages of museums are a great source of information. The virtual institution runs neither museum classes nor organized discussions or meetings; nor does it undertake research or offer publications or souvenirs. Although the interactive aspect is essential for museum practice, the existing websites do not offer any possibilities for such contact (e. g. using forums online). "When visiting online museums, lost to the electronic viewer (...) is the power of display," writes Mary Anne

[18] For example: on Nowa Huta: www.nowahuta.org.pl/index.php?dzial=237, Internet Museum of *Solidarność*: http://elfal.com/solidarnosc/, Warsaw in the PRL: http://republika.pl/printo/warszawa/, Gomułka online: www.gomulka.terramail.pl/, socialism online: www.socjalizm.info/?go=strona_glowna, information on *samizdat*: www.incipit.home.pl/bibula/, (accessed 15 December, 2006).

[19] International Council of Museums: http://icom.museum/, (accessed 24 November, 2006).

Staniszewski.[20] In an actual (non-virtual) exhibition the meaning of an object is transformed by its display through a specific design and installation, which provide a specific context and possible explanation, but these aspects are missing in the Internet Museum of People's Poland.

THE NON-EXISTENT SOCLAND MUSEUM OF COMMUNISM

The number of press articles and various preparatory initiatives makes the SocLand Museum the best-known museum of Communism in Poland.[21] Thus, one may be surprised that it exists on paper only. In 1999, the Soc-Land Foundation was established by the architect Czesław Bielecki, the film director Andrzej Wajda and the artist Jacek Fedorowicz. They decided to create a museum which would show what it was like to live under Communism. The name "SocLand" referred to Disneyland, since the future museum would be organized in a way likely to appeal to young people. The council of the Foundation included the founders along with Krystyna Zachwatowicz (a stage designer), Teresa Bogucka (a journalist and writer) and Anna Fedorowicz (an artist). Members of the council had been involved in anti-communist opposition to different degrees. Teresa Bogucka was arrested after the 1968 revolt and later became head of the team of experts on independent culture in the Regional Committee of *Solidarność*, created in Warsaw after the imposition of Martial Law in 1981.[22] Bielecki took part in student strikes in 1968, in illegal groups in the 1970s, and in *Solidarność* since 1980; he managed CDN, a samizdat publishing house, during Martial Law.[23] Bogucka and Bielecki published in the samizdat *Tygodnik Mazowsze*.[24] Anna Fedorowicz was active in the Primate's Committee of Charity for the Oppressed, established after the

[20] Mary Anne Staniszewski, "Museums as Web Site, Archive as Muse: Some Notes and Ironies of the Conventions of Display," *Convergence* 6/2 (2000): 15.

[21] The project was described by the press in Poland (*Gazeta Wyborcza, Rzeczpospolita, Tygodnik Powszechny, Trybuna, Newsweek*) and abroad (*Die Welt*). It was also mentioned in Volkhard Knigge and Ulrich Mählert (eds.), *Der Kommunismus im Museum. Formen der Auseinandersetzung in Deutschland und Ostmitteleuropa* (Cologne: Böhlau, 2005), 39.

[22] Andrzej Friszke, "Regionalny Komitet Wykonawczy Mazowsze" [Regional Executive Committee Mazowsze] in Andrzej Friszke (ed.), *Solidarność Podziemna 1981–1989* [Underground Solidarność 1981–1989] (Warsaw: ISP PAN, 2006), 473.

[23] Paweł Sowiński, "Czesław Bielecki" in Jan Skórzyński (ed.), *Opozycja w PRL. Słownik biograficzny 1956–1989* [Opposition in the Polish People's Republic. Biographical dictionary 1956–1989], Vol. 2 (Warsaw: Ośrodek Karta, 2002), 34–7.

[24] Friszke, "Regionalny," 373.

imposition of Martial Law.[25] Jacek Fedorowicz produced satirical anti-regime radio programs during the 1980s, which were distributed in Poland and broadcast by Radio Free Europe. He also co-organized the archives of *Solidarność* activity in 1980–1981.[26] Wajda's films, especially *Man of Marble* and *Man of Iron*, contained many political references, the first questioning the myth of the socialist worker in Nowa Huta, and the second depicting *Solidarność*.[27] Some members of the council were active in politics after 1989: Wajda was elected a senator in 1989 (till 1991) while Bielecki was a member of the Sejm in the late 1990s. The list of honorary members included Zbigniew Brzezinski, the former U.S. National Security Adviser, the French historian Alain Besançon and the former Czech President Václav Havel.[28] The stature of the members of the founding committee and the honorary committee led to extensive publicity for the idea, wide media coverage and several preparatory activities.

The council issued the statute with the following main objectives: to pass the historical truth about Socialism on to future generations, to explain the past and rebuild bridges of understanding between the generation affected by Communism and the new one, to help deal with a totalitarian legacy and build a society immune to totalitarian temptation. In 2001 and 2003, the SocLand Foundation, supported by a grant from the Culture 2000 Program of the European Union, organized a number of temporary exhibitions in Cracow, Nowa Huta, Łódź and Warsaw. The exhibitions consisted of photographs, posters ("Watch out for the nation's enemy!"), portraits, newsreels, a duplicating machine used by *Solidarność* in the 1980s, ration coupons, barbed wire, a map of the Gulag archipelago, fragments of documentary films as well as a staged "interrogation room."[29] According to a journalist of *The Warsaw Voice* all the parts con-

[25] Friszke, "Tymczasowa Komisja Koordynacyjna NSZZ Solidarność 1982–1987" [Temporary coordination commision of Solidarność] in *Solidarność*, 74.

[26] Friszke, "Regionalny," 474.

[27] Tomasz Lubelski, *Wajda* (Wrocław: Wydawnictwo Dolnośląskie, 2006), 168–72, 187–93. For an interesting analysis of Wajda's *Man of Marble* and *Man of Iron*, see Charity Scribner, *Requiem for Communism* (Cambridge—London: MIT, 2003), 60. According to the author the films were less stories about workers' collective solidarity than about a patriarchal unity.

[28] Original web page of SocLand Foundation: www.socland.pl (accessed in 2005, no longer available); Marek Mikos, "Muzea PRL-u: w kapciach do komuny" [Museums of the Polish People's Republic: In slippers to Communism], *Gazeta Wyborcza* (21 July 2004).

[29] Wojciech Stanisławski, "Stalinism Made Chic," *Central Europe Review* (21 October 2003), available at:

stituted a coherent whole representing the period of 1917–1989. Further-more, the newspaper reported that the exhibition attracted large audiences and was widely covered in the mass-media.[30]

The temporary exhibitions are described in the catalogue entitled "Mu-seum of Communism (under Construction)," published in 2003. The cata-logue, edited by Czesław Bielecki, presented the themes of the museum—seven sections with pictures and commentaries: "The Specter of Commu-nism," "Invasions and Imposed Revolutions," "The Installation of the System," "Creation of a New Man," "Absurdities of Everyday Life and Revolts," "Opposition. The Birth of Solidarity" and "Conspiracy. Break-down of the System. Victory." It also included a few short essays by the philosopher Leszek Kołakowski, the Soviet dissident Vladimir Bukovsky, the Czech President Václav Havel, the Lublin bishop Józef Życiński and the Polish historians Andrzej Paczkowski and Andrzej Friszke.[31] Interest-ingly, there was no discussion of the reasons why such a museum should be created, but only a few apodictic statements. The editor wrote: "Today we don't like to think about it. Yet we cannot avoid the question: what was Communism? It was the only realized utopia that engulfed half the world for half a century. Its collapse started in Poland and that is why here a Museum that would show the paralyzing power of this system, its dura-tion and disintegration should come into being."[32] This statement contains blatant generalizations and oversimplifications in the assessment of the communist system. Neither was that system the only utopia in history nor did it engulf half the world. Bielecki's commentaries in the subsequent parts of the catalogue represent a few dominant, albeit only vaguely ex-plained, ideas: the totalitarian character of the system, its imposition from above and the implied innocence of Poles, the creation of *homo sovieticus*, and implicit support for lustration.

Among a few introductory sentences on the inside cover one reads: "The Communist system and its disintegration will be shown in such a way as to give a powerful insight into the everyday reality of that totali-

www.tol.cz/look/CER/article.tpl?IdLanguage=1&IdPublication=14&NrIssue=53&NrSec-tion=5&NrArticle=10836&ALStart=120 (accessed 24 November, 2006).

[30] "Red Letter Days," *The Warsaw Voice* (31 July 2003) available at: www.warsawvoice.pl/view/3138/ (accessed 24 November, 2006); Jerzy Sadecki, "Siedem od-słon komunizmu" [Seven scenes of Communism]. *Rzeczpospolita* (17 April 2003) avail-able at: www.rzeczpospolita.pl (accessed 24 November, 2006).

[31] Czesław Bielecki (ed.), *SocLand. Muzeum Komunizmu (w budowie). Museum of Com-munism (under construction)* (Warsaw: Oficyna Wydawnicza Volumen, 2003).

[32] Bielecki, *SocLand*, 7.

tarianism."[33] Similar goals were revealed on the earlier website of the SocLand Foundation: it was to show how inhuman and crude the communist system was, how deep the brainwashing went, and how the revolts were organized and crushed before the system was finally overthrown. This intention makes this museum project different from the previously described exhibitions on Communism. Here the idea is precisely to define clearly the context of the displayed objects. The intention of the initiative is to evoke Communism in order to remember it, or more precisely, to remember certain well defined aspects of it.

There is a nationalistic tone both in the introduction to the catalogue and in Bielecki's commentaries: "we, the Polish nation were the first ones to overthrow the system, so we should create such a museum." While the first part, "The Specter of Communism," focuses on the number of its victims in the Soviet Union,[34] the next two parts describe how the communist system was imposed in Eastern and Central Europe after Yalta. The author states: "Poles, just like other subjugated nations, fell into the trap of history: the struggle was hopeless, resistance was a question of honor and loyalty, surrender did not guarantee anything."[35] Communism is presented as having been forced on Poles from above by the Communists, who are undefined. This is an example of historical revisionism implying that Communism was imposed from above by foreigners and Poles had noting to do with it.[36] Again there is an emphasis on "Poles" as if no other groups lived in post-war Poland. The language ("honor," "loyalty," "no guarantee") evokes questions of morality or its absence: for Poles honor and loyalty are important values while it is implied that the Communists lack these virtues. The last two parts of the catalogue describe the birth of *Solidarność*, showing photos and names of its leading members and quoting the words of John Paul II: "There can be no just Europe without an independent Poland."[37] Again, the uniqueness of the Polish nation is emphasized, also by recalling the name of the most prominent Pole in recent history.

[33] Bielecki. *SocLand* cover.

[34] During the time when "the Soviets showed how Utopia in power changes into tyranny and terror." See Bielecki, *SocLand*, 19.

[35] Bielecki, *SocLand*. 36.

[36] A similar example was analyzed by István Rév, "Parallel Autopsies," *Representations* 49 (1995): 33. "According to post-Communism revisionism, Communism in Hungary was the tragic result of a conspiracy organized from abroad, it was the work of outsiders."

[37] Bielecki. *SocLand*, 77.

The way people are presented on the pages of the catalogue is also inter-
esting. They are either victims—soldiers of the Home Army, private entre-
preneurs, and Primate Stefan Wyszyński (imprisoned in the early 1950s)—
or party leaders.[38] In contrast, the next part presents the "Creation of a New
Man," drawing attention to the characteristics of the system and of the new
man, *homo sovieticus*. According to Bielecki, "the essence of the system
was its all-encompassing greed, insane propensity towards monumentalism
and façades (…) inspiring jealousy, suspicion and mistrust (…) a front men-
tality."[39] Bukowski in his essay about the Soviet Union stressed the unique-
ness of the communist system and its impact on society: "so what re-
mained? A castrated country with a degenerate social system, in which the
type of human who is capable of work was utterly exterminated. Fear re-
mained, not sitting just under the skin, but in the genes."[40] The catalogue
suggests that the system created by "the others" divided societies into vic-
tims and oppressors (the Communists) and transformed humans into a new
species. This view resembles a discourse that was constructed in the Polish
mass media and also in the works of sociologists after 1989.[41] In this do-
mestic version of orientalism, analyzed by Michał Buchowski, a passive
part of society which was demoralized under Communism, called lumpen-
proletariat, socialist nomads, or orphans of the PRL, today forms the Other,
the legendary *homo sovieticus*.[42] Buchowski links these orientalizing prac-
tices with liberal thinking, the legitimization of political practices and the
concoction of distinctions between elites and plebs, winners and losers of
the economic reforms in Poland.

Two essays by the historians Andrzej Friszke and Andrzej Paczkowski,
at the very end of the catalogue, contradicted many statements about the
repressive and imposed nature of the regime and the creation of a new man.
Paczkowski called for an honest description of the events, and rejected gen-

[38] The picture of the leaders of the Polish United Workers' Party shows a few leaders
during Mayday in 1968 without commentary. There is no mention of the first commu-
nist leader, Bolesław Bierut, who ruled the country in the Stalinist period when the sys-
tem in Poland was at its most criminal. Izabella Main, "President of Poland or "Stalin's
Most Faithful Pupil"? The Cult of Bolesław Bierut in Stalinist Poland" in Balázs Apor,
Jan C. Behrends, Polly Jones, E. A. Rees (eds.), *The Leader Cult in Communist Dicta-
torships: Stalin and the Eastern Block* (New York: Palgrave, 2004), 179–93.

[39] Bielecki, *SocLand*, 45.

[40] Vladimir Bukowski, [no title] in Bielecki (ed.), *SocLand*, 13.

[41] Michał Buchowski, "The Specter of Orientalism in Europe: From Exotic Other to Stig-
matized Brother," *Anthropological Quarterly* 79/3 (2006): 467–72.

[42] Buchowski, "The Specter of Orientalism," 463–82.

eralizations. By the example of young people he showed a more nuanced picture: although some objected to the system others supported it, and therefore one should avoid drawing the general conclusion that the system was based on younger people. He also opposed the identification of every rebellion with resistance or opposition, pointing out that strikes often had material causes while the protests of the young against the "old system," were generational.[43] Friszke focused on the issue of who benefited and who suffered in the Polish People's Republic. Tellingly, he never used the term "Communism" but referred to the system using the official name of the state. The two essays are unconnected to the rest of catalogue and it is hard to believe that these established Polish historians would agree with the commentaries published in it. The catalogue shows that the idea of SocLand Museum was formed with little, or only ineffective, consultation with the historians, sociologists and researchers who had been analyzing the period for more than a decade.

At the same time the Foundation started to collect objects for the future museum, appealing for donations. One of the days for collecting future exhibition material was organized in Warsaw on July 22, 2005. Recordings of official speeches by the former communist leaders and the listeners' applause were played around the Palace of Culture. Across Warsaw billboards showed the figure of a young man holding a sizeable volume with the names of Marx, Engels and Lenin on its cover, accompanied by the perky slogan "Bring Communism to the museum."[44] The first attempt at collecting revealed some misunderstandings. Some citizens of Warsaw brought old and broken household equipment, although many contributed documents, collections of medals, money and cards. Were the broken objects meant to be put on display as representations of Communism as a period when things were of poor quality, or were people using the opportunity to avoid paying for rubbish collection? The media reported that many came to see the temporary exhibitions and many donated objects, which showed the existence of social support for the idea of creating this museum.[45]

[43] Bielecki, *SocLand*, 106.

[44] Konstantin Akinsha, "Bring Communism to the Museum" in *Kontakt. The Arts and Civil Society Program of Erste Bank Group. Report* (December 2006), available at: http://kontakt.erstebankgroup.net/report/stories/issue12_story+den+Kommunismus+ins+ Museum/en (accessed 21 March, 2007).

[45] Ewa Michałowska, *SocLand. Czyli w oparach absurdu* [SocLand: In the fumes of absurdity], Polskie Radio (Polish Radio) Program 3, Documentary (23 June 2005). In the collection of I. M.

The location proposed by the Foundation was the Palace of Culture and Science in Warsaw, the "gift" of Joseph Stalin to the Polish people in 1955. The Palace seems the perfect place for the museum, with its symbolic meaning and socialist realist architecture. The building is in itself controversial. On the one hand, there were plans to destroy it in the early 1990s, on the other, it won a competition for the favorite place of the citizens of Warsaw in the category of architecture.[46] In early 2007 the debate about the future of the Palace was resurrected after plans had been announced to list it in the national register of historic monuments.[47] Already a few years before, an architectural project of the Museum had been prepared by Czesław Bielecki, who proposed building an entry hall in front of the Palace and using the Palace's corridors and cellars.

In 2003, the Foundation signed a contract with the City Council of Warsaw and the Office of Coordinator was established. It is funded by the City of Warsaw. The media reported the beginning of construction work in 2005, on the 50th anniversary of the Palace.[48] Yet, the City Board decided that Bielecki's project should not be accepted *a priori* but that an open competition for the architectural design ought to be organized: public money had to be spent according to the procedures of a democratic state. In December 2006, the future Museum still exists only on paper and the tentative date for its opening is 2009 or 2010. Its fate depends not only on political alliances and the parties in power but also on the existence of an active and determined group of curators and organizers. It seems that the members of the Foundation and, later, of the Office of Coordinator, were not very good at finding supporters for this initiative. The view that the post-communist parties would not support such initiatives while post-*Solidarność* and right-wing parties would be more in favor is hard to prove since any actual support for the project—or the lack of it—will be only revealed when the politicians decide upon the budget for the museum. At the end of 2006, the Office of Coordinator is under the authority

[46] "Sentyment do PKiN" [Sentiments for the Palace of Culture and Science], *Rzeczpospolita* (26 June 2006); "Plebiscyt pozytywne miejsca Warszawy rozstrzygnięty" [The plebiscite of favorite places in Warsaw is resolved], www.pozytywnemiasto.pl (accessed 27 November, 2006). The citizens voted for different buildings for one month; the results were announced on June 8, 2006.

[47] "Dar Stalina największym zabytkiem Warszawy. Czy warto chronić Pałac Kultury?" [The gift of Stalin is the biggest historic monument in Warsaw. Should the Palace of Culture be protected?], *Gazeta Wyborcza* (16 January 2007).

[48] Izabela Kraj, "Zabytkowy Pałac Kultury" [Historic Palace of Culture], *Rzeczpospolita* (9 December 2004).

and funding of the City Council of Warsaw, while it would be easier to create the museum if its support came from the Ministry of Culture. In the case of such expensive projects, the support of many institutions is necessary, especially since a few new museums have been recently created or approved in Warsaw (The Warsaw Rising Museum, the Museum of Contemporary Art, and the Museum of the History of Polish Jews). Although the encouragement of museum tourism by creating clusters of museums is an established strategy in urban development,[49] there are also financial limits to such activities under the present economic circumstances in Poland.

THE PRESENTATION OF OPPOSITION, TOTALITARIANISM AND EVERYDAY LIFE BY THE KARTA CENTER

The oldest center of research and popularizing activities concerning the recent history of Poland and Eastern Europe is The Karta Center, an independent non-governmental organization. It continues the activities of the illegal group that published the *Karta* journal and started the clandestine Eastern Archives of the 1980s. In 1982, the first issue of the samizdat *Karta* was published by Zbigniew Gluza. At the same time, the editors started to collect documents and related material about opposition, Martial Law, and the political upheaval in March 1968. The Eastern Archives began to document the history of the Soviet Union, a remarkable activity to be undertaken under communist rule. Before 1989, the Karta Center was organized as an underground organization; after 1989, it was sponsored by the Ministry of Higher Education and many international and Polish foundations.[50]

In 1991 the first legal issue of the *Karta* monthly was published and the archive of the Polish People's Republic created. During the 1990s, The Karta Center organized many public debates, which made important contributions to facilitating cooperation between historians. In 1992, it organized the Week of Conscience, during which Polish, Ukrainian and Russian historians and researchers met and embarked on an exchange of views. The Karta Center coordinated the work of its local partners in these

[49] Irina van Aalst, Inez Boogaarts, "From Museum to Mass Entertainment: The Evolution of the Role of Museums in Cities," *European Urban and Regional Studies* 9 (2002): 195–209.

[50] Zbigniew Gluza, "Karta—sposób na historię" [Karta—History in its way], *Karta* 50 (2006): 112, 115.

countries and published the *Dictionary of Dissidents in Poland*; other volumes are being prepared.[51] When Gluza, in a recent interview, claimed that The Karta Center documents the experience of people and social groups living in the PRL, he meant, first of all, the attitudes of dissidents and opposition figures.[52] It is a peculiar perspective to choose only the experiences of dissidents to represent life under Communism, but it is related to the personal experiences of the Karta founders themselves. The Karta Center has organized conferences and meetings with witnesses of the Stalinist terror, the imposition of Martial Law, March 1968 and other important events; it has published books and occasional newspaper articles, and produced television programs. Since 1997, it has organized annual essay competitions dealing with contemporary history for secondary school pupils (since 2001 within the EUSTORY network), as well as a number of other projects, including "Remembering the Polish People's Republic."

Along with popularizing and educational activities, The Karta Center has organized several temporary exhibitions about the Gulag, opposition in Eastern Europe, the political changes of the 1980s, *Solidarność*, Swedish aid for Poles in the 1980s, meetings and relations between Poles and Hungarians, private companies in Poland, and others. These exhibitions have taken place in museums, galleries and public buildings in Poland and abroad since the early 1990s. They have usually been in the form of large panels with private and archival photographs, fragments of diaries, and commentaries. Most often, they followed themes documented in the journal *Karta*, which had a section on "the picture of the system," and another section with voices and testimonies from the past. The exhibitions did not usually display objects.[53] The objective was to present the event from lay perspectives: to hear the story of a previously silent witness, to comment on his/her story through another story or picture, to provoke a dialogue between stories and pictures, or to reject a story by providing counter-

[51] The Karta Center web page: www.karta.org.pl/historiaOsrodka.asp (accessed 26 November, 2006); personal communication with Zbigniew Gluza, President of the Management Committee, Karta Center, Gluza, "Karta," passim.

[52] Zbigniew Gluza, "Historia na huśtawce" [See-saw of History], *Gazeta Wyborcza* (10 February 2007).

[53] The exception was a recent exhibition, "From the Ashes of Sobibor," displayed in July and August 2006, where panels with pictures and historic documents were accompanied by a few installations of a hiding place, barracks, a barrack square, the entrance to a gas chamber. The Chronicle of The Karta Center: www.karta.org.pl/Kronika_Wiadomosc. asp?WiadomoscID=687&jezyk=1 (accessed 30 January, 2007).

evidence. This was a new formula for constructing a historical exhibition, formed little by little by the team of The Karta Center. It is based on their belief that testimonies (visual and oral) are so powerful that they offer the best way of representing the event from inside, while objects would bring in their own stories.[54]

A recent large temporary exhibition, entitled "Faces of Totalitarianism: Twentieth Century Europe," was organized by The Karta Center in the History Meeting House between September 2005 and December 2006. The History Meeting House was created by the City of Warsaw and The Karta Center. Its partners are well-established institutions for the study and research of contemporary history: the Institute of National Remembrance, the Institute of Political Science of the Polish Academy of Science, the Sikorski Museum in London, the Memorial in Moscow, the Hannah-Arendt Institute in Leipzig and the Körber-Stiftung in Hamburg.

The exhibition "Faces of Totalitarianism" relates to some of the most tragic episodes of twentieth-century history. It is divided into eighteen parts, covering the Soviet and Nazi regimes. It starts with a presentation of the results of the Great War, Bolshevik Russia, the Polish–Bolshevik war of 1920, the class struggle and the Great Terror in the USSR. It continues with the racial divisions in Nazi Germany, the alliance of two totalitarian regimes, the Soviet occupation, the Soviet repression, and the clash of two totalitarian regimes. The last part displays the Nazi occupation and repression, the Holocaust, the Warsaw Uprising, the underground state, the expulsions and "the defeat of Nazism and the triumph of Communism." Parallels are drawn between crimes and repression committed by Nazis and Communists. The occasional leaflet published by the History Meeting House claims that the exhibition presents a sequence of stages in the totalitarian experience. With only a few short introductory commentaries, the majority of the exhibition consisted of historical accounts (fragments of personal memoirs and recollections), copies of documents, photographs, propaganda posters and original recordings of witnesses and participants of the events.

In my reading, the objective of the exhibition was the visualization of the thesis expressed by Stéphane Courtois in the introduction to *The Black Book of Communism: Crimes, Terror, Repression*. The juxtaposition of Nazism and Communism as equally criminal systems in the essay by Courtois led to disagreements between the co-authors of the edited vol-

[54] Interview with Zuzanna Bogumil, Department of Exhibitions and Public Relations of the History Meeting House, conducted by the author in February 2007.

ume and provoked a public debate in the French media.[55] *The Black Book*, published in French, Italian and German in 1997, appeared in Polish two years later, also triggering debates about Communism. The themes of repression, crime, opposition and struggle with the communist regime is a common subject of research in Poland. But another part of historical research and writing covers aspects of social, cultural and economic history. Popular publications about the Polish People's Republic are often devoted to the absurdity of life, cult objects (packages, toys, clothes, cars), jokes and music. These different themes are often intertwined: for example, the same historians write both about repression and about everyday experiences. The exhibition "Faces of Totalitarianism" covered the period until 1947, when the faked elections led to the communist takeover in Poland. The narrative presented the background of the system in Poland and Eastern Europe, stressing its totalitarian character.

The other exhibitions organized in the History Meeting House presented different aspects of Communist history: "Warsaw–Budapest 1956," "Private Small Companies under Communism," "Zielna 37" (a street in Warsaw), "The White Rose" (a non-violent resistance movement in Germany during World War II), "The Student Movement of Dissent," "Warsaw in the 1960s" and "Martial Law." Gluza, the founder and director of The Karta Center, stated that its goal—which had not changed during its history—was to attempt to name what was happening under Communism and to search for spheres of freedom in totalitarian conditions.[56] Accordingly, everyday life was shown as partly controlled by the authorities but also as permitting individual choices and stances. The totalitarian character of the regime was thus not the only story presented by The Karta Center, even though it was the dominant motif of its largest and longest exhibition.

[55] Krystyna Kersten. "Wstęp do polskiego wydania" [Introduction to the Polish edition] in Stéphane Courtois, Nicolas Werth, Jean-Louis Panné, Andrzej Paczkowski, Karel Bartosek, Jean-Louis Margolin (eds.), *Czarna Księga Komunizmu. Zbrodnie, Terror, Prześladowania* [The black book of Communism: Crimes, terror, repression] (Warsaw: Prószynski i S-ka, 1999), 8.

[56] Interview with Zbigniew Gluza, conducted by the author, January 2007.

THE POLITICS OF HISTORY

The leaders of Law and Justice (the Polish acronym is PiS), a political party in power since October 2005, expressed their support for another project, a Museum of Freedom, which would present the struggle for freedom during the communist rule and in previous centuries in Poland. Kazimierz Ujazdowski, the Minister of Culture and National Heritage, expressed in an interview the view that such a museum would show "unique aspirations for freedom during the time of the First Republic (sixteenth–eighteenth century), the struggles in the nineteenth century, and the successful struggle with two totalitarian dictatorships of the twentieth century: the Polish victory over Communism and Nazism."[57] This project, although it soon disappeared from public discourse and its realization is highly unlikely, represents nationalistic thinking about history and recalls the messianic vision of the role of the Polish nation in history.[58] In this vision the nation is the ultimate hero of history as the fighter for freedom and democracy and also the ultimate victim of historical injustices, including Nazism and Communism.

The idea of creating the Museum of Freedom went hand in hand with the idea that the state should have a "politics of history."[59] Both the need for such a policy and the meaning of this concept were debated in a number of polemical essays, published in leading Polish newspapers: *Gazeta Wyborcza, Rzeczpospolita, Tygodnik Powszechny*. In 2005, Tomasz Merta, a conservative politician and the author of the PiS's program of culture, co-edited a volume entitled *Memory and Responsibility*.[60] In the introduction, Merta and Robert Kostro (both authors of school textbooks in history and civil education) stated that history was not only the subject of historians' interest and internal discussions but also the reason for international controversies. Furthermore, they wrote that Poland was not well prepared for the "battle about memory," although they did not elaborate what this battle should be about. They continued with the claim

[57] Robert Traba, "Kicz patriotyczny" [Patriotic kitsch], *Gazeta Wyborcza* (6 January 2006): 10.

[58] On the messianic tradition see, for example, Andrzej Walicki, *Philosophy and Romantic Nationalism: the Case of Poland* (Notre Dame: University of Notre Dame Press, 1994); Ewa Morawska, "Civil Religion vs. State Power in Poland," *Society* 21/4 (1984): 29–34.

[59] Kazimierz Ujazdowski, "Powrót do historii. Rozmawiał Paweł Wroński" [Return to History. A conversation with Paweł Wroński], *Gazeta Wyborcza* (8 July 2005): 21.

[60] Robert Kostro, Tomasz Merta (eds.), *Pamięć i odpowiedzialność* [Memory and responsibility] (Cracow—Wrocław: Ośrodek Myśli Politycznej—Centrum Konserwatywne, 2005).

that a section of the political and intellectual elite had decided that the politics of memory was an anachronism. They noted with regret that this conviction had led to neglect of the "politics of history" in both the internal and the foreign policy of the state.

Merta and Kostro listed several areas of neglect and controversy and proposed their own solutions. They first addressed the issue of "critical patriotism," that is, the greater affinity of some citizens for "Others" than for "Us." For example, Dariusz Gawin, another author in the volume, compared the different attitudes to Germans expelled from the former German territories and to Poles expelled from the East. In his view the suffering of German expellees was more often referred to than the fate of Polish expellees from the Eastern provinces, which was shrouded in silence. He also argued that critical and self-accusatory attitudes among Poles prevailed over positive assessments of their own past.[61] It is rather a particular view, taking into account that both before and after 1989 history was mostly written from a national perspective and the idea of Poles as perpetrators during or after the war came as a surprise for many.

Second, the authors argued that a lack of awareness of one's identity, one's past, one's national community hindered or even prevented civil education and international agreements. The authors pleaded for attractive methods of popularizing historical knowledge, citing as examples the House of Terror in Budapest and the recently opened Warsaw Rising Museum.[62] The latter, opened in 2004, is applauded by the proponents of the "politics of history" for presenting a heroic vision of the insurgents and citizens of occupied Warsaw and paying homage to the victims in a technologically advanced and interactive way. Gawin, one of the museum's directors, stated that the Warsaw Rising Museum aimed at offering neither a story of heroism nor of victimization.[63] However, the less heroic moments of the uprising, the disagreements about its meaning and its failure were hardly mentioned in the exhibition.[64] It is also telling that the House

[61] Dariusz Gawin, "O pożytkach i szkodliwości historycznego rewizjonizmu" [About the benefits and harmfulness of historical revisionism] in *Pamięć*, 28.

[62] Robert Kostro, Kazimierz Michał Ujazdowski, "Odzyskać pamięć" [To regain memory] in *Pamięć*, 48.

[63] "Polski patriotyzm po przejściach" [Polish patriotism after trying experiences], *Dziennik* (9 November 2006).

[64] A political scientist and philosopher, Marcin Król, wrote with irony that, having seen the exhibition, one might not realise that the Uprising was defeated. See Marcin Król, "Nie używajmy historii do politycznych celów" [Let us not use history for political goals], *Dziennik* (19 June 2006): 28–9.

of Terror in Budapest was given as an example. The presentation of the crimes of Nazism and Communism between 1944 and 1956 in the House of Terror tries to imply that the two regimes were equivalent, but the comparison is highly problematic and controversial.[65] For example, as the critics of the Museum have pointed out, only a couple of rooms are devoted to Nazi crimes, the rest being devoted to communist ones.[66] Rafał Stobiecki, in his study of contemporary Polish historians of the communist period, suggested that there were two common ways of conceptualizing their work: either as belief in the search for absolute truth (the positivist, scientist model) or as the pursuit of axiomatic, missionary and moralistic objectives.[67] I would suggest that the supporters of the "politics of history" understand history in both ways: as a missionary search for absolute truth.

The slogan "politics of history" entered the mass media at the time of the presidential and parliamentary campaigns. The idea was criticized by Robert Traba, historian and editor of the journal *Borussia*, in his essay "Patriotic kitsch."[68] He objected to the affirmation of national history, heroic patriotism and the role of the state in forming and promoting the politics of history. Traba's essay triggered a debate among historians, political scientists and politicians.[69] Andrzej Nowak, a right-wing historian, stated that during the last sixty years a false history had been propagated and there was a need for counter-propaganda at the moment. He expressed this view together with his criticism of the post-1989 system at a conference in the Institute for National Memory (IPN), where politicians

[65] See the analysis of Zsolt K. Horváth in this volume. See also István Rév, *Retroactive Justice: Prehistory of Post-Communism* (Stanford: Stanford University Press, 2005), 277–303 and a comparative essay about museums of Communism by Arnold Bartetzky, "Visualizing the Experience of Dictatorship: Communism in the Museum," *Centropa* 6/3 (2006): 183–93.

[66] Beverly A. James, *Imagining Postcommunism: Visual Narratives of Hungary's 1956 Revolution* (College Station: Texas A&M University Press, 2005), 3–4. Gabriella Ilonszki, Sándor Kurtán, "Hungary," *European Journal of Political Research* 42 (December 2003): 967.

[67] Rafał Stobiecki, "Spór o PRL. Metodologiczne oblicze debaty" [Argument about the PRL. The methodological side of the debate], *Kultura i historia* 2 (2002), available at: www.kulturaihistoria.umcs.lublin.pl/archives/80 (accessed 30 January, 2007).

[68] Traba, "Kicz patriotyczny," 10.

[69] Among the participants in this debate were Paweł Machcewicz, Andrzej Romanowski, Paweł Cichocki, Aleksander Smolar, Adam Leszczyński, Paweł Wroński, Robert Krasowski, Anna Wolff-Powęska, and Andrzej Nowak.

and historians discussed the "politics of history."[70] Paweł Wroński, a jour-
nalist and historian, criticized this view, maintaining that the project of the
"politics of history" was part of the election campaign, and that the goal of
the project was to turn historians into supporters of the government.[71] Paweł
Machcewicz, professor of history and former director of the education of-
fice of the IPN, attempted to reconcile different stances by claiming that the
politics of history was nothing new and was not actually neglected after
1989. The only issue which had not received enough attention was the re-
membrance of *Solidarność* and its role in the process of overthrowing the
Communist regime.[72] Marcin Kula, a professor of history, protested against
any attempts to involve historians in politics. He criticized the idea of "one
true history" being popularized in society, and opted for constant research
and debate. He noted a serious concern that history will be instrumentalized,
which would resemble the communist ideologization of the past. Con-
versely, he pointed out that recent history was in fact being studied and its
important events and anniversaries commemorated.[73] Kula's voice is sig-
nificant because he is one of the more active researchers and promoters of
contemporary history as an editor of the series *In the country of the Polish
People's Republic*, which includes almost forty volumes about the social,
political, economic, and cultural history of Communism in Poland.

The PiS government meanwhile reshaped its program on the "politics
of history." On May 2, 2006, the Ministry of Culture and National Heri-
tage announced the creation of a Museum of Polish History which would
"undertake civil and patriotic education (…) emphasizing exceptional,
specific and fascinating elements of Polish history."[74] In an essay entitled
"History: A Space for Dialogue," Traba expressed his hope and faith that
before this museum was opened, there would be a public debate, and that
politicians would not dictate either "affirmative" or "critical" approaches
to history.[75] As a matter of fact, there are many examples showing that the

[70] Paweł Wroński, "Polityka historyczna. Fundament IV RP" [The politics of history: The
 foundation of the fourth polish republic], *Gazeta Wyborcza* (31 March 2006): 4; "Polska
 polityka historyczna" [The Polish policy of history], *Biuletyn IPN* 5 (2006).
[71] Wroński, "Polityka," 4.
[72] Paweł Machcewicz, "Polityka historyczna to nic nowego" [The politics of history is
 nothing new], *Gazeta Wyborcza* (20 April 2006): 20.
[73] Editorial, "Polityka historyczna—za i przeciw" [Politics of history—for and against],
 Mówią wieki (17 August 2006).
[74] Robert Traba, *Historia. Przestrzeń dialogu* [History: a space for dialogue] (Warsaw: ISP
 PAN, 2006), 104.
[75] Ibid., 108.

"politics of history" was realized during the post-communist period, before the PiS won the elections.[76] It is particularly visible in the establishment and activities of the Institute of National Remembrance.

<div align="center">

THE INSTITUTE OF NATIONAL REMEMBRANCE –
THE INSTITUTIONALIZATION OF HISTORY

</div>

The Institute of National Remembrance—Commission for the Prosecution of Crimes against the Polish Nation,[77] created in 1998, was invoked by the proponents of the politics of history as a good example of the popularization of recent history. The IPN was established to preserve, manage, make use of and disclose the materials of the state security agencies from the period between 1944 and 1989.[78] The three main tasks of the Institute are archival, judicial and educational. The vetting process,[79] the investigation of the Jedwabne murder[80] and the disclosure of secret agents dominated the media coverage of IPN activities. However, one of its publications, a monthly *Bulletin of the IPN*, covers a wide range of topics in contempo-

[76] The changes in the national emblem and national holidays, the removal of monuments and the amendment of the name of the state in 1989 were already part of the politics of history.

[77] The second part of the name refers to the earlier Commission, established in 1945, incorporated into the IPN.

[78] The official website of the Institute is www.ipn.gov.pl. It is partly translated into English, German, French and Russian (accessed 21 March, 2007).

[79] When the Parliament passed a bill creating the IPN on September 22, 1998, it intended first of all to start an institution appointed to hold, manage, make use of, and disclose the materials of the state security services from 1944–1989. The lustration concerns senior public officials, such as the President, members of parliament, senators, judges, public prosecutors, and top functionaries in the state-owned companies. They must sign a statement that they never cooperated with the security services between 1944 and 1990. This is then checked with the archives held by the IPN. If an incriminating file is found, the person concerned loses the office. Private persons may apply to obtain their files. The Act introduced various categories of people whose files were in the IPN: "observed party" (*pokrzywdzony*), "secret informer" (*tajny współpracownik*), "open informer" (*jawny współpracownik*). Only those who received the status of "aggrieved party" may obtain their files from the IPN. It was up to the IPN to decide whether or not to disclose the names of secret informers. See: www.ipn.gov.pl.

[80] Jan Tomasz Gross, *The Destruction of the Jewish Community in Jedwabne, Poland* (Princeton: Princeton University Press, 2001); Tomasz Łukowski, "Les conflits de discours sur le massacre de Jedwabne en Pologne," *La nouvelle Alternative* 56 (2002), available at: www.nouvelle-alternative.org/num/56/chronique1.php (accessed 21 March, 2007); Marci Shore, "Conversing with Ghosts: Jedwabne, *Żydokomuna*, and Totalitarianism," *Kritika: Explanations in Russian and Euroasian History* 6/2 (2005): 345–74.

rary Polish history. The majority of issues involve research into the political opposition, the secret police and the "observed parties," but social, religious and cultural aspects of communist history are also included.

The IPN has organized more than seventy temporary exhibitions, among them: "People and Documents of the Security Services," "For Bread and Freedom—Dissent in Communist Poland," "Celebrations of the Millennium of Poland's Baptism," "Defectors from the Polish People's Republic," "Martial Law," "Mourning the Death of Stalin," "Jerzy Popie-łuszko," "Polish Help for the Jewish Population in Bialystok under German Occupation," "The Extermination of Polish Elites—Action AB and Katyń," "Those Sentenced to Death During Stalinism and Their Fate," "Land Reform After Sixty Years—Documents and Recollections," "The Self-Defense Workers' Committee," "The State Against the Church," "The Stalinist System" and others.[81] The exhibitions varied in form: they either consisted of large panels with commentaries and pictures (especially when displayed outdoors, as for example a current exhibition in Poznań showing the victims of Martial Law) or panels accompanied by authentic objects. Each exhibition was shown in several towns, both larger and smaller, across Poland. The exhibitions presented the outcomes of research projects in the IPN archives, documenting the activities of the state apparatus for the surveillance, persecution and repression of individuals, opposition groups and the Catholic Church. Since the exhibitions used the archival documents of the former security services they reflected the regime's search for signs of opposition and discontent, its propaganda and its attempts at manipulation and conspiracy. The picture is one-sided. To take only opposition as an example, the dissidents who are the subjects of these documents frequently prove dishonest. What is more, the IPN archives overlook many other spheres of Polish life (private, social, economic, sporting activities) which are also neglected in the exhibitions organized by the IPN.

The IPN represents an attempt to institutionalize and, due to its favorable human (more than 1500 employees) and financial resources, to situate in a dominant position a particular version of Polish history. The name implies that the Institute is dealing with national remembrance; it attempts to define the way in which Poles should remember the past. It works on the assumption that an institution, with its established structure, its scheduled tasks, its clearly defined responsibilities, and assisted by a number of well-educated historians, archivists and lawyers, can create a coherent and

[81] Institute's webpage: www.ipn.gov.pl (accessed 1 December, 2006).

proper vision of the national past. The files of the security services, on the other hand, were created with a clear agenda: to investigate and to control illegal activities during the communist regime. Thus, relying on these sources, even only for scholarly research (not to mention lustration), is insufficient.

The Institute of National Remembrance—although it has given rise to several interesting research projects, the publication of extensive source material and analysis, and a number of exhibitions and conferences—was and is immersed in controversies, resulting from its mission and the founding Act, which create the possibility of the political use and abuse of historical research. A moral judgment on the past, which mixes the functions of historians and moralists, easily leads to manipulation and omission. Remembrance may easily mean forgetting, if the choice between what to remember and what to forget is made by a state institution which itself threatens the independence of scholarly research. This became even clearer after the election of the new president Janusz Kurtyka, on December 22, 2005, by the new Parliament with a PiS majority. The election resulted in immediate changes in the IPN staff, which also increased expectations of a rapid and widespread vetting as well as possible changes to the research agenda. Recently the IPN has supported an initiative of the PiS to change the last remaining street and square names as well as monuments and plaques related to the communist period.[82]

EVOKING COMMUNISM: TO FORGET AND TO REMEMBER

The relationship between the representation of Communism in exhibitions and contemporary Polish politics is vague and complex at the same time. In the case of an institution such as the IPN, politicians had and have a significant influence on its activity (for example, its president is appointed by Parliament). The recent idea of creating a Museum of Freedom as an expression of the idea of "politics of history" was formulated by politicians and supporters of the current government formed by the Law and Justice Party. Their idea of history encompassed both moral duties and a nationalist perspective on the past. The Karta Center, though a non-governmental organization, depends not only on its employees and volunteers but also on the support of state institutions and their funding for the scope and success of its activities. The realization of the project of the

[82] A press release of February 21, 2007. See IPN webpage: www.ipn.gov.pl/wai/pl/ 305/4663/ (accessed 21 March, 2007).

Socland Museum of Communism in Warsaw also requires substantial funding and, clearly, the support of political parties. The present PiS government, supporting a "politics of history," may prove to be a difficult partner when it comes to give both financial assistance and freedom of realization.

However, I do not think that there is a clear link between political parties, subcultures and the different projects. Many projects received state funding during the government of the Democratic Left Alliance,[83] while it might have been assumed that the Alliance, as a successor to the Polish United Workers' Party, would not be in favor of them. At the same time, the establishment of the IPN and the politics of history show that, for some politicians and parties that attempt to use the legacy of the *Solidarność* movement, dealing with the past is an important aspect of politics. The character of the exhibitions in Kozłówka and the Ethnographic Museum in Warsaw was defined by the curators and there were no links to political groups. The Internet Museum of People's Poland and the commercial Proletaryat Café are private initiatives and their message seems to be that anybody can create his or her own version of the representation of Communism, and that the field is not restricted to historians and other professionals.

Many of the existing exhibitions and museums offer a display of objects representing the communist period in Poland without any reference to the life of people in the PRL, the nature of the system or the emergence of dissent and opposition, and many other themes. These exhibitions offer a collection of items, either art (in the Ethnographic Museum and in Kozłówka) or documents, photographs and objects (Internet Museum, Proletaryat Café) without any background narrative. Such an attitude actually leads to an a-historical view of the communist period. In the case of Proletaryat Café, the owners offered a mixture of objects from different times and places. Communism is thus turned into an allegorical past as it is not situated in a proper historical context.

Narrative representations of the communist period were created in the Karta exhibition entitled "Faces of Totalitarianism," temporary exhibitions organized by the SocLand Foundation, The Karta Center and the IPN, the SocLand catalogue of the Museum of Communism and the pro-

[83] The Democratic Left Alliance triumphed at the elections in 1993 (it was the second largest party in 1991 and 1997) and the former minister of the Polish United Workers' Party, Aleksander Kwaśniewski, won the presidential elections in 1995 and 2001. See Kate Hudson, *European Communism since 1989: Toward a New European Left?* (New York: Palgrave, 2000), 202–7.

ject of the Museum of Freedom. These narratives had several themes in common. First, the emphasis on the totalitarian nature of the system, its repressive character, and sometimes, its imposition from outside. Second, the strong nationalist overtones in some projects and the linkage between the treatment of the past and moral issues. Third, the restriction of the history of people living in the Polish People's Republic to opposition circles (individuals, organizations, the Catholic Church) and circles of power (security agents, political leaders). This representation (in Karta, IPN) resulted from their background, the character of their sources, and related research projects. In some projects, a peculiar *homo sovieticus* appeared—the "other" in contemporary society—and remained undefined, a-historical and imaginary.

Finally, the exhibitions and museums of Communism reflected different attitudes to the question of authentic objects from the past. In some cases, the curators decided to use authentic sounds and enlarged photographs and documents as the best way, in their opinion, to give testimony about a selected event (especially in the Karta exhibitions). This attitude results not only from the character of the Karta collection but probably also from its distrust of museums. The exhibitions organized by the IPN consist mainly of large panels with texts and photographs while objects are only sometimes used as illustrations. The Internet Museum offers no possibility of a direct relationship between the visitor and genuine historical objects, there are only copies on-line. Other exhibitions were based on authentic historical objects, but these objects were either mainly works of art–paintings, drawings, sculptures, etc. (exhibitions in the Ethnographic Museum and Kozłówka)–or if they were authentic historical objects they were mixed with modern copies without any explanations (Proletaryt Café). Only the temporary SocLand exhibitions offered a larger and more diverse selection of objects as well as installations.

In my view, the limited use of authentic objects results from the lack of collections in museums and institutions, which also leads to similar ways of representing Communism in subsequent exhibitions. There are many private collections, often resulting from a fascination among younger Poles with the art and objects of the period. Such fascination would be aroused by the creation of a narrative display of historical objects representing personal experiences and memories of the PRL, not limited to opposition and repression but showing a wide range of human experiences. However, the current political atmosphere, with its condemnation of the previous regime and its nationalistic program, offers hardly any space for such projects, especially since those constructed by independent

groups like The Karta Center, actually offer a representation of the Polish People's Republic as opposition of oppressors and oppressed which is structurally similar to the politically-driven narrative of the current government.

About the Authors

Péter Apor (b. 1971) is a research fellow at Pasts Inc., Center for Historical Studies at the Central European University. His dissertation on communist representations of history in Hungary was defended at the European University Institute in Florence in 2002. His main research themes include the politics of history and memory, popular culture, and the history of historiography.

Gabriela Cristea (b. 1980) is a research assistant at the Romanian Peasant Museum, Bucharest. She received her MA degree in Sociology and Social Anthropology from the Central European University. She is editor and host of the *Realitatea TV* programs "Old customs of Romania" and "Euro-patches in Central and Eastern Europe." Her research interests are ethnography, urban studies, museography, and the representations of Communism.

Nevena Daković (b. 1964) is associate professor of Film Theory and Film Studies in the Department of Theory and History at the University of Arts in Belgrade, Serbia. Her research focuses on representations of national and multicultural identity in cinema. She is the author of *Melodrama is Not a Genre* (1995) and *Dictionary of Film Theoreticians* (2002).

Petra Dominková (b. 1972) is a lecturer at the Council on International Educational Exchange (CIEE) and teaches at the East and Central European Studies (ECES) program at Charles University, Prague. She is currently enrolled in postgraduate studies at FAMU. Her research interests include Czech and Eastern European cinema, feminist film theory, and *film noir*.

Zsolt K. Horváth (b. 1972) is assistant professor in the Department of Theory of Art and Media Studies at Loránd Eötvös University, Budapest. He is finishing a PhD dissertation at the École des Hautes Études en Sciences Sociales, Paris and at the Atelier Center, ELTE, Budapest. His research interests include the study of collective memory, historical representations in monuments, museums and films.

Izabella Main (b. 1972) is a lecturer in the Institute of Ethnology and Cultural Anthropology, Adam Mickiewicz University, Poznań. She published on political and religious rituals, monuments and memory. Her research interests include historical anthropology (monuments, memory and space), the social and cultural history of Poland, and religious phenomena in the 20th and 21st centuries.

James Mark (b. 1972) is a lecturer at the University of Exeter, United Kingdom. His research interests include the social history of Communism and the political and social memory of Communism in post-communist Central and Eastern Europe. His studies have been published in *Past and Present*, the *Historical Journal* and *Europe-Asia Studies*.

Kacper Pobłocki (b. 1980) is doctoral candidate in the Department of Sociology and Social Anthropology at the Central European University, Budapest. His dissertation project *Space, Class and Capitalism in Central Poland* traces the Polish "protracted transition" to flexible capitalism (1976–2006). His research focuses on the region surrounding the city of Łódź.

Simina Radu-Bucurenci (b. 1980) is a doctoral candidate in history at the Central European University, Budapest and research assistant at the Romanian Peasant Museum, Bucharest. Her research interests include the status of documentary images under the Communist regimes of Central and Eastern Europe and the reassessment of the Communist past in these countries.

István Rév (b. 1951) is Director of the OSA Archivum and professor in the History Department at the Central European University, Budapest. He has taught at the University of Chicago Law School; Jesus College, Oxford; the Political Science Department at Columbia University; the Anthropology Department at Princeton University; and on the History and Literature Program at Harvard University. He is the author of *Economic*

and Social History of Hungary in the Period of "Socialism" (1990) and *Retroactive Justice: Prehistories of Postcommunism* (2005).

Oksana Sarkisova (b. 1974) is a research archivist at OSA Archivum and program director of the International Documentary Film Festival Verzio in Budapest. She holds a doctoral degree in History from the Central European University, Budapest. Her publications and research interests pertain to visual anthropology, ethnographic cinema, Russian and Eastern European cinema, and visual culture.

Alexandru Solomon (b. 1966) is a filmmaker, based in Bucharest. He has written, photographed, and directed several documentaries based on recent history and culture, broadcast on the BBC, Arte, ZDF, and other international channels, and screened at numerous festivals. He is currently producing a film on Radio Free Europe.

Renáta Uitz (b. 1973) is associate professor of Comparative Constitutional Law in the Legal Studies Department of the Central European University, Budapest. Her research interests include the transition to democracy, problems of transitional justice, the rule of law and constitutionalism in post-authoritarian democracies. Her book *Constitutions, Courts and History: Historical Narratives in Constitutional Adjudication* was published in 2005.

Balázs Varga (b. 1970) is a film historian and researcher at the Hungarian National Film Archive. He is co-editor of the film quarterly *Metropolis*. He is currently finishing his doctoral project *Ideologies, Politics and Social Representation in Hungarian Films of the 1950s and 1960s* at Eötvös Loránd University (ELTE) in Budapest. His research interests include post-World War II European and Hungarian film history.

Nikolai Vukov (b. 1971) is a research associate at the Institute of Folklore in the Bulgarian Academy of Sciences and assistant professor in the Department of Anthropology at the New Bulgarian University, Sofia. He holds a doctoral degree in anthropology from the Bulgarian Academy of Sciences and a doctoral degree in history from the Central European University. His research interests include socialist and post-socialist monuments in Central and Eastern Europe, the historical anthropology of death and commemorations, and the politics of memory in 20th century Europe.

Name Index

Subject Index